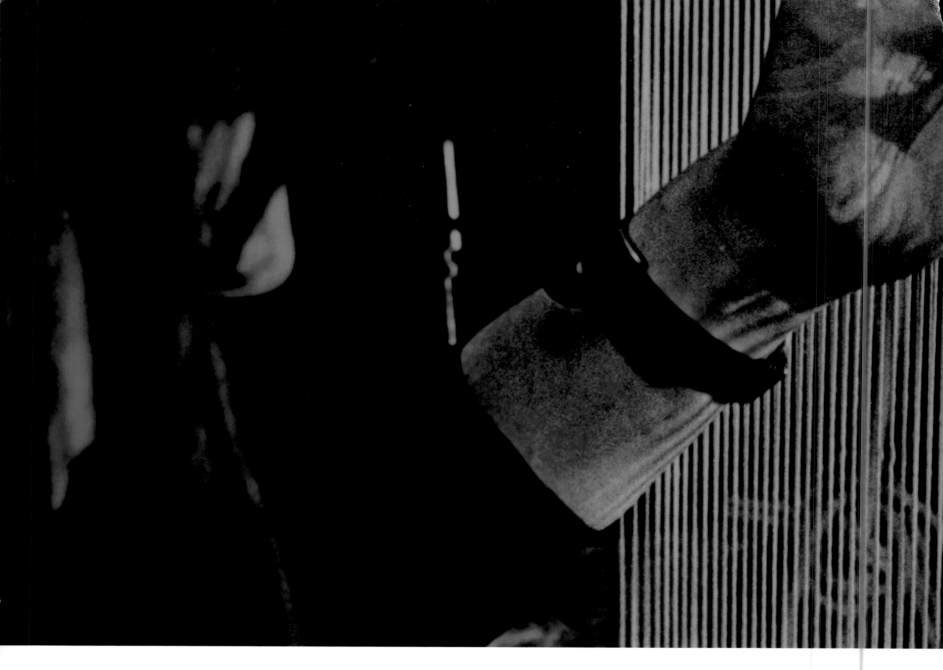

Gloria F. Ross

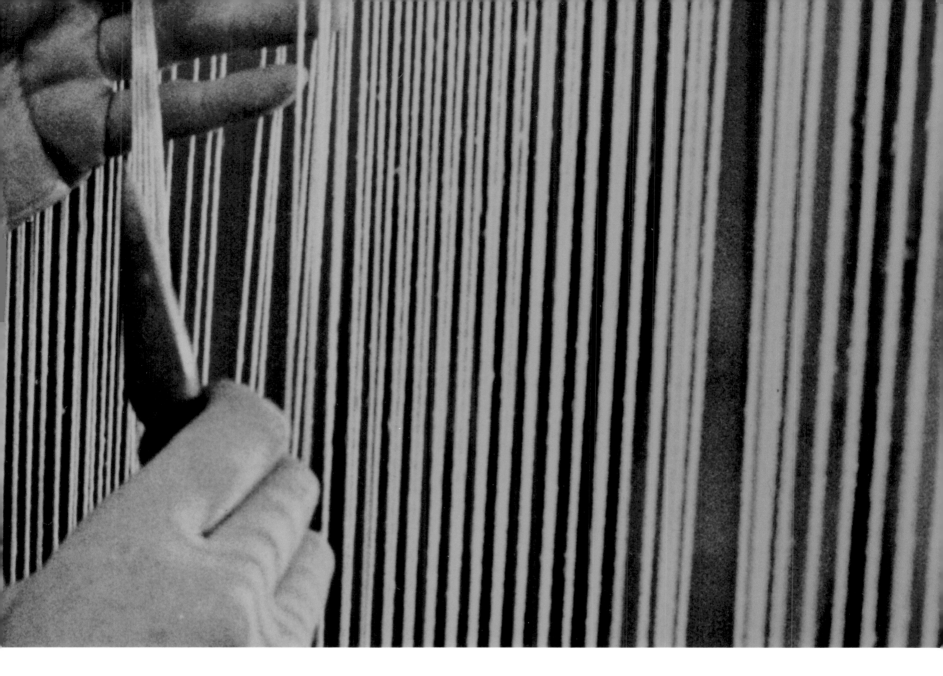

& Modern Tapestry

ANN LANE HEDLUND

FOREWORD BY GRACE GLUECK

YALE UNIVERSITY PRESS, NEW HAVEN AND LONDON

IN ASSOCIATION WITH

ARIZONA STATE MUSEUM, THE UNIVERSITY OF ARIZONA, TUCSON

To my mother
father
sister
husband
with deep thanks
for a loving family

This book was made possible by grants from the Gloria F. Ross Foundation, New York, to the non-profit Gloria F. Ross Center for Tapestry Studies, Inc. (1997–2009) and to the University of Arizona Foundation (2009–10) in Tucson. Following the corporate dissolution of the GFR Center in 2010, the Gloria F. Ross Tapestry Program & Fund was established as a research unit of the Arizona State Museum, University of Arizona, Tucson. The mission of the GFR Tapestry Program, like that of the former GFR Center, is *to foster the creative practice and cultural study of handwoven tapestries, used worldwide from ancient to modern times.*

Library of Congress Cataloging-in-Publication Data
Hedlund, Ann Lane, 1952-
 Gloria F. Ross & modern tapestry / Ann Lane Hedlund.
 p. cm.
 Includes bibliographical references and index.
 ISBN 978-0-300-16635-4
 1. Ross, Gloria F.—Criticism and interpretation.
 2. Tapestry—United States—History—20th century.
 I. Ross, Gloria F. II. Title. III. Title: Gloria F. Ross and modern tapestry.
 NK3012.A3R634 2010
 746.392—dc22 2010029172

Published by Yale University Press
P.O. Box 209040
302 Temple Street
New Haven, Connecticut 06520-9040
www.yalebooks.com

In association with Arizona State Museum
The University of Arizona
Tucson, Arizona 85721-0026
www.tapestrycenter.org

Edited by Elizabeth Hadas
Proofread by Carrie Wicks
Indexed by Madelyn Cook
Designed by Jeff Wincapaw
Typeset by Marissa Meyer
Produced by Marquand Books, Inc., Seattle
 www.marquand.com
Printed and bound in China by Artron Color Printing, Ltd.

Except in chapter 7 and where otherwise indicated, all photographs are by Gloria F. Ross. In chapter 7, photographs are by the author unless otherwise noted. Reference materials and images are from the Gloria F. Ross Papers, Archives of American Art, Smithsonian Institution, Washington DC, unless otherwise identified.

Front cover: Detail, Conrad Marca-Relli, "after *Multiple Image*," 1975–90, woven by Pinton. © Archivio Marca-Relli, Parma/Estate of Gloria F. Ross. Photo courtesy of Minneapolis Institute of Arts. (See plate 41.)
Back cover: Gloria Ross at the former Richard Feigen Gallery, 27 East 79th Street, New York, 1971. The Helen Frankenthaler tapestry, "after *1969 Provincetown Study*," is visible through the doorway. Photo by Clifford Ross.
Page i: Detail, black-and-white cartoon (with colors reversed) for Jack Youngerman's "*Enter Magenta II*," GFR Papers. (See plate 94.)
Title pages [ii–iii]: Detail, Fiona Mathison at the loom, 1972. Courtesy of Dovecot Studios.
Page iv: Detail, *bolduc* (label) for Louise Nevelson's "*Desert*" (Unique no. 3) with insignia of Dovecot Studios. Photo by the author. (See plate 51.)
Page v (top left): Detail, Helen Frankenthaler, "after *1969 Provincetown Study*," 1970–90, woven by Dovecot Studios and Micheline Henry. (See plate 21.)
Page v (bottom right): Sample of canvas color for white lines in Frank Stella's "after *Flin Flon XIII*." GFR Papers. (See plate 89.)
Page 1: Gloria F. Ross, 1979. Photographer unknown.
Page 7: Gloria, *rear*, and sister Marjorie Iseman, *front*, at Richard Feigen Gallery, New York, 1969. Photo by Clifford Ross.
Page 37: Detail, Fiona Mathison at the loom, 1972. Courtesy of Dovecot Studios.
Page 59: At the Pinton atelier, Felletin, France, 1972. Photographer unknown.
Page 91: Spider Woman Rock, Canyon de Chelly, Arizona, 2002. Photo by the author.
Page 119: Many weavers at one loom, 1972. Courtesy of Dovecot Studios.
Page 301: Gloria entering Richard Feigen Gallery, New York, 1969. Photo by Clifford Ross.
Page 325: Detail, Robert Motherwell, "*Homage to Rafael Alberti-Blue*," 1970–71, hooked by Anna di Giovanni. © Dedalus Foundation/Licensed by VAGA, New York. Photo by Eric Pollitzer. (See plate 43.)

Contents

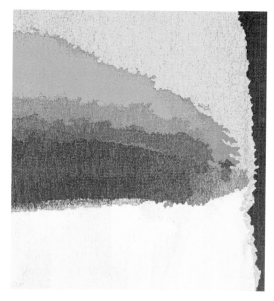

COLLABORATIONS

NEW YORK

Starting a Workshop

SCOTLAND

Understanding Handwoven Tapestry

FRANCE

Exploring Tapestry's Roots

THE AMERICAN SOUTHWEST

Continuing Traditions

THE ARTISTS, THE WORKS

Working with Painters and Sculptors

Anuszkiewicz—Avery—Bearden—
G. Davis—S. Davis—Dubuffet—Feeley—
Frankenthaler—Goodnough—Gottlieb—
Held—Hofmann—Jenkins—Liberman—
Lindner—Louis—Marca-Relli—Motherwell—
Nevelson—Noland—Podwal—Poons—
Ross—Samaras—Smith—Stella—Trova—
Youngerman—plates 1–96

TAPESTRY IN THE LATE TWENTIETH CENTURY

Valuing Tapestry

How did I first get to know Gloria Ross? Was it on the tennis court, where she could be a powerful partner as well as a formidable opponent? Or was it on the telephone via her occasional calls to praise or politely take issue with a story I had written in the *New York Times*? (One of these calls, I remember, was to alert me to what she saw as inadequate storage facilities for textiles at the Museum of the American Indian, then in cramped uptown Manhattan quarters.)

In any case, as we began to get better acquainted in the early 1970s, I was attracted to her live-wire connection with art, artists, and artisans. Her inviting apartment on East 87th Street, shared with her second husband, Dr. John Bookman, reflected her wide-ranging tastes, with paintings and sculptures by Léger, Matisse, and Calder, and lamps by Diego Giacometti. They mingled happily with objects like a T'ang porcelain horse, an eighteenth-century English breakfront, and an antique lazy Susan of Minton china that she found in Edinburgh. (Gloria was a fond collector, spelled with a small "c," not the "C" that designates more socially ambitious art acquisitors.)

I wasn't initially aware that she was a practicing craftsperson in her own right, with a passion for making woven wall hangings. She had done needlework since childhood, stitching a telephone book cover and desk accessories, and even crocheting an afghan from a Mondrian painting, to the bemusement of family and friends.

But in the mid-1960s, she became aware of possibilities other than her own creations. Why not give the work of painters and sculptors a new presence by extending it into the medium of woven wool?

She had been spurred, perhaps, by a tapestry show at the Stephen Radich Gallery in Manhattan and, for starters, she was not unlucky in having Helen Frankenthaler as a sister and Robert Motherwell as a brother-in-law. She had used motifs by them in her early hooked rug hangings, and it was with their imagery that she began her new venture. When I got to know her, she had achieved considerable status in the field, less as a creator of images than as an inspired facilitator, translating the work of contemporary artists into the lively medium of woven surfaces. By then she had closed her own New York workshop and was contracting with weavers in Scotland and France, among other places.

Now for a confession. At the time I met Gloria, you could put what I knew about the long chronicle of tapestry into a fly's eye. Oh, I was acquainted, of course, with what is shown of the magnificent fifteenth-century Unicorn series at the Cloisters of the Metropolitan Museum in New York, and aware of the accomplishments of contemporary European artists like Lurçat and Miró.

As an art lover and reviewer, I gave my real attention in those days to flat painting on a canvas support. The thought that a two-dimensional painted surface might take on the body and fabricky texture of woven wool didn't really appeal. And then, like some others in the art world, I felt that an existing image translated into another medium was—well, a compromised copy, a kind of violation. I didn't fathom that such work, like an etching after a painting, could be a vital image in its own right while conveying the content and flavor of the original.

When I saw some of the creations that Gloria orchestrated by working hand in glove with artists and artisans, my mindset began to shift. Initially inexperienced at working with what others had wrought, she went about learning the process with impressive dedication and strove to do it right: divining how the imagery of a particular artist would lend itself to the new medium; learning to negotiate and work with professional weavers, from long-established European firms to Indians of the Southwest; and securing clients for the results.

Sometimes she selected existing painted images; at other points she would persuade or encourage artists to make entirely new works for the medium. She embraced this very communal experience with characteristic vigor and enthusiasm. She worked over a period of thirty-odd years with some thirty artists—besides Frankenthaler and Motherwell they included Milton Avery, Louise Nevelson, Romare Bearden, Jack Youngerman, Lucas Samaras, Frank Stella, Kenneth Noland, and her own son Clifford Ross, among others. One artist, Mark Podwal, also happened to be her dermatologist. She was responsible for the production of at least 100 tapestry designs and nearly 250 individual works.

Added to my increasing awareness, one of Gloria's greatest coups was the remarkable series of tapestries that emerged from her collaboration with Kenneth Noland and Navajo weavers. She spoke of this as "the truest collaboration I've ever brought about." It produced nineteen tapestries woven by five Navajo loom masters plus an additional six created by Ramona Sakiestewa, a noted Pueblo weaver from Santa Fe. While accustomed to working with sophisticated ateliers in New York and Europe, Gloria had long admired the Navajo artisans of our own Southwest and wondered if their fabled weaving know-how might be enlisted for her enterprise. But how to approach them? She knew little about them and how they might respond.

To shorten a long story, after extensive research from her New York base, Gloria made her initial foray into Navajo country in 1979, where she arranged to meet and travel with the cultural anthropologist and author of this book, Ann Lane Hedlund. It was Hedlund's

knowledge of Southwest cultures and acquaintance with local native peoples that made possible the spectacular results of the venture. Through her, Gloria was able to find traditional weavers fully capable of matching their own techniques with Noland's intricately calculated stripes and chevrons and ready to make tapestry history. For the full version of this remarkable event, read Dr. Hedlund's account in chapter 7.

Another prolific artist was Jack Youngerman, whose vibrantly colored hard-edge imagery was translated by an American, a French, and even a Chinese workshop into no less than seven tapestry projects—two of them for substantial public buildings. Youngerman liked tapestries for "the softness and sensuality they bring to the hardness of paint," he said in a recent conversation. And he enjoyed working with Gloria. "On the whole, she was a very civilized person," he mused, "very much aware of the art scene in New York. Perhaps because of her comfortable life, she seemed a little removed, a little grand. But I liked the fact that she took tapestry seriously as a form. And she was very careful about everything she did."

Indeed, the care with which she did things and related to people was one of Gloria's great gifts. The "comfortable life" that Youngerman speaks of was made possible by family money. Her parents set high standards for their three daughters (Gloria was the middle one); they were well schooled, socially adept, intellectually aware, and not entirely lacking in a sense of entitlement. Still, Gloria could operate on many wavelengths, as evidenced by the friendships she formed with artists and artisans from Southwest Indian women to the likes of Youngerman and Motherwell.

Personally, I couldn't ask for a more compatible friend, although her strong self-discipline put mine to shame. (One example: she rarely took taxis, proclaiming that Manhattan was made to be walked in.) She was always there when she said she'd be, responded to birthdays and other important occasions, and would go out of her way to do a favor. And despite her intense involvement with her projects, she had a keen sense of fun. One of her foibles was an arrangement with the New York State Lottery, which automatically chose numbers for her and on which she gleefully collected more than once.

Her mild manner did not entirely conceal definite opinions, likes, and dislikes, as people who knew her longer than I did attest. Madeleine Plonsker, a Chicago art collector and patron who shared with Gloria a Mount Holyoke education and served with her on the advisory committee to the college art museum, saw her as "a really connected person. She was very verbal, aggressive, didn't hesitate to speak her mind. Everything about her was knowledgeable and direct. She had

all this expertise, but didn't toot her horn. She conducted herself in a background sort of way, but she was clearly in charge."

Another Holyoke alum, Odyssia Skouras Quadrani, a power on the committee in Gloria's time, remembers: "Gloria put her heart in whatever she undertook, and she did things very, very well. She was opinionated, but in a way she had a broader vision for the college museum than most other members. For example, her donation of some prints by André Masson brought a Surrealist voice to the collection that hadn't even been thought of before."

Gloria undertook her last tapestry project in 1994 with Mark Podwal, who specialized in Jewish themes. As her 150th anniversary gift to Temple Emanu-El, the upscale bastion of Reform Judaism on Fifth Avenue where her family attended services for many years, she commissioned him to design a tapestry curtain and Torah covers for the Ark in the temple's main sanctuary and arranged for their weaving in France.

Podwal's eloquent, richly symbolic designs took some time to reach final approval. Their execution was further delayed by many factors, both human and technical, local and global.

But Podwal found that Gloria worked through the ordeal with patience and fortitude. She was, he said, "extremely helpful and professional," and the project was ultimately celebrated by artist, officials, temple-goers, and Gloria. She lived long enough to relish the tapestry's charismatic presence, a final testimonial to a career of inspired accomplishment.

—Grace Glueck

Beginnings

I met Gloria Ross in 1979 after she had flown from New York to Albuquerque and taken a late-night bus to Gallup, New Mexico. Some days earlier, I had written in my field journal, "Mrs. Gloria Ross called this am re: a NYC tapestry firm she runs. Is interested in Navajo weavers commissioned to weave her U.S.A. artists' designs/plans. Kenneth Noland has done 2 striped paintings to be done"[1]

Gloria arrived in Navajo country via Continental bus. I remember the company because I went first to the Greyhound station to meet her. I waited from half past nine until nearly midnight, but no bus and no Mrs. Ross arrived. Meanwhile, she was waiting for me across town on the old Route 66 strip. Continental had no formal station in Gallup. As it got later, a local motel owner took pity on the New York traveler standing on the dark roadside with her bags and invited her inside the neon-lit office. When I finally located her, relief was palpable for all of us.

Gloria came to the Southwest because she wanted to engage Navajo weavers in her latest enterprise. For well over a decade, she'd already worked with mainstream American and European artists and orchestrated many tapestry projects in France and Scotland. Through her efforts, painted imagery was "translated," not reproduced, into a handwoven tapestry. Always sensitive to others calling this "copying," she and her collaborators took pains to interpret the artistic intent and use a weaverly approach. In 1979 she hoped to work in similar fashion with Navajo weavers.

A Friendship

Although I never took part in her tapestry making business, I provided a bridge, through my contacts as a cultural anthropologist, to Navajo and Hopi weavers, Native American culture, and museum projects during one segment of Gloria Ross's career. At the time we met, I was conducting doctoral field research around the Navajo Nation and consulting with several museums. Once we started traveling together, her curiosity often furthered my research questions and her grants fueled my summerlong fieldwork. For eighteen years, we shared a friendship of ideas and adventures.

Born in 1923, Gloria was close to my own mother's age and I, born in 1952, am her youngest son's age. She and I traveled together in the American Southwest for a week or two almost every summer between 1979 and 1994, and throughout each year we talked for hours on the phone and exchanged constant faxes. If we had used email back then, the networks would have bulged with our messages.

We became close because of common interests in historic and contemporary arts, worldwide textiles, and museums (both their positive contributions and the juicy scandals),

all the while delighting in the distinct contrasts of our lives due to age, background, geography, and myriad other differences. She was an urban New Yorker with a domineering attitude who could overtalk and out-talk me anytime. She also had great curiosity and was a good listener, asking penetrating questions when entering new territory. Her undergraduate degree in economics was followed by years of dedicated volunteering. Raised outside Washington DC and trained as a social scientist and weaver, I was, and still am, an enthusiastic scholar of the American Southwest, with a fondness for outdoor adventures and gardening. My doctorate in cultural anthropology paved the way for an academic career in museums. Fascinated with each other's lives, we could drive for miles and hours, never lacking for a subject; my dusty red VW bug was never silent on our backcountry trips together.

Making This Book

Only after Gloria's death in 1998 did I begin work on a book about her career. My research and writing have brought back the many conversations in which Gloria's contemporary art interests and my cultural anthropology formed counterpoints. Originally, I envisioned a coffee-table book, a simple showcase for the wide scope of her tapestries. However, when Gloria's exhaustive archives became available to me, I realized that a detailed history was possible and that it would enable readers to understand the negotiations and collaborations that were a crucial part of Gloria's body of work. The project has evolved into a profile of a career and how it was forged; essentially it has become an ethnographic study of a unique career in the arts.

It is important to understand that my knowledge of Gloria Ross's life is drawn only from what she shared with me from 1979 to 1998 and from her extensive files, which I consulted after her death. I do not pretend to comprehend or portray the complexities of her life beyond what is presented here. Interviews with a wider circle of associates would undoubtedly offer fresh ideas and perspectives.

Work on a manuscript began in earnest during 1998 when the GFR Center in Tucson received a multitude of file boxes from the Gloria F. Ross estate in New York. Gloria kept meticulous notes, handwritten and full of abbreviations, about every meeting, phone call, or conversation in which her tapestries were discussed. She and several part-time assistants filed originals and cross-filed copies of notes, correspondence, bills and all other documentation for the tapestries. More than ten thousand papers, photos, yarn samples, and other records compose the GFR Papers, to become part of the national Archives of American Art of the Smithsonian Institution, Washington DC.

For several years in my office at Arizona State Museum, a team of student workers and volunteers scanned all documents and entered concise information into a FileMaker Pro database. Once we processed the records and constructed finder's guides, substantive investigations and writing commenced in summer 2005. We sought additional information and conducted interviews from 2006 to 2008. These resources are documented in the endnotes throughout this volume and in its bibliography; more detailed references are maintained in my research files.[2]

The color plates presented here are the results of an elaborate and near-miraculous process. Most of the GFR Tapestries & Carpets were photographed by professionals in New York shortly after they arrived from weaving studios. The large format transparencies (4 × 5s, 5 × 7s, and 8 × 10s) remained in dark files through many years. While the photographic details remained perfectly sharp, the colors shifted and faded over time. In 2009, Richard McBain of Centric Photo Processing in Tucson, Arizona, scanned each transparency at high resolution (resulting in files of about 200 MB for each image). With modern software he adjusted the photos' colors to match the original woven trials and yarn samples that are preserved among the GFR Papers. The comparisons with these still-brilliant archival materials enabled us to produce color plates that are remarkably faithful to the original tapestries.

Although there is much writing herein, I found my model for this book not in writing but in exhibiting, and specifically from Katharine Kuh's descriptions of her 1948–49 retrospective on the art of Vincent van Gogh. "The aim," she writes, "was to show rather than to tell. Being told rarely compensates for finding out. My hope was to illuminate the artist's work through visual comparisons, contrasts, analyses, and strategically placed questions encouraging the viewer to become more than a passive observer." In that original blockbuster, Kuh notes, "Color charts, linear graphs, everyday objects, photographs, maps, original works of art, X-rays, and much more were included."[3] Similarly, I have included as much as possible from Gloria's archives to show the workings of a complex creative process.

Acknowledgments

I am deeply grateful to many people and institutions for their valuable contributions to this book. Any errors, omissions, or other misalignments with reality are, of course, entirely my responsibility. I offer heartfelt thanks to dozens of individuals and organizations.

The generous trustees of the Gloria F. Ross Foundation, New York—Michael I. Katz, Elizabeth H. Froelich, and the late Henry Kohn.

The encouraging and enlightening members of the Board of Trustees for the Gloria F. Ross Center for Tapestry Studies—Alice M. Zrebiec (president), Sue Walker (emerita), Lotus Stack (emerita), Ramona Sakiestewa, Susan Brown McGreevy (secretary), Helena Hernmarck (emerita), Margi P. Fox (treasurer), Hal Einhorn (emeritus), Darienne Dennis (emerita), Archie Brennan (emeritus), and Ann Bookman (emerita).

The GFR Center's able administrative assistant Bobbie Gibel (2001–9), and former assistants Nancy Chilton, Lucia Andronescu, and Angelica Afanador. The GFR Center's capable staff and consultants—Madelyn Cook, permissions coordinator and indexer; Linda Gosner, reproduction rights coordinator; Rachel Freer, research assistant; Richard McBain, Centric Photographic Processing; Judith Billings, volunteer/glossary contributor; Olga Neuts, volunteer/photograph organizer; Darden Bradshaw, Heather Mikolai, Karen Pennesi, and Nick Smith, dedicated student assistants; Kyoko Higuchi and Anna Musun Miller, inspiring interns; Jennifer Treece, bookkeeper; Ludwig Klewer & Associates, accountants; Mark A. Stempel, financial adviser; and Susan M. Freund and Costa Leonidas Papson, legal counsel. Major donors to the GFR Center Library—Helga Berry and Joan Jacobson. Supportive members of the GFR Center Associates Program—too numerous to name and too important to leave out.

The Archives of American Art, Smithsonian Institution, Washington DC—for an extended loan of the Gloria F. Ross Papers between 1998 and 2011. Helpful museum specialists—LaRee Bates, archivist, Heard Museum; Catherine Giraud, Centre de documentation d'Aubusson, and Michèle Giffre and Suzanne Bourré, le Musée départemental de la tapisserie, Aubusson, France. Staff members of institutions that generously provided supporting materials—the Art Institute of Chicago; Bard College; Center for Creative Photography, University of Arizona; Cleveland Museum of Art; Corcoran Art Gallery; Dedalus Foundation; Denver Art Museum; Fondation Dubuffet; the Frances Lehman Loeb Art Center, Vassar College; Herbert and Eileen Bernard Museum of Judaica, Congregation Emanu-El; Georgia O'Keeffe Museum; Joslyn Art Museum; Kreeger Museum; Louisiana Arts and Science Center; the Metropolitan Museum of Art; Minneapolis Institute of Arts; Mount Holyoke College Art Museum; Museum of Fine Arts Boston; Museum of Northern Arizona; Neuberger Museum of Art; Palmer Museum of Art of The Pennsylvania State University; Racine Museum of Art; Scottish Arts Council; the Textile Museum; Tougaloo University; Wheelwright Museum; and Yale University Art Gallery. Expert copyright purveyors—Janet Hicks, Adrienne Fields and colleagues, Artists Rights Society (ARS), and Robert Panzer, Visual Artists and Galleries Association, Inc. (VAGA).

Designers of the GFR Tapestries & Carpets—especially Helen Frankenthaler, Mark Podwal, Frank Stella, Jack Youngerman, and the late Kenneth Noland. And the artists' dedicated representatives—Maureen St. Onge for Helen Frankenthaler; Katy Rogers, Dedalus Foundation for Robert Motherwell; Maria Nevelson, Louise Nevelson Foundation; Sophie Webel, Fondation Dubuffet; trustees of the Paul Feeley estate; Victoria Woodhull and Sterling Robinson for Kenneth Noland; Nancy Litwin, Adolph and Esther Gottlieb Foundation; Paula Pelosi for Frank Stella; Earl Davis for Stuart Davis; and Andrea Foggle Plotkin, Roy Lichtenstein Foundation.

Tapestry studios, weavers, and relatives of those involved in making the GFR Tapestries & Carpets: In France, Olivier and Marie Pinton, François Pinton, Lucas Pinton, Félicie Ferret, and Christine Baillon, Manufacture Pinton; Micheline Henry and Patrice Sully-Matégot, Angers. In Scotland, director David Weir, head weaver Douglas Grierson, and staff members at the Dovecot Studios, Edinburgh Tapestry Company; Gerald Ogilvie-Laing, Kinkell Castle. In the United States, Archie Brennan, Carole Kunstadt, Mollie Fletcher, Ramona Sakiestewa; Navajo weavers Mary Lee Henderson Begay, Irene Clark, Sadie Curtis, Martha Terry, and the late Rose Owens; and Nancy Kinneer-Luckey, Betsy Kinneer Fields, and Mary Gail Adams, descendants of the original Hound Dog Hookers.

Galleries and art dealers: Dick Solomon, Pace Editions; Arne Glimcher, PaceWildenstein Gallery; and Jane Kahan and Charles Mathes, Jane Kahan Gallery. Also Richard Feigen, Richard L. Feigen & Co.; Karen Swager, Brunk Auctions; Carly Sharon, Neil Meltzer Fine Art; Alice Kauffman, formerly with Gallery 10; and Rutgers Barclay, the former Rutgers Barclay Gallery.

Owners of GFR Tapestries & Carpets: the institutions and corporations listed in the GFR Tapestries & Carpets Checklist, and many generous private collectors.

Creative and scholarly associates from the textile arts world—Susanna Cuyler, Nathalie Fontes, Sheila Hicks, Christine Laffer, Jack Lenor Larsen, Jean Pierre LaRochette and Yael Lurie, Susan Martin Maffei, Rita Maran, Jean Manuel de Noronha, Ruth Schmidt, Virginia Troy, and Mary Zicafoose. Members of the American Tapestry Alliance, Centre

International d'Études des Textiles Anciens (CIETA), Federation of Arizona Weavers Guilds, and the Textile Society of America. The best brainstorming friends and colleagues I could ask for—Jacqueline Butler-Diaz, Carolyn O'Bagy Davis, Margi Fox, Janet Lever Wood, Marion MacDonald, Maggie McQuaid, Robin Omata, Derek Ostergard, Jehanne Schweitzer, Sandra Szelag, and Christine Szuter. My supportive co-workers at Arizona State Museum, the University of Arizona, and the University of Arizona Foundation.

Amazing book-making people—Elizabeth Hadas, editor extraordinaire and a wonderful mentor; Patricia J. Fidler and Lindsay Toland, Yale University Press; Ed, Adrian, Jeff, Brynn, Keryn, Sara, Becky, Carrie, and the entire crew at Marquand Books. Photographers—Jannelle Weakly, Malcolm Varon, Jack Parsons, David Heald, Paul Mozell, Peter Ferling, and others credited in the Checklist of GFR Tapestries & Carpets. Grace Glueck, for engaging conversations and her foreword to this book.

My parents, Jim and Doris Hedlund, who established the values that sustain me and who continue to show their confidence in me and my work. My sister Carey, who listens, shares ideas wisely, and is a great traveling companion. My husband Kit Schweitzer, the artist in my life, whose goal has been to make one of everything and who makes everything worthwhile.

And Gloria F. Ross, who made it all possible.

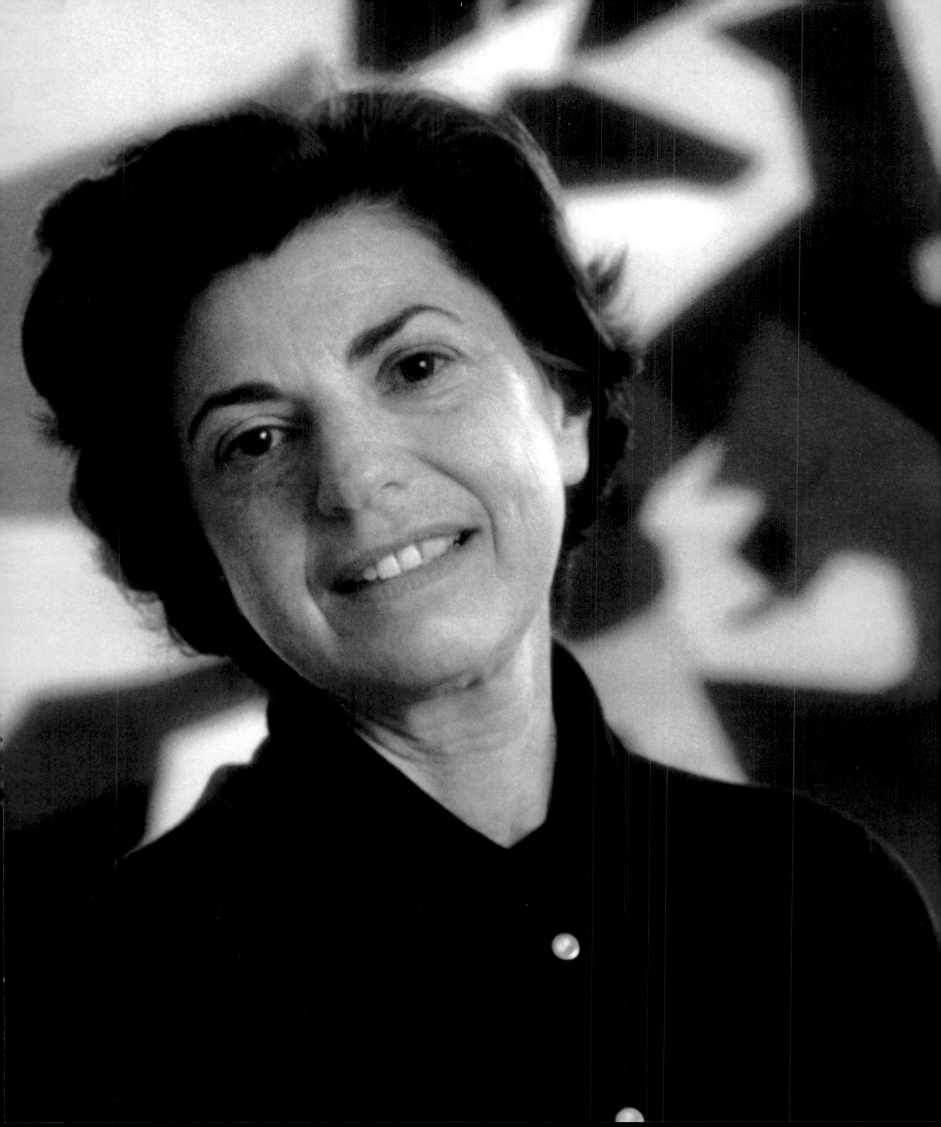

In knowing both the artist and
the artisan, I have been able to
develop a true collaboration in
my GFR Tapestries.
—Gloria F. Ross[1]

Gloria Frankenthaler Ross (1923–1998) combined modern American and
European art with traditional European and American weaving to orchestrate
expressive tapestries.[2] During her career of thirty-four years based in New
York, she worked with twenty-eight well-known American and French artists
to translate their abstract and figurative imagery into the textile medium.
These individuals included her sister Helen Frankenthaler and brother-in-law
Robert Motherwell, Kenneth Noland, Louise Nevelson, Jean Dubuffet, Frank
Stella, and Jack Youngerman, among others discussed throughout this book.

As an intermediary and catalyst—akin to a musical conductor, film pro-
ducer, print publisher, or book editor—she forged a distinctive identity as
tapestry *éditeur,* producing tapestries and carpets by coordinating the efforts
of traditional artisans and contemporary artists. In the evolution of her
career she engaged closely with several dozen highly accomplished weavers
and rug hookers in France, Scotland, and the United States, including Native
American weavers of the American Southwest. She also worked more briefly
with weavers in Portugal, China, Australia, and elsewhere.

Tapestry weaving often multiplies the hands engaged in art making.
Much like film partnerships, acknowledged at award ceremonies with near
unending speeches, it may involve many people and processes. Gloria Ross
as tapestry éditeur brought together painters, sculptors, collage makers,
cartoon makers, dyers, weavers, collectors, galleries, and sponsors. By
describing and illustrating the *praxis* of tapestry making—the experimenta-
tion and decision making, the successes and failures—I hope to make clear
the shared artistic contributions and creative roles, as well as the struggles
to negotiate them.

For every hour that Gloria spent planning, traveling, meeting, and pro-
moting the Gloria F. Ross Tapestries & Carpets, there were weavers, needle
workers, dyers and other specialists behind the scenes. The ultimate accom-
plishments described and illustrated in this book are the direct results of the
artisans' hard work. They took the artists' paintings, Gloria's guidance, the
studio director's or trading post manager's instructions, and converted them
into the final physical products. Every story drawn from the GFR Papers and
told here has backstories that could be related by others who knew these
projects as intimately as Gloria did. These chronicles are imbedded in the
quality of workmanship and the intensely personal and professional transla-
tions for which only the artisans were ultimately responsible. The skilled
hands, sharp minds, deep experience, and dedication of the weavers do
shine through.[3]

Tapestry Defined

The word *tapestry* holds powerful imagery for many—something to warm
the walls of a castle, to express the dignity or devotion of royalty, to tell a
story in monumental proportions. In popular modern parlance, any flexible
and colorful wall hanging may be called a tapestry, no matter whether it was
woven, painted, printed, embroidered, or otherwise decorated. Tapestry can
refer generically to floor rugs and upholstery as well as garments and other
fabrics, as long as they are brilliantly patterned. For nonspecialists, this
embellishment is what seems to matter.

For specialists, tapestry is a specific fabric structure that can only be
woven by hand. This structure is described as *weft-faced plain weave with
discontinuous weft-faced patterning,* which allows for highly varied patterns.
A tapestry-woven cloth must be made by hand, with the weft (pattern) yarns

Detail, Alexander Liberman, "after #41," 1975,
hooked by the Ruggery. (See Plate 38.)

going over and under the warp (foundation) yarns, and completely covering them. Wefts of many colors appear only where the design is formed as they interlace with the warps. This process has never been successfully automated. Even when working on a large tapestry loom, a skilled weaver must manipulate each weft thread to make the free-form patterns.[4]

Early in her career, Gloria Ross embraced tapestry as fabulous mural art, no matter how it was created. She stretched the term to cover other fabric art such as hooked rugs intended as large-scale wall hangings. As she became acquainted with European handwoven tapestries, she used the phrase "true tapestry" for those textiles handwoven in the Aubusson or Gobelins styles. In later years, she avoided using "tapestry" for anything but the strictly handwoven variety.

Gloria recognized the deep history of tapestry. In her lectures, she acknowledged the ancient Egyptian, Greek, and Coptic traditions. Middle Eastern flat-weave carpets provided clues to tapestry's origins in the wool-producing areas of the Fertile Crescent. By the 1400s, elaborate tapestries were handwoven in northern European workshops and served as portable emblems of wealth and high status. Small workshops grew to encompass many specialized roles for designers, dyers, loom-dressers, weavers, and others. During medieval times, weavers still controlled many aspects of design. By the Renaissance, some of the most famous artists of the time planned tapestries to be woven by dedicated craftspeople. In the eighteenth and nineteenth centuries, the weavers had essentially lost their creative role and were relegated to rendering imagery better suited to painting than weaving. Early in twentieth-century France and Britain, a return to collaborative relations between designers and weavers led to new vitality.[5]

Twentieth-Century Trends

In the mid-twentieth century, when Gloria began exploring various textile techniques for wall hangings, several trends were converging in the international art world. In both America and Europe, modernism had a firm hold on painting, sculpture, and the graphic arts. Abstract expressionism, through which artists articulated ideas in nonpictorial forms, prospered. Modern art predominated in museums, galleries, studios, shops, and the popular media. The image of singularly inspired artists working entirely on their own was romanticized and reinforced through monographs and solo shows, while notions of open collaboration and collective installation art were just beginning.

Simultaneously, European tapestry workshops experienced a postwar revival as museums and private collectors sought the highly stylized work of designer Jean Lurçat and his artist-weaver colleagues. In France, both government and private workshops collaborated with living artists. In Scotland, a generations-old tapestry workshop looked to contemporary painters for subject matter. In Australia, the much younger Victorian Tapestry Workshop also invited painters to collaborate with its weavers and create fresh new imagery. Scandinavia and Eastern Europe had their own well-developed studios and rising stars. In Egypt, Wissa Wassef had established an innovative collaborative workshop. In the United States, the modern craft movement forged ahead with articulate leaders such as *American Craft* founder Rose Slivka and world-class textile designer Jack Lenor Larsen (both personal friends of Gloria). Private workshops using classical tapestry techniques were established by Ruth Scheuer on the East Coast and Jean Pierre Larochette and Yael Lurie on the West. Individual weaver-artists were producing intriguing bodies of work, but public understanding of tapestry weaving lagged behind many other handcrafts, including basketmaking, ceramics, glassblowing, woodworking, and functional handweaving.[6]

Meanwhile, a movement to take tapestry off the wall and explore three-dimensional fiber art grew. American artists Sheila Hicks, Lenore Tawney, and Claire Zeisler pushed their woven work into sculptural forms. In central Europe, the Lausanne Biennial exhibitions, begun by Jean Lurçat and Toms Pauli in 1962, portrayed the dramatic divide between traditional and innovative textile arts. The monumental work of Magdalena Abakanowicz from Eastern Europe, Olga de Amaral from South America, and others championed in Constantine and Larsen's seminal work *Beyond Craft: The Art Fabric* rose to international prominence.[7]

In the midst of this, Gloria Ross energetically espoused the notion that the strengths of American modernist painting and traditional European textile techniques could be fruitfully combined. Gloria didn't *cause* a renaissance in modern tapestry, but she actively participated in and contributed to one that was in flux. In 1947, the Museum of Modern Art in New York turned down the loan of a contemporary French tapestry exhibition for lack of interest. By 1965, MoMA organized Tapestries and Rugs by Contemporary Painters and Sculptors, in which Gloria showed two hooked wall panels designed by Helen Frankenthaler and Robert Motherwell (plates 17, 42). In planning the exhibition, the Museum's director, René d'Harnoncourt, pronounced these works, "absolutely magnificent . . . too beautiful to let go."[8]

A Developing Career

At first she didn't know what to call herself, nor did anyone else in the American art world. Even toward the end of her career, Gloria avoided titles or quick summaries of what she

did. In her notes for an international gathering of tapestry weavers, she recorded thoughts on how to introduce herself: "[I have] really no title. I've not been pigeonholed. An 'éditeur'? That sounds affected. And 'editor' one associates with the written word."[9] Two years later, almost in jest, she gave herself the full-blown French title, *Éditrice americaine de tapisseries d'artistes contemporains*.[10]

Gloria took a hands-on approach to executing each project. Although she was never an *artisan-lissier* or *cartonnier* in the European sense, her editorial involvement deepened as her career progressed. The GFR Papers are replete with sketches and annotations that indicate the many tasks she performed. In her earliest projects, Gloria created her own full-scale patterns for the hooked rugs. When working with European tapestry makers, she stopped short of making full-scale drawings or woven trials. The French ateliers always hired specially trained cartonniers, and the Dovecot weavers developed their own versions of full-scale cartoons. With the Native/ Noland projects, she again made scaled drawings and cartoon-like templates for the Navajo weavers, as they generally worked straight from images held in their minds.

Her tapestry making, as described in coming chapters, involved coordinating the actions of painters and other artists, weavers, dyers and other textile specialists, and galleries and their clients. She functioned as an intermediary, what the French would indeed call an *éditeur* (or the feminine version *éditrice*). Quite literally, an éditeur is a producer of editions. This encompasses selecting the artist, artwork, and weaver or weaving company; establishing and assuring the tapestry's scale, materials, quality, and number of editions; reviewing dyed yarn samples and woven trials; overseeing construction of a cartoon enlarged from the original artwork (the model or maquette); approving the final woven work; and, equally important, financing the project. The traditional role of éditeur links metaphorically to the English sense of an editor being a publishing supervisor who oversees all efforts to produce a book, newspaper, or magazine. As understood in France, however, the actions of a tapestry éditeur are not as detailed as the tasks of many publication editors who delve into actual content and presentation, whether of text or textile. Linguistically speaking, we might say that the French *éditeur* is not to be equated with the English *editor* any more than the French *amateur* (lover of art) is with our English "amateur" (whose meaning has shifted to that of an avocational practitioner).

The European system of producing limited editions contrasted generally with the American approach of working as an independent studio artist and making one-of-a-kind tapestries. This separated Gloria from the larger modern American craft movement. Her work also ran counter to the romantic concept of fine artists as uniquely inspired and solo-driven creators. Instead, she connected with the earlier workshop traditions of Europe and elsewhere around the world. She asserted that an original painted image should be "translated," not copied or reproduced, into the handwoven textile medium. One museum director affirmed her approach: "The resultant tapestries cannot be called reproductions since they become new works in wool, notably different from the original."[11] In the United States, her work raised awareness of modern tapestry's broad applications and appeal. In Europe, she engaged tradition-based workshops that needed artistic and financial support to survive.

Neither gallery owner, dealer, curator nor workshop director, Gloria took responsibility for educating others to what she called her *métier*—which can be translated into English at once as a profession, craft, and loom.[12] She became intent on educating the American public, collectors, and galleries about the rich heritage of European tapestry and its expressive possibilities for modern American art. "Whereas in Europe there is now a renaissance of tapestry," she wrote, "America has only a meager history of tapestry per se. Although Americans are familiar with the term and recognize a tapestry when it hangs on the wall, the vast majority do not really know what it is. . . . Educating Americans particularly, about quality textile art has become a prime mission of mine."[13]

What follows is the unfolding of a creative career in the art world and how Gloria Ross persistently negotiated between two somewhat contradictory goals for her work. On the one hand, she intended to remain true to each individual artist's aesthetic intent for the artwork. On the other, she learned and maintained that the best tapestries should be created and viewed as objects in their own right, the weavers' unique creations, not illusions of something else. Any assessment of her achievements is best left until the stories that follow are told. And just as opinions are likely to differ among readers, perhaps they will prove different for each artwork examined, as each represents a unique set of relationships among the éditeur and the artists, designers, weavers, and viewer.

As we shall see, the process of creating art is rarely simple, whether the results are painting, sculpture, prints, photography, or—one of the most intriguing and complex of all collaborative media—the tapestry.

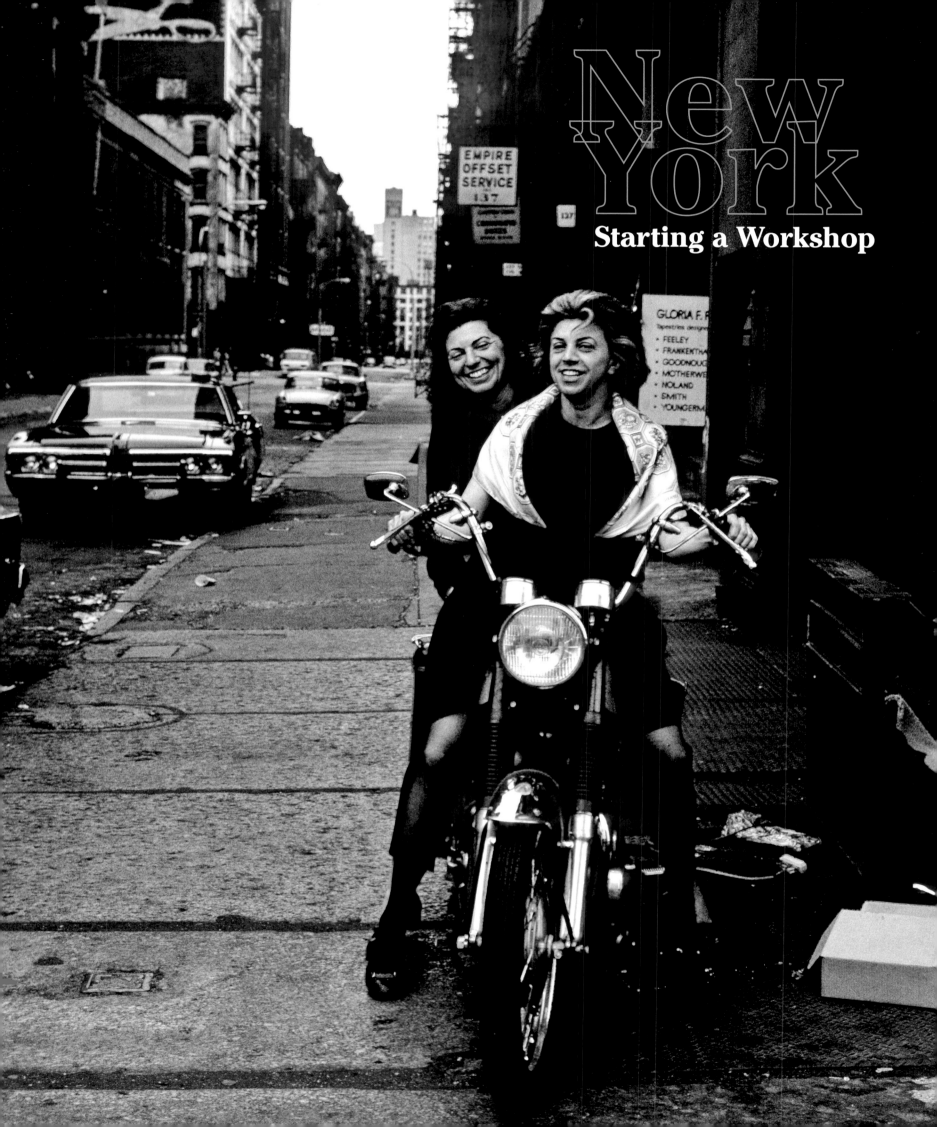

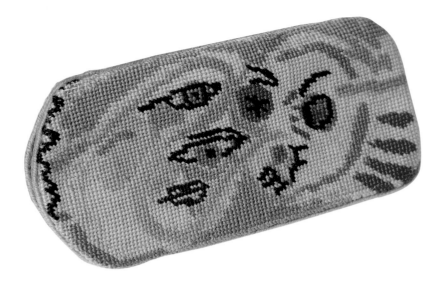
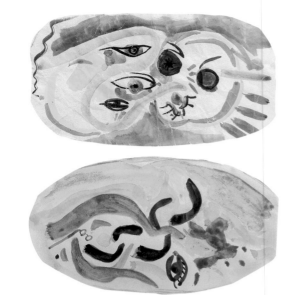
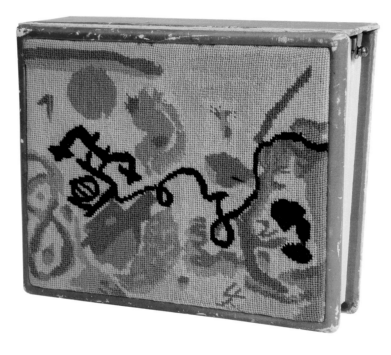

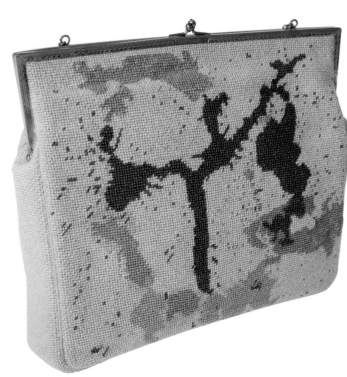

A New York Life

A New York Life

> I am "born and bred"
> in New York City, where
> I've lived all my life.
> —Gloria F. Ross

> I had a grandmother who always had
> busy hands, primarily crocheting, and
> she brought me the love of textiles.
> Her "work" was not considered
> textile art, but indeed what she
> created *is* textile art.
> —Gloria F. Ross

Gloria Ross always did needlework. In the 1950s, she stitched abstract imagery designed by her sister Helen Frankenthaler to make a decorative cover for a Manhattan phone book and an eyeglass case. On plane, train, and road trips, she stitched wool yarns into needlepoint canvas, making elegant pillow covers and small decorative items. Simple geometric designs encased her fashionable desk accessories. A stylized row of houses from a modern painting by her mother became a small needlepoint picture to hang on her home office wall. Using a Piet Mondrian painting as inspiration, she even crocheted an afghan, scaling down the artwork and carefully matching the colors. In 1966, she entered a needlepoint "pocketbook" designed by Frankenthaler in the third national exhibit of the Embroiderers' Guild.

These relatively simple yet sophisticated bits of handwork presage her later career in tapestry, which she pursued with great passion. From a distinctly privileged and urban background, Gloria initially followed the traditional domestic path of many mid-twentieth-century American women. She often disavowed feminist leanings, like many women of her generation, but gradually forged a distinct role for herself in both the art and business worlds. Her family and her early school experiences were strong influences on the forthright person and dynamic entrepreneur she eventually became.[1]

A Manhattan Family

Louis Frankenthaler (1832–1919), Gloria's paternal grandfather, was born in Germany and came to the United States in the early 1850s. Her paternal grandmother, Mary Strauss Frankenthaler (1855–1929), was born of German parents in New York City. Louis ran a dry-goods store on Avenue B, between Houston and 2nd Street, and was known among Lower East Siders for his charitable and social welfare work.

Gloria's father, Alfred Frankenthaler (1881–1940), was born September 24, while the family was living on 10th Street between Avenues A and B in Lower Manhattan. He attended Public School 25 and graduated first in his class in 1895. Alfred attended the College of the City of New York for five years. Elected to Phi Beta Kappa, he won a Ward Medal for proficiency in algebra and geometry and the Belden Gold Medal in mathematics during his sophomore year and a second Ward Medal in chemistry in his senior year.[2] He graduated in 1900 with a Bachelor of Arts degree, second in a class of 134 young men, and delivered the salutatory address at the graduation ceremony, held at the Carnegie Music Hall, as it was known at the time.

Like many German Jews, Louis and Mary moved uptown. According to the New York census, by 1900 they were living on East 87th Street with their four sons and a twenty-year-old Hungarian "servant girl." By this time Louis had retired; Alfred's older brother, Joseph (1867–1929), was a publisher; Benjamin (1873–1936) was in real estate, a field in which Alfred also worked for a time; and George, the youngest (1886–1968), was still in school. Ten years later the family relocated again, to East 91st Street near Madison Avenue.

Alfred earned a public school teaching license in 1900 and then attended Columbia Law School, graduating in 1903 with an LLB degree. His brother George, five years his junior, also received a law degree from Columbia.

In 1915, Alfred and George opened their own law offices, located at 120 Broadway, at Cedar Street, in Manhattan's financial district.[3] With a practical background in real estate, Alfred specialized in commercial and financial law. In 1918–19, he served as assistant to the U.S. Attorney General in

Helen Frankenthaler, untitled designs for needlepoint items stitched by Gloria F. Ross, wool yarns on needlepoint canvas. Clifford Ross collection; © Helen Frankenthaler/Estate of Gloria F. Ross.

a. Eyeglass case, 1957, 3 × 6.4 in.

b. Design for eyeglass case, 1957, gouache and watercolor on paper, 3.5 × 6.4 in., *upper*, 3.6 × 6.5 in., *lower*

c. Phone-book cover, 1954, 8.75 × 6.4 in.

d. Design for phone-book cover, 1954, gouache and watercolor on paper, 8.5 × 11 in.

e. Evening bag, 1962, 7.5 × 9 in.

f. Design for an evening bag, 1962, oil on paper, 7.5 × 8.5 in.

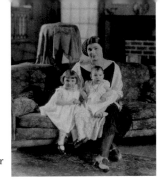

Martha Lowenstein Frankenthaler
with her two eldest daughters

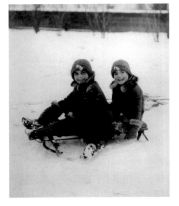

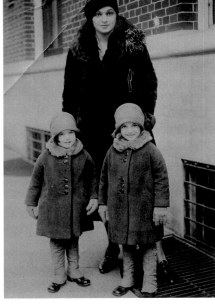

Marjorie and Gloria often
appeared in identical clothing
and sometimes were mistaken
for twins.

the southern district of New York, where he
worked for the New York Port Alien Enemy
Bureau. His reputation was outstanding. A
colleague at Fordham University, for example,
called him "a lawyer of . . . splendid qualifica-
tions, sterling integrity and eminent fitness . . .
with . . . gracious, winning personal qualities"
and "an able, disinterested and conscientious
adviser, a lawyer of brilliancy combined with
a generous liberality of viewpoint, a man pre-
eminent among men."[4] Today, the law firm of
Frankenthaler, Kohn, Schneider & Katz carries
on the Frankenthaler brothers' legal legacy.

Typically for the time, while he was estab-
lishing his career, Alfred lived with his parents
at 1215 Madison Avenue, between 87th and
88th streets, until he married. Both before
and after his 1921 wedding to Martha Lowen-
stein, he was active in the National Democratic
Club, the Democratic County Committee, the
Tammany Hall Law and Finance Committees,
and many fraternal, civic, scholastic, and chari-
table organizations. He belonged to the Har-
monie Club, known for its affluent, progressive
Jewish membership and located in an elegant
1906 McKim Mead and White building just
off Fifth Avenue on 60th Street. He was also
a member of the Manhattan Club, the oldest
national Democratic club in the United States.

Martha Lowenstein (1895–1954), the
daughter of Olga and Solomon Lowenstein,
arrived in New York from Germany in 1897 at
the age of two. She had two brothers, Louis
and Carl, and two sisters, Elsie and Selma.
Gloria recalled, "My mother came of a most

modest background, went to school through
about sixth or seventh grade, but was a very
wise lady. And she and my father had a superb
marriage!"

When they married in 1921, Martha was
twenty-six and Alfred was forty. She had
previously worked as his secretary. Some
months later, the *Times* "Social Notes" column
reported that "Mr. and Mrs. Alfred Franken-
thaler, who reside at the St. Regis," were to
sail the next day on the *Rotterdam* "to spend
a few months in Europe."[5] Their first child,
Marjorie, was born in Switzerland on July 23,
1922. When they returned, the young family,
as did many other Jews in the 1920s, moved
to the Upper West Side. They lived at 230 W.
79th Street, between Broadway and Amster-
dam Avenue.

Even though Marjorie once described
both her parents as six feet tall, Alfred and
Martha Frankenthaler are recalled by others
as a couple with distinct physical contrasts—
he was shorter and somewhat portly, while
she stood erect and projected a powerful air.
A family friend fondly remembered Martha's
exuberance as well as her stature: "In every
way she was monumental."

Alfred and Martha shared an interest in the
cultural life of New York and enjoyed consider-
able social prominence. At the time of Alfred's
wedding, he and his brother George held a
Grand Tier box in the "Golden Horseshoe" at
the Metropolitan Opera for opening nights
on "odd Mondays."[6] Their opera box afforded
important opportunities to entertain, as, for
instance, when the *Times* social columnist
reported "Governor and Mrs. Edwards of New
Jersey were the guests of Mr. and Mrs. Alfred
Frankenthaler in Grand Tier Box 39 at the
opera last evening, Judge and Mrs. Mitchell
May and Mr. and Mrs. George Frankenthaler
also being members of the party. A dinner party
at the St. Regis preceded the opera."[7] Subse-
quently, the Frankenthaler name appears in
Grand Tier box 50 annually in the *New York
Times* opera listings, just below such names
as Astor, Frick, Whitney, and Vanderbilt.

Gloria was born on September 5, 1923, a
year after Marjorie. The sisters were occasion-
ally mistaken for twins. Helen arrived five years
later, on December 12, 1928.

In November 1926, Alfred was appointed to
the New York State Supreme Court, First Judi-
cial District, where he served for the rest of his
life. His great achievement was the six-year
reorganization and rehabilitation of mortgages
and mortgage certificates by special assign-
ment of the Appellate Division. The *New York
Times* credited "the Frankenthaler plan" with
"untangling the chaotic mortgage situation."[8]

Judge Frankenthaler was generally
described as a modest person, but occasion-
ally he attained celebrity status. Sometimes he
performed weddings, including that of Russian

concert violinist Jascha Heifetz to film star Florence Vidor on August 20, 1928, making the front page of the *New York Times*. In 1935, he officiated at the wedding of Isadora Duncan's adopted daughter Irma, a well-known modern dancer herself.

By the late 1920s, Alfred, Martha, and their three girls had returned to the Upper East Side, where they lived at 1192 Park Avenue, near 94th Street. They were well-to-do by most standards, paying the sizable sum of $450 for monthly rent in 1930, with three live-in German servants who worked as cook, chambermaid, and baby nurse. The three Frankenthaler girls were then seven, six, and just over one year old.

Martha was an enthusiastic and generous hostess. She was known fondly for the "Frankenthaler Farewell," during which she would accompany departing guests to the door and then detain them with new and lengthy anecdotes, as though she just couldn't bear to part company.[9]

Martha served on Manhattan's Nineteenth District School Board.[10] She was active in the New York section of the National Council of Jewish Women and served on various social committees for the Women's Auxiliary of Congregation Emanu-El, where the Frankenthalers were longtime members along with such prosperous German Jewish families as the Bloomingdales, Gimbels, Lehmans, Lewisohns, Ochses, Strauses, Stroocks, Sulzbergers, and Warburgs.

Founded in 1845, Emanu-El was the first Reform synagogue in New York. It was established by German immigrants "who came to this country with the hope of planting a Judaism both liberal in response to American democracy and simultaneously loyal to the inherited traditions of the Jewish past."[11] This institution parallels the Frankenthaler family's own trajectory in New York society.

Gloria and Marjorie were confirmed at the Temple. In 1929, a new building, the largest synagogue in North America and Emanu-El's fifth home, was completed on Fifth Avenue at 65th Street. Gloria maintained membership there throughout her life. Much later, this building became the permanent home of Gloria's final tapestry project—an Ark curtain designed by Mark Podwal and handwoven in France (see plate 83).

The family's affiliation with this particular congregation reflected the charitable interests of Gloria's parents as well as their social connections. In keeping with the Congregation's long-standing dedication to social welfare, Alfred was active with the Jewish Probation Society and the Federation of Jewish Philanthropic Societies. His generous charitable contributions set a pattern that Gloria was to follow for the rest of her life. Also, Gloria's aesthetic sensibilities were undoubtedly fostered by belonging to "a house of worship

A dinner party hosted by the Frankenthalers, with Alfred seated on left and Martha standing on right. Photo by Stanley W. Gold.

that was . . . world-renowned for its beauty and influence."[12]

Frankenthaler family life on the Upper East Side of Manhattan in 1938, when the girls were fifteen, fourteen, and nine, was conducted with panache, as Marjorie recollected. "The Sunday morning walk was a family ritual," she wrote years later. "It was my father's pleasure to parade his 'four girls,' my mother and his three daughters, all of us turned out in the tailored tweeds that he favored for women's dress. In the lead on these walks was my father, the judge, with my mother on his arm—a woman of impressive carriage and striking good looks. My parents

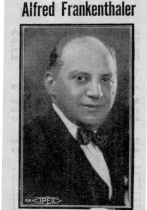

Alfred Frankenthaler

Democratic Candidate for JUSTICE OF THE SUPREME COURT
Manhattan and Bronx

Alfred Frankenthaler

A New Yorker born in New York City, educated in New York public schools, C. C. N. Y. and Columbia University Law School

Twenty-four years' experience

Assistant in U. S. Dept. of Justice

Member Commission to Investigate Defects in the law and its administration. (Appointed by Governor Smith 1923).

Member Mayor Walker's Committee on Planning and Survey

Vote for three Group 8

JUSTICES OF THE SUPREME COURT		
★	X	JOSEPH M. CALLAHAN
★	X	CURTIS A. PETERS
★	X	ALFRED FRANKENTHALER

Alfred Frankenthaler's campaign card, c. 1926

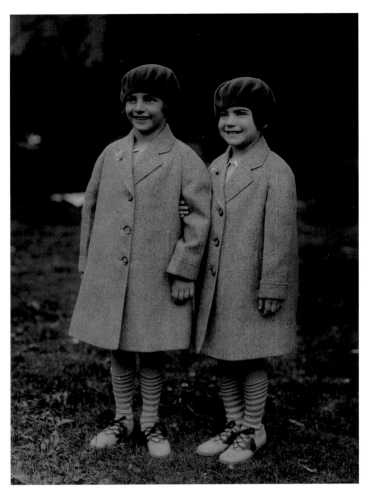

Marjorie and Gloria, sisters in striped sox

An *Atlantic City Magazine* camera caught the strolling family in 1928, just nine months before Helen was born.

were both six feet tall, and they set a brisk pace. We girls took up the rear, a pale-faced, gangling lot who dawdled behind and then hastened to catch up, three pairs of long skinny legs with bony knees. My father thought we were beautiful. . . .

"My mother . . . had a way of making the most casual happening into an occasion, into some kind of party. That party edge was always there in her talk and in her eyes, in the whole childish expectancy of her face, so at odds with her Valkyrie posture and her monumental height. And though it was wearing on a day-to-day basis to live with her high energy and excitement, we were all so used to it that by comparison other households seemed dull. My father treated her alternatively as an adored goddess who was not to be crossed and as a spirited child who had gone too far.

"My father . . . was considered a modest man of plain tastes, but in his secret heart he had always regarded himself as the equal of any man alive—with a few exceptions, such as Justice Benjamin Cardozo, Justice Louis Brandeis, Florenz Ziegfeld, Will Rogers, John L. Lewis, Fiorello La Guardia, Albert Einstein, [and] my father's good friend the New York saloon-keeper and restaurateur Dinty Moore, and perhaps a dozen others whom he viewed in one way or another as being clearly superior to himself. . . .

"He never took long walks along empty country roads . . . He used to say, in a general

context, that to stay happy and healthy a man ought not to wander too far from the lamp-post at Forty-second Street and Broadway.

". . . He was one of those born lawyers. He had practiced law in New York City for some twenty years before his election to the New York State Supreme Court, where he served until his death. When he sat on the bench in his judicial black robes, his idiosyncrasies were in abeyance. He was known as a distinguished and influential jurist, also as one who showed extraordinary patience and compassion toward anyone who entered his courtroom. . . . His life had two fulcrums—his family and the court."[13]

Gloria often described her mother as "a talented amateur painter."[14] She recalled with pride, "Long before abstract painting was accepted . . . [my mother] was really a closet painter. I think [she] didn't show people her work because she never knew that people painted abstract paintings, and I think she was concerned as to what people would think. . . . After her death, one of my sisters came across many of these abstract expressionist paintings [by her]. She also did some wonderful floral paintings, and she was a good artist. If she had lived at a later time, and really pursued her art and wanted to become professional, I think she would have been one of the out-standing painters of the period. I did love her, and maybe the way I looked at her paintings is colored by my love of her, but I try to look at her work objectively—and she was good!" She noted, "It's very interesting to see the influence of my mother's work on Helen's work." (This was strictly her own opinion; as far as we know, no one else has commented on that influence.)

During most of Gloria's school years, the family lived at 791 Park Avenue, between 73rd and 74th streets. The girls went to private schools and summer camps. Gloria attended the Dalton School through the sixth grade and then transferred to the Horace Mann School for Girls, an independent college preparatory

school at 120th Street and Broadway.[15] Although students came from all parts of the city, Gloria associated mostly with a tight clique of girls from the Upper East Side.

Sister Marjorie was a year ahead of Gloria at Horace Mann. She showed an early interest in art and apparently excelled at sculpture for a brief period in school. Unfortunately, a bout with polio prevented Marge from pursuing physically demanding projects. The illness didn't hinder her intellectual pursuits, however. In 1936 Marjorie received the Lewis May Medal for highest scholarship among the female graduates at Congregation Emanu-El Religious School. She graduated from Horace Mann in 1939 and four years later from Vassar College.

It appears that during their school years Gloria was caught as the middle sister between two artistically precocious siblings. Not surprisingly, Helen, who later became a world-famous painter, exhibited even more early artistic promise than Marjorie. Gloria showed no such distinction in her school days. Outside of school, she was recognized as a popular pianist—"enormously adventurous, really good, and fun—good at a party where she could just knock out a song!" And while most classmates were still wearing their hair long, she broke from tradition and opted for a shorter bob with a permanent wave, "dashing, adventuresome, and yet very becoming."[16] Following a year behind her sister Marjorie, Gloria too made a presentation at the closing exercises of the Temple Emanu-El religious school.

Gloria graduated from Horace Mann in 1940. Her black-and-white portrait in the high school yearbook is captioned "Elegance as simplicity." A classmate remembered Gloria as "always grown up, no acne or baby fat or dieting, not precocious but not a little girl either, fully formed really. She never overdressed—always looked natural, while the rest of us were never so pulled together. She never looked fussy, just had a natural elegance."[17]

On January 7, 1940, during Gloria's senior year in high school, the girls' father died, apparently of complications from gall bladder surgery several months earlier. "The Judge," as he was called by family friends, was fifty-eight years old. As a show of respect, the offices of

the State Supreme Court in New York and Bronx counties closed for one day. Services were held at Temple Emanu-El, with burial at Mount Neboh Cemetery in Queens. The story was headlined in the *New York Times* "2,500 Attend Rites of Frankenthaler—Senator Wagner Eulogizes the Justice for His Service to the Community—Notables in the Throng—Former Governor Smith, Mayor La Guardia and Members of Bench are Bearers."[18]

The *Times* also reported that Justice Frankenthaler left an estate worth more than $900,000 to his widow and three daughters. One month following his death, the family held a memorial service where at least seven luminaries of the court system spoke in his honor at the Wall Street Synagogue. Martha and his daughters dedicated a tablet inscribed "His works are his monument."[19]

When their father died, the girls were seventeen, sixteen, and eleven. Their mother and two of the Judge's colleagues and close associates were appointed executors of the estate. In later life, Gloria fondly recalled one of these Wall Street lawyers who provided the "three gangly girls" with avuncular financial advice. This tutelage would prove useful to Gloria as she later managed her considerable philanthropic and business affairs with a meticulous eye for detail.

By 1941, Martha had moved from 791 Park Avenue to 1016 Fifth Avenue, directly across from the front entrance of the Metropolitan Museum of Art and next door to the Goethe Institute. The *New York Times* noted that she "gave a supper dance . . . in the Starlight Room of the Waldorf-Astoria to introduce to society her daughters, the Misses Marjorie and Gloria Frankenthaler. The debutantes . . . received . . . before a bower of palms and cymbotium ferns. Miss Marjorie Frankenthaler, a junior at Vassar College, wore a turquoise taffeta bouffant gown embroidered with pearls, and her sister, a member of the sophomore class at Mount Holyoke College, was gowned in shell pink chiffon trimmed with black lace."[20]

College Days

Gloria's four years at Mount Holyoke College coincided with World War II. She was very happy there. "Holyoke was really, as I look back on it, the perfect school for me," she recalled. "There was a certain quietude about South Hadley, and having lived in New York City all my life, South Hadley and the atmosphere of Holyoke was wonderful. And, of course, during war years where no one had cars—no faculty, no one had cars—it was a particularly focused life. A life focused on the college. At that time we were only permitted three weekends a semester away. And then the trains were so crowded to New York—they were filled with soldiers. It was really an effort. So . . . most of my college life was very much centered there."

Alfred Frankenthaler, *middle*, sworn in as a justice of the New York Supreme Court, 1926

She valued her new experiences: "It did expose me to many things that I'd not been exposed to here in New York. People from many different areas. Remember in the thirties—I graduated from high school in 1940—people did not travel as much and you didn't have an opportunity to meet as many people from different parts of the country. And Holyoke always had more foreign students than other schools had. It had a wonderful language department. I think my main contact with the arts was through my roommate, who was an art major. In those days, you studied slides a great deal. College art museums were not as enriched as they are today. Our room was always full of slides! I used to test Bobbsie on her slides, and learned and was exposed to so much right in our tiny room! (The WAVES, the military Navy women, trained on campus, so what had been single rooms were double rooms.) So this was really my introduction to art, in this tiny room with all these slides. Yes, I'd been to museums in New York, but I really became interested and focused and learned a lot. A strange way to do it, but that was it! . . . I took no art history courses. But I'm sure I learned more than many of the students!"

One of her most memorable teachers was a French professor "who was also a great actor and would act out Molière, and used to have classes at his home over tea." Such experiences served her well much later when she worked in French tapestry studios. "[The Holyoke experience] was very expansive . . . and made me interested in many fields. And I think [it] made me susceptible [to] all the factors that led me to become the tapestry maker that I am today. And this is why a liberal arts education is so important. It just expands the mind and

makes you open to all of the elements available to you in this world."

When college came to an end, Gloria returned to New York. "We all felt the world was waiting for us and, like many of my classmates, I went to summer school for two summers and so graduated in December 1943. I was an economics major at college and worked for the Federal Reserve Bank in New York for a while, until I married."

Gloria's elder sister Marjorie graduated from Vassar in 1943 and then worked on the editorial staff of *Life* magazine. In 1947 she married Joseph S. Iseman at the Harmonie Club in New York. Trained at Harvard and Yale, her husband joined the law firm of Paul, Weiss, Rifkind, Wharton & Garrison, where he was a partner for more than sixty-four years. In 1948, the first of their three children was born in Greenwich, Connecticut.

Helen Frankenthaler attended Horace Mann and Brearley before graduating in 1945 from the Dalton School, known for its progressive style. She has commented, "While I conformed to the protocol and fine, upper-bourgeois manners and proper window dressings of the social environment and schooling in which I was raised, I was also a renegade and a maverick, and capable of great humor."[21]

At Dalton and continuing after the school year ended, Helen studied with Mexican painter Rufino Tamayo and showed much artistic promise. Gloria believed that nurturing by their artistic mother and her sister's attendance at "experimental and progressive schools" set the stage for Helen's highly successful artistic career. The three Frankenthaler girls regularly visited New York's many museums.

Helen attended Bennington College in Vermont, where she studied with painter Paul Feeley. She made use of nonresident terms to work and study in New York with Hans Hofmann's protégé Vaclav Vytlacil at the Art Students League, and with Australian painter Wallace Harrison in his Greenwich Village studio. By the time Helen graduated from Bennington in 1949, Gloria was a young mother.

Married Life

Gloria Frankenthaler was twenty-three when she married Arthur Ross on January 20, 1946, at Sherry's, a popular restaurant and site of many family festivities. In a scene out of a Romare Bearden tapestry (plates 5, 6)—"a white and green setting of gladioluses and chrysanthemums against a background of ferns and tropical greens"—the bride wore a "white satin gown, trimmed with heirloom rosepoint lace, and a tulle veil embellished with the lace and fastened with orange blossoms. She carried a bouquet of white spray orchids."[22]

Also a native New Yorker, Arthur Ross (1910–2007) was thirteen years Gloria's senior

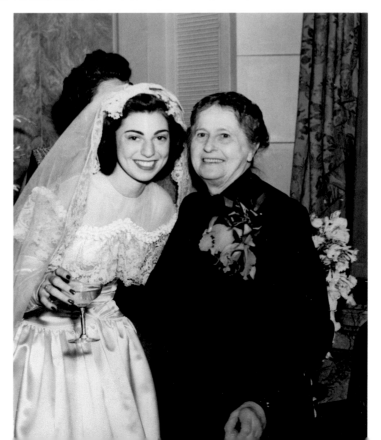

A relative embraces Gloria on her wedding day, 1946

and from a family of Russian Jewish descent. He attended the University of Pennsylvania and Columbia University, graduating with a B.S. degree in 1931. He worked for Sutro Brothers & Co., a Wall Street brokerage firm, from 1932 to 1938. During World War II, he received a commission in the Naval Reserve and served in Panama and Ecuador. He spent the rest of his career with the Central National Corporation, an investment banking subsidiary of D. S. Gottesman & Co., one of America's largest private companies, a marketer of pulp and paper.

During their first years of marriage, the Rosses lived at 324 East 41st Street, between First and Second Avenues, just south of what is now the United Nations Plaza. They had three children. As she later gleefully acknowledged, their names were chosen in alphabetical order: Alfred F. (b. 1946), named for Gloria's father; Beverly (b. 1948), and Clifford Arthur (b. 1952).

Around 1948, the growing family moved to 935 Park Avenue, at the corner of 81st Street. By 1958 they were living at 888 Park Avenue, between 78th and 79th streets. Friends from those days recall gracious dinner parties. Others remember less glamorous days when the apartment hosted family activities, schoolwork, and craft projects. Sometime in the mid-sixties, one of the children's bedrooms was overtaken by an enormous frame for hooking rugs—Gloria's growing pastime and prospective career.

Volunteer Work

During her early married years, Gloria served as a Red Cross nurse's aide at the Lenox Hill Hospital. "I did volunteer work part-time for a number of years," she recalled. "Here in New York we didn't have the day care systems in the mid-forties, and so it was a matter of taking your children to the park and all of that, which I enjoyed in those years. I did a variety of volunteer work, everything when it could be very part-time and when I wanted. I read for the blind—in those days you were in a little booth and it made the big black records. . . . we read everything from novels and plays and poetry to textbooks. I did quite a bit of that at a neighborhood library where they gave Recording for the Blind public space. . . ."

In 1955, when Clifford was three and Alfred and Beverly had started school, Gloria joined the board of the Child Development Center (CDC) in Manhattan.[23] "I did a great deal of work for Child Development Center, which was a part of the federation of Jewish agencies here in New York City. And eventually I chaired that board. I really devoted a lot of time and energies to that and enjoyed that work."

After seven years of trusteeship, in 1967 Gloria became chairman of CDC's management committee. In that capacity, demonstrating her talent for solving problems, she inaugurated a series of meetings that aimed,

as she wrote emphatically, "to get *information* on the different ideas and activities which exist in the community. It should help us in a crystallization of our own thoughts and attitudes relating to the Center's future program. It [is] therefore important to select speakers who may or may not be close to our own approach." Prefiguring her later interests in applying systematic analysis to problems, her annual report for 1967–68 emphasized, "Our work has always been research oriented; there is ever the built-in approach of study and evaluation to all the projects we undertake. This has been a vital aspect of the Center's program and these endeavors continue to expand and new ones emerge."[24]

Gloria was active with other charities—serving, for instance, as chair of the Adoptive Mothers Committee of the Louis Wise Services, which provided services to unmarried parents, to children before their adoption, and to adoptive parents. She raised funds to renovate the agency's building at 6 East 93rd Street. She supported a scholarship fund at the Town School, which her children attended. The benefit included a Royal Ballet performance of *The Sleeping Beauty* at the Metropolitan Opera House. She also co-chaired a committee to benefit the Town School fund through an Artur Rubinstein recital.[25]

In her volunteer work, Gloria applied newfound leadership skills with grace and even levity. Included in her CDC farewell speech were "humorous lines of verse, which descriptively pinpointed members' activities and efforts for the Center."

While Gloria and the family lived at 888 Park Avenue, her sister Helen Frankenthaler maintained a painting studio just blocks away at 83rd Street and Third Avenue. On April 6, 1958, Helen married artist Robert Motherwell "at the home of the bride's brother-in-law and sister, Mr. and Mrs. Arthur Ross."[26] Through the ensuing years, Gloria and her new brother-in-law forged a friendship and working association that lasted beyond Motherwell and Frankenthaler's divorce in July 1971. This useful connection enabled Gloria to produce several significant Motherwell wall hangings.

As mentioned earlier, the seeds of Gloria's tapestry making career were planted in the 1950s by casual handwork at home—needlepoint projects and even a crocheted afghan from a Mondrian painting. During the late 1960s, she produced at least forty-four hand-hooked wall hangings (many as editions of five), participated in six solo and group shows, and began to work in Scotland as well as in New York. As we will see in the chapters to come, she developed professional standing with galleries, artists, and collectors.

The stresses in Gloria's life between 1965 and 1970, with a growing family, a discordant marriage, an active social life and newfound

Martha Lowenstein Frankenthaler, untitled needlepoint panel, c. 1950, stitched by Gloria, 9 × 7 in., glued to cardboard. Martha incorporated "M G H," the initials of her three daughters, into the pattern. GFR Papers; photo by Jannelle Weakly, ASM.

Gloria in her studio, New York, 1970.
Photographer unknown. (See plates 20, 57, 91.)

career, grew even more profound with the diagnosis of uterine cancer in 1969. She underwent surgery and subsequent therapy.

Forging Friendships

Following a divorce from Arthur in 1970, with an empty nest and new "tapestry career," Gloria continued to develop lively social and professional roles for herself. As she always had, she surrounded herself with accomplished friends and extended family members. She projected an intense sense of purpose—through her strong attachment to New York City and its institutions, her staunch support of museums and the arts, and, above all, her tapestry making. It was at this time that she began the important task of educating people about world tapestry traditions and her own role as tapestry éditeur.

Textiles and family were intertwined. She once reminisced, "I had a grandmother who always had busy hands, primarily crocheting, and she brought me the love of textiles. Her 'work' was not considered textile art, but indeed what she created *is* textile art. She taught me quality and just love of the art. As I grew up I crocheted. I could never knit—the American Red Cross during the war even turned down a scarf I knitted! But I loved crocheting and embroidery."

My many conversations with Gloria during her later life—most on long drives around the American Southwest and through New England—often featured stories of family and friends, past and present. Her fondness for these people was evident. "My friends, my close friends . . . are like family to me. We're all just so close. Two of my three closest New York friends are women that I went to school with starting in sixth and seventh grades. And we all still live near each other. In my era we came back [to New York City from college], married and settled in our home towns. Youth today are lucky in that they travel a great deal, but me, my generation we're fortunate in that our close friends are still a few blocks away."

Gloria chose to emphasize the positive in her friendships with childhood buddies, college alumnae, her husbands' families and colleagues, other extended family members, neighbors, tennis partners, and her children's friends, as well as a wide circle of professional colleagues in the art and museum worlds. They were a sustaining source for her identity and a way to feel connected. This gregarious spirit, perhaps inherited in part from her mother, sought, encouraged, and nurtured *productive* relations—friendships in which ideas were exchanged, projects were undertaken, and positive outcomes were expected. As she said, "We don't just sit around and gossip!" Her datebook was always filled with shared meals and meetings. Her address book was thick and well-thumbed, and her list of

contacts wherever she traveled was complex and cross-referenced.

Gloria was a gracious hostess who especially enjoyed bringing together friends who had not yet met each other. Typical is a note she sent to a friend in Scotland: "I can arrange for a few dates/meetings you might enjoy. Helena Hernmarck has a magnificent studio now in N.Y.; Jan Yoors would like to meet you; we might go to Youngerman's studio, to sister Helen Frankenthaler's etc."[27] She often greeted favored visitors with the pronouncement, "You will not be treated as a guest," which was meant as a great compliment.

In spite of a thrifty streak—she delighted in finding coins on the sidewalk and urged prudent management through her trusteeships—Gloria could also be an inspired gift-giver. She enjoyed surprising friends with appropriate and unexpected finds and, in fact, loved being surprised herself. Thank-you notes to and from Gloria are an important part of her copious correspondence. She apparently endeared herself to newfound friend and rug hooker George Wells with the simple gift of a new radio, for Wells wrote in his wonderfully embellished handwriting, "Elegy to Gloria Ross/ Thinker upper of perfect and wonderful gifts . . . the very first evening van Cliburn played for me while I worked—It was just wonderful of you to think of doing such a nice thing. My only radio was a little plug in about 20 years old with no F.M. so you can imagine what a new life I shall lead—George W."[28]

Sometimes the purpose of a gift was paramount. When she retired as chair of the Child Development Center, the secretary recorded in the organization's minutes that Gloria selected potted plants as table decorations so they could later replace the CDC waiting room's aging plants and instead of giving members the usual take-home gifts, she made a contribution to the Research Fund equaling the members' total years of service.

The relationships between Gloria and members of her immediate family were at times turbulent and unresolved. Her attempts at control frequently made things worse as she struggled with her complex and layered roles as daughter, sister, wife, mother, and stepmother. Although genuinely felt, bonds with friends and more distant relatives appear in retrospect as possible attempts at compensation. External acts of charity and a developing career provided alternate outlets for her creative energies.

The Seventies

As documented in following chapters, the 1970s were some of the busiest and most pressured years for Gloria professionally, with her expertise and contacts growing exponentially, public interest in tapestry snowballing, and plans for New York exhibitions

recurring each year. In the early seventies, she continued working in Scotland, made her first working trips to the French weaving towns of Aubusson and Felletin, and participated in a series of group shows in New York, Denver, and Germany.

Gloria's travels involved family as well as professional matters. She wrote to former brother-in-law Robert Motherwell, "After a few days in California with [daughter] Bev and then an all-too-brief journey to Aubusson, Paris and London, I am glad to be resettled in New York. I will spend weekends near Rhinebeck, which I enjoy; and, of course, I will have a week with [sister] Marge at the Vineyard. It has been nice to have [son] Cliff with me more and more. All in all the summer seems to go well. Best to you and Renata."[29]

Although she rarely acknowledged it, Gloria was unquestionably both proud and envious of her sister Helen's worldwide fame as a painter.[30] By the 1970s, public recognition of Frankenthaler's paintings was at its height. Exhibitions of her work received international acclaim and exposure in popular and critical media. Following the Whitney Museum's 1969 exhibition and catalogue, a major monograph was published by Abrams in 1971.[31] In 1974, Frankenthaler was elected to the American Academy of Arts and Letters, an honor bestowed only on the most distinguished American artists and writers. She received ten honorary doctorates in the arts and humanities between 1969 and 1985, six of them during the 1970s.

There is no question that the arc of Frankenthaler's career made significant impacts on Gloria and her professional endeavors. Gloria's choice of a career in close proximity to her sister's, often involving the same cast of characters, was not a coincidence, nor was her ambitious quest for recognition for a little-heralded corner of the art world. The relationship among all three sisters was alternately competitive and collaborative. (For more about specific projects shared by Gloria and Helen, see section on Frankenthaler in chapter 8.)

A New Marriage

In 1975, Gloria wrote to a friend in evident anticipation and high humor, "I will wed on Friday, April 4th, to Dr. John J. Bookman. Professionally, I will remain Gloria F. Ross. The new address for both women will be 21 East 87th Street, New York, NY."[32] And much later she recalled, "I married the most wonderful man in the world. I hope many of you listening feel the same way about your spouses. Doctor John Jacob Bookman was a veteran of World War II. He was captured by the Japanese in Bataan and survived three and a half years in a Japanese prison camp. It's just amazing that this did not seem to leave any scar on his personality, his character, his soul, his ability to

work, his ability to laugh. We really had wonderful, wonderful years together."

Also a native New Yorker from a well-to-do German Jewish family, Dr. John J. Bookman (1911–1988) was an internist specializing in diabetes. After earning his MD at New York University School of Medicine, he served overseas as a physician in the medical corps during the Second World War. Starting in 1967, he was an attending physician at Mount Sinai Hospital and served as an associate clinical professor at Mount Sinai Medical School. During their marriage, he became chief of the Diabetics Clinic of the hospital.

During previous decades, the Ross family of five and the Bookmans—John and Ruth Bookman and their two children, Ann and Richard—were acquainted through the children's school friendships. After Ruth's death from cancer in 1973, the families continued to socialize, and John and Gloria became closer. Their relationship was predicated on deep respect and pride in each other's professional lives, as well as shared personal values and growing affection.

Gloria moved into the Bookman apartment at 87th Street and Madison, which had belonged to John's parents before he and Ruth raised a family there. Gloria soon embarked on a yearlong remodeling project, which included an office with storage space for her tapestries and business records. Coincidentally, she found herself living just downstairs from her sister Marjorie Iseman, by then an independent writer and chronicler of New York City history.

Life with John Bookman, a man of calm and cultivated habits, took on a stable, predictable rhythm that provided great comfort for Gloria. Beyond their busy and independent city lives, the couple developed a consistent seasonal schedule, taking an annual winter vacation in the Caribbean, which Gloria described in a December 1984 letter: "John and I will be in the Caribbean for that [winter] holiday he always enjoys and needs; and of course I never find this a punishment."

Summers with her "Doctor John" meant three weeks in August spent at their country house at Jackson Corners, in the Hudson

Mrs. John J. Bookman at her new husband's home in the country, 1975

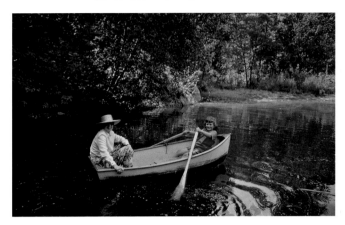

The Bookman family at Jackson Corners—Nick Buehrens (four years), Ann Bookman Buehrens, John Bookman holding Emily Buehrens (six months), and Gloria, 1986. Photo by Eric Buehrens.

valley near Rhinebeck, New York. "[W]e are in the midst of our three week holiday in the country," she wrote in an August 1983 note to me. "The summer zips by too fast, perhaps because it has been so pleasurable. I do feel somewhat pressured these few weeks when John spends three weeks in the country, and I make brief forays into the city to do a week's work in one day. I do some work up there, but it is difficult."

John's regular schedule also provided counterpoint and a platform for Gloria's travels abroad and her visits with distant weavers, New York galleries, and exacting clients. On trips, she phoned him each evening and he often served as a sounding board for many discussions and decisions. During this period, she and I began traveling through the Southwest several times each year. (She first contacted me in 1979 in search of Navajo weavers who might work with her, as explained in the preface and chapter 7.)

The Ross/Bookman families continued to expand during the 1980s. Holidays were often a mix of blended kin. Gloria emphasized their positive nature no matter what stresses were also present. A postcard from Lake Mohonk Mountain House in upstate New York announced, "I spent Labor Day Weekend with my 3 offspring + husband and 2 sisters—Fun!" Other correspondence echoed the sentiments, "A busy week or so before the forthcoming busy holidays. We will be in the country with a sprinkling of children and grandchildren. Christmas and New Year's will be here in New York with other family folk." As years went by, "John and I are well, busy with our rapidly-growing *familia*. John's fourth grandchild is due this summer, and I am blissfully happy with my ten-month-old grandson, who lives a mere seven blocks from us. My younger son Cliff plans to wed this spring to an attractive young dance teacher who brings to our in-law collection a nice new interest. 'Tis a motley crew, but it is fun." And the family further expanded, "My young grandson brings joy, and I enjoy my Grandmother role, which I play to the hilt, tremendously."[33] "Thanksgiving was fun, a blur of turkeys, diapers, very energetic 5 and 7 year-olds and I guess very much the traditional holiday."[34]

Gloria continued to travel for work as well, but because of a controlled heart condition John couldn't accompany her to Santa Fe or other high-altitude spots. During the late eighties, his heart began to give him more trouble. She reported optimistically, "Unfortunately, John was hospitalized for several weeks and is now impatiently progressing through a slow, but sure recuperation."[35]

Because of this illness and planned recuperation period, Gloria renewed her plans to lecture and travel in Australia during 1988: "Of course, Sue [Walker, symposium organizer] told me long ago of the May/88 plans. I had told her that I would not participate because John and I had then expected to be in Australia in the fall of 1988 for International Diabetes Association meetings. As of now I doubt if he will be able to make such a strenuous journey. So, I write to Sue today hoping that it is not too late to include me in these plans."[36]

In March 1988, thirteen years after their wedding and following a brief period of declining health, John Bookman died in a car accident on his return to the city from their country house. Gloria, in a typically forthright manner, wrote to a close friend in France, "I write to you with the very sad news of my husband's death on March 27 [1988]. . . . As you can well imagine, these have been terrible, terrible weeks, but I am all right and managing to get back to work."[37] She and her stepchildren, Drs. Ann Buehrens and Richard Bookman, established the John J. Bookman Memorial Prize at Mount Sinai School of Medicine.

Continuing Work and Travel

Despite deep grief at John's passing, Gloria did travel to Australia to lecture and tour briefly. After her return, her passion gradually returned in full force to orchestrate new tapestries and work directly with designers, artists, weavers, galleries, clients, and museums. "I am at last feeling better than I have for months," she observed, "and though life will never be quite the same, I really think that I have recuperated from the shock of John's death. I realize now how low I felt these last months, on the move, but kind of dragging my feet. I had a good visit to the Navajo reservation late August, and when I returned I realized that that seemed to effect a good break. It is a world I love, and you too would become enamored of the weaving and weavers."[38]

Gloria's love of travel showed in the planning, execution, and documentation of her many trips, both on business and vacation. She maintained detailed handwritten lists of items to pack, things to do, places to visit, and people to call on. She visited Europe, especially Scotland and France, often several times in a year[39] and made regular pilgrimages during various phases of her life to New England, the American Southwest, and the Caribbean, with further forays to Egypt, Russia, China, Australia, and Brazil. All her trips were punctuated by lively cards to family and friends, sometimes part of an informal family contest to discover the world's ugliest postcard.

Trips nearly always combined pleasure and work for Gloria. "After a few dandy weeks in Europe (Yugoslavia to meet our daughter-in-law's family, Italy for vacation, Vienna for John's medical meetings, Scotland to launch some new weavings), I am glad to be home— and I guess literally & figuratively picking up loose threads."[40] As her son Alfred worked in Geneva for a time and she had a former brother-in-law and nephew in Paris, an occasional European family rendezvous was possible. "I hope very much, and do think, that I will have some 'free time' in Paris. The nicest part is that Alfred may join me there for a day or two at the start of my trip when he will be en route London/New York." And she relished occasional nonwork trips, almost always with certain enlightened consequences: "Truly another world here. Long lines for food + all essentials in Moscow, Leningrad. In Tsibili, Georgians seem better off, up-beat and obviously soon to pressure for independence. After Georgian is taught in schools, then comes English then Russian. Great pride in their own culture. Adore Americans. Difficult trip. Navajo Nation Inn seems like the Waldorf! Soon to Helsinki overnight + on to Paris + then I'll be so happy to be home." All this fit on a single postcard: "1/14/85 En route Cairo/Abu Simbel. Hey dears, Look where I am! Watching the desert sunrise from the air makes up for the agony of a 2:30 am wake up call. A fascinating journey + the tour is well run, the guides excellent. You will be here one day. One is constantly in awe of the achievements of 3000BC + seeing these beautiful amazing creations in situ. I've fallen in with a lively group including a music publisher from NYC, a Harvard economics prof, their spouses, etc. I've been astride a camel, eyed Cheops tomb + belly dancers (they are amazing, too!). So it's fun. . . . —Love, Gloria."

France was an especially adored destination for both work and enjoyment. Gloria was enamored not only of historic French tapestries, but also of French culture, aesthetics, and friendships. Her trips often produced ebullient reactions, such as, "Olivier, my visit to Aubusson [the second trip in six months] was indeed a delight in every way and I thank you and François for your most kind hospitality. The many beautiful tapestries, the new atelier, your wonderful home, the croissant for breakfast et al, are nice memories."[41]

Having visited the American Southwest on a family vacation with her children years earlier, Gloria rediscovered the territory professionally in 1979, when she first contacted me.[42] She enjoyed repeated visits, sometimes several each year, to expand her Native/Noland series of Navajo-woven tapestries (see chapter 7). In addition, she eagerly extended her circle of strong personal and professional friendships.

Utterly unlike anything in her New York and European experiences, the Southwest made a strong claim on Gloria, as she wrote to me, "When I looked over your slides again last night, I realize how much I love [that] part of the world, its life and its history, its art and its people, and I had such a yearning to take the next plane. . . ."

Service and Philanthropy

A conscientious volunteer and lifelong philanthropist, Gloria joined the Board of Trustees for the Child Development Center in 1955. As

Touring Egypt, 1985

described earlier, she chaired that board from 1967 to 1970 and worked with other New York charities during her early married life. As her arts career expanded, her charitable contributions strengthened professional alliances with kindred organizations and causes.

Gloria established an eponymous private foundation, the Gloria F. Ross Foundation, which has contributed to a wide array of non-profit enterprises including schools, museums, and medical research projects.[43] She was also a supportive member of ArtTable, Inc., a national organization for professional women in the visual arts.[44]

From 1980 to 1992, she contributed generously to an annual collecting fund at the Denver Art Museum, which resulted in the purchase and documentation of thirty-eight contemporary Navajo rugs and tapestries. This collection, to which she added pieces from her personal collection, formed the basis of an exhibition that toured the country from 1992 to 1995, funded by the National Endowment for the Arts. A fully illustrated catalogue, *Reflections of the Weaver's World*, accompanied the show.[45]

In the early 1980s, Gloria's dedication to New York City appeared with renewed passion, as H. Ross Perot (no relation to Gloria's part of the Ross family) tried to wrest a major cultural institution from the city and move it to Texas. At stake was the Museum of the American Indian/Heye Foundation. First, Gloria wrote, "I can report on a wonderful meeting with Dr. Force and Dr. Anna Roosevelt, both of the Heye Foundation I had heard that the museum and this great collection might move out of New York, and of course I am delighted that it remains in town, where the multitudes can study and enjoy it."

Then things escalated slightly. "On Sunday [a Heye board member] and wife will visit us for lunch in the country (They are 5 minutes away from our house) and I hope to engage him in talk of the proposed (?) effort to keep the Heye here in NYC. I get strange vibes that really not much effort is really being made to keep it here. Hope I am wrong, but I am sure that with the proper effort a city like NY could easily (with public and private funding) keep it here. Don't mention this to anyone, because I may be all wrong—but I am determined to find out. I do care."

Almost a year later, a *New York Times* article, "Perot Seeks to Move Indian Museum" by Douglas C. McGill on February 21, 1985, prompted Gloria to write a hotly argued letter to NYC Mayor Koch. "The greatest scandal that has ever concerned the Museum of the American Indian is ongoing," she began. After expressing her shock and anger at such a proposal, she concluded, "I will do whatever I can to preserve this landmark collection in New York City." On the way, she pointedly invoked her faith in "our Supreme Court."[46]

On a postcard to me, she noted, "I'm busy trying to get The Times, others, somewhat stirred up too about the museum. Hard to beat 70 mill. but we'll try."

Ultimately, the Smithsonian Institution took control and established the National Museum of the American Indian, with a major edifice on the National Mall in Washington DC and a New York presence in the Customs House at the southern tip of Manhattan. Gloria was proud that the exhibition of her collection, Contemporary Navajo Weaving from the Denver Art Museum, opened at the Customs House during the second series of exhibitions to inaugurate that location. She became a founding member of the National Museum of the American Indian and donated several prized Navajo textiles to the permanent collections. The NMAI board and staff memorialized her in the *New York Times*: "Her dedicated work and enthusiastic support of Navajo people will be remembered always."[47]

She was a trustee for Mount Holyoke College from 1986 to 1991 and worked on the advisory board of the college's art museum from 1975 to 1997. When she served on the board's building and grounds committee, her experiences with architects on tapestry commissions informed her recommendations for campus planning. Regular trips to South Hadley became a highlight of those years, when she gathered with collectors and like-minded supporters and worked closely with the college's president Elizabeth Kennan.[48] Gloria's enduring friendship with Dr. Teri Edelstein, then director of the College Art Museum (she later moved to the Art Institute of Chicago), provided Gloria with useful insights into trusteeship and the museum world for many decades.

Four major tapestries from her private collection reside in the Mount Holyoke College Art Museum. In 1997, Gloria worked with her friend Evelyn J. Halpert, retired head of the Brearley School, to establish a scholarship fund at Mount Holyoke College for New York students from Brearley, Stuyvesant, and Hunter College high schools. In addition, Gloria became aware of the archaeological accomplishments of Dr. Anna Roosevelt in South America and arranged for her to receive an honorary doctorate from the college.

From 1991 until her death, Gloria served on the Board of Trustees for the Textile Museum in Washington DC. The director praised her "particular interest in educational programming, especially programs for families and children. Always concerned with presenting programs of the highest quality, she was also a realist, encouraging the creative use of limited resources. Her guidance and unfailing support of the Museum made an indelible mark on our institution."[49]

In 1992, chairman Edwin Zimmerman appointed Gloria F. Ross, Jack Lenor Larsen,

Sponsoring an award for Navajo weaving at Santa Fe Indian Market, 1991. Barbara Teller Ornelas wove the winning tapestry. Photo by the author.

and Eleanor Rosenfeld to an ad hoc committee for contemporary textile exhibitions and charged them to investigate prospects for modern fiber art shows at the museum. Larsen's typically declarative statements on his boldly designed "JLL" notepaper stood also for Gloria's connoisseur-like wishes for all things: "All of us agree that the Textile Museum must have the *best* of whatever category we focus on, and that we should tie the contemporary to the past."[50]

As with other institutions with which she affiliated, the Textile Museum received donations from Gloria's private collection, including a number of significant Navajo textiles. Because of her work in the American Southwest and a friendship with several board members, Gloria supported the Navajo Churro Sheep Project of Utah State University. Her southwestern visits also prompted her to fund an annual award for contemporary Navajo weaving at the Santa Fe Indian Market.

Gloria often expressed gratitude for her own good fortune—her family, education, personal wealth, and professional freedom. Raised with the Jewish tradition of *tzedakah,* she believed in giving back to society through volunteerism and charitable contributions.[51] Critical of donors who wanted their names in lights, she took pleasure nevertheless in having her own name associated with her chosen causes and was quick to object if it was omitted. She used her professional name—Gloria F. Ross—as a donor, never her social names Gloria Bookman and Mrs. John J. Bookman. In addition to representing her earnest commitment to philanthropy, this served her career well by forging new ties to important public institutions.

The Value of Work

Doing a good job was a major theme for Gloria. "These last few weeks have been a little too busy, but . . . I feel fortunate in the pleasure I get from my work." When asked about her values, she replied during a 1996 interview, "Work to me is good. It's a *good* word. People are happy when they are working, when they are achieving, when they're trying to achieve. Good word, yeah."

As noted in the eulogy at her memorial, "In her very full life, Gloria valued, above all else, earnest and productive work. . . . the word 'work' appeared constantly in her conversations and it took many forms: 'When I take my *work* to France. . . . Do that artist's imagery and colors *work*? Everyone needs to *work* to feel useful. . . . What *work* should the foundation accomplish? When I *worked* in Edinburgh. . . . As I *work* through the specifics. . . . When I *work* from an existing painting. . . ."[52]

Despite her fervent belief that Manhattan would always be the center of the modern art world, Gloria delighted in broadening her

Gloria and the author with archaeologist Joe Ben Wheat, Yellow Jacket, Colorado, 1983. Gloria became intrigued with his research on early Navajo textiles and cosponsored completion of his 2003 award-winning book, *Blanket Weaving in the Southwest.* Photo by Kit Schweitzer.

perspectives. In rough notes she made for a Denver Art Museum lecture, she wrote, "Good for art museum audience to have a show curated by an anthropologist. I for one have whole new app[reciation] + look on my European weavers + weavings differently."[53] Shortly afterward, another hastily scribbled note recorded: "Leon[ard] Bernstein *The Unanswered Question: 6 Talks at Harvard* [1976], The sense of interdisciplinary values—that the best way to 'know a thing is in the context of another discipline.' 'The spirit of cross-disciplines' anthropology history art."[54]

Gloria's children pursued careers in the fields of political science and the fine and performing arts. Her eldest son, Alfred F. Ross, a graduate of Columbia University Law School like his grandfather, founded and has served as president of the Institute for Democracy Studies, a nonprofit center established in 1999 to study antidemocratic religious and political movements and organizations in the United States and internationally. Her daughter, Beverly, became a theatrical and film actress in California and New York. Son Clifford graduated from Yale University and developed a successful career in New York as multimedia artist and innovative photographer. Gloria was intensely proud of these professional accomplishments.

Collecting

Gloria lived a profoundly aesthetic life. She embraced her urban surroundings and the pleasures they offered: "Living in New York, we're so enriched with all that's available to us. I live right near what's called Museum Mile— the Metropolitan, the Whitney, the American Academy of Art, the Guggenheim, the Jewish Museum, ICP-Photography, the Museum of the City New York (just with their dolls and doll houses!), just walking the streets with the galleries! The catalogues that I get from Christie's,

The Bookman's dining room with a Bearden tapestry and other *objets*, 1981. (See plate 5.)

Gloria's first Motherwell rug, made for her home, c. 1970. (See plate 42.)

and just going to some of the Christie's exhibits, is like going to one of the great museums in the world. And I just feel we're so fortunate here in the city to have all this available. And now, places like the Met are open in the evenings, and you have concerts and dinners there, and then [you can] walk through the galleries of Greek sculpture. I mean it's just too much to contemplate really."

When it came to personal collecting, Gloria was passionate. Seated in her living room, below two Matisse images, across from a 1913 painting by Fernand Léger (one of his earliest in the Contraste de Formes series), she once proclaimed, "I love beautiful things! Or at least things that I think are beautiful. And I have been fortunate to be able to get to own many of the things that I've admired. I can also have great, *tremendous* pleasure seeing things that I'm not going to buy or would love to have but couldn't buy. I don't feel I must own things to enjoy them, but I feel very fortunate that I have a home filled with a great variety of things that I really love." Looking around the living room she continued, "I love the fabric on the couch that I'm sitting on; it just is beautiful I think. The chair next to me and all of these things were upholstered at least thirty years ago, great fabrics and I paid well and kept things well. Now there's a damask, not a fine damask but sort of a partially wool damask on the chair next to me, that I think is just exquisite." And glancing into the dining room, "I just enjoy what I have. My good friend Edith Fischel is a great potter and I have a lot of her sculpture. Diego Giacometti, Alberto's brother and who made wonderful decorative art, was a good friend of mine and I have some marvelous pieces of his. I have a great variety of things, but I really love what I have. And get great pleasure in what I think is beautiful. Of course, I have some of my own tapestries hanging all the time, most of which change. I have things like a lazy Susan that I can see—it's an early Minton lazy Susan that I spotted for a song at an antique shop on the Royal Mile in Edinburgh. And carried home on my lap on a plane some

thirty years ago! This was when I was up there at the tapestry workshop. Well, I love it!"

Gloria's eclectic but choice possessions included fine eighteenth-century British furniture and a typically quirky metal table and companion sculpture, *Chat maître-d'hôtel,* created by Diego Giacometti. A striking 1956 Calder mobile, *Perforated Sunflower,* hung over the dining table, while an ancient Mesoamerican stone ax and a T'ang dynasty ceramic horse shared space on the George III mahogany sideboard. A Boudin painting of ships at harbor contrasted with her classically Cubist stone sculpture carved by Henri Laurens. Her art library held more than three hundred volumes with subjects ranging from the ancient world to the most contemporary installations. Even one-time visitors to her home found Gloria's collections memorable.

She bought relatively unrecognized works at major auction houses during the 1950s and 1960s in New York and France. (In 1955 she appears to have been especially active.) As the auction house of Christie's acknowledged, "Her home was a salon to artists long before they became household names, and her sensitivity to their vision not only translated into her work as a master weaver but also influenced the choices she made as a collector. . . . Gloria Ross devoted her creative life to the extremely sensitive requirements of collaboration with the most noted artists of her generation and in doing so trained her eye."[55] She delighted in informal works—a pencil sketch by Jean Cocteau, several figural drawings by Mary Cassatt, and two Stuart Davis renderings of the Empire State and Chrysler buildings in the 1930s. Not only was she proud of her possessions, but of the relatively reasonable prices she'd paid for works that appreciated later in value and recognition.

This collector became thoroughly engaged in the chase and capture of appealing objects and could also generously contribute to that end. As she and I began to collaborate on a collection of contemporary Navajo textiles for the Denver Art Museum, she wrote, "I encourage you to buy all you want for the DAM as soon as you can easily do so. The second part of the grant will be mailed to them soon and this, plus the balance from last years', plus interest on the latter, should be burning a hole in that proverbial pocket. Also, I remind you that if an advance is ever needed, lest a gem escape you, just a phone call is required. Do not hesitate to push ahead . . . with any other weavings for our collection. As you move along, if you spot any weavings for my own growing collection, call me collect. I love that small Two Grey Hills you spotted for me." Her letters during the 1980s are sprinkled with eager comments such as "it would be great to locate some more 'finds' for the collection."

Creating a Legacy: A Center for Tapestry Studies

In June 1995, Gloria was diagnosed with inoperable lung cancer. She urgently battled it through chemotherapy and attention to healthy and artful living. Although given a prognosis of only a short time to survive, she lived fully for several more years. At the time of her diagnosis, she exclaimed to me, "How shall we continue our projects together?!" Through the next two years she endured brutal chemotherapies and flagging energy, awkward wigs and cancelled trips, but rarely a mental lapse. Between treatments, she simply restructured "certain corners of my life," forged ahead with extant projects, and created one new program—the founding of the Gloria F. Ross Center for Tapestry Studies.

Determined to perpetuate the recognition of tapestry as a major art form and the subject of scholastic attention, she brainstormed with her longtime friend Henry Kohn and his son-in-law Michael Katz, both partners in the Wall Street law firm established by her father and uncle. Together we formulated plans for the Gloria F. Ross Center for Tapestry Studies, a nonprofit research institute and educational foundation. In November 1997, Gloria hosted the first GFR Center trustees' meeting at her home. The founding board of trustees included anthropologist Susan Brown McGreevy as president, anthropologist and step-daughter Ann Bookman as secretary, and restoration architect Hal Einhorn as treasurer, plus ex-officio members Michael Katz (her attorney and estate executor) and me as founding director. The board established the GFR Center's original mission, "To increase the public appreciation and scholarly understanding of tapestries through the organization of artistic, historical, and cultural research and public programs."

It was Gloria's wish that the GFR Center foster both the creative practice and cultural study of tapestry. It was not meant to continue her business endeavors nor focus on her own work alone. Following her plan, the Center's research projects and public programs have addressed the art of traditional and contemporary tapestry, handwoven in many societies from ancient to modern times.[56] Activities have included the conduct of active interdisciplinary research; recognition of excellence in research, publication, exhibition, and teaching; and collaboration with like-minded arts organizations.[57]

The GFR Center's inaugural event was an illustrated public lecture by Gloria's good friend and collaborator Archie Brennan, held at the Yale Club of New York City on March 10, 1998. More than three hundred people heard "The Work o' the Weaver: Fifty Years in Tapestry." Gloria was unable to attend, but a close friend and fellow Holyoke alumna reported back to her, "The room was charged with excitement and warmth. I spoke to several weavers and curators from far and wide. One from Rhode Island, another from upper New York State. They came just for the event and were returning home right after it. You are truly renowned and loved by your workers in the art of weaving. I overheard, 'Gloria Ross was the person who put tapestries and weaving into new importance in the world of art.' . . . Some people walk on the moon—others open up more doors to the world of art. It's great to be within your orbit."

Gloria died at Mount Sinai Hospital on June 21, 1998. Following a funeral service at Temple Emanu-El in Manhattan, her body was interred in the Frankenthaler family mausoleum in the Cypress Hills area of Queens.[58]

It was fitting indeed that the funeral took place at Temple Emanu-El, one of the largest synagogues in the world, where her last major tapestry project was on permanent display—the celebrated Ark curtain designed by Mark Podwal and handwoven in France. Once and for all, this brought together Gloria's appreciation of her family's spiritual and cultural heritage, her love of New York and its artistic institutions, her expertise in the French tapestry tradition, and her skill in working with talented artists. Her work, as the following chapters attest, is indeed her monument. As the eulogy for her concluded, "She valued deeply her connections with interesting people, who were *doing* fascinating things and *making* significant contributions to the world around them. And she was, of course, one of them herself. Throughout life she was, indeed, totally engaged and thoroughly engaging."[59]

The Denver Art Museum's 1992 exhibition showcased thirty-eight Navajo rugs from a collection created by Gloria and curated by the author. The NEA-funded show traveled to the Heard Museum, the Joslyn Art Museum, the Smithsonian's Renwick Gallery, and the National Museum of the American Indian in New York.

I have always enjoyed working with
wool and in the early 1960s, as a hobby,
I made some wall hangings designed
by contemporary painters.
—Gloria F. Ross[1]

Start with a linen-like heavy fabric
and apply the wool with punch needle.
—Gloria F. Ross[2]

. . . for faithfully translating the artist's
design Ross has adapted the hooked rug
technique [which] allows her to render
completely the fine distinctions in color
and texture that the artist requires.
—Richard Feigen Gallery[3]

Gloria Ross made her first "tapestries" using a hooked-rug technique with
a handheld hook, heavy wool yarn, and fabric stretched on a wooden
frame.[4] "When I first made wall hangings," she recalled, "I was unaware
of all that was going on in this field in America or elsewhere. I was a crafts
person working primarily in wool. I followed traditional patterns and often
designed my own work, but more and more, I worked from the paintings
and maquettes [models] of others."[5] After her first highly successful experi-
ments in 1963 (plates 17, 42), she broadened the approach, first establish-
ing her own studio, then hiring others who assisted and streamlined the
process, and finally contracting all the work.

In 1966, Stephen Radich Gallery in New York organized the show called
Rugs, which featured over a dozen custom-designed works in the latch-
hook-rug technique. The show was inspired by Leslie and Rufus Stillman,
who commissioned Alexander Calder to design a rug in 1964 for their
Marcel Breuer home. Louisa Calder reportedly taught the Stillmans to create
a latch-hook rug using one of her husband's designs. Other works in the
exhibition were designed by painters, architects, and other artists. Although
Gloria began hooking earlier as a hobby, the Radich show undoubtedly
spurred her forward. It may also have provided a business model, as sug-
gested in Susanna Cuyler's account. She wrote, "Fourteen artist-friends of
the Stillmans and two other well-known painters designed rugs and each
was given a rug with his own design in return. . . . The rugs were priced
according to their size; the smallest sold for three hundred dollars, and the
two largest, designed by John Johansen and Marcel Breuer, sold for fifteen
hundred dollars each. The rugs were displayed in the gallery in such a way
that they could be walked on and seen from all angles. Consequently the
workmanship could be properly inspected and appreciated."[6]

From 1963 to 1976, over seventy hand-hooked wall hangings and floor
pieces resulted from Gloria's efforts, which are described in this chapter.
These were designed by ten artists.[7] In addition, George Wells designed and
made two wall hangings for the 1985 renovation of the Mazza Gallerie in
Washington DC and Gloria initiated projects for five commercial pile carpet
designs by Jean Dubuffet, Hans Hofmann, and Jack Youngerman.

Sometime in the mid-1980s, with pride and a note of surprise in her
voice, Gloria showed me the simple hand tools that began these projects.
Tucked into her desk drawer (and now in my own), they seemed to me like
relics from another era. Her tone of surprise hinted at how far removed from
that formative time she found herself, having moved from home-crafter to
transatlantic éditeur.

Terms and Techniques

Rug hooking apparently originated in eighteenth-century England, where
weavers recycled yarn scraps ("thrums") left from factory woolen looms and
worked them into a fabric backing to create small hearthrugs.[8] Across the
Atlantic, American housewives of the colonial period thriftily adapted the
technique, in which "strips of cloth about three-eighths to one-half inch in
width are pulled through a coarse foundation fabric by the aid of a small
hook. The hooked-in strips are left in raised loops of even width, about one-
half inch or a little more, which form the pile of the rug. The under side is
kept flat. . . . In some cases the looped pile has been clipped which makes
a soft and velvety surface."[9] Only simple tools and materials were needed:
"Hooked rugs were made on a frame with a thickly woven homespun or

Detail, Larry Poons, "after *Julie*," 1970, hooked
by Anna di Giovanni. (See plate 84.)

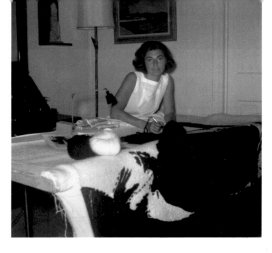

Gloria made her second hooked rug on the dining room table, 1964. (See plate 42.)

A hooked sample with uncut looped background (orange) and sheared motif (golds), 9.5 × 12.5 in. GFR Papers; photo by Jannelle Weakly, ASM.

coarse linen (much later, burlap) material stretched tightly over it. Patterns were drawn on the fabric with a charcoal stick from the fire."[10]

Eighteenth-century New England rugs contained linen, wool, and cotton cloth strips. Making rugs out of these scraps was an excellent way to recycle worn fabrics and preceded hooking with separate wool yarns, which is how Gloria's pieces were made.

The hooked-rug technique used by Gloria resulted in a pile fabric, in which yarns are looped into a canvas foundation and then either left as short uncut (looped) pieces or cut for a sheared surface. Both the looped-pile and cut-pile versions may be used in the same fabric for different textural effects. Irene Emery's *The Primary Structures of Fabrics* elaborates further. "Pile added to a finished piece of fabric is *accessory pile* . . . , whether made . . . with sewing thread and eyed needle . . . or 'hooked' through the fabric in loops or tufts, as in 'hooked rugs,' et cetera."[11]

In a section on embroidery and accessory stitches, Emery includes hooking only as an aside: "NOTE: that accessory pile can also be produced by drawing loops of an accessory element up through a foundation material by means of a hook (i.e. by 'hooking')—a technique probably best known for its use in so-called 'hooked rugs.'"[12] A related term, *tufted*, "refers either to untwisted and usually natural-length bunches of fiber . . . secured in a fabric structure . . . or to the 'hooked-rug' or 'tufted bedspread' type of accessory structure."[13] In industrial parlance, the process of tufting, contrasted to weaving, is a mechanical technique of inserting yarn fed from continuous spools through a base fabric by means of a pressurized "gun." Mechanical tufting is widely used in commercial and custom carpet manufacture.

The hooked-rug technique, a non-loom process, is also distinguished from other carpet-making techniques in which pile yarns are integrated into a fabric's handwoven structure by interlacing or knotting as the weaving progresses.[14] Many Oriental carpets and Scandinavian *rya* rugs are handwoven in this manner.

Gloria's standard contracts with artists in 1969 referred to her hooked creations as *rugs,* but soon this was crossed out and *tapestries* written into each contract, indicating her shifting perspective. Commission contracts sometimes used the intermediate term *wall hanging.* While technically not made with tapestry weave, the works were intended as wall hangings rather than floor rugs, and their designs, while not often figurative or narrative (features commonly associated with tapestry), were nevertheless part of a painterly and decorative tradition. Given the strong distinctions of tapestry weave in a structural sense, I have used *carpet* or the French term *tapis* for the pile pieces that Gloria produced. Many of these were intended as wall hangings, but were not handmade using tapestry weave.

The two terms *tapestry* and *tapis* derive from the same linguistic origins: "Middle English *tapiceri, tapstri*, from Old French *tapisserie*, from *tapisser*, to cover with carpet, from *tapis*, carpet, from Greek *tapētion,* diminutive of *tapēs,* perhaps of Iranian origin." Each has both functional and technical, generic and specialized, meanings. In English, the term *tapis* is considered obsolete (from Middle English and originally Old French), having generally meant "tapestry or comparable material used for draperies, carpeting, and furniture covering."[15] In France, however, the term survives and refers to pile carpets used as floor coverings and other furnishings. (Just to confuse issues, Middle Eastern kilim carpets, woven in true tapestry weave without pile, are referred to as *tapis plat* in French, that is, flat "tapis.")

The best-known tapis in France are the handwoven pile carpets of La Savonnerie, produced since 1624 in a former soap factory adjacent to the famous Gobelins tapestry manufacture. Today, pile carpet weavers in France work from centuries-old cartoons as well as from contemporary designs by modern painters. Gloria never worked with the French pile carpet or tufted rug studios.

The Hooking Process

Hooking may involve recycling of old materials such as sacking for the backing and rags cut into strips, or the use of new backing cloth, virgin wool yarns, and fabric stripped for a specific project. Tools range from the simplest metal hook to semimechanized implements. Techniques, however, remain relatively constant.

Gloria ordered backing materials from the Ruggery on Long Island. Almost any coarse fabric can be used for hooking; burlap and flour sacking were the original backing materials. Most modern hooked rugs are made with backings of cotton "monk's cloth" (also known as warp cloth, rug warp, or cotton warp) or other sturdy commercial goods. Sometimes linen fabric or jute burlap is used.

To begin, a pattern is transferred onto a backing fabric. Yarns or fabric strips are inserted into the canvas using a handheld hooking tool, making loops that follow the printed pattern. After the hooking is completed, a latex backing is applied to the reverse side, and the piece is hemmed or edged. The loops may be left intact, cut individually, or sheared en masse.

Whenever she acquired a new design, Gloria first had the artwork photographed professionally in black-and-white and had the image reversed. Technically, this was known as a "cartoon," just as in the world of woven tapestry. The pattern was then transferred to the canvas as a guide for the hooking from the wrong side of the fabric. Typically, George Wells or one of his five employees at the Ruggery produced the pattern transfer. The canvas backing was then stretched onto a frame for insertion of the colored yarns that form the pattern.

Primarily, Gloria used Paternayan "Persian" wool yarns with a long-staple 100 percent virgin wool from New Zealand sheep.[16] She chose from the company's four hundred pre-dyed colors and also had yarns custom-dyed at the Ruggery, known for its dye expertise.

Several tools can produce similar hooked products, starting with a simple metal hook inserted into a wooden handle. One expert reports, "When a hand hook is used, the loops are pulled up individually through the weave of the cloth to any height the rugmaker desires. With a speed hook, the pile is pushed down through the backing and the height of the loops is adjustable to set heights from one-quarter inch to 1½ inches. Speed hooking is the fastest method of rugmaking. There are three varieties of speed hooks: the punch needle, the shuttle hook, and the speed tufting tool. The last two are the fastest methods because they automatically space the loops."[17]

The hand-hooking technique employed in GFR tapis involved a punch needle—"the lightest, smallest, cheapest, and slowest speed hook."[18] In another rugmaking process, a latch-hook tool is used, not for rug hooking but for inserting precut yarn into an open mesh

backing and knotting the yarn in place.[19] These hand-controlled tools with their simple mechanics contrast markedly with the modern power-tufting gun, which inserts yarns into a backing by means of compressed air.

In speed hooking, yarn from a continuous ball or skein is fed through the tool's hollow handle and inserted into an eye in the needle's tip. The needle's length, and therefore the length of each yarn loop, is set but adjustable. Working from the reverse side of the backing stretched onto a frame, the tool is handheld like a pencil, with the tip used to punch into the fabric's topside and insert the yarn, withdraw from the fabric, and form a loop on the underside. This motion proceeds until the entire surface is covered with loops.

Some wall hangings were left with uncut loops, while others were sheared or partly shorn. The shearing was sometimes done by the person doing the hooking, but sometimes the Ruggery did this later. Paul Feeley's "after *Untitled (Yellow, Red)*" was completely shorn, leaving a velvety smooth surface. In contrast, Feeley's "after *Lacona*" was left with loops intact, allowing the stitches to follow the curves of the design (plates 15, 16). For Larry Poons's "after *Julie,*" just the ovals were shorn, with the background left looped (plate 84). Gloria's handwritten notes direct Anna di Giovanni and others: "Anna—make full length rows?" and "Turq[uoise] circles very deep—shear completely—& even [with] other surface." One of her helpers made their own notes, too: "Shear dots—make very deep & shear all loops as near as possible."[20] As is common for hooked rugs, a latex backing was applied, locking the yarns into place and providing a less flexible and non-slip reverse side. Gloria contracted this job out, as well as the shearing, hemming, and labeling for most rugs.

Gloria F. Ross Studio, New York

In 1963 Gloria made her first two hooked rugs in the dining room of her Manhattan apartment at 888 Park Avenue. By March 1966, she had converted one of the children's bedrooms into her "studio," where she hooked three small wall hangings of her own design. In

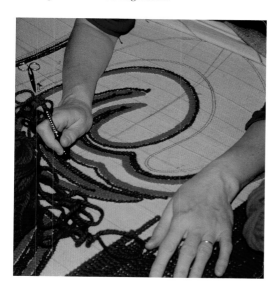

Inserting yarn loops into monk's cloth backing with a pencil-like hooking needle

Gloria F. Ross, "*Rolling Stone,*" 1966, hooked by GFR workshop, wool on commercial cotton cloth, 16 × 40 in. GFR Papers; © Estate of Gloria F. Ross. Photo by Jannelle Weakly, ASM.

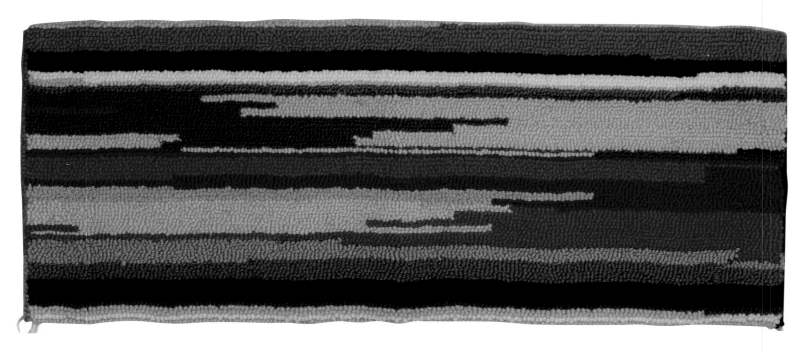

Gloria F. Ross, "*The Striped One*," 1966, hooked by GFR workshop, wool on commercial cotton cloth, 16 × 40 in. GFR Papers; © Estate of Gloria F. Ross. Photo by Jannelle Weakly, ASM.

"*Hour Glass,*" "*Rolling Stone,*" and "*The Striped One,*" she used wool left over from other handwork. These were followed between July and December 1966 by "*Tulip,*" later called "*Blue Tulip,*" hooked by one of the doormen in her building, a man named Jorge whom Gloria trained and hired. In the same year, she and Helen Frankenthaler also initiated three hooked projects (plates 18, 19, 20).

In 1969, as Gloria recalled later, "My first large commission literally drove me out of my house."[21] This was a commission designed by Jack Youngerman for Chicago's John Hancock Building (Checklist entry 92). After briefly sharing a studio with a friend, Gloria moved with this project into her own Manhattan workshop.

Her work continued to expand, and Gloria sought further assistance. "As I began to enjoy the advantages and excitement of working in all these different ways, in 1971 I closed my own workshop. [I] realized that for the sort of tapestry I was creating, i.e. with these many varied designs [and] artists, I could achieve my goal more successfully by seeking weavers here and abroad who could best bring out the distinctive qualities of a given artist's work. The effort of the artisans is as important, of course, as the artists in this collaboration."[22]

Anna di Giovanni

Anna di Giovanni, a rug maker from Glen Cove, Long Island, had stationery imprinted "Hooked Rugs Made To Order / Cleaned and Repaired."[23] Prior to setting out on her own, she had worked for the Ruggery, known for hiring local Italian-American artisans to produce custom-made carpets. Gloria contracted with di Giovanni for at least eight titles, resulting in almost thirty hand-hooked pieces.

Gloria turned to di Giovanni in 1969 for the large panel (102 × 264 inches), designed by Youngerman for the Hancock Building. In April, di Giovanni agreed to "get it on cloth—can do this as soon as have cartoon."[24] She completed the "Hand hooked rug, 9½' × 22'—209 sq. ft." by early September.[25] George Wells of the Ruggery backed and mounted the piece.

In 1969 di Giovanni also began hooking Motherwell's "*Homage to Rafael Alberti—Blue*" tapestries (plate 43). She finished the first of the series with a plain blue edge, but Gloria and the artist planned for the next one with a canvas-colored border. By spring 1970 the full edition of five, plus one or two artist's proofs, was completed, using over 180 pounds of Paternayan wool yarn.[26]

Anna di Giovanni visited Gloria in Manhattan on October 18, 1969, and agreed to hook an edition of six wall hangings, "after *Every Third*," designed by Kenneth Noland (plate 57). Gloria's detailed notes indicate that di Giovanni marked the canvases and hooked each piece with loops "all in a vertical direction." Using a total of 106 pounds of Paternayan wool, she completed the order in December 1969. The Long

Anna di Giovanni in rug studio, c. 1968

The Westinghouse commissions designed by Frankenthaler and Motherwell required more space than worktables provided at the Ruggery, 1971.

Island Carpet Cleaning Company hemmed and applied latex backings to these.[27]

In 1970, fourteen separate colors of the Paternayan wool yarns were selected for Morris Louis's "after *Equator*" (plate 40). George Wells made six canvases after Gloria wrote in June 1970, "I enclose photos of a Morris Louis painting—They were taken with different filters & I send all because one may show edges not obvious in others—So many colors adj[acent] to each other are of the same value-tone so that they were diff to photograph in black & white—All fotos are reversed and ready for your use. I plan to use about 14 colors so include as many of the subtle changes as possible—without making the work too much of a struggle."[28]

Two Westinghouse Broadcasting Company commissions in Philadelphia were designed by Frankenthaler and Motherwell (plates 23, 45). George Wells transferred the artists' patterns to canvas and di Giovanni agreed to do the hooking: "Nice hearing from you. Our summer so busy—no vacation. Things look better now. Hope yours was good. Will do your hangings when you are ready & would like them put on cloth as usual. Kindest regards."[29] In 1986, Gloria planned for Anna di Giovanni to hook a George Wells design for the Calder Court commission at Smith Haven Mall in New Jersey, but this project wasn't completed.

George Wells and the Ruggery

A graduate of Rutgers University, George Wells made his first rug in 1951. He established his own business on Long Island in 1956, expanding the Ruggery, which was founded there in 1921.[30] Before he took up rug making, Wells was "Head of the Bureau of Merchandise Design for Lord and Taylor; Assistant Display Manager for Montgomery Ward retail stores; Head of display and store modernization for Franklin Simon; Director of Merchandise Presentation for James McCreery; freelance designer for store interiors; and has written several articles about rugs for national distributed magazines. . . . His rug designs have received top recognition from the American Institute of Decorators, Architectural League, National Designer-Craftsmen Exhibition, and the Craft Exhibit in the American pavilion of the Brussels World Fair."[31]

Wells provided custom-designed, hand-dyed hooked rugs to "a Who's Who of politics, theater, banking, education and industry . . . Rockefeller, duPonts and the Stephen Smiths, as well as Audrey Hepburn and the late Richard Rodgers."[32] Described as an unpretentious and congenial man, Wells built a national reputation for his single-minded focus on hooked

rugs. His legacy lives on: "For more than 80 years, interior designers, celebrities and local residents have come to a small business on the North Shore of Long Island to commission custom-designed, hand-hooked rugs. The Ruggery creates unique, meticulously crafted rugs of the highest quality work here in our workshop. We're one of the few places in America where you can have a carpet hand made to suit any space or occasion. . . . At the Ruggery, it's our job to provide you with home furnishings that are beautiful and useful: rugs of incomparable workmanship that please the eye and warm the soul."[33]

Gloria contacted "Marie S." at George Wells's workshop in 1966 about finishing a rug that she herself had hooked. By 1969, Gloria had shifted to hiring Wells and di Giovanni for most of the hooked-rug production, including pattern transfers, hooking, backing, and hemming. At various stages over the next two decades, George Wells served as advisor, supplier, canvas marker, and maker of Gloria's hooked wall hangings and floor pieces.

The Westinghouse pair, reinstalled in Reading Terminal at the Philadelphia Convention Center. (See plates 23 and 45.)

George Wells, proprietor of the Ruggery, Glen Cove, Long Island, 1985.

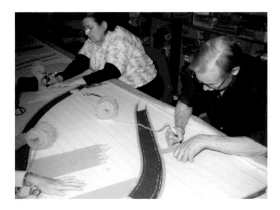

Work proceeding at the Ruggery on Youngerman's GSA commission, 1976. (See plate 95.)

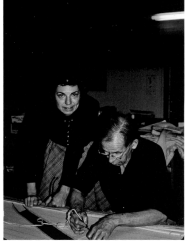

By 1970, Gloria and Wells were so in sync that she would send photographs of tapestries and abbreviated instructions requesting, "Dear Mr. Wells, I enclose photos and transparencies . . . made to scale for 4½' × 6' hangings—Please make 6 of these with as much detail as possible—Thank you. Regards—Gloria."[34] During the early 1970s, however, Gloria became occupied with exploring options for loom-woven tapestries in Scotland and France. The hooked projects diminished.

On February 13, 1976, Gloria and Wells established a new contract for a fourteen-foot-square hooked wall hanging designed by Youngerman for a federal office building in Portland, Oregon (plate 95). Wells sagely wrote, "As it is really impossible for wool to match paint—it comes to the point eventually for him [Youngerman] to pick 4 wool colors that he likes together—If one of these Reds is OK I'll dye it myself." After another round of dyeing and color matching, he suggested, "Yellow I think they could redye a bit 'eggier.' . . . If you think the yellow would do—OK—it's certainly a clear color but—George." Still another dyeing took place: "I'm beginning to think the color varies according to what I ate in the preceding 2 hours—Any hoo—I'm pretty near—after redyeing the entire lot 3 times."[35] The hanging was completed in May 1976.

In July 1985, Gloria and George Wells signed a contract with Prudential Insurance Company in Newark, New Jersey, and the British Petroleum Pension Trust for two wall hangings designed and hooked by Wells himself. These were for Mazza Gallerie, a Wisconsin Avenue shopping center whose dramatic renovation designed by the architectural firm RTKL was widely celebrated in Washington DC.[36] Playing off the turn-of-the-century Viennese design theme for the galleria's $6 million overhaul, Gloria chose to work with floral motifs inspired by the Wiener Werkstätte. She asked Wells to make her "twenty-five feet of flowers." Wells designed horizontal and vertical panels with stylized floral motifs. The unique wall hangings were hand-hooked with hand-dyed pure wool yarns made on a cotton backing of monk's cloth with a latex compound on the back.

Gloria received fan mail for these panels from a shopper who wrote to say "how much I admire the beautiful wall-hanging of yours. . . . Each time I go in, I stand & look at the tremendous amount of work you must have put into it. The individual flowers are so perfect you can almost smell them, & there is so much detail. My father, during his lifetime, was an avid gardener so I can really appreciate your work. Thank you for the pleasure you give me & I'm sure, countless others."[37] The panels were sold early in the twenty-first century and, unfortunately, have not been located.

Following completion of the Mazza Gallerie commissions, Gloria and Wells planned a hooked wall hanging, seventeen feet high by forty feet wide, designed by Wells for the Calder Court in Smith Haven Mall on Long Island. After much discussion, Gloria replaced the hooked technique with embroidery as a more fluid means of depicting Wells's motifs. Ultimately, they changed "wall hanging" to "mural" and deleted "hand-hooked" on the contract, agreeing that it should be painted instead: "My first proposals for a mural for a

Portland architects with Youngerman's wall hanging, 1976; *left*, Tom Houha; *right*, Phil Rude.

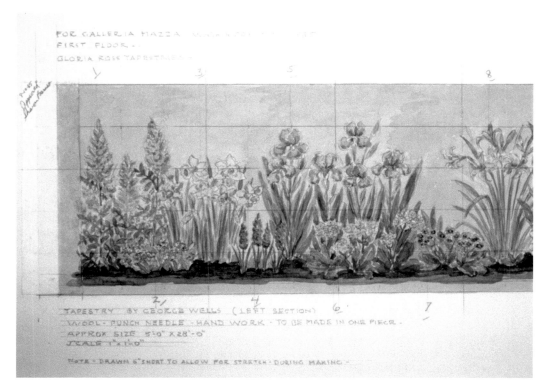

Long Island Prudential shopping mall have been accepted, and so I am moving along with this. When I was asked to make a tapestry for this space and replied that it seemed inappropriate and recommended a mural, Prudential asked me to proceed with this new-for-GFR project."[38] Gloria considered having the mural done by a commercial billboard company in Brooklyn,[39] but the project was never completed.

Hound Dog Hookers of Blackey, Kentucky

When they first began to work together, George Wells suggested that Gloria might also work with an Appalachian group of craftswomen. He noted, "The Group I have worked with in Kentucky can hook well—But—It would mean your translating each project into a 'By the numbers' layout on the backing just as I do with my abstract shaggy things when Joe the handicapped chap helps. . . . Also—on 2 projects I hooked the tricky and unmarkable parts and let them fill in the big backgrounds. If you are willing to do it they can hook for you and it would be great for them to have the work . . . They really need the work. So— if you are out for helping in Appalachia, it is a real possibility."[40]

In 1966, Gloria used the Hound Dog Hookers of Blackey, Kentucky, for at least the fourth and fifth pieces in the edition of Frankenthaler's "after *Blue Yellow Screen*" (plate 20). She put in her notes, "G outlined and did smaller color parts at end—They did blue & yellow."[41]

Josephine Whitaker, Irene Dixon, Alicene Fields, and Irene Kinneer were Hound Dog Hookers. Kinneer's daughter Nancy Kinneer-Luckey remembered working alongside her:

"My mother was one of the originals and I myself have made many of their pieces." She added, "I was about 12–13 when my mother and three other women formed the HDH and until the last 2–3 years of their existence, they were located out of our home (they used a room for the store). At times, they obtained large orders for displaying rugs for Aunt Lydia yarns, and we younger children were recruited to help out; I have hooked dozens myself. . . . I will sit down and think about the many trials and tribulations of the HDH, they have a piece in Lyndon Johnson's museum, one huge piece went to the governor's mansion (I guess they are still there) and other historical notables. I even check regularly on eBay, hoping one survived that I recognize,

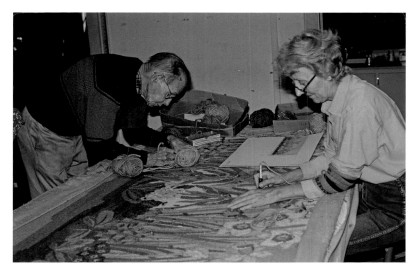

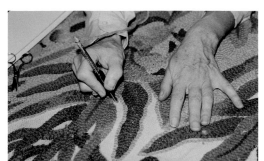

Working on Mazza Gallerie commission, panel a, 1985

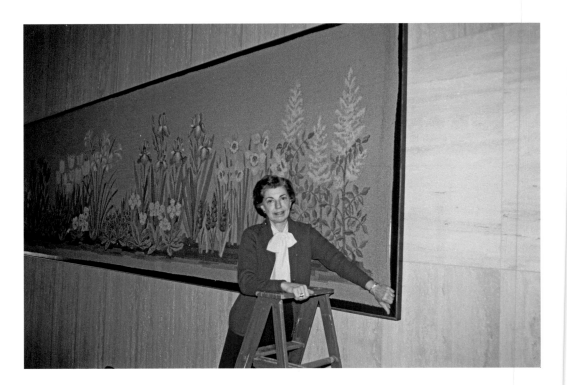

Gloria with Mazza Gallerie commission, Washington DC, 1986. Photo by Marvin Ickow.

and is listed for sale—the rooster, for the Democratic party, the cabin, for Republicans, the Hound Dog himself, and the Cardinals, many, many, others as well."

Betsy Kinneer Fields, another of Kinneer's daughters, recalled, "I worked with the Hookers in 1965 when I was home while my husband was in Viet Nam. We did a lot of beautiful pieces for George Wells and a lot of samples for the American Thread Co."

Mary Gail Adams, Whitaker's daughter, also remembered the hooking fondly. "We all made rugs when mom got a lot of orders or got behind. My dad, my sister and myself. I have lots of scrapbook mementos from those days. I only possess one of the rugs, a quail. I have the original hound dog pattern that my mother drew. I would love to find some of her rugs. . . ."

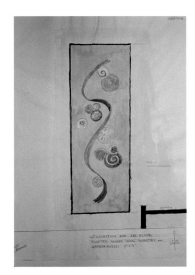

George Wells, maquette for Mazza Gallerie commission, panel b, 1985

Working on Mazza Gallerie commission, panel b, 1985

Gloria's several versions of "after *Blue Yellow Screen*" were executed in 1966, but none of these descendants recall it: "I don't remember the abstract pattern," Betsy Kinnear Fields said. "It must not have been made the year I was with her."[42]

Other Hookers

Gloria kept an eye out for other specialists. She gathered information about Heritage Rugcrafters of Etobicoke, a grassroots rug-hooking organization in Ontario, Canada. Through George Wells, she was contacted by Susanna Cuyler, author of *The High-Pile Rug Book* (1974) and *Modern Rugmaking and Tapestry Techniques* (1985). Gloria also knew needlework instructors such as Laura Schoenfeld, and served as an inadvertent example to their students.[43] She sought out custom rug manufacturers with "electric hookers"—notably Edward Fields, Inc., based in New York City, and V'Soske with its Puerto Rican factory. Despite the latter's claims to re-create rugs with "any effect from rose petals floating on water to varying weights of charcoal as it's drawn on paper,"[44] Gloria always returned to Wells and di Giovanni, the team that accomplished most of her hand-hooked projects.

In 1989, after some years of working with hand weavers and commercial mills, Gloria hoped to return to the hand-hooked-rug technique. She and artist Jack Youngerman met with her friend Saul S. Wenegrat, director of the art program for the Port Authority of New York and New Jersey, which owned the World Trade Center. Afterward she wrote, "I supplement Jack Youngerman's presentation of wall hangings proposed for the main lobbies of the World Trade Center, with a sample made in the hooked-rug technique. I recommend it as one which adheres to the suggestion of

yours and Maria Aasland's [senior architect, Planning Division, WTC], that a wall hanging with a pile is most suitable for these spaces." She specified, "I would work in regard to the method(s) to be used, the colors, etc., with an American workshop which produces the finest handicrafts of this kind. Before that I would familiarize Jack with all of its possibilities as he creates his final designs."

The company in question was the Mills-Mosseller Studio, a family-run business founded in 1925 to produce custom hand-hooked rugs.[45] Gloria visited the workshop in Tryon, North Carolina, during September 1989, but these wall hangings were never made.

Long Island Carpet Cleaning Company

In Gloria's day, the Long Island Carpet Cleaning Company advertised "Renovating of Carpets and Rugs, Washing, Repairing, Dyeing of Carpets a Specialty, Remodeling, Relaying . . . Carpets Tacked Down. Cleaned at Home, Office or Showroom."[46] Founded in 1917, this family-run business in Long Island City did the backing, hemming, and labeling for dozens of GFR wall hangings from 1966 to 1970.[47]

Commercial Pile Carpets

Gloria contrasted the nubby texture of hand-made hooked rugs to what she called the "carpeting quality" of commercially made pile rugs. In 1980, she wrote to *Architectural Digest*, "After we made the decision to produce floor pieces, it followed rather naturally that they be made of carpeting, durable but of the finest quality. These will be advertised as 'rugs for the wall or floor' because we feel that many will want to hang these on the wall. They are sufficiently light in weight to make this practical. This is a 'first' for me and obviously I am enthused. I worked with the carpet makers on the prototypes (4 × 7½ feet) which are now at the Fields New York City showroom."[48]

Gloria worked directly with company president Jon J. (Jack) Fields, André Emmerich Gallery, and Pace Editions on several projects that resulted in limited edition carpets or "art for the floor," as they were called. Founded in 1935, Edward Fields, Inc., was a New York–based manufacturer of commercial and custom rugs and carpets.[49] Gloria developed the prototypes for two Hans Hofmann works at the company plant in Flushing. She delighted in talking about her "factory days."

Thirteen "tapis" (pile carpets) manufactured by Fields are recorded in the GFR Papers. In 1973–78, one prototype called *"Tapis nº 1"* (61 × 94 inches) and an edition of three custom-shaped pieces *"Tapis nº 2"* (84 × 129 inches) were produced in New York from Jean Dubuffet designs (plates 12, 13). From 1981 to 1987, two prototypes and an edition of one hundred rugs were planned after *Blue Loup* and *Purple Loup,* paintings by Hans Hofmann (plates 34, 35); however, the final

The Mills-Mosseller Studio, Tryon, North Carolina, 1989

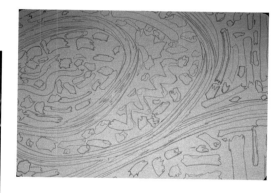

Detail, marked-up canvas backing prepared for commercial pile carpet

Inserting wool yarn into canvas backing on vertical frame, Edward Fields factory, 1980. (See plate 34.)

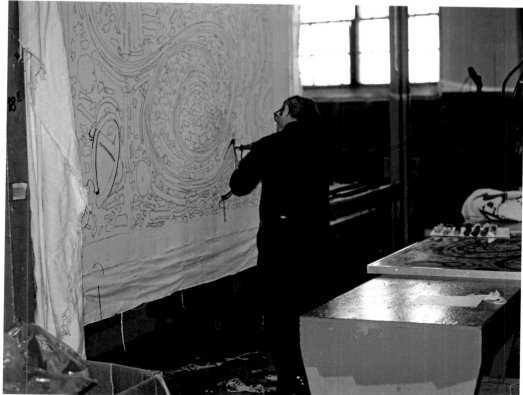

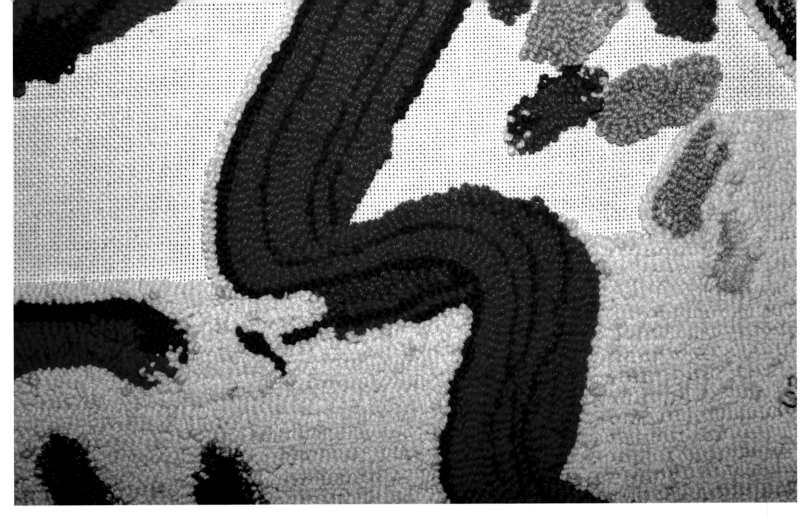

Detail of Hofmann's "*Purple Loup*" carpet, showing uncut loops inserted into canvas backing, 1980

Left to right, Jack Fields with Jack Youngerman and worker consulting on "*Maritimus*," Edward Fields factory, 1985

Shearing the surface of Youngerman's "*Maritimus*" carpet. (See plate 96.)

quantity was much smaller, for only three sales are recorded in the GFR Papers. Finally, in 1989 an oval carpet called "*Maritimus*" was designed by Jack Youngerman (plate 96). Although an edition of twenty was planned, apparently only one carpet was completed.

Gloria ventured even further afield in 1979 when she sent a Youngerman design to the Shanghai Carpet Factory in the People's Republic of China. She worked through Charles I. Rostov, the head of Trans-Ocean Import Company and director of the American Importers Association and the National Council for U.S.-China Trade. Together they developed a long-term plan to distribute

"high quality, hand knotted tapestries made in China," expanding its extant carpet industry: "We consider these tapestries to be works of art, and a market must be developed to create a desire on the part of the American public to use these tapestries in many different ways. They will be used as wall hangings in various types of buildings, they will be sold as works of art, and they will be eventually used as wall hangings in American homes."[50]

In February 1979 they requested an ambitious arrangement with the Chinese government for exclusive production and marketing in the United States, Canada, and Mexico. Gloria began making plans and in August, fatefully underlined the words, "*best to get color swatches*" in her notes. In September, she recorded a hasty decision following a "call from Peking—Rostov—special price . . . G: go ahead, let's gamble—use stronger blue—G reported to JY."

Youngerman's "*Octosymmetry*," a paper cutout done in 1971–72, served as the prototype. The weavers in China worked from a professional eight-by-ten color-corrected transparency and a one-eighth-scale black-and-white line drawing. An edition of five was originally planned, but Gloria decided on a unique piece, seven feet square. Woven with lustrous silk yarn in a hand-knotted pile carpet technique at ten thousand knots per square foot, the surface had a "velvety look" as requested. Gloria and Youngerman were, however, dissatisfied with the final results, as

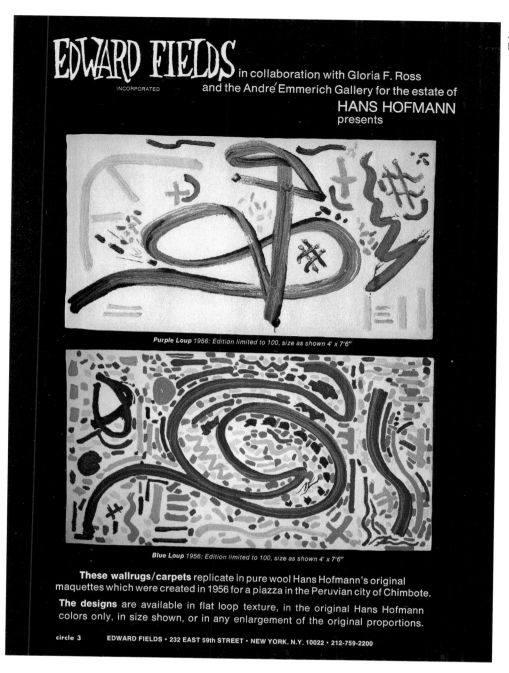
Advertisement for custom-made carpets designed by Hans Hofmann. (See plates 34 and 35.)

recorded in her notes: "Blue is wrong—Image not right—Selected in rush." Even so, Gloria later confided to the artist, "Once we have sold this work, from which we have all learned, I would be more than ready to do another in China, with greater consideration to the color, and made in a less costly weave." In defense of this piece, Gloria wrote, "Youngerman's *Octosymmetry* . . . was hand-knotted in mainland China. . . this is the first time the Chinese have ever worked from an image of an American artist; and the exquisite technique gives it a truly velvety quality."[51]

The work was acquired in 1995 by the artist.[52] Gloria conducted no further work in China.[53]

Farewell to Hooking

Some historians take a nostalgic view of domestic carpet making. "It was the hooking or braiding of rugs which gave the housewife solace and a deep sense of fulfillment as she sat up late by the fireside after the strenuous chores of the day were completed."[54] For Gloria Ross, hooking was a springboard that connected her with artists and moved her toward other artistic explorations. In the late 1960s, she discovered another traditional technique that would largely replace the hooked rug. As she wrote to Frank Stella a few years later, "I have just returned from France, from Aubusson in particular, where I visited numerous tapestry workshops, and I am especially eager to speak with you about designing a tapestry. I could work from an existing picture, if necessary. These flat woven hangings are truly elegant, beautiful, and I think that on seeing them, you will agree that this would be a most appropriate medium for your work. . . . I made . . . earlier wall hangings in a heavier tufted hooked-rug technique. I find the woven tapestries to be a more refined art form and a more flexible one. It is, too, more highly priced and more highly prized."[55]

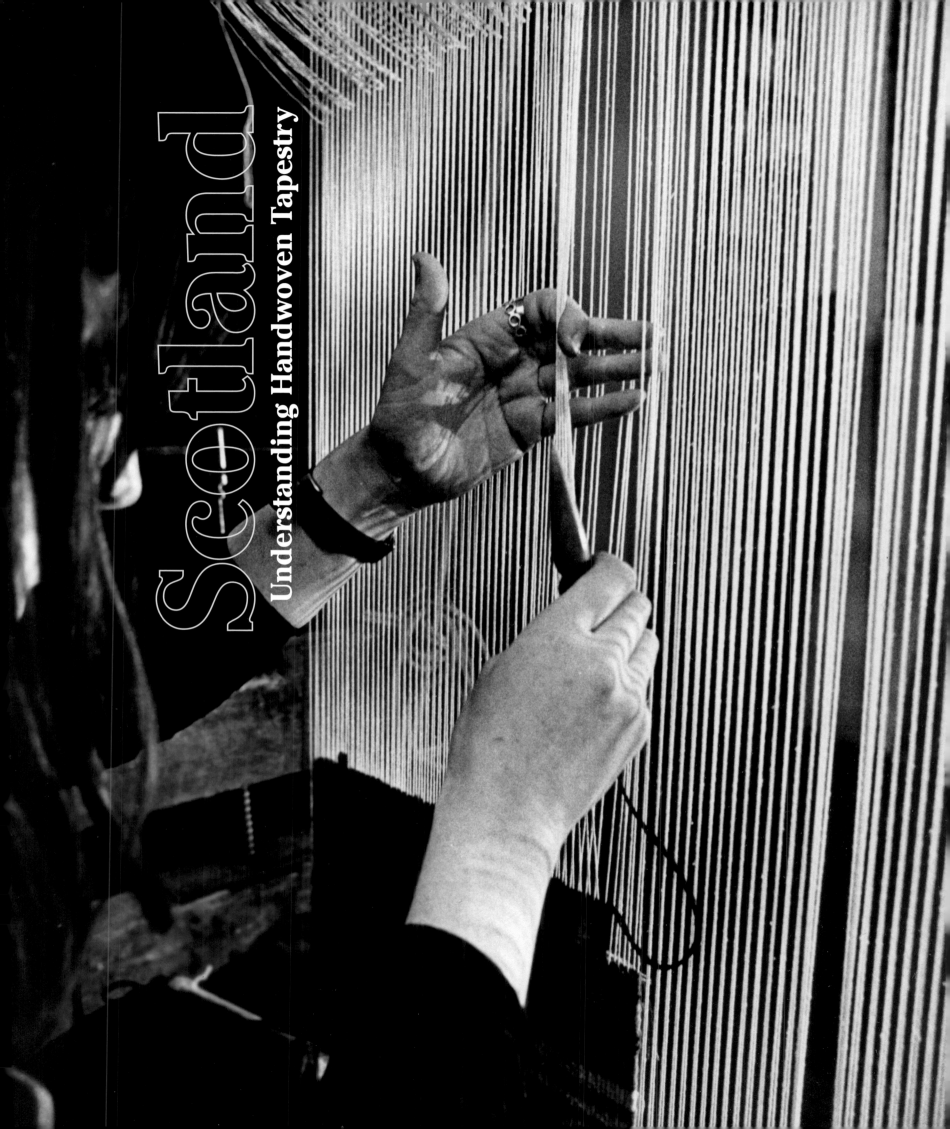

Scotland

Understanding Handwoven Tapestry

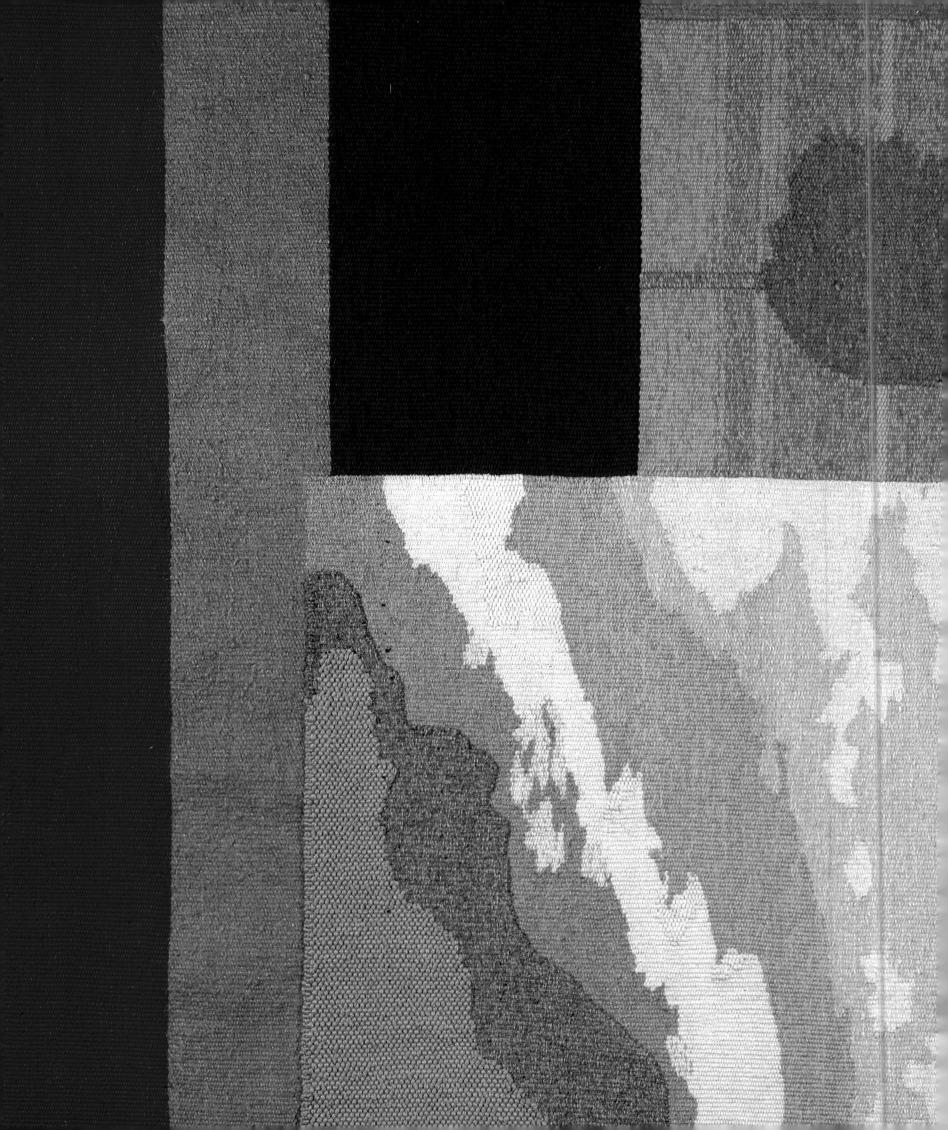

Archie Brennan is one of the great
contemporary artisans. Archie can
make a loom dance. He can make
it do whatever he wants it to do.
—Gloria F. Ross[1]

. . . there is great advantage, in our
time, in weaving tapestries that are the
result of collaboration between painter
and weaver. Given that the submitted
design, sketch, cartoon or painting is of
merit, there is at the outset a key ques-
tion to be answered . . . : Will the ensu-
ing tapestry be a proper extension of
the original work? Not just a variation
of the original using some adopted sys-
tem of techniques and colour transpo-
sition, but such that the tapestry will
have an identity that is its own. . . .
Seeking this identity is the heart of the
approach. . . .
—Archie Brennan[2]

Gloria learned about Archie Brennan and his skilled weaving colleagues through her friend Louise Cooley, a textile conservator, in 1969. Brennan was then artistic director at the Dovecot Studios of the Edinburgh Tapestry Workshop. A natural teacher given to delivering pithy aphorisms in a hearty Scottish brogue, Brennan became an important mentor for Gloria and she a major advocate of his work. Forty-eight GFR Tapestries (about one-fifth of the total output) were handwoven from 1969 to 1980 by the experienced team of artisans at the Dovecot. After Brennan resigned as artistic director in 1978, he and Gloria stayed in touch. They discussed possible future col-laborations, but Brennan made no more GFR Tapestries. Certain creative tensions and occasional controversies arose, but throughout her life Gloria remained a staunch "A. B. fan" (as she put it with her characteristic fondness for initials).

Dovecot Studios of the Edinburgh Tapestry Company, Ltd.
The fourth Marquess of Bute, a prominent Scottish nobleman, established the Dovecot Studios in 1912 to create tapestries for his family's many homes. He built the studio, furnished it with high-warp looms, and employed two accomplished weavers from William Morris's renowned Merton Abbey work-shop in England.

Between 1912 and 1945, with World War I intervening, these master weavers and their four apprentices wove six enormous tapestries depicting detailed historical scenes. A seventh still remains unfinished on its original Dovecot loom.

After World War II, the workshop was directed by four members of the Bute family and renamed the Edinburgh Tapestry Company. Leading artists such as Henry Moore and Graham Sutherland provided designs for tapes-tries that were smaller in scale, coarser than earlier work, and therefore easier to make. All weavers and apprentices of the time were men.

The company was purchased in 1954 by Scottish art supporters John Noble and Sir Harry Jefferson Barnes, who transformed the Dovecot into a commercial venture. The workshop began making custom-made and speculative tapestries for public sale. Sax Shaw and Archie Brennan became principal in-house designers.

In 1964, Brennan, who had started his seven-year apprenticeship at the Dovecot in 1948, was appointed artistic director. He and his colleagues developed highly visible projects with artists Harold Cohen, Elizabeth Blackadder, Eduardo Paolozzi, David Hockney, and Tom Phillips, among others. He also hired the first women and the first college-educated weav-ers. Maureen Hodge, one of Brennan's first students and a master weaver herself, described his accomplishments: "The years of Archie Brennan's directorship at the Dovecot were marked by his selfless efforts to expand and popularise the medium so that by the late sixties the tide had turned in tapestry's favour. His enthusiasm had caught on and spread—the Dovecot was financially viable and tapestry an accepted, even desirable art form."[3]

Since 1964, the Dovecot has employed weavers trained through its apprenticeships and in the tapestry program at Edinburgh College of Art. As Joanne Soroka, a subsequent Dovecot director, pointed out, "The combination—Dovecot-trained weavers with years' experience working on a variety of projects and college-trained weavers willing to take risks—has proven successful."[4] Unlike French studios of the same period, Dovecot dispensed with strong divisions of labor. As weaver Douglas Grierson has

Detail, Louise Nevelson, "*The Late, Late Moon*,"
1980, woven by Dovecot Studios. (See plate 55.)

The namesake Dovecot, a lodging for doves, Edinburgh, 1977

described workshop activities then and now, "The weavers draw their own cartoons, weave the samples, and make significant contributions to the translation of the tapestries in conjunction with the artist and the artistic director."[5]

During the late 1970s, about one-quarter of the Dovecot's annual production was devoted to GFR Tapestries.[6] In those years, Brennan served as the artistic director for all but the final two Nevelson tapestries, when Fiona Mathison replaced him. Brennan, Mathison, and Harry Wright, in turn, served as master weavers on the GFR projects. Others who worked on GFR Tapestries included Fred Mann, Maureen Hodge, Douglas Grierson, Neil McDonald, Jean Taylor, and apprentices Johnny Wright and Gordon Brennan (Archie's nephew).

Archie Brennan, Master Weaver/ Independent Artist

One observer quoted Brennan as saying, "Tapestry is about as sensible as building a life-size model of St. Paul's Cathedral out of matchsticks." The writer went on to comment on this "wonderfully pithy clue to his own motives and, perhaps, to the motives of other artists. You don't always do things that are sensible. You do them because they invite you, compel you, seduce you, obsess you and, sometimes,

because you relish the delicious perversity of doing things that don't make sense."[7]

Archie Brennan was born near Edinburgh in 1931 and studied tapestry in Edinburgh and France from 1947 to 1956. In 1961 he graduated from Edinburgh College of Art with a focus on tapestry. He did postgraduate work there in the following year, when he began developing the Department of Tapestry at Edinburgh College of Art, while concurrently directing work at Edinburgh Tapestry Company and designing many of their tapestries. He served as artistic director at the company's Dovecot Studios from 1964 until 1978.

One Dovecot co-owner summarized Brennan's independent approach as designer: "Archie Brennan has a most remarkable range of talents. By nature he believes in the superiority of the designer-weaver controlling the whole operation so that the design can develop as the weaving proceeds, and he offers only rather grudging admiration of the famous 17th and 18th century masterpieces where the designs were dominated by the painters' rather than the weavers' aesthetic. This is, of course, in line with the contemporary movement in tapestry in such countries as Norway, Finland and Poland."[8]

Very much an artist in his own right, Brennan wove (and still weaves) on his own.

Accolades for every aspect of his work abound: "Brennan's work readily demonstrates the renewed vigor of tapestry weaving. He combines consummate control of the technical aspects of his craft with a sense of visual structure that possesses high intelligence and humor, tradition newly infused with extraordinary personal energy . . . [Brennan's treatment] gives [the artwork] metaphorical weight as fragments of a rich and remarkably durable tradition."[9]

Letters to Gloria enthusiastically record his dual roles. "Life is busy, as I have a show of my own tapestries in June, in London, & in order not to interrupt Dovecot commitments, all the work on them takes place at home, late in the night. But I enjoy it, & so far find less sleep not a problem. It's a kind of winter's hibernation, I suppose, with a difference."[10] "Phew!" he continued in whirlwind fashion, "My feet are at last almost on the ground again. These last 2–3 months have been a series of changes. My own exhibition work/Mexico [World Craft Conference]/London Exhibition [of his own work]/Dublin/film making/London Miniature textiles and at last a stretch ahead of normality for 3 months. A chance to complete the 'new' Nevelson tests and the two Sky Cathedrals [II]."

Mindful of his creative needs, Brennan explicitly, if only occasionally, claimed time away from the Dovecot for his own art, as he did in 1977: "I am off [for four months] until December to New Guinea. (Gloria, I am going off to get back in touch with weaving as I have been losing touch recently.)"

An exhibition mounted in 1980, Work by the Edinburgh Tapestry Company from 1912–1980, featured five pieces of Brennan's own design, all woven at the Dovecot. One reviewer commented, "Archie Brennan's Aberdeen [Art Gallery] tapestry is a marvelous concatenation of rhythmic shapes moving in musical shoals across a subtly staggered grid of granite-like blocks of complex woven textures. Allowing that even master-weavers are human, the show includes a number of woven jokes such as Archie Brennan's three-dimensional Steak 'n' Sausages. . . ."[11]

Described as one who never accepted the easy or obvious solution to a problem, Brennan often espoused contrarian views that he used to great advantage. Of the great architect and designer, he wrote, "Le Corbusier. I had the good fortune to spend a day working with him in Paris, 1962. And he was a very forceful character. His two arguments were [that] tapestry had above all to be mural in size—filling a wall—and essentially flat—had to recognize the wall and be two-dimensional. Not to make holes in the wall. [T]apestry being two-dimensional and shouldn't make a hole in the wall immediately made me question that thought. So I set out to do a series of tapestries that were essentially windows, holes in the wall. Textile references, for sure. Because *above all tapestry is an object to me, not totally illusion*. The presence of the cloths is so strong . . . when you put them into a pictorial context. So the very ambiguity about the solid cloth and the sense of breaking the wall has been a great attraction to me. Sometimes [I'm] more respectful of two dimensions, other times leaning into three dimensions."[12]

Helping to establish tapestry workshops and other arts programs in Australia, Papua New Guinea, and the Arctic enabled Brennan to spread his distinct version of tapestry-as-object to far-flung parts of the world. In 1974, while holding a six-month arts fellowship at the Australian National University in Canberra,

Archie Brennan with a tapestry of his own design for the Edinburgh Sports Center, 1977

he began consulting on development of the Victorian Tapestry Workshop in Melbourne. Praised as "our long-standing mentor with a worldwide reputation" by the workshop's founding director Sue Walker, Archie continued to provide guidance and inspiration to VTW through the years. Walker articulated their deeply shared goals, also held by Gloria Ross: "Adventure and ambition could be encouraged while maintaining truth to the inherent qualities of tapestry and truth to the intention of the artist whose work was being interpreted."[13]

Neither Gloria nor Brennan was a fan of the trends of the time in fiber art. Every couple of years they traded critical barbs about the Lausanne Biennale. In 1977 he reported, "A trip to Switzerland largely to see the exhibition. . . . The whole tapestry Biennale thing leaves me feeling exactly as I did 2–4 and 6 years ago. Whatever the debates about the word 'tapestry' the real problem is of a general lack of quality, whatever the process. There was so much downright bad art!"

Brennan has been fond of describing some fiber art, with his usual levity, in which "'Tapisserie' [tapestry] was perilously close to 'Patisserie' [pastry]." In contrast and by his own account, his tapestry has served as "a vehicle to convey concepts, comment, harmony, discord, rhythm, growth and form."[14] Brennan has been a studious enthusiast of ancient, historic, and ethnographic tapestries in museum collections, and his work has ranged from witty visual puns to artful, insightful portraits and acerbic social commentary.

About tapestry's place in the world and in his life away from the Dovecot, Brennan later mused, "So, today, for me . . . tapestry is an obsessive, compulsive activity. I sit at my loom ten, twelve, sometimes sixteen hours a day, weaving contentedly, with no effort. Every day if I can possibly manage it. And I'm very content to work within the traditional restraints that define woven tapestry. And I do respect, however, and delight very often in, the work of others who choose to move away from the more technical boundaries that are defined as woven tapestry. But I'm far more excited by the reality that today tapestry making is still seeking a purpose, even if it's a modest role in the late twentieth century."[15]

Archie Brennan, Artistic Director

Apart from his role as an independent artist/weaver, Brennan took seriously the challenges of the workshop environment, in which outside artists made designs and a team of expert weavers wove them. Another observed, "Brennan . . . is recognized as being largely responsible for the revitalization of interest in tapestry both through his own work and through the collaborations nurtured between the studio and contemporary artist."[16] He perceived a special chemistry in some projects: "I do not think of tapestry as a reproductive medium. It's not something where there is an artwork and we set out to reproduce that art work in weaving. It's a creative medium. I don't see the setup where there is 'the designer,' 'the weaver,' 'the dyer,' 'the cartonnier,' as a series of compartments. I don't think the work happens that way at best. I think the richest way in a workshop production is the process, is the creative process from beginning to end. We don't have an artwork that is then made and reproduced. That is the work. And I've been privileged to work with some artists who saw it that way as well."[17]

He compared the contemporary Scottish workshop with the way medieval tapestries were created. "I've had the fortune to work with seventy-six (I counted the other day) different tapestries by other artists, and no two were alike. We had to find the way to deal with [each one]. Sometimes the way was quite firm—'this is what I've done, I want you to reproduce it'; other times it was an extremely creative, evolving process. And that gave us a very special result, I think. And I think at best, that's how medieval tapestries were made. So the fact that the designers and weavers . . . were anonymous is great. Because they *were* anonymous. They were part of a great complex

Dovecot weavers at the loom, 1972

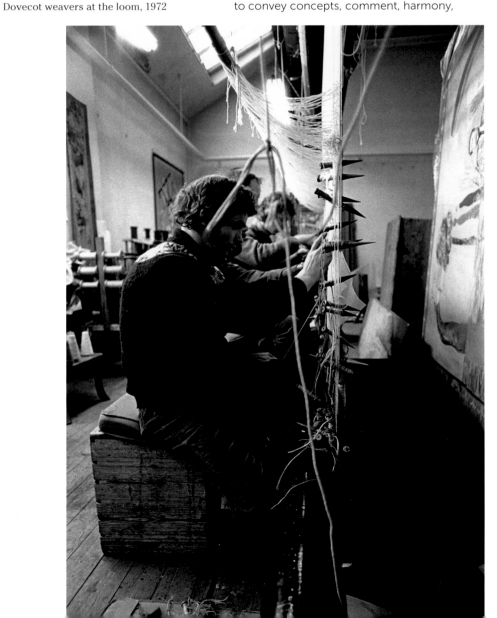

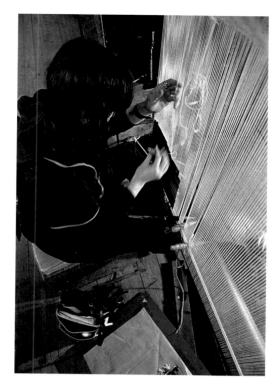

team; a changing and growing team that made the pieces grow on the loom."[18]

Despite a strong personal preference for weavers designing their own artistic work, his approach to commissions and collaborations— what he termed "transposition of a painting into tapestry"—was refined. "Brennan insisted that tapestries be interpretations of the original design, in the same way that a piece of music is interpreted by a particular group of musicians. The result has more of the spirit of the original than any copy."[19]

Brennan and all the studio's weavers were thoroughly engaged in the GFR Tapestries produced at the Dovecot. He directed the process of weaving test and trial samples, as he explained, "to establish the specific approach and handling for each GFR/Dovecot project, but everyone in the studio contributed." The current head weaver, Douglas Grierson, continues the story of shared responsibility as he recalled, "All the weavers were given tapestries to work on and come up with a manner of weaving, starting at the sample stage. For example, Maureen Hodge did samples for the Motherwell; Harry Wright on the Gottlieb; I on the Dubuffet, and Fiona Mathison came up with the translation for the [early] Nevelsons and later she did the 'Uniques' with Jean Taylor."[20]

Championing a dynamic approach, Brennan continued, "I would also be very involved, as head weaver, in the first days of the actual weaving of the first tapestry of any edition for GFR, as one of the weavers. However, the subsequent tapestries of the editions were normally woven by 2 or 3 studio weavers with a senior weaver as team leader. My role then would be simple [sic] as overall supervisor."[21]

The GFR Tapestries represented a departure from other Dovecot work, as many were limited editions rather than singular pieces. This presented new challenges in motivating the weavers, as we shall later see.[22]

As studio director, Brennan was always mindful of the financial and managerial aspects of the business. Reviewing a list of major tapestries and the workshop's tight schedule, he reacted ambivalently. "I am sorry to be so hesitant about what really is splendid news, the sale of these tapestries. I'm sure however, it would be unwise of the Dovecot to expand to meet current demands. I think that we would just be following the Aubusson workshops and if we did, we would have to systemise work as they have done and end up the same—and we actually prefer to work in our slower disorganized way, because we do enjoy the work more."

His own words notwithstanding, he was a master at scheduling and tracking many tapestries at once, and a personal champion for each Dovecot employee, artist, apprentice, and student. Under his direction, the studio created over 275 tapestries in fourteen years, averaging more than one and a half tapestries every month.

The Dovecot Approach

The weaving technique used at the Dovecot— known variously as Gobelins, high-warp, *haut lisse*, arras, or slit tapestry—was adapted from a traditional style employed at the Gobelins manufactory in France since the seventeenth century and by William Morris in England during the nineteenth. As one Dovecot expert described it, "In 'High Warp,' the warp threads are kept vertical on a tall loom with rollers top and bottom and the weavers work from the back, building up the 'weft' with small bobbins passed between the warps by hand. The weaver observes his progress and the design as it develops in a mirror which he looks at

Fiona Mathison at the loom, 1972

A large Dovecot loom in the Gobelins style, 1972

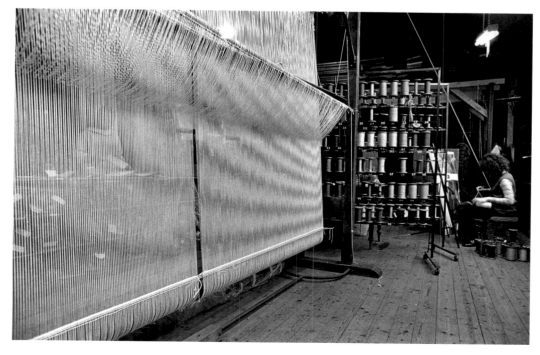

43

Gloria and Archie Brennan confer, 1972

through the warp. (The mirror has been discarded at the Dovecot.) Although a needle may be used frequently for securing the ends of yarn when the colour is changed, it is essentially a weaving not an embroidery technique. . . . The Dovecot uses the 'High Warp' method exclusively. An added complication with both methods [high- and low-warp] is that the design is built up sideways as the 'weft,' which carried the design and all the different colours, must eventually hang vertically while the 'warp,' which is the structure, ends up running horizontally."[23]

In other workshops, a number-coded cartoon system first developed in France connects an original artwork and subsequent tapestry. Weavers follow the cartoon in a fashion similar to painting by numbers. However, "At the Dovecot the work is never copied; it is always translated and interpreted which is a much subtler and harder method. If a small design is to be enlarged, for instance, then the quality of the lines within it must also be reappraised, the range of colour opened up, the painter's marks reproduced in weavers' terms—and so on."[24]

The Dovecot's color palette also became distinctive: "The experience of the weaver is reflected . . . also in the incredible skill with which he can choose and mix the colours to interpret the wishes of the designer. Each workshop will carry its own 'palette' of wools, in the past this might have exceeded three hundred different hues. At the Dovecot this number has been reduced . . . [but] the Dovecot has maintained the tradition of selecting colors not by the French numbering system, but by hue." The writer continues, "In spite of the very high costs of weaving, the Dovecot stak[es] its whole reputation on the quality of interpretation from design to finished tapestry. Most artists are more than gratified when they see their intentions rendered in paint translated into the rich rather vibrant colours created by a multiplicity of weft strands. The final colour is often created by the juxtaposing of several pure colours as in a fine 'pointillist painting.'"[25]

Brennan introduced a critical change to the Dovecot's approach by returning to the early Coptic, pre-Columbian and premedieval practice of weaving from the front of each tapestry. Under his direction, weavers faced the front of their work on the loom, rather than working on the backside of the cloth. They no longer had to look through their warps to view the fabric's face in a mirror placed behind the loom. He made this switch in his own work in the late 1950s and transferred the practice to the studio by the mid-1960s. Maureen Hodge commented on the impact of discarding the mirror, "Though sometimes the bobbins get in the way and it may be fractionally slower to weave, the positive gain of being in direct

contact with what is being woven has proved to be of inestimable value."[26]

Brennan also found innovative techniques for documenting certain tapestries, especially those designed in collage form by Louise Nevelson. Handwritten notes and sketches record how the tapestry cartoons were annotated. For example, he explained how diagonal lines in the design were created: "These [annotations] would not normally be marked on a cartoon, but [as] we were adapting some cloth weaving techniques into the tapestry, it was valuable as a reference for repeats of the edition in certain passages. What it means, however, is fairly basic. Stepping, or steps, are what angles not vertical or horizontal become in tapestry. 'Rise of 1; rise of 2' indicates the height of steps on particular angles. A step can rise one pass of weft on each warp; 2 passes of weft on each warp, and so on. Such a sequence—'rise of 1'—would give a particular angle, but only according to number of warps per inch, and weft thickness and density. . . . Just to confuse the issue, these are rarely calculated beforehand, as too many incidental factors can change the resultant angle!"

Ultimately, the goals of the Dovecot were set apart by "the staff's involvement in the interpretive process and the refusal to do slavish copies from other media."[27]

GFR Tapestries at Dovecot Studios

The Dovecot completed its first GFR Tapestry in 1970, beginning a dynamic relationship between two strong personalities who eventually collaborated on forty-eight GFR Tapestries.[28] Typed and handwritten letters, postcards, and telegrams, interspersed with phone calls, flew across the Atlantic on a near-weekly basis during busy times in the early 1970s. Gloria fashioned a stack of blue self-addressed postcards for Brennan's quick response to issues at

hand. Their copious correspondence testifies to the nature of the working relationship— each was curious to review experimental outcomes and eager to advance their collaborative projects.

Gloria's first inquiry to Brennan is missing from her archives. Brennan's May 1970 response appears cordial but exceptionally formal: "Dear Miss Ross, Many thanks for your interesting letter. The enclosed leaflet should give you some indication of costs and our average studio output is approximately 10 sq. ft. per week, so from this you can get some idea of time. . . ."

Gloria visited Edinburgh and the Dovecot in July 1970. Afterward, she wrote, "Dear Archie, How much nicer it is to write now, knowing you, picturing you at Dovecot as you read this . . ." Her handwritten scribbles from their July 21 and 22 visit indicate that she hoped the workshop would begin tapestries designed by Frankenthaler, Motherwell, and Goodnough that fall, and that they even began contemplating a Nevelson, as Gloria mused, "Do in gossamer sort of way—could get veiled feeling in weaving." Her notes that year show a near-frantic flurry of calculations for the thickness and sett of warp and weft, the "use of metallic—irregular stitches for brush stroke direction," and notes on maintenance, marking, and signing. By September, Brennan assured her that "We are raring to go at the Motherwell now."

The Work

(Roughly in chronological order; see chapter 8 for details about each of the artists and their work.)

Motherwell

The workshop commenced weaving its first GFR Tapestry—after Robert Motherwell's diminutive *Elegy to the Spanish Republic No. 116*—on September 17, 1970. Two months later, Gloria deemed the results, translated from a painting of 7 by 9 inches to a tapestry of 84 by 108 inches (from less than half a square foot to 63 square feet!), "magnificent" (plate 44). Brennan described his team's process. "This tapestry was taken from a small canvas with very direct black brush strokes on a partially covered white canvas. The main intention in the translation was to retain this directness and the power of the original without slavishly copying the marks. The background was woven in linen in various thicknesses which created greater texture in some areas, which in turn created shadows on the finer, smoother sections. The addition of white wool to the linen produced the quality of the thinner paint over canvas. The movement to be found in places within the black shapes was achieved by running the weft in the direction of the brush strokes and so weaving at an angle rather than horizontally in the more usual manner. Some knotting and *half-hitching* was employed to highlight important directions or thick areas of the paint."[29]

Detail, Robert Motherwell, "after *Elegy to the Spanish Republic No. 116.*" 1970–76. (See plate 44.)

Remaining true to the first tapestry in subsequent pieces became a challenge as the artist maintained editorial power and suggested changes. Brennan acknowledged, "I had a letter from Robert Motherwell last week re No. 2. His comments are as we discussed when you were here—mainly to reduce the colour and texture difference on the whites. I shall write and discuss this with him. I shall of course comply, but you may remember that the whitest white we used, a linen, is a bleached white and it does revert slowly, so that in 4–5 years it will settle and may then be right. Anyway, we shall reduce the activity in the white."

Gloria replied, "I discussed your comments on whites with Bob Motherwell. He understands the 'settling' of the linen, etc., and agrees to a go-ahead on number two. However, he indicated that he would like to hear directly from you about it."

Ultimately, the second and third works in the edition (2/5 and 3/5) proceeded without problems, but when it came to weaving the artist's proof (0/5) for Motherwell, further issues arose in duplicating the original's effects. Lengthy correspondence in 1974 and 1975 ensued. Two 0/5s were woven, neither considered entirely successful. Both were returned to the workshop, and after modifications to match more closely the apparently incomparable 1/5, the first 0/5 became 4/5 and the second went to Motherwell as the official artist's proof.

Motherwell and Brennan met when the Scotsman visited New York in 1975. In 1976, Gloria brokered a second meeting between the two.

"I spoke with Motherwell on October 5th. If you are here in January, he wants to meet with you about weaving tapestries for the Edinburgh exhibition. We had a long telephone conversation, and though it is difficult to quote him, he is not really happy with the later editions of the Elegy, and if he is to have more woven at Dovecot, he would want to spend some time here with you looking at his work in painting, collage, tapestry (made by you and others) and discussing his sophisticated sometimes very subtle, wise views. He said that we would not want you to make the journey just for him, but that he would like to work with you if you came here. His show concentrates on 5 or 6 things: 'massive black and white, a room of collages, a room of the Zen series, a room of the A la Pintura series.'" This meeting occurred in May 1977, when Brennan also met with Pace Gallery owner Arnold Glimcher, Pace Editions director Richard H. Solomon, and Louise Nevelson, and viewed the Miró tapestry at the World Trade Center.

After Brennan's departure from the Dovecot in 1978, plans began for a second artist's proof of "after *Elegy to the Spanish Republic #116*." The workshop's Julia Robertson wrote to Gloria, "*Motherwell Elegy*. Great news, 00/5. We do have a record of materials used so if you can return the maquette we shall cope. All of the senior weaving staff have been involved in the weaving of the Motherwells (including Fiona). No problem. We are chasing up a supplier of the linen we used in the past, that is the only fly in the ointment at present."[30]

Frankenthaler

In December 1970 Brennan proclaimed, "We are now in the thick of the Frankenthaler." The completed tapestry, "after *1969 Provincetown Study*," was mailed seventeen days later, on the day before Christmas (plate 21). Several

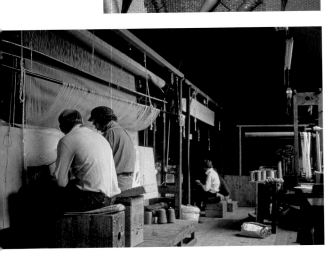

Suspended wooden bobbins used to carry weft yarns and pack them in place

Douglas Grierson and Harry Wright working on Frankenthaler's "after *1969 Provincetown Study*," 1976

Detail of cartoon behind loom; heddle strings visible through warps on upper part of loom. (See plate 21.)

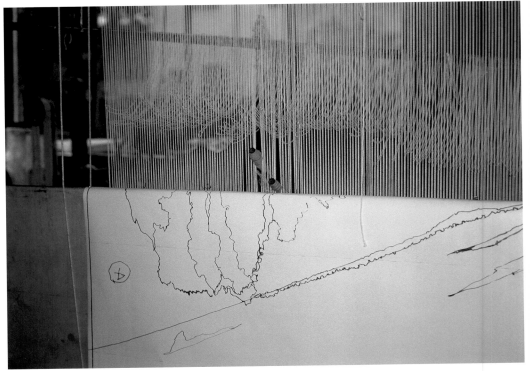

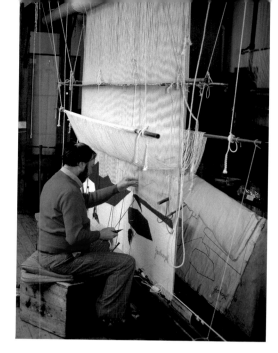

Fred Mann weaving Goodnough's
"*Red/Blue Abstraction*," 1978. (See plate 28.)

weeks after, Brennan inquired, "How did the Frankenthaler look? I never saw it properly, as it was only briefly on a most unsympathetic wall here, and it had turned out to be the most difficult to weave. Dependent on the light source, the values change as one looked at it, particularly in the white and we did not get a satisfactory resolvement of this in the weaving. This could perhaps have been handled by using a finer weft, but I felt that we would then have made some of the soft transparent color changes (as in the blues) too scratchy and tight."

Gloria replied, "The Frankenthaler tapestry is good, but as in the case of the Motherwell, we may make a few minor changes or simplifications in the second editions." Four pieces plus the artist's proof were woven at the Dovecot; two others were woven later in France.[31]

Goodnough

Brennan preferred Robert Goodnough's tapestry, "*Red/Blue Abstraction*," over his original paper collage (plate 28). In December 1970 he reported, "Goodnough near enough completed. . . . I think it looks very well, and has really benefited from the change into tapestry." Three months later Gloria herself noted, "The [second] Goodnough I would make exactly as you made the first edition."

Youngerman

Following a misstep in Portugal with the first handwoven version of Jack Youngerman's bold "*Blackout*" (see chapter 6), Gloria returned to the Dovecot workshop for the rest of this edition in 1971 (plate 93). Brennan's attention to the artist's intent is clear. "The Youngerman tapestry looks extremely crisp and rich. We had to redraw Youngerman's full size cartoon as it was off square and not at all symmetrical, but I think it is correct as per his instructions, in the weaving." And Gloria anticipated the transatlantic shipment: "I know that 'Blackout' will

be a knockout, and eagerly await its arrival." All but one of the completed five plus two artist's proofs were woven at the Dovecot between 1971 and 1977.

Noland

After hooking two works from this artist's 1960s paintings, Gloria wanted to use his most current work, toying with plaid, a popular textile theme. In late 1971, she wrote to Brennan, "I now have a beautiful cartoon from Kenneth Noland for a tapestry. It is one of his new series, a plaid-like design . . . you might begin to mull over this new project. Yes?"

Due to color disparity in one design band, the 1971 weaving, "after *Seventh Night*," missed the mark. After much correspondence and internal consternation among the workshop's weavers, Brennan established that the band couldn't be replaced. Gloria expected better in subsequent editions, as she wrote, "This seems a good time to pursue the proposed change in the Noland tapestry. You will recall that the horizontal band of pink is 'off.' Can you get the correct color, and too can you weave this band with linen as we had discussed? Noland had hoped to have this a different texture, as in the painting. Hopefully I will order a second edition in the not-too-distant future and then the right materials will be on hand. The color is most important, but I would like to correct both." Ultimately, only the first (1/5) was made (plate 58). The unique piece was lost in transit, reported stolen in 1982, and never recovered.

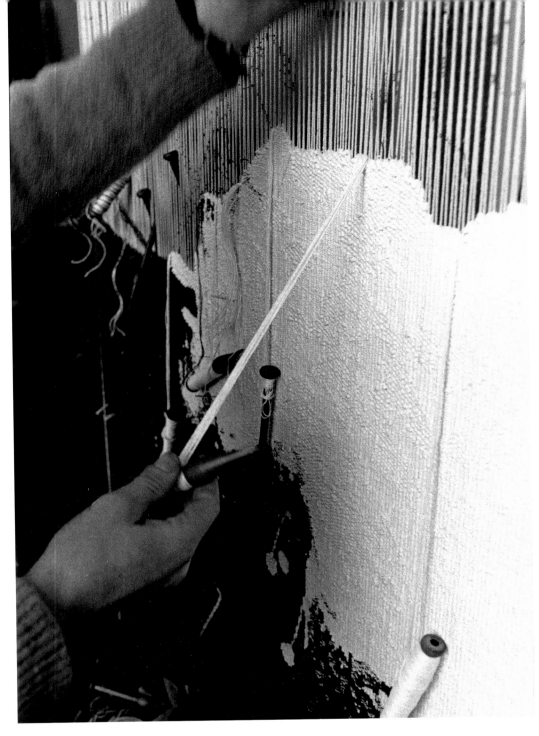

Weaving Gottlieb's "after *Black Disc on Tan*," 1972. (See plate 31.)

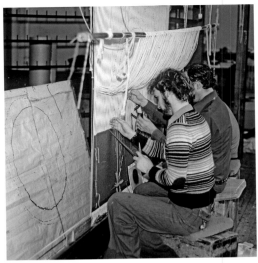

Gottlieb

The Dovecot's transposition of a painted image into a woven artwork in "after *Black Disc on Tan*" was another tour de force (plate 31). In Brennan's 1972 correspondence, the master weaver expressed his team's sensitivity to achieving the artist's original details. "The 'tan' & whites are on the small trial where marked X," he wrote, "It could be woven finer, but I feel the handling of the whites would become self-conscious & stiff if we did so. We can get the detail required on 6 w.p.i. [warps per inch] & if we work to keep the tan background relatively neutral the final result should be of the character of the original." Later he reported, "The Gottlieb is over halfway, & we are weaving it upside down. We felt we wanted to weave the 'black' disc first, & related the white to that, rather than weave the 'proper' way. We are now well into the (linen) white."

Brennan's report on the weavers' progress continued two weeks later. "We completed the . . . Gottlieb . . . yesterday. We all thought the Gottlieb particularly, was one of the most successful we have done for you. Somehow in its new size and material it moved on from the original to a new dimension. The black disc throbs and the white is quite alive and moving below it. But your reactions are awaited. You will see that in the end we had to use a quiet mixture for the background rather than the one we both opted for, yet I don't think it is a mistake because the life in the black and white areas on it, make it neutral and static. Do comment on this for No. 2. (I'm sure it will be sold immediately.)"

Gloria, too, was enchanted: "The Gottlieb is indeed 'most successful.' It is really perfection. It 'works' and you were right in using the mixture [of yarns] for the background." Between 1972 and 1976, five editions plus two artist's proofs were woven at the workshop.

Years later, Brennan had more to say about this work: "Seemingly the same [as other tapestries done after paintings, this was] an imitation of paint, but one that meant a great deal to me because I discovered something I had never found before. This is about five feet wide, out of a Gottlieb called Black Disc on Tan and you can see it's surely imitating paint. But when we came to deal with that black disk, about three feet in diameter, maybe four, five square feet of seemingly plain black weaving. But if you stand in front of that actual size, and look into that black, and see how the black has been handled with a complexity of blacks. It went up in size from the original sketch, so the marks had to go up in scale, the mood had to be enlarged. And the way that we did it was not by having many different dyed blacks, but actually taking the same dye vat, but having introduced into that vat many variations of spinning, so that you were really inside that

black to a depth and a reality when you see the actual tapestry that really is quite pure in tapestry weaving. The quality of color that is available is very different from any other medium."[32]

Nevelson

Although Gloria and Brennan discussed tapestries from Louise Nevelson designs during their first meeting in 1970, it took several years to advance the project, finally under way in 1972. Later, he reported: "Nevelson Unique Series (1–7) was a major involvement for me, developing and planning new complex tapestry structures of Louise Nevelson's small collage works. I had opportunity, too, for some one on one communication with Louise, in New York, independent of Gloria & Pace Gallery. Dovecot weavers of that period also made high quality contributions."[33]

The Dovecot team and Gloria began the series in 1972 with Nevelson's "*Sky Cathedral*," originally intended as an edition of five plus one or two artist's proofs. In the end, only one of this dusky Nevelson image was made, using linen, wool, and metallic threads (plate 47). The correspondence details a variety of experiments aimed at achieving the artist's intentions. "This is offering a real range of possibilities," Brennan exclaims. "The grey hair trials are perhaps the most explanatory but not firm or crisp enough in their shape. . . . [and] it would be difficult to get the metallic threads not looking 'foreign' with the hair. . . ." Gloria replies, "The black background is fine. . . . Color, texture, weight all fine. . . . The most important change is that each 'element' is to be metallic and no brown is to be used at all. The metallic should be used with black in part for differing effects. . . . Both Nevelson and I envision the tapestry as really gold with black background. Please do not use [the brown] hair at all for this work should have . . . elegance."

Another celebratory note from Brennan proclaims, "We completed the . . . Nevelson . . . yesterday. . . . One thing for sure, it reacts excitingly to a changing light, from direct to oblique, as we turned the loom at one stage during the weaving. We could not put a lot of

Archie Brennan and Jean Taylor discuss a Nevelson sample, 1976

Weaving a sample for Nevelson's *Night Mountain*

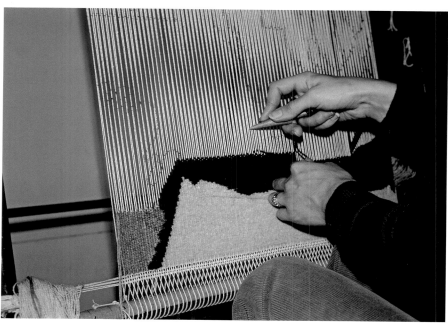

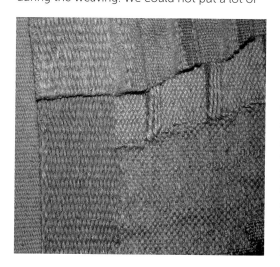

gold metals in as they are extremely difficult to obtain in any quantity. At the moment, Switzerland is our only known source. But I do like the muted metallic result by using a mixture of metal/synthetic thread." In turn, Gloria responds, "I erred in urging you to use too much glitter in the Nevelson although it is spectacular and received much positive reaction. The gallery feels that they will surely sell this, so I would like to order #2 as soon as we have worked out a few changes which should too make this one 'work.' It just misses. My thoughts, and I await yours. Obviously you were not completely satisfied either." She continues the critique, "The background color is fine but I would like to see it woven tighter and I think in the same number w.p.i. as the Gottlieb. What is that? Can you omit the very fine weaving outlining the metallic elements as well as the signature and insignia, weaving the entire background in the same way? If there is a technical reason for the latter, perhaps this will be obviated when the background is more tightly woven. Yes? . . ." Throwing the discussion back to Brennan, she concludes, "Within one 'element' there might be great contrast between the approximately three levels. Metallic threads in the thickest part are so loose that I fear they will catch and pull. Can you use a

Detail of Nevelson's *Night Mountain.* (See plate 49.)

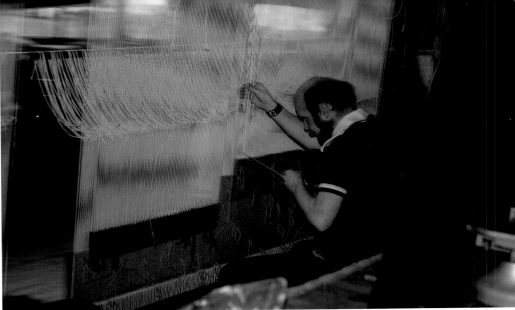

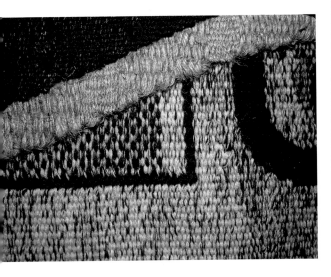

Detail of Nevelson's "*Dusk in the Desert*," 1977

Douglas Grierson weaving Nevelson's "*Dusk in the Desert*," 1977. (See plate 50.)

metallic thread something like the enclosed, perhaps in the flattest part; a more mixed in the next, one less metallic in the thicker parts? Archie, how would YOU handle it? Would you send to me one or two trials, perhaps of the very smallest 'elements' the way you would like to see it? I bow to the master! Basically, I think the problems are that it is too tinselly, without enough contact, and threads a bit too loose. It might be even more textural as you originally suggested."

A complete edition of seven tapestries was woven for "*Sky Cathedral II*" between 1974 and 1977 (plate 48). Challenges emerged in making the editions identical, as Gloria noted, "The Nevelson has arrived, but it is surprisingly different from edition #1. The designs within each 'element' have been woven so that the effect is much harsher. It lacks the subtlety and also the sculptural feeling of #1. Since the first edition is in far away California, it is difficult for me to be explicit, but we have all been struck by the difference in the two tapestries." To which a baffled Brennan replied, "There was only one minor difference—that the 'grey' used with the white was not an exact dye match to our previous dyeing."

Following the trials of making multiples, Nevelson agreed to continue working with Gloria, but only on the basis of doing "Uniques," as the artist called them. The éditeur saw this as a grand opportunity: "During a meeting with Arnold Glimcher, he said that Nevelson wants to make a series of tapestries incorporating wood or wood fibers. She knows little of wool and tapestries, but Arnold explored the thought with me. I realized immediately that this would be just the sort of thing we might work on together."

Brennan met with the artist in New York during fall 1976. He returned to Edinburgh with the Nevelson "constructions/collages," eager to begin: "I have been fighting a temptation to lunge straight into the tapestry of one of the collages. Rather than jump to any decision, I've had them before me since my return, to

absorb them, and consider directions for tests. I am now pretty much clear as to what I would like to do as trial-sections, so you can expect a letter following this with proposals."

Late in 1977, weaving of the singular and challenging Nevelson pieces began in earnest. "We are now 'going' on the next three Nevelson Uniques. Tests are complete, materials coming in; the first is started weaving proper today and we are weaving them together—so it's almost the Nevelson Tapestry Co. (with a David Hockney in a corner). I'll keep you posted as to progress. Warmest regards, Archie."

Five weeks later he reported: "We are well ahead with #3, #4 and #6 of the series. #3 has only a few hours for final adjustment. (It's been hanging for a week.) #4 is having its last section woven; & #6 is begun. So soon they will start to arrive, but we shall keep you informed. We have been weaving them, technically, in a method somewhat between 'Night Mountain' and 'Dusk in the Desert' although the resultant 'feel' is more like the latter. This was because, if we had 'collaged' all the sections, there would have been an overstated 'bulk' and a crude 'hang' to the works, as our preliminary tests showed. So we have developed a way of weaving an initial 'cloth' containing some of the sections in a range of weaves from 4/6/8/9/12 warps per inch. Then we superimposed the remaining sections. (Now you are worried?) Anyway, it *looks* like collage!"

Fiona Mathison chimed in, "Jean Taylor was the weaver responsible for the Nevelson Unique samples and I believe, like Archie told you, that much of the success of the panels was through her inventive and sensitive approach in the interpretation of the maquettes."

Both Gloria and the Dovecot weavers were justly proud of the unique tapestries translated from original collaged models (plates 49–55). Brennan described them as "a wonderful series of works . . . a very interesting set of complex cloths that really haven't been done before or very much since. The weaving is woven

into the weaving, the warp becomes weft, and the weft becomes warp. It's complex overlays that started out with a very simple Nevelson collage of fairly mundane papers."[34] Gloria reported to Brennan in 1978, "The 'Uniques' are superb and I kept wishing you had been at Pace as Nevelson viewed them for the first time. She is delighted with them. With great batting of the mink lashes she inquired of you and expressed her hope that A. B. would be involved in future work."

The Nevelsons had engaged everyone in the workshop. Dovecot's office manager, Julia Robertson, wrote, "We were delighted at the impression you gave us of Louise Nevelson's reactions to the new 'Unique' ["*Landscape*"]. You really implied she was very happy at the results. It makes it so rewarding to the weavers to hear this sort of thing and it was good of you to let us know how pleased she was."

Each piece drew more attention from workers, as Julia Robertson reported in 1980: "The new Nevelson ["*The Late, Late Moon*"] is well underway. Fiona puts in an appearance frequently just to keep a close check on its progress. The colours are marvelous, quite different from 'Landscape upon Landscape' but equally superb. Her designs really 'work' in tapestry, don't they? There are 4 weavers on the panel which is unusual on a work of this size but we are all having to work flat out to complete all we have to do for the exhibition. It is interesting and quite revealing to listen to all the comments while they work. Each one has her/his favourite part. I don't think you'll be disappointed."

"*The Late, Late Moon*" was the final Nevelson tapestry, completed in April 1980 (plate 55).

The workshop and Gloria had hoped for others. "I am confident," Fiona Mathison wrote, "that the series could be enlarged. . . . I feel that they constitute a very successful series and an exciting development in the translation of an artist's work into tapestry." Gloria pursued and revised ideas. "Ignore my tracings and all information about the Festival Nevelson tapestry as Arnold Glimcher disapproves the maquette and I am pushing very very hard to have a new one selected this week. I will write the moment we have done this as I know how anxious you are to start. This series you know is not totally in my hands. Louise has been ill, so that delays our going to her studio/home."

In 1988, Gloria looked back at the Nevelson projects and commented in rough notes for an international tapestry conference: "Louise [said] Darling must do more—Archie to NY to get smack of what Nev all about. 'Make 100 & I'll cut'—Archie made a few shapes but—won't say she bowed out—we bowed her out by then."[35] To an audience of weavers from the world over, the notion of cutting up Archie's precious tapestries to form a collage, even if they were samples, must have sounded blasphemous, as it did to Gloria and Brennan!

Dubuffet

In 1973 and 1974, Gloria and the Dovecot worked in partnership with Jean Dubuffet and the Pace Gallery to create a large-shaped tapestry onto which a separately woven life-sized figure was to be positioned. Brennan considered the artist's work carefully, "I have looked at a number of catalogues & reproductions of 'Hourloupe' series & others, & they seem eminently suitable for weaving, so I'm

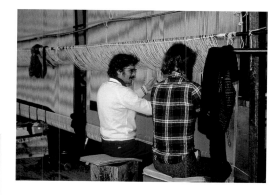

Harry Wright and apprentice Gordon Brennan weaving Nevelson's "*Dusk in the Desert*," 1977. (See plate 50.)

Detail, trials for Nevelson's "*Landscape (within Landscape)*." (See plate 54.)

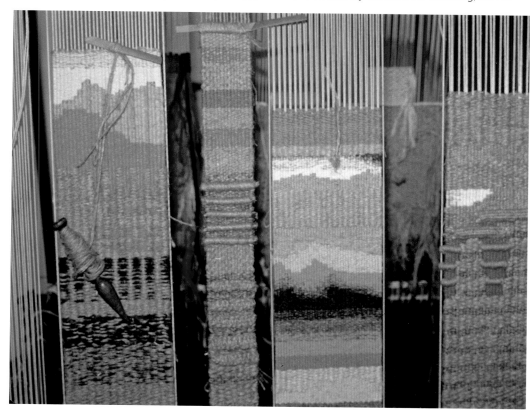

sure we can go ahead. The one for the floor we shall ensure is strong enough to withstand the extras strains."

First, the Dovecot team wove the shaped figure, all wool and standing just under four feet tall (plate 14a). Mounted on wooden boards and shipped in 1974, this creation acquired affectionate appellations during its travels between workshop, éditeur, artist, galleries, museums, and beyond—"Personnage," "Mini Dubuffet," "Little Fellow," "Wee Man," The Funny Man," "Dubuffetino," and "Dubuffet petit." Brennan reported, "He is quite marvelous. I took him for a walk in the spring sunshine in the garden this afternoon. We took each others' pictures. I don't think his will turn out, but mine of him should be fine and I'll send them on." And the play continued, "He's lovely, but not good at making tea. Maybe he will grow up to be a weaver."

Not every moment was lighthearted. Gloria commented, "This [figure] was not woven as I had expected, and does not quite have the feel of Dubuffet, but I will enjoy having it." She then discussed a "corrected Dubuffetino and . . . large panel" to be woven with white linen rather than all wool.

The use of wool versus linen remained a contentious issue during the entire process. Brennan wrote, "I expect to have little chance of talking you into it, but somehow the all wool version seems, in the now completed figure, more happy. On these trials it does not look very white, but it does on the complete figure and above all it has a new personality in wool, rather than somehow looking exactly like a Dubuffet cut out in the harder linen. I feel that rather than do this, we should be offering a slight variation in tapestry, working with an artist."

He defended the studio's choices. "Even on the little Dubuffet, our feelings are very strongly that the woolen white added a slight

dimension as an extension of the original, although the new linen whites do look very well, I have to admit." Ultimately he bowed to the éditeur's request: "No. 2. is on the loom along with the main background, both in white linen as you asked. Everyone is now on Dubuffet—can you see 7 weavers clustered round the 'brow' tapestry?"

At roughly the same time, Gloria worked with Dubuffet on several projects for which he requested "real carpet" (plates 12, 13). "So," Gloria explained, "I am having that made here by one of the fine rug manufacturers in a regular (but shaped) tufted technique." Once the Dubuffet "carpet" was completed, she reported, "You might be interested to know that as a real rug, it is most successful. I am all the more anxious to see the tapestry in wool for I can see that Dubuffet-in-wool is great."

Weaving the large, shaped background tapestry in one piece required innovation at the loom and expert engineering for its supporting frame (plate 14b). Brennan reported on his team's progress, "We found that as well as weaving the projecting shapes around the main panel, we required to 'fill in' the spaces with weaving to support and keep these shapes in control, then remove this on completion."

Following a transatlantic conference call among Gloria, Arnold Glimcher, Richard Solomon, and Brennan, and with considerable experimentation by the weavers, labor on the large piece proceeded. On June 20, 1974, the workshop shipped to New York the large background and a second figure in linen and wool on cotton warps, listed as "Wall Hanging in 2 Parts, Handwoven Gobelin Tapestry Mounted on Plywood with Metal Fittings." (For the rest of this tapestry's story, see the section on Dubuffet in chapter 8.)

Roles & Relationships

Gloria Ross and Archie Brennan established their productive working friendship through years of negotiation, copious correspondence, and joyous reunions on both sides of the Atlantic. They appear to have collaborated eagerly, compared views of exhibitions and artwork (not restricted to tapestry alone), and exchanged useful contacts. The GFR Papers attest to years of gracious notes and collegial conversation full of warm regards and well-wishing. The two shared personal news outside work and often asked after one another's respective partners and offspring.

Formal roles at the workshop were, however, easy to misinterpret. A *Craft International* article once emphasized the workshop's autonomy in weaving the GFR Tapestries.[36] With Gloria's prodding, the author attempted to set the record straight with four emphatic statements:

Archie Brennan, sketch for mounting Dubuffet's "*Untitled with Personnage*," 1974. GFR Papers.

Brennan with Dubuffet's "*Personnage*" on the loom, 1974. (See plate 14.)

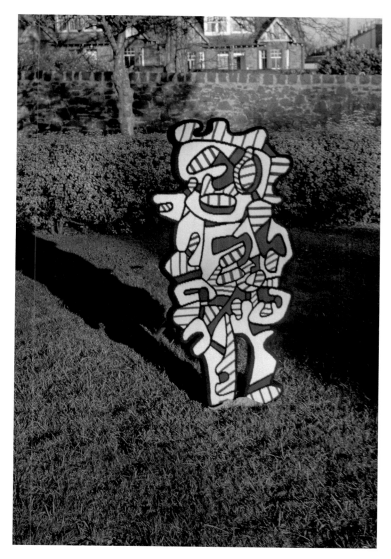

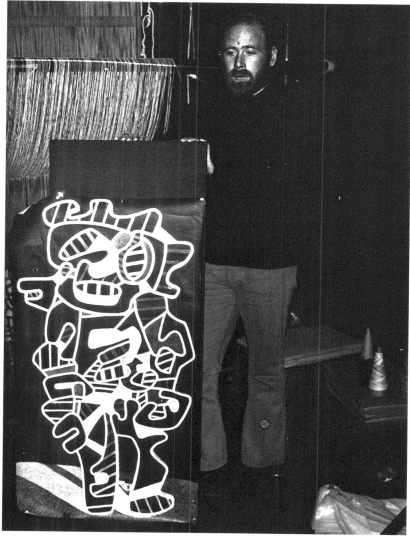

Dubuffet's "*Personnage*" on Dovecot lawn, 1974. Photo by Archie Brennan.

Douglas Grierson with black-and-white cartoon for Dubuffet's "*Personnage*," 1974

- It was Gloria F. Ross who brought to the Edinburgh Tapestry Company the maquettes of Robert Motherwell, Helen Frankenthaler, Louise Nevelson, Jack Youngerman, Adolph Gottlieb, and Robert Goodnough, and it was she who worked with us in the development of these tapestries.

- Gloria F. Ross has sold these works primarily through Pace Gallery, in New York City, to . . . the IBM World Headquarters in Armonk, N.Y., the Avon Building in New York, and the executive offices of the Port Authority at the World Trade Center.

- Pace Gallery carries Gloria F. Ross Tapestries and those of the Edinburgh Company only in that they are Mrs. Ross'.

- Mrs. Ross' long and fruitful collaboration with the Edinburgh Tapestry Company began in 1970 with the weaving of a large Motherwell tapes-

try and continued with the work of all the artists mentioned in the previous paragraph. She selected and adapted the work of these leading artists, and she frequently visited the Dovecot's studio and had extensive discussions with the then Artistic Director, Archie Brennan. Her role was particularly strong in the case of the Nevelsons. A maquette made of corrugated paper, wood, or silver foil is a long way from a woven tapestry, and Mrs. Ross was the link between these very different media.[37]

The journal subsequently published an article specifically about Gloria and her tapestry work, highlighting non-European projects such as the Native/Noland tapestries.[38]

Not all the exchanges that crossed the Atlantic were so serious. In a discussion of what to wear for the 1980 Edinburgh Festival, the workshop's Artistic Director Fiona Mathison wrote, "Dress is whatever you choose as unless there is Royalty or similar to open the

show it is very much up to the individual. As you will be one of the important personages there, I suppose you can really dress however *you* please and everyone else will have to feel over or underdressed accordingly—I am being a great help aren't I."

To which Gloria replied, "When I asked about dress I was still uncertain as to whether the openings were during the day or evening. . . . As for your other comments, you and everyone of the Dovecot are the stars and I have accepted the invitation to join you all as one who has ardently believed in what the Studio has stood for. My work with the E.T.C reflects my admiration for Archie and the Studio's talents and imagination. This is why I have brought about our collaboration on all these tapestries."

Brennan had once encouraged Gloria to explore weavers in France, but a rare sign of offense crept into a series of notes in 1971. He wrote, "Sorry the new Frankenthaler is to be done in France. I had heard when I was there this summer, but do let us know immediately [if] you make any change on any projected work as we have a very full programme ahead and need to keep it in order."

At which Gloria demurred: ". . . how could you have heard about it last summer, if I gave Pinton the order only last month, when I wrote to you about it? Knowing that I would have a number of tapestries in work this season, I did plan last summer that in addition to the Dovecot tapestries I would do some additional ones in France. . . ."

To which Brennan offered a lengthy explanation. "Last night I was watching an Australian play on television and recognized one of the actors as a boy I was at school in Edinburgh with 30 years ago. Last week I was in London and met by chance in the streets probably half a dozen acquaintances in the art world. The point I make is that the tapestry world is a lot smaller. I was in Paris August 9th–15th and met a number of people from Aubusson, Felletin, and Gobelins [in Paris]. I heard that you were enquiring about having work woven. You are perfectly right to do so. I shall be perfectly willing to pass on the address of Portuguese, French or any other workshops I have been in touch with. I am enthusiastic enough to encourage any weaving anywhere, but I am not naïve."

He continued, "We are a small workshop here and prefer to stay small because we enjoy getting the most from, and giving the most to, any project we are asked to weave, with us all involved. Therefore I again support anyone's right (or choice!) to have work done where they will. Currently, our work is well received and we are asked to weave by many different people. This means a full programme for some time ahead and it grows steadily. When I agree to undertake projects I give dates and happily accept that work will go elsewhere if we cannot do it earlier and indeed certain works are better woven at certain workshops."

"All in all," he said in summary, "my attitudes are happily clear and simple, honest and open. Very best wishes for the panel at Pintons. I think they will be able to offer much that we cannot!"

Hoping this unpleasantness could be laid to rest, Gloria replied, "Dear Archie, Let us have no more correspondence about work done outside of Scotland for I regret the tone of it and our friendship and work together is so happy and so successful. You knew I planned to do that one work in Portugal (unfortunate as that tapestry was!), and that I would work in France. Jacques Potin had introduced my name to Pinton some time ago and both he and you knew that I might work with other ateliers too in Aubusson. None of this reflects as you know on the very high esteem I have for you. Happily, as you know I am working on a number of tapestries, and I hope this list will continue to grow."

Brennan's professional curiosity, nevertheless, surfaced less than six months later. "I would like to know how, if complete, your Frankenthaler from France turned out. It would be interesting to compare the two approaches. Do let me know. Not that A is better than B or whatever, but just how they saw it and interpreted it!"

Other differences arose and were dealt with. For example, Nevelson's first *"Sky Cathedral"* prompted a 1972 exchange about tapestry labeling that was the first of many such disagreements. Gloria requested, "Please weave the insignia in grey rather than in metallic so it will not detract from the design. Too, if the Dovecot insignia is to go on the front of the tapestry it should be in grey. However, I wonder if the insignia could be woven on a tab on the back, near the label where it can easily be seen. I think that you did this in some of the earlier tapestries?"

Brennan responded, "Sorry there is a wish to remove our studio mark from the front of the tapestries. I don't think we should because (a) Historically, and for good reason, studio marks have been on the front (see W. G. Thomson, *A History of Tapestry*). Even those on a border edge have in the past, for various reasons been removed, leaving no knowledge of workshop origins. (b) In putting the mark discreetly on the face, we are no more than in line with all established workshops. (c) Often it is our only recognition in exhibitions etc., when the artist, the instigator or the gallery are clearly promoted."

Several years later, the insignia issue arose again. "Arnie [Arnold Glimcher] requests that you omit the Dovecot insignia. He is averse to it for it is distracting. He does not in any way oppose having identification of the studio on

the tapestry, but he objects to that form. How about some sort of ETC . . . or putting it on the reverse side? Your reaction please."

The Dovecot weavers—"the gang" as Brennan occasionally called them—rarely engaged in correspondence but were clearly involved with decision making. In early 1977, Brennan indicated that "the weavers, not unreasonably, are not at all enthusiastic" to create a second artist's proof (00/5) of *"Sky Cathedral II,"* extending the already completed set of five plus one artist's proof.[39] Later he explained, "The weavers have carried out four consecutively. It would not be right to now ask them for another. It would also mean a repeat special dyeing, as we have used the yarns prepared for these four."[40] On this Gloria was apparently persuasive, as 00/5 was under way by August 1977.

Another conflict arose regarding the financing and brokering of certain tapestries. In 1976, Gloria discussed with Dovecot's trustees the possibility of Edinburgh Tapestry Company "funding of the weaving of all or some of these Nevelsons" and her becoming the company's "exclusive agent in America," potentially working with Richard Solomon. Although Gloria and Pace partnered the Nevelson "Uniques," the company wasn't prepared to enter such a relationship.

Other Plans

During the creative rush of preparing for the Nevelson series, Gloria and the Edinburgh Tapestry Company also discussed jointly establishing a New York workshop. Brennan explained, *"N.Y.C. Atelier.* Following your information re wage rates etc., in N.Y. area, I had a full discussion with Johnny [Noble] and David [Bathurst] yesterday. Our feeling[s] were that it would be currently beyond our resources to set up there as it would make costs very high. However, we discussed 2 main advantages of such a project and it seems there is an interim way that helps fulfill the aims. One weaver from here (perhaps me!) to plan extended trips to carry out the preamble tests and preparations in conjunction with artists on a few projects at once, say over a month, then the actual production in Edinburgh. This means equipment, materials, space and costs are all restricted, yet we do gain the advantage of speedy and direct communication when most critical."

Instead, Brennan moved to Papua New Guinea for four months, and New York plans stalled. Ever eager to see tapestry on a broader stage, Gloria reintroduced the subject upon his return to Scotland.

"I wonder what 'longer term things' you have in mind for us to discuss. One thing I would like to discuss is the possibility of a joint project with you, Dovecot, or establishing a workshop here (possibly similar to the one in Australia). I have recently come to know quite well, someone who could be most helpful in procuring a government grant to launch such a project. I hope you might still be interested . . . I send this to your home because I do not know how public you wish to make the paragraphs on a U.S. workshop."

Inconclusive discussions continued for several months.

Brennan Flies the Coop

In 1978 Archie announced his retirement from the workshop and a return to Papua New Guinea as resident artist for the National Arts School. He broke the news to Gloria in a letter. "Now for some news that may disappoint, but perhaps not be too much of a surprise. As from mid-April, I am retiring from the Dovecot. I am going back to New Guinea to take up a minor teaching post that will give me plenty time to concentrate only on my own tapestries. I *had* no plans for this, but my spell there recently brought about the question, and an opportunity offered last month helped me decide. I shall not be weaving other than 'A.B's so I'll not be in competition with the Dovecot, which will continue with a successor to me, as yet to be appointed. I hope, Gloria, that you may be able to continue your connections with Dovecot, although it means an end to a personal collaboration that I have enjoyed a great deal. I am afraid it throws up in the air all our plans & thoughts for future developments with my involvement but life has here become so administrative & complex, and has taken me so far away from what I do best that it now seems to me to have been inevitable that I make this change. I shall, of course, be involved in completing the current works in hand, & be available to help in any projected discussion you may wish to undertake. My departure date is around 15 April. I am sorry and sad to be writing this, but hope you will realize of my need to return to being a weaver—even to fail in such. Very sincerely, Archie."

Almost a month later, following a phone call between them, Gloria replied, "I shall miss you very much and treasure the time we have worked together and the full correspondence that we developed. Certainly we shall exchange letters, and maybe even speak again before you leave on April 15th. I hope that we can keep in touch thereafter. I will be interested in knowing of your work. I do wish you well there, Archie."

Archie prefaced his next letter, "Probably my last Dovecot letter to you. Sad thought." After taking care of various project details, he concluded, "Gloria, we shall keep in touch and I'll let you know how my own work goes— I might even have that N.Y. show I've oft delayed, but meanwhile the most complete way to finish this letter is—thank you. Very sincerely, Archie."

One more letter came eight days later, to cover more business and a final note. "As for me, of course I would be interested in working through you. My only reservation is that anything on a very large scale I would perhaps think of design and woven tests by me, then woven at the Dovecot. . . . Gloria, symbolic—and nice—that my last 'Dovecot' letter is to you. Go well, Archie." At the bottom, the Dovecot secretary (and Brennan's sister) Julia Robertson wrote, "The very last thing he did, Gloria, truly, he didn't stay long enough to sign it! . . . I feel like my 'prop' has been removed!"

Gloria perked up in her next letter to the Dovecot, "Fortunately, we have all worked well together, and I look forward to continuing my relationship with you all. And so, Julia, we begin . . . !" Then follow many business details, ending with "Thank you, and cheers, Julia. I know how you must feel, but the world is so small today and Mr. A. B. will surely be back visiting Dovecot before long."

The Dovecot after Brennan

After Brennan left Edinburgh, the workshop completed the Nevelson series and a final two Goodnough *"Red/Blue Abstraction"* tapestries, but Gloria put no new work on order. To Brennan, she confided, "I do hope to launch new Nevelsons perhaps in late summer or early fall. Either I will proceed with more of this series; or work from a new series of collages that she plans to work on in New Mexico this summer." Her loyalty to him slighted the team whose talents underpinned every work so far, when she worried needlessly, "Very, very, very confidentially I do not feel that the Dovecot staff at present has the imagination flair, a je-ne-sais-quoi to develop new work like this. My general feeling after my May Dovecot visit is that work will be performed efficiently and certainly later editions like the Goodnough I expect will be well done. . . . I question work such as future 'Uniques.' Would you consider doing any of these?"

To the new artistic director, she inquired, "Fiona, if I wish tapestries woven from other collages of this series I believe Archie suggested at one time that he might be involved; or would I work directly with you? Who, now at Dovecot developed these with Archie and who wove them? Future works in this series should have the same feeling." Mathison reassured her: "Obviously, Archie's departure may make you feel a little uneasy, but we have all been working with him on your projects for a long time and I think we would find it hard to move very far from that way of thinking, particularly when part of the series has already been woven. The series has a very distinctive feeling which I am sure will be carried into the remaining tapestries. . . . Like you, I am hoping the series of Nevelson uniques will be woven. I

think, as a set, they will be stunning, a modern equivalent of the great medieval sets."

The last three Nevelsons were woven by an expert team—*"Desert"* in fall 1978, *"Landscape (within Landscape)"* in 1979, and *"The Late, Late Moon"* in 1980 (plates 51, 54, 55). Some of the best yet produced, they received high compliments from Gloria: "Fiona, I must write to let you, Jean, all—know how magnificent *Landscape* looks. It now hangs in the gallery itself at Pace (as opposed to hanging from the trolley in the back room) and it is a BEAUTY. How different it looks when properly hung. Dovecot continues on in its great tradition!"

Gloria never returned to work at the Dovecot although she expected to. When Fiona left the Dovecot in December 1981, Gloria wrote Julia Robertson: "I really did like working with Fiona and now that I will soon commence work with you on another Nevelson, I shall miss her presence. After years of work with Archie, it took time for both Fiona and me to develop a proper working system and lingo. Archie and I just understood each other so thoroughly. To whom shall I write when I have the next Nevelson collage selected?"

Five years later, Gloria continued diplomatically to leave the door open: "I do hope to work with the Dovecot again, as I did, in most congenial fashion in years past." She never did.

Brennan after Dovecot

In the decades after Archie Brennan left the Dovecot and Scotland, he lived in Papua New Guinea, Hawaii, and New York. In 1981 Queen Elizabeth II appointed him an Officer of the British Empire for his exceptional contributions to the arts.

Confident in all his accomplishments, Gloria approached him about a final Nevelson project, which unfortunately didn't happen. "We (you & I) have touched upon the possibility of your weaving, chez Archie or possibly with and closely supervising VTW [Victorian Tapestry Workshop in Melbourne, Australia], one or more tapestries based on a Nevelson collage. I have no particular commission in mind, but if I know that this is a possibility, I would suggest it for a future project. . . . At this point of your career you may no longer want to work on a Nevelson image, but they really become Brennan Tapestries as well. They have dual recognition and perhaps you would consider just supervising VTW's production of one, yes?"

In July 1994, Gloria, Brennan, Jack Lenor Larsen, and Congregation Emanu-El entered an agreement to produce a handwoven tapestry Ark curtain and five embroidered Torah mantles for the temple's main sanctuary. The curtain was originally to be woven by Brennan and the Torah covers by Larsen. Although Gloria strongly recommended Brennan to design and weave this important hanging, the temple's administrative committee struggled

Archie Brennan, lecturer for the First Annual Gloria F. Ross Lecture, Yale University Club, 1997. Photo by Carey Hedlund.

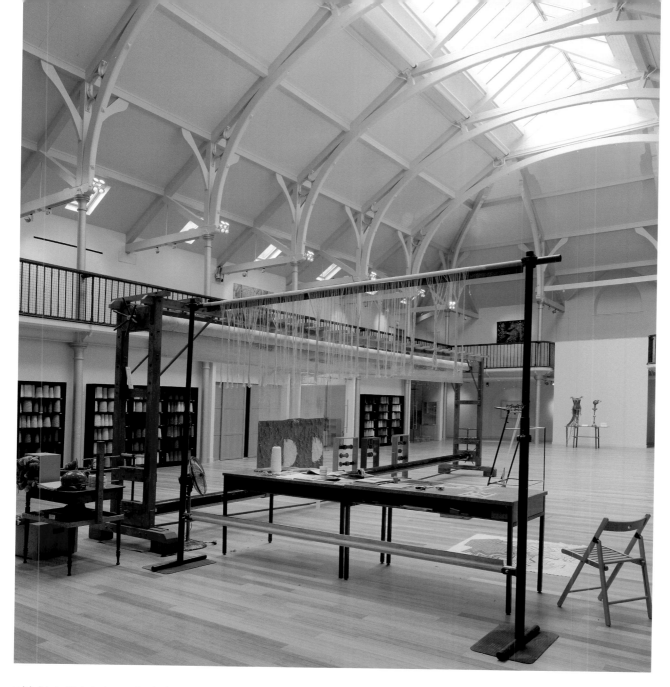

with his initial design submissions, stating "symbolism is the problem." Brennan's involvement in the project was canceled, leaving hard feelings that were perhaps never quite resolved. Larsen withdrew from the project. (The rest of the Temple Emanu-El story is told in chapters 5 and 8.)

Gloria and Brennan stayed in touch as long as she lived. Unquestionably, of all the tapestry experts whom Gloria sought out, Archie Brennan exerted the strongest and longest-lasting influence on her approach to the art form. He readily shared his philosophy and opinions. She respected his independent views and considered him her closest ally for many years.

After Gloria died, Brennan served as a trustee of the GFR Center for Tapestry Studies from 1999 to 2002 and was elected as trustee emeritus following his term. Reflecting on fifty years in tapestry making, and sharing his sharp observations of the tradition, he presented two Annual Gloria F. Ross Lectures to overflow audiences—the first in New York (1998) and

five years later in Chicago (2003). Despite his wry avowal that the best "I can handle in life is to keep the edges straight and get the color as right as I could," Brennan's career continues to encompass extensive teaching, lecturing, and consulting as well as prolific art making.[41] And the Dovecot Studios continue to produce stellar tapestries by a dedicated group of accomplished artisans, while training a new generation of tapestry weavers.

The new weaving studio. In 2008, the Dovecot Studios expanded into renovated facilities, formerly Edinburgh's first public swimming baths. The building also houses the Dovecot Foundation, championing art, craftsmanship and design through exhibitions in three gallery spaces. Photo courtesy of Dovecot Studios.

France
Exploring Tapestry's Roots

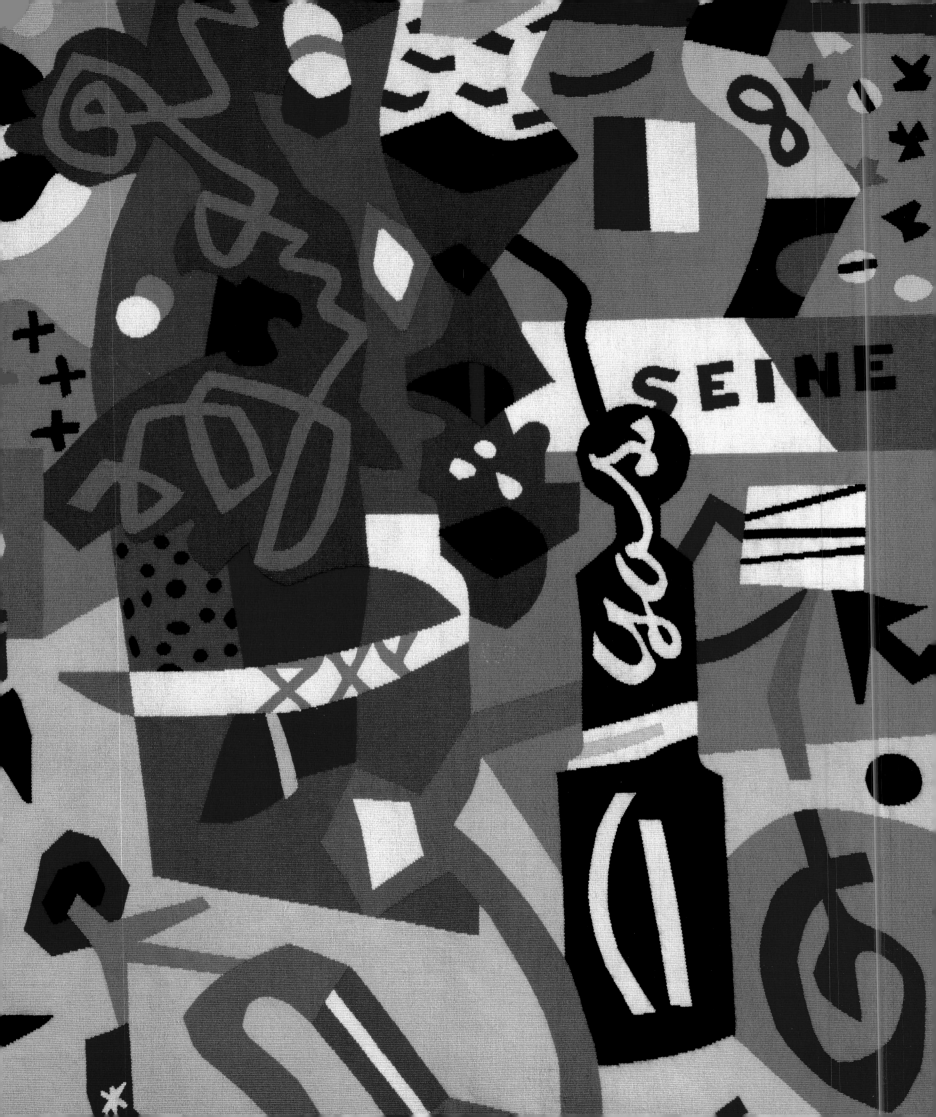

To France

Gloria visited the weaving towns of Aubusson and Felletin in central France for the first time in July 1971, after Archie Brennan encouraged her to explore their way of working.[1] Although she went "just to familiarize myself with Aub[usson], its various ateliers, its methods etc. and most im[portantly to] meet some of the people with whom I might work," she fell in love with the Creuse valley.[2] Who wouldn't? The region tends to inspire rhapsodic descriptions: "The landscape seems to have escaped from another time. La Creuse, the former [medieval] province of La Marche, a land of granite, forests and rivers, hills and ponds, has managed to preserve its natural heritage. Perhaps that is why, for over six centuries and despite many upheavals, it has also managed to maintain the last privately-owned tapestry production centre in Europe. Halfway between Limoges and Clermont-Ferrand, Felletin is one of the gateways to the Plateau de Millevaches (despite the many cows in the region the name actually means 'A thousand springs', deriving from the Celtic word 'batz')."[3]

Ten kilometers from the town of Aubusson, "the world capital of tapestry," is the village of Felletin, "the cradle of tapestry weaving," where Gloria did most of her work. She visited the area dozens of times during the next several decades.

Tapestry in Twentieth-Century France

As Gloria's career advanced, she identified most with her French colleagues and became particularly eager to share the French system with American connoisseurs. Although famed tapestry designer Jean Lurçat is often credited with moving tapestry fully into twentieth-century France, other individuals and institutions also shaped modern tapestry. Some of them set the stage, provided role models, and offered particular challenges for Gloria's tapestry making projects.[4]

In the heart of French weaving country, Marius Martin served as director of the École Nationale des Arts Décoratifs d'Aubusson (ENAD-Aubusson) from 1917 until 1934. Exerting great influence, he sponsored professional training for weavers and encouraged contemporary artists and decorators to produce new tapestry designs. He and master-designer Elie Maingonnat reacted to the aesthetics of eighteenth- and nineteenth-century tapestries, which were "mere copies when the era of slavish imitation reached its peak, annihilating all creativity."[5] As early as 1918 they began to limit the color palette, preferring stylized hatching to minute gradations. They also developed coded cartoons in an effort to bring back handwoven originality. Maingonnat followed Martin as director in 1934 and trained another generation of fine art weavers, some of whom undoubtedly wove GFR Tapestries.

Meanwhile, in Paris, Jacques Adnet (1900–1984) directed the Compagnie des Arts Français (CAF) from 1928 to 1959, at which point he became director of the influential École Nationale Supérieure des Arts Décoratifs de Paris (ENSAD-Paris), holding that position until 1970. Adnet followed the aesthetic principles set forth by the Union des Artistes Modernes and acknowledged artists' entry into the industrial age. As a designer and interior decorator, he incorporated tapestry into modern environments, but with neoclassical designs that recalled the seventeenth century. Principally decorative, his work integrated modernity with French traditions.

Adnet began a long and fruitful relationship with the weaving house of Pinton in Felletin and Aubusson in 1928. He worked with French genre

Detail, Stuart Davis, "after *Report from Rockport*," 1991, woven by Pinton. (See plate 10.)

Aubusson in the Creuse River valley, France, 2004. Photos by the author.

artists such as Lucien Coutaud, Maurice Brianchon, Roland Oudot, and Maurice Savin, encouraging them to create their own cartoons especially for tapestry, and was in position to coordinate large orders. During the Second World War, Adnet's Compagnie des Arts Français became the principal supporter of the Pinton workshop.[6]

The career of Marie Cuttoli (1879–1973) resembled Gloria's. Whether the two ever met in person is unknown; almost certainly they both worked with Manufacture Pinton toward the end of Cuttoli's life. Parallels are apparent between their backgrounds, modes of operating, and goals. Not only did Cuttoli work with her country's most famous artists, but she collaborated with native North African artisans as well as operating in classic French workshops. The wife of a wealthy Algerian-born French politician, she developed close ties with many contemporary artists. Forward-thinking, she and her husband, Paul Cuttoli, amassed an exceptional collection of paintings and sculpture by Picasso, Léger, Dufy, Braque, and other avant-garde modernists. Through these friendships, she first acquired artists' designs to be handwoven, embroidered, and appliquéd by Algerian artisans. She imported naturally dyed yarns from France and India to be used in handwoven rugs, wall hangings, and cloth. During the 1920s, her knotted pile carpets for wall or floor gained enormous popularity in both France and America.

Along the way, Cuttoli added to her stable a lesser-known artist, the idiosyncratic Jean Lurçat, as well as Jean Arp, Max Ernst, and Joan Miró. Cuttoli carpets, woven in editions of no more than five and marketed under the "Myrbor" label, were shown at the Paris Exposition International des Arts Decoratifs et Industriels Modernes in 1925, the Art Club of Chicago in 1927, and the Art Centre in New York in 1928.[7]

In 1930, she established the Galerie Vignon in Paris, signaling a shift away from Algerian production. While showcasing modernist French painting and sculpture, Cuttoli turned to the quintessential French tapestry tradition, which she hoped to protect. She and Lurçat initiated their first Aubusson project in 1933. This was a landmark undertaking that launched Lurçat but kept Cuttoli in the background. As one art historian has described it, "Before this time, Lurçat had not envisioned his work in tapestry, only needlepoint. . . . Cuttoli commissioned additional tapestries from Lurçat and remained an avid promoter of his work, exhibiting it at her galleries in 1931 and 1936, and decorating her apartment with his tapestries as an example of the fashionably modern interior. Yet her important role as a sponsor and marketer of his work in textiles—carpets, needlepoint, and tapestry—for nearly two decades during the 1920s and 1930s remains insufficiently acknowledged."

Although Lurçat made little mention of her efforts in his expansive writings, by the mid-1930s the indefatigable Cuttoli had engaged a number of private workshops in Aubusson and Beauvais, and added Le Corbusier, Matisse, and Man Ray to her already stellar list of designers. From all reports, the Cuttoli Tapestries, as she called them, were remarkable. "These pictorial tapestries dazzled the eye with their amazingly colorful palettes and textural surfaces, as well as their large scale and multi-functionality that enable them to function as wall hangings or carpets. As successful as the Myrbor carpets, these tapestries represented an entirely new kind of art, decorative, architectural, pictorial, utilitarian."

Cuttoli remained active in the international art and tapestry scene until her death in 1973. By 1968, she had partnered with Galerie Lucie Weill-Seligman and had even begun promoting American artists such as Robert Indiana and his

famed *LOVE* for woven pile carpets.[8] As late as the 1970s she collaborated with an Aubusson workshop, likely Pinton, that used some of her earlier 1920s and 1930s cartoons to create "new" tapestries.[9]

Gloria clearly identified with Cuttoli's groundbreaking role. As she explained, "[Cuttoli] worked with the French School as I have worked with (primarily) American painters and collagists."[10] She admired Cuttoli's pioneering work and further explained, "In 1932, Marie Cuttoli experimented when she had tapestries woven from paintings by Rouault, then Picasso, Dufy, Braque, Matisse, Leger, Miró, Derain, and other artists of the French school. These are in the tradition of truly great masterpieces, again collaborations of the great artists of the day and the finest craftsmen and women with Marie Cuttoli as éditeur. She knew the artists and their work, and the craft. She could work with craftsmen, for she knew (not they) what the artists were trying to portray."[11] Cuttoli's lack of critical recognition also paralleled the difficulties Gloria faced in establishing a reputation. Gloria was fortunate, however, in not having had to contend with an impassioned and egoistic French artist such as Jean Lurçat.

Lurçat (1892–1966) was a visionary painter and "one of the twentieth century's most renowned designers of pictorial tapestry."[12] From his 1933 debut, with Marie Cuttoli's assistance, he championed designs made specifically for tapestry, rejecting the use of extant paintings as designs. In 1937, Lurçat visited Aubusson, where he initiated work with François Tabard's studio; other Parisian artists followed. From the late 1940s to the mid-1960s, his remarkably distinct, dissected style appeared in tapestries woven by the French ateliers of Tabard, Goubely, Picaud, Pinton, and others. A writer of great panache, he is often credited as the force behind the major tapestry revival of the mid-twentieth century.

Drawing on strengths that he perceived in medieval tapestry, Lurçat reinvented the medium not only in modern terms but in *weavers'* terms. His major goal was to honor tapestry's underlying woven structure by avoiding the illusionistic and painterly formats of the preceding century. Tapestry would thus regain its relationship to the wall—"no longer to make a hole in it, to open it to the illusion of the painted picture, but to dress it with the supple warmth of its fabric to illuminate it with the full brilliance of the wool."[13] The solution was to reduce the "riot of hues" to fewer than seven or eight colors in no more than five shades each, with bolder outlines and less shading. He also replaced the traditional painted cartoon, usually an original painting, with a black-and-white image on paper, with colors numbered and linked to a set of dyed wool samples. Lurçat's conversion of the cartoon to a schematic served to elevate the role of the *artiste-cartonniers*, giving them power to determine the woven image more precisely. Ironically, this approach controlled the weaving, while freeing the weavers. Some modern weavers have likened this new sort of cartoon to a musical score from which the tapestry takes its shape through the weavers' interpretation.

Gloria's direct link to Lurçat was tenuous—he died before her career was in full swing. Nevertheless, her work in France was only possible because of the principles he helped to establish. Several other figures whose work in tapestry flowered after World War II were also path breakers for the American éditeur.

If Lurçat was the arch-designer, Pierre Baudouin (1921–1970) was unquestionably the master orchestrator of twentieth-century French tapestries. Following a distinguished career as *cartonnier* at Gobelins, he became a professor at the National School of Tapestry in Aubusson, teaching also at the technical school in Sèvres. Although not referred to as *éditeur,* probably because he did not finance the tapestries, he brought together artists and weavers and served as intermediary. As an *artiste-cartonnier*, he went much further—literally designing tapestries from an artist's original work through construction of an original cartoon. His name is associated with actions such as *traduire* (to translate), *transposer* (to transpose), and *transformer* (to transform). His roles are described as *l'adaptateur* (adaptor), *le maître-d'œuvre* (project manager), "technical director," *entrepreneur,* and *un imprésario d'artiste.*[14] French writers have further described him in glowing terms: "Pierre Baudouin opened new paths for tapestry, his knowledge of the technique and his respect for both artists and weavers, his story represents one of the most beautiful chapters in the history of tapestry in the 20th century. He departed at once from the quarrelsome needy debates opposed to tapestry-painting and to the extent that one and the other still exist, the insights—the end of which couldn't be achieved—nourished original thought."[15]

"Baudouin, man of conviction," as one French writer described him, "was a perfectionist who explored a new voice. He made exceptional interpretations between the maquette and the woven work." So impassioned that he has been described as a fool for tapestry, Baudouin worked closely with major artists, workshop directors, weavers, dyers, and galleries to champion the "mural of the modern era." To achieve an especially modern effect he reintroduced techniques such as *"fil à fil"* (pick-and-pick, or *piqué*) with alternating black and white wool instead of shading. His writing was also noteworthy for its intelligence. "Tapestry," he stated, "should never be placed over a chest or buffet table,

Bas relief in stone outside La Maison du Tapissier, Aubusson, France, 2004. Photo by the author.

not for its size nor for the context. It is not a table, large or small. Tapestry should fill the eye, at the height of a person."[16]

Gloria's enthusiasm and passion for tapestry matched Baudouin's. Her skills, however, differed, as she worked from outside and he was an inside painter and cartoonist. Ironically, she attached her name to each tapestry, just as Marie Cuttoli had; he refused to sign or include his name on any tapestry.[17] Nevertheless, they were both significant aesthetic arbiters, producers, and promoters. Most importantly, they both aimed to express the artist's particular intent rather than their own.

Although he died prematurely in 1970 before she began working in France, Gloria encountered Baudouin's impressive presence when she considered brokering several Corbusier tapestries orchestrated by Baudouin and offered for sale by François Pinton. "Knowing the tapestry technique perfectly," Pinton wrote to her in 1993, "he transposed numerous cartoons of contemporary painters such as Adam, Braque, Picasso, Ernst, Le Corbusier . . . work that he executed in strict collaboration with the artists and the weavers in order to protect the designer's/creator's idea."

Gallery owner and organizer Denise Majorel (b. 1917) was another major force in the tapestry world during the last half of the twentieth century.[18] Her inaugural show was held in Bordeaux in June 1945, with tapestries developed in Aubusson where Lurçat, Gromaire, and Dubreuil conducted a postwar research trip for the Mobilier National. A close associate of Baudouin beginning in the 1940s, Majorel organized traveling tapestry exhibitions throughout Europe and Asia and to more than fourteen American venues.

Working with both artists and weavers, Majorel served as co-founder and secretary of the Association des Peintres Cartonniers de Tapisserie. Established in 1947, following the close of La Compagnie des Arts Français, this group took the lead in preserving and promoting the tapestry tradition, especially contemporary tapestry.

In 1949 Majorel obtained an entire floor of the Parisian department store Le Printemps for a tapestry exhibit. The following year, she joined Madeleine David in the Paris gallery known as La Demeure (literally "home"; originally a decorator's shop). There she featured contemporary tapestries and expanded to an additional Left Bank showplace in 1954. La Demeure reigned at 6 la place St. Sulpice, just around the corner from the Café Les Deux Magots, favored by Hemingway, Sartre, and de Beauvoir. Called "the most beautiful gallery in Paris," it was housed in an eighteenth-century building designed by proto-Neoclassical Italian architect Giovanni Nicolo Servandoni. Gloria treasured a catalogue from one La Demeure exhibit, "des peintres, un lissier [master weaver],

une oeuvre concertée," and may have attended the February 1972 show, which featured the highly interpretive weavings of Pierre Daquin from the Atelier de Saint-Cyr.

Majorel's long-standing efforts not only helped re-establish tapestry as a French fine art but reshaped the entire enterprise, reopening the subject of tapestry designing for its own sake. Her exhibitions showed French tapestry that complemented contemporary interiors. In her 1972 catalogue, she referred to the gallery's "27 years of activity through which it encouraged artists to refuse the temptation of reproducing paintings in tapestry and instead incited them to design a 'cartoon,' which would force them to 'think in wool.'" With a theme now familiar to readers of this book, she praised efforts "to avoid literally copying the painting" that try instead "to impart a rich tapestry quality by using a special and varied vocabulary of weaving equivalents." "Others also have tried tackling this difficult task," she observed. "Few have succeeded."

After retiring from the gallery in 1985, Majorel curated La Tapisserie en France: La Tradition Vivante, 1945–1985 at the École Supérieure des Beaux-Arts in Paris, which published an accompanying catalogue. (Aubusson-woven GFR Tapestries were not included, perhaps because they were designed by Americans and not considered sufficiently French.)

Following Pierre Baudouin's 1970 death and the 1976 demise of La Demeure, Galerie Denise René carried the banner for art tapestries. Denise René worked with Josef Albers, Hans Arp, Sonia Delaunay, Kandinsky, Le Corbusier, and Vasarely. In the first mention of actual "editing," the catalogue *Tapisseries d'Aubusson* noted that "Galerie Denise René edited [a édité] all the tapestries illustrated in this catalogue. . . . All these tapestries have been executed in the ateliers Tabard. . . ."[19] (In this context, *editing* refers specifically to financing a tapestry edition.)

A tapestry éditeur in the fullest sense of the tradition was Yvette Cauquil-Prince (1928–2005), who also earned the title *"maître d'oeuvre de tapisserie."*[20] Originally from Belgium, she established a weaving studio in Paris and expanded her expertise from weaver to *cartonnier*, hiring experienced Aubusson weavers to execute her complex cartoons. From her careful study of ancient Coptic textiles, she developed a special way of using eccentric wefts (which cross the warps at oblique rather than right angles). She broke away from tradition to use silk and linen rather than wool, and employed multicolored yarns to break up solid areas with a pointillist effect. She generally produced unique pieces, or an edition of 1/1 with one or two artist's proofs (0/1, 00/1), in collaboration with many famed artists. Among those were Alexander Calder,

Max Ernst, Lee Krasner, Henry Miller, the Hungarian photographer Brassaï, and above all Pablo Picasso and Marc Chagall.

Spending as much as a year on a single cartoon, she worked closely with Picasso and Chagall during their lifetimes and continued to produce tapestries authorized by their estates, plus those representing Paul Klee and Wassily Kandinsky. "'I am like a conductor,' she told an interviewer, 'and Chagall is the music . . . I must understand the work of Chagall so profoundly that I myself do not exist. I must almost become the artist myself in order to transfer his ideas into wool. . . . Chagall is the creator,' she stressed. 'I am the interpreter. It must be all Chagall and no Yvette at all.'"[21]

Gloria amassed a thick file of correspondence with Cauquil-Prince between 1973 and 1985.[22] By mutual agreement, Gloria typed in English and Yvette responded in handwritten French. During 1973 they discussed various Chagall, Klee, Kandinsky, and Matta tapestries then for sale. Cauquil-Prince noted that she had full responsibility to produce and sell the artists' tapestries, with the exception of the artist's own proofs. She also warned Gloria that her work was unusual and expensive, and often made as a single piece rather than an edition. Gloria approached her about collaborating: "From what I know of your work, I believe that you could successfully *translate* (as opposed to 'reproduce') maquettes and/or paintings of some particular artists I have in mind. I know that they would fail as tapestries in a traditional weave. I believe they would succeed with your imagination and skill." Rough notes suggest that Gloria considered works by Frankenthaler, Léger, Jim Dine, Clifford Ross, and even Edward Gorey.

The two women met in Paris in late 1973 and apparently made tentative arrangements to work together. In 1975 Gloria wrote, "I am glad to know that you might weave some tapestries for me" and, five weeks later, "I am happy . . . to know that we could work together. Although your costs are appreciably higher than most weavers, I know how fine your work is; and when I next come to Paris, perhaps I will have some new maquettes."

The esteem appeared mutual, as Cauquil-Prince also sent overtures to Gloria in 1977, indicating that she might possibly work with Giorgio de Chirico and would prefer to have an American partner on the project. Gloria turned down the offer, saying she had "sufficient commitments with the numerous artists with whom I now work."

A crisis in communication occurred in early 1978, however, when Gloria wrote, "I would expect that any tapestries on which we work together, will be identified as Gloria F. Ross Tapestries—of course woven in collaboration with Y. C.-P." Cauquil-Prince responded with astonishment that Glora would think to sign

tapestries that she did not make. She emphasized her own role as the interpreter of an artist's work and suggested that Gloria's involvement could be acknowledged on labels with the phrase "edition Gloria Ross."

Curiously, this point of contention went virtually unacknowledged, and correspondence and visits in New York and France continued amicably. In 1980, Gloria and the French *artiste-cartonnier* discussed working together on a Saudi Arabian project. Many notes indicate a special warmth and fond memories of past meetings, but no GFR Tapestries were ever made in conjunction with the formidable talents of Yvette Cauquil-Prince. Meanwhile, Gloria had worked quite steadily since 1971 with Manufacture Pinton, a subject for more thorough discussion.

Pinton Frères/Manufacture Pinton, S.A.

La Maison Pinton

The Manufacture Pinton is a privately held workshop that has produced tapestries, carpets, and rugs for generations, in accord with both traditional and modern taste. As early as the seventeenth century the Pinton family (also spelled Pineton or Pinthon) was associated with Aubusson tapestry weaving.[23] Jehan Pinthon was listed in 1607 as a tapestry weaver as well as town consul. The family company was formally incorporated in 1867 and became known as la Maison Pinton Frères, for several brothers managed its affairs. In 1898, one brother took responsibility and the company became Jean Pinton et Compagnie. Eventually his nephew Olivier Pinton (1862–1914), the youngest of thirteen children by Jean's brother Mathieu, came into the business. Around the turn of the century the Pinton enterprise relocated to nearby Felletin, where Olivier partnered with Jean Châteauvert from 1904 to

Left to right, François Pinton, Gloria, and Jacques Bourdeix, Felletin, 1990

Custom-dyed yarns, Pinton workroom, Felletin, 2004. Photos by the author.

1906 and became sole director in 1906. The facilities were consolidated and expanded in Felletin in 1912, making it the manufacture's base from then on.

Oliver and his wife, Valérie Bayard, who came from another local weaving family, had three children, Jean (1898–1986), Louis (1901–1953), and Marie-Madeleine (1906–1990). Following Olivier's death in 1914, his wife ran the business until 1921, when the elder son, Jean, took the firm's reins. In 1925, returning to the brotherly tradition of Pinton Frères, Louis entered the firm. They operated the company through the twenties and thirties. Around 1930 Louis established a stately Paris office at 26 rue des Jeûneurs, in the wholesale fashion district of the city, where the company offices remained until 2003. Jean and his wife had three sons, Olivier (b. 1929), Michel (b. 1937), and François (b. 1940), and two daughters, Martine (b. 1927) and Solange (b. 1933). In turn, Olivier and François each headed the company.

The first half of the twentieth century was a favorable time for tapestry and the house of Pinton, as Nathalie Fontes has cogently argued, despite two world wars and considerable flux in the larger art world. Although Jean Lurçat was celebrated for having galvanized a

twentieth-century tapestry revival, his efforts were preceded by those of lesser-known entities, including the influential Manufacture Pinton. Unlike more traditional ateliers, Pinton hired few in-house painter-cartonniers and instead actively sought the designs of outside artists. Realizing that famous names provided a ready marketing tool as well as brilliant imagery, Pinton employed works by painters well-known in France. In doing so, and through a strong alliance with Jacques Adnet's Compagnie des Arts Français in Paris, the Pinton workshop served to champion tapestry as an integral force in modern French art.

Among regional ateliers during the prewar years, Pinton was the largest and most productive. In the early years of the twentieth century, Savonnerie carpets were Pinton's mainstay. Four-fifths of the company's carpet weavers then worked at home, a practice that continued until the 1950s. In 1951, the firm employed 54 people including 43 weavers or about 20 percent of the entire population of 209 weavers from all ateliers.[24]

Beginning in 1956, Olivier managed the firm under the original name Pinton Frères (represented in the enduring corporate marks, "PF" and "FP"). In 1973 the Felletin atelier moved into spacious modern buildings designed by the distinguished French architect Jean Willerval. The company name remained Manufacture Pinton, but the name la Societé Pinton, as its Paris gallery on the Boulevard Saint-Germain became known, was also introduced.

Since the 1960s, Manufacture Pinton has boasted the largest low-warp loom in Europe (the largest in the world is in Kyoto and the largest in the Americas in Argentina). On the Pinton loom, David Sutherland's monumental *"Christ in Glory"* was completed in 1962 for Saint Michael's Cathedral at Coventry, near London. At 264 square meters, this tapestry, the largest in the world, was woven by seven weavers in four years.[25]

Following the death of patriarch Jean Pinton in 1986, François became director. During his brother Olivier's tenure, François

Cartonnier Jacques Bourdeix with yarns for "after *1969 Provincetown Study,*" Felletin, 1990

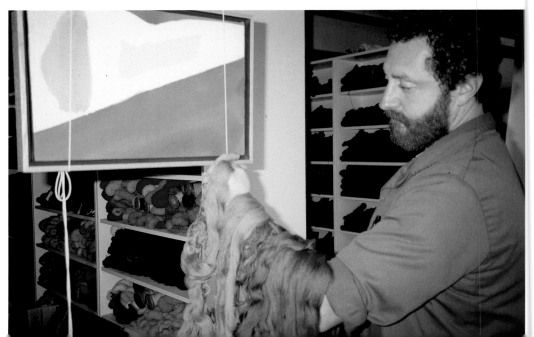

was earning his MBA at the Wharton School at the University of Pennsylvania. Looking to the future, François founded the International Center for Woven Architecture; a company brochure advertised "Completely woven interiors for tomorrow's buildings. 'New spaces created for living.'" A younger brother, Michel (b. 1937), served as longtime mayor of Felletin, underscoring the family's local and regional influence.

In 2003, François's son Lucas (b. 1979), with business interests like his father's rather than weaving skills like his uncle's, took over when François retired. Production expanded to include hand-tufted carpets, representing about 60 percent of the workshop's sales by 2005 (the percentage has continued to increase since then).[26] The young entrepreneur introduced a new company name, Les Ateliers Pinton, while retaining the classic logos of his forebears. Since 2006, Lucas's oldest sister, Félicie Ferret (b. 1971), has served as the United States and French representative for Ateliers Pinton. In addition, the company has representatives in the United Kingdom, Germany, Eastern Europe, and Dubai.

Working at Manufacture Pinton

From 1971 to 1977, Gloria worked closely with elder brother Olivier at Pinton. Following Olivier's early retirement in the 1980s, she collaborated with François. From 1972 through 1992, the workshop produced seventy-one Gloria F. Ross Tapestries from twenty-five separate designs by fifteen artists. France's legal restrictions allow for a maximum of eight tapestries woven from a single image—six numbered works and two artist's proofs. Most GFR Tapestries were planned in this manner, although not all were executed.

Gloria looked to France because she sought certain woven effects, but her approach wasn't purely aesthetic. Olivier expressed concern that she wouldn't work exclusively with him and wanted to continue with others such as Brennan at the Dovecot. Her reply reflects her practical concerns. "Archie Brennan's atelier is so small that they can make only a very few tapestries for me each year, and for this reason you should not consider him a competitor. Also, may I remind you that he was the one who recommended you to me. It is to your benefit that you be able to weave tapestries for me designed by the same artists that Archie might be working with for me. For example, he has woven only one edition of a Nevelson tapestry, and it will be years before he completes all 5 of this edition. During this time I may very well ask you to weave another design of Nevelson's. You are both weaving Motherwell's for me at the present time, and I hope to do more with you of his work, Olivier, etc., etc."[27]

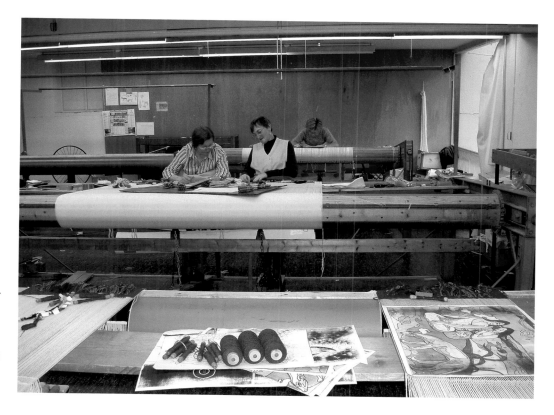

Pinton's weaving room, Felletin, 2004. Photo by the author.

Working at Pinton no doubt influenced Gloria's choice of artists and imagery. The atelier's output was diverse in style, with imagery by hundreds of artists, resulting in thousands of orders. Because the French approach to weaving resulted in a smooth, even surface, Gloria explored more densely patterned modernist works with a flat effect. With its own specialized dyeing facility and the renowned "pure" waters of the Creuse River, the workshop offered further options. At the Dovecot, the color palette was purposely limited to fewer than one hundred basic colors. The Pinton dye house boasted over three thousand colors of wool yarn, plus new combinations with cotton, linen, gold, and silver threads.

Yarn samples for Stella's "after *Flin Flon XIII*." (See plate 89.)

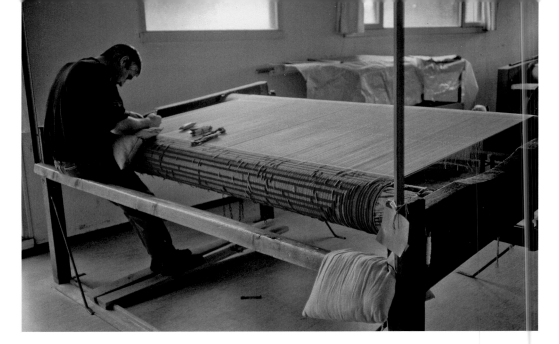

Working on an Anuszkiewicz tapestry, 1990. (See plate 1.)

With these opportunities, the contents of the GFR Tapestry *oeuvre* shifted in new directions, with a broader selection of American artists. Those chosen represented painterly abstract expressionists like her sister Frankenthaler and brother-in-law Motherwell, to be sure, but also those exploring hard-edge abstraction, minimalism, pattern painting, and op art. Conversely, to acquaint the workshop with "her artists," Gloria frequently sent books, catalogues, articles, and brochures about the artists to broaden the Pinton brothers' understanding of her projects.[28]

Gloria first brought to Pinton images from two Frankenthaler stained canvases—*1969 Provincetown Study* and a commission from the Winters Bank Tower Building, both showing large expanses of white (plates 21, 24). With further exposure to the atelier, she introduced the color-filled, hard-edged geometric imagery of Gene Davis and Frank Stella and the bold and stylized figures of Ernest Trova (plates 7, 89, 90). These suited the French style of flat tapestry weaving. Equally suitable, and distinct from her pieces hooked in New York or woven in Edinburgh, a pair of all-over-striped Anuszkiewicz images followed in 1973 (plates 1, 2). Working in France also prompted Gloria to turn toward the works of three senior modernists—Milton Avery, Stuart Davis, and Hans Hofmann—beginning in 1973 (plates 3, 8, 33). In 1974, two more Romare Bearden pictorials ensued and a troublesome Robert Motherwell abstraction, "after *In Brown and White*," was initiated (plates 5, 6, 46). An Alexander Liberman geometric, a Conrad Marca-Relli collage, and an intricate pastel by Lucas Samaras entered the inventory in 1975, with a Goodnough collage in 1976 (plates 38, 41, 86; plate 29). Two of the most illusionistic of tapestry editions—both from Paul Jenkins's acrylic-stained works—followed in the late 1970s (plates 36, 37).

Canvas sample for white in Stella's "after *Flin Flon XIII*"

Working with Olivier Pinton

When Gloria first visited Olivier Pinton's offices in 1971, she found him on rue des Jeûneurs, in an elegant historic building near Paris's bustling wholesale garment-making district. As head of the company, he oversaw all operations and production. Traveling every ten days to the ateliers in Felletin, he supervised the weaving of preliminary samples and directly monitored all projects' progress.

Olivier started working in his father's atelier when still a schoolboy, at age six or seven. He and his wife fondly recalled when he became the company's chief officer, having worked alongside the senior weavers for years. In private the workers continued to speak with him casually, addressing him with the informal *tu* for "you," but in front of visitors, in a sincere show of respect, they would switch to the formal *vous*. Olivier oversaw major expansion of the workshop and participated in local, regional, and Parisian arts promotions. He was responsible for fundraising. A friend of the architect Le Corbusier and the artist Henri Guerin, he personally involved them in the successful restoration of l'Église du Chateau in Felletin, where he established a noted exhibition series.[29]

Gloria's earliest collaboration with Pinton was a Frankenthaler design for the large Winters Bank Tower commission, begun in the summer of 1971 (plate 24). After their initial visit in France, Olivier cabled Gloria: "21 METERS TAPESTRY COULD BE WOVEN FOR END JANUARY IF MAQUETTE REACH PARIS END OF AUGUST LETTER FOLLOWS." The artwork was detained in customs and didn't arrive until late October. On its arrival, Olivier wrote, "Though it is our first work, I do hope you are confident I shall do the best I can. Shall I express, as an end [to this letter], how happy I am, with this first collaboration. With thanks for your confidence, and best regards. Olivier Pinton." He assigned seven weavers to work on this project, woven widthwise (in contrast to

Pinton's usual sideways format) and completed in April 1972.

Although cleaned and pressed before shipping from France, when the tapestry arrived in New York it was marred with dirty footsteps and wrinkles. Gloria suspected that French customs had opened the large parcel and mishandled the cumbersome piece, but what actually happened remained a mystery. Repeated cleaning and pressing resolved the problems.

Other technical and handling issues—impressions from packing materials on delicate fabric, modifications of overall size, labels sewn on the wrong side, signature tabs woven backward—plagued the French-American project at first, but each was dealt with in turn, requiring patience from both sides of the Atlantic. In the long run, nothing deterred either Gloria or Pinton from working toward their common goal of bringing French tapestry and American painting together.

Later in 1972, Gloria and Pinton hammered out a cooperative arrangement in which they would share costs of production and receive portions of the sales price for a series of tapestries. Ambitiously, they planned to produce the work of fifteen artists, each in editions of six plus two artists' proofs, for a 1974 exhibition. Initial weaving of images by Milton Avery

Examining full-scale cartoon for Davis's "after *Punch-Card Flutter #3*," 1988. (See plate 8.)

Pinton yarn room with all-important natural daylight, Felletin, 1990

drawing, he said that he would be glad to send a full scale cartoon to insure symmetry of design. He thought it might also insure more accurate following of his design, e.g. in the top corners the red and black should meet exactly at the corner. . . . Although the tapestry was pressed before it was hung in the current exhibition, Jack also noted that it is slightly 'lumpy' in certain areas. He is a perfectionist and I know you admire this quality as do I. When you personally give your full attention to my tapestries, they are superb, so I hope that you will always attend to them as you have to ones like the Samaras. We will be doing more of these. It is great."

Sometimes quality control was addressed after the fact, leading to serious disappointment. "Last Friday I was able to see the Youngerman tapestry hanging on a wall, and I find numerous faults with it. In addition to the many lines throughout the tapestry (about which I have already written . . .), the yellow wool was poorly dyed, and it has some black mixed in with it. It looks to me as though some black wool was caught in with the yellow when it was spun. The image is meant to be symmetrical, and there are several important areas in the tapestry which are blatantly different on each side. Please comment on the possibility of reweaving this hanging. The Youngerman is not what is expected of either Ross tapestries or Pinton tapestries. Please have all of my work carefully checked before it is shipped over here."

Followed by Olivier's sympathetic response, "I'm sorry about your concerns for the Youngerman tapestry, in which the execution seemed perhaps too simple to need monitoring as attentively as the others. I propose to make the weaving of the second edition at half price to compensate for the problems that you found in the first edition." In the margin of Olivier's letter, Gloria wrote, "redo 1/7 can't sell," and took a loss.

While these occasional failures were dealt with sharply, they were exceptions. Gloria showed extreme pleasure with most of the GFR Tapestries woven at Pinton, and she and Olivier appeared to genuinely enjoy working with each other.

In addition to working with Olivier, Gloria occasionally wanted to work more directly with the weavers. In 1976 she suggested, "I could work with you and your master weaver in Felletin . . . that week. It is best that I work closely with him as well as with you on these new tapestries [Jenkins among others]; and that we review other tapestries such as the Motherwell and Youngerman with which we have had problems." She and master weavers Henri Bacaud and Jacques Bourdeix did indeed confer on numerous occasions.

Seven renditions of Ernest Trova's "Falling Man/Canto T" were woven under Olivier's

and Jack Youngerman presented some technical difficulties, but these projects eventually moved forward. Gloria wrote, "I have faith in you Olivier! so that in spite of the problems with the Avery and Youngerman, I am sending to you a new maquette by Alexander Liberman. . . . the color, I think, is exquisite, and I hope that you can capture it. . . . Please put your very finest weavers to work on this tapestry. It really must be accurate and in the finest Pinton technique."

By 1975–76, Gloria and Olivier were planning six or seven more tapestries and constantly exchanging details across the Atlantic. Olivier Pinton was ever the gentleman in his correspondence—formal, precise, and always gracious.

As work proceeded, Gloria typically made rather blunt observations and demands. "Olivier, Samaras is quite unhappy with his échantillon. It does not make use of the subtle color changes, nor does it have the feel of a pastel. . . . Olivier, all of my tapestries require your personal attention and ability. Particular in these Samaras tapestries every aspect of them is to be the highest quality. If more colors are needed, please use them. The flower stem and leaves are particularly flat and do not at all have the effect of pastels. Do you know of the Segal tapestry woven by Daquin? Although it was made in a very heavy weave and unlike a Pinton Tapestry, it does have the feeling of a pastel. I studied it carefully, and I think it was done by gradually changing the colors in the threads."

As their body of work grew, she continued the close oversight. "I remind you about the bits of black wool that are in the yellow areas in 1/7 [of "Enter Magenta II"]. The yellow should be free of this. Although you have his line

direction (plate 90). Eight of Romare Bearden's *"Recollection Pond"* were directed first by Olivier and later completed under his brother François (plate 5). Four other tapestries designed by Hofmann, Samaras, Stella, and Youngerman were made (each in editions of one to five pieces), and two large works designed by Frankenthaler were produced as singular commissions (plates 33, 86, 89, 94; plates 24, 25).

Gloria once described Olivier as "the *most* sophisticated Parisian you'll ever meet." Business aside, warm personal correspondence continued between the two through June 1986, when he and his wife Marie retired from Paris to an elegantly modernized chateau in Sèvres, not far from Versailles. From there he completed a degree in theology, with a specialty in ancient Hebrew. Marie, originally from Grenoble, was known widely as a superb hostess.

Gloria made evident her pleasure in their visits. "Olivier, my visit to Aubusson was indeed a delight in every way and I thank you and François for your most kind hospitality. The many beautiful tapestries, the new atelier, your wonderful home, the croissant for breakfast et al, are nice memories." From then until her death, Gloria and Olivier's family exchanged fond greetings every year. Gloria and Marie both warmly recalled their transatlantic visits.

Shifting to François Pinton

François Pinton joined the family business in 1971 and became director in 1987.[30] To Gloria (and perhaps many others), the shift from Olivier to his younger brother appeared abrupt and somewhat mysterious. Apparently an internal family decision sent Olivier into retirement and ruptured the brothers' relationship.

After frantic inquiries from Gloria about the fate of the workshop, François wrote to assure her that things would not change under his leadership. "After Oliver's departure, nothing has changed, neither our manner of work in Felletin nor in Paris. The workshop has much work, we have the same structure and setting, the same weavers and the same dyer."

To Olivier, Gloria confided that she found the situation "difficult and sad." She added, "I already miss working with you personally and perhaps someday in some way this will come about again."

But proceed she did. In reply to François, Gloria wheedled—"Do give me a good price to initiate our work together. Yes?" Shortly after, when she inquired about doing a large tapestry commission, François replied in somewhat

awkward English, "If this tapestry [Stuart Davis, *"Punch Card Flutter #3"*] has some changes to be realized, we shall indeed initiate superbly our work together. First of all, I don't see any difficulty about the loom: our largest one is 11,60 m width (i.e. about 38')." Despite the fact that François had been educated at Penn's Wharton School, Gloria suggested in her next note: "Olivier and I always found that correspondence was easy if he wrote in French and I wrote in English, and I propose that we do the same."

Thereafter Gloria and François developed a steady correspondence; their business dealings were "both fruitful and pleasant."[31] Gloria acquired a fax machine in the late 1980s and it became her favorite office tool—much to the consternation of some correspondents, as she expected (and indeed demanded) almost instantaneous attention to this modern form of messaging.

Her archives attest to constant demands and micromanagement as tapestries grew on the Pinton looms. A typical example: "I have reviewed in my mind one particular conversation we had during your visit and that was in relation to having your very best workers weaving GFR tapestries. You said that you would do this whenever possible, but unless there is a special reason that this cannot be, and we discuss it before hand, I want to be assured that you will have *only* your finest workers involved in my tapestries. Please give me this assurance. I realize that at times this will cause a delay in the manufacture of my work, but I am willing to accept that."

In 1989, Gloria and François renegotiated their contract. This process required many revisions and consultations with their respective attorneys. In the midst of these negotiations, Gloria inquired about a baffling contact, "François, I received a telephone call a few days ago from a friend of Anna Silali, and I cannot seem to figure out who she is, or what is her role in the tapestry world and with Pinton."

Winding yarn onto bobbins at Pinton

Weaving a trial for Davis's "after *Punch-Card Flutter #3*," 1988

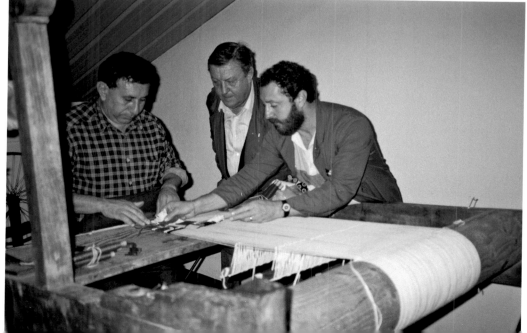

François replied that she must have meant Anne Filali, for whom Pinton had woven a tapestry after a work by her father, the sculptor Gerhard Swoboda. Gloria continued, "When I finally spoke on the telephone with Mme. Filali here in New York I was shocked to realize that she had never heard of me. Obviously, the woman who called me six weeks ago from France, with various criticisms of Pinton S.A., was a 'fake.' She misrepresented herself as a friend of Mme. Filali and in saying that Mme. Filali had asked her to call me. Mme. Filali never asked anyone to make such a call and seemed as surprised as I with the entire conversation. I would guess that someone knows of our proposed arrangement and is trying to present it. Anyway, I am glad to have learned the truth about it all."

Gloria later brushed the puzzle aside. "Madame Filali apparently knew of your and my plan to create an ongoing series of tapestries and quite honestly, she contacted me only to tell me about her Delaunay tapestry problems with Pinton S.A. It was a brief call and of course I have been curious as to her identity."

Seven tapestry images begun under Olivier's direction were completed with François.[32] Production of five new images began during François's tenure, with others considered but not executed. Avery's "after *Excursion on the Thames*" and three unique Stuart Davis tapestries were developed solely with François (plates 4 and 9–11).

In addition to working with Pinton's director, Gloria worked closely in Felletin with master weavers (*maître-lissiers*) Henri Bacaud and Jacques Bourdeix. Because of his expertise as a colorist, Bourdeix traveled to New York in 1988 and again in 1990 to visit galleries and work directly with Gloria and the original artworks. Manon Lerat, Françoise Boucher, and others assisted in the weaving rooms and business office.

Gloria was adamant that her name be associated with "her" Pinton tapestries. More than once she protested. "I have your mailing, 'Cahiers no. 2,' but I am surprised and most unhappy—to put it mildly—that my Avery and the names of Frankenthaler, Jenkins, Goodnough, Motherwell, Marca-Relli, Hofmann, Trova, Al Held and Anuszkiewicz are not identified as Gloria F. Ross Tapestries!!! A correction should really be sent to those who received your mailing, but if not, a very obvious and strong correction should be noted in your next mailing. Please assure me that in the future any tapestries on which you and I have collaborated, will be so noted. I am always proud to mention the Pinton atelier, and I hope that you will reciprocate."

Gloria continued working with Pinton into the mid-nineties, during which period she started treatments for lung cancer. Her dealings with François became increasingly contentious as she attempted to wrest control not just of tapestries but life itself. Eight months before she died, she wrote, "Sadly, yes, because of my critical illness, it is time to end our work together, and to settle financial matters. I trust that you accept this in a sympathetic and friendly manner. Obviously I regret having to do this, for we have enjoyed a good relationship and I expect our personal friendship to continue. . . ."

Nonetheless, disputes persisted regarding outstanding fees, missing tapestries, and, most unpleasantly, a matter of sixteen cartoons that Gloria wanted destroyed but which couldn't be found in France. In spite of François's assurances, she feared these would be used for unauthorized tapestries after her death. Resolutely she noted, "We will not only try, but we will find resolution to any questions regarding this matter [of cartoons to be located and destroyed]." Throughout 1997, correspondence from Pinton remains cordial, conciliatory, and firm regarding the company's honorable business dealings. "These sudden and belated demands astonish me and seem to me improper and harassing. Manon has always informed you of changes to the list of woven works."

Other French Workshops and Weavers

Atelier Raymond Picaud

Gloria visited Raymond Picaud at his workshop during the summer of 1971, and again in July and December 1973. Between times, she wrote to him eagerly in English about prospective commissions, with many technical questions and frequent pleadings for immediate replies by return mail. They created an ambitious list of prospective tapestries designed by Anuszkiewicz, Avery, de Kooning, Frankenthaler, Held, and Lindner. Later she added works by Motherwell and Jenkins as well.[33]

Raymond Picaud (1925–1996) was an essential participant in the contemporary Aubusson tapestry revival.[34] His ancestors had been weavers since the seventeenth century. Born in Aubusson, he taught weaving at the Atelier École Nationale de Tapisserie d'Aubusson during the 1940s, preceding the formation of the École Nationale des Arts Décoratifs (ENAD-Aubusson).

The first tapestry from his atelier was designed by Jean Lurçat, followed by work from more than two hundred other artists, many extremely well-known. "I knew Braque when he was elderly. Tapestry wasn't his favorite [*son cheval de bataille*]. Le Corbusier came to Aubusson where he designed a factory. Calder visited me many times. I've never forgotten his humor. He was a fantastic character. I met Dali. I wove many compositions by Cocteau, but worked only with his adopted son Edouard Dermit. I particularly appreciated

Raymond Picaud and son with photo of Frankenthaler's painting for Wichita commission, 1973. (See plate 25.)

Jacques Lagrange, Mark Petit . . . [ellipse in original]. Nicolas de Staël and I were pals. He died way too early. I knew Poliakoff well but never wove his work: he wanted to make tapestries that couldn't be done. I remember fondly forgotten artists who did a lot of tapestry work like Ferréol. He was simple, unselfish. All my life, I've woven solely contemporary tapestries, by choice because I loved them."[35]

A master weaver and head of his own workshop since 1946, he employed twenty-eight professionals during the 1970s, making the Picaud atelier one of the five largest in the area at that time.[36] In addition to monthly trips to Paris, he traveled extensively to New York, Los Angeles, Moscow, and Brussels. He served as president of the Association des Anciens Elèves de l'ENAD and Syndicat des Maîtres Artisans Lissiers d'Aubusson and directed the Association pour le Rayonnement de la Tapisserie d'Aubusson. He was awarded both the Chevalier de l'Ordre National des Arts et Lettres and the Ordre National du Mérite.

The early seventies were busy times for the Picaud atelier and, although Gloria expected her tapestries would get priority, most were delayed well beyond her tolerance. Several months after submitting a list of planned tapestries, in November 1973, she inquired, "I have given to you these many orders because I recognize the excellence of Picaud tapestry. I appreciate the time involved in fine tapestry weaving and I know it cannot be rushed. However, when we established the schedule for the tapestries to be completed by January or February, you said that this would provide adequate time. I have scheduled an important New York exhibition for the Spring. . . . do you still expect to have the [tapestries] completed by January or February?"

Gloria's letters and telegrams were often marked "URGENT." Once, feeling characteristically pressed, she wrote, "I am deeply concerned about the progress of the work you are doing for me. I have written to you many times, and even cabled last week, and still I have no reply." As she became more demanding, he grew more reticent. After a visit in December 1973, Gloria learned that Picaud's son, Jean-François, himself an ENAD-trained weaver and member of the atelier since 1970, was only partially translating letters from her English into their French, and no one was prepared to respond in writing. From then on, her letters included some translations into French (at times by someone with cryptically styled European handwriting). Letters on file show that Picaud usually responded in a professional and timely manner, but Gloria remained dissatisfied.

The first GFR Tapestry woven at Picaud was a unique piece, "after *Telephone*" (1/1), from a painting by German-American artist Richard Lindner, who painted weirdly erotic figures in vivid hues (plate 39). In order to obtain accurate colors, Picaud sent his workshop's colorist to Hamburg to examine the original painting at the collector's home. Completed in February 1974, the tapestry was deemed by Gloria "beautiful" and "a great success"—"all color, shading, edges were woven so well." The delay in this and other projects, however, caused cancellation of Gloria's planned New York vernissage.

After a seemingly cordial visit in June 1974, Gloria wrote, "I am disappointed that after my third visit with you about the same set of tapestries . . . you still do not reply to my letters. The trips, calls, telegrams are very expensive, and I shall soon have to deduct the cost of the calls and telegrams from my payments to you. I do expect an immediate reply to the following questions . . . Raymond, would you prefer me to complete the Avery and small Frankenthaler elsewhere? I cannot afford to wait for these any longer. I begin to feel that you really

Raymond Picaud and helper examine a full-scale cartoon from a Frankenthaler painting for "*Tapestry from Bookcover*," not woven, 1973

been a tremendous financial burden to me too. It is difficult to account for this loss."

At which point Picaud wrote, "This is to inform you that I have absolutely no interest in the WICHITA tapestry that has caused me a considerable loss. It seems that the business practices that you espouse are very different from our own and couldn't in any case apply in FRANCE."

His letter's closure, "*Bien á vous*," roughly equivalent to a cool "Good day," stood in stark contrast to his earlier flourishes such as "*Veuillez croire, chère Madame Ross, à l'assurance de nos sentiments très dévoués.*" Of all the artists whose work Gloria brought to Picaud, only Lindner is mentioned in the 1986 Picaud catalogue.[38]

Micheline Henry, Tapisseries Contemporains, Editions MH

Beginning in 1974, Micheline Henry (b. 1948) operated an Aubusson workshop with eight to ten weavers. Like her, many of these artisans had studied at the École Nationale des Arts Décoratifs d'Aubusson during the sixties. The free-spirited young *directrice* was much loved by her workers, who, it is said, all had keys to the workshop and could arrange their own hours. Her husband, Patrice Sully-Matégot (b. 1949), is the son of renowned artist and designer Matthieu Matégot (1910–2001). An artist in his own right, Patrice developed many cartoons for the tapestries produced by Editions MH.

The small "artisanal" atelier had a reputation for its painterly approach to weaving, with carefully shaded coloration. Originally trained at the École Nationale Supérieure des Arts Decoratifs in Paris, Patrice studied dyeing with an Aubusson specialist and could produce nuanced tints unlike those from other workshops. As painters and printmakers themselves, he and Micheline Henry maintained close rapport with the artists and galleries, trusting the studio's abilities to translate subtle imagery into handwoven works of art.

Gloria first learned of Henry's work from a 1976 *ARTnews* ad that said, in effect, "Micheline Henry weaves in Aubusson; she can do the

are not interested in working with me, and at this time it is best to be honest. This is all too difficult for me, and I am unhappy about having to write such a letter."

After Gloria and Picaud *frère et fils* met in the summer of 1974, two other projects were completed that September. Picaud announced with pleasure *la tombée du métier,* the tapestries' removal from the loom.[37] These were bold abstractions—one by Richard Anuszkiewicz, intended as the first of a pair, and the other, "after *Cultural Showcase*," by Al Held (plates 1, 32). Despite these successes, Gloria chose to discontinue work with Picaud and sent future projects to the Pinton workshop.

Disagreements persisted through 1974 and culminated in a permanently flawed tapestry, the Frankenthaler commission for the Fourth National Bank and Trust in Wichita, Kansas. Although initially Helen Frankenthaler was "positively delighted with it," the Picaud tapestry was deemed a total failure when conservator William C. Stark determined that it was too unstable to withstand hanging. Measuring 114 by 510 inches, the hanging was destroyed in June 1975. A replacement was successfully woven by Pinton later in the year (plate 25).

In October 1974, Gloria complained bitterly to Picaud. "I am certain that you realize that this affects my reputation. Your inexplicable delays in working on the other tapestries have

same for you." Later that year Sully-Matégot visited Gloria at her Manhattan apartment and viewed the GFR Tapestries at Pace Gallery on 57th Street. Subsequently, Gloria visited the Henry atelier in Aubusson. There she initiated a tapestry from a flowing acrylic painting, *Phenomena Peal of Bells Cross* by Paul Jenkins. Over the course of several years, a full suite of tapestries was woven from this image (plate 36).

The studio was accustomed to weaving multiples of the same image. In May 2008, Henry described their particular approach: "I tried to choose the same weavers who had woven the first example to make the others so that there wasn't too much difference between them, but in practice no edition from the same cartoon is totally identical. The studio commonly worked with French and other artists who understood perfectly the weaving technique, and they furnished us with a maquette and a color cartoon made by themselves. In the case of the Paul Jenkins, and this also happened with other artists, we had to make the cartoons and [face] the difficulty of translating the color gradations. It was essential to have a great number of colors at hand and to use a relatively fine thread count, but in using a fine thread count the possibilities for mixing the colored yarns were reduced and so the work took more time and required more customized colors . . ."

She also noted, "Patrice made the cartoon in pencil and the principal difficulty was to re[-]create the effects of the melting [*fondu*], which we call shading [*dégradés*] in the language of tapestry."[39]

In 1978–81, another set of Jenkins-designed tapestries was made from *Phenomena Mandala Spectrum Turn* (plate 37). Years later, Henry acknowledged the risks and Gloria's vote of confidence. "You should know that for us this type of work was a bit risky because an artist might not be satisfied with the weaving and we would have to assume the entire responsibility. But it seems to me that Gloria Ross was always satisfied with the interpretations that we made."

She also commented on the communications process. "In principle, Gloria Ross always chose the maquettes to be realized, but she would ask us for our advice regarding difficulties of one maquette or another and we would first discuss this. This was too long for the mail and the web didn't exist. . . . We took photos during the course of weaving or made sketches, and we waited for responses before continuing if we had any doubt, but generally we [all] made those decisions before the start of weaving."

Upon receiving a finished tapestry, Gloria would sometimes return a color photograph to Henry with handwritten annotations for "improvements" for the next one. Henry never knew whether Gloria had discussed these changes with the artist; lack of such notes in the archives suggests that she likely did not. For example, in 1979, Gloria wrote about her "Jenkins tapestry hanging": "The left side is fine but when you weave the next one, the dark 'fingers' should be omitted. Your translation is accurate, but these 'fingers' somehow do not translate well. I enclose a sketch showing some of these areas. In the future just blend the colors as you have in the areas I have circled. Just to confirm this, you might send a small échantillon of the area in the square."[40]

Weavers in the Henry atelier who made the GFR Tapestries are not identified in the GFR archives. Bernard Battu, now an independent fiber artist in Aubusson, has recalled working on some of the Jenkins pieces, but never met Gloria. As Henry explained in 2008, "It isn't common for studios to mention the names of the weavers working on a tapestry. I tried [to record the weavers' names] with four or five weavings, but then stopped."

During the late seventies and into the early eighties, Gloria began work in the American Southwest. At the same time, Henry's workshop wove twenty to thirty tapestries each year for a single French artist. When that patron died in 1981, Henry cut the atelier back to two or three weavers and in 1985 the formal studio closed for good. She and Patrice Sully-Matégot pursued other art projects.

In 1987, Gloria returned to Micheline Henry to complete the edition of Helen Frankenthaler's "after *1969 Provincetown Study*," for

Detail, Paul Jenkins, "after *Phenomena Mandala Spectrum Turn*," 1978–81, woven by Micheline Henry. (See plate 37.)

Detail, reverse side of Frankenthaler's "after *1969 Provincetown Study*" (5/7) in process. (See plate 21.)

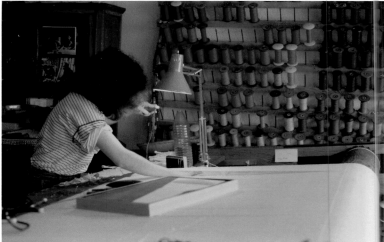

Micheline Henry works on Frankenthaler's "after *1969 Provincetown Study*" (5/7) in her Aubusson studio

which earlier pieces had been woven in Edinburgh from 1969 to 1978. Snapshots sent by Henry to Gloria show two female weavers working on this piece at the loom.

In 1990, Gloria wrote to Henry to let her know that she was now in partnership with François Pinton and could no longer work with her. "You must know how very much I admire your abilities, but you have not heard from me because Pinton is funding my work and therefore quite naturally requires that I work exclusively in France with this atelier."

That same year Henry and Sully-Matégot moved to Angers, a growing arts colony in the Loire Valley where they pursued a variety of independent and community-based art projects. Between 1990 and 1992, working with weavers in both Angers and Aubusson, the couple also produced a series of tapestries for the Disney Studios of France. Of these, Henry recalled, "These tapestries weren't very interesting from the viewpoint of aesthetics but very interesting for the technique."

Other French Prospects

Gloria kept her eye on other Aubusson-area weaving studios. Snapshots in a photo album show her visiting the Aubusson atelier of Gisèle and Henri Brivet, but she apparently never worked with the couple.

At several junctures during the eighties and early nineties, Gloria discussed with Pinton and Picaud the possibility of her representing in America other works that had been produced in the Aubusson and Felletin ateliers. She became especially interested in several large Le Corbusier tapestries, a pair of Léger hangings, and a series of Calder pieces, as well as works by somewhat lesser-known French artists such as Georges Chazaud, René Fumeron, Antoine de Jacquelot, and Delphine Bureau-Chigot. She also corresponded with Alain Lemery, then director of La Demeure gallery in Paris, regarding other Le Corbusier

and Sonia Delaunay tapestries, and possibilities of an American show in a New York gallery. None of these developed.

Gloria provided François Pinton with useful introductions to Americans when he visited the United States. In 1991, she planned an intense three days in which they met with Milton Avery's widow Sally and with Stuart Davis's son Earl (also executor of his father's estate). They visited a private collector and with designers in the architectural offices of Robert A. M. Stern, Skidmore, Owings & Merrill, and Beyer Blinder Belle. They strolled along Museum Mile one evening and viewed the Stuart Davis paintings at the Metropolitan Museum. Such visits cemented useful contacts for Gloria as well as creating new ones for François.

On one of her French trips, Gloria met Georges Bauquier, *conservateur* at the Musée National Fernand Léger in Biot, to discuss one or a pair of Léger tapestries that she hoped to have woven at Pinton workshop for a "large lobby space in a prominent and prestigious new building in New York." The Léger project never happened, and Gloria explained to Pinton that the owner had "decided to wait until the current severe real estate recession in New York has subsided . . . typical of what is going on in the city at present." Later, a Stuart Davis design was chosen instead for the Rudin building at 345 Park Avenue. Also in 1993 Gloria inquired about a Léger tapestry at Jane Kahan Gallery in Manhattan, but no deal was made.

Gloria mentioned yet another tantalizing project in a postcard from France: "Brought over some tapestry projects & suddenly a huge one emerges from France—which I *think* I'll do. Tapestries to be woven in France from American & French artists' designs & I've been asked to select and work on The Americans! To be exhibited & funded by a US corporation. We'll see."[41] Like many other prospects, this one didn't materialize.

A Final French Project

The last tapestry woven at the Pinton work-shop for Gloria F. Ross represented a project unlike any she'd previously undertaken. "Brave new world!" she exclaimed in a 1994 letter to me, followed by further explanation, "I was selected to develop the textile art for Temple Emanu-El's altar, and of course this will be an exciting project to develop . . . It is a great Art-Deco space, and of course we are developing religious symbolism within this context."

Mark Podwal, a talented illustrator and expert on Jewish iconography, designed the Ark curtain (*parochet*) and Torah mantles (*m'eelim*) (plate 83; see chapter 8 for more on Podwal and the significance of his designs). A brochure written for the dedication of the Ark curtain explains, "Traditionally, the *parochet,* the 'hanging curtain' or 'veil,' adorned and concealed the Ark in the ancient Tabernacle. The Bible states: 'And thou shalt make a veil of blue, and purple, and scarlet, and fine twined linen. . . .' (Exodus 26:31–33). Thus the use of rich materials was prescribed; the richness of motifs soon followed. . . . The Torah mantle (*m'eel*) highlights the Scrolls of the law. The decorative covering hearkens to the Talmudic dictum: 'Have a beautiful Scroll of the Law prepared, copied by an able scribe with fine ink and fine calamus; and wrapped in beautiful silk' (Babylonian Talmud, Shabbat 133b). . . . The wimple, or Torah binder, symbolized the belt (*chagorah*) worn by the Temple priests. . . ."[42]

Gloria approached Manufacture Pinton about weaving the curtain and related items. François Pinton responded in high spirits, "I believe in signs from heaven and we are God's tools. It happens that Ahmed Moustafa has ordered some Islamic tapestries from us. Moustafa is a Muslim, earnest and enlightened. Several days ago Jean Bazaine asked me to weave a tapestry for a Coptic Catholic chapel [Saint Dominique] in Paris. If you confirm with me the weaving of your tapestry for the synagogue of Emanu-el, the three churches born of Abraham will be represented on the looms of Felletin. If this is the wish of God, Felletin will replace Assisi and I expect of course to invite on the same day: the grand mufti of Paris, the grand rabbi of France, and the archbishop of Paris. I'm sure, dear Gloria, that you will accept my invitation on that day."

For this, as with many previous projects, Jacques Bourdeix served as master weaver. Gloria wrote directly to him at his home and explained that the tapestry would be placed in ". . . one of the most beautiful spaces in this city. The tapestry is to go in the Ark, which is the most sacred place and centered on the altar. It will hang behind the Torahs which are our holiest scriptures. These are written on scrolls which are beautifully bound in velvet with gold embroidery."[43]

Throughout 1995 and into 1996 numerous instructions, reactions, and requests continued, even as Gloria cycled through rigorous cancer treatments.

When the tapestry neared completion in France, Gloria turned her attention to the lining and mounting of the Ark curtain and the creation of the five embroidered Torah mantles in New York. After much research and many samples, she selected a sumptuous beige velvet from F. Schumacher & Co. for the lining. After seeing an article about Penn & Fletcher, Inc. in *Architectural Digest* (August 1996), Gloria hired the firm, whose card offered, "Fine embroideries and embellishments for interiors, In the European tradition, Crafted with quality of the highest calibre."

The owners, Ernest Smith and Andrew Marlay, "veterans of theatrical costume design," later expressed their double gratitude to her. "Thank you so much for the wonderful seats

The Torah Ark in the main sanctuary, Temple Emanu-El, New York. Photo by Malcolm Varon, courtesy of Herbert and Eileen Bernard Museum of Judaica, Congregation Emanu-El, New York. (See plate 83.)

Lucas Pinton with the workshop's master weaver, Felletin, 2004. Photo by the author.

at Carnegie Hall—The Boston Symphony was magnificent. We also want to thank you for bringing us into the torah mantle project. Your superb taste has guided us in creating some of our best work. It has been a pleasure working with you."

Penn & Fletcher embroidered Podwal's designs on the five Torah mantles. Under Gloria's direction, these were cut and assembled by J. Levine Company. With the slogan, "A Modern Tradition Since 1890," this Lower East Side firm has specialized in Judaica for generations.

Originally Manufacture Pinton was to celebrate la tombée du métier of its "Tapisseries des Trois Religions" in October 1995. The workshop invited President Jacques Chirac and religious leaders representing each of the three churches, but production delays prevented the ecumenical gathering the workshop director had originally envisioned.

The Ark curtain, measuring just over nine feet in each direction, was nevertheless fêted on its own. In March 1996, on receipt of the completed tapestry panel, Gloria wrote to Pinton, "The tapestry received rousing cheers from Emanu-El's senior rabbi, Chairman of the Board, Chief Administrator, Mark Podwal and above all from your friend Gloria Ross! François, the tapestry is beautifully woven and you managed to adhere to the many directives I sent to you these past many months."

On the morning of October 5, 1996, as part of Temple Emanu-El's 150th anniversary celebration, several hundred people attended the dedication of the new Ark curtain, Torah mantles, and Torah wimples. The event coincided with Succoth, the Jewish holiday of harvest and thanksgiving. The Temple's

newsletter proclaimed, "Brilliant in color, imagery, and Jewish content, these newest additions to our Sanctuary Ark will bring joy to our hearts and pleasure to our eyes for countless years to come. We are blessed by the creativeness of our artist and the generosity of our benefactors."

Gloria described to the French weavers "[t]he hundreds of people who attended the beautiful service." She commented on the tapestry bringing "a whole new feeling of lightness and joie to the altar." The project evidently did the same for Gloria herself, as she attempted to rally against both cancer and the effects of chemotherapy.

Impact of GFR Tapestries in France

Manhattan tapestry dealer Jane Kahan has called the 1970s a period when a "second tapestry revival was in full swing." This occurred, she says, because of the many GFR Tapestries that were created in France and are now located in significant American public collections.

When GFR Tapestries were woven in France, however, they were shipped immediately from Aubusson looms to New York, gaining little exposure in Europe. Among the many possible workshops, Gloria only worked with Pinton, and briefly with Picaud and Micheline Henry. The rest of France remained oblivious to her efforts. Despite her representation of a unique approach—unique because it used American painters rather than European ones—the French public, dealers, collectors, and museums would have found her projects relatively commonplace. After all, her approach was far from new, as venerable ateliers often collaborated with famous painters.

Only one brief French exhibition, Les Tapisseries Americaines in 1990, focused on outside artists, including eight who designed GFR Tapestries. Significantly, GFR Tapestries are overlooked by every major publication about tapestries woven in France. Only three American artists (Frank Stella, with whom Gloria worked, plus Alexander Calder and Sheila Hicks, with whom she did not) are briefly mentioned in one major survey of French tapestry.[44] In a list of the 371 painters who designed tapestries woven at Aubusson between 1940 and 1983, only Anuszkiewich [sic], Frankenthaler, Held, Paul Jenkins, Linder [sic], and Smith are mentioned. The only other Americans included are Mark Adams and Calder.[45]

Thus Gloria Ross participated in a renaissance of tapestry in the United States, but not in France nor for the Aubusson ateliers of the time. Her contributions to the Aubusson tradition were largely ignored. Her enthusiasm for French tapestry brought no new clients to Pinton or the other moribund Aubusson ateliers. In 2004, six years after her passing, ENAD-Aubusson closed its tapestry school, keeping only a restoration program open.

Twenty years after working with Gloria for the last time, Micheline Henry thought about her Aubusson experiences and the future. "When I created my studio in 1974, I think there were about 100 weavers in Aubusson and Felletin. In 1985 there weren't more than 50 in these two towns. Now (although I'm no longer in a position to know) I think there aren't more than 20 weavers, even though at the beginning of the twentieth century there were several hundred. The art of tapestry isn't far from disappearing. Unfortunately today it is no longer possible to work for hundreds of hours on one weaving, except for huge public commissions for which, even so, the price doesn't amount to much, [and] today that is more and more rare."[46]

She also reflected on her own career path. "I have very much loved this profession for the contact with the artists whom I've understood so well, being a painter myself. We have travelled a lot to meet them in Europe, Germany, Switzerland, Italy, Spain, the USA with Gloria Ross, but on the financial side this has been particularly difficult. I have not gotten rich and could even say that I've become indebted. I haven't worked in tapestry for more than fifteen years. The one, unique, and last tapestry that I wove personally dates to 2004 Today I'm sure that I won't return to the loom, nor will I ever want to return there. We still have many weavings. . . that we can't sell, because no one is interested in tapestry anymore!! This is very sad, but what can we do?"

Current government and civic programs reflect some attempts to save the art form. Le Mobilier National, France's national "storehouse" of decorative arts, continues to select artists to create designs that are woven at its centuries-old workshops in Beauvais and Gobelins. Once a year a relatively recent competition sponsored by the Hôtel de Ville (Town Hall) in Aubusson seeks a single artist to design a major tapestry. The award carries prestige and has significantly expanded the organization's permanent collection of original tapestries.

Ironically, Lucas Pinton, workshop director and successor to the centuries-old Manufacture Pinton, has expressed interest in working directly with American artists of the generation following those who worked with Gloria. These artists, he believes, might represent revitalization for French tapestry of the twenty-first century.[47]

**I am never committed
to any one technique.**
—Gloria F. Ross[1]

Gloria's world revolved around New York, Scotland, France, and the American Southwest. However, she looked beyond these for collaborators—China, Portugal, Spain, Turkey, Sweden, Mexico, and Australia. Likewise, even though traditional tapestry-weave and hooked-rug structures were her mainstays, she explored variant techniques—painting on handwoven fabric, modified rosepath weave, a shift to heavier materials and unusual fibers. The distinguished weaver Helena Hernmarck put it well in describing Gloria as "inclusive, not exclusive, not uptight" about how to define tapestry.[2] And she was equally inclusive in her continuing quest for interesting partners and experiences.

Some projects worked out and others didn't. Those described here, roughly in chronological order, all illustrate the reach of Gloria's imagination, whether or not they led to successful products.

Portuguese Possibilities

Gloria initiated discussions in 1970 with the Portuguese firm Manufactura de Tapeçarias de Portalegre Ltda., directed by Guy Fino. His memoir gives a taste of his colorful personality. "Born in Colvilbã, land of wool, and son of a wool merchant, it is almost true to say that I was born in a sack of wool back in the distant twenties. For I was born at home and in my parents' house the mattresses, as was usual at the time, were filled with raw wool. I soon began to enjoy going to the factory with my father where I liked playing in the warehouses, jumping into the binds of wool, wandering through the workshops where the skilled craftsmen taught me how to walk past the moving machines, satisfied my curiosity and loved the little boy. I remember that one of my favourite occupations was to sit for hours on end inside the moving waste box of knitted yarns next to the spinner while he, my great friend, told me stories to the rhythmical to and fro of his machine. They were almost always related to the wool industry and were to form useful memories that have accompanied me though life. . . ."[3]

In 1946–48, Fino revived a distinctive knotted style of tapestry. Originally a partner in the Fábrica de Lanifícios de Portalegre (the Portalegre Woolen Mills), he described the beginnings: "When Manuel Celestino Peixeiro (junior) and I made up our minds to revive the knotted tapestry which Manuel do Carmo Peixeiro (senior) had made in Portalegre I was in my element: wool. Then when Manuel do Carmo Peixeiro appeared in the factory with his sample of tapestry, born in Roubaix twenty-five years earlier, three thoughts entered my head. Firstly the tapestry that I had seen in museums and old palaces was the highest form of expression, the greatest tribute that I could pay to the queen of all natural fibres. Second that it would be an exciting challenge to make a tapestry with a new technique which would be quite different from the comparative ease of reproducing something traditional by centuries-old techniques. Thirdly, here was a new material at the disposal of national artists who would have to study the new technique along with us, so we could produce beautiful works of art."

Fino's first innovation was to combine the precision and control of the French high-warp loom with the mechanical foot-treadle system of the low-warp loom. His second was a technical change in the woven structure. Working with well-known Portuguese artists, the workshop eventually received a number of commissions, working to establish Portuguese tapestry with the stitch that is known today as Portalegre.

Detail, Helen Frankenthaler, "after *This Day,*" 1982, woven by Janet Kennedy. (See plate 26.)

Guy Fino and Gloria in Portalegre, 1970

Weavers at Tapeçarias de Portalegre, Portugal, 1970

In April 1958, Jean Lurçat visited the Manufactura de Portalegre. He was asked to compare two tapestries based on the same cartoon—one of his tapestries woven in France in the traditional method and another made in Portugal using the new technique. José Ribeiro, director of the Gulbenkian Foundation's Modern Art Centre, reported, "Faced with the two samples and asked to identify the French one, Lurçat pointed at the Portalegre product. From then up to his death, many of Lurçat's tapestries were woven in Portalegre. Numerous Portuguese artists benefited from Lurçat's experience and the contact they had with him. We can say that it was largely due to Lurçat that Portalegre established connections with other artists and foreign customers."[4]

In 1969 or 1970, Gloria and Fino established a contract to make a woven rendition of Robert Goodnough's collage *Three Colors*, but this project was never realized. No reasons are revealed in the GFR Papers.

In 1971 Gloria contracted the Portalegre workshop to weave Youngerman's "*Blackout*." This first of a series was originally labeled 1/5, but she deemed the results unsatisfactory. To Archie Brennan at the Dovecot, where she'd recently begun working, Gloria wrote, "I will soon send to you a study and full-scale cartoon (an accurate line drawing) of a work of Jack Youngerman to be made into a tapestry 8' × 8', again to be no. 1 of 5. Confidentially (VERY confidentially) I had it made by Fino in Portugal and I'm afraid that I shall have to cross it off as a loss, and will have to scrap it. His wool . . . is low grade, short fibers, more like a textile wool and though I will hang it in my show, the purchaser will be told that it will be replaced. I have never sold anything that is not top quality and will not do it now. It is a hard edge painting, striking and again, very different from any of the others. . . . Will you do it?"[5]

Brennan agreed, and Gloria discontinued work in Portugal.[6] Her particular dissatisfaction is ironic given Fino's pride in his native Portuguese wool: "Wool is the noblest of all the fibres, even able to forgive bad handling in its transformation. It might even be said that there is no such things as good or bad quality, only good or bad uses to which it is put. . . ."[7]

Snapshots in the GFR archives also show that Gloria visited Gino Romali's studio in Madeira, but no specific work came from this visit.

Turkey

Through a mutual friend in 1972, Gloria met Zehra D. Bellibas Boccia, who had been a classmate of designer Jack Lenor Larsen at the Cranbrook Academy of Art. She and husband Thomas J. Boccia operated a gallery billed as "The Boccia Collection—Arts of Turkey" on 57th Street in Manhattan. They led Gloria to understand that they operated a weaving workshop in Turkey.

During 1973 and 1974, two Paul Jenkins tapestries (1/7 and 2/7) were woven in a Boccia workshop, but Gloria deemed the process and product unsatisfactory. She began to suspect that the Boccias had misrepresented their enterprise and claimed that they used her expertise to set up a new workshop in Turkey. Gloria had supplied the Boccias with information about warp and weft materials, dyes, techniques, costs, prices, and related details. "Above all," she wrote in retrospect, she brought them "the idea of making contemporary tapestry."

Gloria's requests to visit the Turkish workshop were repeatedly declined. In 1976, the Boccias refused to weave any further pieces and the Jenkins design was sent to the Pinton atelier in France, where the rest of the series was woven.

Flights of Fancy

After several years of exploring classical tapestry weave, Gloria opened up a new subject with Archie Brennan in 1972. "A thought that most intrigues me . . . concerns the possibility of making 'a painted tapestry.' Once you confirm that it is possible and practical, I will proceed to contact Miró (through someone here). If he does not wish to participate in the project, I would work with another artist. If a solid color tapestry were woven beautifully in Dovecot tradition, either plain or in a design developed with the artist, would it be possible for him to 'paint' or spray on it? Would the color hold? could it be cleaned? Perhaps a set of 4–6 could be woven identically for a Miró to paint, or different patterns could be woven. There are many possibilities. I envision an exhibition solely of these few tapestries.

" . . . I hope to talk to Jules Olitski about the carpeting he spray painted and inquire about their success and failure. Surely he enjoyed the freedom of design that I would like to be able to offer the artist working on weavings of this sort. If you feel the project would be total disaster, I steel myself for your reply. If you feel it might be worth a try on a small weaving, I could ask Helen to experiment with us. Maybe you are ready to take on a Miró. What?"[8]

Brennan responded after a few weeks. "Painted/Sprayed/Tapestries. I have no feelings in principle against this. I've always thought that there are 2 kinds of tapestries—good ones, bad ones and 'how' alone will never dictate this. I also have no knowledge on what happens on sprayed paint or dyeing. What we can do is a series of say 12" × 12" pieces in one and two colours and I think in wool and cotton. Perhaps the 2 colour in simple changes: [sketch of four squares with simple geometric patterns]? and probably not too contrasting colours so that any spraying/painting has the chance to affect both colours. I cannot see much point, however, in weaving an absolutely plain ground in tapestry for subsequent spraying/painting, when a simple cloth could be obtained from a power loom at much less cost."

Gloria added, "I will soon meet with a man in New York who is an authority on early Peruvian textiles and of course many of these were painted and they just might provide some clues."

The idea was dropped.

Mexico

In late 1972, Gloria began investigating possibilities in Mexico. She contacted the New York office of the Consejería Comercial de México. The commissioner of the Instituto Mexicano de Comercio Exterior (Mexican Foreign Trade Institute) sent her a list of ten weaving workshops, and she contacted all ten by mail.[9] She obtained price lists from Tejidos Artísticos in Mexico City, an article about weaver Pedro Preux of the National Fine Arts Institute (INBA) who had studied in Aubusson, a letter from artist Saul Borisov in Mexico City, and woven samples from Artes Populares de Tequis in San Miguel de Allende. Although she visited Mexico City during December 1972, no work emerged from these sundry explorations.

Belgium

In 1972, Gloria also contacted the Belgian consulate in New York and the Office Belge du Commerce Exterieur (Belgian Office of Foreign Trade) in Brussels, from which she obtained a list of four tapestry workshops.[10] She corresponded with the tapestry workshop of Gaspard De Wit near Brussels and visited some of the workshops during the fall of 1972. She left an image by Paul Jenkins with the Chaudoir studio, which provided two woven samples (labeled "échantillon point moyen" and "échantillon gros point"). A month later, Gloria sent a photograph of a Lindner poster to Mme. Chaudoir in Brussels through M. B. Gilsoul, another weaver who spoke English and lived in New York, writing, "I look forward to working with you a great deal. . . . Your work is beautiful." The Jenkins was never executed and the Lindner project was completed at the Picaud atelier in France during 1974. Despite her explorations, Gloria never worked in Belgium.

Sweden

After consulting Helena Hernmarck in New York, Gloria traveled to Sweden in November 1975.[11] She visited the Alice Lund Textilier AB in Borlänge, and obtained woven trials from the workshop. She also toured the Handarbetets Vänner in Stockholm. Although she maintained a friendship with Hernmarck, later visiting her SoHo studio, Gloria never looked to Sweden again.

The school and workshop of Handarbetets Vänner (Friends of Textile Art Association), Stockholm, Sweden, 1975

Sheila Hicks

Gloria and contemporary fiber artist Sheila Hicks were Manhattan neighbors and friends. Hicks had gained an international reputation for large-scale sculptural works and small-scale tapestries.[12] They traded textile notes via lively postcards. In 1979, Gloria mentioned the possibility of their working together, which they had evidently discussed before: "Your brief talk some months ago about our working together, comes to mind. Perhaps you are set, but if not, when you are next in N.Y.C., let's pursue it (& otherwise just a lunch or whatever, to visit together). I trust your Israeli work went well. How too bad it coincided with my recent trip—but perhaps some where some place too, we will be in an atelier together."

Hicks responded with hopes that they would continue following each other's projects and would eventually collaborate in some way. She noted, "I'm sure there are enriching exchanges awaiting us if we can only spell them out."[13]

While correspondence and visits remained more than cordial, no collaboration emerged.

Mollie Fletcher

In the summer of 1978, Mollie Fletcher wove "after *Big John's Special*" as a single and unique GFR Tapestry (plate 85). Daughter of Norman Fletcher, an architect originally with the Walter Gropius Group, Fletcher earned her BFA from the Rhode Island School of Design and an MFA from Cranbrook Academy of Art. In the seventies she studied with Swedish artist Helena Hernmarck, then living and working in Lower Manhattan.[14] Recommended by Hernmarck, who was occupied with her own artistic work and no longer taking such commissions,

Fletcher accepted Gloria's invitation to weave a tapestry from *Big John's Special,* a large painting by Clifford Ross, Gloria's youngest son.

Before weaving started, Gloria meticulously calculated a scaled-down size for the tapestry—from 93⅜ by 86⅛ inches, the size of the painting, to 78 by 71½ inches for the woven version. Fletcher apparently made samples, because notes indicate that they discussed making the "gel clearer—whiter . . . more distinct" and the "blue surface purer."[15] Both Gloria and Clifford visited Fletcher's studio to see the work in progress.

Over the course of eleven weeks, Fletcher wove the tapestry on a four-harness Swedish floor loom in her SoHo studio. She used a mix of wool, linen, rayon, and cotton fibers in a technique she called a "four harness twill inlay." Also known as the modified rosepath technique, this tapestry-like method based on a handpicked overshot weave was developed and made famous by Hernmarck for her own large commissioned works.[16]

Gloria and Fletcher apparently discussed a second project, because the weaver inquired, "Have you the Frankenthaler cartoon yet? I am anxious to see it." No further collaboration took place, as Gloria wrote, "At this period I am not planning work that is suited to your particular technique."

Meanwhile, the weaver had raised concerns about how the first tapestry was credited. "The catalogue from your show . . . has recently come to my attention; it is beautiful but it left me slightly puzzled. Nowhere in the catalogue did you give credit (even a footnote) to the weavers. One is left with the impression that you wove those tapestries.

"When you and I worked together last year, I greatly appreciated and enjoyed the creative rein that you extended to me, as well as the relationship that developed between you, Clifford, and myself. It was a very rewarding time for me. Because of all this, it never occurred to me that I would not be a part of the recognition that followed the tapestry's completion.

"The important thing that sets the work you commission apart from the other tapestries being produced today, is that you encourage the weavers to experiment with color and texture. It is *their* creative abilities that make the tapestries what they are. The Louis Nevelson maquettes are testament to this. Dovecot studios should be recognized as more than 'magic fingers'; they are a very talented group and should be given credit as such.

"That you are trying to extend the woven medium as you are is a very justifiable and commendable effort—but you will never get the quality and creative juice from the weavers unless you extend the same credit to them as you do to yourself. Best regards, Mollie."

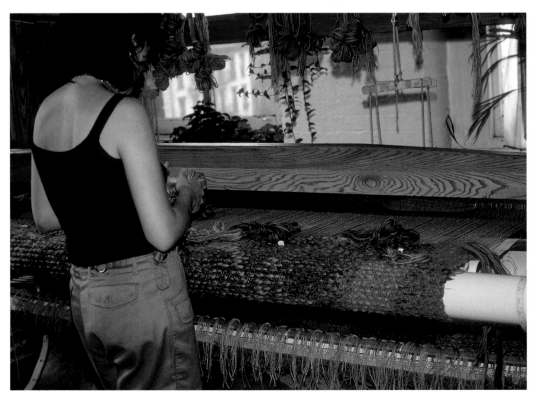

Mollie Fletcher working on Clifford Ross's "after *Big John's Special*" in her Manhattan studio, 1978

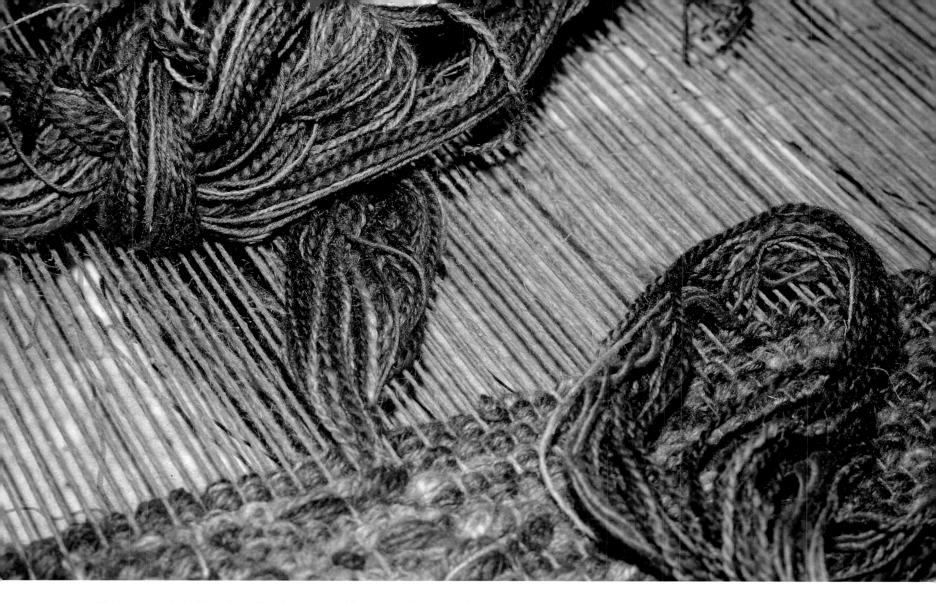

Gloria responded obliquely to Fletcher with examples of articles that explained her editorial role in the tapestry making process. She also highlighted her efforts to include the weaver in meetings with "important persons in the corporate world—as well as in publishing, arts and architecture—along with collectors." Missing the weaver's points almost entirely, she never directly addressed the omissions Fletcher had discerned, and the two did not work together again.

The Kennedy/Kunstadt Workshop

In 1981, inspired by Helena Hernmarck's successful commissions, weavers Janet L. Kennedy and Carole P. Kunstadt established a small tapestry-weaving workshop. From Kunstadt's Manhattan home on West End Avenue the two developed projects and marketed their original work. They rented a thousand square feet of studio space at 242 West 27th Street, behind architect Scott Bromley's office in the heart of New York's garment district.[17]

Janet Kennedy had worked as an apprentice and an assistant to Hernmarck in Ridgefield, Connecticut, between 1976 and 1981. She held a 1973 BA degree from the University of California, Berkeley, and had studied weaving at Parsons, Haystack, Brookfield Craft Center,

Fiberworks Center for Textile Arts, and the Fashion Institute of Technology. She had also roomed with weaver Mollie Fletcher for a time and had watched "after *Big John's Special*" grow on her friend's loom, so she was familiar with Gloria's work.

Fellow weaver Carole Kunstadt worked for Hernmarck from 1979 to 1981, starting as an apprentice and working up to an assistant's role. She began her training in two-dimensional design, graduating magna cum laude in 1973 with a BFA from the Hartford Art School in Connecticut and later studying at Akademie der Bildenden Künste in Munich.

Detail, Clifford Ross's "after *Big John's Special*" on loom, 1978. (See plate 85.)

Janet Kennedy in front of Frankenthaler's "after *This Day*," 1982. (See plate 26.)

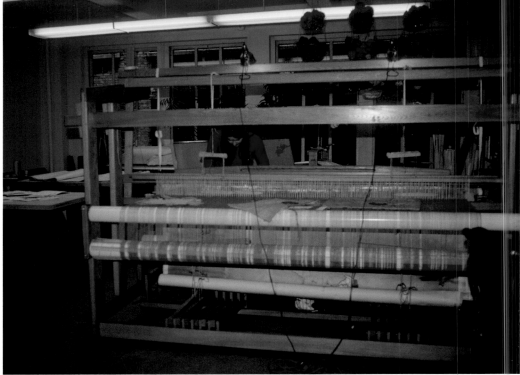

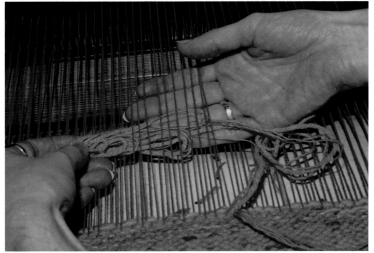

Frankenthaler's "after *This Day*" in process, Kennedy/Kunstadt workshop, New York, 1982. (See plate 26.)

Her design skills complemented Kennedy's technical expertise. She has described how, when she was an apprentice, the daily preparation of hundreds of blended yarn "butterflies" for Hernmarck's subtly shaded and woven palette instilled in her a sensitivity to color and texture. Another skill set gained from working with Hernmarck's large-scale projects came from participating in the complex development of a major art piece, from initial client contact through production, to the tapestry's final installation.[18]

In June 1981, Gloria contracted with the Kennedy/Kunstadt Workshop to "execute and weave" a Gloria F. Ross Tapestry based on an original painting, *This Day*, by Helen Frankenthaler (plate 26). For their first jointly contracted commission, the weavers met briefly with Helen Frankenthaler at her home in Westport, Connecticut—a "nerve-wracking" meeting because both earnest thirty year olds felt exceedingly shy in approaching the famous artist. In a 2008 interview, Kunstadt recalled, "We were both very excited about the project and Janet, while speaking about it during this

visit, actually responded with an obvious blush. . . . Helen appreciated this show of emotion, I recall. It was then that she decided that we would be right to create the woven interpretation of her work." Kunstadt modestly mused, "I'm not sure we understood [the scope of this work] but we accepted the challenge."

Once the project was under way the two weavers also met with the artist at her East Side studio in New York as shown in a series of snapshots. Years later Kunstadt had no memory of Gloria's presence or receiving instructions from her—the famous artist had overshadowed her sister.

The tapestry was created on an eight-foot-wide horizontal floor loom. To translate the highly textured painting into fiber, the partners employed custom-dyed linen, wool, cotton, and rayon yarns and a multi-harness weave based on Hernmarck's variation on the Swedish rosepath technique. Through a series of woven samples the weavers sought a perfect mixture of color and texture. Because Kunstadt was tending to her newborn son, project priorities shifted and Kennedy did the actual weaving. Kunstadt consulted on interpreting the design and recalled in 2008, "This was particularly challenging to work on a painting which was so fluid, abstract and painterly. At first, we thought, why couldn't *we* have picked the one to be woven? We had been doing mostly photorealism with Helena. We were both drawn to abstract work, but this was over the top." When the tapestry was shown at Rosa Esman Gallery in New York, the label stated, "A Gloria F. Ross Tapestry/ Woven by Janet Kennedy," as agreed upon by the partners.

Gloria was certainly proud of this innovative work, as she wrote to one dealer, "My newest work is a Frankenthaler woven by a superb weaver right here in New York. We really

developed a new technique for this recent image of Helen's, and really very much want you to see "after *This Day*," unique in all aspects of the word."[19]

To Kennedy she wrote, "When this is sold, as you know, I look forward to doing another tapestry together." They did not, however, seize that opportunity.

Return to the Middle East— "Le projet Arabe"

In July 1980, Gloria began to work with Wayne V. Andersen, MIT art historian and corporate arts consultant, and the Fine Arts Management division of his Vesti Corporation, headquartered in Boston.[20] The principal project involved fourteen tapestries for the King Abdulaziz International Airport in Jeddah, Saudi Arabia, the fourth largest airport in the world (after those at Hong Kong, Bangkok, and Seoul). Paintings by Hassan el Glaoui, Adel Saghir, Mahmoud Souid, Ahmed F. Salim, Issa Ikken, Rafif Rifai, Safia Binsagr, Abdul Halim Radwi, Nabil Nahas [classmate of Clifford Ross's at Yale], and Ahmed Moustafa, among others, were to be translated into tapestry.

With Jean Pierre Larochette in Berkeley, California, Gloria explored the execution of a cartoon for a large Ahmed Moustafa design. Best known of the artists, Egyptian-born Moustafa is director of the Research Centre for Arab Art and Design in London and distinguished for his calligraphic studies and art that includes intricate tapestry designs.

Because, as she explained, "the company has requested that I work with several different ateliers," Gloria discussed the weaving of some tapestries in 1980 with Yvette Cauquil-Prince and with the Pinton atelier in France. She approached Dovecot in Scotland about doing several works, but mysteriously wrote regarding one, "Moustafa—*Don't* show to *Dovecot.*" Her initial descriptions and plans reveal Gloria's creative zeal: "(Ms.) Safeya Binzagi [Safia Binsagr]—2 sketches of Jeddah. Can play w/ texture, not color—but can be more off white—probably heavier weave on simpler one to strengthen feel of design and color Redui [Abdul Halim Radwi]—painting of Jeddah—warm—heavy wooly weave." She wrote to the weaving workshop, "I suggest use of metallic threads in some of these to promote a required opulence."

In February 1981, Olivier Pinton and the Vesti Corporation signed a contract for eight of the fourteen tapestries by Middle Eastern artists (none by Moustafa). Gloria was informally designated as an artistic consultant (*conseiller artistique des tissages*). Several months of delays were accompanied by tense correspondence in which, for instance, Pinton wrote to Gloria of his hopes "*de faire cesser ces ambiguités*" with Vesti. An "explosive telephone call" and an apologetic letter between

Anderson and Gloria led to the admission that the situation had "proved unfortunate for both of us," as Anderson put it. He maintained that Gloria was to have consulted directly with Vesti, rather than serving as an ally to Pinton as subcontractor. In her defense, she described at great length her role and activities to Andersen: "I traveled to Boston several times, to Paris and to Aubusson, first setting the tone for the overall Jeddah project, relating one tapestry to another, to the use of the room in which each was to hang, to the quality that you initially said you wanted for the project. You acknowledged at my very first presentation that it gave Vesti a totally new and proper direction in regard to tapestry, as opposed to what had heretofore been provided by others whom you had approached. You received information then and subsequently, that will help you in all your future work in this field. In addition, I introduced you to my weaver, Pinton, with whom you made separate arrangements for the production of the tapestries, utilizing my preparatory work, but eliminating me as the 'conseiller artistique.' (I note here that at my suggestion you commissioned Edward Fields Inc. to do the work in a Saudi Arabian mosque; and many Fields carpets have been delivered to you for possible purchase, for use on walls or floors.) I applied my experience and expertise to the overall concept, and to each individual image, on the mode of translation, the weaving technique, size and proportion, the weight, materials and colors, etc. and the image in terms of what I felt would translate successfully into tapestry. I was ready willing and available to proceed with the project for eleven tapestries, evaluating trials, etc., but you eliminated my role as consultant."

Gloria's verbal agreement with Vesti was canceled. After a volley of attorneys' letters, Vesti offered a development fee to Gloria for her efforts.

Only five of the planned tapestries were completed. Gloria's role was minimized by Vesti—"you did not even see, let alone exercise supervision over, the tapestries we produced, at Pinton and elsewhere." Gloria commented about the five in a drafted paragraph never sent: "Considering purely the aesthetics of the project I am disappointed that, judging from what I have heard, that the concept and quality of the hangings falls far short of what you and I first conceived and what I could have developed for Jeddah."

Spain

In 1982, Gloria sought out the renowned artist and weaver Josep Royo, represented by Francisco Farreras, director of Galleria Maeght in Barcelona, Spain. They signed a contract for Royo to weave a twenty-eight by twenty-three-foot tapestry designed by Helen Frankenthaler, commissioned by a

Florida bank. Royo followed with a postcard: "Tarragona/En espera de noticias para poder empezar a trabajar lo mas rápido posible en la obra de Helen./Reciba un abrazo/Royo,"[21] which made the project seem imminent. However, a Frankenthaler/Royo tapestry was never realized.

Victorian Tapestry Workshop, Melbourne, Australia

Established in 1976, the Victorian Tapestry Workshop (VTW) represents many stellar achievements, accomplished in a relatively short time. Initially working with Archie Brennan as consultant, founding director Sue Walker brought together a team of weavers who were cross-trained as artists and who worked closely with carefully selected designer-artists in residence. Their innovative collaborations have resulted in major international commissions that support continued operations and public programs. Widely varied in artistic conception and in weaverly interpretation, VTW tapestries range from modern European-influenced styles to historical Australian motifs and exceptional aboriginal imagery.[22]

The 1988 International Tapestry Symposium in Melbourne, yet another organizational achievement of the VTW, brought together weavers and scholars from all parts of the world. In preparation for the meetings, Gloria and Sue Walker began a lively correspondence. Gloria proposed to orchestrate a small tapestry designed by Paul Jenkins and woven at the workshop for the World Weavers' Wall. This installation of small "personal" tapestries from around the world was curated by Sue Trytell and held at Gryphon Gallery, Melbourne College of Advanced Education in May 1988.

In the spirit of experimentation with small works, Walker suggested that three different VTW weavers might produce three interpretations of the same maquette. Gloria preferred to have them realized as a trio of identical works. Ultimately, three identical pieces, each twenty centimeters square, were woven from Jenkins's painted model—the original plus one for the artist and one for Gloria. Woven by Joy Smith at the workshop, the GFR Tapestry joined 255 others on the wall, described by curator Sue Trytell as showing "a palette of thousands of colours, designs and interpretation of ideas, lives and dreams across the world."[23]

After attending the conference in Melbourne, Gloria traveled to Canberra where she toured the Parliament House and viewed VTW's enormous tapestry designed by Arthur Boyd—"its magnificence in concept, structure, and detail is difficult to describe." She lunched with the building's architects Romaldo (Aldo) Giurgola and Rollin LaFrance, both with the firm of Mitchell/Giurgola & Thorp. After visiting Cairns and the Great Barrier Reef, she returned to New York via Honolulu, where she took in a lecture by Archie Brennan.

When she spoke at the tapestry conference, Gloria drew commonalities between America and Australia: "Whereas in Europe and Asia

A tapestry designed by Christopher Pyett and woven by Sue Batten, Peta Fleming, and Rebecca Mounton, Victorian Tapestry Workshop, Melbourne, 2004. Photo by the author.

Daisy Andrew's painting, *Lumpu Lumpu Country,* with a nearly completed tapestry by Irja West and Louise King, Victorian Tapestry Workshop, Melbourne, 2004. Photo by the author.

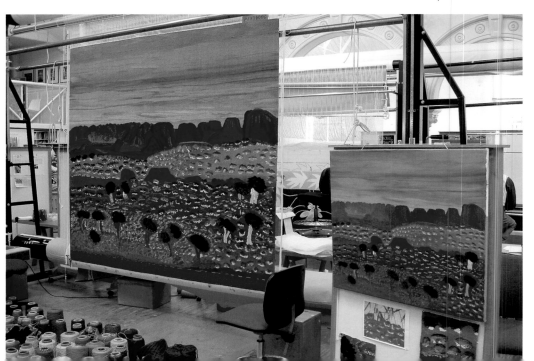

Paul Jenkins, maquette for "*Tapestry of Sounds*," 1988, watercolor on paper, 8 × 8 in. GFR Papers; © Paul Jenkins/Licensed by ADAGP. Photo by Jannelle Weakly, ASM.

Paul Jenkins, "*Tapestry of Sounds*," 1988, woven by Joy Smith, Victorian Tapestry Workshop, wool and cotton, 7.5 × 8 in. GFR Papers; © Estate of Gloria F. Ross. Photo by Jannelle Weakly, ASM.

there is now a renaissance of tapestry, America and Australia have only a meager history of tapestry per se. Although we Americans and Australians are familiar with the term and recognize a tapestry when it hangs on the wall, the vast majority do not really know what it is."

Gloria originally wrote Walker about bringing several maquettes to discuss with the VTW staff, but her plans changed, likely due to the death of her husband just before the trip. In any case, no GFR Tapestries besides that designed by Jenkins were made at VTW.

Gloria and Sue Walker also discussed and corresponded about the New York éditeur "representing the Workshop on working with US artists and/or clients." Specifically she suggested that Helen Frankenthaler might meet with VTW's director in Melbourne. Not all well-intentioned prospects panned out, this being among them.

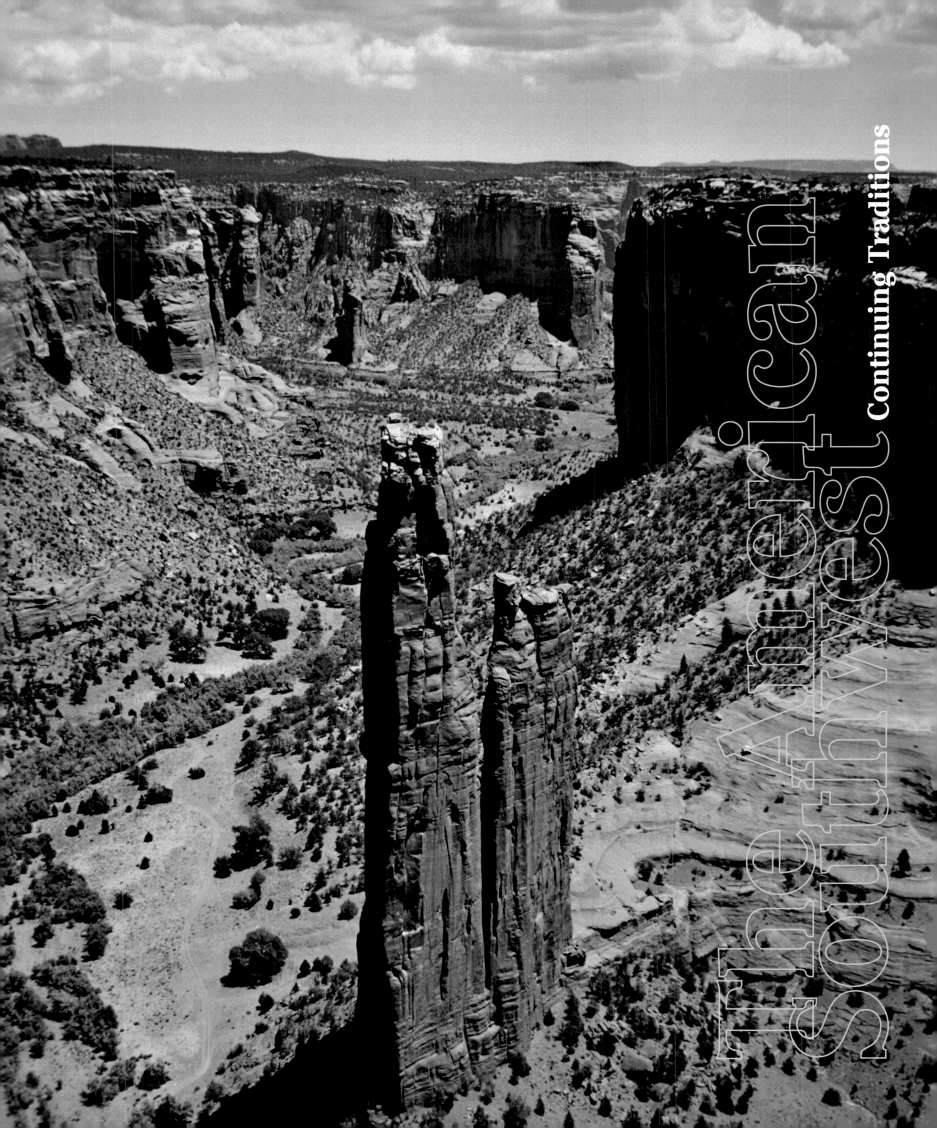

The American Southwest

Continuing Traditions

I had always admired Navajo weavings, but I knew little about the weavers and their culture. How to approach them?

—Gloria F. Ross[1]

I have never before been so intimately involved in the processes that go on before the actual weaving. To be able to select the fleece itself for a Noland tapestry was exciting.

—Gloria F. Ross[2]

These tapestries achieve dual recognition. They are very Noland and very Navajo. They represent the truest collaboration I've ever brought about.

—Gloria F. Ross[3]

In 1979, Gloria began working with Native American weavers, creating tapestries based on Kenneth Noland's geometric paintings. Noland was the first artist beyond Gloria's extended family to work with her; he was also one of the last artists who collaborated with her. Ultimately, nineteen unique tapestries incorporating Noland's chevrons, stripes, and targets were woven by five Navajo Indian weavers. An additional six tapestries were created by Ramona Sakiestewa, a Santa Fe artist whose Pueblo Indian heritage informs and flavors her work.

For this series, unlike others, Gloria first targeted the weavers and then settled on the artist. "With all of this work [previously done in New York, Scotland, and France], I realized that some of the world's greatest weavers were nearby. I had always admired Navajo weavings, but I knew little about the weavers and their culture. How to approach them? I couldn't just get into a car and drive off. After I did extensive research from my NY base, my contacts figuratively and literally led me down many different roads." Eventually her search connected the two of us: "I went to the Reservation where on my first trip I met the anthropologist Dr. Ann Lane Hedlund."[4]

Selecting Noland

Gloria considered Noland's geometric imagery to be "simpatico" with native southwestern weaving. His emphasis on symmetry and fascination with centering made a good match with both Navajo and Pueblo design traditions. The artist's abstractions fit the weavers' geometric sensibilities. Both Noland and Navajos saw complex process-oriented meanings in their work rather than simplistic symbolic interpretations.

Noland's tapestry maquettes are very different from his earlier highly complex palette—the "fauve" colors of his most famous paintings.[5] His work for Native American weavers uses relatively mild primary hues that relate to historic native and imported dyes and to natural wool colors. However, as the artist pointed out, his work is "also about scales and juxtapositions."[6] For generations, Navajo weavers have explored scale in the sophisticated balance of their geometric motifs. They have played with abstract optical qualities, just as Noland did. In the Native/Noland series, spanning almost two decades, the artist and weavers further expanded these principles.

Kenneth Noland and assistants in his Connecticut studio, 1990. Photo by Gloria F. Ross.

Detail, Kenneth Noland, "*Hawkeye*," 1984, woven by Mary Lee Begay. (See plate 65.)

Examining a maquette for Noland's target, "*Time's Arrow*," 1990

Apart from his own work, Noland was familiar with traditional Navajo proportions and color schemes. Before working with Gloria on her American Southwest project, he had already acquired a number of historic Navajo wearing blankets from the nineteenth century through fellow painter and dealer Tony Berlant. Noland's admiration of classic Native weaving and the weavers' lives influenced his decision to join this venture.

The artist's way of working was also well suited to tapestry collaboration. One of the major monographs on Noland has described his working "in series as regards both format and color; within a single format he often explores one group of related hues and then moves to another. A change occurs when he finds himself acting uncreatively, as it were, failing to surprise himself with color."[7] Even his studio practices suggested openness to collaboration. "Noland sometimes used assistants actually to paint some of the bands. . . All of the inspiration, all of the feeling and invention were concentrated in Noland's color choices. . . . Assistants . . . permitted him to work more quickly, more prolifically, and on several pictures at once."[8]

Throughout his career, Noland focused on "art as problem solving, the direct handling of

materials, . . . and the emphasis on color . . . not theoretically but in terms of intuitive feeling for relationships." His attitude toward painting has been described as "experimental and workmanlike" and "remarkably searching, open, and unprecious."[9] All these proclivities made this artist a perfect partner who would provide Gloria at regular intervals with maquettes for translation into wool.

Traveling West

Gloria found her way west through contacts at the Denver Art Museum.[10] Chairman of the Board Frederick Mayer and his wife, Jan, owned several GFR Tapestries. Mayer suggested that Gloria might contact Richard Conn, curator of native arts, and Imelda deGraw, curator of textiles and costumes. They put her in touch with assistant curator David Irving, who knew I was doing field research in Navajo country at the time.

While working at the Navajo Nation Museum in Window Rock, Arizona, in July 1979, I recorded in my field notes, "Mrs. Gloria Ross called this a.m. re: a NYC tapestry firm she runs. Is interested in Navajo weavers commissioned to weave her U.S.A. artists' designs/ plans. Kenneth Noland has done 2 striped paintings to be done. Dave Irving [then a curator at the Denver Art Museum] gave her my name. Glenmae [Tsosie, an elder weaver] would have been perfect!! Suggested she talk to Kent Bush [National Park Service curator at Hubbell Trading Post]. Russ [Hartman, Navajo Nation Museum curator] says maybe a chapter level project somewhere would work. [The community of] Gap might be an interesting place to start?"

In August, I briefly noted, "Picked up 2 Kenneth Noland paintings—protos for Navajo weavers for Gloria Ross."[11] Later, I elaborated, "I will never forget picking up a modestly wrapped package at the Greyhound bus

Views of Navajo country. Gloria traveled many back roads to visit the Native American weavers who worked with her.

Opposite, Spider Woman Rock, Canyon de Chelly, Arizona, 2002. This spire was named for the legendary originator of weaving among the Navajo people.

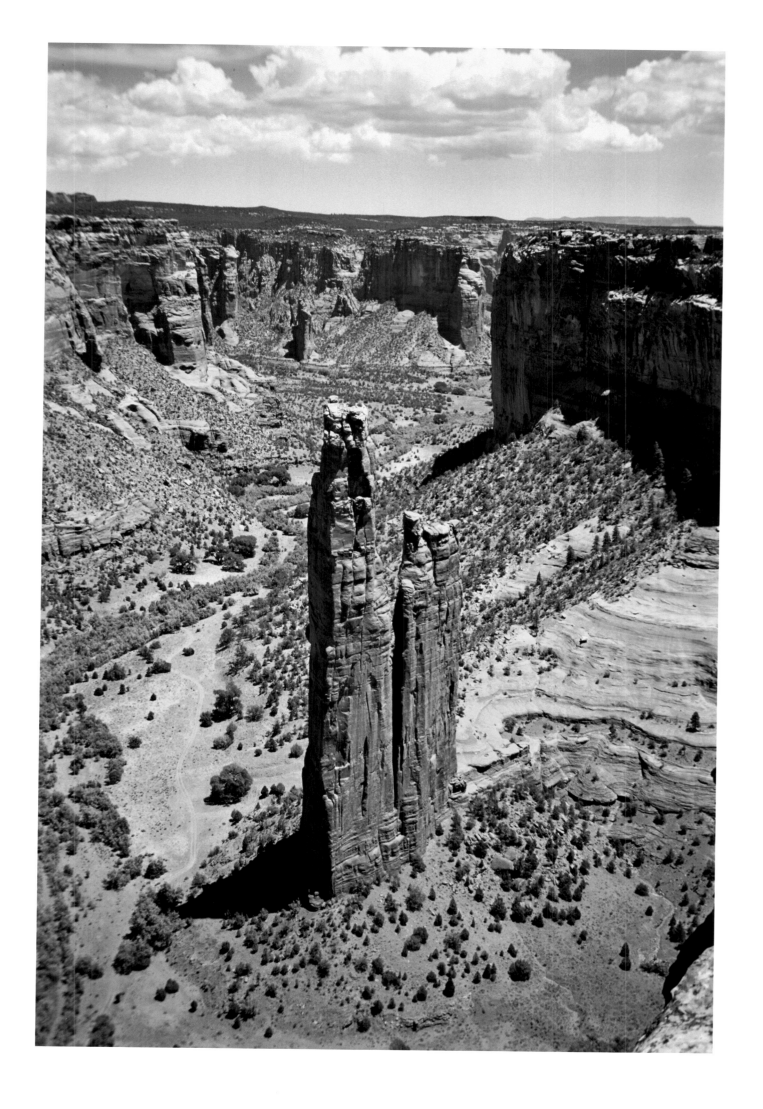

Sarah Natani's flock of sheep,
Table Mesa, New Mexico, 1980

Gloria visiting with Audrey Wilson, Indian
Wells, Arizona, 1981

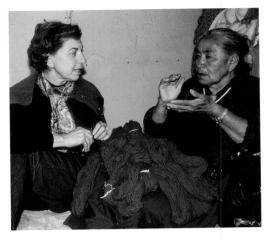

station in Gallup, New Mexico, and unpacking Noland's two gemlike artworks—one was handmade, tinted paper, the other a painting in acrylic."[12] I propped them on a makeshift mantle in my short-term rented flat.

Our suspenseful first meeting is recorded in the preface to this book. On her first trip, I took Gloria to the Hubbell Trading Post in Ganado, Arizona, where she talked with manager Al Grieve about prospects for working together. We also stopped at the Wide Ruins Trading Post, plus several other stores, and traveled to Santa Fe, where she toured local museums and galleries, getting an eyeful of the southwestern Indian arts and crafts boom then well under way. Gloria later recalled that I guided her "to some of the Reservation's leading artisans, and gently introduced me to their culture and their weaving, an integral part of it."

Gloria came west again in April 1980 to travel with me in Navajo country for a week, to talk to weavers, deliver several more Noland images to the Hubbell Trading Post, and attend Noel Bennett's first Shared Horizons symposium on southwestern textile traditions at the

Wheelwright Museum in Santa Fe. I took her to several weavers' homes in the Ganado area. We met retiring trader Don Jensen at the creaky old Crystal Trading Post (soon to go out of business, as many posts were doing at the time), and also visited the communities of Two Grey Hills and Farmington in New Mexico and Durango in Colorado.

That same year, she returned in August for Santa Fe's annual Indian Market and again in September, when, in addition to visiting weavers in Ganado and other communities, we traveled through the Hopi Mesas of northern Arizona.[13]

From then until 1994, Gloria traveled to the Southwest at least once each year and sometimes two or three times. Each visit added new friends and business relationships to her already broad network. Later she would recall, "I have never before been so intimately involved in the processes that go on before the actual weaving. To be able to select the fleece itself for a Noland tapestry was exciting."[14]

On her final western trip, she brought Nick Buehrens, the young son of her stepdaughter Ann Bookman, to show him "her" Southwest. Two years later, more than twenty Navajo weavers and family members visited New York City to see Gloria and celebrate their own rugs in her collection, which was on display in the National Museum of the American Indian (NMAI) at the U.S. Custom House.[15]

Tools and Techniques

As in Scotland and France, Gloria worked directly with weavers in their own settings. On her southwestern travels, she visited weavers at their homes, in their weaving sheds, at trading posts, and in galleries. She encountered weavers who were willing to incorporate outside imagery into their work while remaining true to their traditional techniques and processes.

Models provided by Noland ranged from extant formal paintings to colored pencil sketches on graph paper. For certain designs, in addition to drawing from his well-known repertoire of geometric forms, Noland also explored classic Navajo motifs and layouts, including the bold chief-style blankets. Through Gloria's stories and his own 1981 visit to the Southwest, the artist learned that Navajo weaver Rose Owens made circular rugs within a metal frame on her vertical loom. For two projects, he returned to his famous target patterns on shaped canvases.

Native American weavers have not traditionally used drawings or other representations to guide their woven designs, preferring instead to weave directly from their imaginations. However, a growing number of weavers in the late twentieth century did indeed use drawn imagery, either their own or from someone else.[16] Working from Noland's small paintings and sketches presented no major obstacles to native weavers. As one writer recorded, "'They are geniuses,' Ross said, citing an example: Normally, Ross takes an artist's small painting and enlarges it to the desired scale for the weaver. But, 'with many of the Navajo weavers, it's in their soul—without even measuring, they translated it to the larger scale.'"[17]

Navajo weavers use a generations-old style of freestanding vertical loom and homemade hand tools. (In contrast, Hopi artist Ramona Sakiestewa employs horizontal floor looms in her Santa Fe studio, rather than the native upright loom.) The weaver mounts the foundation threads (warps) on her loom, sets up the heddle devices, and weaves the cloth by hand, using a hand-carved wooden batten and weaving comb. Navajos use traditional tapestry weave, a weft-faced plain weave with discontinuous weft patterning, and employ traditional twined selvages on all four edges of each fabric, with knotted cords on each corner.

A range of wool yarns, handspun and mill-spun, appear in the Native/Noland tapestries. Some weavers used the natural sheep colors in the style of the Two Grey Hills community, others the vegetal-dyed colors of Crystal and Wide Ruins regional styles or the deep aniline-dyed reds of the Ganado area. In short, these GFR Tapestries, though set apart by Noland's distinctive designs, resemble, in relative weight, size, texture, and technique, rugs made with the weavers' own designs.

The Navajo "Rugs"

Any handwoven Navajo textile is ordinarily termed a *rug* in English by bilingual Navajo weavers today, whether destined for use as a floor covering, wall hanging, bed blanket, truck-seat cover, or tabletop coaster. Gloria called these textiles *tapestries*. The term was perfectly appropriate in the textile world, but among Navajo weavers and Southwest textile aficionados, *tapestry* has a specialized regional meaning of very fine weaving with over ninety weft threads per inch. The Navajo weavers usually just called the GFR works *Gloria's rugs*.

Martha Terry of Wide Ruins

Martha Terry (b. circa 1958) wove "*Painted Desert*," the first Native/Noland tapestry, at Hubbell Trading Post under the direction of manager Al Grieve in 1979 (plate 59). The original maquette was delicate handmade paper, with four broad rough-edged bands of earth tones separated by narrow white bands. This initial model represented one of Noland's newest directions. It also suited Terry perfectly, as her home community of Wide Ruins, Arizona, is known for a regional rug style with vegetal-dyed colors and borderless banded patterns.

Starting in 1976, Noland had initiated a series of handmade paperworks. A catalogue from the time described his turn to this new medium. "For an artist disenchanted with the impersonal nature of conventional printmaking, the making of paper by hand is very appealing. Papermaking demands total involvement and is rewarded by a completely unique, one-of-a-kind image which clearly reflects the processes of its creation. It is an especially appropriate venture for Noland who approaches his art as a series of discoveries, as continuous experimentation with materials and procedures. It is also very much in keeping with his concern to make the appearance of a picture 'be the result of the process of making it . . . be the result of real handling.'"[18]

A further shift was also noted. "In the *Horizontal Stripes* . . . the artist has been most daring in succumbing to softness. By this I mean he has permitted large areas of uneven texture and brushed-on, mottled color in the

Kenneth Noland, Maquette (PC-110) for "*Painted Desert*," 1979, handmade paper, 18 × 23 in. © Estate of Kenneth Noland/Licensed by VAGA, New York. (See plate 59.)

Al Grieve, Hubbell Trading Post manager, and weaver Martha Terry with Noland artwork, 1981

central bands to suggest an open expanse of indeterminate space. But this expansive spaciousness which conveys a wonderful sensation of openness and amplitude, in turn, is balanced and controlled, brought back to the surface by the brighter or lighter and more uniformly colored, narrow bands placed near the top and bottom edges of the larger bands."[19]

Although original in medium, the wide horizontal bands of color hark back to works such as *Slow Plane*, a 1967 acrylic on canvas.[20] Subsequent maquettes often included motifs familiar from Noland's earlier paintings, but each was made specifically for one of the weavers selected by Gloria.

Having begun weaving in the summer, Terry phoned Gloria in October 1979 to discuss the white edging cords that she was using. During another call about naming the piece, Gloria took notes: "Colors rep[resent] sunset, early morning, father night [sky], mother earth. Colors are entwined w/ prayers—traditions. Colors are like a prayer. Father-in-law, father & grandfather said to name it by colors, etc.— approp[riate]. She'll send names for title." Once the tapestry was finished, the post manager wrote, "Martha Terry named the rug 'painted desert.' I think that name fits the rug since many of the colors in the painted desert match that of the rug." This tapestry was sold at a Christie's East auction in 1995.

Although Gloria did not work again with Martha Terry, the weaver apparently had hoped for more work when she wrote to Gloria in February 1980.

"Dear Gloria, Here's some wool that you wanted, these are just a small sample of some colors that can be colored by vegetables. Remember now, that they never come out the same color if you should run out while

weaving. We make enough or maybe more to do a whole rug without running out. Mom was happy to help out with some colors that she had. Thanks for letting me weave your rug. It was a pleasure working with you. Bye, Love, Martha Terry."[21]

Mary Lee Begay of Ganado Mesa

Mary Lee Begay (b. 1941; now known as Mary Henderson Begay) began demonstrating weaving at Hubbell Trading Post in 1971. Her mother, the famed weaver Grace Henderson Nez, preceded her there.[22] Both established longstanding careers, weaving both at the post and at their homes behind Ganado Mesa. Begay's work ranged from elegantly simple versions of early classic blankets to large modern rugs with complex Ganado Red designs. Beginning her work with Gloria Ross in 1979, she continued to weave Noland imagery until 1996, making eleven tapestries in all—nine chevrons and two banded designs.

Begay wove "*Rainbow's Blanket*" in the Visitors Center at the trading post in full view of the touring public (plate 60). Completed in January 1980, this tapestry required sixty-eight days for spinning eight and a half pounds of pre-cleaned, carded wool; dyeing the yarn; and weaving and finishing the piece.[23] Manager Al Grieve's report to Gloria sounds like something out of trader J. L. Hubbell's nineteenth-century journals. "It took Mary Lee quite a number of times to get the exact color to match the painting. I know you'll be very pleased with the rug. It has an exceptional good weave, very straight edges and great colors."

The primary colors of this second Native/ Noland tapestry contrast with "*Painted Desert*," although both pieces relate to Noland's well-known horizontally striped pictures. A collector of traditional Navajo blankets, Noland

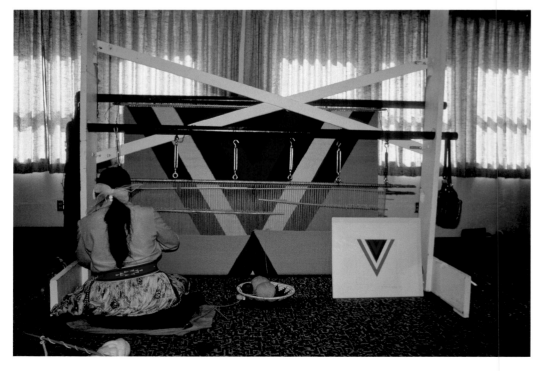

Mary Lee Begay working on "*Nizhoni Peak*," Hubbell Trading Post, Ganado, 1980. Begay chose to weave the image upside-down, with the chevron pointing up. The properly oriented design appearing at the back is the already-woven portion, which wraps around the loom's lower beam and rises to its upper beam.

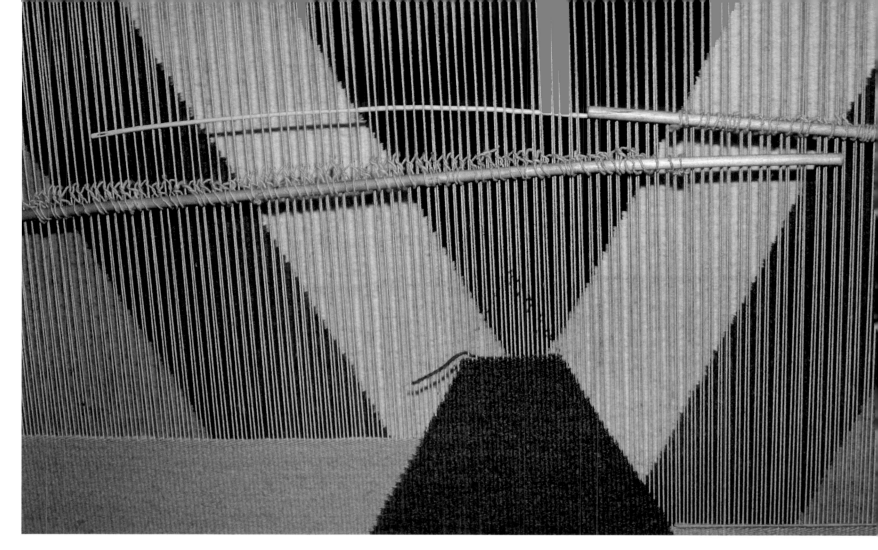

Detail, "*Nizhoni Peak*" on loom, 1980. (See plate 61.)

was familiar with Navajo designs and sensitive to the distinct historical color palette, which included indigo blue and reds originally derived from ancient insect dyes of cochineal and lac, and with slight touches of yellow and green from plant dyes.

Back at home, Gloria pored through stacks of books from the New York Public Library on Navajo culture and craft. To start the New Year and a new series, she wrote eagerly and at great length to Noland in January 1980.

"A few thoughts as you think Navajo under the Florida sun. I remind you that the huge Navajo nation encompasses many [communities] scattered over Arizona and New Mexico in which use of color and quality of weaving vary. Their common bond is their exquisite technique which cannot be matched or copied. It is in their soul; it is their religion; it reflects all their thinking. As you know the images are primarily geometric and if not symmetrical, always balanced (a reflection of the order in their lives). It is best (for now anyway) to avoid round images, because of circular symbolism in Navajo lore."[24]

She continued, "Now that we have one successful weaving in hand (the other one is due for completion within the week) I anticipate developing a series perhaps of 10–12 hangings which I hope will evoke responses similar to this one: It's a Noland—but it's a Navajo!? I want our audience to feel this dual

recognition. Ken, save all sketches you make, for even if we do not select a particular image now, we may do so at a later time. Needless to say, I am fascinated and optimistic about this project; and I so much appreciate and enjoy your mutual interest in it—the time, energy and talent you are putting into it. But I think you know that already."

She added, "A few specifics: I am uncertain as to how you are proceeding, but I envision several 'groups' of maquettes or studies for the tapestries which might be rectangular or square (there's one lone weaver, described to me as 'ornery,' who weaves round rugs. They are 28–32" in diameter, the size of a wagon wheel, this being the frame for the loom. When I'm out West in April, locating her and wooing her to work with us, will be one of my projects. The few she makes are collector's items. Each group will consist of maquettes suitable for weaving at a specific area."

She elaborated, "A. First of all, enjoy using these colors with great abandon in any combination. The dark green reminds me of the early Noland/GFR chevron tapestry. Beautiful color. The women who will weave this group of tapestries are used to looms no more than 5' wide so the first few anyway, will have a maximum of 5' square; or of rectangular the longest side will have a maximum of 5'. We agreed that the maquettes will be small but to scale. You might enjoy thinking in terms of a diptych

Al Grieve and Gloria with Sadie Curtis and Mary Lee Begay preparing wool, Hubbell Trading Post, Ganado, 1981

Gloria calculating proportions from two maquettes for "*Silent Adios II*," Hubbell Trading Post, Ganado, 1980

tapestry. They also established a temporary naming scheme for his growing collection of maquettes, following the letters first of his name and then her initials, ignoring any repeated letters. Thus the first maquettes he created were dubbed *K, E, N, T, H, O, L, A, D, G, R, I, F.* They were not necessarily woven in this order, as weavers received images at different times.

The maquette *K* was a set of concentric chevrons painted on white paper, for which Noland turned to a Ganado regional color scheme—a deep red with natural white, gray, brown, and black. Approximately twelve inches square, *K* became "*Nizhoni Peak*," fifty-two by eighty inches, woven by Mary Lee Begay in July 1980 (plate 61). Store-bought RIT dyes were applied to commercially cleaned and carded wool that Begay spun on a long Navajo-style wooden hand spindle.

Weaving this first chevron offered a new challenge. Noland intended his chevrons to be viewed pointing down, opening to the top. Begay wove hers pointing up, as the tapestry joins were technically easier to execute. When naming the piece, Begay consequently saw the design as a peak rather than a valley. She wove all but one chevron tapestry in this manner. Ironically, as the fabric looped under the loom's lower bar and appeared from the back, the image was rectified. This tapestry sold to the New York/New Jersey Port Authority art collection in 1981.

Gloria continued to guide Noland in the design process. In March 1980, she wrote, "Last month you sketched images like these, wondering if the Navajos would/could weave them. I have enquired and yes, you can develop maquettes similar to these, as well as stripes, chevrons—as you wish. . . . Some in the natural wool colors (to be done by a Two Grey Hills weaver—finest of Navajo weavers): white, grey, brown, black—similar to those in my Navajo rug which you have. Some in traditional Ganado colors: grey, white, black and the traditional Ganado red (marked in this

or triptych, where we *could* sell them individually or as part of a set; or solely as a set??????

"B. The same applies to the size limitations in this group i.e. those to be woven in the Two Grey Hills area, where the very finest of all Navajo weavers live. This is where my Navajo/Navajo—as opposed to a Noland/Navajo—was woven, the one you have now. Here only, are sheep bred with that very special brown wool, as well as sheep with grey, black or white wool, which can be mixed. A very fine wool is spun by the weaver herself and because of the extraordinary length of time and the genius required to complete a tapestry, these are the most costly. This group, like most, has never worked with outsiders so I suggest that some of your maquettes in this group be relatively simple designs—with which I can introduce myself. Although it is for sale, the first is experimental. Again, I assume that while you develop images for these natural, undyed wools, that you will develop varied ones, and when you return we can select those to be woven first.

"C. Typical Ganado colors are white, black, grey and Ganado Red (I have labeled this red) and if that Navajo spirit so moves you, wouldn't it be loverly to have a Noland/Ganado in this color combination. These tapestries can be larger than the A. & B. groups.

". . . Fun. Yes?" She concludes, "Best to you."[25]

Gloria and Noland signed a contract in March 1980 for the painter to deliver up to ten original maquettes to be translated into woven

Mary Lee Begay, 1981.

batch of color samples* more recently received). Some in the wonderful colors of wool samples I sent to you some time ago. *Should you wish to use a combination of any of these colors in a maquette, that is fine too. Be sure to keep this batch of colors separate from the other. Weavers in one area use these, while weavers in another area use the other colors. You will have all this clear in your mind once you have been to 'my' reservation!"

Gloria called Noland in April, and he indicated that two gray chevrons, one Ganado chevron, another chevron, and three gray striped designs would be ready for her. The project was truly on its way.

Noland designed the fourth tapestry in all natural sheep's-wool colors, responding to fiber samples that Gloria shared with him. The chevron "*Twilight*," from maquette *N,* was completed by Mary Lee Begay on September 15, 1980 (plate 62). According to trader Grieve, the black was dark wool re-dyed black, and the darker background gray (brown) was also over-dyed to provide more contrast; otherwise, the colors were said to be natural.[26] This was also sold to the Port Authority in 1981.

Toward the end of 1980, Gloria felt increasingly comfortable with the Navajo/Noland project. To a Boston art dealer she wrote, "I have just opened my new Navajo/Noland and I am satisfied that I really know how to work with them now." In a letter to another colleague, she joked possessively, "Before I depart tomorrow for 'my' Navajo weavers . . ."

In early 1981, Mary Lee Begay created a striped rug from Noland's maquette *D,* woven at Hubbell Trading Post under the supervision of Al Grieve. Trying to head off problems and maintain control even at long distance, Gloria wrote to the post manager. "Some of the questions we should discuss on the telephone are: estimates of cost and time; how heavy the weaving will be; color of the binding, etc. The white, I think, should just be a natural white, which I believe you used in all previous weavings. It may not be quite as white as the

one in the canvas strip, but I think the natural white is preferable. I do want to discuss too, the very slight but important difference in the true black between the green horizontal stripes, and the bluish black at the very top. Of course there is no problem about the true blue in the very wide stripe between the green and the yellow."

That blue, in the end, appeared in the tapestry as purple and was deemed unacceptable. Originally dubbed "*Silent Adios II*" by Noland, the completed tapestry was rejected by Gloria. "The problems of the weaving made at Hubbell," she explained to the weaver's brother, who happened to be an attorney working for the Navajo Nation, "were that the colors were not right and one of the wide bands was not as wide as it should have been."

Noland and Gloria gave permission for the piece to be sold at Hubbell Trading Post without their names attached. Ironically, it took first prize for the most original design at a regional art fair. The tapestry was almost immediately purchased by Chicago collector Robert Vogele, who has reported, "I was intrigued by the rug as a visual object—a wonderful contemporary painting."[27]

During the weaving process, Begay expressed interest in weaving other commissions more directly with Gloria: "When I finish weaving this rug, I'll be glad to make another one, any size, large or small. This I can do at Hubbell or in my own home."

Meanwhile, following a store scandal, Hubbell Trading Post hired a new manager, Bill Malone, who decided that after the rejected *D,* he didn't want to accept private commissions at Hubbell. Despite this break, Malone and Gloria maintained a cordial relationship for several decades.

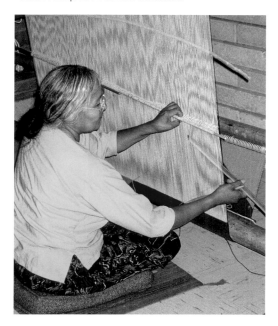

Mary Lee Begay working on "*Silent Adios II*," Ganado, 1981

Fifteen years later, Begay weaving "*Arizona Sky*," Ganado Mesa, 1996

"*Arizona Sky*" on Mary Lee Begay's loom at home, Ganado Mesa, 1996. (See plate 70.)

Wanting me to confirm her understanding of cultural customs, Gloria reported to me, "At Billy Malone's request I returned Mary Lee's last weaving. Both he and Mary Lee acknowledge its errors. Since Billy M. has told me that Hubbell will no longer weave for me I feel free to work with Mary Lee directly. I expect to talk with her this evening about redoing this last one. Mary Lee ascribes the failure of the last weaving to the fact that she was so rushed by Hubbell, I guess Al was in a rush to complete it before departing. At any rate Billy Malone seems surprised that I had been in direct contact with Mary Lee. I do not want to create any problems for her so I do not plan to (nor do I see any reason to) notify Hubbell that I might work with her. This should be her choice. Yes?"

In October 1981, a second tapestry from maquette *D* became the first tapestry that Begay wove for Gloria at her home instead of at the Hubbell Trading Post. It too ended unsuccessfully. Gloria monitored its progress

Kenneth Noland, maquette *B* (PT-83-01) for "*Shooting Star*," 1983, acrylic on paper, 14.3 × 15.5 in. Although the background was only partially painted, Noland asked the weaver to complete it in solid gray. GFR Papers; © Estate of Kenneth Noland/Licensed by VAGA, New York. Photo by Jannelle Weakly, ASM. (See plate 64.)

through Mary Lee's brother David Begay and several other English-speaking relatives. Notes and phone calls back and forth indicate an early concern for color matching, as the very dark blue and a green were not typical colors for a Ganado weaver. Begay matched the colors to a narrow strip of painted canvas that was trimmed from the reverse side of the original painting, showing both color and stripe proportions. For unspecified reasons, Gloria rejected this tapestry when completed. Its ultimate fate is not known.

Toward the end of 1981, Gloria again worked with Mary Lee Begay at her home. Begay wove the successful "*Morning Star*" from maquette *R* drawn on lined graph paper (plate 63). This dynamic quartered design represents a departure from Noland's previous formats. At this time, he was returning to the chevron format after more than a decade away, but adding the twist of considerably rougher texture. Ever inventive, he "dissected the chevron itself, . . . doubling and inverting them" for the Navajo series.[28]

Interpreting the maquette and dotting every *i* as usual, Gloria wrote to the weaver in December 1981, "I am sure you understand that the blue lines of the graph paper should not be used. Also the ink lines, outlining each color should not be used. I suppose you will use grey on all edges, on the sides, top, and bottom. . . . As we discussed the shades of the colors in the painting are inaccurate; they just show what colors are to be used. . . . I think it would be a good idea for either David or Dollie to telephone me collect after you have received this letter, as you may have ideas about it that you would like to share with me. . . I do want you to keep the $400 deposit I gave you for the earlier weaving. These colors [several shades of blue? requested for an earlier project] are difficult to get. From now on we will use only colors that you usually use in your weavings."

The maquette was delivered in October 1981. The tapestry was completed in August 1982 and given to Noland in December 1984.

In "*Shooting Star*" (1983), as in the earlier work "*Twilight*" (1980), Noland played with the chevron format, floating the concentric chevrons on a visually separate ground (plate 64). This was woven by Begay from maquette *B*, a suggestively incomplete chevron painting on paper. In June 1983 Gloria exclaimed, "I hope that I can get the weavers to capture the variety of Ganado reds in each image." Noland responded by phone, suggesting that the weaver mix a brown wool with red dye or use an intense brown, rather than using two shades of red. Once the rug was completed, the weaver sent a postcard, saying, "Hi Gloria, We receive[d] your mail. Thank you to send the check. The name of this rug is shooting star rug. The next rug will be finished within two

weeks. . . . Shooting star rug symbolize shoot star across the galaxy with shining bright colors. Love, Mary Lee Begay."

In *"Hawkeye"* (1983–84), the red background of maquette *V* was also changed to brown (plate 65). Noland and Gloria intended this to form a pair with maquette *B*, which was never woven.

Because of a death in the family and pressing orders from a Tucson dealer, Begay's completion of *"Mood Indigo I"* (1984–85) was delayed. The tone of the weaver's (translated) notes indicates that funds for these projects were an important incentive, "As soon as you receive the rug send us the check right away. Thanx."

"Mood Indigo I" (1984–85) and *"Mood Indigo II"* (1985) departed from Noland's earlier chevrons by expanding to cover the entire surface (plates 66, 67). For a handwritten letter translated into English by one of her relatives, Begay dictated, "As for the name of the rug, it very difficult to name something like that. I never made one like that. No name I could think of seem to fit. Maybe you could think of a name, and if you could think of one, let me know."

Despite naming difficulties, Gloria was pleased with the work, which was, she told the weaver, "very, very beautiful weaving. In every way, it is truly expert: the weaving, the colors, the wool." To Noland, she gushed, "I wish I could give you the feel of this weaving along with the imagery, for the quality is among the finest in the Noland series. I want you to see it the very moment you return to the east."

Later she explained to the weaver, "A beautiful song was written 40–50 years ago called 'Mood Indigo,' and I have used this title for the beautiful weaving you recently completed. It will be called Mood Indigo I; and the new one you are now weaving for me will be called Mood Indigo II." The name was particularly appropriate, of course, because indigo was not just a Duke Ellington composition but was also the dye used prominently in nineteenth-century Navajo blankets. Although Gloria referred to herself (perhaps to be expedient) in the note cited above, it was Noland who actually dubbed the two pieces *"Mood Indigo."*

Noland departed from his previous paintings as he sliced the symmetrical chevron into varied color bands. This experiment resulted in *"Valley"* (1986/1987) and *"Line of Spirit"* (1990–93) (plates 68, 75).

When *"Valley"* (1986/1987) was nearly done, Begay wrote via translator to Gloria, "I'm back to work at Hubbell T.P. [following a vacation]. I'm still working on your rug [at home], probably it will be finish[ed] in January 86. I [won't] probably give it a name until [after] it [is] finish[ed]." And then in February, "I am shipping you the rug. It took me a long time to finish the rug project but I hope its in your best interest. I thought for a long time to give a name

Kenneth Noland, maquette for *"Hawkeye,"* 1983, acrylic on paper, 14.25 × 15.5 in. GFR Papers; © Estate of Kenneth Noland/Licensed by VAGA, New York. Photo by Jannelle Weakly, ASM. (See plate 65.)

for the rug, but I am unable to give a name. I will leave this up to you."

In turn, Gloria wrote Noland, "Mary Lee writes that she is 'unable to give a name,' so over to you, Ken." The original owners of this tapestry donated it to the Wheelwright Museum's permanent collections in Santa Fe in 1996.

The predominance of red in *"Untitled"* (1991), another chevron, was unusual in the Navajo/Noland repertoire (plate 69). Upon completion, Gloria wrote to the Begays, "I note that the Ganado red is a particularly beautiful deep shade." Gloria's note shows that Begay planned to use striking black twined selvage cords and several eccentric wefts to follow the diagonal chevron forms—interesting innovations.

This was the only Native/Noland tapestry to remain permanently nameless. After several requests from Gloria, the weaver sent a note, "Dear Gloria, Hi! I named the rug 'tryed [*sic*] again' due to the fact that the rug was hard and the check was hard to cash also. Thank you very much. God bless you." On the envelope of this note, Gloria penciled, "poor name, don't use." The untitled work is now in the permanent collection of the Joslyn Art Museum in Omaha, Nebraska.

In *"Arizona Sky"* (1996), Noland again added blue to the Ganado palette of natural sheep's colors and deep red (plate 70). Ordered in September 1993 and begun in June 1994, it

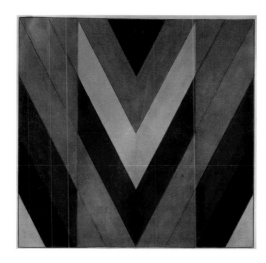

Kenneth Noland, maquette for *"Valley,"* 1985, gouache on paper, 8 × 8 in. GFR Papers; © Estate of Kenneth Noland/Licensed by VAGA, New York. (See plate 68.)

contains Wilde and Wooly—brand yarns from a historic mill in Germantown, Pennsylvania, that supplied Burnham Trading Post in Sanders, Arizona. These yarns, generically called Germantowns, revive a centuries-old tradition of colorful multi-plied mill-spun yarns that gained popularity among Navajo weavers in the late nineteenth and early twentieth centuries. Gloria described the materials to Noland. "For the first time, I have chosen to use a different kind of wool, which is particularly popular today with the weavers, traders, and collectors, and to use a yarn finer than Mary Lee has used in the past. When you are here, you will see that five of the colors available are fine. Mary Lee will dye the darker blue, and we are awaiting arrival of the proper shade of black, really a charcoal. The search for the wools I particularly sought is a saga and I will tell you of this and of the many joys of the journey when we are together."

In December 1996, she appeared lukewarm about this last Native/Noland tapestry, writing only, "It is a fine replica of the original picture . . . Let me know what name you would like to give this new weaving."

One of the weaver's daughters responded, "Gloria it is up to you to give a title. If I give you a title you might not like it. We are doing fine, except that we still have big snow and lots of mud. Very cold lately. Mary & Lena."

While visiting the Begay home, where Mary Lee's large loom dominated the living room, Gloria requested the design be woven on its side rather than point up like the rest. Her reasons for this odd request (since all others were successfully woven upside down rather than sideways) are obscure. When the weaving was completed, Gloria received the following note: "Gloria, Hi and How are you? Hope everything goes well and we're praying for you. We had a good New Year, all my Children and Grand Kids were home for the holidays. I enjoyed working on the project although it took a while to complete. It's very lovely, absolutely beautiful. It reminds me of the landscape, the scenery, also the sky. I think we should give a name "ARIZONA SKY." What do you think? It's very difficult to weave vertical [lines]. If you're planning to make or purchase another vertical pattern I would not be able to make another. Also thank you for your friendship and working together. We will keep in Contact and write us. Thank you Gloria, Sincerely your friend, Mary Lee Begay P.S. Thank you for the amount of purchase. I'm very gladly to work with you."

Gloria responded, "'Arizona Sky' is a perfect name for this beautiful weaving."

Rose Owens of Cross Canyon
Rose Owens (1929–1994) was a master weaver known for making circular rugs, an unusual style that was well matched to Noland's widely

known shaped canvases. She worked at home in Cross Canyon, Arizona. Speaking no English, she corresponded through family members just as Mary Lee Begay did.[29]

Noland's first circles were placed within an enclosing square, rectangle, or diamond shape. One series begun in the late 1950s includes circular canvases, so-called tondos or concentric circle pictures. He continued to work with shaped canvases for decades.

Maquette *F* is a drawing in which Noland used magic marker on graph paper, which ultimately became *"Games"* (plate 71). The original, a tiny thing left with Owens in October 1981, recalled Noland's early asymmetric work, such as *Abstraction* (1947–48), in which "flat planes of adjoining colors, in triangular and rectangular shapes, are laid down side by side."[30] For the woven version, the artist reworked his original concept, applying traditional Navajo symmetries and combining them within a tondo form.

Noland's center element originally consisted of two horizontal rectangles, but Owens wanted to quarter this into four small squares to make it quadrilaterally symmetrical.[31] She drew an example for Gloria, who gained Noland's approval over the phone. From this came *"Games,"* forty-three inches in diameter, completely finished with Navajo twining around all edges, and woven in May and June 1982. In the end, Owens wove it as designed, with two central bars. Ironically, this resembled a segment of a traditional Navajo rainbow line, as depicted in both religious sand paintings and handwoven rugs. As Gloria noted, "It is rather interesting that she made

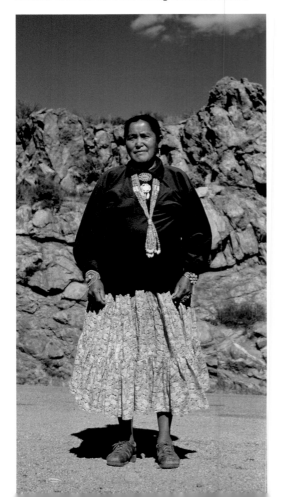

Rose Owens, Cross Canyon, Arizona, 1981

104

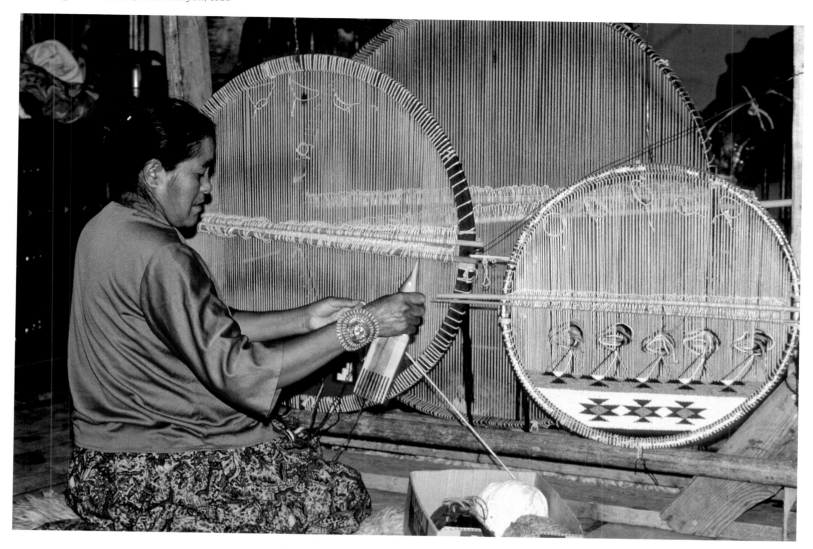

the very center image just as Ken had designed it, and did not weave it in a symmetrical image as she had said she would."

Gloria was justifiably proud of Owens's work, as she told the noted architectural firm of Graham Gund Associates, "I have worked with a superb weaver whose loom is a wagon wheel, and she has completed the first round 'Noland.' In addition to its aesthetic value, it is a technical feat to produce a round weaving." *"Games"* was sold to a private collector through Gallery 10 in December 1985.

A second round rug completed by Owens in 1991 became *"Time's Arrow"* (plate 72). In Navajo, the weaver called it *"k'aa' ba naskąą,"* which roughly refers to "arrows in four directions." Gloria responded, "I received . . . the title of the weaving, and I thank you. It is poetic and beautiful, and it gives the weaving further meaning." Shortly afterward, *"Time's Arrow"* became its official name, likely at Noland's suggestion.

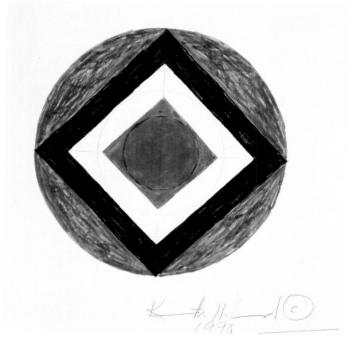

Kenneth Noland, maquette (90-31) for *"Time's Arrow,"* 1990, ink, gouache and pencil on paper, 11.5 × 11 in. This is one of the few maquettes that Noland signed. GFR Papers; © Estate of Kenneth Noland/Licensed by VAGA, New York. Photo by Jannelle Weakly, ASM. (See plate 72.)

Sadie Curtis of Kinlichee

Sadie Curtis (b. 1930), a former employee of Hubbell Trading Post, was another masterful weaver. She became famous for weaving a United States flag that appeared on the July 1976 bicentennial cover of *Arizona Highways* magazine. After working as a weaving demonstrator at Hubbell Trading Post for many years, she retired from the Park Service in the mid-eighties. She regularly wove commissions for many clients, but, as Gloria once noted in frustration, "Sadie has no fone [sic]." Gloria communicated with Curtis through her daughter June and niece Genevieve Shirley.[32]

Curtis wove *"Reflection"* in 1983 from maquette *I*, drawn on graph paper (plate 73). Here again, Noland showed his familiarity with historic Navajo weaving and his ability to toy with a classic design, producing a meld of Noland and Navajo. As one reviewer put it,

"The very contemporary design of nine rectangles in interlocked color stacks is still translated in conspicuously Navajo terms."[33]

Again, the center design of two rectangles (bilaterally symmetrical rather than quadrilaterally so) caused initial concern for the weaver. Curtis, like Rose Owens earlier, proposed quartering the bars or at least making the colors equal to the rest (originally white and red, they contrasted with the light gray and red of the others). Noland agreed to the weaver's change. However, when the rug was delivered, Sadie had woven it as originally drawn. Gloria and Noland agreed to a partial donation and sale of this tapestry and its original maquette to the Denver Art Museum in 1992.

Curtis's daughter June called Gloria on Valentine's Day 1984, saying that the weaver would like to do more tapestries for Gloria. According to Gloria's notes on the conversation, she responded with some hesitation, "fine! may be a few mos."

In 1984 Gloria left a design from maquette *M*, based on broken horizontal stripes, for Sadie Curtis, but it was never woven.[34] In March 1985, Sadie finally returned the model, having her daughter write, "Mom is willing to weave for you so if you can, you can send her the next diagram." Gloria responded, "As soon as I have a new design with your favorite colors, I will send it to you."

At the same time Gloria explained to Noland, "Sadie Curtis returned the maquette because she was unable to successfully dye the indigo blue. She eagerly awaits another Noland maquette using the colors to which she is accustomed. Therefore, the colors should be whites, grays, browns, blacks, and Ganado reds."

Sadie would not use "commercial blue wool" and didn't use indigo herself (indeed, few Navajo weavers did at that time). This meant she could not work on several Noland images sent for her use. In a typically generous mood, Noland suggested that Gloria "let Sadie redo a maquette without Indigo; she should replace the color." There is, however, no evidence this happened.

In *Four Corners* (1985), Noland took four concentric chevrons and transformed them into a quartered layout—the quadrilateral symmetry sought by Navajos (plate 74). This design was skillfully woven by Sadie Curtis with her aunt Alice Belone, another accomplished Ganado weaver. Sadie called this *"Naskąą'"* (meaning "old pattern" in Navajo) and *"Del ką́ą na'i dełi"* (referring to a "plain pointed design").

Some years later, Sadie Curtis was chosen to weave segmented chevrons of *"Line of Spirit"* (plate 75). Because of the ways the angles met, it was one of the most difficult of the Noland designs and took from 1990 to 1993 to execute. The piece was acquired by

"Line of Spirit" on Sadie Curtis's loom, Kinlichee, 1993. (See plate 75.)

Sadie Curtis at her aunt Alice Belone's loom, Kinlichee, 1985

Kenneth Noland, maquette *I* for *"Reflection,"* 1983, ink and gouache on graph paper, 8.5 × 11 in. Denver Art Museum; © Estate of Kenneth Noland/ Licensed by VAGA, New York. Photo courtesy of the Denver Art Museum. (See plate 73.)

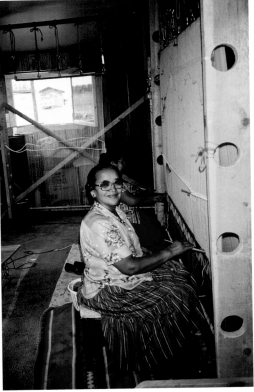

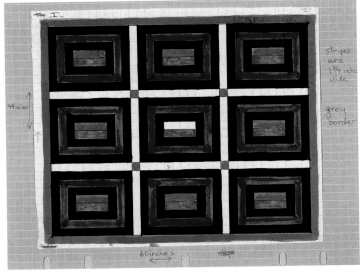

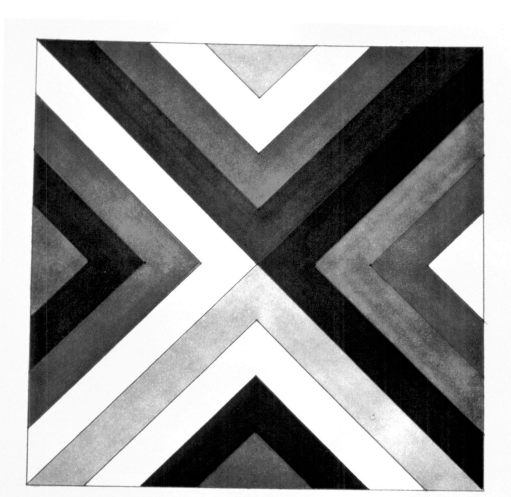

Kenneth Noland, maquette (85-24) for "*Four Corners*," 1985, ink and watercolor on paper, 8 × 8 in. © Estate of Kenneth Noland/Licensed by VAGA, New York. (See plate 74.)

a Washington DC couple. When they donated it to the Art Institute of Chicago in 1995, Gloria wrote at length to her friend Teri Edelstein, then deputy director there. "In 1990 I brought the maquette to Sadie, because she is one of the finest weavers on the reservation, and had successfully translated other Noland maquettes for me. Although I was aware at the time of the difficulties this image would present, it was not until my next visit in 1991 that I realized I had to give her strong encouragement not to give up on it. I even tried to encourage her to use French weaving techniques, and had a full-scale black-and-white cartoon made for her. This proved to be too foreign for her, but it seemed to bring back her determination to master it—and she did! It was completed in 1993.

"The enclosed Xerox of the maquette shows that it had no frame. As always, I enjoy the freedom Navajo weavers assume, because I want the tapestries to have dual recognition as Navajo weavings and as Nolands. When 85-25 (our code number for the maquette) arrived, lo and behold it bore the grey frame along with the Spirit Line. This is always woven into an all-encompassing frame, to release the weaver's spirit for future work. Ken was as delighted as I when he saw it. The image of the Noland with a Spirit Line is delicious! Rightfully, Sadie is especially proud of this beautifully woven tapestry.

"Sadie frequently works with Ganado colors (natural, undyed wools such as blacks, greys, browns, whites, and Ganado red. The latter is a synthetic dye and varies with each weaver each weaving). I always know which weaver I plan to work with, before I approach Ken for a maquette. Because I know the weaver's oeuvre, if she works primarily in vegetable and/ or synthetic dyes or in natural wools, if she can make a round weaving, etc.—then I guide Ken as to the sort of colors, size and shape I want. Ken has been wonderfully cooperative in this entire project, and I do think he has enjoyed it just as much as I have. Several years ago he even made a trip to the reservation and met some of the weavers."

Several aborted attempts preceded the successful *"Line of Spirit,"* hence its lengthy production time. In a 1991 version, Sadie wove her initials SC into one corner of the tapestry. Even the final version, which deviated somewhat from the original model, was not immediately acceptable to Gloria. She told Noland that she'd ask Sadie "to sell the rug she has just completed—sans your name or mine." When Sadie took it to a respected Sedona dealer, he realized the difficulty of selling something so remarkably different from the Ganado weaver's own style and recognizable as a Noland image, names or no. He sent the tapestry directly to Gloria to show to Noland. Ultimately, the artist approved, named the rug, and signed its label.

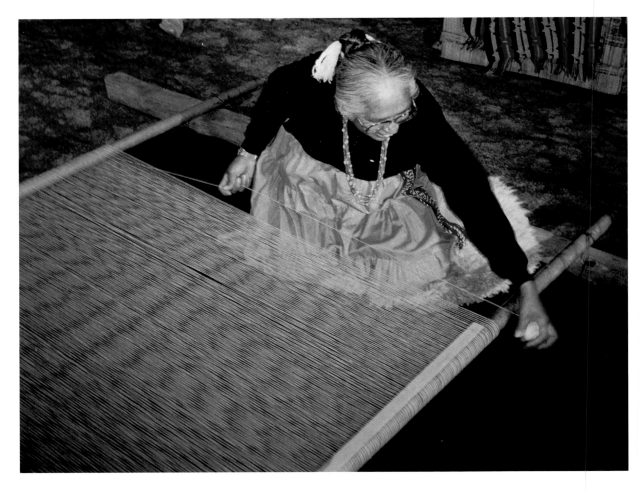

Irene Clark of Crystal

In August 1990, I introduced Gloria to Irene Clark (b. 1934), who lives at the edge of the Chuska Mountains outside Crystal, New Mexico. Crystal weavers typically create banded, borderless rugs—a perfect match for Noland's well-known horizontal band paintings. Guided by Gloria, the artist designed a very wide horizontal image with bands of color geared to Clark's vegetal-colored palette (plate 76).

When she completed the tapestry, Irene and her son Ferlin Clark wrote, "Dear Ms. Ross: Upon your request to name the rug you bought from me, I had to take some time to think what it means to me. Usually, Navajo rugs are not given a name, but are distinguished according to geographic location.

"Crystal is a community that derives its name from 'Crystal' clear streams that run off the beautiful, majestic Chuska mountains. My great grandparents settled in Crystal and established our homeland in the Chuska foothills at a place called Tsa Be Toh—Sand Springs. All the rugs I have produced thus far have been from real life stories of my family, and our every day struggles to succeed in our professional and artistic endeavors.

"I am proud of the rug I wove and sent to you. Proud, because this rug symbolizes the strength of my family. Every strand of naturally-dyed yarn interwoven is my family's clanship and the belonging to one another. All the colors of the rug symbolized the array of colors depicted in the rainbow. The rainbow is a strength that protects and paves the path to beauty and harmony. As a nation, the Navajo people and our government continue to be protected by the rainbow. The rainbow also signifies sovereignty. Believing in our rich culture, our dynamic clanship and our authentic language are genuinely Navajo, and so is the rug you have now.

"Thus, I have named the rug, 'Nááts'íílid.' I hope the above interpretation of the rainbow helps you to understand the story of the rug. I also hope to hear from you soon.

"Sincerely, Irene H. Clark."[35]

Irene Clark preparing the warp for her loom, Crystal, 1991

Clark and Gloria planning a project, Crystal, 1990

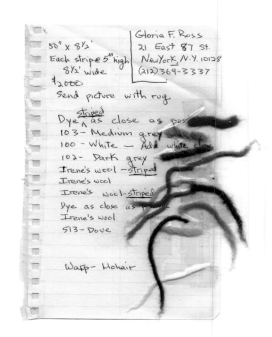

5' X 12' K #N↵ 1990 ©

Kenneth Noland, maquette (90-32) for "*Nááts'íílid (Rainbow)*," 1990, ink on paper, 3 × 5 in. Denver Art Museum; © Estate of Kenneth Noland/Licensed by VAGA, New York. Photo courtesy of the Denver Art Museum. (See plate 76.)

Irene Clark with "*Nááts'íílid (Rainbow)*," National Museum of the American Indian, New York, 1997

Despite a major tensioning flaw across its center, the tapestry and its naming received high praise from Gloria.

"I thank you . . . for your wonderful thoughts, spirit and love that went into the rug. . . . I can write of my deep appreciation of the rug, and my good fortune in knowing you. 'Nááts'íílid,' which I assume means rainbow, a meaningful title for the rug and I thank you for concerning yourself with this. I know that until I came along rugs were not named on the Reservation, but here in the East it is a custom."

The tapestry *"Nááts'íílid"* and its original maquette are in the Denver Art Museum permanent collections.[36]

The Studio of Ramona Sakiestewa

During one of our annual Santa Fe visits, I introduced Gloria to Ramona Sakiestewa (b. 1948), a weaver of Hopi Indian and German-Irish-English descent who eventually wove six Noland images as GFR Tapestries. Sakiestewa was then a close friend and neighbor of textile scholar Kate Peck Kent and had strong interests in worldwide textiles and design. An alumna of the School of Visual Arts in New York, she heads Ramona Sakiestewa LLC, which is internationally renowned for "its radical re-invigoration of the traditions of fiber art. Over three decades [Sakiestewa] has pressed issues of scale, texture, color and tone in works that shatter old barriers separating weaving, painting and mixed media."[37]

A self-taught artist raised in the American Southwest, Ramona Sakiestewa has combined the prehistoric Pueblo weaving tradition with contemporary design, horizontal-floor-loom techniques, artwork in other two- and three-dimensional media, and a very active career in architectural, museum, and design consulting. In 1981 she established her Santa Fe weaving practice with Molly Mahaffe; in 1985 Candace Chipman joined the studio. By 1989 the

practice included another excellent weaver, Rebecca Bluestone.[38] They worked on a Gilmore, a Cranbrook, and two McComber looms —modern handweaving equipment rather than traditional Spanish "walking treadle" looms.

Sakiestewa's creative work appears in numerous private and public collections, including major installations in the Smithsonian's National Museum of the American Indian. Having worked in New York, Mexico City, Peru, Japan, and China, she proved an excellent match for Gloria's interests. A fast friendship formed. Following their first meeting, Sakiestewa wrote in July 1984, "It was a pleasure to meet you! It is a rare treat to talk about textiles with someone who has such a wide comprehension of fiber and such a unique relationship with important artists' work. It is nice having a face with a voice on the phone now."[39]

Gloria replied, "I have enthusiastically joined the group of Ramona admirers. . . . It is nice to be able to picture you in your wonderful studio in Santa Fe!" Later she wrote, "I am always intrigued with your many fascinating and successful projects."

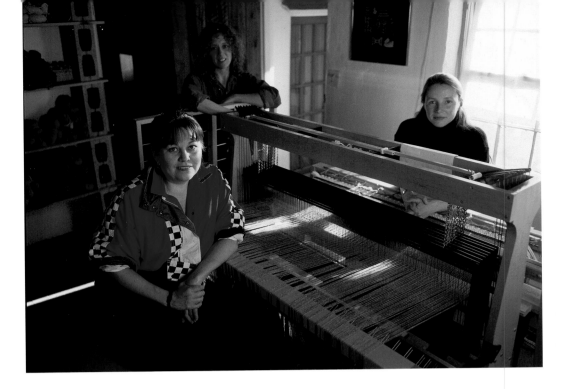

Left to right, Ramona Sakiestewa, Candace Chipman, and Rebecca Bluestone, Santa Fe, 1989. Photo by Jack Parsons.

Spools of yarn, the Sakiestewa studio, Santa Fe, 1989. Photo by Jack Parsons.

Ramona Sakiestewa's loom with a tapestry of her own design under way, Santa Fe, 1989. Photo by Jack Parsons.

The first Sakiestewa/Noland, *"Ute Lake,"* turns Noland's "traditional" concept horizontal stripes sideways and plays off earlier southwestern striped blankets (plate 77). It was completed from maquette *O* in 1984 before Gloria and Ramona met in person. For this, Sakiestewa used the mill-spun Naturals line of yarns from Harrisville in New Hampshire, on a Halcyon brand warp, and her own indigo dyeing. During the weaving, Gloria sent a handwritten request: "As with all weavings in this series, I hope that you will give this a title. What?" Sakiestewa responded, "We have been calling the piece UTE LAKE as this color variation and banding was popular with the Ute people and the large blue band feels like water. You may or may not like the name, but it [was] an enjoyable piece to do." The title indeed became *"Ute Lake."* Other Noland/Sakiestewa works also received geographically and culturally evocative names.

Sakiestewa commented on the naming of *"Ute Canyon"* (1984–85), another vertically striped piece (plate 78). "The 'J' piece came out well, a very nice feeling . . . reminding me of facets of canyon walls when you walk through. Perhaps UTE CANYON as it has the same use of color as UTE LAKE." Gloria deemed this "another R.S. success" and a "fine weaving."

The third piece continued the series with bands of blue, brown, black, and white, woven horizontally but displayed vertically (plate 79). Upon completion in October 1985, Sakiestewa

explained, *"Twin Springs Canyon* (or Twin Springs) is the name that came to mind. This is a canyon running into the Grand Canyon from the north side. This piece repeats pairs of colors and holds the blue like a body of water between canyon walls." In *"Twin Springs Canyon"* (1984–85), Sakiestewa incorporated Churro sheep's wool raised through Dr. Lyle McNeal's Navajo Sheep Project at Utah State University.[40]

In 1984 the Churro project's colored fleeces rapidly sold out. Sakiestewa ordered white on which to dye the black and brown as well as indigo blue. Later, she commented to Gloria, "When you visited the studio I'm sorry you did not see the dyed churro wool. It is very beautiful."

Sakiestewa selected a small cooperatively run mill outside Taos, New Mexico, to transform the wool into yarn. She reported, "Have taken the wool to the Rio Grande Wool Mill in Tres Piedras, NM and they think it may be ready the first week in Dec. We have had poor weather (rain and snow) up until two weeks ago then it turned cold so the dyeing and wool washing was delayed. . . . I have taken slides all along and the raw fleece photos are good and will take more at the mill when it is spinning. . . . It looks like the indigo dyeing will be taking place in the bathroom of the studio at this point in winter."

Churro wool held great cachet and marketing potential for Gloria, as did the notion of native hand-processed wool. Having warned herself, ". . . will use [John] Usury [at the Rio Grande Mill] but for future [I]'ll seek a Native American," she was not entirely satisfied with using a mill, even if locally owned and small in scale. Further, she shared with a colleague that "Lyle agreed with me that this phase of the project should be done by a Hopi or Navajo, so that the entire project is Native American. . . .

The demise of the Navajo Sheep so many years ago, the Utah State Project, and the current use of these Navajo Sheep in the tapestries of Noland imagery is indeed dramatic and makes for a dramatic saga. This should be an added highlight for the proposed May/85 exhibition."

Once the project was concluded, Sakiestewa wrote to Gloria, "I must thank you for providing the opportunity to work with the churro; it certainly has a light and dye quality unlike other yarns." Another note continued the thought, "the luster and texture are very different." In a 2001 lecture, she commented, "It's always interesting to do something that is out of your own experience," remembering that the Churro sheep fleeces were the highlight of her work with the GFR Tapestries.[41]

Returning to mill-spun Harrisville yarns, Sakiestewa completed *"Jeddito"* in August 1985 (plate 80). She sent Gloria a note explaining, "The name which came to me was JEDDITO— Jeddito wash meanders up a canyon like the broken bars of color."

Like the Navajo-woven *"Games," "Dazzler"* (1985) evokes the overall patterns of triangles that Noland explored in the late 1950s (plate 81). The name was selected by Sakiestewa once she finished the work, playing off the popular Navajo "eye dazzler" style of the late nineteenth century. During the process, she wrote in October 1985, "It is a much more difficult piece, but we are very pleased thus far with the color and optics." All concerned hoped to use the Asian insect dye lac as well as Central American cochineal for the two reds, but unfortunately, the lac bugs were scarce that year and the dyestuff wasn't shipped to the United States. Instead, cochineal with two different mordants, plus natural cutch brown, indigo blue, and brown wool over-dyed with indigo were used on Harrisville yarns for *"Dazzler."*[42]

The balanced chevron of *"Ute Point"* (1991) was woven in the Sakiestewa studio using Swedish wool yarns with Ramona's signature

spacing of eight warps per inch (plate 82). The maquette was a sketch on an 8½-by-11-inch piece of cardboard. Sakiestewa recalled, "We referred to the weaving in the studio as the 'Howard Johnson' piece until it was named. With the exception of the blue ballpoint pen ink, the other colors are what you used to see in the restaurants back east. It seemed like a hard color combination, but in the end it worked."

The project proved to be a continuing lesson in communication. To retain the artist's desired proportions and proper thread counts, the interlocked diagonal color joins advanced in tiny incremental steps, in contrast to the smooth Navajo style to which Gloria was accustomed. When the tapestry arrived from Santa Fe, Gloria wrote in her notes, "Techniques & color not right for maquette—Not fuzzy, Not rendition I want." After conversations with both Noland and the weaver, Gloria noted, "G said Ken approved but G feels it'll be hard to sell as a Nol as his work is hard-edged (in re feathered edge)." Diplomatically, Sakiestewa wrote to Gloria, "We felt it was one of the best, however, the work did not meet your expectations for technical reasons and I have discounted the bill. Hopefully this will help you overcome your negative feelings about it potentially selling well."

Gloria avowed to the weaver, "For our next collaboration we must discuss all details more carefully." Later Sakiestewa reflected, "The small stepping of the interlocks didn't bother [Noland]. It was the most difficult piece but represented the scale and sharpness of his drawing exactly."

Gloria worked to distinguish Sakiestewa's tapestries from the Navajo works. In one instance she explained her rationale, "The reason I preferred the 70", and colors that were 'not too strong' is that Mary Lee Begay is weaving two chevrons which will be 64" × 66", and in all ways I was hoping to have this different in terms of color, the R.S. stamp as opposed to Mary Lee's, and a difference in size."

As usual, Gloria wanted to keep in close touch on decisions. "Regarding the chocolate (natural black) to be used in the brown areas, your sample is substantially lighter than the natural black used in Ute Lake. This is fine, but be sure to carry through with this lighter color, which I prefer for this weaving. The 'charcoal for grey' looks good, but could you please weave a tiny bit for me so that I can see it more clearly. The white is fine. May I assume that the indigo is the same as Ute Lake, because this would be fine. The aniline black on black, the same as in Ute Lake, is fine."

The Sakiestewa/Noland series was co-produced by Gloria Ross and Lee Cohen of Gallery 10 in Scottsdale AZ and New York. On more than one occasion, Cohen suggested that Gloria encourage Noland to consider

Ramona Sakiestewa, Santa Fe, New Mexico, 1989. Photo by Jack Parsons.

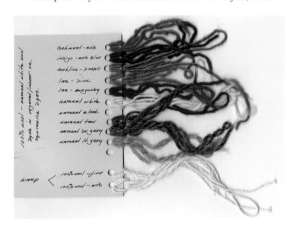

Indigo-dyed wool drying at the Sakiestewa studio, Santa Fe, 1989. Photo by Ramona Sakiestewa.

Samples of yarn with natural colors and dyes, 1989

styles that evoked historic Pueblo and Navajo weaving. On the phone, he mentioned seven possibilities, "all based on 19th century wearing blankets," which Gloria listed in her 1984 notes. These included classic sarapes, second- and third-phase chief's blankets, indigo striped wearing blankets, wedge weaves, "some form of eye dazzler," and "floating design elements" with Moqui striped backgrounds, noting the last were "especially good" sellers. As a collector of historic Navajo textiles, Noland already drew on certain of these ideas, but in his frankly abstract manner. While Gloria took careful notes, it isn't clear what specific thoughts she conveyed to Noland. In any case, it appears that the painter pursued his own ideas, drawing on his long-term experiments with color and shape juxtapositions.

Attempting to clarify their roles, Gloria wrote to Cohen in 1984, "I really do not think it necessary for you to concern yourself with the final decisions on exact color shades, weight and cost, but let me know if you wish to do so." In other words, don't go to Sakiestewa directly.

Gloria also counseled the weaver. Using code names for maquettes prior to actual titling, she wrote, "Before you give the title of 'J' to Lee, please check with me first. I know that he is printing up the announcements soon and will obviously want the title." Later she clarified, "Rather than discussing these matters with Lee, because I do make the final decisions and because it will save time, I suggest you contact me about questions that arise. Of course I do keep in close touch with Lee about all this."

The triangle of negotiations continued as Sakiestewa wrote, "After Indian Market I will graph out 'C2' for you and send it. . . . Lee feels it should be the larger size and two colors of

cochineal would be fine. The supply of lac last year was not as prevalent and was not shipped abroad apparently."

Meanwhile, Gloria remained solicitous regarding Sakiestewa's ideas: "So Ramona, what are your thoughts, your choice?" when deciding between two of Noland's designs, and "Again, your thoughts" regarding the dyes and overall sizes of certain pieces.

Paths Not Taken

Noland created a number of maquettes that were not used. Some were sent to Navajo weavers who held onto them long enough to indicate lack of interest. Others Gloria never shared with weavers. As the painter worked in his studio, the maquette-making process tended to speed ahead of the weaving; there were more designs than available weavers to execute them. In 1990, after producing many successful works, Gloria wrote to Noland, rationalizing the slow pace at which work was produced, "A Navajo can handle maquette and concept of only one at a time. Each weaving requires a separate visit by me."[43] Notes indicate that Gloria planned several series of images for certain weavers, but time ran out.

Sometimes it was difficult to find the right weaver for a design, although most matches proved successful. Working through Tom Wheeler, fourth-generation trader at Hogback Trading Company in Waterflow, New Mexico, Gloria located weaver Sarah Begay in February 1980. Sarah (now known by her professional name, Sarah Natani) is an expert Two Grey Hills weaver and an active weaving instructor and demonstrator. Noland created three striped designs specifically for Natani in the classic Two Grey Hills colors of natural white, gray, brown, and black. The weaver suggested she do the tapestries with heavier commercial yarns

rather than her award-winning hand-carded, finely handspun natural sheep's wool. Over several years, the weaver's lack of response to repeated inquiries made it clear the project wasn't happening. In February 1985, Gloria noted, "No—skip her!" The Navajo weaver's attachment to her handspun sheep's wool for her own creative projects was too strong for her to share this labor-intensive material on commissions.[44]

Gloria delivered the striped maquette *H* of natural colors to Audrey Wilson of Indian Wells in September 1980. Wilson was accomplished in two-faced, twill, and other weaves.[45] After repeated queries about progress and long silences in response, Gloria asked for the maquette's return in February 1985. The weaver reported that she preferred to concentrate on her own designs.

After Rose Owens wove the successful round *"Games,"* another round target painting (maquette *G*) was presented to her. This design, a red, gray, black, and white tondo with concentric circles, proved too challenging even for this expert artisan. After waiting to hear the weaver's reactions and receiving none, Gloria retrieved the painting in October 1981, but only after the Owens family children had a good game of stick and hoop with the original circular canvas, right down their dirt driveway.

Gloria initially attempted to work with Steve Getzwiller, a rug dealer from southern Arizona. One piece, a banded version of *T* (later woven and named *"Twin Springs Canyon"* by Ramona Sakiestewa) was to be woven entirely in vegetal-dyed and natural-colored sheep's wool by Marie Begay of Wide Ruins. Unfortunately, this tantalizing project never happened. Another talented weaver, also working in natural materials, opted to concentrate on her own work, as Gloria reported, ". . . I had hoped to be able to work with D. Y. Begay who is pretty much based here

with her husband in N.J., but she is used to weaving small pieces. . . . She is busy selling her own and others' rugs, doing demonstrations, etc."

In addition to maquettes not made and weavers not engaged, Gloria approached one artist who soundly refused. Full of enthusiasm, she wrote to Frank Stella in 1990. "I am just back from the Navajo Reservation where my thoughts frequently turned to you. Although you recently turned down my offer to collaborate on tapestry, I don't give up easily!

"I know that you are familiar with Navajo Teec Nos Pos weaving, so I assume you will understand when I project the image of a Stella woven in this style. Their colors are your colors and the spirit of their weaving would support your spirit, your statement. I could work from an existing image, but preferably from a Stella maquette specifically designed for their loom. The guidelines are simple and I need not take much of your time.

"As you may know, I have been working on the Reservation for some ten years now and truly I can think of no more appropriate collaboration than this. It could be an exciting project, a rewarding creation. May I call you once again about your interest in this? I will not be in the Southwest again for some time so we could discuss it at your convenience.

"Regards, sincerely, hopefully."

Stella's secretary replied by phone, saying that the artist wouldn't presume to tell Navajos what to weave and felt they should proceed with their own work.[46]

Grasping the Project's Intent

Gloria once noted, "It takes a great deal of time and research to find these experts. I spent 6 mos. research Nav[ajo] weaving before even setting foot on the reservation. By now I've had many wonderful adventures there. I have good friends there."[47]

Gloria and Sarah Natani confer on a project, Table Mesa, 1983

Sarah Natani's handspun sheep's wool with a Noland maquette, not woven, 1983

Along the way, a few misconceptions
emerged. For instance, Gloria was fond of
saying, "This is the first time the American
Indians have ever worked from designs of a
leading 'Anglo' artist, and we are both quite
excited about the results of this collaboration.
Of course, each weaving is a unique work."
Her efforts were not, in fact, the first, for she
had been preceded decades ago by traders.
Between 1897 and 1909, J. L. Hubbell invited
Chicago artists E. A. Burbank and H. G. Maratta
and local teacher Bertha Little to paint both
classical and imaginative rug designs to inspire
Ganado area weavers.[48] Dozens of these small
paintings still hang on the Hubbell Trading Post
walls, and weavers continue to consult them.
Commissions are often based on them.

To many Navajo weavers, Gloria's roles and
goals remained murky. She became a patron
and friend, but what, they asked, was she
doing with these rugs? Early on, Irene Clark
posed this question to Gloria, who replied
simply that she was selling them. Other weav-
ers seem to have misunderstood the purpose
of the collaborations, as when Mary Lee Begay
wrote in 1981, "I hope you'll like [this tapestry],
and hope you'll enjoy it for many years." The
GFR Tapestries were intended for sale, but
Gloria could afford to build her personal col-
lection of Navajo rugs, which she eventually
donated to the Denver Art Museum. The tap-
estry commissions remained cross-cultural,
cross-country puzzles, even as they provided
an important and continuing source of income
to native weavers.

In contrast, Ramona Sakiestewa grasped
Gloria's larger purpose and the importance
of her professional studio taking a role in the
project. In a public lecture, she commented,
"Gloria Ross's commissions . . . were very big.
Also, they were somebody else's works and
we were obsessed about precision. You have
to get over the fact that it's not really your
work. You want it to be even better than your
own work."[49] Indeed, in the years following
the Native/Noland tapestry project, GFR Tap-
estries may have inspired Lee Cohen of Gal-
lery 10 to commission thirteen tapestries
from the designs of Frank Lloyd Wright by
the Sakiestewa studio.

The Noland/Ross Relationship

When Gloria and Noland began to collaborate,
they realized risks were involved but faced
them boldly. "I selected Noland for this series,"
she explained to Smithsonian curator William
Sturtevant, "because I admire his work, because
we have worked together successfully in the
past, because he was willing to proceed shar-
ing my doubts as to the possible success of
this new collaboration, and I knew enough
about Navajo weavings to know that these
artisans would be simpatico to the typical
geometric Noland image."

After their first discussions, it was clear
that Gloria and Noland's mutual aim was
quality. In 1982, she wrote, "If you have three
maquettes for new Navajo woven chevrons,
it would be great to have them before [a trip
to the Navajo Nation]. I have withheld weaving
of other existing maquettes. As we agreed,
the 'signature' images are probably the most
successful." In 1983, reflecting Noland's stan-
dards, she wrote, "Don't worry re: loss or
damage of maquettes. [He] cares 'more about
value & intensity than color.' Darker red for
background, or use brown. Solid colors."

At first, selected images came from
Noland's well-established repertoire. In time,
Gloria shared samples of wool and yarn with
Noland to indicate the best color palettes for
Navajo weaving. "The first weavings were based
on existing Noland images," she explained to
a colleague, "but as I came to know more of
this Navajo artistry, I brought Navajo wools
and colors back to Ken, and he then designed
specifically for their looms. Beyond what I
have done in the past, I look upon this as a
true collaboration. I do think that I achieved
my goal, and that these tapestries have dual
recognition—they are very Noland, and they
are very Navajo."

In 1985 Gloria steered Noland toward
future tapestry designs. "As to imagery, there
are a variety of stripes in work, so I recommend
that you develop one or two chevrons. The
enclosed sketches are outlines of maquettes
that include indigo blue, and I send them along
merely as suggested imagery."

She further suggested, "I require only small
(8–10" is fine) maquettes. The outlines should
be clear and to scale and the colors indicated,
but they need not be 'finished' paintings. I will
continue to make the weavings approximately
35 sq. ft. I do feel that in addition to the
chevrons, some of the most successful have
been Reflection, Four Corners, Rainbows Blan-
ket, Morning Star, Valley. Among the chevrons,

n.b. the white line above the chevron in Twilight which gave it a marvelous somewhat floating feeling. These maquettes, as opposed to Rose's [round with Ganado colors], can really have a variety of colors as Ann and I located a source of wonderfully dyed wools at a trading post we visited on our last journey. I do love the use of some natural wools, but this post also has great vegetal dyes and synthetic dyes in the wools (also part of the Navajo tradition, as you well know)."

Unlike Frank Stella and other critics who thought that designing for native weavers might somehow be improper, Noland was open to the opportunities that collaborating presented. The painter saw beyond Gloria's specific suggestions, to the weavers' particular ways of working. During the 1980s, he and his wife Peggy Schiffer visited the Navajo Nation and the Sakiestewa studio in Santa Fe, where he showed, as Sakiestewa recalled, "interest in every aspect of the weaving and the studio."

In a 1985 interview, Noland commented, "The Indians prepare their materials for weaving as I would for a painting, which involves getting the canvas and mixing my colors. The Navajos collect the wool from the sheep or use vegetable dyes. In, say, Aubusson, they do the same thing but it's not handled by one person. The Navajo tapestries are handled by one person, making it a personally expressive and interpretive event, which is compatible with me as an artist painting. I appreciate their personal and spiritual involvement."

He also noted, "I enjoy working with people in a harmonious way. . . . I'd love to fly some of the Navajo weavers to New York where I could teach them how to make handmade paper in my workshop. Art, like music, relies on collaboration."

Even if Noland wished for further contact with the weavers, he observed, "I've worked with other weavers besides those Gloria chose and feel the results weren't as successful."[50] Gloria, too, was more than satisfied: "Ken, your enthusiasm and total involvement in this project," she wrote in a 1985 letter, "is wonderful and has brought joy and success to my work."

Navajo/Ross Relationships

Gloria took pleasure in learning about Navajo culture, adapted as best she could to different sensibilities, and saw humor in the striking cultural contrasts between her New York approach and that of the Navajo weavers. "I would travel for hours and they'd say 'No,' or say, 'Meet me' and then be gone for a week," she recalled. "Some said they would do it, and then I'd go back to the reservation and for one reason or another, they hadn't done it; so I'd have to start all over again."[51] She described one such situation to me, "Of course, I am well educated to Navajo time, and I took this news [of a delay in completing a tapestry] in my stride and replied graciously and tactfully, not sounding the tense New Yorker. When I call about the holidays, I will inquire again about its progress." Despite her own punctuality and strict standards for timely responses, Gloria came to understand that Navajos operated with different priorities. Their schedules had to accommodate entire sets of activities and responsibilities that hers did not—rural roads and unreliable transportation, livestock

Gloria greeting Mary Lee Begay and son Johnny Begay, Denver, 1992

Gathering of weavers during exhibition opening at the Denver Art Museum, 1992. *Left to right*, Barbara Teller Ornelas, Irene Julia Nez, Ann Hedlund, Mary Lee Begay, Grace Henderson Nez (seated), Gloria Ross, Irene Clark, and Ella Rose Perry.

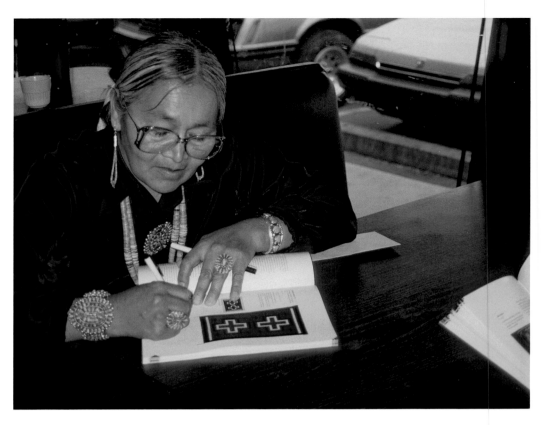

Mary Lee Begay taking credit for her work at a book signing, Denver, 1992

needs, inclement weather, extended family obligations, religious observances, and many other events an outsider could not predict. Whether because she worked with Navajos later in her career, or maybe just because of cultural deference, she was certainly more sympathetic to Navajo weavers than she had ever been to the French workshops.

Gloria developed strong personal friendships with several Navajo women and their families, and her generous sentiments are clear in the letters she wrote them. From a 1990 letter: "Dear Rose, Here is the additional gift which I told you would come in the mail, to help you buy replacements for possessions you lost in the fire. I know that in so many ways one's home cannot ever be replaced, but in some small way I hope that this will help." She sent the women money for weddings, new babies, and funerals, as well as good wishes, congratulations, and encouragement.

In 1995 Irene Clark received the prestigious Women in the Arts Award from the College Art Association, presented in San Antonio, Texas. Gloria fired off a warmly worded note, "My heartiest congratulations on your recent award, which you so richly deserve. . . . I have admired your artistry ever since I first saw it. And, dear Irene, you must know how very much I admire the artist herself. I treasure our friendship. I send love to you and trust that you and your wonderful family are all well. Good wishes, and again congratulations."

Gloria's interest expanded easily to acquiring works the weavers had made independently of her commissions. She wrote to her good friend and professional publicist Caroline Goldsmith in 1984: "During the time I spent on

the Reservation, I found Navajo weavings to be quite irresistible, and I have now almost completed a collection of the finest contemporary weavings for the Denver Art Museum. I hope that in addition to exhibiting the Noland imagery, that my DAM collection and eventual exhibitions will also make a statement about their superb artistry and craftsmanship. Working in both my professional capacity as well as with the DAM collection I anticipate will benefit Anglos and Native Americans. Many of the latter live below poverty level, and they and their abilities just begin to be appreciated in our contemporary society."

The Navajo Nation's official perspectives on native arts and their status attracted Gloria's attention. During an April 1981 trip she and I met with Wanda McDonald, wife of Peter McDonald, then tribal president. In Mrs. McDonald's tribal offices at Window Rock, the Navajo Nation's capitol, the First Lady and Gloria discussed the tribe's programs for Navajo children in both performing and visual arts, including opera and ballet, although Mrs. McDonald downplayed native crafts like weaving. They also talked about the need for reservation

Navajo weavers at the symposium, Navajo Weaving Since the Sixties, The Heard Museum, Phoenix, 1994

libraries, the growth of museum collections, and a potential exhibition of the Navajo rug collection then forming at the Denver Art Museum.

Gloria formed friendships and found a new cause to champion through her Native/Noland projects—she believed that American Indian artists could stand shoulder to shoulder with fine artists from the rest of the globe. A note made in 1989 while we prepared exhibit labels revealed her ultimate concern for the recognition of Native American weavers. She wrote, "One miscellaneous but important thought is that the name of individual weavers (as opposed to the more anonymous weavers in a large workshop) should always be noted."

Acknowledging the weavers' perspectives, she summarized in one letter, "I am pleased to report that they are happy with these endeavors. We have become great friends, and each one has asked to work with me again." Speaking for herself, she concluded in another essay, "I am satisfied that the resultant tapestries have achieved my goal of dual recognition—they are very Noland and very Navajo."

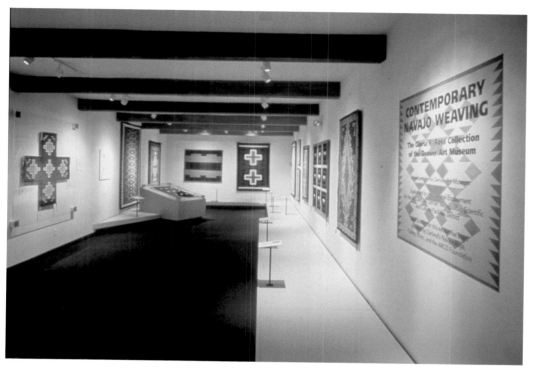

Exhibition of Contemporary Navajo Weaving, The Heard Museum, Phoenix, 1994

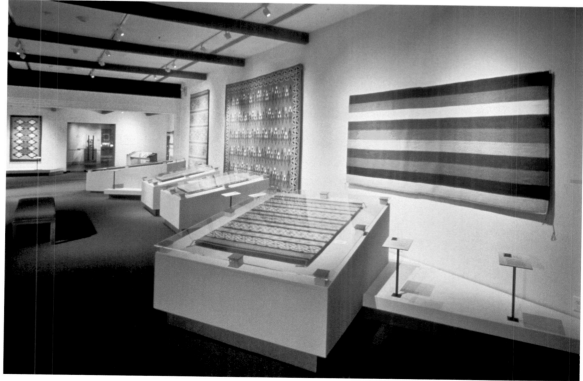

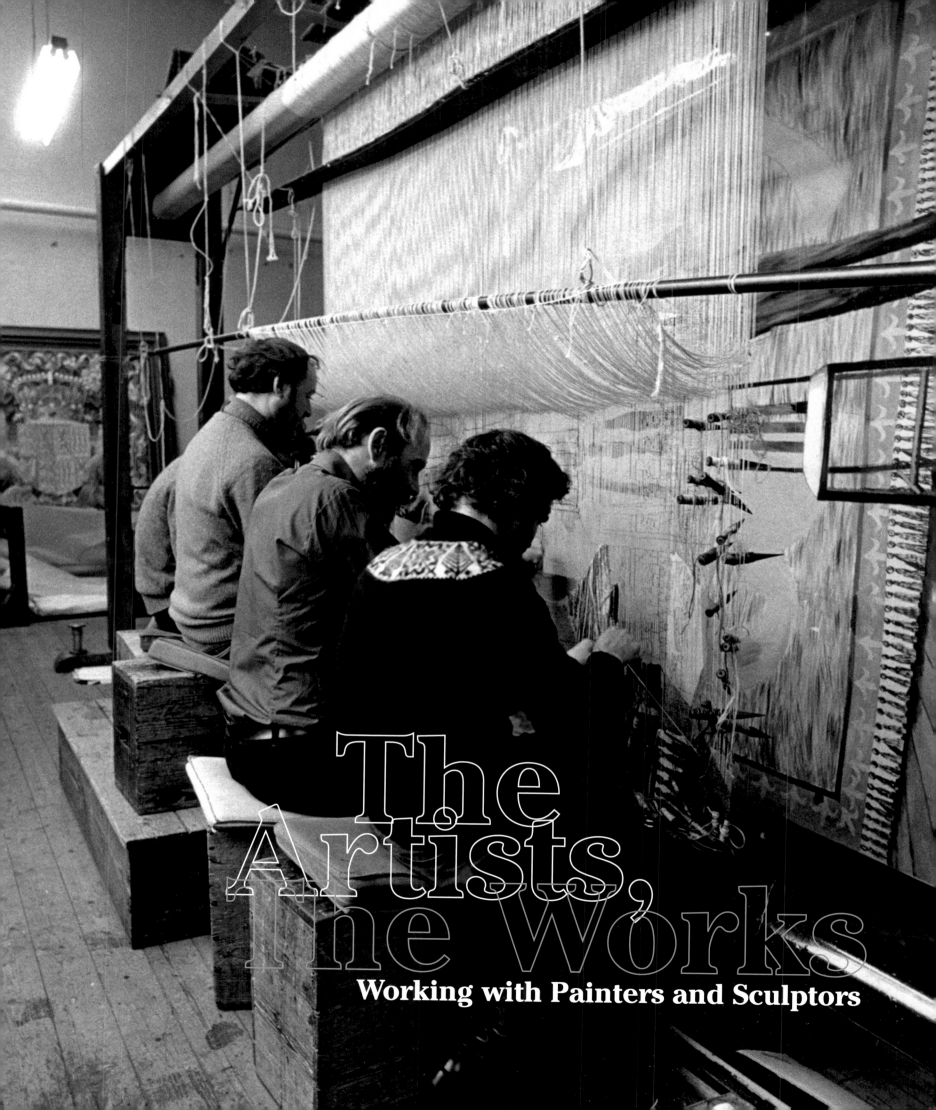

The Artists, The Works

Working with Painters and Sculptors

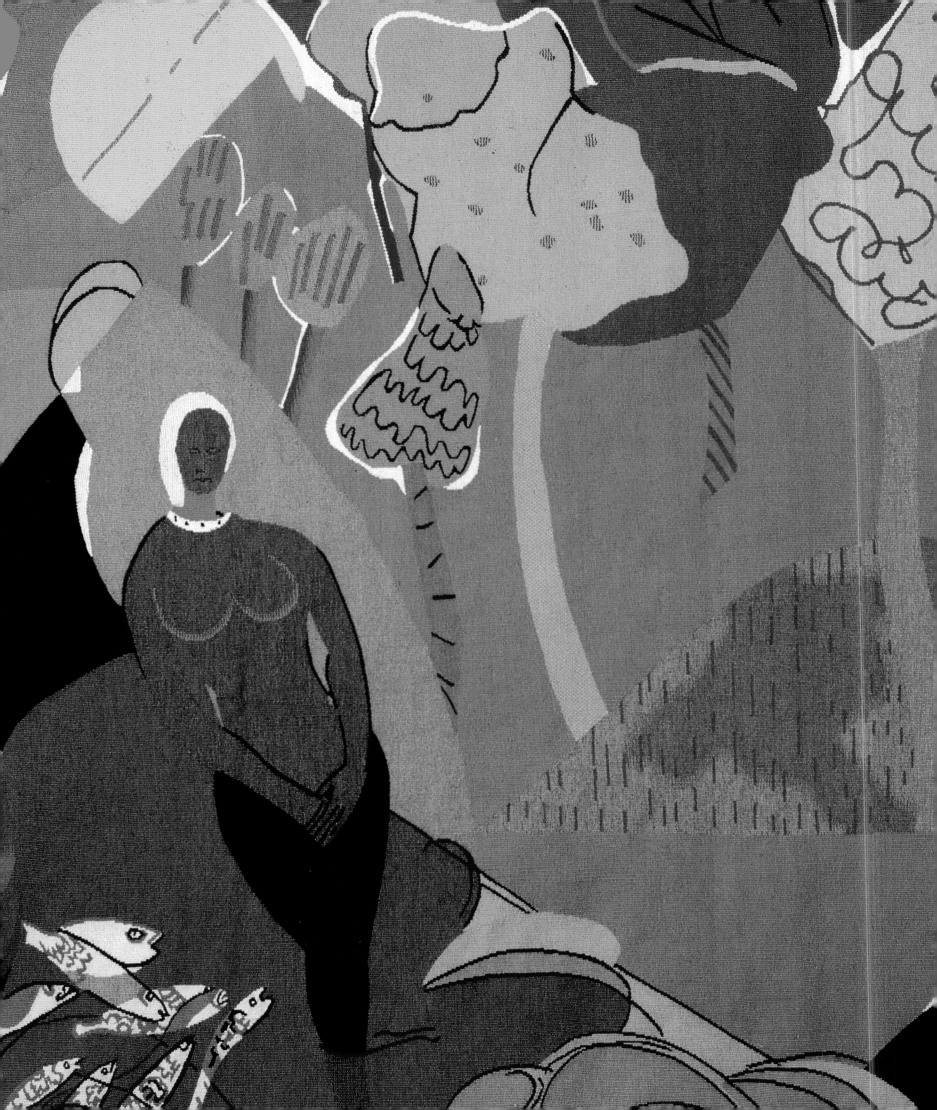

Chapter 8

The Gloria F. Ross Tapestries & Carpets

Artists are often intrigued by the
translation process when their
work becomes a mural, major
sculpture, or a tapestry.
—Richard Solomon[2]

**Gloria F. Ross Tapestries are
distinguished by their diversity
and individual character.**
—Gloria F. Ross[1]

Representing many artistic styles of the mid- and late twentieth century, twenty-eight artists designed GFR Tapestries & Carpets. Gloria selected extant paintings by early modernists Milton Avery, Hans Hofmann, Adolph Gottlieb, and Stuart Davis. Iconic works of abstract expressionism by Helen Frankenthaler and Robert Motherwell became iconic GFR Tapestries. Imagery based on color field, hard-edge, and pattern painting came from Kenneth Noland, Frank Stella, and Jack Youngerman, along with Richard Anuszkiewicz, Gene Davis, Paul Feeley, Al Held, Alexander Liberman, Larry Poons, and Richard Smith. Sculptors Jean Dubuffet and Louise Nevelson offered shaped canvases and complex collages, challenges for executing unique tapestries in bas relief. The flowing techniques of Paul Jenkins and Morris Louis and the crusty impasto of Clifford Ross were likewise transformed into wool. Modernist collages by Romare Bearden, Robert Goodnough, and Conrad Marca-Relli presented layered planes of color for crisp renderings. Finally, the figurative imagery of Romare Bearden, Richard Lindner, Mark Podwal, Lucas Samaras, and Ernest Trova added further depth to the GFR collection of translated works.

Through her sister Helen Frankenthaler and brother-in-law Robert Motherwell, and the museums and galleries that they all frequented, Gloria knew many artists socially. She maintained a wide circle of friends and associates who furthered connections with accomplished artists. Later she met others through her professional work with galleries, especially Feigen and Pace Editions. A few she sought directly after seeing work on exhibition and in public spaces. Tapestry and textile history books lined her office shelves, and a library of art books and gallery catalogues covering the leading artists of the twentieth century filled one wall of her large living room.

Maquette is the traditional term for an original artwork after which a tapestry (or sculpture) is made, regardless of whether a translation of the model was initially planned. "When I work from maquettes specifically designed for my tapestries," Gloria noted, "I feel I eke out some of the artist's finest works."[3]

More than half the tapestry and carpet designs (fifty-eight out of ninety-six) came from original art intended specifically for translation to fiber. These included twenty-four Noland designs and nine Nevelson collages, all woven as "uniques." For nine singular commissions, Frankenthaler, Motherwell, Podwal, Smith, and Youngerman created original works for Gloria and collectors. Anuszkiewicz, Bearden, Dubuffet, Goodnough, and Trova painted fresh imagery for sixteen titles that were woven in multiple editions.

The production of multiples is considered standard by traditional weaving studios—five examples were approved for each hooked rug title, five for tapestries woven at the Dovecot, and seven for French tapestries. Each suite could also include one or two artist's proofs, which were generally identical in appearance and construction to the numbered series and assigned 0 and 00 (as in 0/5 and 00/5). Whereas forty-eight designs for GFR Tapestries & Carpets were made as unique works (each labeled 1/1), twenty-three were authorized as editions of five, eighteen in editions of seven, one commercial carpet in an edition of twenty, and two carpets in editions of one hundred. (Originally, the Stuart Davis tapestries were planned as exceptional editions of three, but only one of each was woven.) Counting all known examples, at least 248 GFR Tapestries & Carpets exist and almost two hundred of these panels belong to editions of five or more.

Detail, Romare Bearden, "*Recollection Pond*,"
1974–90, woven by Pinton. (See plate 5.)

Other Artists Approached

For understanding Gloria and her work, the projects not realized are as important as the most successful ones. Her extensive documentation reveals a creative persistence; she usually kept the door open for future projects.

Gloria approached an international array of artists who might design for her, but for various reasons never did. The diverse group includes Romanian-born Israeli painter Avigdor Arickha, Swiss artist Max Bill,[4] photographer Marie Cosindas, Australian artist Virginia Cuppaidge, Salvador Dalí, color field painter Thomas Downing, designer and stylist Erté, illustrator Edward Gorey, painter Jasper Johns,[5] abstractionist Ellsworth Kelly, African American painter Jacob Lawrence, American pop artist Roy Lichtenstein, French architect Le Corbusier,[6] Egyptian calligrapher and painter Ahmed Moustafa, the elusive Georgia O'Keeffe, and British sculptor Henry Moore.[7] A few anecdotes will serve to illustrate Gloria's perseverance.

Not Working with Georgia O'Keeffe

Correspondence between the hopeful éditeur and Georgia O'Keeffe (1887–1986), one of only a handful of female artists Gloria considered, spanned eight years.[8] Gloria imagined doing an original O'Keeffe tapestry with Archie Brennan at the Dovecot. Things started hopefully, as O'Keeffe replied in her own hand to the initial request: "Dear Mrs. Ross: I would be very interested in working with you to develop a tapestry but at the moment there are other things I have to attend to. In two or three months I would be pleased to undertake it. Would you write me again around that time to remind me? Sincerely, Georgia O'Keeffe."

A second letter dims the prospects for a lengthy visit, which as O'Keeffe wrote "would be quite impossible for me. If you would like to come for perhaps an hour you may. Sincerely, Georgia O'Keeffe."

Gloria's letter a week later, in contrast to the painter's characteristically spare wording, came frantically packed with details of travels and tapestry making. When she again requested a visit in 1973, O'Keeffe sent a $5.00 collect cable: "SORRY BUT WILL NOT BE HERE GEORGIA O'KEEFFE." Gloria wrote again in 1976 and 1978, each time proposing to work in any way the artist might like, "from a maquette painted especially for tapestry or from an existing image . . . as you wish." In 1976, a reply from Doris Bry in Abiquiu said, "Georgia O'Keeffe . . . does not wish to have any tapestries made of her paintings, and as her visitor schedule and work schedule are heavy, she prefers that you not visit." Gloria sent a final proposal just as she began plans to work with Navajo weavers in the Southwest. O'Keeffe responded, "I have so many projects I am working on now, including a major show

of abstractions, that I do not feel able to begin any other projects. Thank you for your interest."

Not Working with Henry Moore

Gloria's approach to British sculptor Henry Moore (1898–1986) was complicated by the frank views of master weaver Archie Brennan.[9] In 1972 she studied Moore's drawings and other works at the Knoedler Gallery in New York. There she found Moore's "Ideas for Textile Designs, 1945, 6¾ × 9¾, black, chalk, pencil, with an eye toward tapestry translations." When she approached the artist specifically in terms of working with her and his fellow countryman Archie Brennan, Gloria received an encouraging reply from Ronald Alley, the Tate Gallery's keeper of the modern collection, suggesting that the artist would like to have a tapestry made from one of his extant drawings but would prefer not to make one expressly for the tapestry. He invited her to view the drawings with Moore so they could make the selection together. He continued by saying that Moore was quite satisfied with an earlier tapestry made by "the Edinburgh people" from one of his artworks. (For more about Moore's tapestries woven by Gerald Laing's Scottish studio, see chapter 9.)

Gloria in turn wrote to Brennan: "About the Moore: I receive word that his enthusiasm is such that he called London from Italy to say he does want to proceed. . . . I would be able to work with Moore on the selection of an early drawing (I know just what I would like to work from). Only *you* could translate it and (need I say more?) I do hope that you will."

Gloria remained eager, but Brennan was reluctant and explained: "*HENRY MOORE.* I do not think it's a good idea. Obviously there are short term attractions, in that *anything* by Henry Moore seems to be a very saleable commodity, carrying much prestige, but since I began weaving, I've been aware of this conflict which began as early as Raphael and Rubens. Weavers have struggled with it for centuries and succumbing to it has brought long periods of troubles. Initially, anything woven well in tapestry has appeal, simply because of the changes, but very quickly this appeal passes and one is left with the real issues of the work. I feel that it is simply that great works in one medium do not necessarily mean great work when put into tapestry. It is wrong to say that Moore could do nothing that would make a good tapestry or that all Motherwells make good tapestries, but I haven't seen a Moore drawing that would not be strained in Tapestry. The delicacy, spontaneity and freshness just can't be woven and always looks stilted. We wove one here around 1950 and I have seen pictures of Gerald [Laing]'s, neither successful. And I cannot see Moore being any more interested than to pick out a drawing or two from a

folder rather than accept the kind of involvement needed. Am I wrong? Obviously, it is important to you and at least I must do what I can to go along with you. Is there any possibility that when next you come over, we meet and look at some Moore drawings together?"

At the same time, ostensibly because he was working intensively on a series of etchings, Moore declined Gloria's request for a visit. After she inquired again about a meeting, he sent a final cable saying that because of pressures from his own work he would not be able to do a tapestry. The episode ended when Brennan sent a postcard to Gloria containing a single sentence: "No Moore is for me frankly."

The Artist Entries

In the sections that follow, the artist's birth and death dates and locations appear in parentheses, followed by their principal places of residence and work. Titles of tapestries and carpets appear within quotation marks. Titles of tapestries and carpets made from original designs (maquettes) and titles of works in other media are italicized. Titles of tapestries and carpets made from an extant painting, drawing, print, or collage are designated as "after *Original Title*." For full provenance and detailed information on each tapestry and wall hanging, see the Checklist of GFR Tapestries & Carpets. Unless otherwise noted, all quotations from correspondence and references to Gloria's commentary are taken from the GFR Papers.

**His imagery and colors challenge how
we see, and how we think we see.**

RICHARD ANUSZKIEWICZ
(b. 1930, Erie, PA), New York, NY

Trained at Yale during the 1950s under famed colorist Josef Albers, Richard Anuszkiewicz became known for combining geometric imagery and intense color. Closely associated with the op art movement during the sixties, he developed a purely abstract style that explored optical vibration and "perceptual abstraction." Put simply, his imagery and colors challenge how we see, and how we think we see. In a 1963 interview, the artist noted, "My work is of an experimental nature and has centered on an investigation into the effects of complimentary colors of full intensity when juxtaposed, and the optical changes that occur as a result."[10] His work received international acclaim when shown in The Responsive Eye, a 1965 exhibition of optical art at the Museum of Modern Art. The artist's career is said to have "suffered an undeserved eclipse in the early 1970s," which may have provided a short-term impetus to explore tapestry as a new medium. Reappraisals in the twenty-first century have positioned him as a highly influential colorist.[11]

"Purplish-Cool Rectangle" and "Purplish-Warm Rectangle" (plates 1, 2)

Gloria felt Anuszkiewicz's work was a match for the refined dyeing and graphic nature of contemporary French tapestry weaving. Indeed, he already had one tapestry in the works with Arras Gallery at 29 West 57th Street when she approached him. She visited the artist's studio, where they began planning a tapestry in June 1971. He brought an initial design to her Park Avenue home in September, but it contained an intractable series of diagonal lines. Gloria consulted with a French weaver, who wrote, "A weaving on the diagonal would be possible. But it would deform

the lines which would become like stairs. Anyhow, the tapestry would be of a very high price which would make the sale very difficult. So, I think we are to give up this project, and expect a better one from him." Gloria and the artist, whom she began addressing as Dick, discussed the puzzle. She assured the weaver, "We are both aware of changes he must bear in mind as he works on this new one."

The results were "Purplish-Cool Rectangle" and "Purplish-Warm Rectangle," a complementary pair of designs made expressly for tapestry. The densely colored pattern of concentric rectangles was named only after the artist viewed the first completed tapestry. His maquette consisted of an unstretched canvas painted with one-quarter of the proposed design at the intended scale. The second of the pair was represented simply by a series of colored stripes on the lower portion of the same canvas, reflecting a new color sequence for the same geometric pattern.

The artist became actively engaged in reviewing all colored yarn samples and woven trials. On March 1974, Gloria's notes relate, "RA at 580 [Park Avenue]—All fine but center green—same color but a *bit* lighter." The first edition of "Cool" was woven at Atelier Raymond Picaud in Aubusson in 1974. Its counterpart, "Warm," followed from the Pinton workshop in Felletin in 1975. Pinton subsequently wove all others in this highly successful suite. Gloria later termed this set, "Most difficult of all to weave," but it was clearly worth the effort as it found prominent homes in corporate collections.

Richard Anuszkiewicz, maquette for "*Purplish-Cool Rectangle*" and "*Purplish-Warm Rectangle*," 1973, acrylic on canvas, 49 × 36 in. GFR Papers; © Richard Anuszkiewicz/Licensed by VAGA, New York. Photo by Jannelle Weakly, ASM.

1 Richard Anuszkiewicz, "*Purplish-Cool Rectangle*," 1973–79, woven by Picaud and Pinton, 82 × 70 in. © Estate of Gloria F. Ross. Photo by Al Mozell.

2 Richard Anuszkiewicz, "*Purplish-Warm Rectangle*," 1973–79, woven by Pinton, 82 × 70 in. © Estate of Gloria F. Ross. Photo by Al Mozell.

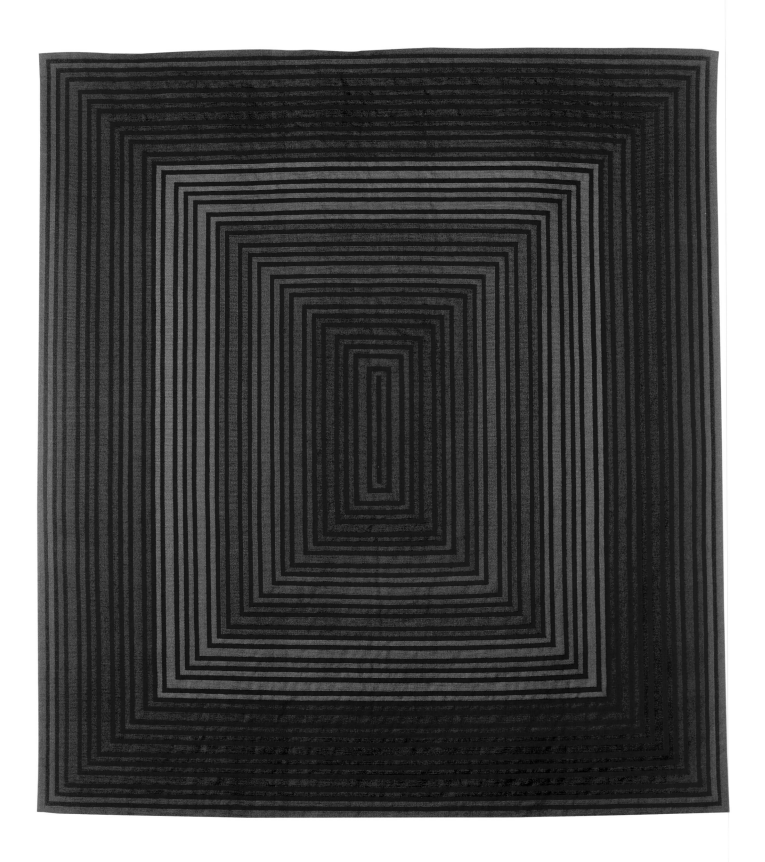

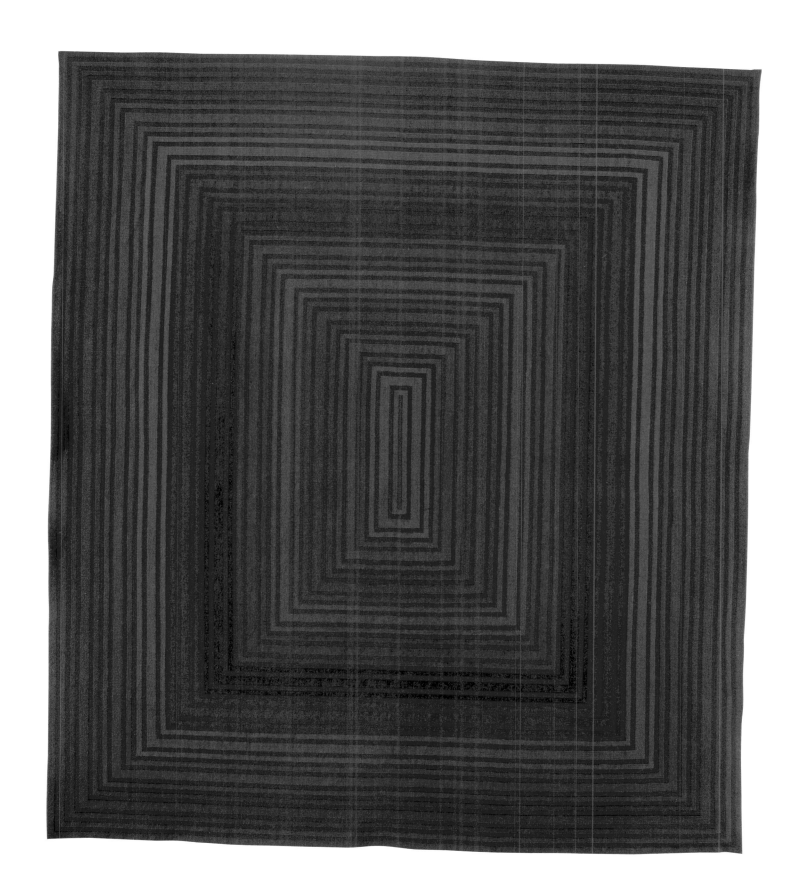

Avery's unconventional surging . . . areas of color . . . [and] daring disregard of traditional compositional principles.
—Katharine Kuh

how he manages to keep his pictures cool in key even when using the warmest hues; with exactly how he inflects planes into depth without shading."[13]

Associated with the Art Students League in New York from the 1920s to the 1930s, both Avery and his wife Sally became members of the Provincetown arts colony in the 1950s. His near minimalist landscapes and spare figure studies are often credited with becoming "a foundation stone for abstract expressionism," influencing painters such as Hofmann, Gottlieb, Rothko, and Newman.

In 1973, without prior acquaintance, Gloria phoned the artist's widow about making a tapestry. Known professionally as Sally Michel (1902–2003), she was a painter and illustrator in her own right. Married to Milton since 1926, Michel served as her husband's professional and social intermediary throughout their careers. When Gloria first approached her as executor of the Avery estate, she agreed, noting that Charles Slatkin was also working on some Avery tapestries for Gloria's sole American competitor, Modern Masters. A warm friendship grew between the two women, who shared not only a love of Manhattan but also visits in the Hudson countryside. They exchanged handwritten holiday notes for almost twenty years. (Michel's were illustrated with her drawings.)

MILTON AVERY
(b. 1885, Altmar, NY; d. 1965, New York, NY), New York, NY

Milton Avery has been called, "one of the most individualistic painters in the 20th century [who] cannot be associated with any modern movement or style."[12] His work puzzled and entranced even critic Clement Greenberg, who wrote, "It is difficult to account for the individuality of Avery's art. . . . There is the sublime lightness of Avery's hand on the one side, and the morality of his eyes on the other: The exact loyalty of these eyes to what they experience. The question has to do with exactly how Avery locks his flat, lambent planes together; with the exact dosage of light in his colors (all of which seem to have some admixture of white); with exactly

"after *Dunes & Sea II*" (plate 3)
With Arne Glimcher's advice, Gloria and Sally Michel selected a dramatically simple oil painting, *Dunes and Sea II* (1960), from Avery's estate. Gloria's June 1973 notes say, "Arne favorite but may be too subtle." This painting certainly represented what curator Katharine Kuh describes as "Avery's unconventional surging and at times palpitating areas of color . . . [and] daring disregard of traditional compositional principles."[14] Gloria's own role as colorist and translator emerged as she took notes on the original work: "texture of canvas comes through. clouds less definite. sky is silvery, grey, not blue. clouds are lighter areas in the blue . . . mauve should be a bit lighter + with a *very* little bit more pink. Can have subtle shadings as in [Frankenthaler's] Wichita pink sample." In July that same year, Gloria

Gloria and Sally Michel discussing a project, 1973. Photo by March Avery.

Yarn in the form of a *chapelet* (rosary) for an Avery tapestry

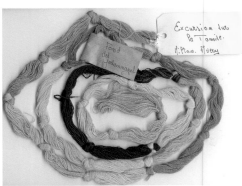

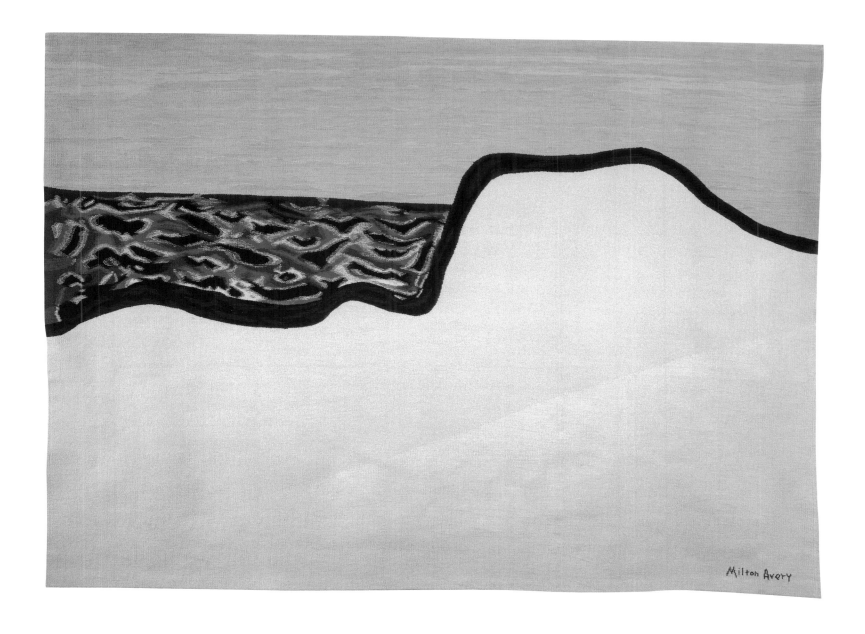

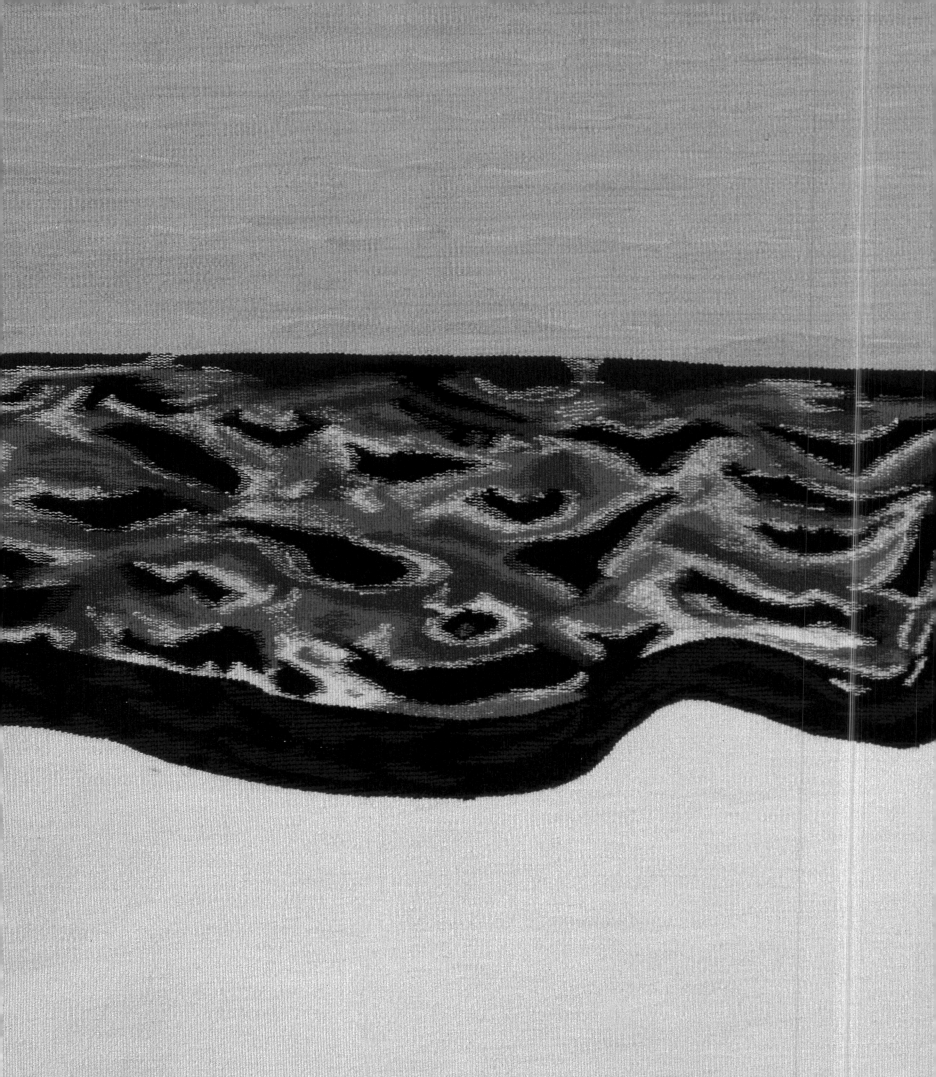

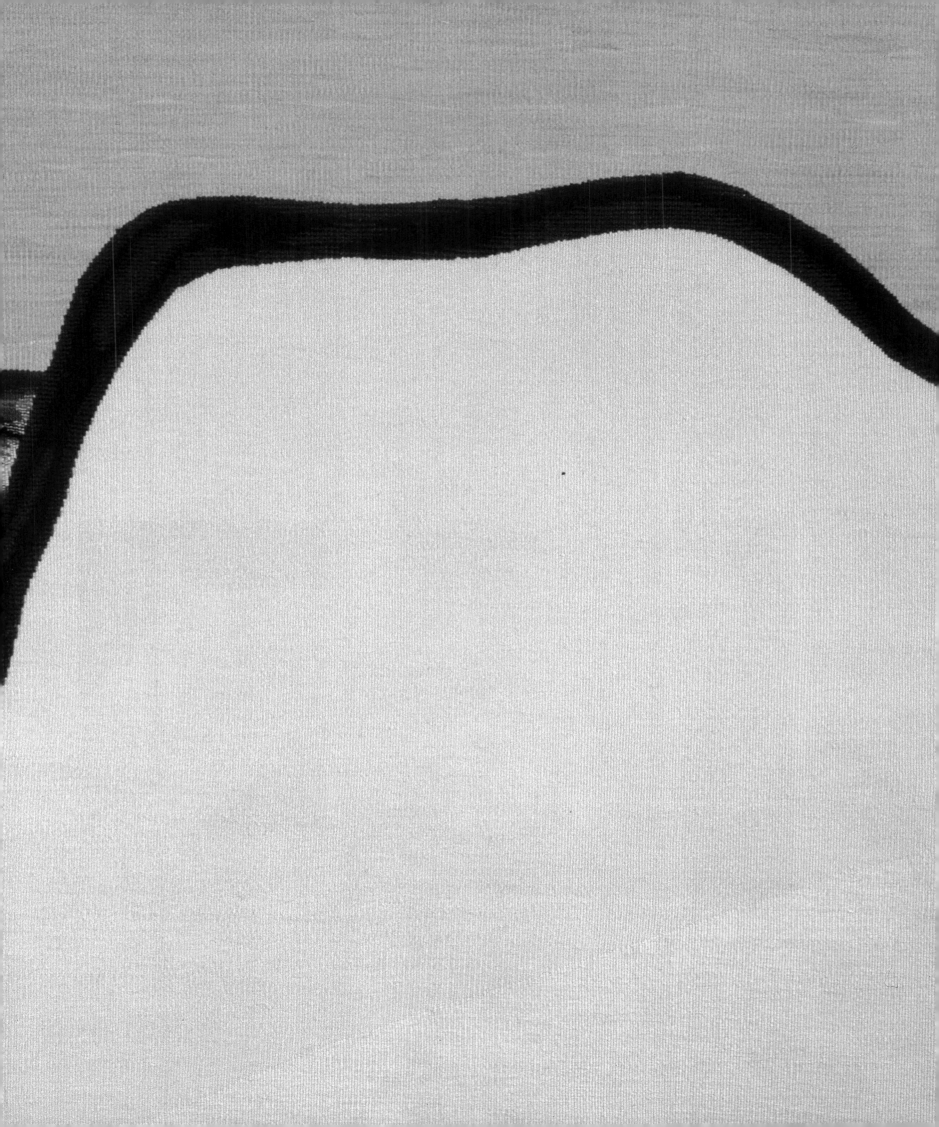

took dyed yarn samples from France to Michel's Woodstock, NY, home, where the two discussed the details of color shading.

A note by Gloria suggests that the studio "should weave right side up so breathes—*interpret* sky." Because the first weaver selected was "unable to capture essence of image," Gloria turned to the Atelier Pinton, where a successful series was woven.

"after *Tree and Mountain*"

In the 1980s, Ross made plans with Michel, the Pinton workshop, Micheline Henry, and Patrice Sully for a tapestry after the painting *Tree and Mountain* (alternately titled *Fir and Mountain*). Gloria wrote to Sally, "The weaver prefers to await a specific order before weaving *Tree + Mountain*," noting that in those days, the studio was responsible for the cost of manufacture. The tapestry was never completed.

"after *Excursion on the Thames*" (plate 4)

In 1990, the two women, accompanied by the Averys' daughter March (b. 1932, also a painter), chose a third oil painting, *Excursion on the Thames* (1953). They discussed with excitement the prospect of weaving a border of metallic threads around the image, as the artist often used plain gilt frames for his original canvases. They even sought examples of historic tapestries woven with borders resembling elaborate carved frames in gold. When the tapestry was executed in Aubusson (only one of the edition was ever produced), they chose a simple gold-colored woven border to enclose the central image. Apart from Gloria's project, the same imagery also appears in a commercial pile-weave carpet without a framing border, likely produced by Modern Masters around the same time.

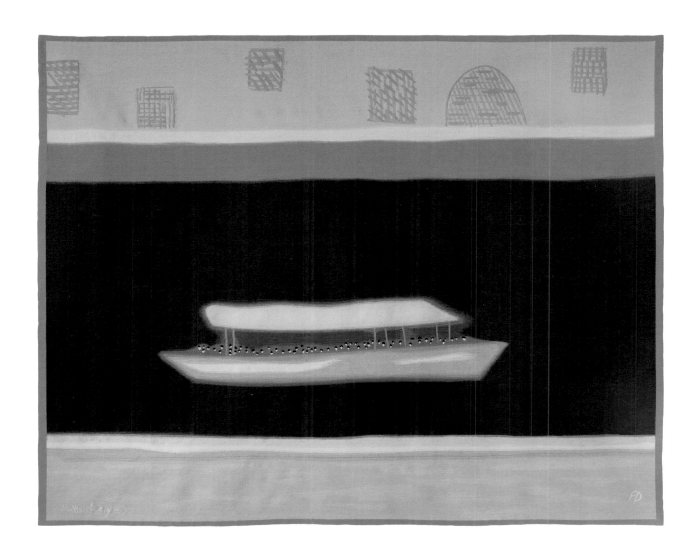

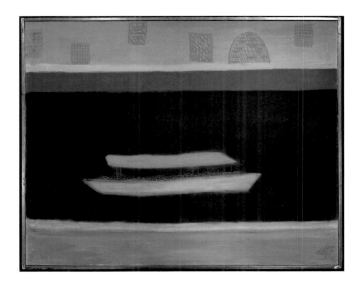

Milton Avery, *Excursion on the Thames,* 1953, oil on canvas, 40 × 50.4 in. Ex-collection Sally Avery; © Milton Avery Trust/Artist Rights Society (ARS), New York. Photo by Malcolm Varon.

Modern jazz and the tropical colors of the Caribbean were his special muses.

ROMARE BEARDEN

(b. 1911, Charlotte, NC; d. 1988, New York, NY), New York, NY

Known as a Harlem Renaissance painter, Romare Bearden embraced a variety of approaches, from social realism and figurative work to vibrant abstraction. A student of George Grosz at the Art Students League in New York during the 1930s, he studied philosophy at the Sorbonne in 1950. Thereafter he made his home above the Apollo Theater on 125th Street in Harlem. His best known collaged paintings, or painted collages, celebrate African American experience in the twentieth century, while showing influences from European modernism, African tribal art, Asian patterning, and other sources. Modern jazz and the tropical colors of the Caribbean were his special muses.

"Recollection Pond" (plate 5)

The only African American artist to work with Gloria, Bearden visited Pace Editions gallery with Dick Solomon and her in 1973 and again in early 1974, each time viewing and discussing various works that might serve as tapestry maquettes. Gloria later recalled that she asked for "something with trees," but otherwise left the design to the artist. One particularly appealing published work was a painting called *Girl Bathing*, but its location was uncertain. In March, Gloria noted, "When G called re tracing *Girl Bathing* orig., said'd do new maq[uette] within week or so—will simplify for tap[estry]." For the new tapestry model, Bearden combined his trademark watercolor and collage techniques. By early May, the artist, Gloria, and Pace agreed on an image to translate.

Gloria selected the Pinton atelier to weave this edition of seven plus one artist's proof in a fine, flat tapestry technique. Only after the first edition was completed did Bearden name the tapestry "*Recollection Pond*." His imagery evokes an almost mystical landscape, a secret place. Of his work at that time, another writer observed, "With his paintings of the 1970s, Bearden achieved visual simplicity and epical effect. In these mostly large-scale works, landscape and architecture function like stage props. Figures appear as if on an opera stage, seemingly less significant than their environment, and demonstrating the use of compositional devices Bearden learned from studying Dutch and Chinese painting."[15]

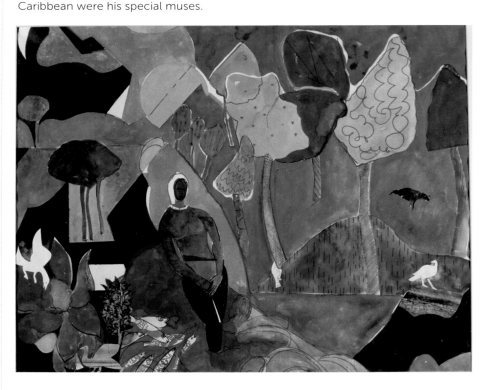

Romare Bearden, maquette for "*Recollection Pond*" 1974, watercolor, ink, and pencil on paper, 18 × 23.5 in. The Metropolitan Museum of Art; © Romare Bearden Foundation/Licensed by VAGA, New York.

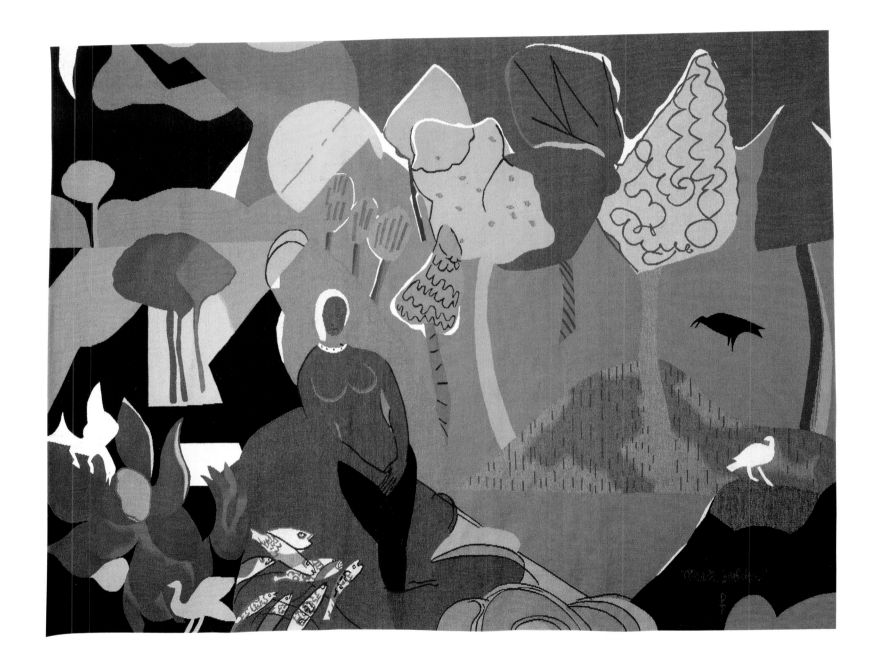

"Mille Fleurs" (plate 6)

A second tapestry suite followed in 1976, when Gloria asked Bearden if he would work on another tapestry in a unique manner—that was, if she proposed a title, would he design the imagery? Her suggestion was *Mille Fleurs,* after the common name for medieval tapestries with thousands of flowers strewn across their backgrounds. His reaction was a bouquet of tropical blossoms, a modern still life.

After Bearden's death in 1988, Gloria and the artist's widow, Nanette Rohan Bearden (d. 1996), worked together on subsequent editions of both tapestries. Although they discussed new work, nothing was initiated. Casual correspondence continued with great warmth between the two women for the rest of their lives.

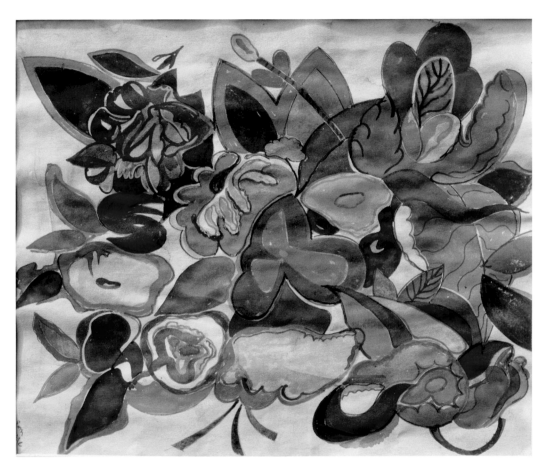

Romare Bearden, maquette for "*Mille Fleurs,*" 1976, watercolor on paper, 16 × 18 in. © Romare Bearden Foundation/Licensed by VAGA, New York.

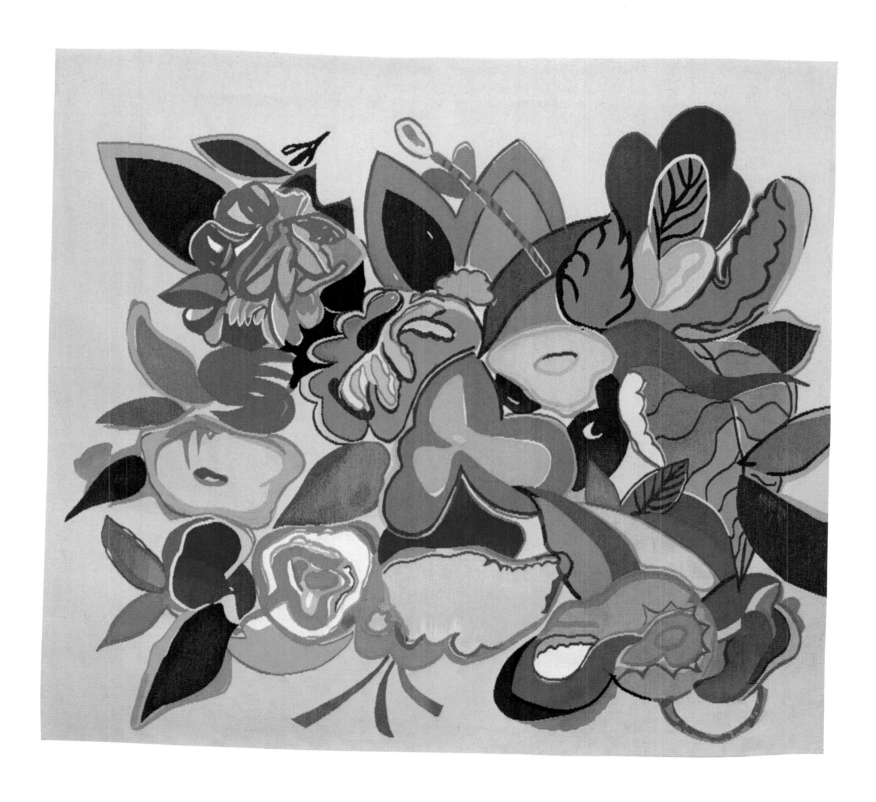

Davis

GENE DAVIS

(b. 1920, Washington DC; d. 1985, Washington DC), Washington DC

A friend and protégé of Kenneth Noland, Gene Davis was a prominent Washington color field painter. In the late 1950s, he pioneered the frank use of masking tape to prep canvases and create hard-edged stripe patterns, avoiding alliance with the more painterly abstract expressionists. Through the 1960s, he explored complex color intervals on equal-width stripes while adding monochromatic paintings to his repertoire. Eventually, his work expanded to include varied stripe widths, unpainted raw canvas, softer stained imagery, and outdoor geometric paintings on a large scale.

"after *Lincoln Center*" (plate 7)

In early 1972, Gloria met Davis in Washington, at the suggestion of mutual friend Gene Baro, then acting director of the Corcoran Gallery of Art. Later she acknowledged that considering Davis was Baro's "brainchild." Given the artist's reputation for experimenting beyond conventional painting, he was a good candidate for translating his medium to handwoven tapestry.[16]

Davis began planning a large study for a tapestry, but he later noted that his first two trials, somewhat ironically for a color field practitioner, didn't have "enough color" for Gloria's purposes. The artist remained eager, "If I can help in any way, please don't hesitate to get in touch. I would hate to have anything happen to interfere with your project to do a tapestry of my work." A day later he wrote, "I do not mind your expanding one of my paintings to fit your needs. My only objection would come if you change the sequence, the intervals or any of the colors. But you may expand or contract at will, if you happen to see a promising painting. I'll be interested to hear if you find something. In the event you do not, please let me know and I'll try to execute another study more along the specific lines you are interested in. Cordially Yours, Gene." Gloria selected *Lincoln Center* from Fischbach Gallery, the artist's Manhattan representative on 57th Street, and one week later they signed a contract.

For accurate color sequencing, Davis and Gloria provided cut strips of stripe-painted canvas from the back of a painting to the weaver. In fact, Gloria noted that Aledor Marburger, the gallery director, "cut off back of pic—½ for G—½ for Pinton."

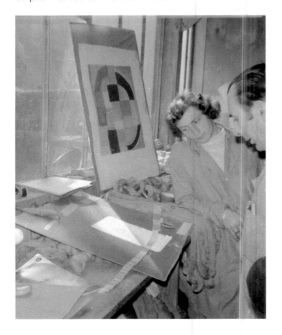

At the Pinton atelier, Felletin, France, 1972. Note the strip of Davis's painted canvas. Photographer unknown.

138

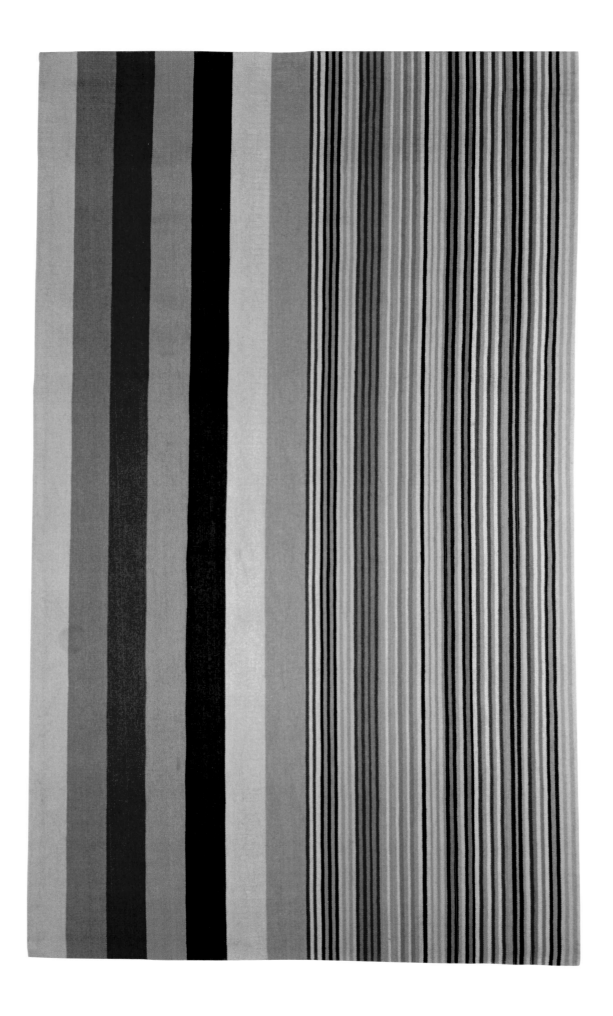

STUART DAVIS
(b. 1892, Philadelphia, PA; d. 1964,
New York, NY), New York, NY

Stuart Davis was called a "great American Modernist" and "a great brash chronicler of the urban American scene" by *Time* art critic Robert Hughes. He "had always liked the American vernacular," Hughes continued, "the look of the street, the jostle and visual punch of signs, life imagined in jazz tempo, hard-edged, Cubist-based and infused with optimism."[17]

In 1910, Davis began studying with Robert Henri, founding member of the Ashcan school of painting. Davis exhibited five watercolors in the New York Armory Show of 1913, the landmark first showing of European modernist work in America. Seeing paintings by Cézanne, Picasso, Kandinsky and Duchamp, among others, further stimulated Davis's break from realism and moved him to a more exuberant display of stylized shapes and colors. Throughout his career, he channeled the urban beat of ragtime and jazz into an idiosyncratic and form-filled approach to painting.

It was natural that Gloria became entranced by Davis's work, as it combined several of her own loves. "Stuart Davis was the American Léger," the legendary curator Katharine Kuh wrote, "a daring artist who understood the American urban landscape and the meaning of America, though he used French methods to interpret them."[18] Sharing his fascination with New York City architecture, Gloria collected several drawings from Davis's 1928–30 sketchbooks—the Empire State building, a rooftop view of the Chrysler building, Rue du Château in Paris—which she purchased from Davis's estate. She also owned one of Léger's *Contraste de Formes*.

Attracted to large-scale formats, Davis painted a number of engaging interior

murals.[19] Although he was gone by the time she was making tapestries in France, Gloria reasoned that the tapestry medium would "exemplify and complement Davis's work as a muralist."

Karen Wilkin, a friend and associate then working on the Stuart Davis catalogue raisonné, suggested that the estate might agree to a tapestry commission. Indeed, when Gloria approached Earl Davis, the artist's son and estate executor (b. 1952), he generously supported the idea, explaining later, "During his lifetime, my father expressed interest in seeing his paintings reproduced in other media so that they would be available to great numbers of people."[20]

"after *Punch-Card Flutter #3*" (plate 8)

Earl Davis and Gloria made plans with their client, Rudin Management Company, and its art advisors, architects, and attorneys, for a major tapestry for the lobby of the firm's modernist headquarters at 345 Park Avenue. The express intent was to create a "signature" piece for the landmark's main entrance, and to "contribute a major art work by an important American artist to the city's public spaces."

Early in the project, Gloria reported to a colleague, "I am fortunate in being able to work from a rather magnificent, rather strong painting which will carry the enlarging." *Punch-Card Flutter #3* (1963) was that painting, an upside-down version of the contemporaneous work *On Location*, which (along with the artist's own love of transposing letters into nonsense) partially explains the artist's inverted signature in the final tapestry.[21] From his series based on the theme of play, Davis's imagery derived specifically from a French chateau pictured in a newspaper photograph, showing a central tree and medieval architectural forms.[22]

Gloria chose the accomplished Pinton atelier to make the tapestry, "after *Punch-Card Flutter #3*," measuring 16 by 22½ feet. The preparations and weaving took almost exactly twelve months. The completed textile weighed several hundred pounds. Two years after the initial contract was signed, installation on the lobby's travertine wall became a protracted operation that required a thick sheaf of transatlantic memos, a team of men, two electric scissor lifts, weeks of planning, and tremendous patience by all.

In 1990, *On Location* was considered as a second Rudin tapestry, but Gloria's notes enigmatically but emphatically conclude with a penciled-in "NO!!!"

Stuart Davis, "**after** *Punch-Card Flutter No. 3*," 1989, woven by Pinton, 192 × 270 in.
© Estate of Stuart Davis/Licensed by VAGA, New York. Photo by Malcolm Varon,
courtesy of Rudin Management Co.

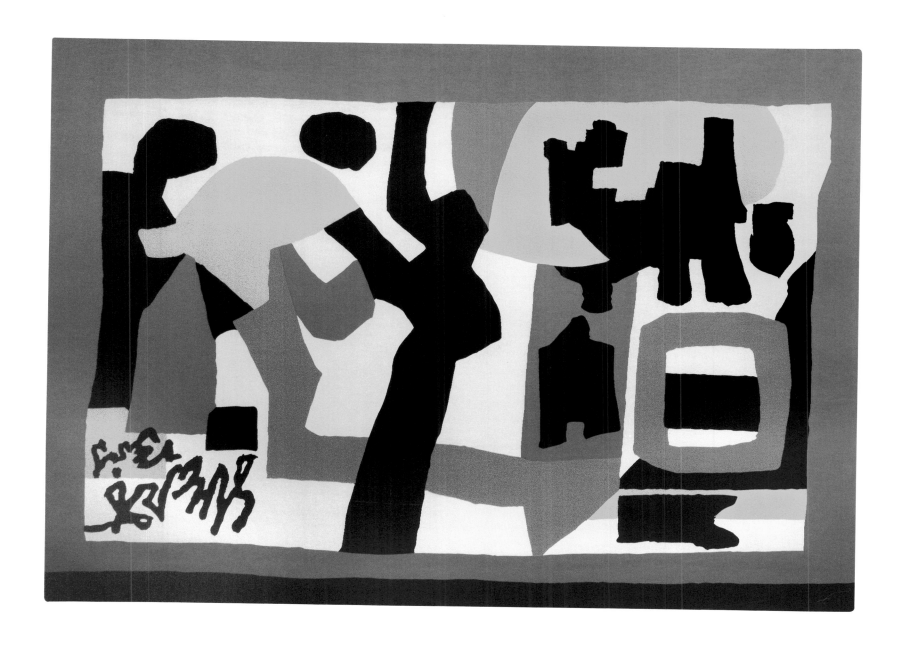

"after *Semé*," "after *Report from Rockport*," and "after *Pad No. 4*" (plates 9–11)

With an eye toward the hundredth anniversary of the artist's birth on December 7, 1892, Gloria returned to work with Earl Davis. An ambitious project of four tapestries was timed for the retrospective exhibition, Stuart Davis, American Painter, held at the Metropolitan Museum of Art and at the San Francisco Museum of Modern Art in 1991 and 1992.

After considering at least fifteen possible paintings, Gloria and Earl Davis signed contracts for four tapestries based on the paintings *Colonial Cubism* (1954) owned by the Walker Art Center in Minneapolis; *Semé* (1953) in the collections of the Metropolitan Museum of Art (and arranged through Gloria's friend Lowery Stokes Sims, then a MMA curator); and *Report from Rockport* (1940) and *Pad No. 4* (1947), both privately owned.

The powerful *Semé* had been exhibited among other American modernist paintings at the Metropolitan Museum. The artist's notes interpret his French title, literally meaning "seeded," as "scattered, dotted, powdered."[23] The tapestry "after *Semé*" covered nearly forty-two square feet, expanding the original painting's size almost threefold. The other two paintings at twenty-four by thirty and fourteen by eighteen inches were enlarged to staggering proportions—nine and twenty-five times larger than the maquettes.

Report from Rockport (1940) expanded on Davis's concept of "optical geometry," which he developed in the 1930s to explore the relationships between color and formal space. The tapestry "after *Report from Rockport*" retains Davis's reference to the coastal Massachusetts town where the artist spent considerable time. The enlarged panel appears almost as a stage set in which the chaos of post-depression life is played out.

One of five small paintings that incorporate the word *pad* into their composition, *Pad No. 4* sets forth a rhythmic set of contrasts ideal for translation into the woven medium. A fourth prospect from *Colonial Cubism* was never made.

The three tapestries were completed by Manufacture Pinton in fall 1991. Just in time to mark the Stuart Davis Centennial Retrospective at the Met, they made a splash onstage at The Fine Art of Jazz, a concert sponsored by Earl Davis and the Jazz Foundation of America and held at the Town Hall on West 43rd Street. The ensemble was exhibited in Manhattan at Gallery 10 in 1994.

9 Stuart Davis, "**after *Semé*," 1991, woven by Pinton, 88 × 68 in. © Estate of Stuart Davis/
Licensed by VAGA, New York.

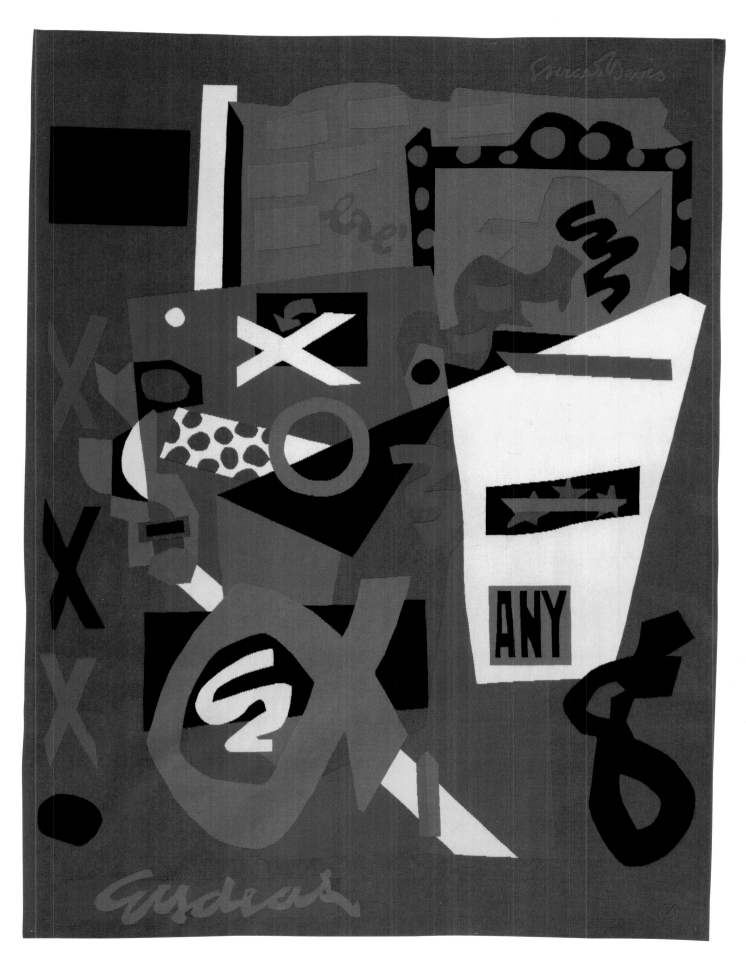

10 Stuart Davis, "**after *Report from Rockport***," 1991, woven by Pinton, 72 × 90 in.
© Estate of Stuart Davis/Licensed by VAGA, New York.

11 Stuart Davis, "**after *Pad No. 4***," 1991, woven by Pinton, 70 × 90 in. © Estate of Stuart
Davis/Licensed by VAGA, New York.

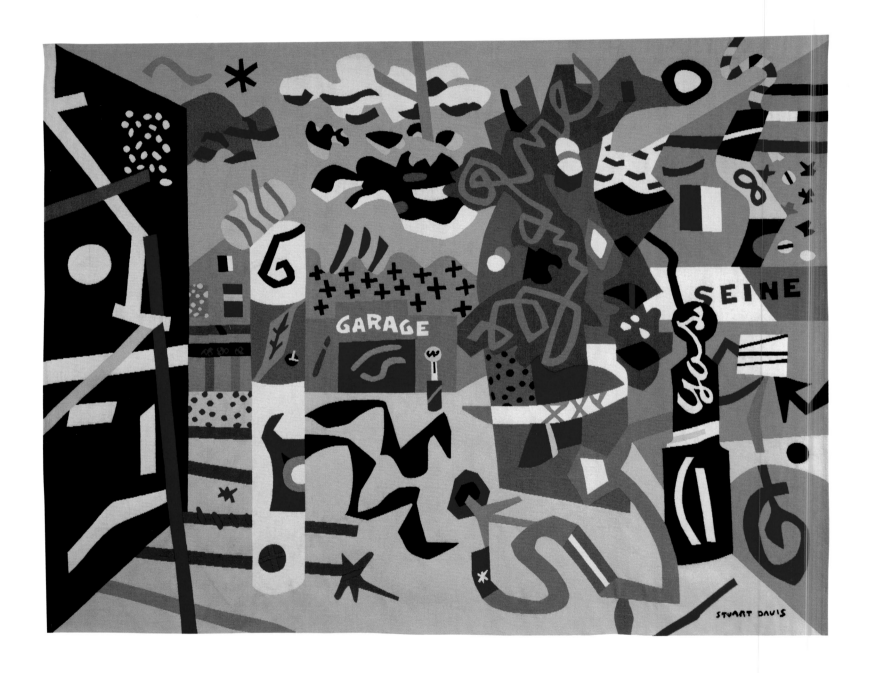

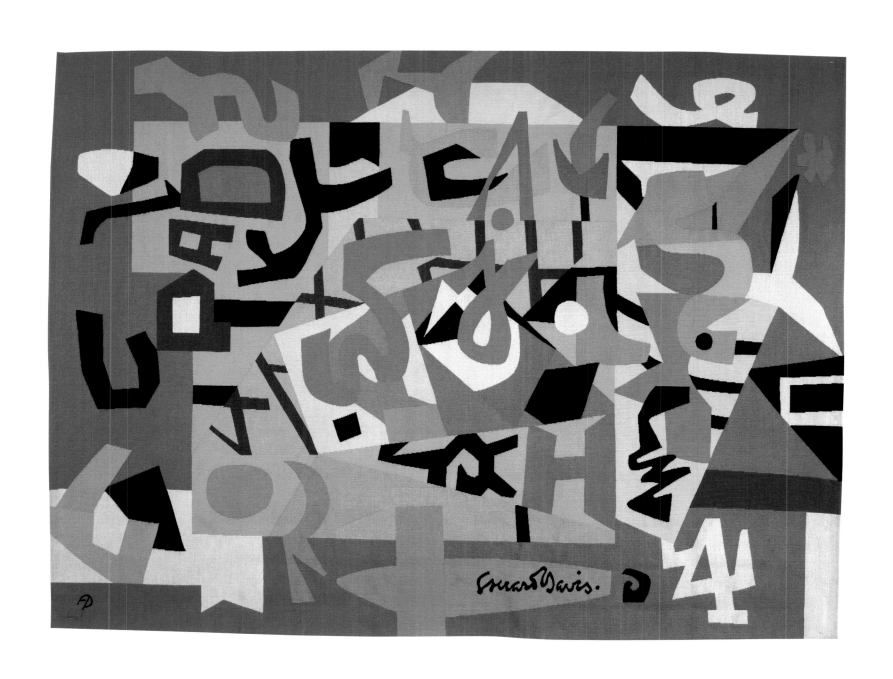

Dubuffet remained the only French painter and sculptor with whom Gloria worked.

Dubuffet

JEAN DUBUFFET

(b. 1901, Le Havre, France; d. 1985, Paris, France), Paris, France

Jean Dubuffet is among the most famous French painters and sculptors of the second half of the twentieth century. He has also been called "one of the most churlish, adamant, arrogant and interesting artists of the century" and "the surliest artist in Europe."[24] Intensely cerebral in his creative approach, he created enigmatic forms that remain curiously endearing to viewers from many backgrounds.

During his school years, Dubuffet took evening courses at the École des Beaux-Arts in Le Havre. With his bold imagery and inventive forms, he established an international reputation after the Second World War. In the forties, he also drew attention to Art Brut, his term for what is now known as outsider or visionary art, that is, art created by nonprofessionals working outside formal artistic canons.

The artist made up entirely new words and aesthetic principles for his own creations. *L'Hourloupe* became the moniker for a major series pursued from the early 1960s until 1974. This quirky cycle of works evolved from drawings to paintings, sculpture, environments, and performance pieces. The meandering outlines, maplike contours, limited color palette of red, white, black, and blue, and cartoonish character of the Hourloupe images captured the attention of critics and public alike. The artist intended to imbue these works with "philosophic humor." He explained, "The cycle itself is conceived as the figuration of a world other than our own or, if you prefer, parallel to ours. . . . This reality [in which we already live] is, in truth, only one option collectively adopted, to interpret the world around us. . . . Had any one of these other options been adopted at the dawn of human thought,

it would today offer the same impression of reality that we now confer upon the established one."[25]

One of many aesthetic series that emerged from the Hourloupe theme was the Praticables, shaped and painted two-dimensional cutouts. Originating from forms that he designed for the wall, some cutouts acquired wheels or casters and became mobile. Intended as inhabitants for his fantastic sculpted landscapes, and especially for his spectacular *Coucou Bazar* installation, the Praticables provided models for several GFR Tapestries & Carpets.

With a strong mid-century presence in New York, Dubuffet had been showing with Pace Gallery since 1968. His work was well known to Gloria even before the Guggenheim Museum opened its 1973 retrospective of more than three hundred works—the museum's largest exhibition ever. Among these were forty of his three-dimensional "tri-colored jigsaw-puzzlish 'Hourloupe' inventions," which formed his installation, *Coucou Bazar*. The museum featured theatrical performances using the Hourloupe figures and settings.[26]

"Tapis nº 1" and "Tapis nº 2" (plates 12, 13)

In 1973, GFR, Pace Gallery, and Pace Editions became partners to translate several Hourloupe designs into tapestry and pile carpetry. No doubt this intrigued the Francophile in Gloria as the artist was pronounced "inextricably conjoined with the acutely civilized tradition of French art" and "not only the best French but the most French artist at work today."[27] Although she collaborated extensively with French weavers, Dubuffet remained the only French painter and sculptor who designed GFR Tapestries & Carpets.

Quite coincidentally, Dubuffet had already prepared three appropriate models. During the height of his Hourloupe explorations, in 1972, he painted *Maquette pour un tapis nº 1* and two others for tapis numbers 2 and 3, each in vinyl paint on paper and measuring several square meters. The first two were originally used in France to create larger works with an elastic epoxy mat or polyurethane paint on a flexible polyurethane "canvas." The artist deemed the experiments entirely unsatisfactory.[28]

At his request, Dubuffet's first maquette was used to create "*Tapis nº 1*," an Edward Fields pile-woven carpet, edited by Gloria and published by Pace Editions. Considered a prototype, this low-sheared carpet was sent to Dubuffet and eventually acquired by his friend the poet Jacques Berne in Le Havre.[29]

The artist's reaction appeared in a 1973 letter to Arne Glimcher: "I have received the rug in some lateness occasioned by the difficulties with the customs. It is now in my hands. I find it very satisfactory and am very happy to

Jean Dubuffet, "*Tapis nº 1*," 1973, produced by Edward Fields, 61 × 93.5 in. © 2010 Artists Rights Society (ARS), New York/ADAGP, Paris. Photo courtesy of Fondation Dubuffet.

have it. It seems to me I remember the fabrication is in Scotland or in Ireland [not so, it was made at Edward Fields, Inc., in New York]. There are some small faults in the interpretation of the drawing it is not of big importance. The wool is not perfectly white, it is strongly tinted with yellow. I believe that it would be possible in fabricating another rug, to get truly white wool."

In 1976–77, three editions of "*Tapis n° 2*," shaped pieces mounted on plywood bases, were made with "½ inch tight cut pile" at Edward Fields, also sponsored by Pace.[30] The third study for "*Tapis n° 3*" was never used.[31]

"*With Personnage*" (plates 14a, 14b)

Dubuffet also provided models for an untitled two-part tapestry, later called "*With Personnage*." Two of the artist's shaped acrylic paintings from the Praticables series served as models—*Les Péréquations* and *Ji la Plombe*.[32] A woven version of the former was to serve as background on which the smaller figure could be moved to three different locations. Gloria and Pace Gallery had the two shaped pieces handwoven in a traditional flat tapestry weave at the Dovecot Studios in Edinburgh. (See the section on Dubuffet in chapter 4 for a description of the vicissitudes of weaving, mounting, and shipping this work.)

Pace sent the completed two-piece wool and linen tapestry to Dubuffet for approval. At the time, Glimcher apparently indicated to Gloria that it was "a highly successful unique work." She considered it "one of my most important works." However, the artist's opinions differed, as Glimcher described only a short while later: "Dubuffet disliked the tapestry based upon his feeling that the weave was too coarse and the mounting was too thick. He considered the quality of line leaden and lacking in spirit. This, I believe, is a gamble

Detail, "*Personnage*" on Dovecot loom. Note markings on warp for design.

that we all take in business and we were all in business together on this project. As a result, the tapestry has to be considered a loss. Dick and I lost our valuable money and [you] your equally valuable time."

The artist ultimately deemed the piece unfit for sale, exhibition, or publication, and offered to reimburse the gallery for the costs of his rejection. The original figure and shaped background stayed in France and were transferred to the Fondation Dubuffet in 1975 for curation. A second handwoven "personnage" remained in Gloria's private collection until her death when it joined the collections of the Minneapolis Institute of Arts.[33]

Other Projects

In February 1995, a decade after the artist's death, gallery owner Jane Kahan, Archie Brennan, and Gloria imagined doing a separate series of single Hourloupe figures, also called "Presences Fugaces," about 43 by 22 inches. As Gloria explained, "The figure, made as a trial for the large Dubuffet shaped tapestry which Pace handled, has charmed many visitors to my home (including my grandson when he too was 43 inches high. He dubbed it 'The Funny Man')."

However, Glimcher intervened, his decision conveyed over the phone and acknowledged by a note in which Gloria scribbled, "Arne—NO." When Gloria pushed the issue, Richard Solomon clarified in a handwritten note, "Arne says . . . as Dubuffet was not really enthusiastic about tapestry during his lifetime, there's no way that it could be done now. Ans[wer] Forget it." They planned no further Dubuffet pieces.

Dubuffet participated in one French tapestry project not orchestrated by Gloria.[34] In November 1974, a year after she began to work with his designs, a tapestry in the Hourloupe style was woven at the Pinton atelier after a color relief titled *Arborescences II* (a serigraph on plastic). Although it was intended as a limited edition, Dubuffet was not satisfied with the first version and discontinued its production.[35]

Some years later, Gloria opined that in contrast to handwoven tapestry weave, "Tufted hangings really have their own special quality. D[ubuffet] seems to favor his work in this medium." As happened with many of the artists who worked with Gloria, none of the published chronologies and analyses of his work mention the Dubuffet maquettes and tapestries. They appear only briefly in his catalogue raisonné, arranged according to style rather than medium.[36]

14a Jean Dubuffet, "*Personnage*," 1974, woven by Dovecot Studios, 44 × 21 in.
Minneapolis Institute of Arts; © 2010 Artists Rights Society (ARS), New York/ADAGP,
Paris. Photo courtesy of Minneapolis Institute of Arts.

14b Jean Dubuffet, "*Untitled (with Personnage)*," 1974, woven by Dovecot Studios,
72 × 122 in. © 2010 Artists Rights Society (ARS), New York/ADAGP, Paris. Photo
courtesy of Fondation Dubuffet.

Feeley

> Get back to simple things in order not to get lost in complex uncertainties.
>
> —Paul Feeley

turned for inspiration to a different classicism— ancient Greek and Moorish decorative patterns and Cycladic and Egyptian sculpture. In response to the lack of structure and form of abstract expressionism (as he saw it), he reduced his painted imagery to curvilinear reciprocating forms in two or three basic colors. According to one analyst, he sought "a reasonable way to get drawing and telling shape back into the picture without reintroducing figurative or planar allusions that would create illusions of perspectival space."[37] Among twenty points outlined in a 1959 manifesto for the Bennington art department, he advocated (as if speaking to himself) "the encouragement to do the most elementary and primitive things in art, if necessary, in order not to operate in a hollow, pretentious manner" and "a willingness at all times to return to first principles, to get back to simple things in order not to get lost in complex uncertainties."[38]

PAUL FEELEY
(b. 1910 Des Moines, IA; d. 1966, New York, NY), Bennington, VT

Paul Feeley taught at the Cooper Union Art School and then joined the Bennington College art department, which he headed during the 1950s and early 1960s. When Feeley was a rising star in the color field arena, his abstract work was selected by Clement Greenberg for the 1954 Emerging Talent show at Kootz Gallery in Manhattan and again for the influential 1964 exhibition Post-Painterly Abstraction that premiered at the Los Angeles County Museum of Art and traveled to Minneapolis and Toronto. In addition to his studio work and teaching, Feeley organized or contributed to significant exhibitions of works by colleagues David Smith (1951), Jackson Pollock (1952), Hans Hofmann (1955), and Kenneth Noland (1961).

Feeley's realist portraiture, paintings, and murals of the 1930s reflect his classical training. Beginning in the 1950s, however, he

"after *Untitled (Yellow, Red)*" and "after *Lacona*" (plates 15, 16)

Gloria's sister Helen Frankenthaler studied with Paul Feeley at Bennington College from 1946 to 1949. It was not, however, until after his death and a 1968 memorial exhibition curated by Gene Baro at the Guggenheim that Gloria considered his work. Through Baro, she arranged with the artist's widow, Helen, to work from two 1962 paintings, originally executed in oil and enamel on canvas and owned by the Feeley estate.[39]

Like many of Feeley's paintings during the late fifties and sixties, "after *Lacona*" and "after *Untitled (Yellow, Red)*" challenge the viewer to see the figure and ground as interchangeable. Intrigued by the planar two-color imagery, Gloria added variation by leaving the hooked loops intact in "after *Lacona*" and having the surface of "after *Untitled (Yellow, Red)*" shorn to a velvety texture. In keeping with her early approach to hooked works, she made the wall hangings the same size as the original paintings.

Detail. Note fuzzy texture of shorn yarns.

Frankenthaler pioneered the technique of "stain painting" by pouring and spilling paint onto very large unprimed canvases on the floor of her studio.

HELEN FRANKENTHALER

(b. 1928, New York, NY), Darien, CT, and New York, NY

Helen Frankenthaler is undoubtedly one of the best-known painters with whom Gloria worked; she was also Gloria's younger sister.[40] Frankenthaler has been called "one of the most gifted and influential artists of our time," "one of the most durable and consistently inventive of contemporary American artists," and "one of the most important American artists of the past fifty years."[41] One writer compared Frankenthaler to Edgar Degas: "Possessed of great talent, a fortunate background, and a thorough academic training, both painters . . . [pursued a] cultivation of the difficult."[42] Another noted, "before her fortieth birthday, Frankenthaler had become an institution: *the* American woman artist, acclaimed as the link between abstract expressionism and 1960s Color-field abstraction."[43]

After training with Mexican muralist Rufino Tamayo, modernist Paul Feeley, and others, Frankenthaler pioneered the technique of stain painting by pouring and spilling paint onto very large unprimed canvases on the floor of her studio. Inspired by painters Hans Hofmann, Jackson Pollock and Willem de Kooning, sculptor David Smith, and art critic Clement Greenberg, among others, she is ranked at the top of the second generation of abstract expressionists.[44] Her innovative work moved outside earlier boundaries and influenced many other prominent artists, including Kenneth Noland and Morris Louis.

An Affinity for Tapestry

Critics have occasionally noted Frankenthaler's penchant for textilelike aspects in her painting, commenting on "the real identity of the canvas . . . as cloth" and the appearance of "dyed fabric."[45] The use of unstretched and unsized cotton duck, originally intended as sailcloth, for the ground of her paintings suggests further sensitivity to fiber art possibilities. The artist's own words reveal her desire to explore: "I am an artist of paint, making discoveries."[46] This experimental attitude left her open to translating paint into tapestry.

The large scale of many Frankenthaler pictures also lent itself to mural-like tapestry projects. Moreover, the artist's avoidance of three-dimensional illusion in her work—where figures and landscape often telescope into a single plane—has played a special role, too, in the imagery of many historic and contemporary tapestries.

In 1956, before she and Gloria worked together, Frankenthaler designed a set of modern tapestries for the Temple of Aaron in Saint Paul, Minnesota, "one red for the year and another white, with the same design, for the High holy days."[47] (Forty years later, Gloria would become involved in a similar endeavor at New York's Temple Emanu-El, but her sister wasn't included in the project.) Frankenthaler worked with Multiples, Inc., in New York to create an untitled appliquéd felt hanging in an edition of twenty, one of which is now in the Smithsonian Institution's Renwick Gallery.[48] In 1984 she also undertook a separate tapestry project, when a wall hanging measuring ten-by-fifty-seven feet was woven after one of her paintings for the prestigious Hong Kong Club building, designed by Sydney architect Harry Seidler.[49]

For her sister's tapestries and wall hangings, Frankenthaler provided ten designs, six from extant paintings and four created *de novo*. Images selected from her repertoire represent a number of distinct phases of the artist's work from 1962 to 1981. Both sisters had strong feelings about "making a picture that works," but neither was strict about which elements or styles to adapt.[50] Each sister realized that many of Frankenthaler's paintings could and did work in translation and their choices remained characteristically eclectic.

"after *The Cape*" (plate 17)

The Cape was painted in oils by Frankenthaler in 1962 as part of her calligraphic exploration of "the ambiguities of symmetry."[51] The original work clearly shows the "aura" of oil stains on unprimed canvas. Using this painting as a model and employing 13½ pounds of wool in the hooked-rug technique, Gloria herself completed the singular "after *The Cape*" in January 1963. Shown in a 1965–66 exhibition at the Museum of Modern Art, the unique tapestry was kept by Frankenthaler despite inquiries about its purchase. Referring to her first major wall hanging, a handwritten note by Gloria simply says "1st rug."

Helen Frankenthaler, *The Cape*, 1962, oil on canvas, 53 × 69.75 in. Clifford Ross collection; © 2010 Helen Frankenthaler/Artists Rights Society (ARS), New York.

17 Helen Frankenthaler, "**after** *The Cape*," 1963, hooked by GFR workshop, 54 × 72 in. Collection of the artist; © 2010 Helen Frankenthaler/Artists Rights Society (ARS), New York/Estate of Gloria F. Ross. Photo courtesy of Helen Frankenthaler.

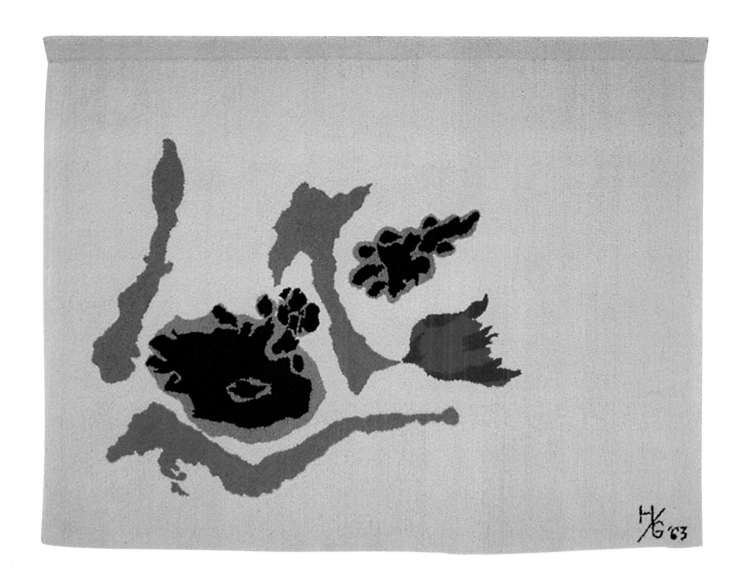

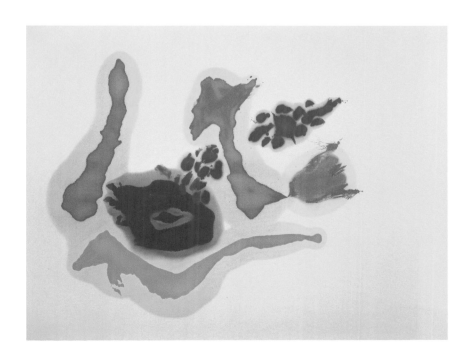

"after *Buddha's Court*," "after *Point Lookout*" and "after *Blue Yellow Screen*" (plates 19, 20)

In 1966, the sisters agreed to make hooked pieces after three extant paintings. *Buddha's Court,* a 1964 acrylic on canvas alternatively titled *Buddha*,[52] is an enclosed composition of concentric rectangles with the quiet symmetry familiar in Frankenthaler's paintings of the early sixties. It was translated into a single unique hooked rug called "after *Buddha's Court*" (see Checklist entry 18). *Point Lookout,* a 1966 work, reflects the artist's move toward sparer "color space" paintings.[53] It provided the model for an edition of five hooked panels. In November 1966, Gloria arranged a hooked edition of five from *Blue Yellow Screen,* also part of Helen's color space work. Several of these were executed by the Hound Dog Hookers of Blackey, Kentucky, rather than in New York (see chapter 4).

Unlike the initial collaboration for "after *The Cape*," a formal contract was established between the sisters for each of these projects. These were the first of many legal documents that Gloria employed for all artists who worked with her.

"after *1969 Provincetown Study*" (plate 21)

Frankenthaler's *1969 Provincetown Study,* with its characteristically subtle color gradations, prompted Gloria to explore handwoven tapestry weave, rather than the coarser hooked-rug technique. The weaving team at the Dovecot Studios made the artist's proof and the first four editions of "after *1969 Provincetown Study*." Because Gloria sought an even finer texture for the color transitions, she had the Pinton workshop in Felletin make a second artist's proof. Micheline Henry, an

independent tapestry artist, wove the edition's fifth tapestry in Aubusson. No other series engaged as many studios as this work did. The Dovecot workshop commented, "The success of the translation of this image to the tapestry was achieved by drawing on a number of weaving techniques. . . [We used] a number of colours, blended together, interlocking and overlapping in a subtle weave . . . punctuated by delicate lines of carefully chosen, broken colour."[54]

"*Untitled (R. M. Halperin commission)*" (plate 22)

Given the success of their early experiments, Gloria and Frankenthaler worked together on one private and three major corporate commissions. After a year's discussions, a California couple and the two sisters established a 1969 contract for a unique hanging, ten feet long, hooked following an original Frankenthaler design for the foyer of their contemporary-style home. The owners purchased the maquette as well as the tapestry.

"*Untitled (Westinghouse Broadcasting Company commission)*" (plate 23)

In June 1971, Gloria approached gallery owner Leo Castelli about working with Frank Stella or Ellsworth Kelly on a Westinghouse Broadcasting commission in Philadelphia. Instead, Frankenthaler and Robert Motherwell, then in the process of divorcing, both agreed to participate in the project, organized through Richard Feigen Gallery. Each artist visited the KYW-TV Newsradio building in Center City Philadelphia with Gloria—Frankenthaler in September and Motherwell in October.

Related to other large paintings of the period and made especially for this project, the untitled work combines Frankenthaler's

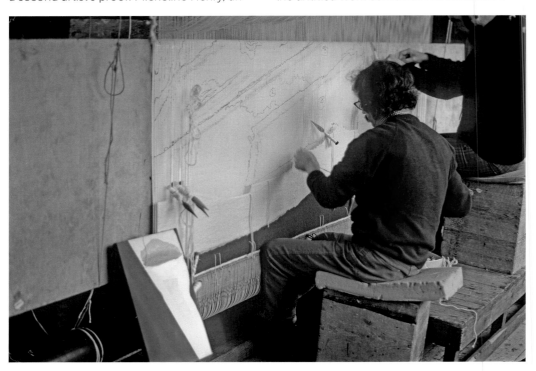

Harry Wright and Douglas Grierson working on Frankenthaler's "after *1969 Provincetown Study*," 1976.

Opposite: Detail, Helen Frankenthaler, "*Untitled (Westinghouse Broadcasting Company commission)*," 1971, hooked by Anna di Giovanni. (See plate 23.)

Helen Frankenthaler, "**after** *Point Lookout*," 1966, hooked by GFR workshop, 72 × 30 in.
© 2010 Helen Frankenthaler/Artists Rights Society (ARS), New York/Estate of Gloria F. Ross.
Photo by Laura Weston, courtesy of Mount Holyoke College Art Museum.

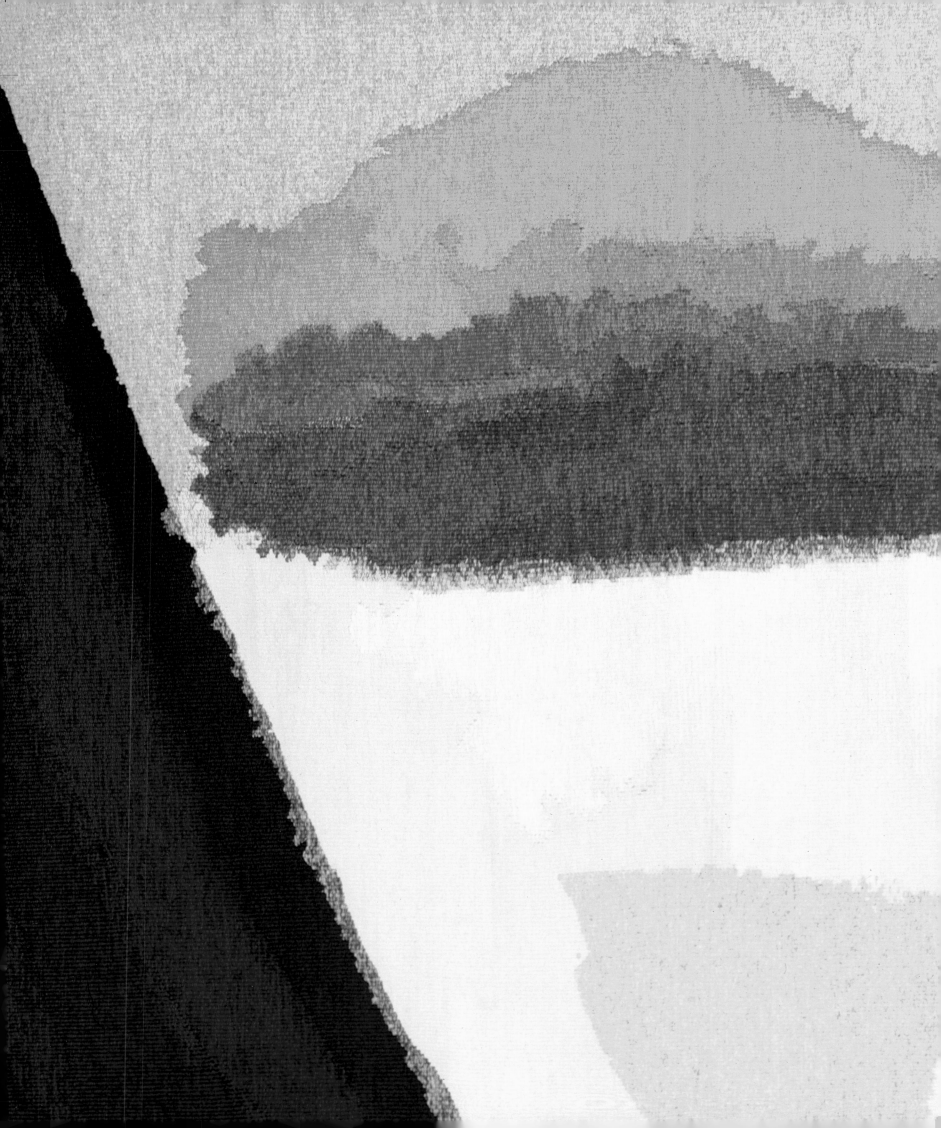

be red) vertical and horizontal lines, should also be done in this manner. Actually I would be pleased to have a 'painterly' feeling to the tapestry. This can be good, although I know many craftsmen fear this.

"As to the color of those lines, the two should be more red, closer to the small red sample, rather than a burnt orange. The burnt orange does match the color in the maquette, but Helen now prefers it to be more of a sepia and sanguine. The two greens are perfect. As you and I agreed, the background color should be yellower and lighter. The eggplant is accurate, but should have more life to it. Except for the greens, she feels, and I think we agree that all the colors are rather 'dead.'

"You can see in the brochure of her paintings what life, movement, joie de vivre there is in her work."

"Untitled (Fourth National Bank & Trust commission)" (plate 25)

Frankenthaler painted a series of small untitled works in 1973 as prospects for a commission from the Fourth National Bank & Trust in Wichita, Kansas, for the lobby of the bank's new headquarters. Designed by Skidmore, Owings & Merrill in Chicago, the nine-story building included an eighty-foot mobile by Alexander Calder—"the largest he has ever created"—and won an Architectural Award of Excellence in 1975. The setting was sufficiently impressive for a major Frankenthaler tapestry.

Reflecting the artist's work of the mid-1970s, the selected imagery consists of thin color washes flowing across an expansive canvas. A painting from the same period, *Hint from Bassano*, prompted some relevant discussion: "This sense of light and color, placed in a huge horizontal format, gives the painting what Frankenthaler calls 'cinerama' quality: 'I was involved at that time with a commission, and I had been asked to make scaled-down maquettes; instead, I decided to make several large canvases.'"[56] The model selected for this commission was also acquired by the bank owners for their collection.

In development for over two years, the tapestry was handwoven in the Pinton workshop and installed in December 1975.[57] Gloria commented, "This collaboration between artist and craftsman has resulted in a work of art whose rich texture and elegant imagery add warmth and humanity to this beautiful example of modern architecture."

An in-house bank publication described the "flowing colors of golden grain creating a fluid image in abstract of the natural world of Kansas." It continued, "Helen Frankenthaler captured the freedom, spontaneity, openness and complexity of this natural image in an acrylic 'wash' in the original painting, and its exactness has been captured in the weaving."[58]

gestural qualities with large swashes of color in a rare vertical orientation.[55] Gloria once recalled, "The Phila. Redevelopment Authority commissioned this for the dark red brick lobby, which is very wide and shallow, and the tapestries developed it into a most exciting space. They are so contemporary but they echo the monumental grandeur of tap[estrie]s of yore."

In 1998, following years of display at Westinghouse, the tapestry was reinstalled with its companion piece designed by Robert Motherwell in the Reading Terminal Head House, serving as part of Philadelphia's convention center.

"Untitled (Winters Bank Tower commission)" (plate 24)

After several months of correspondence between Gloria and Mrs. Eugene W. (Virginia) Kettering and her business associates, the sisters traveled in June 1971 to Dayton, Ohio, to see the site for Kettering's new office building. In August 1971, Gloria visited Frankenthaler's studio and selected an untitled painting as maquette. The Winters Bank Tower of Dayton commissioned a unique tapestry, twenty-two feet long, from this model for its grand new lobby. The broad, sweeping image holds a mere suggestion of a horizon line.

This was the first GFR Tapestry woven in France by Pinton Frères, supervised by Olivier Pinton from September 1971 to April 1972. As Gloria wrote to the workshop head, "I do think that it will be the first woven tapestry made on this scale, designed by one of our leading painters."

After initial trials were woven and reviewed, Gloria conveyed the artist's wishes to Pinton: "I reviewed our talks with her and now pass on her thoughts to you. Helen agrees that the tapestry should be done like the very small red sample i.e. that the colors should be blended . . . in lieu of the hatching in the larger sample based on her maquette. The red (and it is to

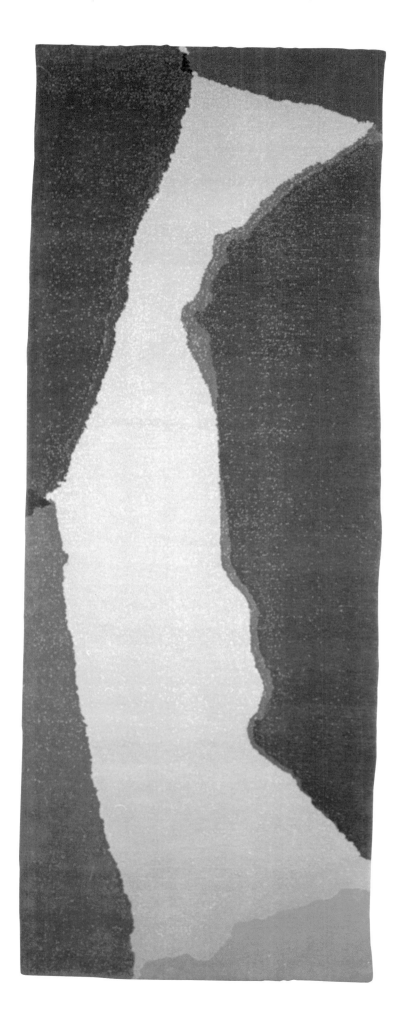

23 Helen Frankenthaler, "*Untitled (Westinghouse Broadcasting Company commission),*" 1971, hooked by Anna di Giovanni, 132 × 96 in. © 2010 Helen Frankenthaler/Artists Rights Society (ARS), New York/Estate of Gloria F. Ross. Photo by Kubernick.

"after *This Day*" (plate 26)

In 1981–82, Gloria and Helen planned a tapestry from the painting *This Day,* which became their tenth and final collaboration. In retrospect, Gloria noted, "HF wanted to do textured." In other rough lecture notes, she recorded, "Again with input of artist. Reflects her work. Globs of paint. Heavier texture." The original painting belongs to a contemporaneous group dominated by a single hue and "a spectrum of textural variations, from transparent washes to hefty 'clumps' of paint . . . [that] . . . takes the place of variety of color."[59]

The exceptional light-filled tapestry was handwoven by Janet L. Kennedy of Kennedy/Kunstadt Tapestries, then of New York. To create the sumptuous texture and visual depth, the weaver employed custom-dyed linen, wool, cotton, and rayon yarns and a multiharness weave based on Helena Hernmarck's famed variation on the Swedish rosepath technique. (For more about the making of this tapestry, see chapter 6.)

The tapestry was included in the 1986 exhibition Tapestry Contemporary Image Ancient Tradition at the Cheney Cowles Memorial Museum in Spokane, Washington, and also shown at the Rosa Esman Gallery in New York. For many years, "after *This Day*" graced Gloria and John Bookman's dining room wall. Keeping the work in the family, the daughter of one of Gloria's cousins purchased the panel in 1990. As one admirer wrote, "It catches and express[es] the spirit of those new paintings of hers marvelously well: the light buoyancy, the quality of swiftness, lightness, space. And the lovely colours."

Other Projects

The two sisters planned several other projects that did not materialize. In 1982, the Southeast Banking Corporation of Coral Gables and Miami wanted a large tapestry to be designed by Frankenthaler and woven by renowned weaver and artist Josep Royo. Gloria worked with Francisco Farreras, director of Galeria Maeght in Barcelona, but the project did not go forward, possibly because the bank underwent financial difficulties.

A small, untitled 1973 painting was prepared as one option for the Wichita commission and became, instead, a fiftieth birthday present. Frankenthaler inscribed a card affixed to the reverse, "For Gloria, 'important one' (5 Sept 1973); a maquette that we've shared! With love, and now Happy New Year, goes with Happy Birthday. x Helen 21 Dec. 1973." No tapestry came from this imagery.[60]

Another intriguing prospect developed from a series of small book covers that Frankenthaler exhibited in a 1973 show at the Metropolitan Museum of Art. A series of six tapestries were to be woven in wool and mohair from the catalogue *Helen Frankenthaler: Sixty-two Painted Book Covers.* Although the project, titled *Corner Play,* interested the Abrams publishing house, the weaver Raymond Picaud failed to make the promised woven trials. In September 1974, after much polite hesitation, Olivier Pinton, head of a separate workshop, finally opined that the design was "too spontaneous" and therefore not appropriate for tapestry. Furthermore, in her boldest handwriting, Gloria wrote, "R[ichard] H S[olomon] & Arne [Glimcher]—don't do—." Without support from any direction, small wonder the project never happened.

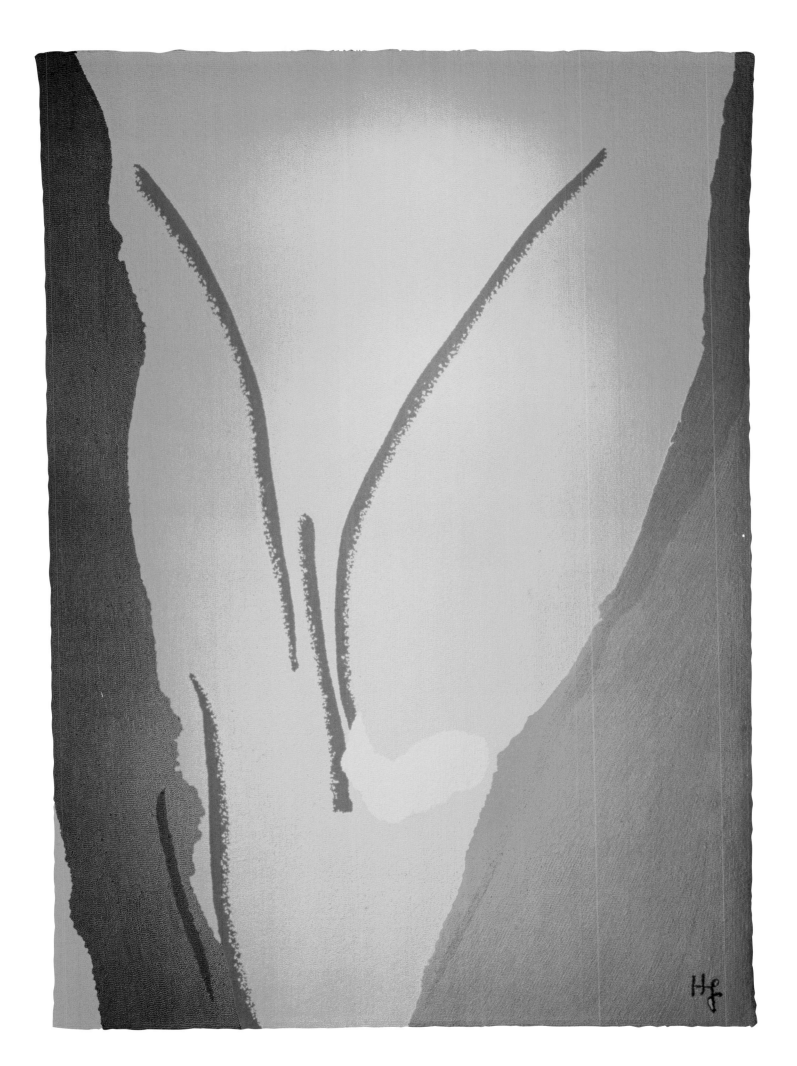

Helen Frankenthaler, "*Untitled (Winters Bank Tower commission)*," 1972, woven by Pinton, 108 × 303 in. © 2010 Helen Frankenthaler/Artists Rights Society (ARS), New York/Estate of Gloria F. Ross. Photos by Jack Holtel, Photographik.

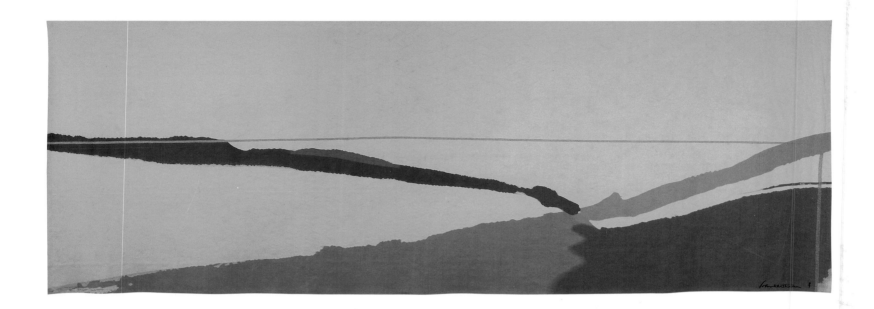

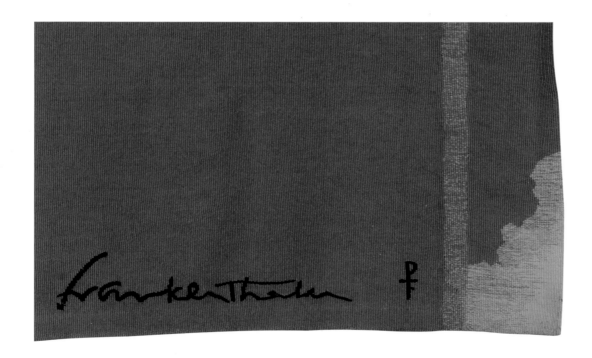

25

Helen Frankenthaler, "*Untitled (Fourth National Bank and Trust commission)*," 1975, woven by Pinton, 114 × 510 in. Bank of America Art Program; © 2010 Helen Frankenthaler/Artists Rights Society (ARS), New York/Estate of Gloria F. Ross. Photo by Kirk Eck, Wichita Art Museum, Wichita, Kansas.

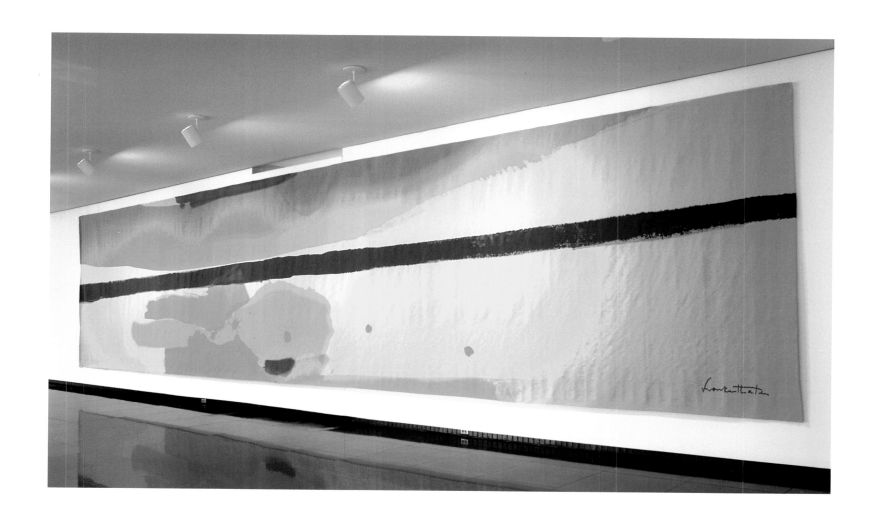

Helen Frankenthaler, *This Day*, 1981, acrylic on canvas, 50 × 73 in. © 2010 Helen Frankenthaler/ Artists Rights Society (ARS), New York. Photo by Malcolm Varon.

> . . . to create a space which is
> neither recessive nor advancing,
> but just special relationships on
> a single plane.
> —Robert Goodnough

ROBERT GOODNOUGH
(b. 1917, Cortland, NY), New York, NY
Active in New York during the 1940s and
1950s, Robert Goodnough is associated
with the second generation of abstract
expressionists. After serving in the army dur-
ing the Second World War, he trained with
Hans Hofmann in Provincetown and com-
pleted graduate studies in art education at
New York University. More reticent than many
members of the lively urban art scene, Good-
nough was nevertheless represented by the
illustrious Tibor de Nagy Gallery during most
of his career and singled out by Clement
Greenberg as a major abstractionist.

In his paintings, collage, and sculpture, he
developed a personal style, described by one
scholar as "epitomized by the rhythmic move-
ment of shapes across a two-dimensional
plane, or 3-dimensional form."[61] The artist
himself once explained, "I try to uncube the
'cube,' to create a space which is neither
recessive nor advancing, but just special rela-
tionships on a single plane."[62]

Gloria and Goodnough worked together
on three projects, all from original maquettes—
colored paper collages that Goodnough
created for this purpose. While the custom-
made models each measured less than a
square foot, the resulting tapestries range
from almost twenty to over fifty square feet,
the same size as many of the artist's large
canvases.

"Abstraction with Black Forms" (plate 27)
Embarking on their first work together, Gloria
addressed the artist in 1967 as "Mr. Good-
nough" but soon he became "Bob." Between
1967 and 1969, five editions of "Abstraction
with Black Forms" were made in Gloria's New
York studio using the hooked-rug technique.

"Red/Blue Abstraction" (plate 28)
A second Goodnough collage was translated
into Gobelins-style tapestry weave beginning
in 1971 at the Dovecot Studios. To accent the
nature of the torn-paper collage, the weavers
used wool, linen, and cotton. With the artist's
"permission and enthusiastic approval," they
reversed several areas of white and beige.
The workshop recorded, "By careful mixing
of wools to give a grainy appearance in some
areas and then by juxtaposing flat areas of
colour against this, a special relationship
was achieved between the shapes to retain
the original feel of the collage. The weft
was often thinned down to give a very crisp
line at the junctions between one area and
another."[63]

"Tapestry III" (plate 29)
The third Goodnough tapestry was woven in
Aubusson-style tapestry weave at Manufac-
ture Pinton between 1976 and 1990. In one of
her lectures, Gloria described this tapestry as
a "smaller, more intimate piece" and "one of
RG's finest, most joyous images." On another
occasion, she noted the "jewel-like elements
that sparkle across the tapestry."

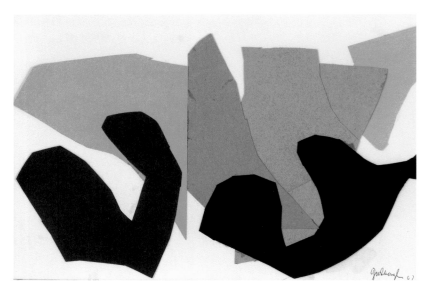

Robert Goodnough, maquette for "*Abstraction
with Black Forms*," 1967, cut-paper collage,
7 × 10.5 in. GFR Papers; © Estate of Gloria F. Ross.
Photo by Jannelle Weakly, ASM.

27 Robert Goodnough, "*Abstraction with Black Forms*," 1967–69, hooked by GFR workshop, 60 × 84 in. © Estate of Gloria F. Ross. Photo by Eric Pollitzer.

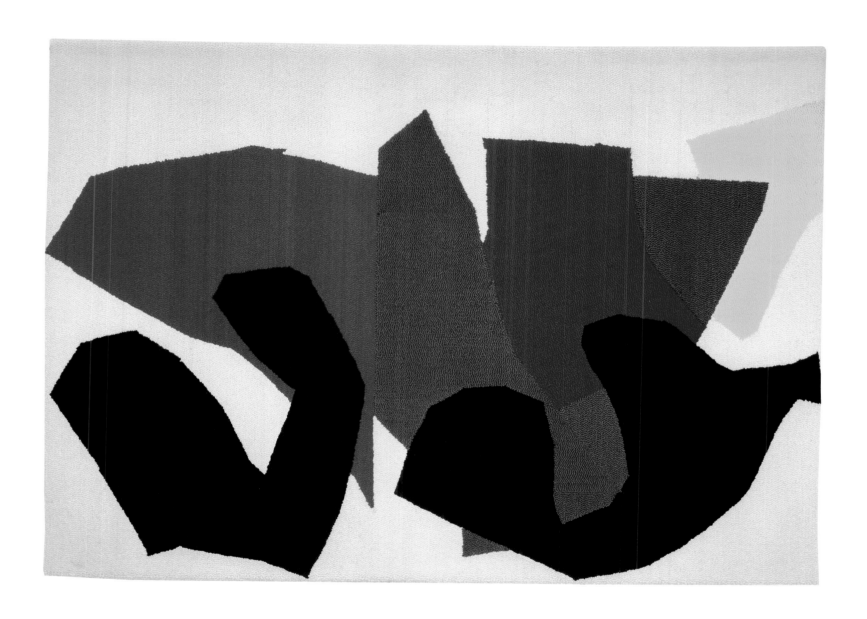

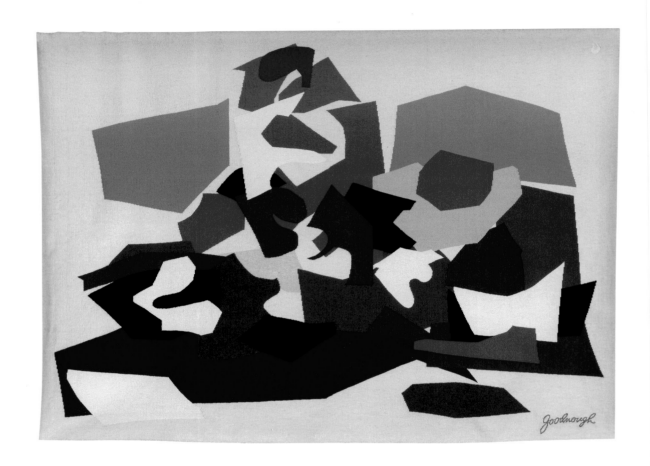

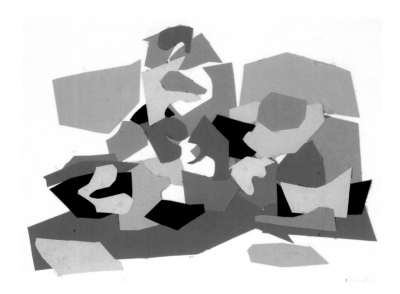

Robert Goodnough, maquette for "*Red/Blue Abstraction*," 1969, cut-paper collage, 8.25 × 11 in. GFR Papers; © Estate of Gloria F. Ross. Photo by Jannelle Weakly, ASM.

Robert Goodnough, maquette for "*Tapestry III,*"
1976, cut-paper collage, 11 × 15 in. © Estate of
Gloria F. Ross.

Robert Goodnough, *"**Tapestry III**,"* 1976–90, woven by Pinton; see Checklist for dimensions, which vary within edition. © Estate of Gloria F. Ross.

Gottlieb

ADOLPH GOTTLIEB

(b. 1903, New York, NY; d. 1974, New York, NY), New York, NY

With a strong international following, Adolph Gottlieb belonged to the first generation of the New York school of modernist painters. In 1935 he became founding member of "The Ten," a group of expressionist and abstract artists that included Mark Rothko, Willem de Kooning, Lee Gatch, and Ilya Bolotowsky. In 1966 his studio and its contents were destroyed by fire, and yet he mustered a major retrospective exhibition, held jointly at the Whitney and Guggenheim museums in 1967.

Before working with Gloria, Gottlieb designed half a dozen tapestries and fiber works executed at other workshops. The Nazareth Workshop (Tapestry of Nazareth Company) in Haifa, Israel, wove his "*Blue Disc*" in 1968 and later made "*Gold with Orange and Black*." Two editions of "after *Pink Ground*" were created at L'École Nationale des Arts Decoratifs d'Aubusson, also in 1968. An untitled work after one of his Burst prints (Untitled #6771P) was made in gros-point needlework by Rita Maran in London. In addition, he designed Ark curtains in 1952 and 1953 for Congregation B'nai Israel in Milburn, New Jersey (now in the Jewish Museum in New York), and Congregation Beth El in Springfield, Massachusetts. In 1969, he ventured into pile carpet designs with Edward Fields, Inc., which produced an edition of "*Beige with Yellow, White and Black*." At least three tapestries in an edition of "*Burst*" were woven in India, presumably also as pile carpeting, for Charles Slatkin of Modern Masters.[64]

Gloria's notes give no indication of how she first met the artist, but they had many opportunities to connect. Gottlieb and Helen Frankenthaler had known each other since 1950 when he selected her work for Fifteen Unknowns at the Samuel M. Kootz Gallery in New York. Gloria was well acquainted with Marlborough Gallery, his representative and one of the world's leading contemporary art dealers. Also, she often passed by Gottlieb's 1954 stained glass façade, based on his pictograph grids, at the Park Avenue Synagogue on East 87th Street. However the relationship began, Gloria first approached the painter about making a tapestry around the time of his one-man show at the Whitney and Guggenheim. In a later interview, she recalled that it took the artist "three years to work up the 'courage' to let me work from one of his images, because he was afraid it might be altered."[65]

Adolph Gottlieb, *Black Signs*, 1967, serigraph on paper, 18 × 24 in. GFR Papers; © Adolph and Esther Gottlieb Foundation/Licensed by VAGA, New York. Photo by Jannelle Weakly, ASM.

Adolph Gottlieb, "**after** *Black Signs*," 1970–71, hooked by Anna di Giovanni, 54 × 72 in. © Adolph and Esther Gottlieb Foundation/Licensed by VAGA, New York. Photo by Eric Pollitzer.

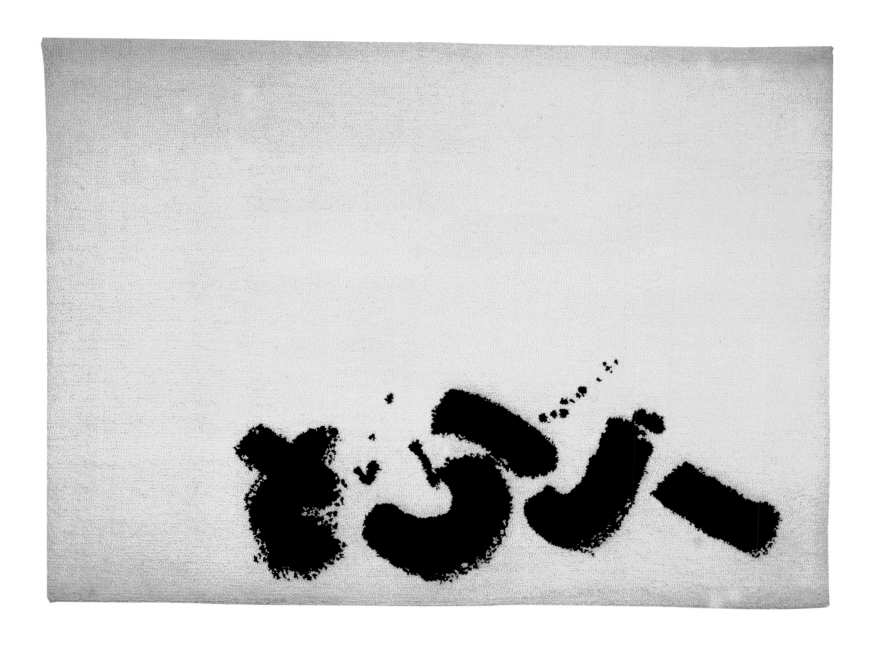

Adolph Gottlieb, "**after *Black Disc on Tan***," 1972–76, woven by Dovecot Studios, 84 × 66 in. © Adolph and Esther Gottlieb Foundation/Licensed by VAGA, New York. Photo by Al Mozell.

"after *Black Signs*" (plate 30)

In preparation for her first Gottlieb work, "after *Black Signs*," Gloria's enthusiastic note records, "Gottlieb 1/25/70 visit at 888—Yes!" At her Park Avenue home, the two agreed to go forward. Later that same year, Gottlieb suffered a stroke and became confined to a wheelchair; he nevertheless continued to paint.

During the 1940s, Gottlieb had begun exploring bold calligraphic imagery that he generically called his Pictographs. Emerging from this series, his original acrylic painting *Black Signs* recurred in many forms—a series of serigraphs (sometimes called lithographs), a preparatory drawing executed as maquette for a tapestry, and Gloria's five-part edition of hooked wall hangings plus one artist's proof.[66]

"after *Black Disc on Tan*" (plate 31)

In 1972 the artist agreed to a second tapestry after the painting *Black Disc on Tan*, which belonged to his Burst series. The 1970 oil on paper was known by the Metropolitan Museum's curator Henry Geldzahler to be located in a private collection. Representing his final working period, Gottlieb's Burst paintings earned him the sobriquet "Adolph Gottlieb of the brooding discs."[67]

When Gloria initially approached Gottlieb about this project, he had an exclusive agreement with Marlborough Gallery. Considerable legal wrangling preceded the tapestry contract. The Gottlieb image was shipped to the Dovecot in April 1972. Gloria wrote the workshop director, "I do think that this is a particularly fine Gottlieb. I have discussed it with him at length. We are free to make minor changes such as omitting some of the splatter, using different material (I mentioned the possible use of linen for the white 'burst' and for the white

'splatter,' etc.)." Ultimately, wool and linen wefts and cotton warps were employed, with the Dovecot studio commenting, "The illusion here of a splash of paint has been achieved most successfully by using linen, a thicker yarn, and by adopting appropriate weaving techniques."[68]

Two years after the first edition of "after *Black Disc on Tan*" was completed, the artist died. Gloria maintained contact with his widow, Esther, as subsequent versions were created over the next two years.

When this tapestry was displayed at the Edinburgh Festival in 1980, one reviewer dangled the query, "Can the dynamic implosions of colour experiences by Gottlieb survive translation into the exactitudes of warp and weft?"[69] Apparently, the curators for several corporate art collections thought so. Further determinations, however, are left to individual viewers.

Fred Mann weaving at the Dovecot Studios, 1972. Photo courtesy of Dovecot Studios

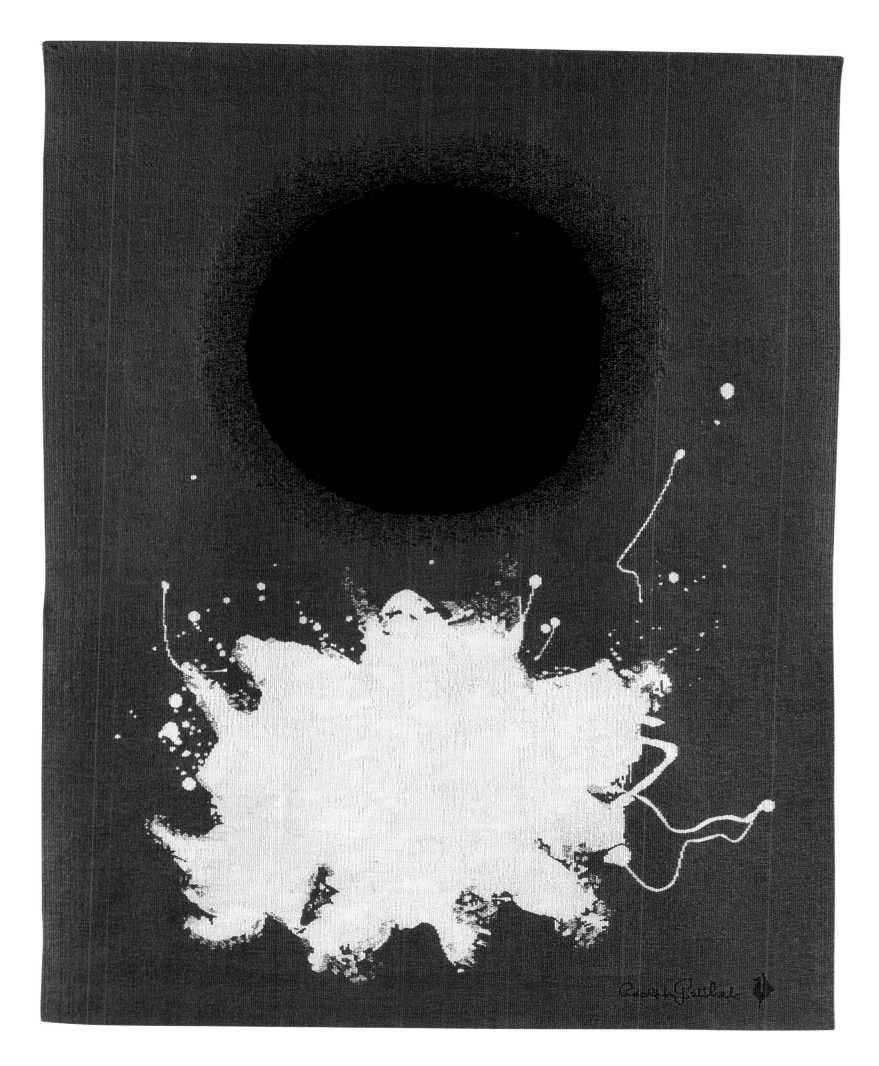

. . . to communicate directly,
feeding the eye with the opulent
pictorialism that made the old
masters rich and appealing.
—Al Held

Held

AL HELD
(b. 1928, Brooklyn, NY; d. 2005, Camerata, Italy), New York, NY

A midcentury political activist, Al Held took courses at the Art Students League in the late 1940s and produced works in a social realist style. Like a number of other New York artists of his generation, he used the GI Bill to study in Paris in 1950. Thereafter, he abandoned figurative painting in favor of abstraction. Early works in this vein show gestural paintings heavily encrusted with paint. By the 1960s, he was producing enormous, flat, bright-colored geometric works, some too big to fit in contemporary gallery spaces. In 1968 the San Francisco Museum of Art and the Corcoran Gallery of Art hosted a major retrospective of his work. Linear and illusionistic black-and-white paintings followed in his next phase, featured in a 1974 show at the Whitney Museum.

Held taught art at Yale from 1962 to 1980 and was fascinated with fifteenth-century Flemish painting, admiring its iconography and systematic use of geometric proportions.[70] His own goal, as recorded in an interview with Barbara Rose, was "to communicate directly, feeding the eye with the opulent pictorialism that made the old masters rich and appealing."[71] Could these interests have influenced his participation in a project to translate his iconic work into the centuries-old technique of tapestry? One can only wonder whether artist and éditeur discussed these interests, since, compared to her other projects, Gloria's notes on working with Held are scant.

"after Cultural Showcase" (plate 32)
In 1973, Gloria met the artist with his representative André Emmerich and her Pace advisors Glimcher and Solomon at Emmerich's 57th Street gallery to consider several Held paintings from his colorful middle period. Included was Held's well-known Mao, an impressive six-foot-square painting of red, black, and white concentric circles, depicting what has been called Held's distinctive "transformation of geometric figures into anthropomorphic metaphors."[72] After deliberation, Gloria deemed this work "less good" because its expanse of white would be difficult to render in tapestry. Ultimately, they chose a poster, Cultural Showcase, with exuberant arcs in primary colors. Produced in both silkscreen and lithograph versions, the work commemorated New York's Cultural Showcase Festival, a citywide celebration of art in public spaces.

After reflecting on the artist's large paintings and gauging them against the cost of finely handwoven tapestry, Gloria decided to almost double the poster's size. She contracted with Raymond Picaud in Aubusson in June 1973 and the first and only version of this tapestry was completed in October 1974.

Gloria visited the artist's 1974 Whitney show several times. She pronounced the artist's black-and-white work "great," and wrote to him that it "inspires me, challenges me to attempt a black and white tapestry." After raising this tantalizing idea, however, no further work was attempted.

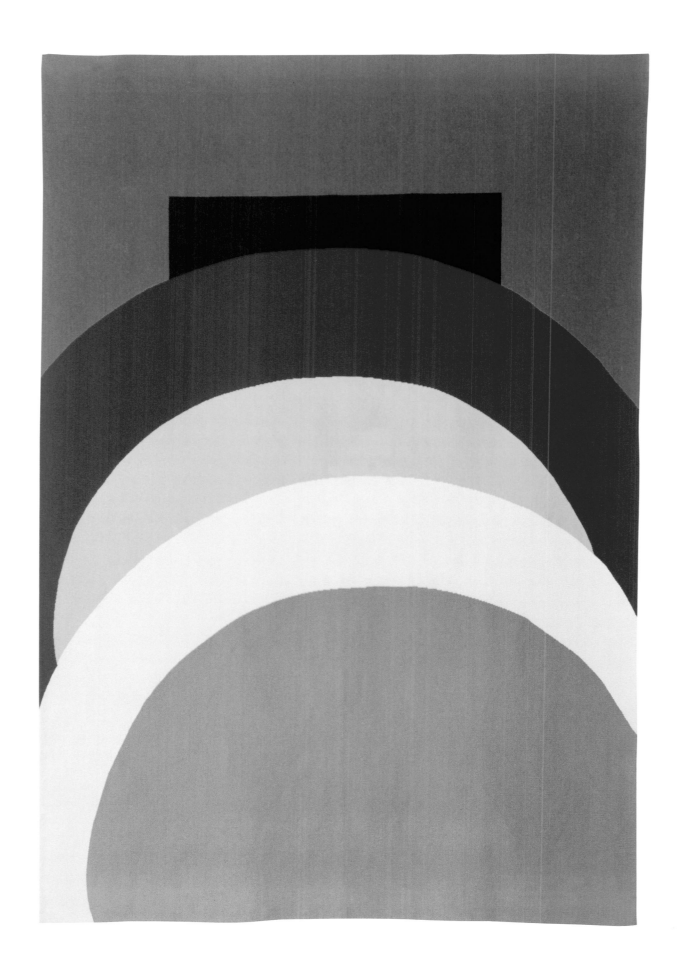

Depth perception in nature and depth creation on the picture-surface is the crucial problem in pictorial creation.
—Hans Hofmann

Hofmann

HANS HOFMANN
(b. 1880, Weissenburg, Bavaria; d. 1966, New York, NY), New York, NY, and Provincetown, MA

The legendary Hans Hofmann holds a position at the forefront of the American abstract expressionist movement. Born in Bavaria, he pursued art studies from 1904 to 1914 in Paris, where he knew Matisse, Braque, and Picasso during the height of fauvism and cubism. Returning to Germany and teaching there as well as in Yugoslavia, Italy, and France, Hofmann became well acquainted with the German expressionists and, most notably, with Kandinsky. In 1932 he emigrated to the United States where he taught art classes in California (Los Angeles and Berkeley), New York City, and Massachusetts (Provincetown), influencing several generations of abstract painters. His students included Helen Frankenthaler, Louise Nevelson, Red Grooms, Lee Krasner, and Larry Rivers; among his close colleagues and friends were Robert Motherwell, Jackson Pollock, and Mark Rothko.

Thoroughly familiar with European modernism, Hofmann developed an innovative style that explored, as he explained, "the counterplay of movement in and out of the depth as experienced in nature." "Depth perception in nature and depth creation on the picture-surface," he elaborated, "is the crucial problem in pictorial creation. Nature as well as the picture plane have each its own intrinsic laws which are dissimilar but do in fact not refuse to compensate each other when handled by a creative mind." "This is painting!" he proclaimed in 1951, ". . . color development under the consideration of pictorial laws that determines integrated objective form."[73] From his theories, teaching, and practice grew many of the tenets of abstract expressionism.

In 1957 the Whitney organized a Hofmann retrospective that traveled throughout the United States. International awards, honorary degrees, and public acclaim continued as he retired from teaching in 1958 and devoted the rest of his life to painting. When planning the disposition of his artwork, Hofmann stated a preference for "museums connected with a teaching institution. To the end, his overriding concern was for education and the young."[74]

"after *To Miz—Pax Vobiscum*" (plate 33)
The idea for a Hofmann tapestry orchestrated by Gloria emerged in 1976, ten years after the artist's death. Although Helen Frankenthaler studied with Hofmann for three weeks during the summer of 1950 in Provincetown, and certainly maintained contact with him, it is not clear whether Gloria ever met the artist in person. Referring to the crucial intervention of André Emmerich, Hofmann's estate representative, her notes record, "*nb* André to G: If ever a question, G. made tapestry at André's urging—*He* quite interested. About the same time, Emmerich also authorized Modern Master Tapestries Inc., to transform two other Hofmann paintings into wall hangings."[75]

On Bastille Day in 1976, Gloria drew up a contract for an Aubusson tapestry from Hofmann's 1964 painting, *To Miz—Pax Vobiscum*, then at the André Emmerich Gallery and now in the permanent collections of the Modern Art Museum of Fort Worth. With its stacked, overlapping, and floating rectangles of intense yet patchy color, the painting was quintessential Hofmann. "Miz" was the artist's nickname for his wife, Maria Wolfegg, whom he met in 1900 and married in 1924. The Latin subtitle, which translates as "Peace be with you," reflects the fact that Miz had died a year earlier.

As authorizer of the collaboration, Emmerich signed the tapestries' tags along with Gloria. Hofmann's own signature on the painting raised some interesting discussion. "I enclose a tracing of the Hofmann signature on the painting, along with the one you gave me. It is particularly poor on this painting, but I think we should use it as it is, rather than using a 'better' signature from another painting (which do exist). On the very small sheet of paper is a clearer reproduction of the signature which can serve as a guide."

Gloria selected Manufacture Pinton to produce "after *Miz*." Unlike many tapestries, the woven panel was reduced from the original canvas size. (Earlier she debated whether it should be even further reduced at Emmerich's request; perhaps the final size represented a compromise between éditeur and gallery?) After five of the seven panels were woven, the series remained incomplete, despite Gloria's enthusiastic declaration in one of her lectures, "Strong—in a 7th Ave. lobby—carries [the]

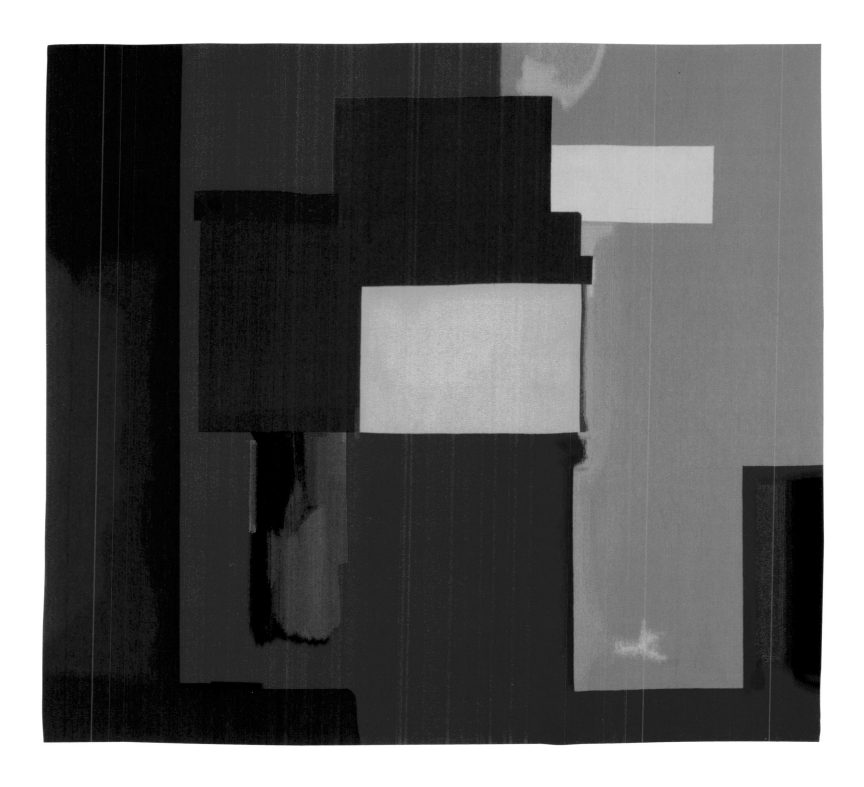

space, tap[estry] stronger than painting in all its emotions!"

"after *Blue Loup*" and "after *Purple Loup*" (plates 34, 35)

In 1981, Gloria, André Emmerich, and Jon J. ("Jack") Fields, president of rug manufacturer Edward Fields, Inc., entered an agreement to produce a limited edition of commercial pile carpets based on Hans Hofmann's paintings on paper *Blue Loup* (1956) and *Purple Loup* (1956). Emmerich explained his choice of designs, "These paintings were originally created by Hans Hofmann as designs for a floor construction [in the form of a mosaic]. Accordingly, I believe that reproduction of these paintings as floor pieces would be appropriate and consistent with Hans Hofmann's original artistic concept."

Responding to an architectural commission for a piazza in Chimbote, Peru, Hofmann designed the "Loups" as splashy ceramic mosaics. They were never installed. In 1956, the year he painted the pair, Hofmann also created a successful mosaic—a brilliant mural that completely encases the lobby elevator of Manhattan's William Kaufmann Building, one block east of Grand Central Terminal.

Gloria pronounced the carpet project "a first in many ways." The capabilities of a commercial plant and a product made in multiples of one hundred couldn't be further from her previous handwork. Individual carpets could be made to order in any size proportional to the original design. Designated the artistic supervisor, she tracked closely the factory processes in Flushing, New York. She relished challenges such as adjusting the design to a pile surface and getting machines to replicate the artist's brushstrokes.

The pair of carpets was released in 1980, on the centennial of Hofmann's birth. Termed "Floor Pieces," they were also promoted as wall hangings. Initial tension arose when the company informed Gloria that only the artist's name would be permitted on the carpet labels. Only after considerable insistence was her name added.

Hans Hofmann, *Blue Loup*, 1956, oil on cardboard, 48 × 30.75 in. © 2010 Estate of Hans Hofmann/Artists Rights Society (ARS), New York.

Hans Hofmann, "**after *Blue Loup***," 1981–86, produced by Edward Fields; see Checklist for dimensions, which vary within edition. © 2010 Estate of Hans Hofmann/Artists Rights Society (ARS), New York. Photo courtesy of Edward Fields, Inc.

Hans Hofmann, *Purple Loup*, 1956, oil on cardboard,
48 × 30.75 in. © 2010 Estate of Hans Hofmann/Artists
Rights Society (ARS), New York.

Hans Hofmann, "**after *Purple Loup***," 1981–87, produced by Edward Fields; see Checklist for dimensions, which vary within edition. © 2010 Estate of Hans Hofmann/Artists Rights Society (ARS), New York. Photo courtesy of Edward Fields, Inc.

Jenkins

PAUL JENKINS
(b. 1923, Kansas City, MO), New York, NY

Paul Jenkins studied painting and drawing at the Kansas City Art Institute from 1937 to 1943, followed by tutelage from Yasuo Kuniyocki and Morris Kantor at the Art Students League in New York. Deeply affected by Asian art and alternative spiritual perspectives, he moved to Paris in 1953. There he began to explore poured paint on canvas and paper, manipulating the substrate to produce abstract works with what one writer called "gem-like veils of translucent and transparent color."[76]

Influenced by Jackson Pollock and Mark Tobey from the start, he developed friendships with Mark Rothko, Willem de Kooning, Franz Kline, Ad Reinhardt, and Philip Guston. He also met Motherwell and others who were central to abstract expressionism. In addition to his prolific paintings awash in flowing color, Jenkins often ventured into other media and artistic contexts through international commissions—stage sets for theater and dance, glass as well as bronze sculpture, experimental "light graphics" based on lithography, and multimedia architectural collaborations. Tapestry represented one more exciting discovery for this versatile artist.

"after *Phenomena Peal of Bells Cross*" (plate 36)

In August 1973, Gloria and Jenkins together selected his *Phenomena Peal of Bells Cross*, executed just a year before. Included in the Corcoran Gallery of Art traveling exhibition of the artist's watercolors on paper, the small maquette's fan-shaped wings of spreading hues evoke the soaring sensation of Jenkins's many large-scale acrylic paintings on canvas. Gloria therefore planned a tapestry transposition that more than doubled the painting's size. The first two versions of this tapestry were woven in Turkey but the rest in France. (For the story of their making, see chapter 6.)

Although many tapestries were executed from color-corrected photographs of original artwork, this did not work with Jenkins's subtly arrayed colors: "With a Jenkins image it is essential to work from a maquette." Seeking further assurance, she queried Olivier Pinton, "Can you capture the brilliance of all the colors in the maquette?" The original painting crisscrossed the Atlantic numerous times as editions were woven. Originally, Jenkins intended to keep the painting, but in 1975 he gave the well-traveled original to Gloria as a wedding gift.

Gloria spoke of Jenkins as a most enthusiastic and appreciative artist. On one occasion he wrote her, "I am waiting with bated breath, and fully anticipate a total success, which required your patience with me and fortitude with the tapestry art form." Success came when the tapestry was accepted into the highly competitive Lausanne Tapestry Biennale of 1979.

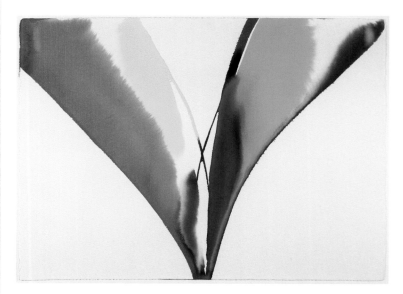

Paul Jenkins, *Phenomena Peal of Bells Cross*, 1972, watercolor on paper, 22 × 30 in. Minneapolis Institute of Arts; © 2010 Paul Jenkins/Licensed by ADAGP. Photo courtesy of Minneapolis Institute of Arts.

Paul Jenkins, "**after** *Phenomena Peal of Bells Cross*," 1973–79, woven by Pinton and Boccia Collection, 57 × 82 in. © Estate of Gloria F. Ross. Photo by Al Mozell.

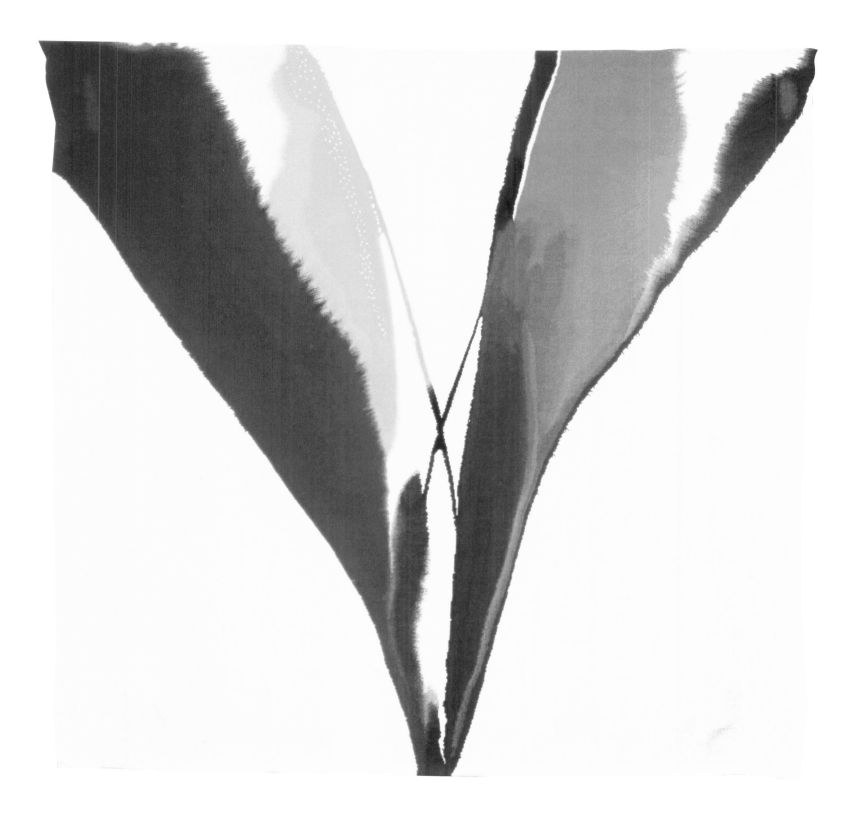

"after *Phenomena Mandala Spectrum Turn*" (plate 37)

Even before the triumph of their first tapestry series, Gloria and Jenkins agreed in 1978 to a second image. They considered several possibilities, including *Phenomena Sign [Day?] of Zagorsk* (1966), a complex acrylic on canvas in his Paris studio. They finally chose the more manageable *Phenomena Mandala Turn,* a watercolor on paper executed in 1971.

Jenkins preferred to have a singular tapestry made rather than multiples, but the high cost of French tapestry meant that an edition of seven was again planned, with the tapestry more than doubling the dimensions of the painting. In the weaving, Gloria directed the weavers to omit a "small, spontaneous gesture which is fine in the painting but will not look right in the tapestry."

Another Project

In 1988 Jenkins designed a special tapestry, only eight inches square, to be woven at full scale as part of the World Tapestry Wall in Melbourne, Australia. (For more about this project, see the section on the Victorian Tapestry Workshop in chapter 6.)

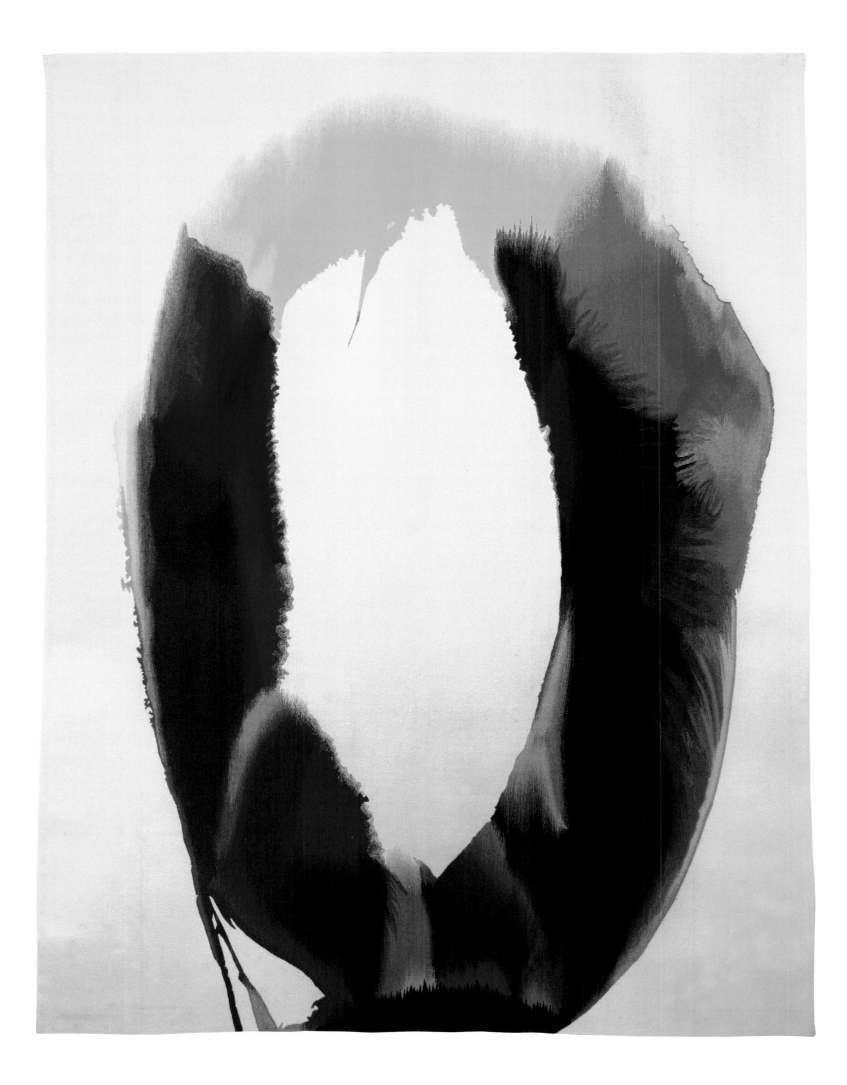

**Artists of the past were fed by
literature. Today we are fed by
a scientific environment.**
—Alexander Liberman

ALEXANDER LIBERMAN

(b. 1912, Kiev, Russia; d. 1999, Miami, FL),
New York, NY

Russian-born Alexander Liberman was a
highly visible sculptor, painter, and photogra-
pher in addition to his fifty-year career as art
director at *Vogue* and editorial director of
Condé Nast Publications. He studied archi-
tecture, engineering, painting, and math at
the Sorbonne, graduating in 1930. There he
befriended some of the most accomplished
modernist artists of the twentieth century
and began to photograph them. His move
to New York in 1941 allowed for return visits
to Europe every year to continue his photo-
graphic project. By the early sixties, MoMA
exhibited his compelling portraits, Viking
Press had published *The Artist in His Studio*
(1960), and the Betty Parsons Gallery offered
him nearly annual solo shows in New York
City. At his death, the Getty Research Insti-
tute received over one hundred thousand
photographic images from his estate, portray-
ing the lives, studios, and surroundings of
Picasso, Matisse, Braque, Chagall, Duchamp,
Dubuffet, Ernst, Giacometti, and Léger, along
with Americans Frankenthaler, Motherwell,
Rauschenberg, Rothko, David Smith, and
others. This collection is considered the single
most valuable visual resource to document
the modernist period.

Made between 1950 and 1964, Liberman's
clean geometric paintings with smooth bur-
nished surfaces became the subject of a solo
retrospective at André Emmerich Gallery in
1974. This was perhaps Gloria's first introduc-
tion to the artist. (Ten years earlier, Liberman,
Helen Frankenthaler, and others had collabo-
rated on a ceramic series at the Bennington
Pottery, but it is unlikely that Gloria made
his acquaintance then.) Paintings were fol-
lowed by monumental sculpture created

from industrial materials and parts, the cleaved
and stacked cylinders equally clean-lined and
boldly colored. "Artists of the past were fed
by literature," he observed, "Today we are fed
by a scientific environment. We see airplanes,
we see rockets. This inspires a new scale."[77]
In a reversal of the tapestry process, Liberman
found himself making three-dimensional
maquettes retroactively for the monumental
sculpture, in order to document their existence
in a less cumbersome format.

"after #41" (plate 38)

One year after his Emmerich show, Gloria
contracted with Liberman to translate an
extant painting, *#41* (1961), into tapestry. To
select this image, they met in February 1975 at
Pace Gallery and first examined her tapestries.
In June they met at his Condé Nast offices in
a venerable 1922 building on Madison Avenue,
two blocks from Grand Central Station, to
consider his paintings. In consultation with
Solomon and Glimcher, she and the artist
initially planned on translating *Light XII* (1975),
a 5½-by-7-foot painting to full scale, but its
purchase by a major art museum scotched
the project.[78] Instead, Gloria and her advisers
chose the graphic and much smaller *#41*.

Gloria sent the original painting rather than
the usual color-corrected photo to France
because, as she explained to Olivier Pinton,
"The color, I think, is exquisite, and I hope you
can capture it." To the artist she emphasized,
"I can get much truer colors and color tones
from the original work."[79] Although an edition
of seven was planned, only one tapestry was
woven, and the maquette was returned to
New York.[80]

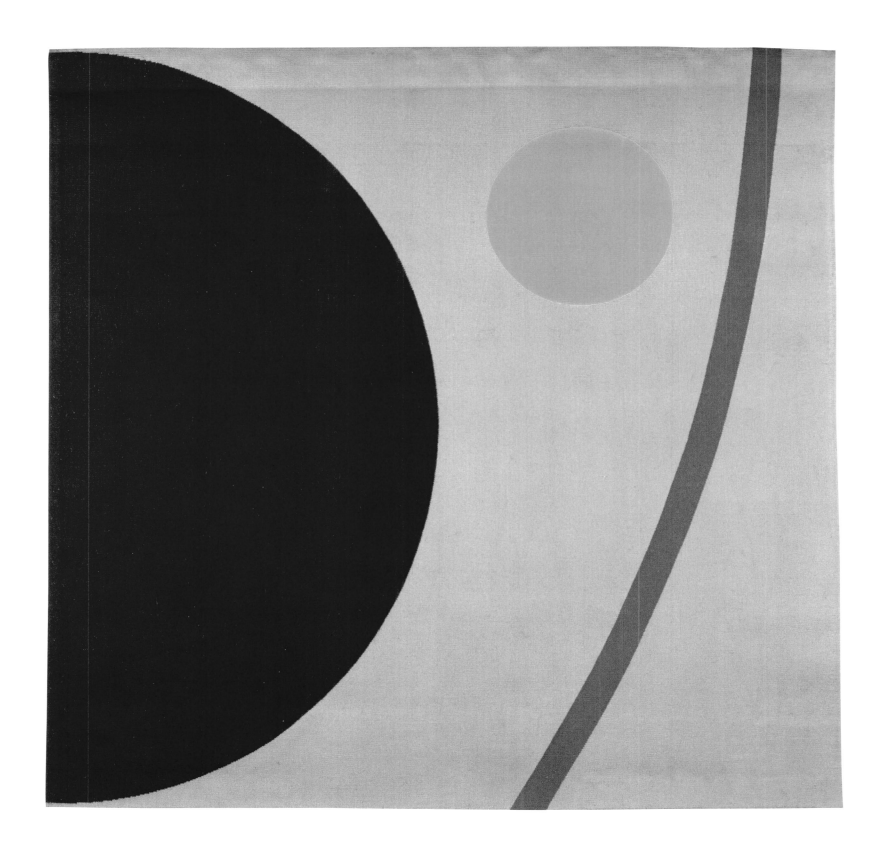

Lindner

RICHARD LINDNER

(b. 1901, Hamburg, Germany; d. 1978,
New York, NY)

Richard Lindner was born in Germany and
worked as a commercial artist in Berlin,
Munich, and Paris. In 1941 he moved to New
York City, where he spent a decade as an
illustrator for fashion magazines before turn-
ing to full-time painting. Growing up near his
mother's Bavarian corset-making shop and
strongly influenced by avant-garde theater,
Lindner populated his paintings with robot-
like men and women, circus performers, and
amazons in bizarre garments and erotic poses.
Although his figurative work was worlds apart
from abstract expressionism, he traveled in
many of the same New York circles as these
artists from the 1950s into the 1970s—
showing at the Betty Parsons Gallery, teach-
ing at Pratt Institute, and lecturing at Yale.

Lindner's social commentary on gender
issues is delivered in a slick but hardly facile
style. His work is separated from pop art by
its introspective and charged content. Dore
Ashton notes, "It is Lindner's lean, meticulously
flattened technique that brings his subject
matter in the arena of the present."[81] It is also
this quality that makes his paintings conducive
to tapestry. Prior to tapestry work, Lindner
designed an appliquéd fabric hanging, pro-
duced by the Betsy Ross Flag and Banner
Company as an edition of twenty. *Banner I*
(1964, 80 × 47 inches) features a female circus
performer surrounded by flames with a man's
head and torso superimposed. Like his future
tapestry project, this expanded the artist's
work to a larger scale.

"after *Telephone*" (plate 39)

Max Palevsky, the Los Angeles venture capi-
talist and technology wizard, approached
Gloria in 1972 about commissioning a tapestry
for his personal collection. Having seen
Lindner's work in Dore Ashton's book about

the artist, he specifically requested the paint-
ing *Telephone,* in which a busty helmeted
female figure and an overcoated man wearing
a Homburg hat speak into separate phones,
standing back to back. The title appears like
a sign on a phone booth as the figures over-
crowd the framing red box.

Gloria expressed interest in collaborating
on the work, which she thought would "trans-
late well." She also observed, "It is a particularly
difficult picture to translate with its many
colors & subtle shadings." Palevsky arranged
for the artist to contact the German owners,
the well-known collectors Klaus and Erika
Hegewisch, about using the original for color
matching. Gloria didn't meet the artist until
after this project was complete, working in-
stead through Palevsky to answer questions.

Although she considered the Chaudoir
studio in Belgium, Gloria ultimately selected
Raymond Picaud in Aubusson to weave the
unique work, the first of three projects he did
with her. Having only a poorly colored litho-
graphic poster of *Telephone*, Picaud sent his
dye specialist to Hamburg to examine the
original painting. She sought the weaver's
assurance: "I wonder if you have ever done
anything like this before! Will your colorist take
the chapelet and essai with him? If they are
not right, will he have similar colors on hand?
I wonder how this will be done. . . . It is good
to work for a man who is such a perfectionist,
yes?" After considerable effort, Picaud com-
pleted the powerful tapestry, somewhat larger
than its painting, in February 1974.

Other Projects

Gloria hoped to work further with Palevsky,
who had also acquired a contemporary
tapestry woven at the Dovecot Studios.
Always eager to "talk tapestry" with clients,
she offered, "I have just seen the medieval
tapestry show at the Metropolitan Museum.
If you did not see it at the Grand Palais [in
Paris], I hope that we might visit it together
when you are next in town. It is of mutual
interest, and too, it might afford the oppor-
tunity for me to discuss some thoughts I
would like to present to you."

After their Met meeting, Gloria proposed
a second Lindner tapestry, considering more
than a dozen paintings. She met the artist in
New York and Paris, and they zeroed in on
Ice (1966), an oil on canvas, seventy by sixty
inches, at the Whitney, to be enlarged for a
slightly larger tapestry (the artist had autho-
rized her to "make any size"). The painting
showed a goggled woman holding a micro-
phone, the figure superimposed by an Indian's
head (resembling that on old nickels). Although
Gloria made arrangements with museum offi-
cials ("my friend David Solinger, Chairman of
the Whitney"), the artist's representatives at
Knoedler, and her advisers at Pace, the project
fizzled after several months' effort.

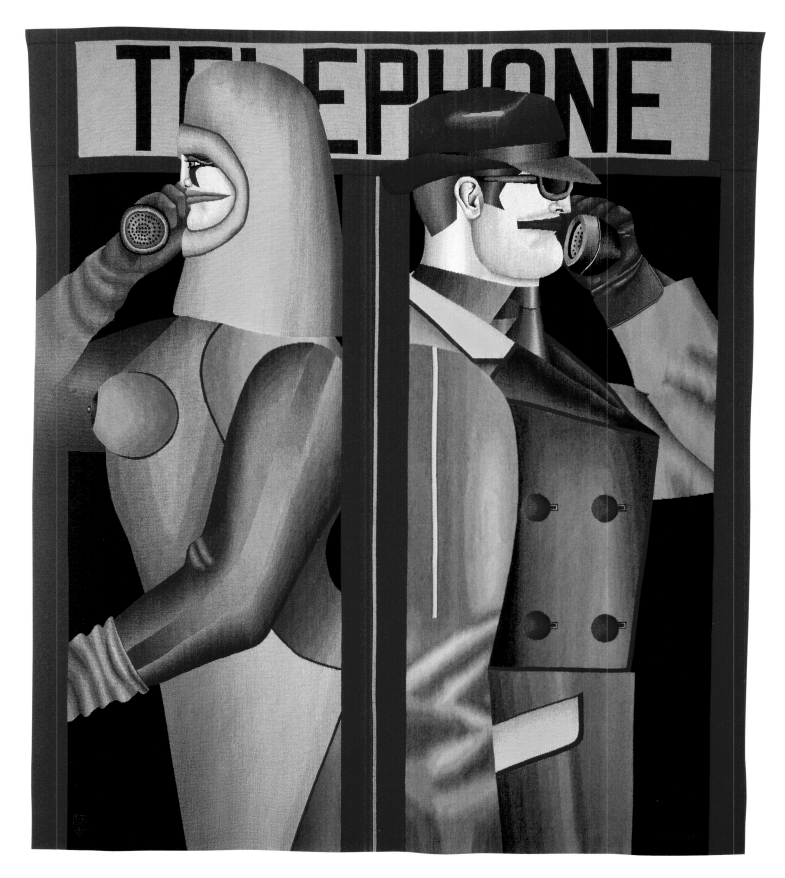

Louis's last paintings are . . . certainly the most dynamic of the Stripes, seeming more the beginning of something than the end.
—John Elderfield

Louis

MORRIS LOUIS
(b. 1912, Baltimore, MD; d. 1962, Washington DC), Washington DC

Morris Louis painted richly stained paintings on raw canvas during the last decade of his life. His layers of sweeping color, laid side by side or overlapping, were directly inspired by the work of Helen Frankenthaler and Jackson Pollock. Raised in Baltimore and trained at the Maryland Institute of Fine and Applied Arts, Louis spent part of his early career in New York City. In 1952 he moved to Washington DC to teach at the Washington Workshop Center of the Arts. One year later, friend and colleague Kenneth Noland introduced him to critic Clement Greenberg, who took both artists to Helen Frankenthaler's Manhattan studio. This seminal event included a viewing of her profoundly influential *Mountains and Sea* (1952), which both Noland and Louis credited for opening their eyes to new painting processes.

Destroying much of his previous work, Louis used Magna, an oil-based acrylic resin, on canvas to create his 1950s and early 1960s series based on themes of Veils, Florals, Columns, Unfurleds, and Stripes. Fascinated with exploring subtle color interactions on a large scale, Louis, Noland, Gene Davis, Tom Downing, and other DC colleagues became known as color field painters who composed the loosely aggregated Washington color school, associated with the Corcoran Gallery of Art. The short-lived career and luminous paintings of Louis have merited major museum exhibitions in nearly every decade since his death.

"after *Equator*" (plate 40)

With a band of close-set stripes moving from upper left to lower right in a square format, *Equator* (1962) was one of eight paintings shown at Emmerich Gallery shortly before the artist's death at age fifty from lung cancer. Apparently, the diagonal orientation evolved after paint was applied, when the artist designed how the canvas would be mounted: "Louis arranged to have three canvases that he had painted with floating stripes stretched as squares with the stripes running diagonally across them."[82] MoMA's chief curator John Elderfield bestowed high praise. "These, Louis's last paintings, are probably the most open and certainly the most dynamic of the Stripes, seeming more the beginning of something than the end."[83]

The painting was acquired by a private collector in Washington DC. In 1970 he and his wife granted permission for its translation into a series of hooked wall hangings. André Emmerich and Gloria discussed having this large piece hooked and eventually finding a smaller image for a European-woven tapestry piece.[84] In 1971, Gloria initiated "after *Equator*," to be equal in size to the original painting, sixty-three inches square. To replicate the artist's gauzy, translucent colors on raw canvas, applied without brushstrokes, Gloria requested that Anna di Giovanni leave the loops of wool yarn uncut and form "no lines absolutely straight, some lines slightly wavy."

Although Gloria arranged for Louis's widow, Marcella Bernstein Brenner, to receive the artist's proof, she returned the hanging, explaining, "I could not possibly accept such a gift. I have done nothing whatsoever to make such generosity to me in any way appropriate."

40 Morris Louis, "**after _Equator_**," 1970, hooked by Anna di Giovanni, 63 × 63 in.
© Estate of Gloria F. Ross. Photo by Eric Pollitzer.

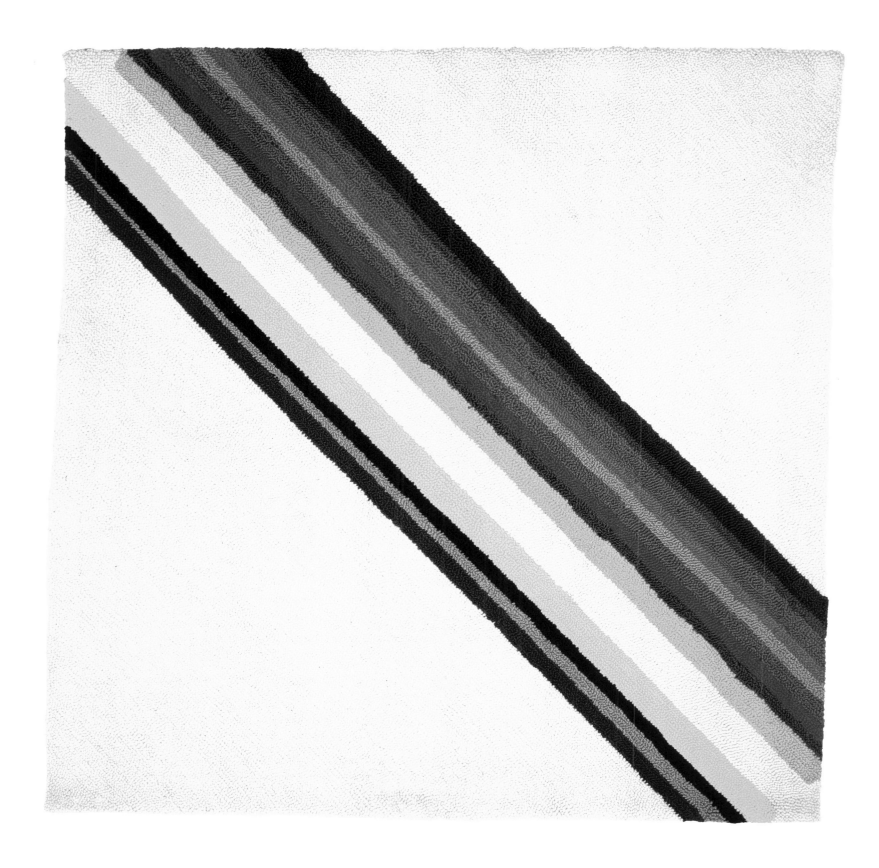

Conrad Marca-Relli's contribution to contemporary art has raised collage to the stature of a major art form.

—Elayne H. Varian

Marca-Relli

CONRAD MARCA-RELLI

(b. 1913, Boston, MA; d. 2000, Parma, Italy)
Associated with the first generation of abstract expressionists, Conrad Marca-Relli's favored medium was large-scale collage rather than painting. Born in Boston to Italian parents, he trained briefly at Cooper Union and later worked on WPA projects, as did many other artists during the Depression. After serving in the Second World War, he established a career that bounced between Europe and America. Neighbor to Jackson Pollock and Lee Krasner in East Hampton, Long Island, Marca-Relli became a familiar part of the arts colony, even as he continued to travel widely. Helen Frankenthaler rented his house and studio during summer 1955.[85] In 1961 he and Robert Motherwell shared a two-person show in Dusseldorf.

His monumental overpainted collages incorporated "shingles" of raw and painted canvas, pieced together with other layered materials. In the 1960s, he added metal and vinyl components to his collages, bringing them into low relief, almost to the point of

Olivier Pinton working on a black-and-white cartoon, Felletin, 1974. Note image is reversed for weaving from the "wrong" side.

sculpture. With industrial tech qualities, his work presaged avant-garde assemblages that followed. In 1970–71, his collages, including one called *Multiple Image* (1969), were featured by Marlborough-Gerson Gallery in a one-man show that traveled from the Norton Gallery in West Palm Beach, Florida, to the Fort Lauderdale Museum of the Arts, and to the Lowe Art Museum, University of Miami, Coral Gables. One observer proclaimed, "Conrad Marca-Relli's contribution to contemporary art has raised collage to the stature of a major art form."[86]

"after *Multiple Image*" (plate 41)

Two years later, the Whitney held a retrospective of Marca-Relli's work and Gloria met the artist at a party thrown by Samuel M. Kootz, the modern art entrepreneur. She studied the artist's published work and his files at MoMA's library, taking copious notes. In November 1973, they visited Pace and Marlborough Galleries together to look at her tapestries and his latest work. In March 1974, they signed a contract to translate the still-available *Multiple Image* (1969), then located at Marlborough's Zurich gallery. Gloria first determined that the collage on canvas would be scaled up slightly to a more impressive seventy-eight by ninety-six inches, but it was later downscaled due to costs of materials and labor.

Originally, Gloria thought to do Marca-Relli's work in Scotland, because she felt that Dovecot's handling of texture would match the layered nature of the collage. Having just seen several appliquéd wall hangings designed by Antoni Tàpies and made in Spain (possibly in collaboration with Josep Royo), Gloria hoped to improve on their technique. She wrote to Marca-Relli, "I am a great admirer of [Tàpies's] work, but I feel that they were not handled quite right in the tapestry medium. The background weaving must be done in a certain way, and the forms then properly applied."

Ultimately, she selected Pinton in France for an illusionistic work in the traditional flat weave. To start this technically complex project, she wrote to Olivier Pinton: "I enclose a good transparency of a collage of Conrad Marca-Relli . . . The green background has some shading which I would like to see in the tapestry. The color is really accurate (according to the artist) in the transparency. The black areas are a flat black without any shading (even though the transparency looks as though there is some shading in the black). The whites are not quite a pure white. The white in the transparency again is accurate. The artists says it is not 'flat' white, but I think just the fact of the light bounding off the woven work will give this the necessary softness. Yes? There is no real shading (as in the green). Olivier, the parts of this collage that are burlap I would like to see woven in *laine cardé* [literally "carded

Conrad Marca-Relli, "**after Multiple Image**" (00/7), 1975–90, woven by Pinton, 71 × 86 in.
Minneapolis Institute of Arts; © Archivio Marca-Relli, Parma/Estate of Gloria F. Ross.
Photo courtesy of Minneapolis Institute of Arts.

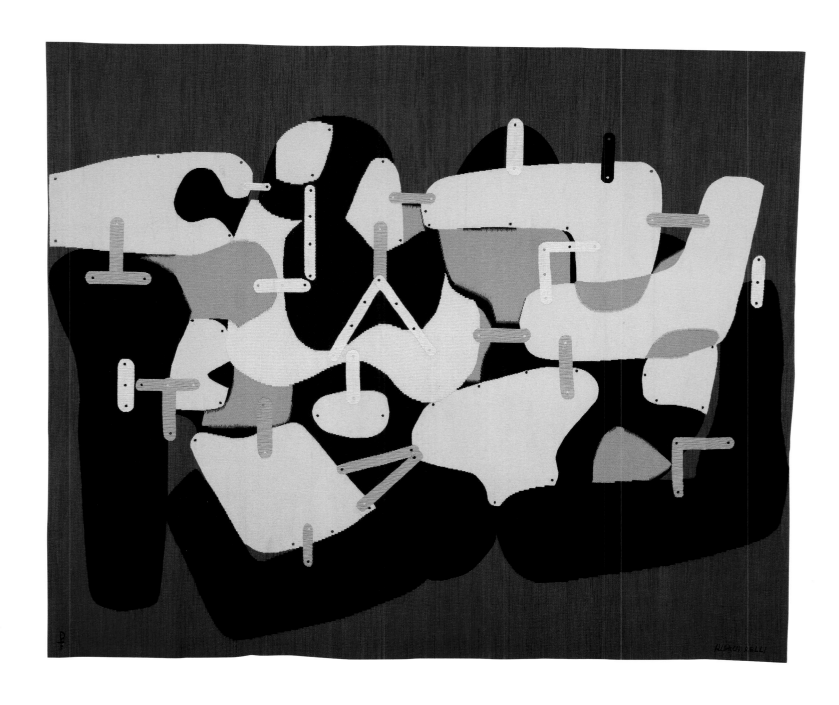

wool," referring to relatively fuzzy woolen-spun yarn, as opposed to *laine peigné* in which wool fibers are combed, resulting in a smoother yarn], in a color as close as possible to the burlap in the collage (I told the artist that this could not be exact and he understands this). It would give these parts a different texture and feeling. Conrad actually burns the edges of the burlap to give them shading. Can any shading be done with laine cardé? Will laine cardé present any problems?"

Experimentation resulted in a truly creative interpretation of the artist's patched work. In later lectures, Gloria often used "after *Multiple Image*" to emphasize the importance of portraying "what [the] artist wants to say." The project underscored the significant role Gloria played in communicating with weavers unfamiliar with a particular artist's work and vice versa.

To gain textures like those of the collage, the weaver varied the interlacing of threads over single or doubled warps and tried yarns made from different fibers—wool, cotton, silk, linen, acrylic. After trials were woven, Gloria noted: "The Marca-Relli is . . . very good, except for the green color. If possible the silk should be more bronze than gold. Olivier, your weaving techniques are exactly what I had hoped for, except that the white silk 'strap' woven double chaine [with paired warps] seems too shiny. Could you perhaps mix some wool with this thread to make it less shiny? The other 'strap' is fine."

Puzzling over the right green for the tapestry, she wrote to the artist, "I believe it is more important to have a true Marca-Relli color than to have an exact duplicate of the original" color on canvas. To which he revealed, "It's hard for me to say what green looks better without seeing it next to the other colors."

Later, he wrote, "Frankly I can't visualize the solid colors as opposed to weaving—so I am leaving it to your best judgment since you are familiar with the effect it will have." Gloria wrote again to raise a different issue, "a minor change which should probably be made when translating the collage into tapestry. Edges will be soft around the burlap forms, but many of the longer threads at these edges should not be translated into the tapestry. Often a spontaneous gesture in an original image looks forced in the disciplined medium of tapestry." Again the artist deferred to her.

Gloria hoped to have the first edition when her one-person show at Pace Editions coincided with Marca-Relli's at Marlborough-Gerson. The tapestry did not, however, reach New York until March. The second of this edition followed in September, with the artist's proof being the third and last of this incomplete edition.

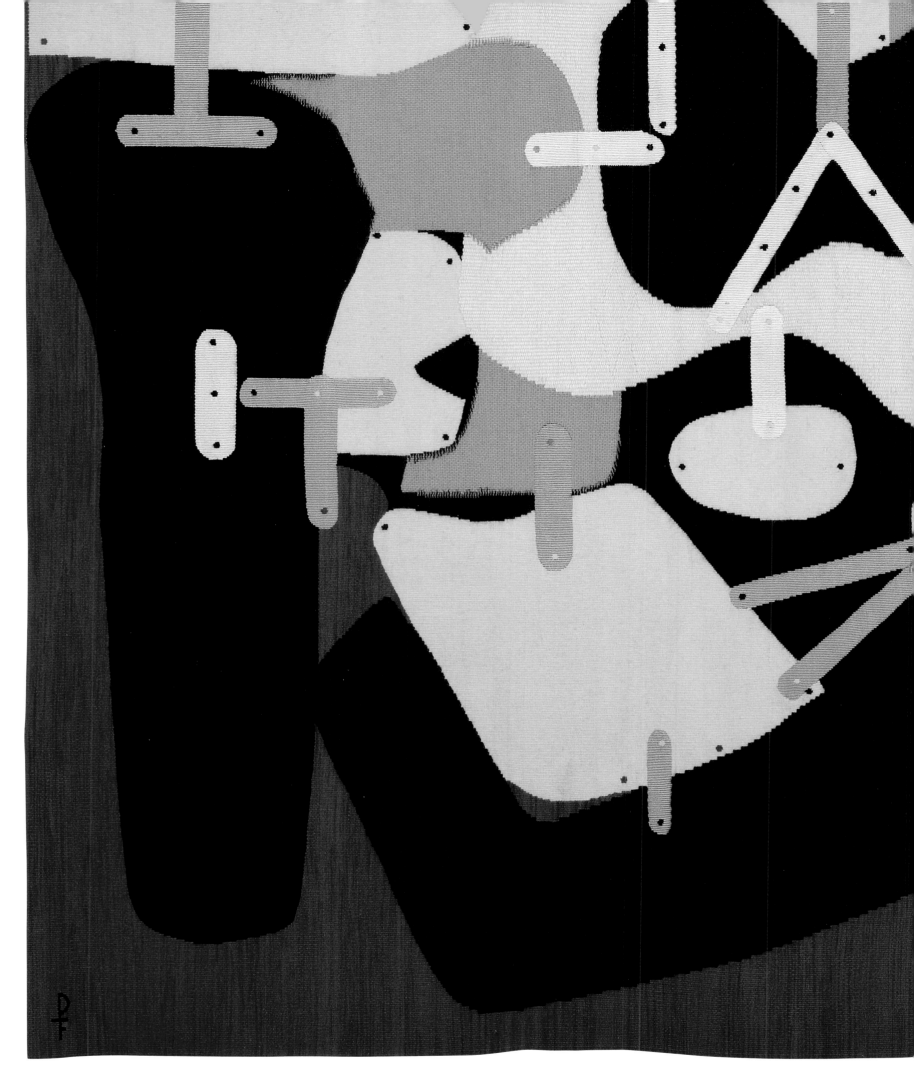

Motherwell

Motherwell

> I almost never start with an
> image. I start with a painting
> idea, an impulse, usually derived
> from my own world.
> —Robert Motherwell

ROBERT MOTHERWELL
(b. 1915, Aberdeen, WA; d. 1991,
Provincetown, MA)

A painter, collagist, and printmaker, Robert Motherwell was a pioneer and prominent exemplar of the abstract expressionist movement in postwar America. Also an eloquent writer and theorist, he defined his approach by focusing on painting's emotional qualities, engaging the artist's and viewer's subconscious, and leaving European formalist concerns behind. As H. H. Arnason has written, Motherwell quite simply "transformed the history of American painting."[87]

After graduating from Stanford University and before entering Harvard's graduate school to study philosophy, Motherwell attended a 1937 Spanish Civil War rally. Between 1948 and 1991, he painted several hundred canvases to express his sorrow over the Spanish revolution—"for the tragically missed opportunity of Spain to enter the liberal modern world in the 1930's. And for its tragic suffering then

and for decades after."[88] Later he elaborated, "I take an elegy to be a funeral lamentation or funeral song for something one cared about. The *Spanish Elegies* are not 'political' but my private insistence that a terrible death happened that should not be forgot. They are as eloquent as I could make them. But the pictures are also general metaphors of the contrast between life and death, and their interrelation."[89]

The Elegies to the Spanish Republic became a lifelong project which the artist revisited continually. Critic Hilton Kramer wrote of them, "The 'Elegies' have always constituted Mr. Motherwell's most heroic theme, and nothing that has occurred in the art of painting in recent years has diminished their power."[90] In these and other works, his combination of bold brushwork (some say derived from action painting) with large-scale and saturated hues akin to color field painting made his work perfect for translation into tapestry.

Working with Motherwell

Motherwell and Gloria worked together on five projects between 1964 and 1989. As he was known to work in varied media and approaches in order "to accommodate the greatest range of thought and feeling," he was open to Gloria's initial requests.[91] Married to Helen Frankenthaler from 1958 to 1971, Motherwell was Gloria's brother-in-law during their earliest work together. Even after the marriage and when their collaborations ended, he and Gloria remained friends.

Known for his thorough engagement in the creative process, Motherwell had considerable involvement in the tapestry making. Gloria noted his reviews in her shorthand— "RM saw 1st finished by Ana di G & OKed it," his modifications—"RM said to do one c 3½" approx canvas colored border," and his monitoring—"RM'll check when ret[urn]s."

Aside from Kenneth Noland with the Navajo weavers, Motherwell was the only artist to request direct contact with the weavers. This was a matter of principle; as he aptly summarized his concern, "Without ethical consciousness, a painter is only a decorator."[92] He also asserted that weavers, like other artists, required certain interpretive freedoms to achieve a successful tapestry. Known for reworking his own canvases and collages, sometimes even twenty years after they were "finished," he recommended that "tap[estry] shouldn't make [the] impact of a painting." They need not emphasize every nuance from the original design, he maintained, but rather should attend to the overall effect.[93]

This restless artist appears to have had a love-hate relationship with the notion of tapestries made after paintings and other artworks. In fact, he thought many tapestries (not just Gloria's) were "overcrafted." A comment of his

Robert Motherwell, *Elegy to the Spanish Republic No. 78*, 1962, oil and acrylic on canvas, 71 × 132.25 in. Yale University Art Gallery; © Dedalus Foundation/ Licensed by VAGA, New York. Photo courtesy of Yale University Art Gallery.

Robert Motherwell, "**after *Elegy to the Spanish Republic No. 78***," 1963, hooked by GFR workshop, 71 × 132 in. Mount Holyoke College Art Museum; © Dedalus Foundation/Licensed by VAGA, New York. Photo by Laura Weston, courtesy of Mount Holyoke College Art Museum.

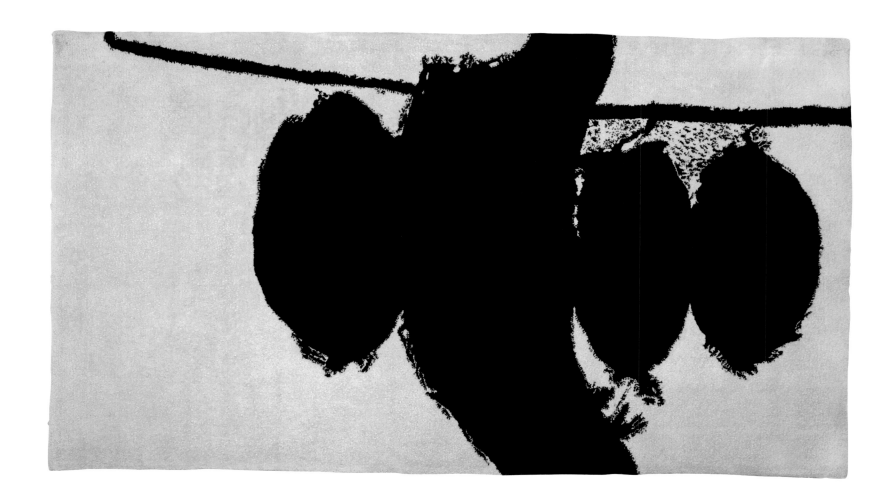

about printmaking may shed some light on this position: "I essentially use the same processes as in painting with one important exception: to try, with sensitivity to the medium, to emphasize what printing can do best—better than say, painting or collaging or watercolor or drawing or whatever . . . Otherwise, the artist expresses the same vision in graphics that he does in his other works."[94]

Despite his skepticism, he accepted an arrangement with Modern Masters, which became Gloria's sole commercial competitor. Beginning in 1967, three years after Gloria's first work with Motherwell, four Modern Masters/Motherwell projects were executed.[95] The artist rejected other proposals and by 1983 had stopped working with the company. Throughout the 1970s and 1980s, unauthorized tapestries by hobbyists also surfaced and irked Motherwell, but little was done about them.[96]

"after *Elegy to the Spanish Republic No. 78*" (plate 42)

In 1964, with informal permission from the artist, Gloria hand-hooked a version of his painting *Elegy to the Spanish Republic No. 78* for her own home.[97] This was her second major wall hanging, and she duplicated the size of the painting for the textile. A year later, she inquired at the Ruggery on Long Island about finishing the Motherwell rug for a first exhibition. George Wells applied a latex backing, sheared, and hemmed the piece, in time to be included in the 1965 exhibition Tapestries and Rugs by Contemporary Painters and Sculptors at the Museum of Modern Art. In 1969 the rug was shown again in New York at the Feigen Gallery. Gloria described it as a piece that "I made myself years ago and

before my professional life began." It remained in her family's private collections until 1978 when Marjorie Iseman, Gloria's sister, donated it with Motherwell's permission to the Mount Holyoke College Art Museum.

"Homage to Rafael Alberti—Blue" (plate 43)

In 1969 Motherwell and Gloria embarked on their first formal arrangement. An etching from his newest series, The Alberti Suite, formed the basis of this initial professional alliance. Motherwell dedicated the work to the Spanish poet Raphael Alberti, who had written eloquently during the 1940s in praise of painting, the palette, the paintbrush, and to the various qualities of black, blue, red, and white.

Gloria ordered 180 pounds of blue and 3 pounds of white wool yarn. After Motherwell approved the first rug, a complete edition of "*Homage to Rafael Alberti—Blue*" was hooked by Anna di Giovanni during spring 1970. To fulfill the artist's goal of reflective light emanating from the surface, the yarn loops were not sheared and contribute to the work's complexity.

In a further extension of the collaborative spirit, the etchings formed the basis of a highly celebrated artist's book of aquatint images and letterpress texts. Working with Tatyana Grossman, Motherwell published *A la pintura* (To Painting) as a limited edition in 1972.

Gloria and Motherwell planned to use a second etching from the same series to become "*Homage to Rafael Alberti—Red*," intended as a sheared piece enlarged to seven by thirteen feet. Inexplicably an order was never placed for its execution.

"after *Elegy to the Spanish Republic No. 116*" (plate 44)

Following the first successful hooked projects, Gloria turned to Scotland and classical handwoven tapestry weave for translation of a small Motherwell painting (only 7 by 9 inches) into a large-scale tapestry. She chose his "*Elegy to the Spanish Republic No. 116*" as her first project with the Dovecot Studios in Edinburgh. Artistic director and master weaver Archie Brennan and his team effectively combined linen of varied thicknesses with the more traditional wool; the weavers used knotting and wrapped "stitches" in the soumak technique for surface texture. The workshop's goal was "to retain th[e] directness and the power of the original without slavishly copying the marks."[98] Gloria felt that using a stark white linen with a dense surface texture "helped to establish virility of image." (For further descriptions of weaving these tapestries, see chapter 4.)

Robert Motherwell, *A la pintura: Blue 1-3*, 1972, aquatint, lift-ground etching and aquatint, and letterpress on paper, 25.5 × 38 in. Limited edition illustrated book by Universal Limited Art Editions; © Dedalus Foundation/Licensed by VAGA, New York. Photo courtesy of Dedalus Foundation.

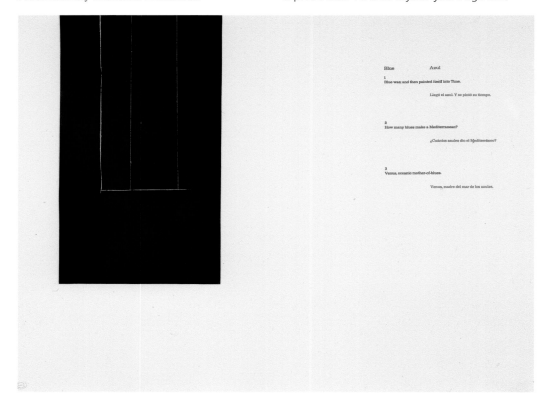

Robert Motherwell, "*Homage to Rafael Alberti—Blue*," 1970–71, hooked by
Anna di Giovanni, 108 × 66 in. © Dedalus Foundation/Licensed by VAGA, New York.
Photo by Eric Pollitzer.

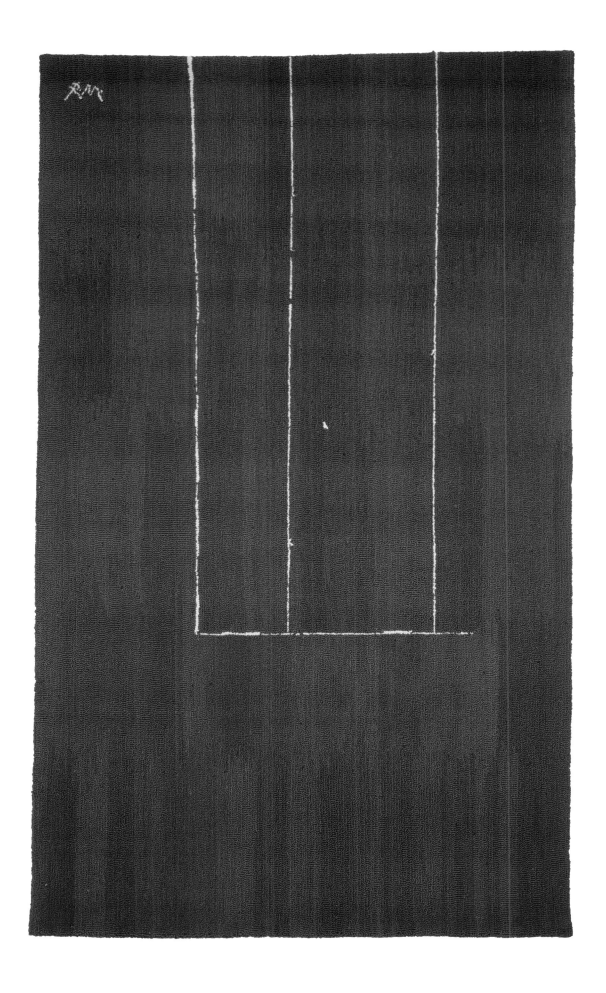

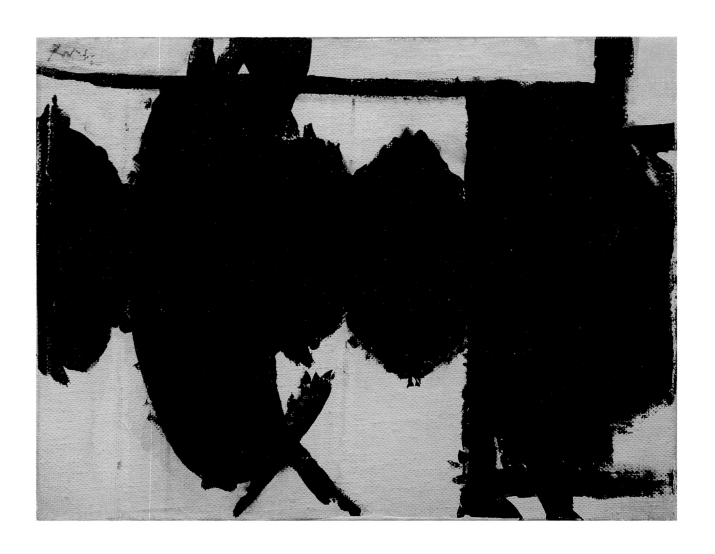

Robert Motherwell, *Elegy to the Spanish Republic No. 116*,
circa 1969, acrylic on canvas board, 7 × 9 in. Clifford Ross
collection; © Dedalus Foundation/Licensed by VAGA,
New York.

Robert Motherwell, "after *Elegy to the Spanish Republic No. 116*," 1970–76, woven by Dovecot Studios, 84 × 108 in. © Dedalus Foundation/Licensed by VAGA, New York. Photo by Eric Pollitzer.

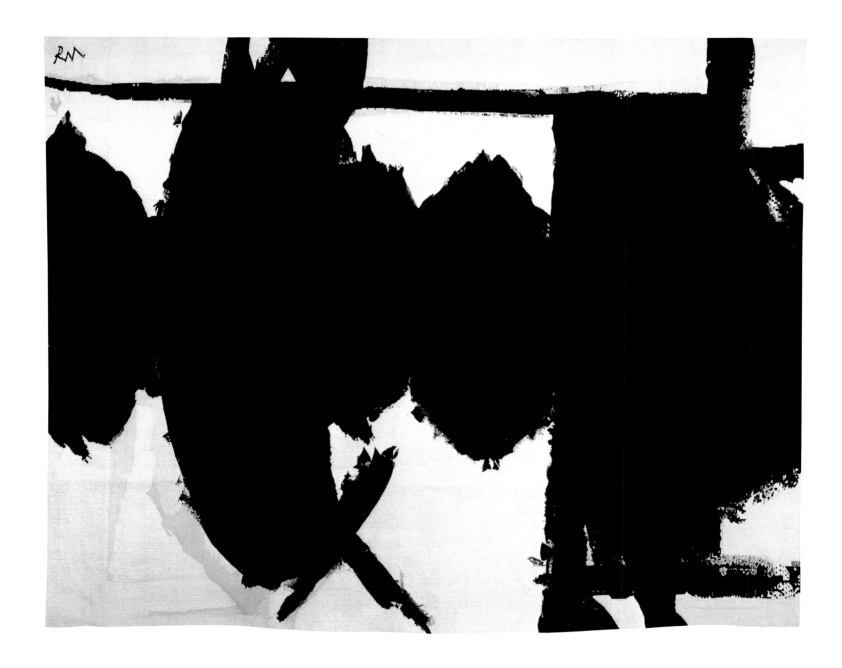

Robert Motherwell, "***Untitled (Westinghouse Broadcasting Company commission)***,"
1972, hooked by Anna di Giovanni, 108 × 72 in. © Dedalus Foundation/Licensed by
VAGA, New York. Photo by Kubernick.

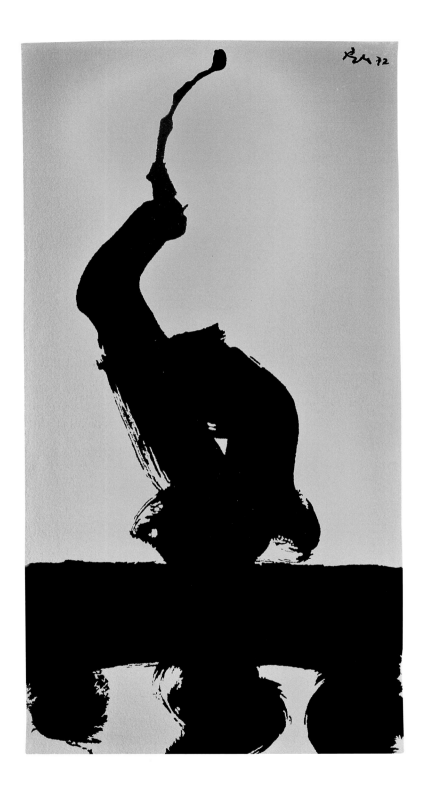

Robert Motherwell, *Untitled,* 1972, acrylic on canvas,
22 × 11.5 in. Private collection; © Dedalus Foundation/
Licensed by VAGA, New York. Photo courtesy of
Dedalus Foundation.

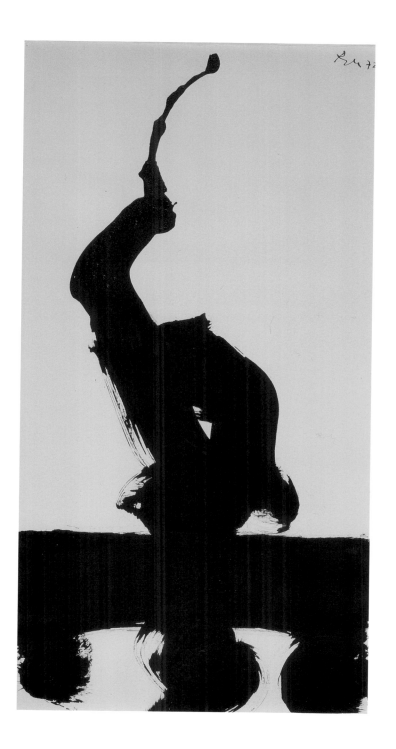

"*Untitled (Westinghouse Broadcasting Company commission)*" (plate 45)

The 1971 commission by Westinghouse, Inc., for its KYW-TV Newsradio building in Philadelphia paired works by Motherwell and Helen Frankenthaler, who were, ironically, then divorcing. Following a tour of the intended spaces, Motherwell wrote, "I finally have the idea for the Westinghouse project, though I'm not satisfied with the actual model. Hope to make revised version during the Holidays."

The painter created at least five studies, from which a vertical maquette with broad elegiac brushstrokes was selected. After the artist reviewed subsequent cartoon and yarn samples, Gloria noted, "RM—not open series," presumably referring to his wish to create something distinct from his solid-colored "Open" canvases begun in 1967, in hard-edge opposition to his painterly "Elegy" series. Reverting to technical discussion, he stipulated that the "white should be canvas color, a bit pinker than RG sample" and otherwise "details up to G."

The dramatic piece was completed in the hooked-rug technique and installed with the companion Frankenthaler panel in September 1972. A dispute about the proper means of mounting the large panels stormed between Gloria and the corporation through summer 1973. In 1998, after a period in storage, both artworks were rediscovered, conserved, and installed in the Reading Terminal Head House, serving as part of Philadelphia's convention center.

"after *In Brown and White*" (plates 46a, 46b, 46c)

Among her many 1974 projects, Gloria initiated "after *In Brown and White*" from a 1960 collage owned by her sister Marjorie Iseman. The finished tapestry was to be roughly the same size as the original artwork. Gloria chose the French atelier Pinton Frères with the intention that this be "different in feel and feeling from the Scottish-woven *Elegy*." She noted that it was "woven heavier than many Aubusson tapestries, but I felt this was necessary."

The painter provided broad guidelines for the tapestry: "In general, I find splashing, automatic edges, nuanced edges and calligraphy not to be suitable for tapestry, especially if the tapestry is not thin and finely woven like a medieval tapestry or a worsted suit." Unlike other artists and true to his reputation, Motherwell continued to modify his designs after an edition had been woven. For "after *In Brown and White*," the first edition (1/7, plate 46a) is unique in design, omitting the central black "splash" that appears in the original collage and having a narrow brown stripe along the right side; the second (2/7, plate 46b) is also unique as the center image was reintroduced and the stripe removed; the artist's proof (0/7, plate 46c) and the final edition (3/7) lack the splash and have a lighter inset area instead.

Not Working with Motherwell

In 1978 Motherwell requested a moratorium on any further GFR Tapestries designed by him. Gloria noted, "6/3/78 by fone to Prov[ince]town do not weave 00/5 Elegy— No more RM taps as of now." She wrote him in 1976 and 1978, requesting to weave further editions, but only one more tapestry was ever woven.

Motherwell's curator, Joan Banach ("who organizes my thoughts"), wrote in 1987: "Bob asked me to reply again to say, yes, you can go ahead and complete the editioning of 'after In Brown and White.' . . . He also asked me to explain that he feels the splashing does not translate well into weaving, and therefore he would prefer that the 'Elegy' not be done. He sends his best personal greetings as always."

The final *Brown/White* tapestry was completed at the Pinton workshop in 1989.

In summer 1990, Gloria and Motherwell began to discuss a new project: "Long, long ago you said that you might want to have an Elegy image woven in a classic French tapestry weave—and I hope that this might be that moment." Gloria visited Knoedler Gallery with François Pinton in July to see Motherwell's paintings: "Our visit to Knoedler was fruitful for it did give my weaver a good feeling for your work, for that very special blackness, the depth of colors, et al." Unfortunately, a stroke later that year caused the artist to reduce his workload considerably and the project never came about. Motherwell died the following year.

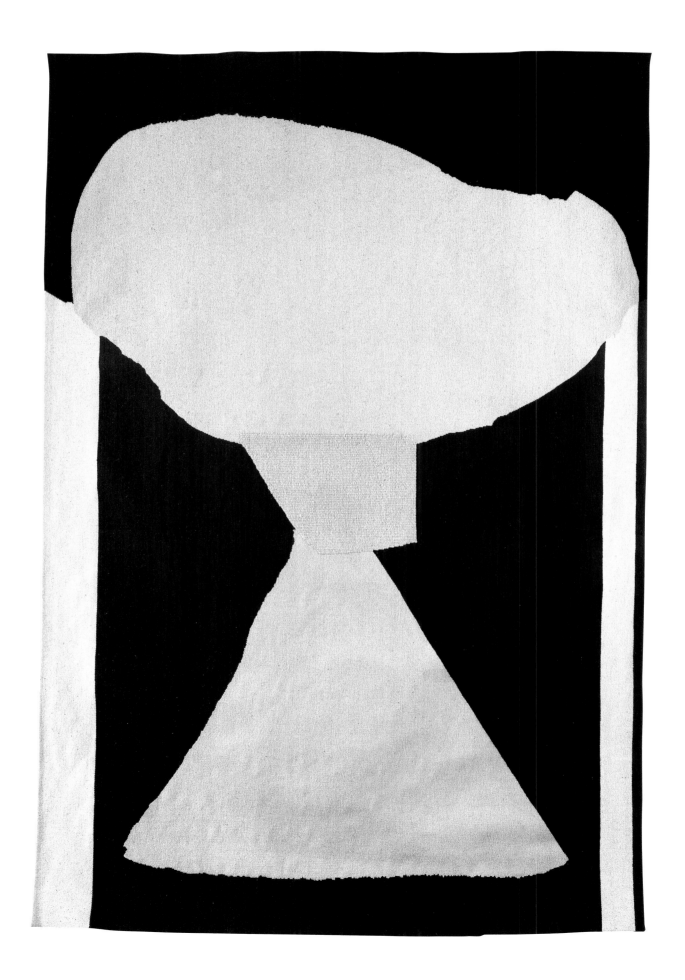

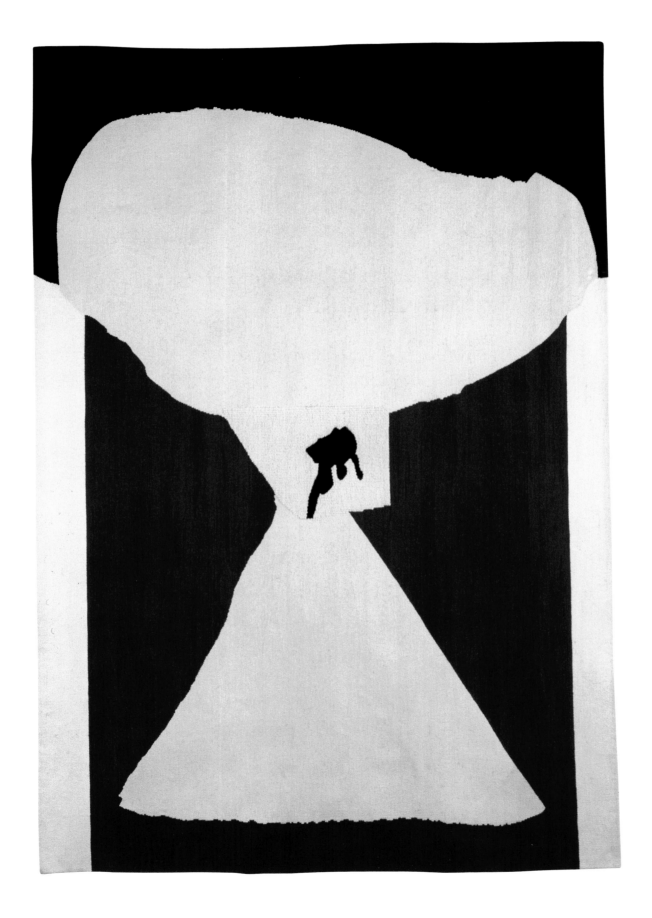

Nevelson

LOUISE NEVELSON
(b. 1899, Kiev, Russia; d. 1988, New York),
New York, NY

Sculptor Louise Nevelson called herself "an architect of shadows."[99] Her monumental all-black, and later all-white, painted wood constructions commanded international recognition. With a striking ability to combine drama and insight, she once stated, "My total conscious search in life has been for a new seeing, a new image, a new insight. This search not only includes the object, but the in-between place. The dawns and the dusks. The objective world, the heavenly spheres, the places between the land and sea. . . . It is not only sculpture, it is a whole world."[100]

Born in the Ukraine, Louise Berliawsky was raised by Russian Jewish parents in Rockland, Maine, a far cry from the common immigrant experiences of Lower East Side Manhattan. After marrying Charles Nevelson and moving to New York City in 1920, she began fashioning a life as an artist—taking classes at the Art Students League and exploring dance, music, and drama. During the 1930s, after separating from her husband, she studied with Hans Hofmann, first in Munich and again in New York; she also worked as Diego Rivera's assistant on a mural and taught art in a WPA-supported program. By the 1950s her reputation for flamboyance was equaled only by the respect given her complex assemblages of painted wood. In addition to sculptures that unified disparate found objects, her work included cast-paper prints, lithographs, etchings, serigraphs, and, most pertinent here, elegant mixed-media collages.

Nevelson was selected to show her work at the Venice Biennale in 1962. She joined the Pace Gallery in 1963, establishing a relationship that lasted for three and half decades. In 1979 she was elected a member of the American Academy of Arts and Letters, New York.

Working with Nevelson

Although all contacts proceeded through Arne Glimcher at Pace Gallery and Dick Solomon at Pace Editions, Gloria reveled in working with Louise Nevelson, as she recalled in 1995: "I think probably the most innovative work we did was working with the Nevelsons. Louise was a character, a wonderful character onto herself. . . . there was something so wonderfully gothic about much of Nevelson's work and Nevelson herself, who was an artwork unto herself. Her wonderful costumes, and those big mink eyelashes, and all the rest—the turbans."

Nevelson designed nine tapestries expressly for GFR Tapestries between 1972 and 1980, all woven in Scotland. The earliest two, "*Sky Cathedral I*" and "*II*," were each planned as editions of five tapestries; seven other designs were conceived and woven as unique and singular tapestries. Gloria noted, "At times we cropped them, using only part of an image; made a vertical a horizontal; enjoyed great freedom in how to translate them, i.e. use of materials, technique, etc." Gloria, gallery, and weavers all attended closely to the artist's views, but Gloria could apparently stand her own ground when necessary; she claimed on that occasion, "I would have discouraged the change, had I not agreed."

The artist once observed, "When you put together things that other people have thrown out, you're really bringing them to life—a spiritual life that surpasses the life for which they were originally created."[101] Just as Nevelson's sculpture featured repurposed materials, working in tapestry offered an exciting possibility for the artist's designs to be transformed into a fresh medium. One of Pace Gallery's press releases emphasized that Nevelson had created these collages specifically to be translated into the tapestry medium; it also asserted that the resulting tapestries "possess all of the tension and mystery of Nevelson's two-dimensional collages."[102]

Nevelson never mentioned the tapestry projects in her public interviews.[103] The Farnsworth Museum's catalogue on Nevelson devoted one page to the tapestries and illustrated "*Sky Cathedral II.*" Curiously (or characteristically?), the tapestries are described as being "by Gloria F. Ross," without mention of the major efforts of the Dovecot Studios.

"*Sky Cathedral I*" (plate 47)

Nevelson's original *Sky Cathedral* (1958) is an all-black sculpture standing over eleven feet high and ten feet wide, acquired by the Museum of Modern Art in the year it was made. Hilton Kramer in the *New York Times* called this and her other work of the time

Louise Nevelson, maquette for "*Sky Cathedral I*" and
"*Sky Cathedral II,*" 1972, lead intaglio reliefs bonded
to paper, 29 × 23.5 in. GFR Papers; © 2010 Estate of
Louise Nevelson/Artists Rights Society (ARS). Photo
by Jannelle Weakly, ASM.

"appalling and marvelous, utterly shocking in the way they violate our received ideas on the subject of sculpture and the confusion of genres, yet profoundly exhilarating in the way they open an entire realm of possibility."[104] The work provided broad inspiration and lent its name to a planned edition of five GFR Tapestries in 1974.

To create a unique model for "Sky Cathedral I," Nevelson worked from *Night Sound* (1971), her second relief collage print in a lead intaglio series, consisting of an assemblage of wood-grained lead-foil relief elements bonded to heavy rag paper, published by Pace Editions in an edition of 150. To the original design's lean stack of low-relief "building blocks," the artist added eight new elements, broadening the image across the white background and adding visual interest for a tapestry.

The Dovecot weavers used a deep blue-black wool and mohair blend as background, woven as one piece with a patterning of crinkled metallic gold threads. When the work was done, Archie Brennan, possibly trying to head off trouble, mused, "It is woven as arranged . . . It's a very different work when the light source is oblique—much, much better than an even direct light as the variations in surfaces in the white are emphasized with a cross light and minimized with an even direct light. I think this is partly because the depth of the blue in contrast to the white tends to limit one's 'seeing' of the white variations."

Back in New York, the Pace Gallery showed the tapestry in private to Nevelson and Gloria. "Louise took one look at it," recalled Gloria, "and said in her wonderful low voice, 'That's not a Nevelson, that's a Ross!' And I quaked in my boots, and she felt the colors were wrong. I still feel it was a marvelous Nevelson and one of the best I ever did."

When it was shown at the gallery, Gloria reported back to Brennan that the woven work "gained much attention for it is something so new (on the New York tapestry scene anyway) and so spectacular and well woven." The *New York Times* noted, "Certainly the Nevelson, a dazzling gold against black hanging . . . is one of the freshest approaches in this genre. The metallic gold loops are of varying lengths, woven in a range of densities so that when light plays across the glittering surface, the effect is of a somewhat flattened Nevelson sculpture."[105]

Despite the positive attention, only one edition of "Sky Cathedral I" was made, presumably because Nevelson felt the translation too far removed from her original model. Nevertheless, the irrepressible artist was game to try others.

"Sky Cathedral II" (plate 48)
The complete edition of "Sky Cathedral II" was woven at the Dovecot between 1974 and 1977, using a textured combination of cotton, linen, wool, and mohair. The same maquette

as "Sky Cathedral I" was employed, but with different colors and a refined woven structure. The pieced blocks were constructed in various two-color "pick-and-pick" and diagonal float weaves in creamy whites against a solid background of midnight blue.

The first version of "Sky Cathedral II" arrived in Manhattan just in time for the opening of Nevelson's spring show at Pace. "Of all the sculptures and prints, the tapestry is really the finest work in the show," Gloria crowed to the weaving workshop. "It is one of your masterpieces, and I am obviously just delighted with it."

A French Attempt
Sometime after Dovecot's "Sky Cathedral II" was under way, Gloria explored producing another multiple edition in France—this time from an all-white bas relief of impressed paper pulp. Because Pace Gallery was financially involved in this series, Arne Glimcher played a stronger role in decision making. Gloria's explanations to Olivier Pinton illustrate the project's evolution. "Glimcher would like to see a greater variety of stitches, and the use of a greater variety of materials and textures. Also, he would like to see the attached red [paint sample] used as almost a frame around the image. Perhaps some cotton, hemp, other unrefined wools, etc. might be used in addition to the wools we have already used. Any thoughts you or George Lepetit might have, will be welcome."

Further issues developed over the course of six months: "The variation in the different weaves is so subtle in much of the échantillon [woven sample] that it is difficult to see the design unless one is very close to the weaving. . . . The weaving should have a more 'sculptural' quality; it could be heavier . . . ; it could employ some materials which are natural colors, but not necessarily white, as these are. Of course this Nevelson should be a true Pinton Tapestry, but I refer you to the trial I sent of a successful Nevelson woven years ago by Archie." Finally, Gloria cancelled the project in June 1977, saying, "The Nevelson échantillon has not met with approval so we will just have to wait for another maquette." She later recorded in rough lecture notes, " My trial weavings in Aubusson [were] unsuccessful but with Archie Brennan we were able to translate the collages on a Gobelin upright loom with its greater flexibility."

The Uniques
For the works officially dubbed Uniques, a special series of collages was developed en suite by Nevelson in 1976. These incorporated corrugated paper, many kinds of cardboard and paper, silver foil, bits of newspaper, and slats of wood, providing impressive challenges on the loom. The maquettes were

shipped to Scotland and the tapestries woven directly from them, not through the usual intermediary photographs. Five of the seven were completed during 1977 and 1978 under Brennan's direction; the last two were done under the supervision of Fiona Mathison, after Brennan retired from the workshop. (For more about the studio's involvement, see chapter 4.)

The Dovecot weavers excelled at woven trompe l'oeil. As Nevelson exhorted them to "go beyond!" they diverged even further from classical Gobelins tapestry, exploring double-layered weaves and separately woven pieces that were manipulated on and off the loom, sometimes stitched together. Gloria termed this dimensional piecework "the focal point of these tapestries." To achieve the artist's distinctive light and shadows, the weavers experimented with different weights and qualities of wool, camel and cow hair, alpaca, jute, flax, cotton, synthetics (including the metallic-like Lurex), and other metallic yarns on cotton warps. Hard-spun two-ply wool yarns countered threads with fuzzy and irregular textures. Although actual wood was not used, one note indicates, "Nev wants to incorporate wood in some taps." Gloria later wrote gleefully in her lecture notes, "All classical weave but work brought into third dimension. Part true collage, part trompe l'oeil, part melding of the two." Brennan described the convoluted process that he developed with his expert team, "The weaving is woven into the weaving, the warp becomes weft, and the weft becomes warp. It was complex overlays that started out with a very simple Nevelson collage of fairly mundane papers. . . ."[106]

"Night Mountain" (plate 49)

For the *Night Mountain* model, Nevelson affixed torn and abraded cardboards and foil onto a black background. Before the final tapestry was woven in one solid piece on the loom, separate pieces were woven to scale to show the artist alternatives to get the right sizes, shapes, and textures. This required numerous back-and-forth transatlantic shipments. Gloria described Nevelson's reaction as she examined and reassembled the woven elements in New York: "Louise really sat, looked, walked around it for a long time, and after playing with these 3 extra forms, recognized that this is as it should be."

At last, the collage's size was multiplied nine times, and a large studio loom was prepared. The piece was woven at right angles to its planned placement on a wall, in the medieval mode. In all respects, the resulting tapestry presents a refined and rather formal translation. Corrugations grew into weaverly ripples and channels; a crumpled piece of silver foil became shiny silver-toned threads; feathered, tattered edges smoothed into more subtle margins. Brennan called the finished work "quite delicious." He added, "We are all thrilled at the result—really worth all the tests + re-tests."

"Dusk in the Desert" (plate 50)

For the *Dusk in the Desert* maquette, the artist again tore and combined papers and cardboards with scumbled surfaces. Following the first Unique, notes from a 1977 discussion with Solomon and Nevelson at Pace say that the artist counseled, "next: colors closer, more harmonious. Follow collages!!! Start warm grey as base." Likewise, Gloria and Brennan avowed that "the balance of the series should be a heavier weave, much more textured, 'sculptural,' not as refined and flat as this first one. They should make fuller use of the different materials."

Working at right angles to the way the design would hang, the weavers created intentionally distorted slits, tightened or loosened yarn tension, varied interlacing over one or multiple warps, and employed on-loom wrapping stitches. They also employed more traditional tapestry techniques like color blending, hatching, pick-and-pick alternation of colors, and modulated shading.

Gloria reported to Brennan, "Nevelson is pleased with the second 'Unique' . . . she seems enthralled with the medium."

Louise Nevelson, *"**Sky Cathedral II**,"* 1974–77, woven by Dovecot Studios, 88 x 70 in.
© 2010 Estate of Louise Nevelson/Artists Rights Society (ARS), New York. Photo by
Peter Ferling, courtesy of Teleflex Incorporated.

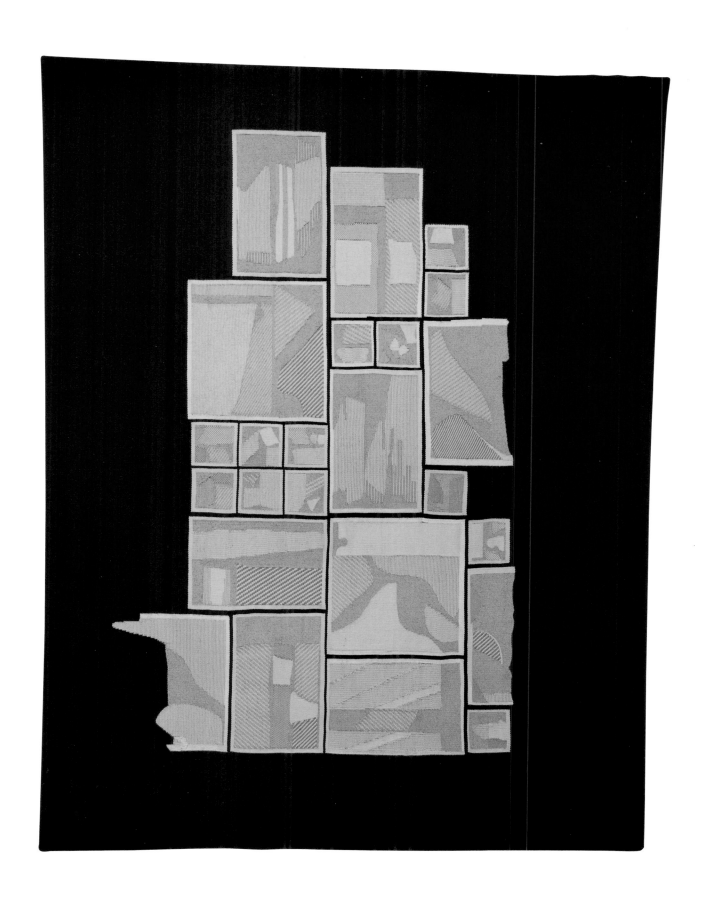

Louise Nevelson, "***Night Mountain***," 1977, woven by Dovecot Studios, 80 × 49 in.
© 2010 Estate of Louise Nevelson/Artists Rights Society (ARS), New York. Photo by
Hans Namuth in the GFR Papers, © 2010 Hans Namuth Estate.

Louise Nevelson, maquette for "*Night Mountain*,"
1976, mixed-media collage, 11 × 8.5 in. © 2010 Estate
of Louise Nevelson/Artists Rights Society (ARS),
New York. Resulting tapestry was displayed both
vertically and horizontally.

Louise Nevelson, maquette for "*Dusk in the Desert*,"
1976, mixed-media collage, approx. 13 × 11 in.
© 2010 Estate of Louise Nevelson/Artists Rights
Society (ARS), New York.

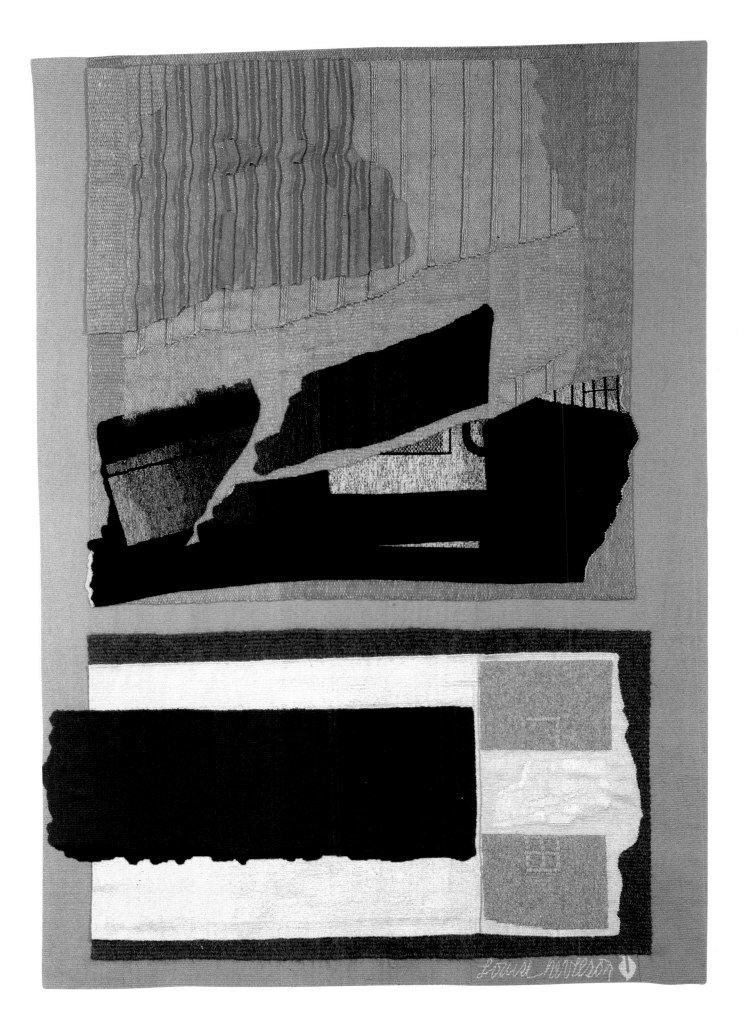

Louise Nevelson, maquette for "*Desert*," 1976, mixed-media collage, 12.5 × 6.75 in. © 2010 Estate of Louise Nevelson/Artists Rights Society (ARS), New York.

"*Desert*" (plate 51)

The *Desert* collage included creased and worn sandpaper and pressed paper pulp with a cut-out "bite," along with a variety of smoother cardboards, set against a stark black backing. The largest of the Uniques, the woven work is a patchwork of pieces, first shaped and finished on the loom, then carefully overlaid with one another. To mimic the effect of pulpy gray and tan paper, yarns were used in bundles with interlacement over many warps at the piece's curved and shaped margins. This was set against the thin twisted background yarns, used singly in a fine weave. The weave directions of separate "chunks" vary according to the way light would cast shadows between the threads.

"*Mirror Desert*" (plate 52)

Research has not uncovered descriptions or photographs of the maquette for "*Mirror Desert*." In the woven work, two separately woven pieces were appliquéd onto a shimmering silver ground. The rectangular piece contains straightforward weaving using evenly heathered brown yarns with two purpose-built folds, whereas the second piece was woven with jagged edges, using several earth-toned yarns loosely combined to effect a rough sandpapery texture from perfectly smooth yarns. The rest of the forms were all woven integrally into the background. The Dovecot workshop commented, "A good deal of metallic yarn was used in the main part of the tapestry to give a very flat cloth on which the overlays sit."[107] The narrow vertical strip of dark shiny black was woven with a subtle all-over diamond pattern (called a "diaper pattern" in weaving circles). A small leaf form is cunningly woven into the strip's lower edge, recalling tapestry-woven motifs in Coptic fabrics of ancient Egypt.

"*Reflection*" (plate 53)

The maquette of stained and creased cardboard included a disassembled flattened box. A spray-painted corner, already eye-fooling in its reflective appeal, became a second reflection in the woven interpretation. The smallest of the Unique series, "*Reflection*" was also the most richly colored.[108] As in *Mirror*, a dark chocolate brown surrounds the torn and fragmented papers. Cardboard with its surface torn away becomes a subtle weave of white on white. The weave itself provides a sense of reflection in the upper-right corner of the main rectangle. Here too the warp-weft direction of weaving is countered in adjacent patches. The weave is very uniform and fine; the only actual textural changes appear at the margins of adjoined pieces.

"*Landscape (within Landscape)*" (plate 54)

The most richly textured maquette, this had heavily abraded corrugated cardboard with singed and smoked edges. On a blackened and weathered wooden backing, Nevelson affixed a jumble of torn, abraded, stained, and overpainted cardboards. Over all, she placed a semicircular form of smooth cardboard—an orb suspended moonlike over an almost

literally depicted landscape. The stormy, cold black-and-gray landscape within landscape sits apart, a self-sufficient picture—the stark scene reflects water, land, sky, clouds. The rest is burned, earthy. In the upper right is a glimmer of cold gray sky, repeated from the landscape within.

The penultimate Unique to be woven, "*Landscape (within Landscape)*" was in many ways the most ambitious.[109] The weaving carried forward the atmospheric qualities of the collage. The tapestry contains an elegant mix of fiber and weave. The weavers used a prominent diagonal float weave to create the left vertical bar, which had been a saw-scored strip of pressboard in the original. Here again, pieces shaped on the loom were applied to overlapping fabrics. Slits and tunnels work against the backdrop of handwoven faux texture.

"'Landscape' has received enthusiastic approval by Nevelson and by the head of Pace, Arnold Glimcher, who knows Nevelson's work more thoroughly than anyone," Gloria wrote to the Dovecot workshop in 1980. "He has but one reservation about it and that is the area running down the left side which he felt could have been less busy with a softer grey. He feels it makes the tapestry 'too rich' (I think he means too busy). I tell you this because it may be helpful in some future tapestry."

"*The Late, Late Moon*" (plate 55)

The model for "*The Late, Late Moon*" presents more pictures within pictures. Its white background and flatter expanses of color distinguish it from the other collages. Considering the maquette's distinctions, Gloria proposed, "I think this tapestry should not be translated as literally as Landscape which will present a feeling of overall busy-ness. . . . Of course," she continued, "it is a quieter image and I would like to maintain its subdued quality."

Viewing the first trials, Gloria conveyed the artist's suggestion that "since the tapestry is so unexpectedly flat, placing it on a background . . . woven of this slate color, would give it more of a collage quality and make it a tapestry with more interest." This did not happen, however. Seeking further solutions, Gloria also requested that the studio "might be able to embroider and add texture as there is in the one small tan area."

The final tapestry seemed to everyone a less gutsy interpretation than previous efforts. The fabric is indeed flatter, smoother, and with less varied materials. All parts were woven on their side, in the same direction, and this accounts for some lack of texture and variation. Smoother boundaries occur between the different materials or colors.

Julia Robertson wrote from the workshop to Gloria, "I really am sorry that Louise Nevelson doesn't like the last tapestry we did. We agree it is very different from the previous one but the maquette had a very different feel about it too, much lighter in texture and colour and our treatment of it, now obviously mistakenly, reflected this. The colour samples were sent and agreed by you just before we began, if you remember, and we worked together on it when you were over. As I explained, we really are not prepared to weave very pale wools as no dyer will guarantee the fastness and we would not like to be associated with tapestries that fade. . . . I have been mulling over how the tapestry might be made closer in mood to the others and I think perhaps we should think about the area of wood—this, I think, could be rewoven. . . . The Nevelsons are such a wonderful set."

Aside from aesthetic considerations, the tapestry also developed a structural flaw— "The left side ripples and is somewhat longer than the right side; the hanging is not quite rectangular. I believe this results from tightening some of the warps more than others when removing the tapestry from the loom." In addition, Gloria noted, "The raised signature seems too prominent and after I examine it, I may remove it."

When repairs were completed, Gloria wrote that the weaving had "received hurrahs from all concerned. I saw it yesterday and it is great + stands on a par with all Dovecot's work. I have been convinced all along that you would be able to correct it—now it *is* superb!"

In the mid-1980s, Gloria discussed making other Nevelsons with Brennan, then working independently, and with Sue Walker at the Victorian Tapestry Workshop. Nevelson died in 1988 without further work going on the loom. Gloria wrote to Brennan, "You would so much have enjoyed being with me at this memorial for Louise. It really captured her crazy elegance and style, humor and artistry."

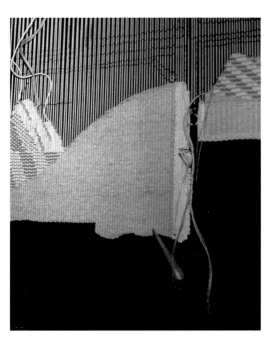

Detail, "*Sky Cathedral II*" on Dovecot loom, 1974

Louise Nevelson, "*Mirror Desert*," 1978, woven by Dovecot Studios, 82 × 60 in.
© 2010 Estate of Louise Nevelson/Artists Rights Society (ARS), New York.

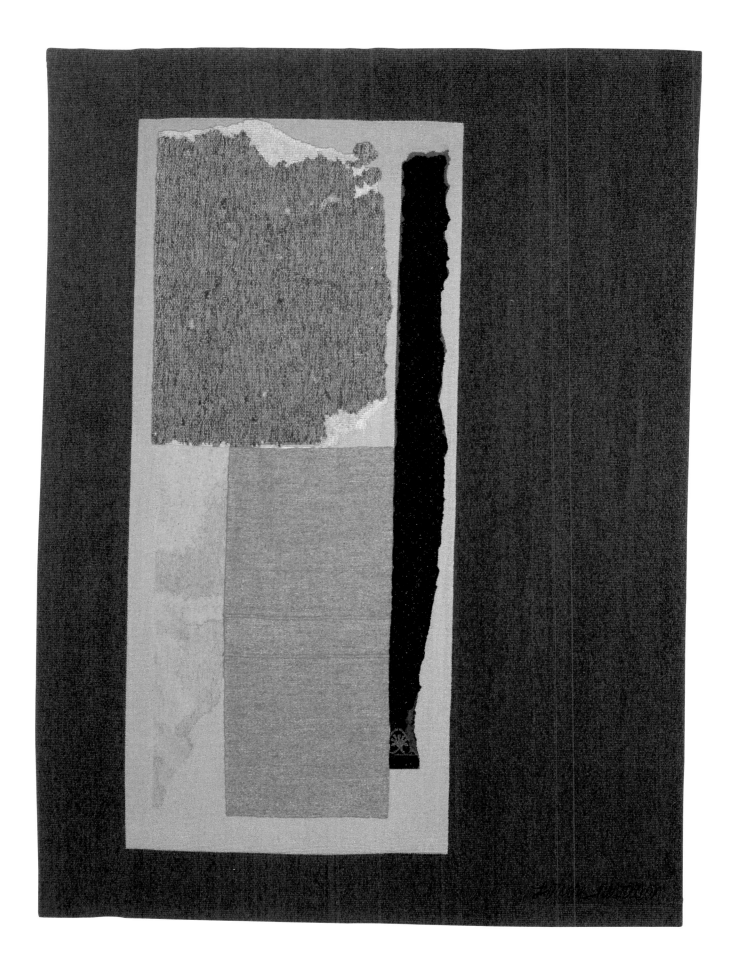

Louise Nevelson, maquette for *"Reflection,"* 1976,
mixed-media collage, 11.5 × 11 in. © 2010 Estate
of Louise Nevelson/Artists Rights Society (ARS),
New York.

Louise Nevelson, maquette for "*Landscape
(within Landscape),*" 1976, mixed-media collage,
11.5 × 8.5 in. © 2010 Estate of Louise Nevelson/
Artists Rights Society (ARS), New York.

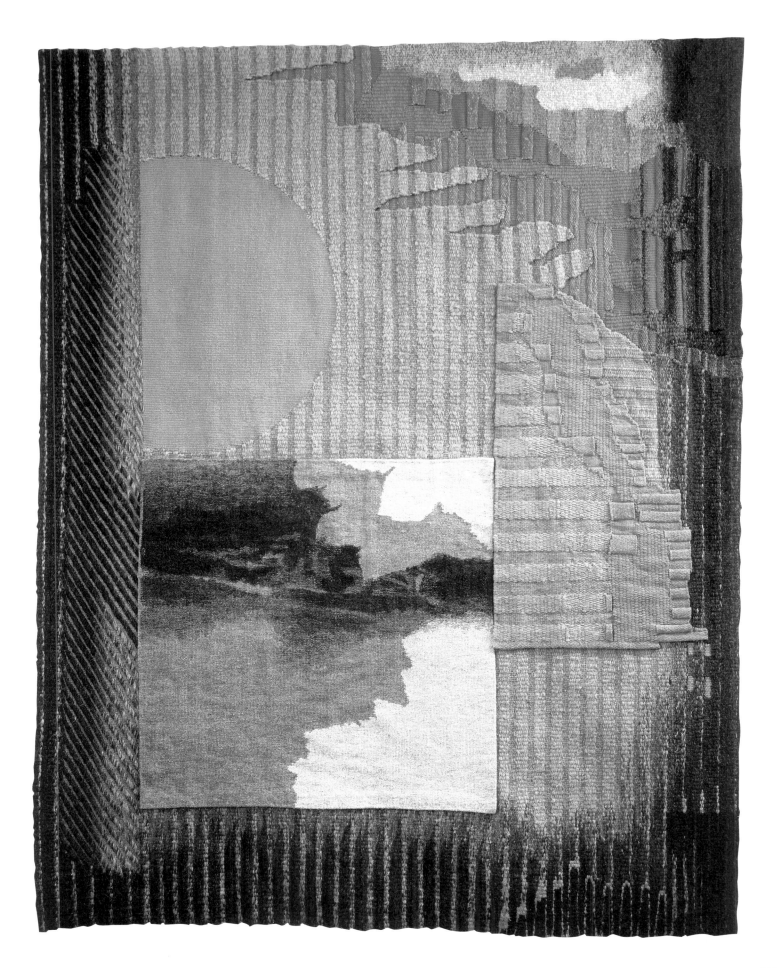

Louise Nevelson, maquette for "*The Late, Late Moon,*"
1976, mixed-media collage, 19 × 20 in. © 2010 Estate
of Louise Nevelson/Artists Rights Society (ARS),
New York.

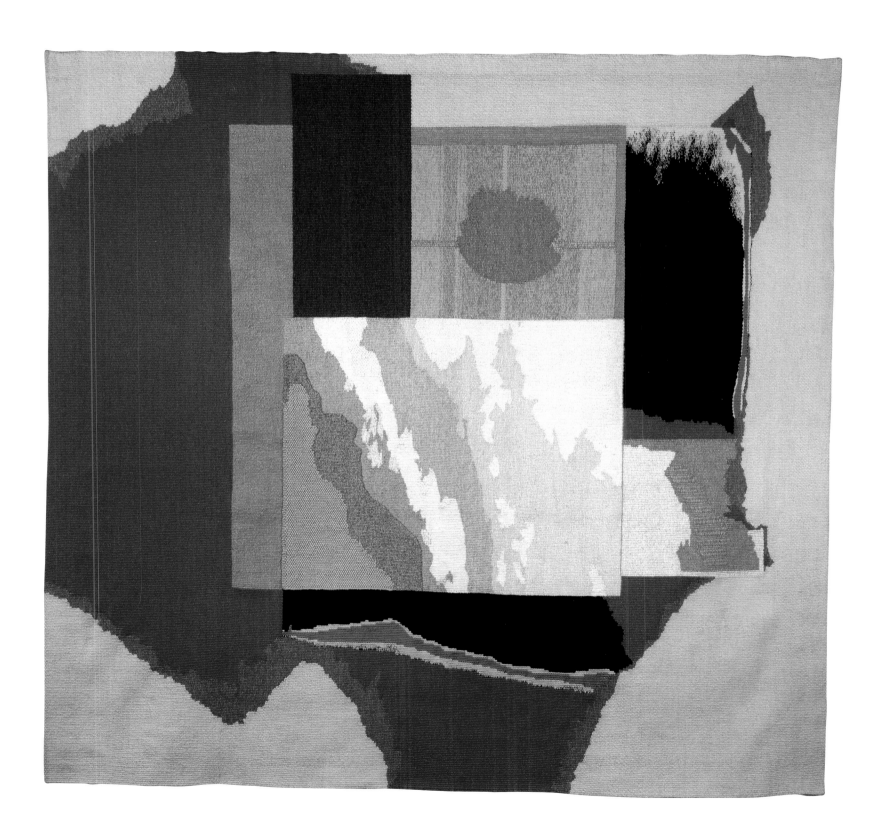

Noland

KENNETH NOLAND
(b. 1924, Asheville, NC; d. 2010,
Port Clyde, ME)

Superlatives are plentiful in assessments of
the painter Kenneth Noland: "one of the
most inventive colorists in all of modern
art—perhaps one should dare to say in the
history of art."[110] "By the early sixties Noland
had been widely acknowledged as having
wrought in large measure a broad change
in the character of American art."[111] "To say
'Kenneth Noland' is to call up a modern day
icon. . . . His pictures are among the most
original, elegant and unabashedly beautiful
of our time."[112]

Trained during the late 1940s at Black
Mountain College in North Carolina, where
both Josef Albers and Ilya Bolotowsky taught,
Noland was one of the first major painters
to be educated entirely in a non-objective
style—"he never had an extended figurative
or representational early period."[113] With critic
Clement Greenberg and colleague Morris
Louis, Noland visited Helen Frankenthaler's
studio in 1953 and later emphasized the
profound influence of her stain painting tech-
nique on his subsequent work. He became
widely known for "large, dynamic, hard-edged
designs to accommodate bright, high-contrast
stained color."[114] Noland's significant series
included targets (initiated in 1961), chevrons
(from 1962), concentric ovals (cat's eyes; from
1962), diamonds (from 1964), horizontal bands
(from 1965), plaids (from 1971), and shaped
canvases (from 1975)—"each is the kind of lay-
out with which many abstract painters built an
entire career."[115]

Noland and fellow painter Morris Louis
forged an important professional friendship.
Based in Washington DC in the 1950s, their ex-
plorations were spurred by close associations
with Clement Greenberg, Jackson Pollock,

Frankenthaler, and others in New York's lively
art scene. After a series of successful Manhat-
tan shows, Noland moved to the city in 1961.
Having studied briefly with Josef Albers,
rejected his rigid formulation, and moved on
to explore Paul Klee's nuanced use of color,
Noland became a dedicated colorist. In 1971
he stated, "I wanted color to be the origin of
painting . . . I wanted to make color the gener-
ating force."[116]

Greenberg dubbed Noland's spare and
smooth geometric art, along with that of
Jasper Johns, Ellsworth Kelly, Frank Stella,
and Raymond Parker, "post-painterly abstrac-
tion," occurring "in the wake of the perceived
painterly excesses of abstract expressionism."
Also known as hard-edge and color field
abstraction, their work "retained the scale,
power, and immediacy of abstract expression-
ism" but, many thought, with more clarity
and directness.[117]

Working Together

Gloria and Noland collaborated on and off
from 1966 until 1997—her longest working
relationship with an artist. Their first three wall
hangings—all from extant works translated
into the hooked-rug technique—represented
three of Noland's major exploratory periods—
the diamonds/circles, chevrons, and plaids.
"When I started working professionally and
established my workshop," she recalled in
1983, "Ken Noland was the first artist to em-
brace the world of tapestry. It was like step-
ping out into space in those days." Noland
was also the most interactive and responsive
of the artists who worked with Gloria, as
attested by the Native/Noland series dis-
cussed in chapter 7.

Even with Noland's reputation as a dedi-
cated colorist, translating his work into the
textile medium using ready-made and custom-
dyed yarns was a relatively smooth process.
Specialized dyers produced the colors he
desired. Gloria double-checked yarn samples
with him, and he generally agreed with the
shades produced.

A further sign of the artist's flexibility
appears when certain earlier goals are consid-
ered: "Morris and I used to talk a lot about
what we called 'one-shot' painting. If you were
in touch with what you were doing . . . each
thing that you did was just done that one time,
with no afterthought and it had to stand. We
wanted to have this happen just out of the use
of the materials."[118] This approach contrasts
deeply with the labor-intensive processes of
tapestry weaving and hooking. Nevertheless,
Noland willingly pursued these textile transla-
tions, perhaps because they raised new issues
through unknown materials, colors, and
textures.

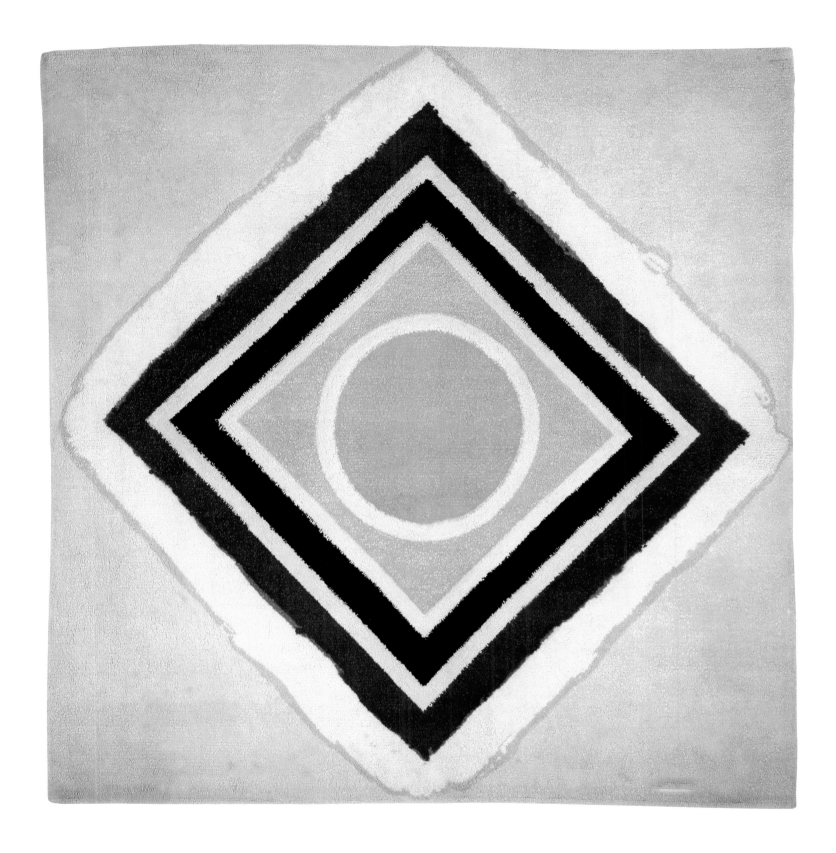

"after *Bell*" (plate 56)

Initiated in 1966, "after *Bell*" represents the earliest work Gloria executed professionally, outside her extended family. The layout of concentric diamonds with a central circle inserted into a square format is often seen in Noland's work from the early 1960s.[119] The *Bell* imagery connects this layout with the painter's long-term fascination with circles. Different versions of the edition show more or fewer splatter marks carefully integrated into the beige ground, according to the artist's wishes at the time each was made. The gray shadow surrounding the largest diamond may be interpreted as either the depiction of a dimensional shadow or the suggestion of a stained "aura" from the original's stained paint. This work was marketed as a wall hanging and for use on the floor.

"after *Every Third*" (plate 57)

Noland began his painted chevron series in late 1962 or early 1963, reaffirming that "symmetry encourages freedom of color choice."[120] By 1964 he moved the motif off-axis and was making eccentric chevrons. Returning to the earlier symmetric type, the complete edition of "after *Every Third*" was hooked in 1970. The original painting's slightly rough boundaries between stained bands translated well into the softly textured hooked technique, where the wool yarns provide a similar, seemingly spontaneous irregularity.

"after *Seventh Night*" (plate 58)

Noland's plaid painting series, begun in 1971 with "narrow horizontal and vertical criss-crossing bands,"[121] provided the model for "after *Seventh Night*," a vertical work from which one tapestry was woven in Scotland during 1971–72. Gloria and the Dovecot weavers all delighted in the clever device of plaid imagery from textile origins, with an illusion of warp and weft interlacements, which Noland adapted to a hard-edge painting (albeit with "stained expanses"[122]), and then moved to the trompe l'oeil effect of tapestry-woven fabric. The original painted plaids "show narrow bands of different degrees of opacity in a soft ambience that is thinly scumbled and therefore transparent and varied."[123] Unfortunately, the unique piece was stolen in 1982, making in-person comparisons with the original painting impossible.

The Native/Noland Tapestries (plates 59–82)

Gloria returned to work with Noland in 1979 when she decided to work with Navajo weavers in the American Southwest. Their collaboration for the following eighteen years resulted in twenty-four unique tapestries woven by Native American women. This extended project and the resulting works are described in chapter 7.

Kenneth Noland, "**after** *Every Third*," 1970, hooked by Anna di Giovanni, 72 × 72 in.
© Estate of Kenneth Noland/Licensed by VAGA, New York. Photo by Eric Pollitzer.

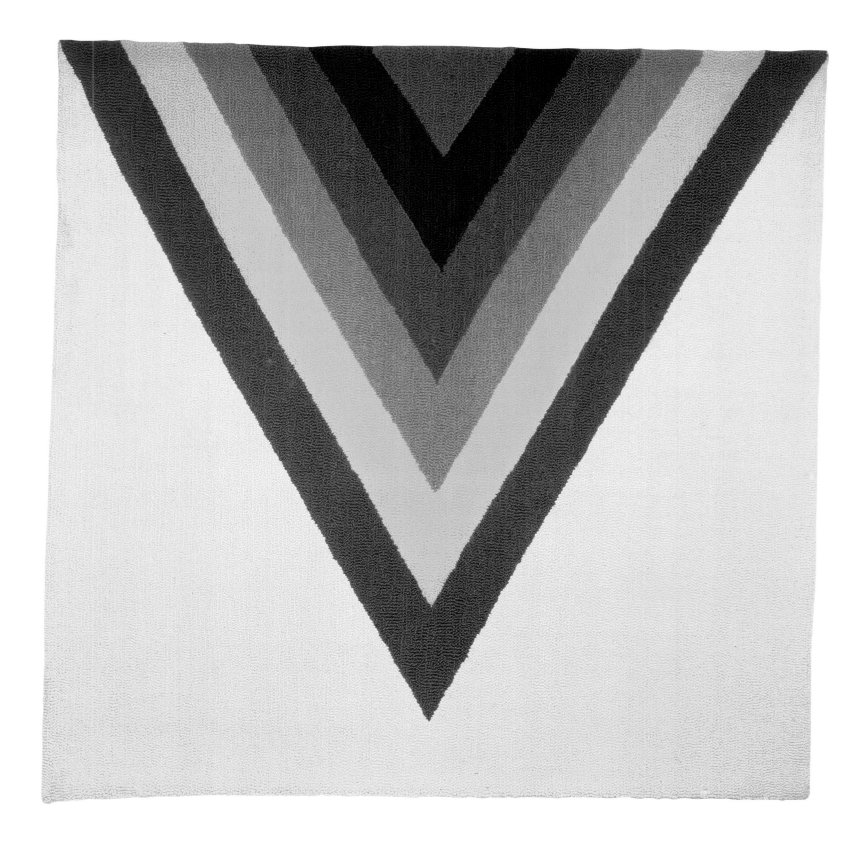

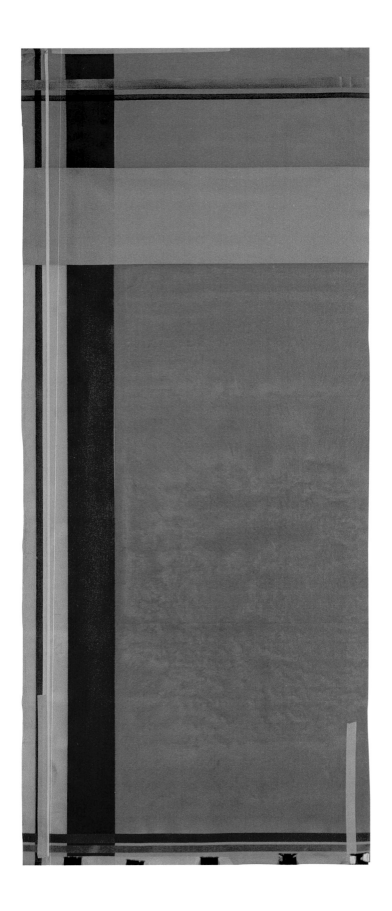

Kenneth Noland, *Seventh Night*, 1972, acrylic on canvas, 91.4 × 33 in. © Estate of Kenneth Noland/ Licensed by VAGA, New York. Note masking tape on painting to indicate tapestry edges.

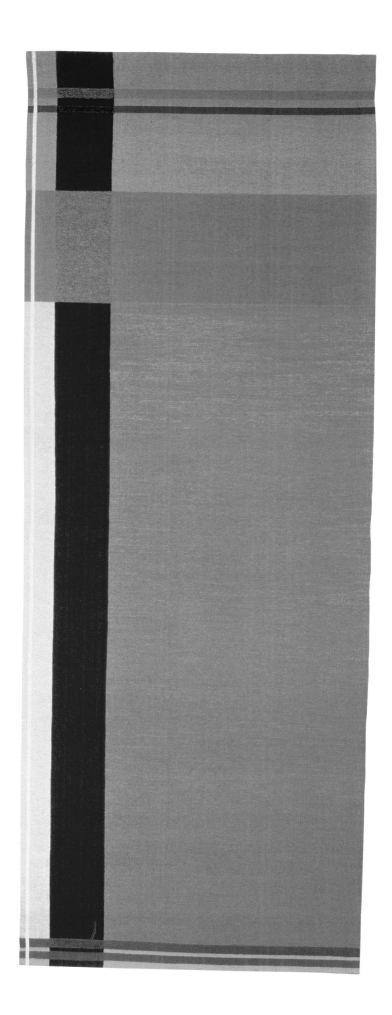

59 Kenneth Noland, "*Painted Desert*," 1979, woven by Martha Terry, 54 × 67 in.
© Estate of Kenneth Noland/Licensed by VAGA, New York. Photo by Eric Pollitzer.

60 Kenneth Noland, "*Rainbow's Blanket*," 1980, woven by Mary Lee Begay, 58 × 78 in.
© Estate of Kenneth Noland/Licensed by VAGA, New York. Photo by Eric Pollitzer.

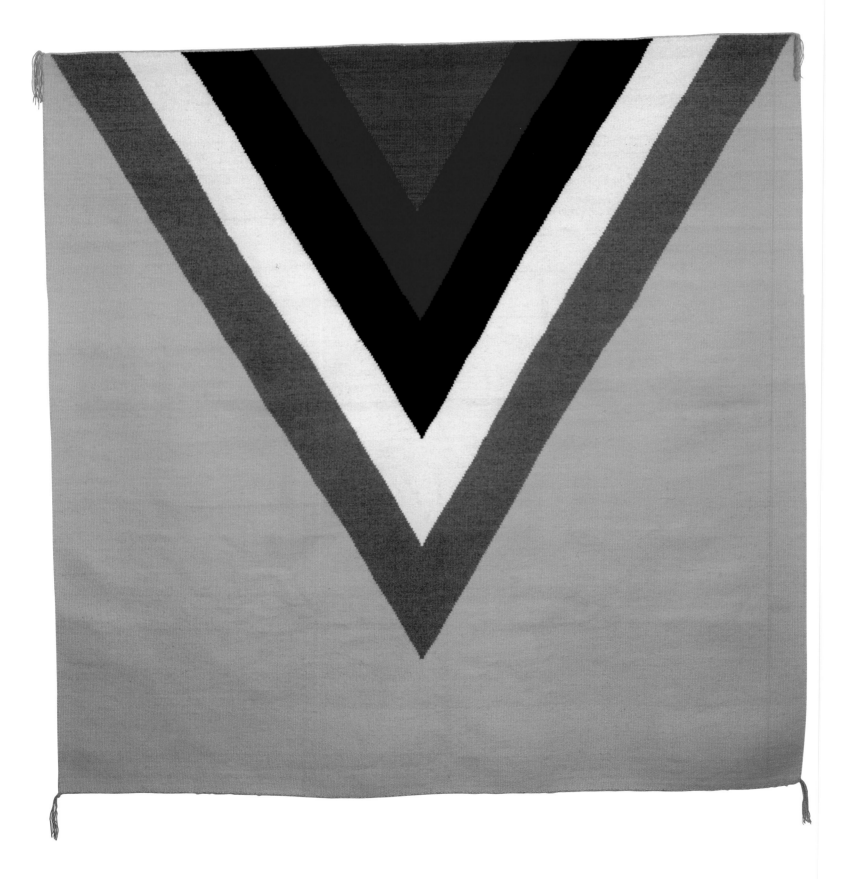

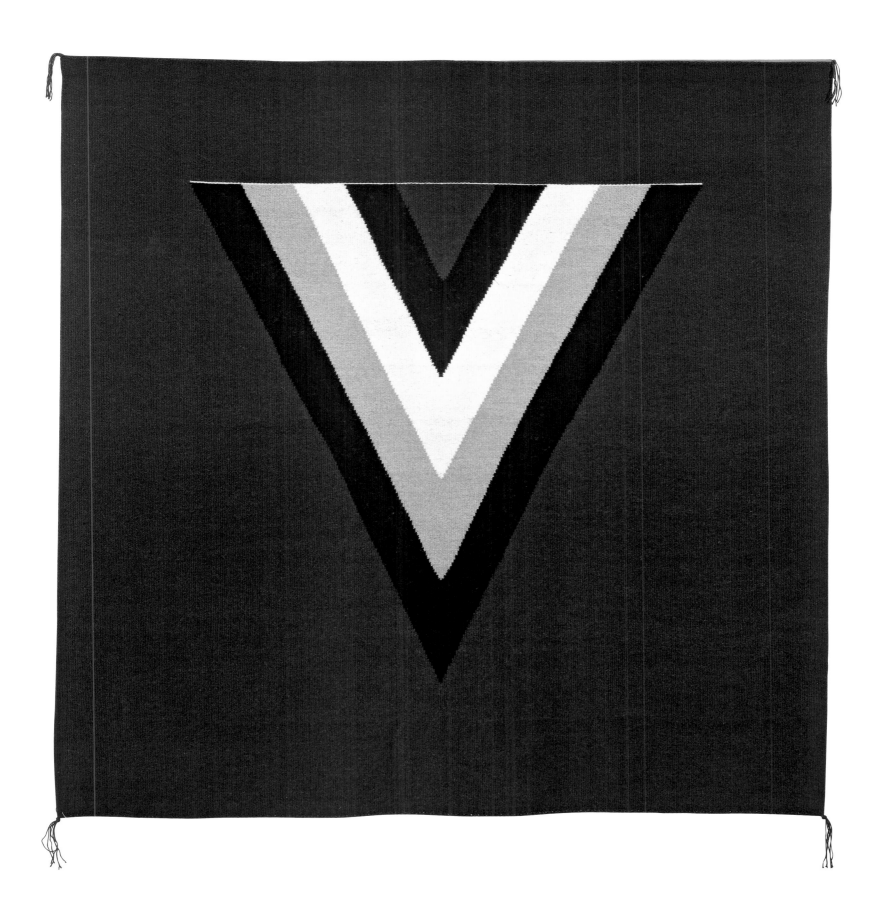

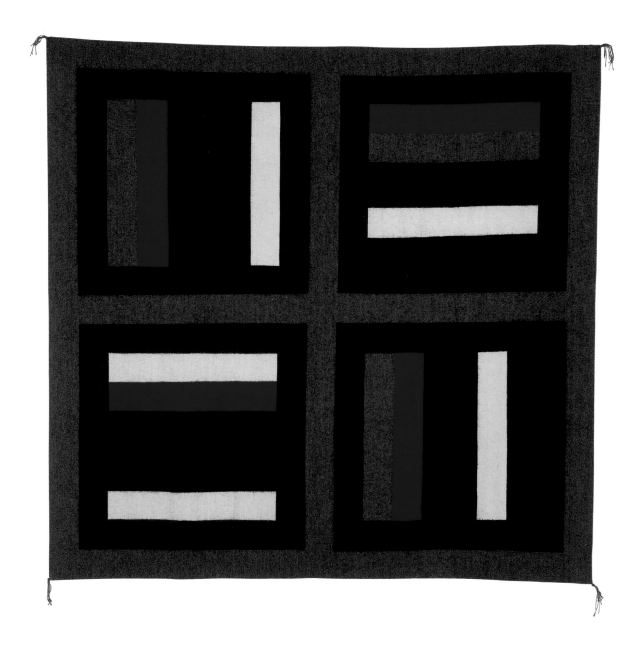

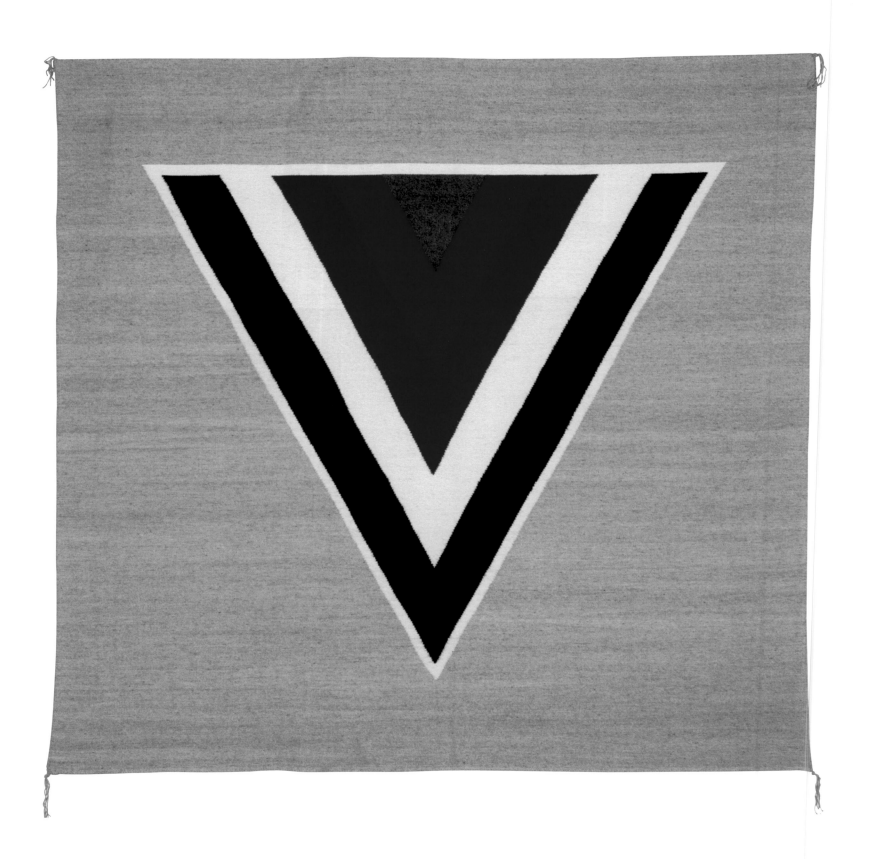

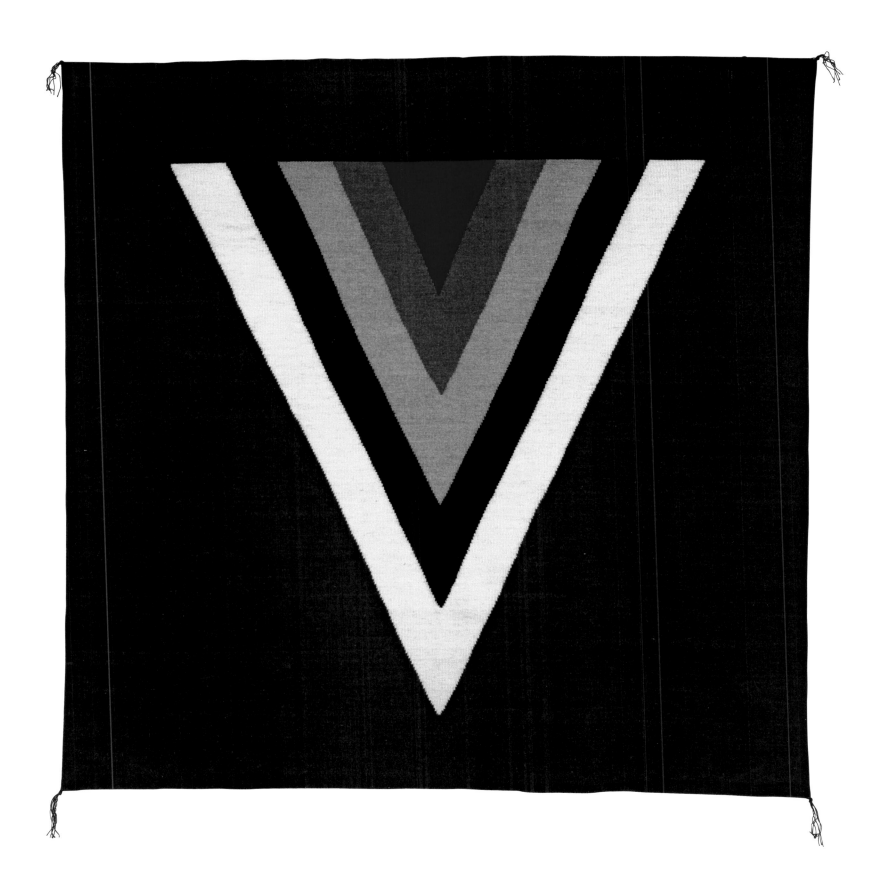

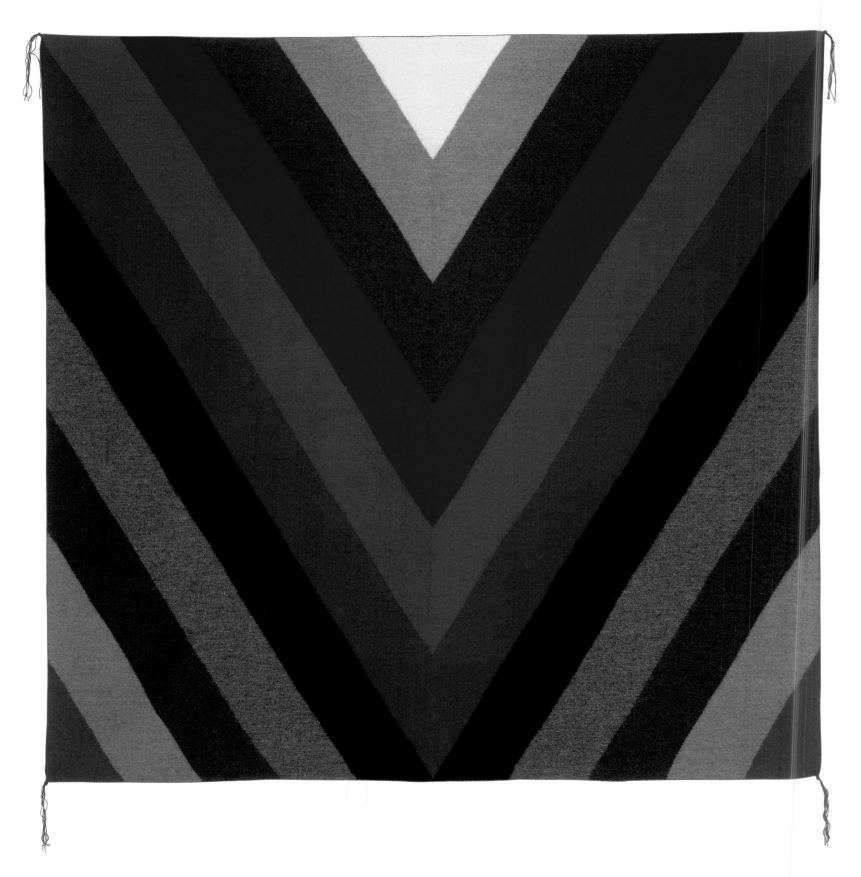

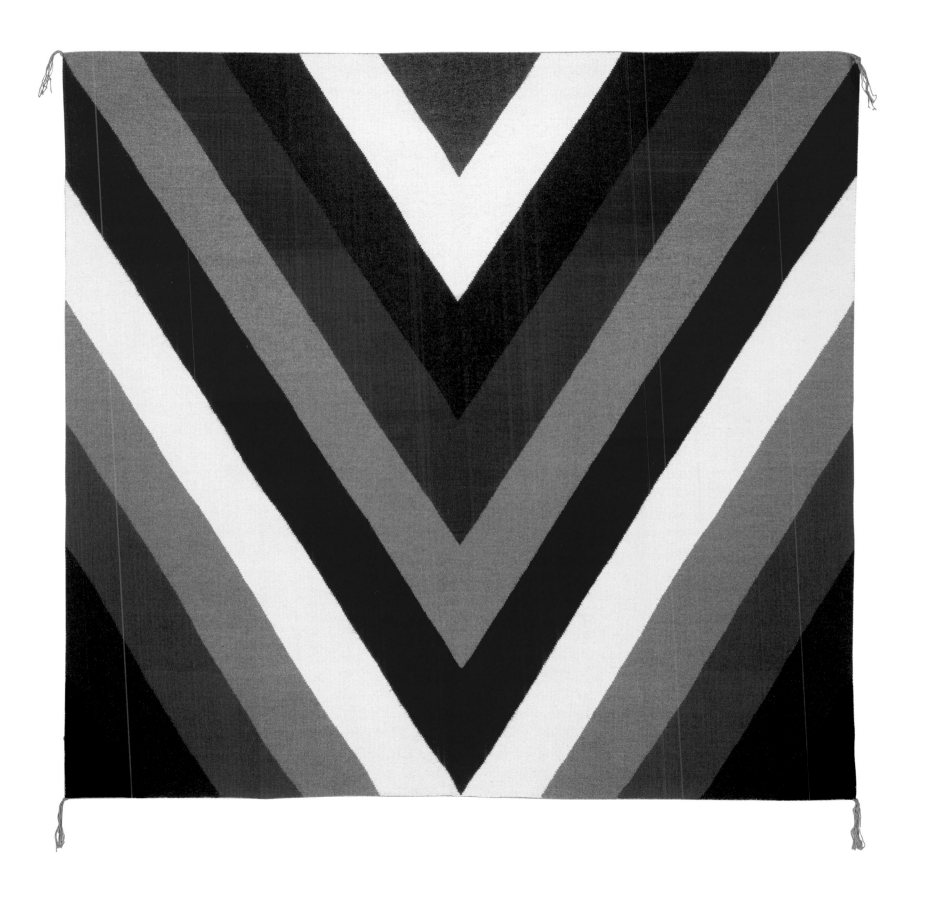

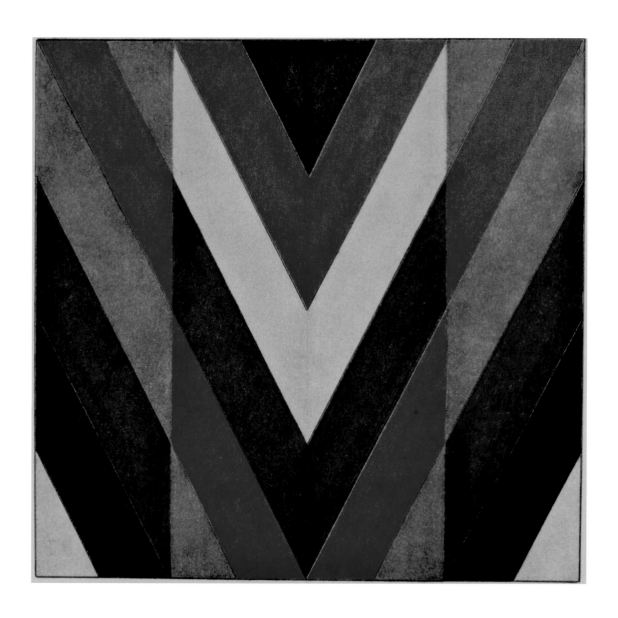

Kenneth Noland, maquette (85-21) for "*Valley,*" 1985,
gouache on paper, 8 × 8 in. GFR Papers; © Estate of
Kenneth Noland/Licensed by VAGA, New York. (For
other Noland maquettes, see chapter 7.)

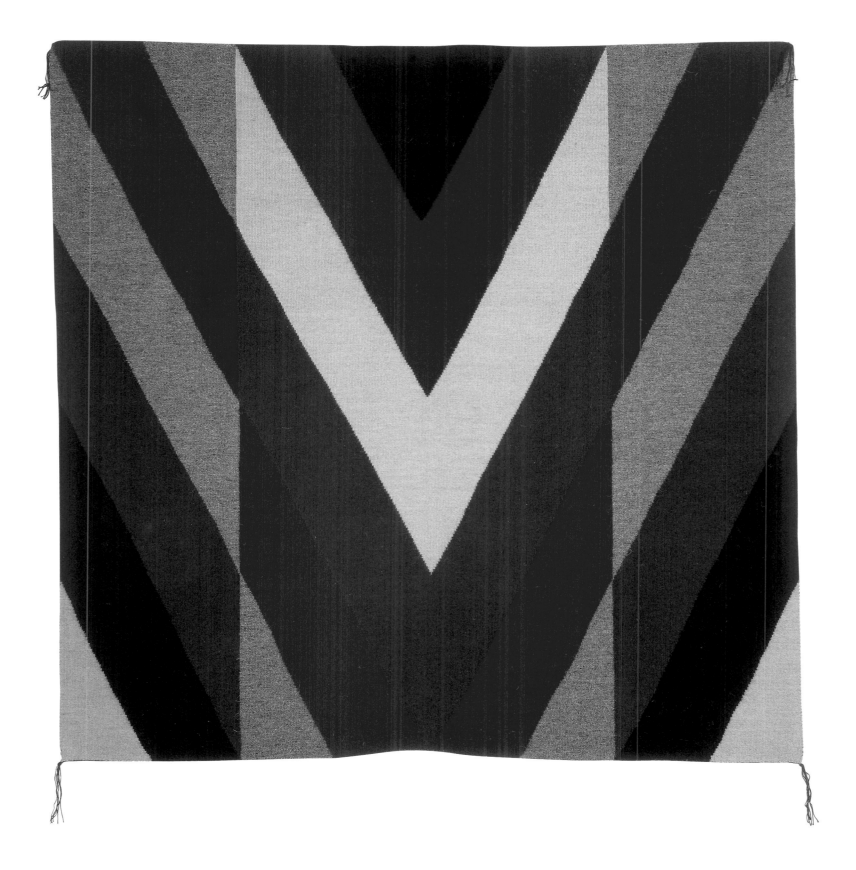

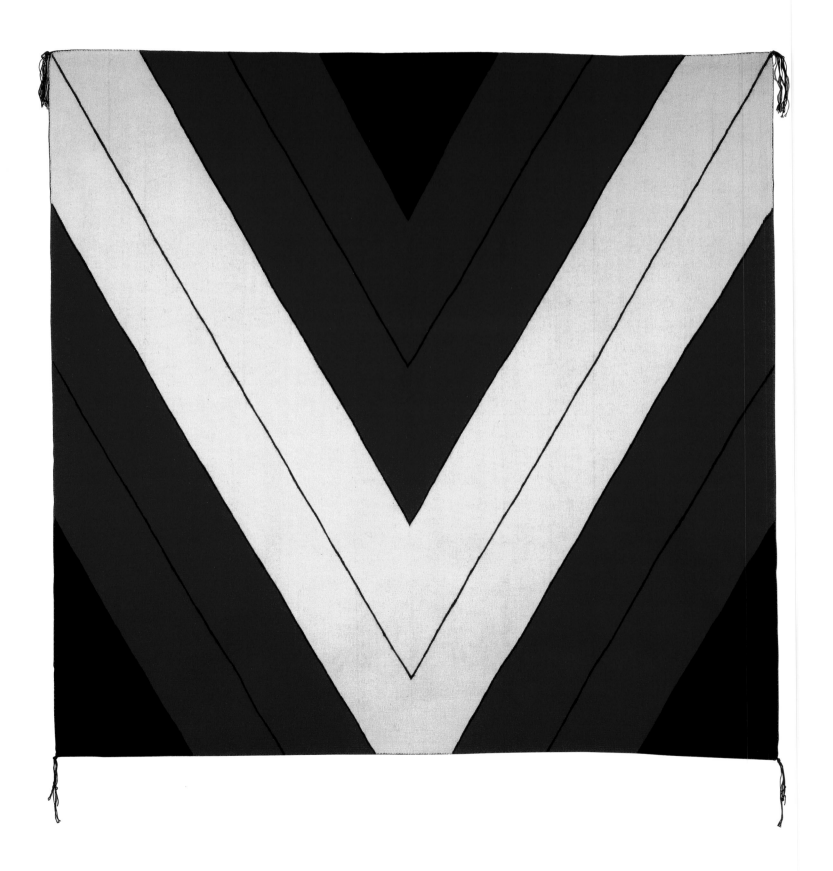

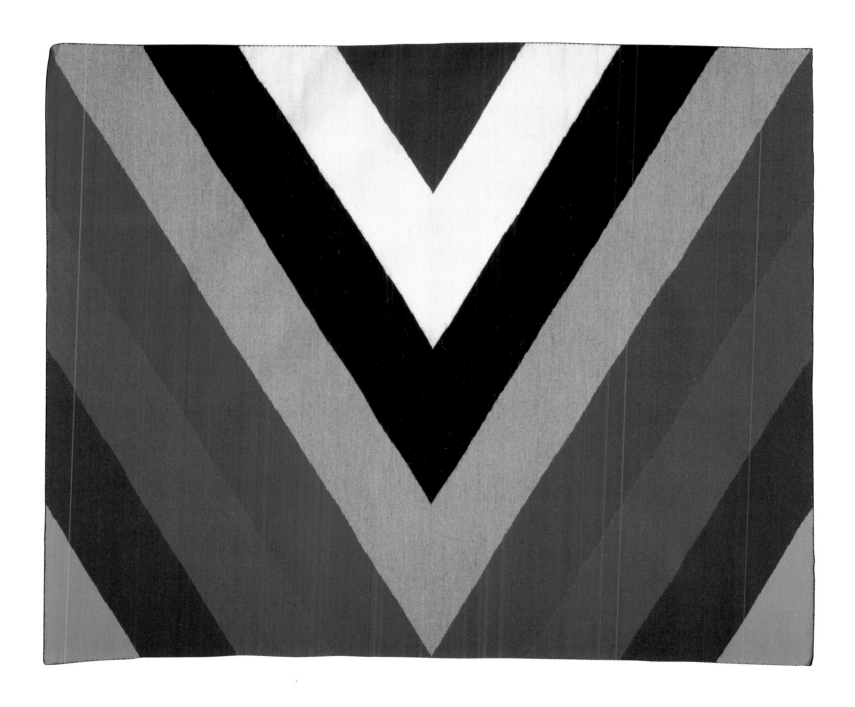

Kenneth Noland, "*Games*," 1982, woven by Rose Owens, 43 in. diam.
© Estate of Kenneth Noland/Licensed by VAGA, New York.

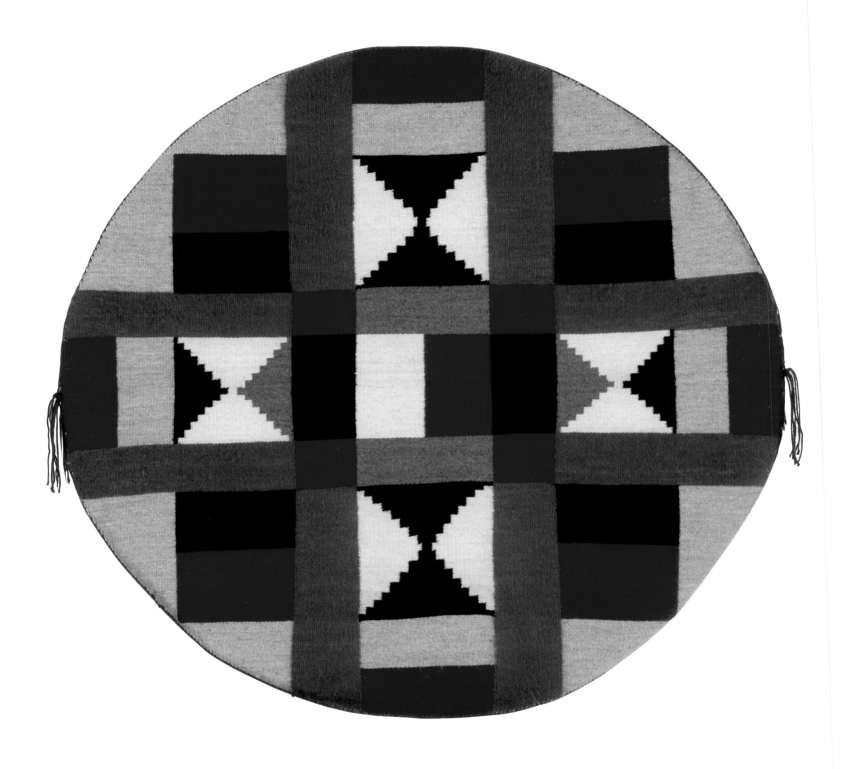

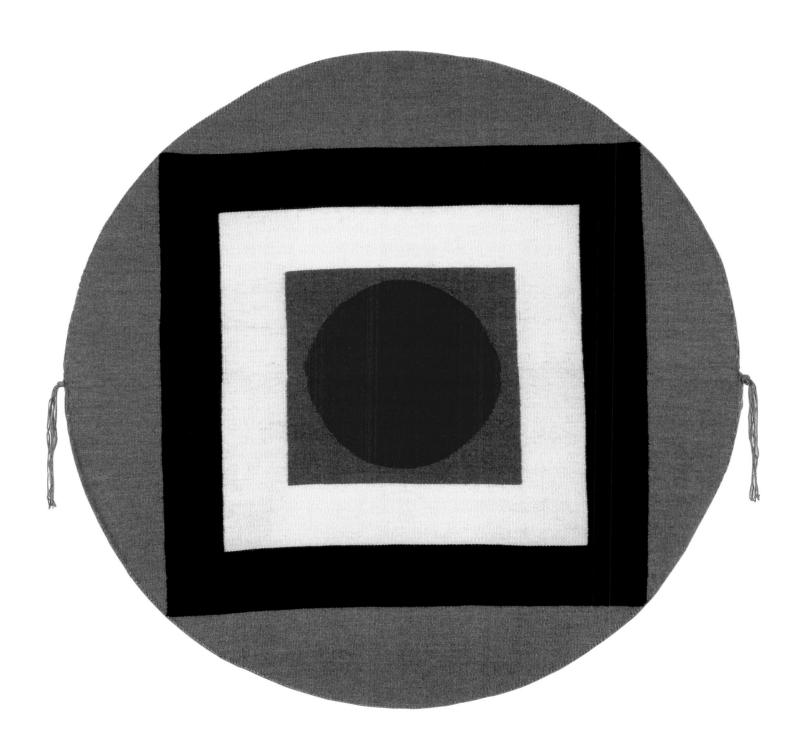

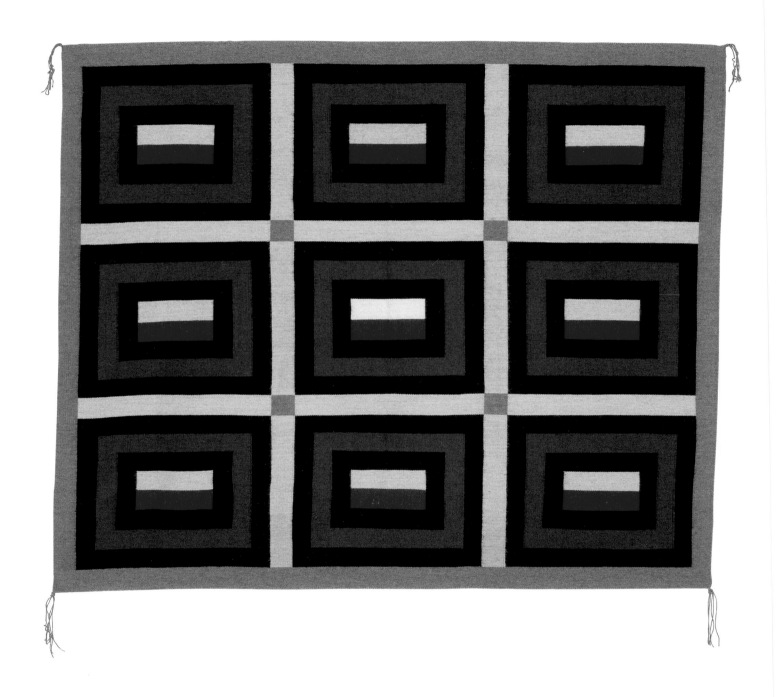

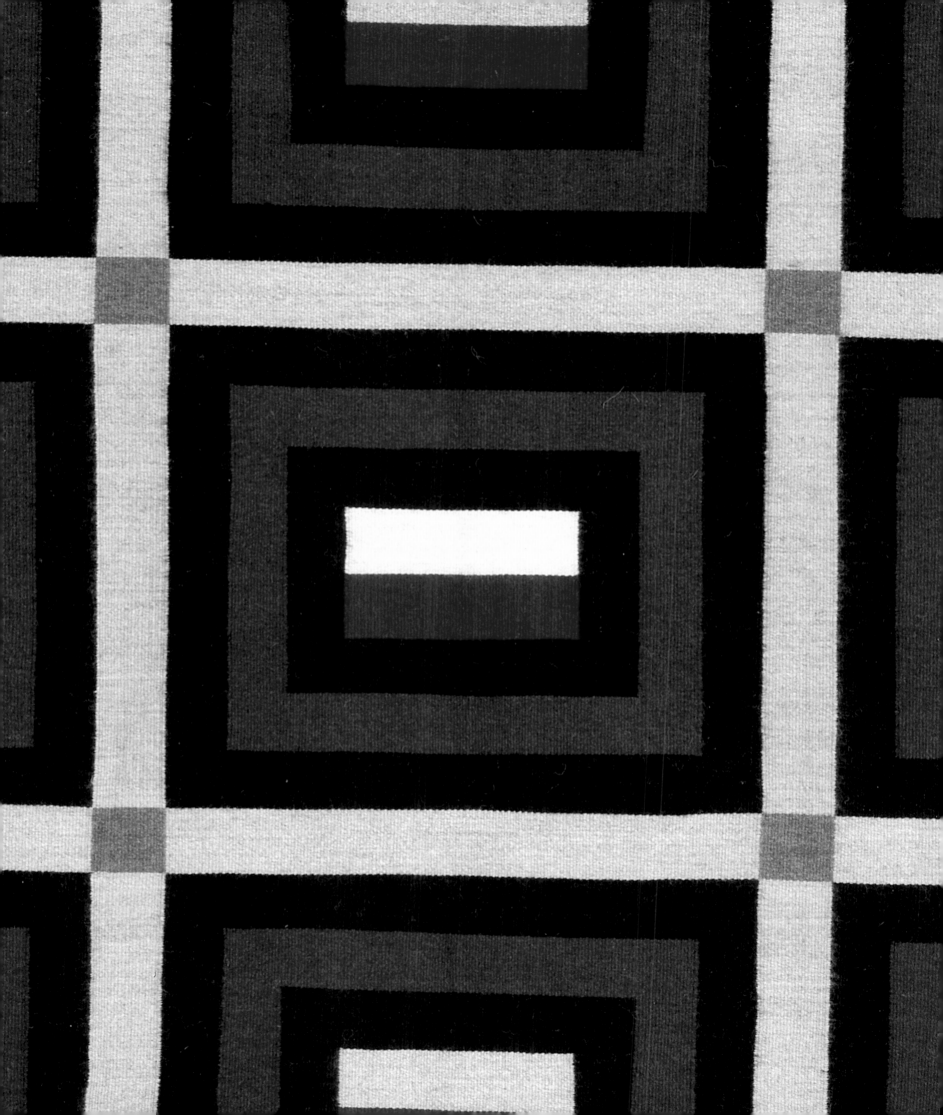

Kenneth Noland, "*Four Corners*," 1985, woven by Sadie Curtis, 59 × 59 in.
© Estate of Kenneth Noland/Licensed by VAGA, New York. Photo by David Heald.

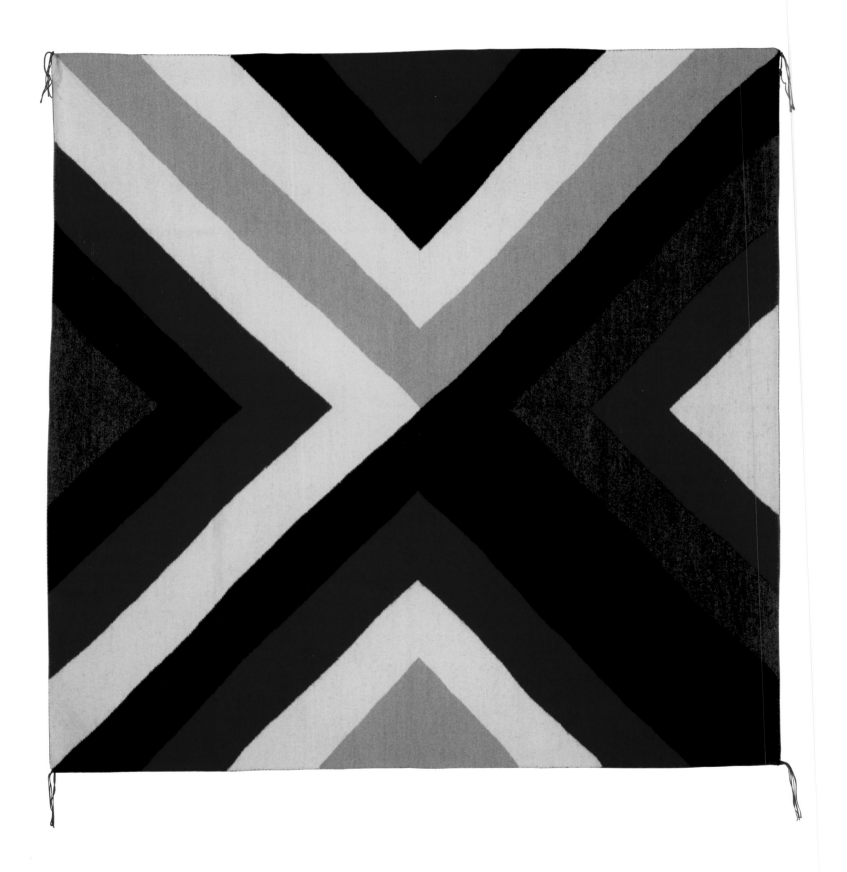

Kenneth Noland, "*Line of Spirit*," 1993, woven by Sadie Curtis, 61.9 × 59.75 in.
The Art Institute of Chicago; © Estate of Kenneth Noland/Licensed by VAGA,
New York. Photo © The Art Institute of Chicago.

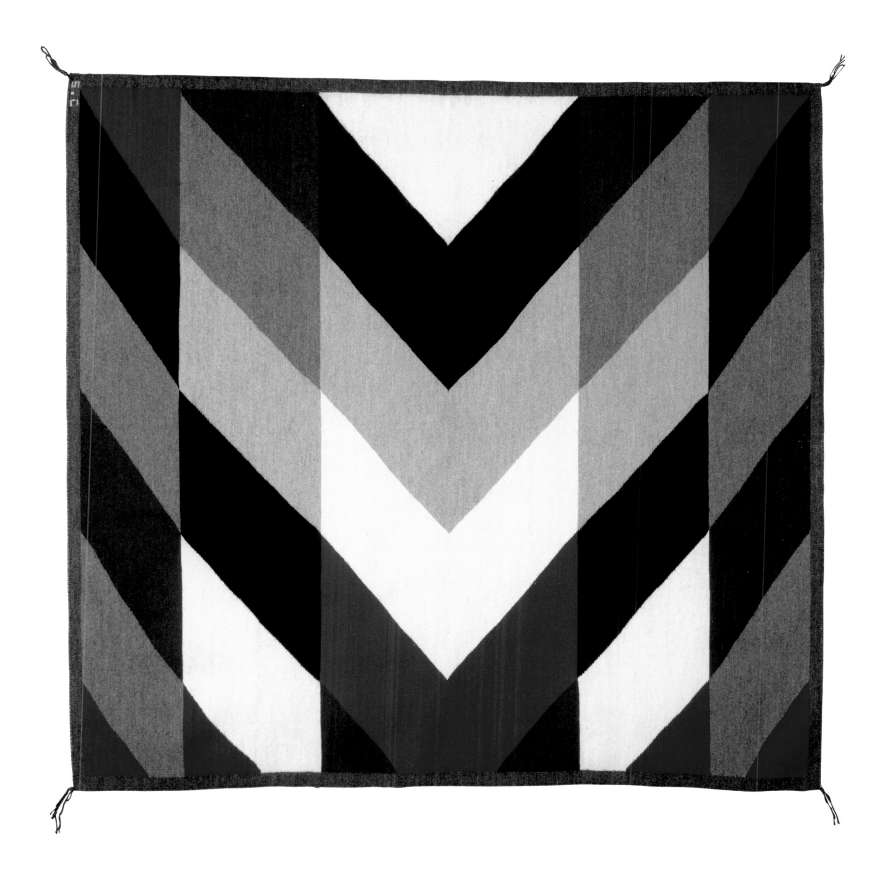

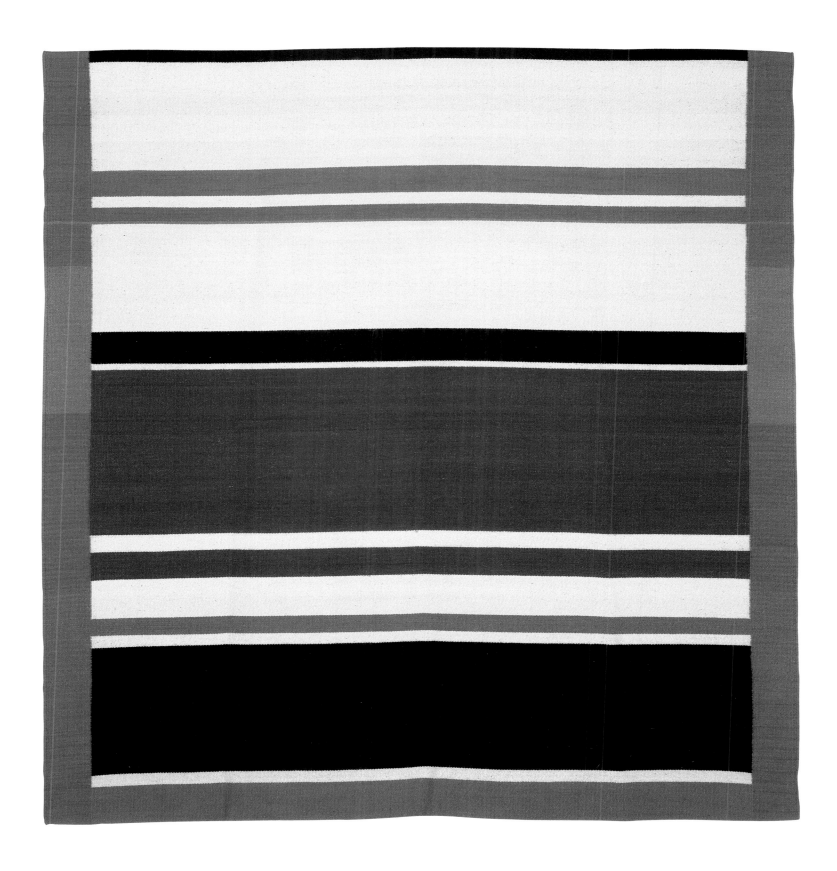

Kenneth Noland, "*Jeddito*," 1985, woven by Ramona Sakiestewa Studio, 45 × 75 in.
© Estate of Kenneth Noland/Licensed by VAGA, New York. Photo by David Heald.

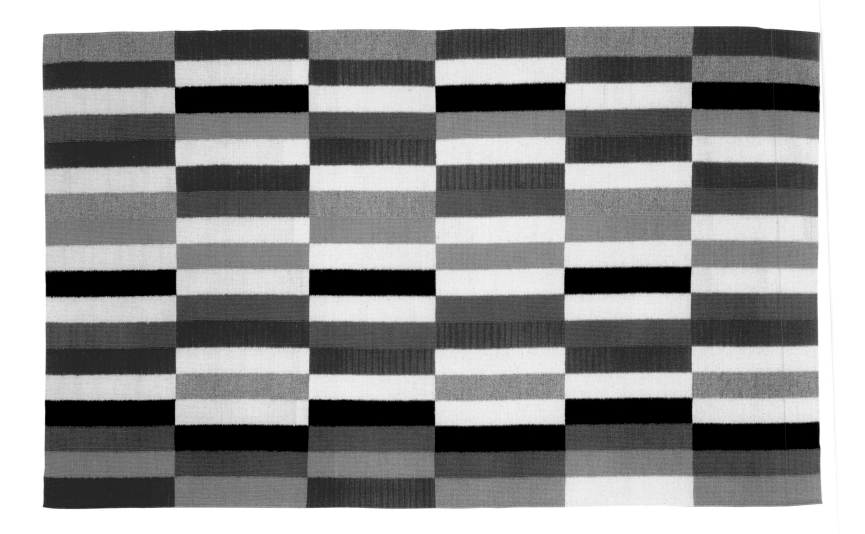

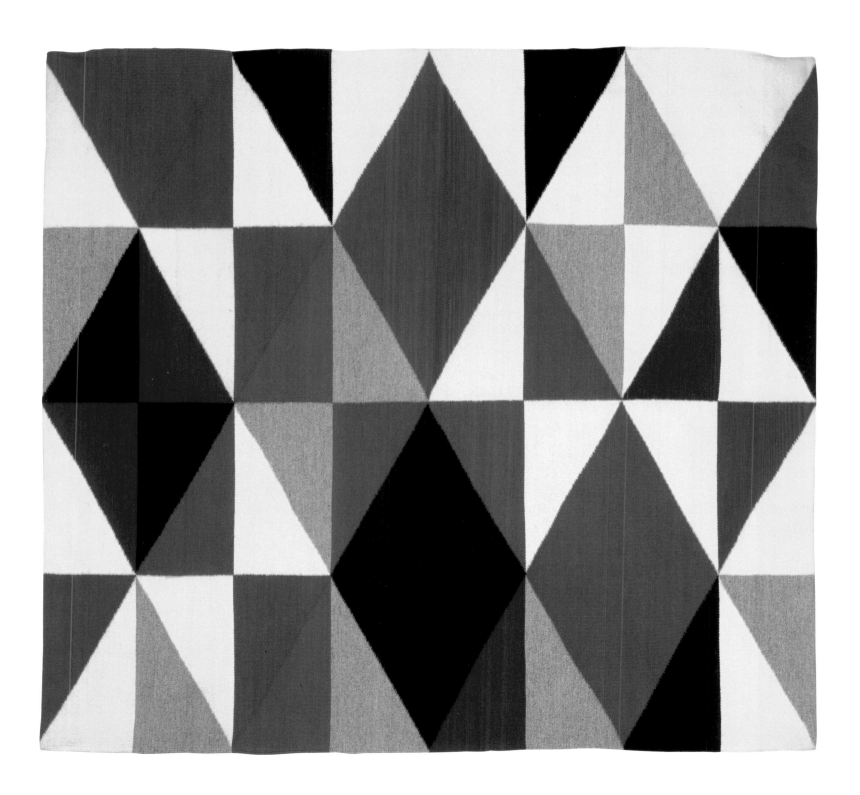

Kenneth Noland, "*Ute Point*," 1991, woven by Ramona Sakiestewa Studio, 74 × 66 in. Minneapolis Institute of Arts; © Estate of Kenneth Noland/Licensed by VAGA, New York. Photo by David Heald.

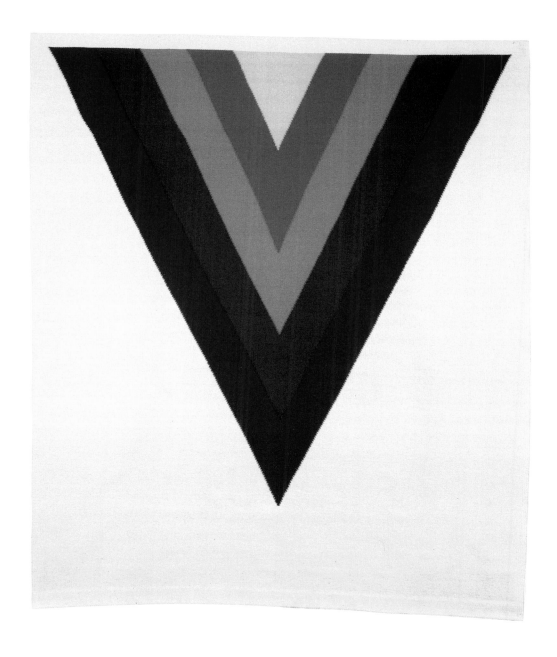

Podwal

MARK PODWAL

(b. 1945, Brooklyn, NY), New York, NY

Mark Podwal is a Jewish iconographic specialist and author/illustrator of numerous books for children and adults. Among his publications are *Golem: A Giant Made of Mud* and *The Book of Tens*. He collaborated with Elie Wiesel on various projects, including *A Passover Haggadah* and the video *A Passover Seder*. In 1993 Podwal was named Chevalier de l'Ordre des Arts et des Lettres de la République Français for his many illustrated works, and several years later he was promoted to Officier of that order. He also happens to be a dermatologist with a well-established Upper East Side practice; Gloria was one of his patients.

With characteristic good humor, he has explained his dual careers: "Because of a minor illness, perhaps just 'a bad cold,' I missed the first few days of kindergarten. As a result my name was not on the class roster. When my teacher read out the class list, as she did each morning, my name was never called. It was not until my teacher noticed a drawing of a train I had made that she asked, 'Who are you?' And so it seemed to me, at the age of five, that my existence depended on my drawing.

"Although I had the ability for drawing, my parents encouraged me to become a physician. In the words of my mother, 'Since you are such a fine artist, you'll make a great plastic surgeon.' Instead, I chose dermatology, since it requires visual discriminations and with its few emergencies allows me time to draw."

In 1970, while attending medical school at New York University, Podwal published his first book of drawings—a chronicle of the turbulent late sixties called *The Decline and Fall of the American Empire*. Beginning in 1972, his drawings have appeared regularly in the *New York Times*. Then came his children's books:

"How I came to write and illustrate my first children's book is a story in itself. When the rabbi of my synagogue was planning his vacation a few winters ago, he asked me to deliver the Friday-night sermon. When I asked what the weekly Torah reading was, he told me, 'The Ten Commandments.' When I asked how long he wanted me to speak, he responded, 'ten minutes.' That Friday evening I spoke for ten minutes about the significance of the number ten in Judaism. My young sons liked the talk so much that I decided to expand it into a children's book. So I called Susan Hirschman, who for ten years had been urging me to do a children's book. The result was *The Book of Tens*."[124]

"Ark Curtain (Temple Emanu-El commission)" (plate 83)

In the winter of 1994, Gloria began work with Congregation Emanu-El to produce a hand-woven tapestry Ark curtain and a set of five Torah mantles for the Temple's main sanctuary on Fifth Avenue at 65th Street in Manhattan. Founded in 1845, the temple is now renowned as "the largest Jewish house of worship in the world." The Frankenthaler family had been members since the early twentieth century. As a contribution to the Congregation's 150th Anniversary Capital Campaign, Gloria offered her services and development costs on a pro bono basis.

After initial consultations with Archie Brennan and Jack Lenor Larsen, Gloria sought other collaborators and needed to look no further than her dermatologist. In early December, the Emanu-El committee approved her recommendation of Mark Podwal as designer of the Ark curtain. Because flat French tapestry techniques fit well with Podwal's cartoon-like drawings, Gloria chose Manufacture Pinton to weave the main panel. As usual, Gloria concerned herself with every detail, and declared, "Brave new world!" (For further discussion of Brennan's and Larsen's original roles in this project, see chapter 4.)

This was Podwal's first tapestry venture. "I am now guiding Podwal in his development of the design, not to have too much detail," Gloria wrote to Pinton. "I am sure that you agree with me, François, that a large hanging should not be too fine. One wants that wonderful feel and look of tapestry, and not have it look like a painter's canvas."

Initial sketches were deemed too informal— that is, "too Podwalian"—and not sufficiently opulent or elegant for the synagogue's committee and major donor. With Gloria's counsel, the artist developed a "new style only for Emanu-El." Ultimately, Podwal's highly symbolic designs managed to combine his playful style with the richness required. His designs, as the Temple's dedication brochure described, embraced "imagery and symbols which reach

83 Mark Podwal, "***Ark Curtain (Temple Emanu-El commission)***," 1996, woven by Pinton, 98 × 65.5 in.
Congregation Emanu-El; © Mark Podwal. Photo by Malcolm Varon, courtesy of Herbert and
Eileen Bernard Museum of Judaica, Congregation Emanu-El, New York.

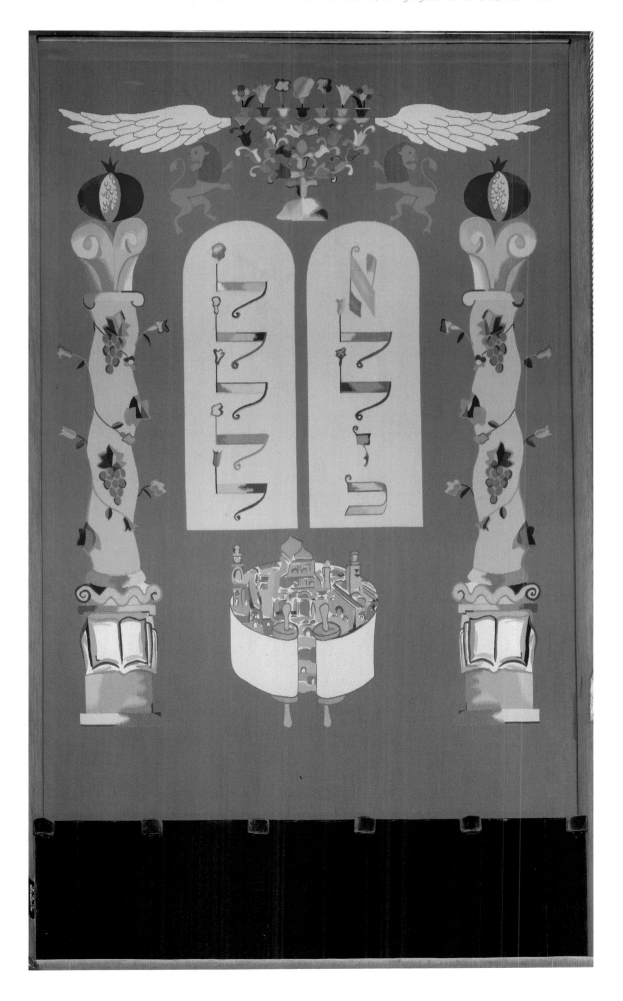

deep into our heritage and history. . . . The central image of the *parochet* is the Mosaic tablets. Rather than represent the commandments in numerical order, the artist has chosen to use the first letter of each of the Ten Commandments. Each letter, unique in its coloration, conveys the distinctive meaning of the commandments, which collectively form the core of Judaic belief. . . . Embedded in the commandments are flowers which adorn the Hebrew letter *lamed*, recalling the ancient reference to the flower as a symbol for the betrothal of Israel to the Torah.

"Immediately above the tablets is a winged seven-branched candelabra, the *menorah* of the Temple, . . . one of the most durable and common motifs of Jewish art. . . . The flowers sprouting from each branch echo the carvings of flowers which ornaments the *menorot* of Solomon's Temple while evoking the beauty and fecund nature of the God-granted life force.

"Flanking the menorah are wings. . . . On the one hand, flowing as they do from the light of the menorah, they portray the *Shekhinah* . . . , an expression of God's feminine principle. . . . Alternatively, the wings are emblematic of the Cherubim, the angelic creatures, with the body of a lion and the head of a man, which hovered over the ark and whose task it was to guard it.

"Completing the groupings at the top are a pair of lions which stand at the base of the *menorah*, supporting it. The image of the lion is an often seen embellishment on ceremonial objects. . . .

"Below the Decalogue is an inventive rendition of the city of Jerusalem. At the heart of this depiction is the traditional image of the Temple as rendered in a 16th century illuminated manuscript of a Dutch Haggadah. Here an open Torah scroll envelopes Jerusalem, fortifying its ramparts and serving as its foundation. The image articulates the strength of the Torah and bespeaks its protective power.

"The last of the four motifs of the *parochet* is the pillars which recall the two columns found outside the Temple, Jachin and Boaz. Though the purpose of these pillars remains enigmatic today, they are said to have borne inscriptions referring to God's permanence and God's strength. . . .

"Surmounting the columns are pomegranates, *rimonim*, which emulate the pomegranates that function as capitals of the pillars of the Temple. Replete with life-giving kernels, possessed of a delicate flavor and germinating into beautiful, red flowers, the pomegranate is often associated symbolically with the Torah, for which it physically serves as a crown. Extending and reinforcing the imagery of fruitfulness and abundance are the clusters of grapes which adorn the pillars.

"The pillars also serve as a frame for the central triptych. The three image groups in the center of the *parochet* are related to one another allegorically. At the top is the heavenly presence, ethereal, spiritual, transcendent. At the bottom is the temporal world of our existence. Between them, serving as a bridge and a vital link, are the commandments, the word of God."[125]

The Ark tapestry resonated on many levels for many people, just as the Temple Emanu-El building had more than half a century earlier: "Surely, among those present for the dedication [of the building in 1930] were some who were impressed by the cost of the structure, the prestigious, outstanding location of the Temple in the city, and the skill with which modern art and science were combined to produce a masterpiece of architecture. There were others, no doubt, who were conscious of the fact that the new building mirrored the story of a certain group of immigrants to whom New York had extended protection and opportunity. To those sensitive participants, the lavish splendor of the Temple and impressive beauty of its Sanctuary must have constituted a thank-offering to America and to God."[126]

Gloria once called this project in its early stages an "ordeal" because it was to be "all things to all people." Nevertheless, as her last and perhaps most personal project, it became a final source of identity and devotion for her. Mark Podwal too included it among his favorites: "Over the years I have been fortunate to see my drawings published in many books, animated for television, engraved on medals, exhibited in museums, and woven into a tapestry to hang in the largest synagogue in the world. Perhaps it all stems from missing those first days of kindergarten and needing my drawings to say that I am here."[127]

The Torah Ark in the main sanctuary, Temple Emanu-El, New York. Photo by Malcolm Varon, courtesy of Herbert and Eileen Bernard Museum of Judaica, Congregation Emanu-El, New York.

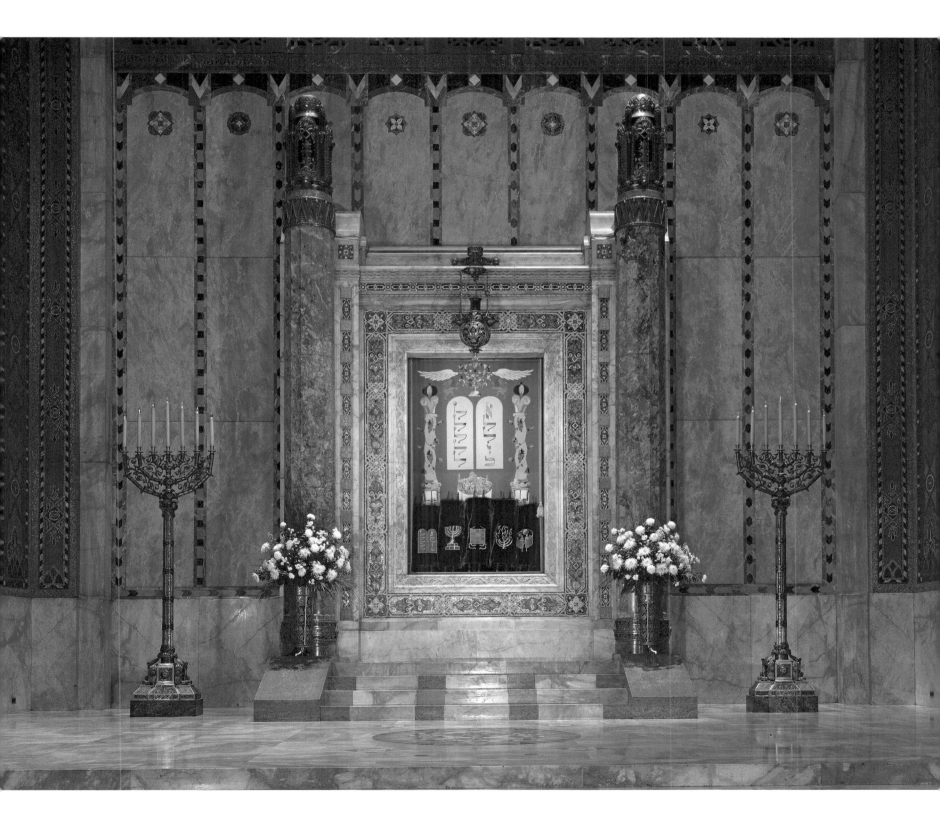

> **Words are words. And painting is painting.**
>
> —Larry Poons

Poons

LARRY [LAWRENCE] POONS
(b. 1937, Tokyo, Japan), New York, NY

Trained in Boston during the 1950s, Larry Poons represents a third generation of the new abstraction painters. His mark was made during the mid-1960s with large-scale paintings that showed floating fields of dots, ovals, and lozenges. Deceptively simple, his canvases drew critical attention: "They come pretty close to being simple exercises, yet are saved by the subtle evasiveness of the overall patterning of dots and ellipses and by the sheer radiance of the colors."[128] Associating the work with op art, another reviewer wrote, "The effect of Poons's pictures—electric points of color on monochrome fields—is the one Mondrian probably hoped to achieve ('dynamic equilibrium') in his boogie-woogie pictures. . . . Poons, as his 'logical' successor, not only demonstrates how color can produce a spatial 'volume' in the flat, but can animate it through 'opticality' to achieve as well as surrogates for movement and plasticity."[129] The artist himself observed in 1965, "I've had three jumps so far in my painting. I've been moved by Mondrian. The next time if I was moved by anything it was [Barnett] Newman. And after Newman the next thing I was moved by was Frank Stella."[130] As well, Kenneth Noland and Jules Olitski induced strong influences on Poons's approach.

By the 1970s, he began pouring and throwing paint to create heavily textured works, which later evolved into his bas reliefs of the 1980s. Throughout his career, Poons has maintained a formalist's approach, as he described in an interview, "Art and life are very, very far apart. The problems of painting a picture have nothing to do with the problems of everyday living. One thing, for me, is separate from the other." He summed it up with "Words are words. And painting is painting."

Prospective design with annotations for a tapestry, not woven, 1969

"after *Julie*" (plate 84)

Gloria saw Poons's color field paintings at the Guggenheim in January 1968. She contacted the artist through Leo Castelli, Poons's gallery representative and her friend and advisor. After considering work in several museum collections (Museum of Modern Art, Albright-Knox Gallery, and Hirschhorn Museum), they finally established a tapestry contract in December 1970 for his 1963 painting *Julie*, from a private collection. At the request of the painting's owners, an edition of the completed tapestry was donated to the International Art Foundation in Meriden, Connecticut, in exchange for use of the image.

Gloria retained the proportions of the rectangular painting and nearly doubled its size for the tapestry. She decided, in addition, to increase the relative scale of the dots and so omitted a portion of the design from the right and lower edges of the original painting. "The important thing," Poons emphasized, "is the interrelationship between all the colors." Working from his painted canvas samples, he and Gloria refined the yarn colors: "Blue is a dot lighter, creamier, red bloodier, background a dot duller, lighter, teeny browner (shading of background)."

For transferring the pattern to canvas backings, George Wells developed a small cardboard template for drawing the precise shape of each ellipse, with placement following several hand-drawn tracings. "The shape becomes the color," asserted Poons of his work. "The color is the shape, you see." Gloria requested a deep tufted pile so that the woolen surface of each elliptical dot could be sheared, standing out from the uncut and tightly looped background. Her notes indicate, "Hooked to make ovals 'dance.'" Always with an eye toward the artist's own intent, she also commented that the effect "worked as it did in the original painting."

Larry Poons, "**after** *Julie*," 1970, hooked by Anna di Giovanni, 80 × 90 in.
© Estate of Gloria F. Ross. Photo by Eric Pollitzer.

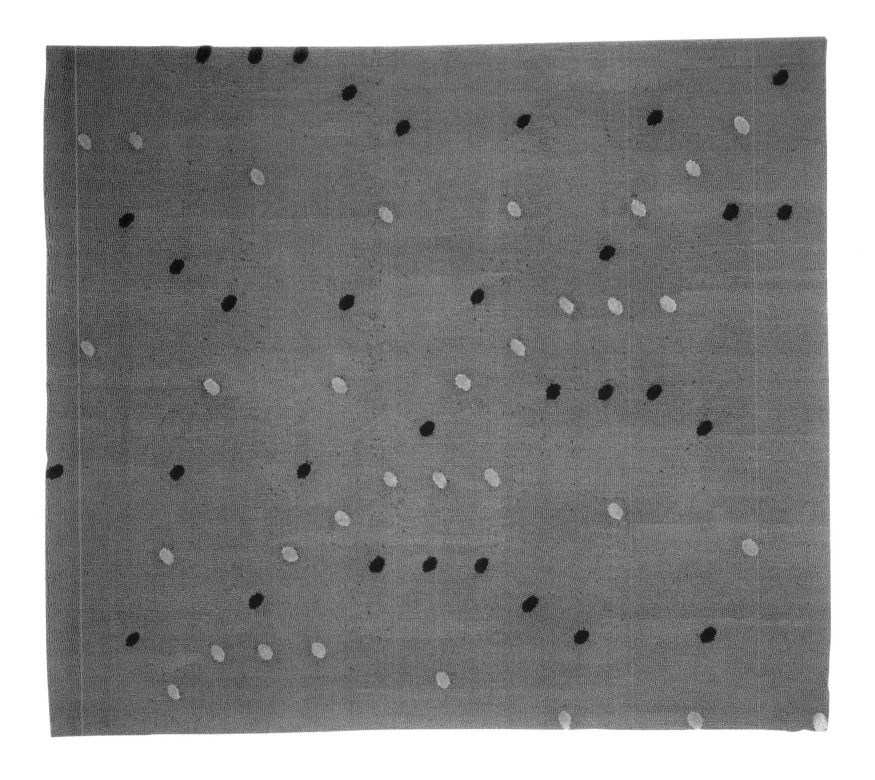

York has carried his photographic work, celebrated internationally for its technical innovations and scaled-up impact.

"after *Big John's Special*" (plate 85)

Gloria and Clifford modified her standard work contract, establishing that only one woven tapestry was to be made from his painting. Although most artists' compensation was specified as either a portion of sales price or one edition of the tapestry, they agreed that compensation was "to be decided by mutual agreement when tapestry is completed and selling price is established; & then herein noted." The artist struck a clause preventing him from having other works "reproduced on rugs, tapestries, banners, or other like fabrics." He also required a personal property insurance floater for the painting.

Translating *Big John's Special* into tapestry presented intriguing but not insurmountable challenges. To interpret the heavily textured work, Gloria consulted with Helena Hernmarck, who had developed an exceptionally versatile technique for her own large-scale tapestries. At the Swedish-American artist's recommendation, Gloria selected Mollie Fletcher, one of Hernmarck's former weaving assistants and an independent weaver in New York. Made with wool, linen, rayon, and cotton yarns, the finished tapestry was reduced to about three-quarters of the original painting's size. (See chapter 6 for details of its production.)

Unlike most other GFR Tapestries & Carpets shown through Feigen, Pace, or Gallery 10, this wall hanging was shown in 1979 at Hadler/Rodriguez Galleries at 35–37 East 20th Street, where the owners showed special interest in modern craft and textiles. The Bank of Tokyo in New York bought the tapestry and Gloria donated the painting to the Corcoran Gallery of Art in Washington DC.

ROSS

CLIFFORD ROSS

(b. 1952, New York, NY), New York, NY

Clifford Ross, the youngest son of Gloria and Arthur Ross, grew up in New York and earned a BA in art and art history from Yale University. In the late 1970s, Clifford's paintings were described as starting like those of his aunt Helen Frankenthaler: "Ross begins by staining the canvas with layers of closely valued color." From there he diverged. "On top of this base, he applies both brushed-on paint and thick, richly textured acrylic gel. Faced with the necessity of reconciling this combination of materials, each of which inherently commands a different effect, Ross then orchestrates color and shape to create a unified whole."[131] Frankenthaler's work was sometimes critiqued as "too decorative," but the reviewer dispelled any tendency toward this in the nephew's work: "even Ross' most pleasing works are never decorative, but retain a hard core that makes them, often, hard to swallow. They are not easy paintings. They force the viewer to question how and why they hold together, to rediscover their internal dynamics and, more important, to understand why the sum is much greater than its parts."

From Ross's early period of painting, *Big John's Special* (1977), a large acrylic on canvas, features gestural gobs of ruddy colored paint. Named for Benny Goodman's big band jazz classic, the painting hung at the American Academy of Arts and Letters when Clifford received the Richard and Linda Rosenthal Award as "a young American of distinction" in 1978. From then into the 1990s, his sculpture and paintings were shown by Manhattan galleries Tibor de Nagy and Salander-O'Reilly.

In 1995 Clifford embarked on a new artistic phase with large-format naturalistic photography. Since 2001, Sonnabend Gallery in New

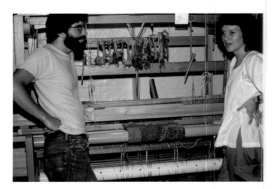

Clifford Ross and Mollie Fletcher
with trial on loom, 1978

Clifford Ross, *Big John's Special*, 1977, acrylic
on canvas, 93.5 × 86 in. Corcoran Gallery of Art;
© Clifford Ross.

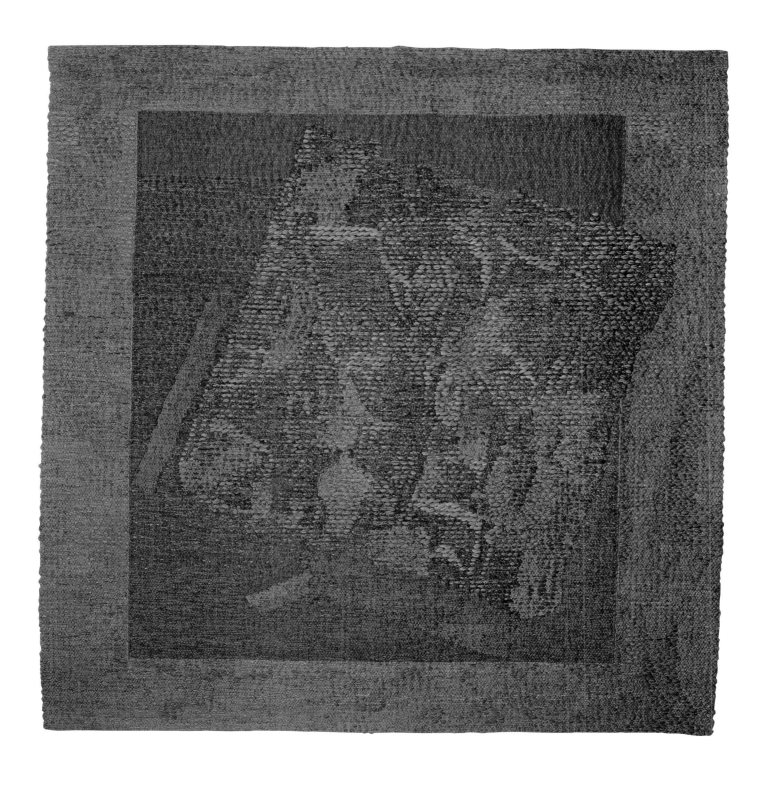

LUCAS SAMARAS

(b. 1936, Kastoria, Greece), New York, NY

Lucas Samaras was undoubtedly the edgiest artist to work with Gloria. Represented by Pace Gallery since 1965, he bore the reputation of "an artist who can usually be counted on to provide a surprise."[132] Trained at Rutgers and Columbia University during the 1950s, he also studied acting in New York and engaged in the early Happenings there. By the 1960s, he was well known as a "man-of-all-media"— drawings and collages; mixed media with found objects; manipulated photographs called, for example, autoportraits and photofictions; mirrored room installations; and performance art. The toughness of his imagery, often erotic and sometimes brutal, includes "objects bristling with pins, broken mirror glass, razor blades and the like."[133] Turning to textiles and softer subject matter, Samaras once again surprised the critics with his brilliantly colored patchworked fabric "Reconstructions" during the late 1970s.

"after *Flowers 2*" (plate 86)

Tapestries from nine oil pastels by Samaras were proposed in 1974 for a Pace Editions show the following year. Timed to coincide with the artist's one-man exhibition at the Museum of Modern Art, the paintings with three vases, three floating women, and three couples were selected to become solo tapestries.

Reviewer Grace Glueck once commented, "No one could ever accuse Lucas Samaras of being a one-image artist."[134] When Gloria proposed to use the classic French tapestry weave for the series, the artist conceived a flowered field, with historical allusion to medieval *mille fleurs* tapestries. The surprise embodied by Samaras's first image, *Flowers 2,* is its decorative and relatively tame nature. The lush oil

pastel on black paper portrays a columnar vase with red flowers, balanced precariously in front of a sketchy upended landscape, on a tablecloth with rainbow and interlaced elements. Although the other eight pastels are not documented in the GFR Papers, the floating women and couples struck the French weavers as inappropriate for tapestry. Gloria relayed a conversation with Arne Glimcher to Olivier Pinton in October 1974: "I mentioned that you were hesitant about making the latter into tapestry, I said I believed it was because of the subject, erotic poses, and not for technical reasons."

Gloria always worked through Pace to connect with Samaras and appeared somewhat in awe of the notoriously reclusive and provocative artist. She also expressed considerable pressure from the prospective series. She justified the work to Pinton in January 1975: "This is a particularly important group of tapestries, and if we are successful in these, I know that much important work will follow."

The first tapestry trials of "after *Flowers 2*" led to many discussions and multiple samples. Writing to Pinton, Gloria explained, "Olivier, Samaras is quite unhappy with the échantillon. It does not make use of the subtle color changes, nor does it have the feel of a pastel." After considerable trial and error, the workshop director offered a solution to the seemingly endless back-and-forth of suggestions: "Rather than making a trial that can't communicate effectively, I've decided to weave the tapestry at my risk and peril. You will receive, within about two months, this tapestry entirely completed. You will be free to refuse it if it doesn't suit you. It seems to me easier in the end to produce the whole thing rather than a fragment that just wouldn't be clear."[135]

A single brilliant tapestry was produced. White acetate (considered longer lasting than silk) was used alongside the usual wools. The classic French *hachures* and *rayures* created stylistic effects like no other GFR Tapestry. Six months later, Gloria acknowledged to Arne Glimcher, "with the Samaras tapestry you have inspired some of my most successful work."

Further work did not go forward, however, and not because of the weavers' reluctance. "For some inexplicable reason," Gloria explained to the weaver, "[Samaras] does not seem to want to proceed now. Glimcher will see him this weekend and we will hope for a change of mind. Artists!"

Lucas Samaras, *Flowers 2*, 1974, pastel on black paper, 13 × 10 in. © Lucas Samaras.

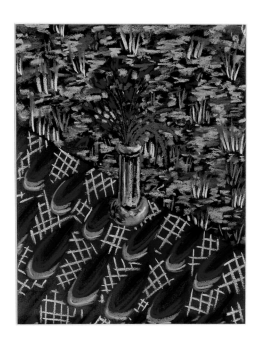

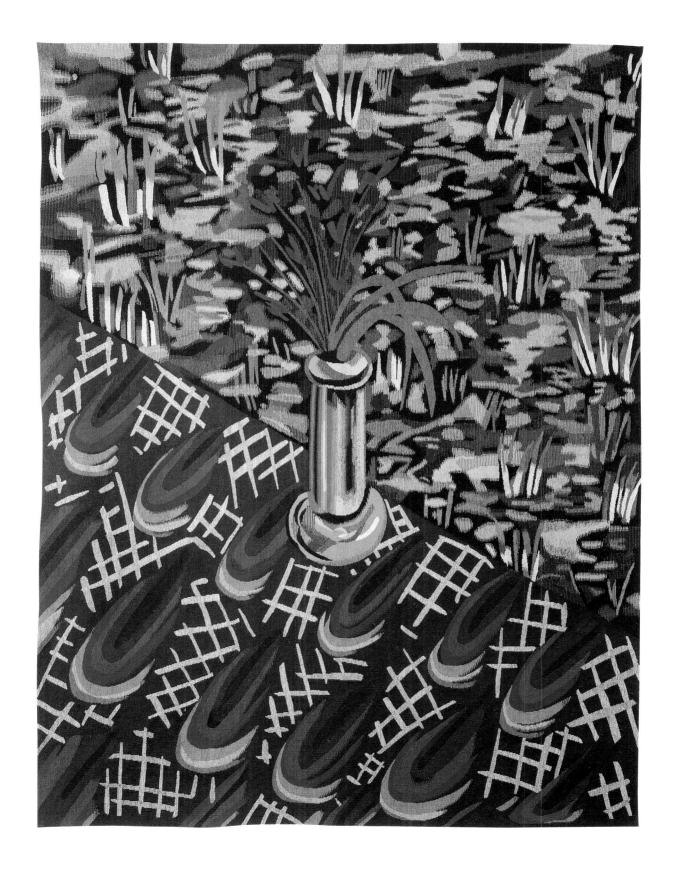

reshaped, sometimes with portions emerging from the picture plane toward the viewer. This experimental attitude extended to his willingness to see his work translated into the textile medium.

"after *Cold Corner*" (Checklist entry 87)

Through Richard Feigen, Gloria reached Richard Smith in Truro, Massachusetts. The artist made a foot-square box-painting for her, which served as a most challenging model for a wall hanging. Mounted inside a Kulicke Plexiglas frame, the cardboard form, almost four inches thick, has two curved "bites" taken out of opposing corners. A triangle of pale lavender-white emerges from a sloping backdrop of hand-painted grass-like green.

In January 1966, Gloria began exploring how to translate this unique three-dimensional maquette into a shaped hooked "rug," five feet on each side. Only one page of handwritten notes on this project survives among the GFR Papers, less information than for any other project, but the model itself remains with the archives. In October, Gloria ordered thirty-four pounds of Paternayan yarn—nineteen balls of lavender and eighty-one balls of green—plus a five-foot-square piece of canvas. She arranged for the piece to be hooked in her home studio. Long Island Carpet Cleaning Company sheared the hanging and applied a latex backing. Only one hooked work was made, but it remains an enigma; no photographs or owner have been located.

"after *Patty, Maxine and Laverne*" (plate 88)

A year later, Feigen provided another Smith painting as the lively model for an edition of three GFR Carpets. By then, Gloria addressed the artist as "Dick," but their personal contact was limited as he was again living in Great Britain. His painting *Patty, Maxine and Laverne* (1962) was named for the Andrews sisters, the trio popularized on television by Lawrence Welk. With three circular forms brushstroked across its upper register, this painting embodied the sense of movement that the *New York Times* later observed was "one of the signature aspects of Mr. Smith's art . . . full of gears, wheels and undulating bands of color, all of which, combined with the lively brushwork, give to the paintings a feeling of speed."[136]

In August 1967, Gloria squared the panel to six feet on a side, rather than following the painting's rectangular shape. She specifically chose an uncut looped surface for this work, asserting that the "mode of hooking gives it motion."

RICHARD SMITH

(b. 1931, Hertfordshire, England),
New York, NY

The only British artist to work with Gloria, Richard Smith rose to fame during the 1960s pop art craze. Trained at the Royal College of Art and associated with postwar British abstraction, he moved to New York in 1959. There his work included features of abstract expressionism, color field painting, and pop art. Smith's links to popular culture appear in his titles and filter more subtly into his refined and formal imagery. Exchanges with Kenneth Noland and influences from Ellsworth Kelly contributed to his proclivity for large graphic shapes awash with intense color.

By the 1970s, Smith was painting on unstretched canvases and occasionally collaging bits of woven canvas onto his paintings. He also created three-dimensional shaped paintings where a corner might be removed or

Richard Smith, *Cold Corner*, 1965, pastel on paper glued to shaped form, 12 × 12 × 3.75 in., in Kulicke Plexiglas frame. GFR Papers; © Estate of Gloria F. Ross. Photo by Jannelle Weakly, ASM. (See Checklist entry 87.)

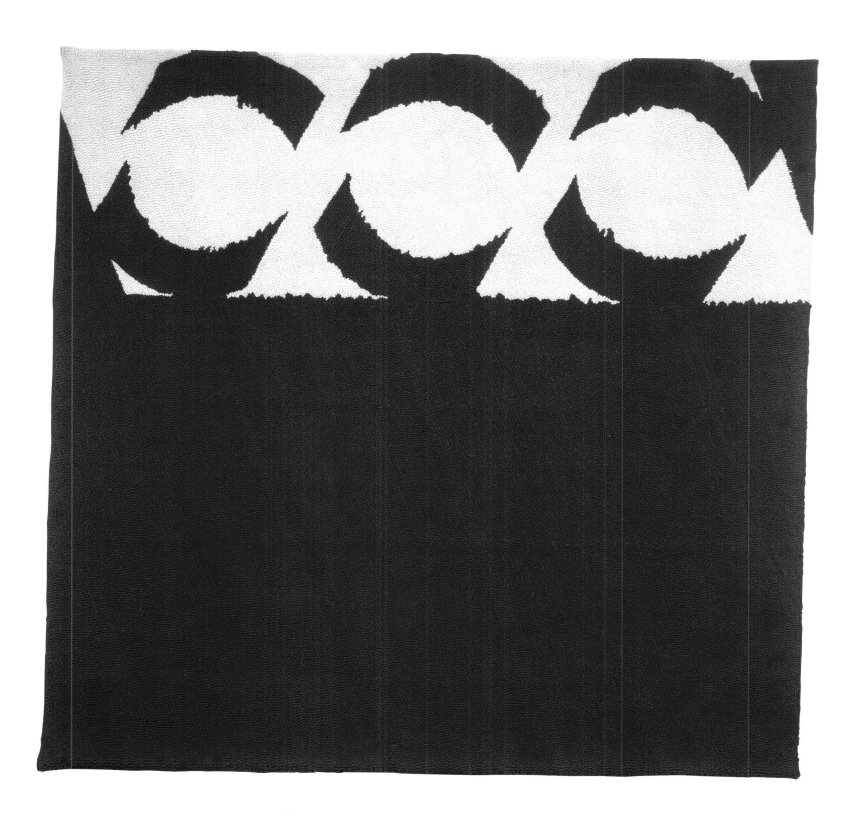

> **The fundamentals: line, plane, and volume. That's all you have, and it's what you make out of them that is important.**
> —Frank Stella

FRANK STELLA

(b. 1936, Malden, MA), New York, NY

Frank Stella's influential and groundbreaking work over five decades has ranged from minimalism to "maximalism," as he has called his later architectural works. After graduating from Princeton in 1958, he moved to New York, where he initiated a series of stark black paintings with pinstripes of canvas showing between the dark bands. Reacting against the painterly expressionism of the fifties, his flat matte paintings emphasized "What you see is what you see," that is, the direct materials and banded patterns without illusion.

During the 1960s, Stella created neon-bright geometric paintings and prints, including the acclaimed Protractor, Irregular Polygon, and other shaped canvas series. Critics have noted the painter's well-articulated interest in Islamic art, illuminated manuscripts such as the *Book of Kells*, and the Moorish-flavored paintings of Matisse as strong influences. In 1970 Stella became the youngest artist ever to receive a retrospective at the Metropolitan Museum of Art. His work of the seventies and eighties became increasingly complex, moving from bas-relief constructions to sculptures on an architectural scale. Yet he's always returned to "the fundamentals: line, plane, and volume. That's all you have, and it's what you make out of them that is important."[137]

"after *Flin Flon XIII*" (plate 89)

At first, Gloria's attempts to contact the celebrated artist encountered resistance. She noted glumly, "Frank Stella doesn't answer fone." In 1968 Leo Castelli suggested that she write, asking the artist for his ideas and avoiding any pressure. In response to a postcard and follow-up letter, Stella called her. In late 1971, she visited his downtown Manhattan studio and he put her in touch with Knoedler Gallery's director Lawrence Rubin.

After obtaining the artist's help, Gloria selected *Flin Flon XIII* (1970) from Rubin's private collection (the nine-foot-square painting is now in the Kreeger Museum, Washington DC) after viewing it in a Santini Brothers warehouse. While teaching at the University of Saskatchewan in Regina, Stella had painted the Flin Flon series, named after a town just across the provincial border in Manitoba. Because his shaped canvases required special supports that weren't available in the area, he resorted to square canvases during this period. Coincidentally, this format proved favorable for a tapestry translation.

Gloria's aim was to emphasize the artist's own approach—"Flat, matte, all same texture"—and so she selected the Pinton atelier to weave the tapestries. Both she and the artist were emphatic that the tapestry be the same size as the original painting. She marveled at the transposition process: "When tapestried this image unintentionally changes. Smooth curves become stepped."

Stella's use of synthetic polymer (acrylic) and fluorescent paints on canvas proved challenging for color matching, and Gloria's notes record, "Larry Rubin—can*not* ship pic!" She reported to the French workshop, "I had that transparency [of the painting/maquette] made especially by New York's best color photographer [Malcolm Varon], who matched the colors by hand to the original painting. Unfortunately I could not send the picture to you, nor could I get paint samples. All the colors are matte, flat. Match them as closely as possible and I will have them checked by Stella. They will be close enough to the original I am sure." Samples flew back and forth across the Atlantic until deemed correct. In some cases, the French weavers twisted differently colored strands of wool together to match the exact hue. The white lines were matched to the unprimed canvas that showed between the painting's large blocks of color.

Later Gloria recalled, "When I conferred with Frank Stella on a color in the Protractor series years ago, his comment was that the color was not the same as in the original painting, but that he preferred the change when translated into wool, and so we left this 'error' as it was."[138]

Stella followed the progress of each tapestry woven between 1972 and 1974. When Gloria approached the artist about other projects, however, the response was always that he wished to focus entirely on his own painting.

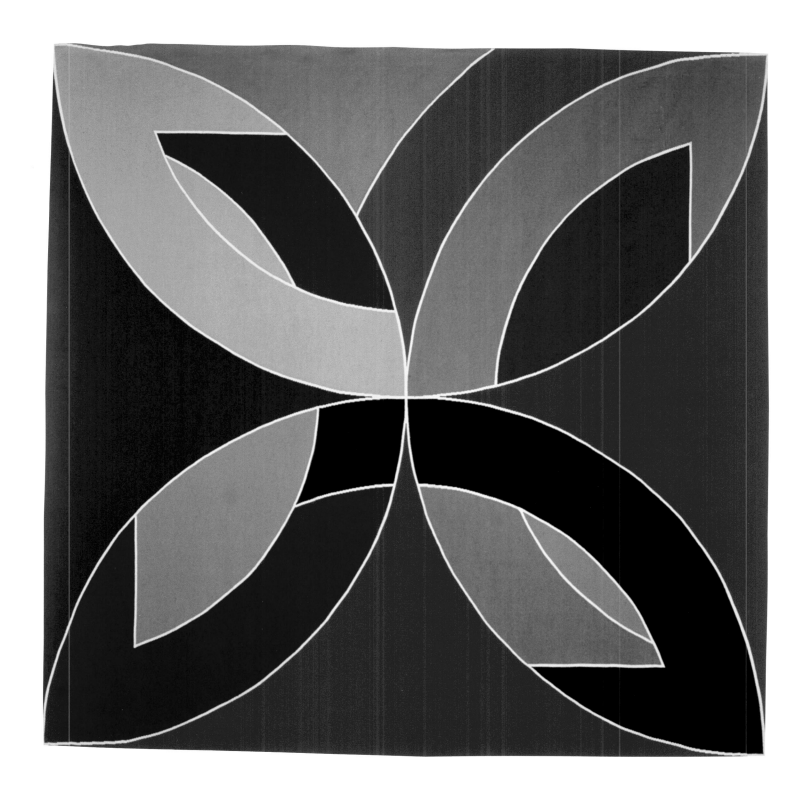

Trova

The symbolism, according to the sculptor, was that of the average, unheroic man caught in the flux of his immediate existence.
—Grace Glueck

The artist with his tapestry in the exhibition Trova: On a Grand Scale, 1994

Weaving at the Pinton workshop with metallic/synthetic threads, 1974

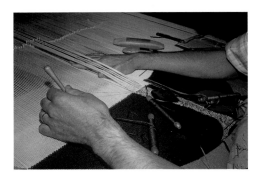

ERNEST T. TROVA

(b. 1927, Clayton, MO; d. 2009, Richmond Heights, MO), St. Louis, MO

A self-trained professional painter and sculptor, Ernest Trova created "Falling Man," a stylized armless humanoid that persisted through five decades of artwork. The stolid and expressionless figure appeared in paintings, prints, sculptures, installations, and even on wristwatches. Trova's sculptures included works in nickel- and chrome-plated bronze, stainless steel, enamel on aluminum, and other polished metals. Alternately complimented and criticized as a "serialist" (à la Warhol and pop art), the artist was fascinated by surreal juxtapositions with classical forms. He is said to have fashioned "Fallen Man" as an emblem of "an imperfect humanity hurtling into the future," and specifically as "the average, unheroic man caught in the flux of his immediate existence and with the certain knowledge of his eventual 'fall' into oblivion."[139]

Although based in St. Louis throughout his career, Trova showed at New York's Pace Gallery from its inauguration in 1963 until 1982. He never visited Manhattan for more than a week at a time and rarely formed friendships with other East Coast artists. His work was nevertheless acquired by the Museum of Modern Art and the National Museum of American Art, among others. His donation of forty sculptures formed the core of a major collection at Laumeier Sculpture Park, in the Sunset Hills suburb of St. Louis.

"Falling Man/Canto T" (plate 90)

Work started between "Mr. Trova" and "Mrs. Ross" through Dick Solomon at Pace Editions in early 1972. Within a month, it was "Ernie" and "Dear Gloria," followed by informal holiday cards and warm exchanges over many years. Trova's quirky sense of humor prompted at least one inside joke concerning Gloria's "bad flannel" projects.

Trova designed Falling Man/Canto T (1972) expressly for a GFR Tapestry in March 1972. The multiple figures arrayed within four circles grew from his silkscreen series F. M. Manscapes, published by Pace Editions in 1969. Also, in the early 1970s, Trova initiated a related sequence of sculptures known as the Profile Cantos (hence Canto T in the tapestry's title), in which the artist toyed with the relationship of his figures and surrounding geometric shapes.

Before the design was finalized, ideas for this special work were tossed around for several months. Wanting to play off the artist's use of shiny metals, Gloria wrote to the French weaving workshop: "Does metallic thread add much to the cost of the weaving? Can you give me the approximate price of a square foot of tapestry woven in wool, in wool dyed metallic, and in metallic thread." The studio director wrote back, "Do not worry about the metallic threads. Of course it costs a little more. But it depends so much on the intricacy of the design that it is negligible."[140]

The artist was engaged in early decision making and Gloria's correspondence indicates frequent contact with him in St. Louis: "Trova is delighted . . . Trova hopes that [the border] will be as much like the woven cotton edging, as is possible. It is just the color he had hoped for. Trova confirms that he does want his signature on a tab on the back of the tapestry."[141]

"Trova is pleased with all the colors and the weaving except for the 'falling man' figure. He prefers the silver color to be flatter, less shiny, less 'tinsely.' He would like the silver to be 'more like the wool' and by this I think he means that he would prefer the use of a rounder thread—perhaps you might use the metallic thread you showed me which was made of cotton with the metallic twisted around it." The first edition rolled off the Pinton loom in July 1972, with others following during the next two years.

Shortly after the tapestry's completion, a New York Times review singled it out in a group show: "A silver on purple weaving that utilizes the artist's falling-man theme, shimmers too. But it is flatter and silver [in contrast to a later Nevelson tapestry with dark metallic threads], as befits any translation of this sculptor's work."[142]

Gloria later regarded the use of metallic yarns as unprecedented: "Contemporary tapestry had not used metallic thread in this way. Wanted it to be reminiscent of Trova's sculpture. Recently identified as somewhat Art Deco."

Ernest Trova, "*Falling Man/Canto T*," 1972–81, woven by Pinton; see Checklist for dimensions, which vary within edition. © 1972 The Trova Studios, LLC. Photo by Al Mozell.

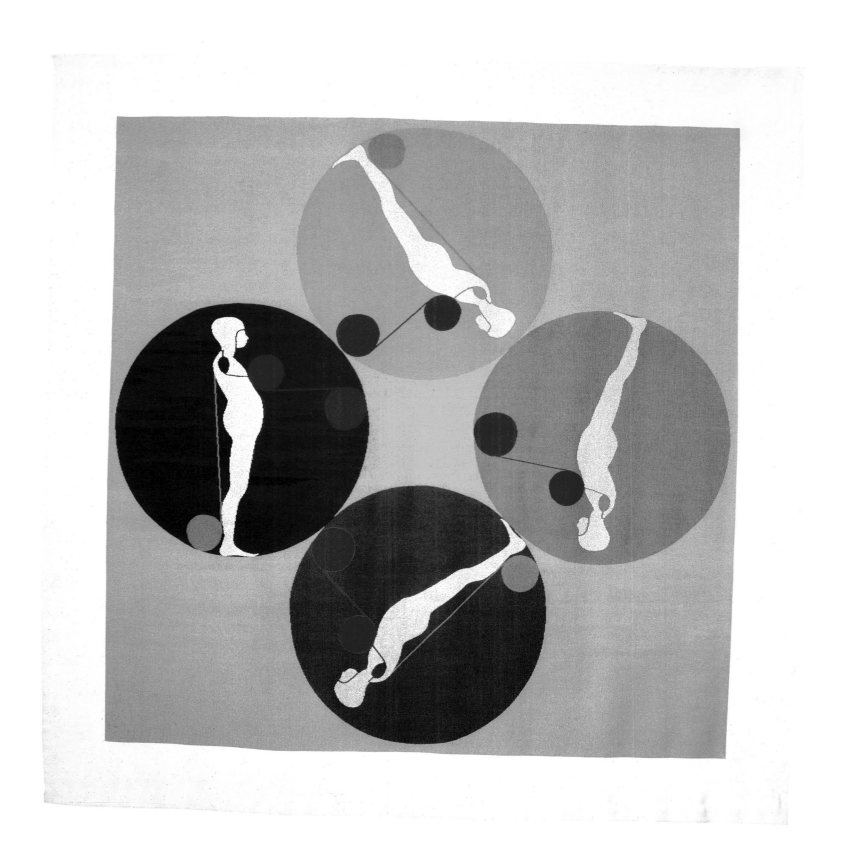

**By its nature, tapestry warms
and softens an image.**
—Jack Youngerman

JACK YOUNGERMAN

(b. 1926, Louisville, KY), Bridgehampton, NY

Another pioneering member of abstract expressionism's second generation, Jack Youngerman studied at the École des Beaux-Arts with GI Bill support. Steeped in Paris of the 1940s, he encountered the influential styles of Matisse, Brancusi, and Arp. After living and painting in Europe for a decade, he returned to the United States, where he found a niche amidst the Lower Manhattan art crowd—Ellsworth Kelly, Robert Indiana, Jasper Johns, Agnes Martin, Robert Rauschenberg, and others. By the late 1950s, he was established in New York with the Betty Parsons Gallery. After summering on Long Island's East End for many years, Youngerman moved there permanently in 1997. He joined Pace Gallery in 1971 and has been represented by the Washburn Gallery since 1981.

Although impressed by the bold brushstrokes of Robert Motherwell's painterly brand of abstract expressionism, Youngerman developed a style characterized by simple, clean-edged forms in a bold and limited color palette. His organic swirling forms are often said to reflect observations from nature but, according to the artist, remain without specific referents. The vibrant, pulsating style also owes much to a fascination with global ethnic arts, yet emerges strictly from his imagination.

By exploring new media and contexts for his flat and formal shapes, Youngerman always sought "to widen the possibilities for painting," as he once put it. He also became accustomed to working in collaboration with other artists and craftspeople. As early as the 1950s he was experimenting with oil paint on coarse burlap. During the 1970s he made a series of paintings on linen and directly on hollow core panels that joined to form folding screens. In later years he worked with woodworker Warren

Padula to create shaped and painted sculptural pieces. Such openness likely primed Youngerman for tapestry collaborations. As he explained during a 2010 interview, "For me, the essential quality of tapestry is its warmth and softness, even voluptuousness. The woven medium brings something unique [to the project], not in the realm of painting. Sometimes I liked a tapestry better than the painting it came from."[143]

Working with Youngerman

Youngerman and Gloria discussed tapestry making as early as 1966 at the suggestion of architect Armand Bartos. The artist personally familiarized himself with tapestries designed by Frankenthaler, Goodnough, Motherwell, and Noland, and came away favorably impressed. He and Gloria toured the Metropolitan's medieval tapestry collection at the Cloisters to further establish common understandings. A lively exchange ensued between éditeur and artist for several years before a Youngerman tapestry emerged. Coincidentally, by that time Pace Gallery represented him.

Once Gloria and Youngerman began working in earnest, theirs became a thoroughly engaged professional relationship and his tapestry series one of the most popular. Their collaborations encompassed all major techniques that she employed, including the hooked-rug technique, tapestry weaves in both the Scottish/Gobelins and French/Aubusson styles, hand-knotted pile weave, and commercial carpeting. Even after their projects were finished, a warm correspondence continued.

Jack Youngerman, maquette for "*September White II*," 1967, gouache on paper, 21.5 × 15 in. GFR Papers; © Jack Youngerman/Licensed by VAGA, New York. Photo by Jannelle Weakly, ASM.

Jack Youngerman, "*September White II*," 1968, hooked by Anna di Giovanni, 84 × 60 in.
© Jack Youngerman/Licensed by VAGA, New York.

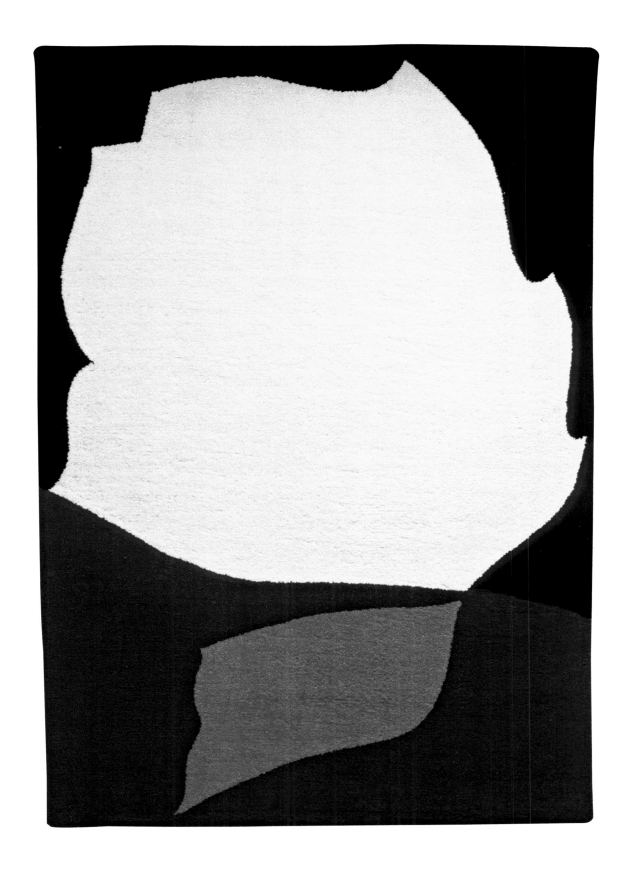

"September White II" (plate 91)

After three years of considering prospective imagery, Youngerman made *September White II*, a gouache on paper, in 1969. Modeled after his painting *September White* (1967), a much larger acrylic on canvas (measuring 108 by 87 inches and in the Hirschhorn Museum since 1972), *II* was a smaller work that the artist created expressly as a model for the hooked rug, serving as a classical tapestry maquette. The hooked panel split the size difference between the two originals.

"Untitled (John Hancock Building/ SOM commission)" (Checklist entry 92)

Following *"September White II,"* Gloria received a 1969 commission via Richard Feigen from Skidmore, Owings & Merrill for the firm's award-winning John Hancock Center in Chicago. Completed in 1970 and standing one hundred stories tall, the building was the world's first mixed-use high-rise. With this project, SOM became known for its "comprehensive design," in which they managed everything from building design and engineering to landscaping and urban planning to interiors. This collaborative ideal made SOM a perfect client for GFR Tapestries & Carpets.

For the modernist icon's lobby, Youngerman designed a broad sweep of golden yellow across a blue backdrop, grounded by smaller black and white elements. Gloria proudly asserted that this was "the first wall hanging commissioned in this country, designed by a major artist." She elaborated, "When SOM commissioned me to make a very large Youngerman tapestry for the John Hancock building in Chicago, I was literally driven out of my house where I had my workshop, and I worked in an atelier outside." During its construction, she shared a rented workspace and engaged a team of hookers to complete the work. She hired "the late great George Wells" to transfer the design onto a canvas measuring 102 by 264 inches and to custom dye the yarns.

"Blackout" (plate 93)

In 1970 Youngerman made a small cut-paper collage especially as a "tapestry study." Intensely joyful colors offset the almost ominous masklike design. Of his work at this time, Gloria aptly observed, "Youngerman is much concerned with 'bilateral symmetry.'" Woven eight feet square, the imagery and colors became even more powerful.

Gloria praised *"Blackout"* as one of GFR Tapestries' "signature images—one of Jack's greatest. It 'worked.'" Although she initiated work in Portugal with Tapeçarias de Portalegre (see chapter 6), the entire edition was woven in Scotland. The Dovecot workshop described their goals: "In order to translate the symmetry, and the crisp lines of the Youngerman collage, Blackout was woven on an especially fine warp and the weft thinned down at all the junctions of one colour and another. Owing to the nature of the wool the tapestry is much richer in colour and more vibrant than the original collage. The red, blue and orange glow through the black cut-out shape, and the smaller, pale yellow and green areas add sparkling freshness. The panel gives an overall impression of fineness with the surface absolutely uniform throughout."[144]

"Enter Magenta II" (plate 94)

During 1973 Archie Brennan wove several trials for Youngerman's *Andiamo*, an ironic name (meaning "Let's go" in Italian) for this dead-end project. After several months of trying to interpret the textured quality, "All agreed not to proceed, so JY did *Enter Magenta II*."

An original painting titled *Enter Magenta*, also produced as a popular poster, was selected. The shieldlike imagery prompted Gloria to comment in a 1974 note to Brennan, "Makes one think of the 15–16 century heraldic tapestries, yes?" She also observed that Youngerman "begins to understand + get the feel of tapestry. When he first saw '*Blackout*,' he, like so many others, was concerned about the ridges in the curves. Now he feels if they are a bit more pronounced, it will project more as a tapestry rather than a painting or collage. Victory!"

Jack Youngerman, *Tapestry Study: Blackout*, 1970, cut paper, 8 × 8 in. GFR Papers; © Jack Youngerman/ Licensed by VAGA, New York. Photo by Jannelle Weakly, ASM.

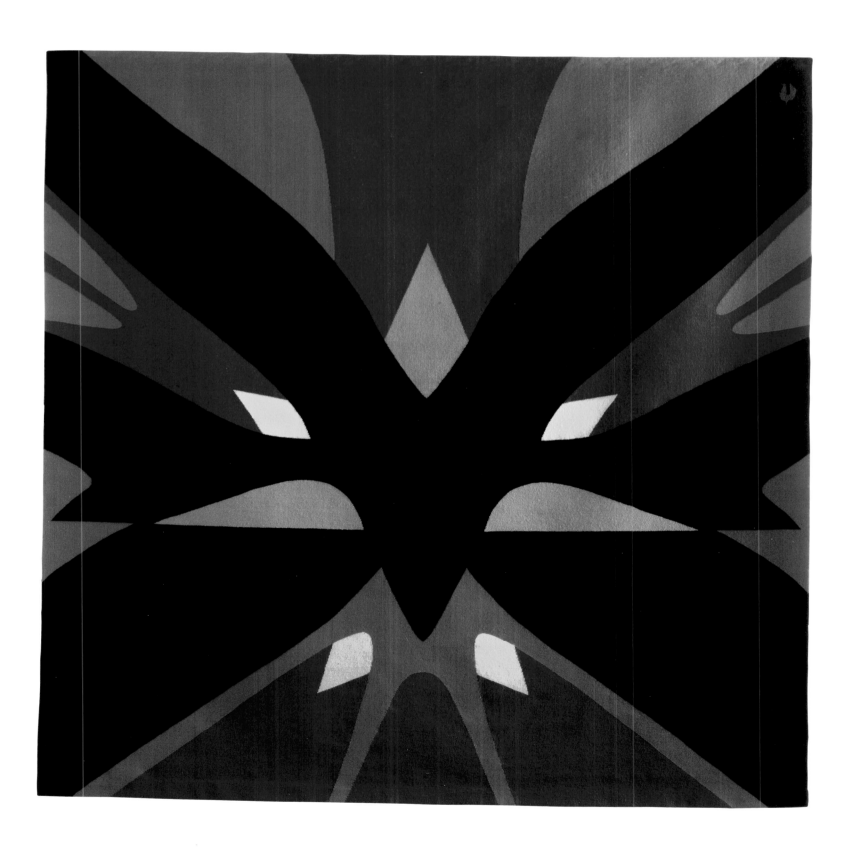

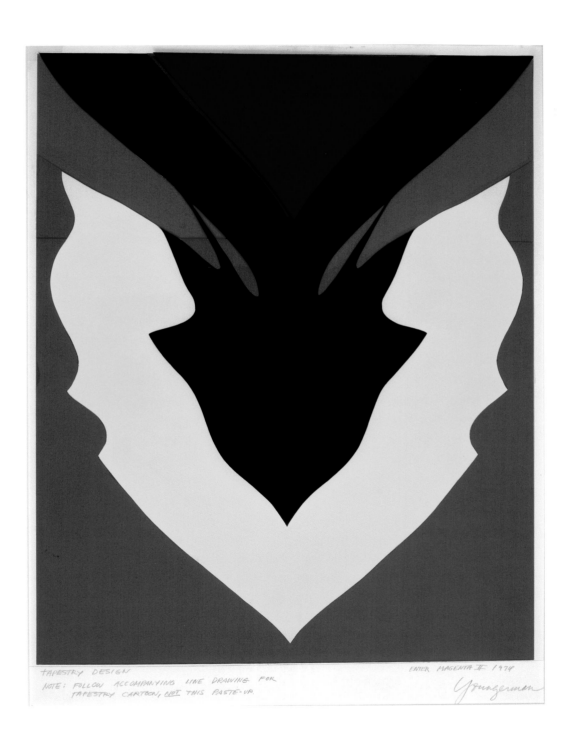

Jack Youngerman, maquette for "*Enter Magenta II,*"
1974, cut paper, 25 × 20 in. GFR Papers; © Jack
Youngerman/Licensed by VAGA, New York. Photo
by Jannelle Weakly, ASM.

Jack Youngerman, *"Enter Magenta II,"* 1975–76, woven by Pinton, 90 × 72 in.
© Jack Youngerman/Licensed by VAGA, New York. Photo by S. S.

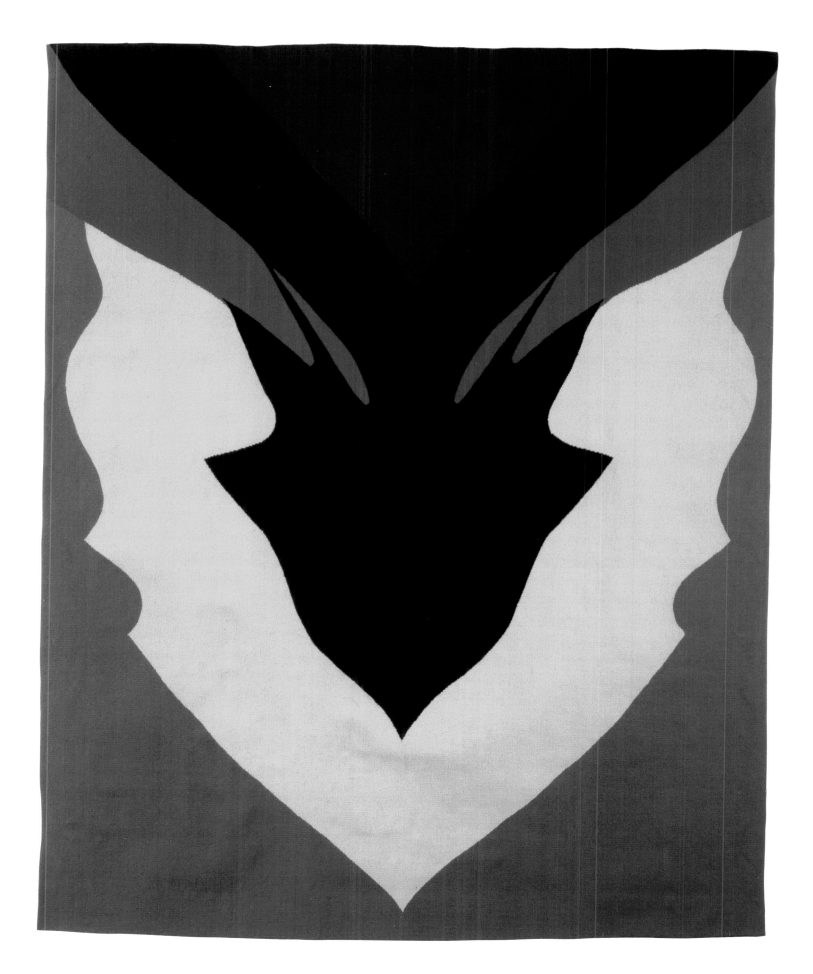

Although she first discussed this project with Brennan, Gloria turned to the Pinton atelier because the artist sought a heavier weave and a flatness that she felt the Aubusson looms produced. Youngerman proved to have a sharp eye and strong opinions about the handwoven French technique. "He is delighted with all of the colors but on future editions," Gloria wrote to Olivier Pinton, "he would like the black to have less sheen and to be more like the flat black in the Marca-Relli." And other concerns were raised: "Jack Youngerman saw the tapestry last week and telephoned me to say that he thinks the design of the tapestry differs slightly from the maquettes. . . . Jack Youngerman was really not happy with the weaving itself, Olivier. He too noticed the many lines throughout the tapestry and notices, too, that they were particularly obvious in the yellow area. . . . Please do give my tapestries your very special and talented attention."

"Rumi's Dance" (plate 95)

In 1976, Gloria and Youngerman embarked on a second large commission, this time arranged through Richard Solomon and the federal Art in Architecture Program for an office building in Portland, Oregon. For the lobby of the imposing eighteen-story modernist building by Skidmore, Owings & Merrill, Youngerman designed a wall hanging with circular swirls in jewel-like colors.

The work, titled *Rumi's Dance,* grew out of Youngerman's fascination with meditational images based on the mandala. His title honors Jalalud'din Rumi, the thirteenth-century Sufi poet, whose whirling dervish practice is evoked by the tapestry's swirls. The artist has described his "secular vision" as based on the principles of opposition, with "dynamic shapes suspended in symetrical [sic] composition," and multiplicity, with "shapes in a surrounding 'force field' as distinct from single figure/ground compositions."[145] He also

likens the layout to a central sun and circulating planets.

George Wells custom-dyed the wool yarns for the hooked panel, measuring fourteen feet on each side. Gloria traveled to Portland to supervise its installation in the Edith Green–Wendell Wyatt Federal Office Building. In 2010, thirty-five years after its completion, the commissioned work was still hanging in its original position.

"Octosymmetry" (not illustrated)

Youngerman's paper cutout, Octosymmetry, served as the prototype for a brand-new albeit failed experiment. As Youngerman has described the project, it was "as if Gloria and I both did our worst. Gloria called me in a big rush—her contact from China was in New York and leaving and she wanted a maquette from me. She came down to the studio and I had maybe twenty-five works in progress, all scattered around. Gloria saw this one and pounced on it. She pleaded for it. Aside from its simplistic design, I felt it was not yet full or strong or developed enough. It wasn't yet a work—just a beginning. I never developed a full scale model for it as I did with the others to see how each would change when enlarged. Once it went [overseas], we had no contact from China and the people who made it."

The unique piece, six feet square with a quadrilateral "florette" in reds and purple, was made in 1980 by the Shanghai Carpet Factory in the People's Republic of China (for details about making arrangements for this, see chapter 3). It was to be the sole example of a hand-knotted pile carpet among the GFR Tapestries & Carpets. Averaging an impressive ten thousand hand-looped knots per square foot, the silk yarns created a lush, velvetlike surface.

Although Gloria cited its "superb, most subtle shadings," she and Youngerman never felt it was their best work—she, because the colors were not accurately rendered, and he, because the design was inappropriate for the hanging's final scale. Because of these shortcomings, the work has been withdrawn from the repertoire of GFR Tapestries & Carpets. Both Gloria and Youngerman hoped to work again in China, but never did.

"Maritimus" (plate 96)

The contract for "Maritimus" took from 1982 to 1990 to finalize, in part because of what the artist called "affectionate disagreement" regarding his freedom to contract other textiles at the same time. Indeed, Youngerman initiated parallel work with Modern Masters and Masland carpet manufacturers in 1982.

Imagery for this oval-shaped carpet developed from a series called Ukiyo-e, four lithographs published in an edition of 150 by Pace in 1976, and from related works of the same period. From an untitled graphic came a floral swirl in black and dusky blue, which Gloria had woven as a commercial pile carpet at the Edward Fields factory. According to the artist who visited the plant, the aspect that most contributed to this work's success was its relief-carved surface, which, he has observed "picks up light in interesting and different ways" and sets it aside from his prints and paintings.

Jack Youngerman, "*Maritimus*," 1989, produced by Edward Fields, 63 × 84 in.
© Jack Youngerman/Licensed by VAGA, New York. Photo by Kubernick.

Tapestry in the Late Twentieth Century

Valuing Tapestry

GLORIA F. ROSS

Tapestries designed by:

- FEELEY
- FRANKENTHALER
- GOODNOUGH
- MOTHERWELL
- NOLAND
- SMITH
- YOUNGERMAN

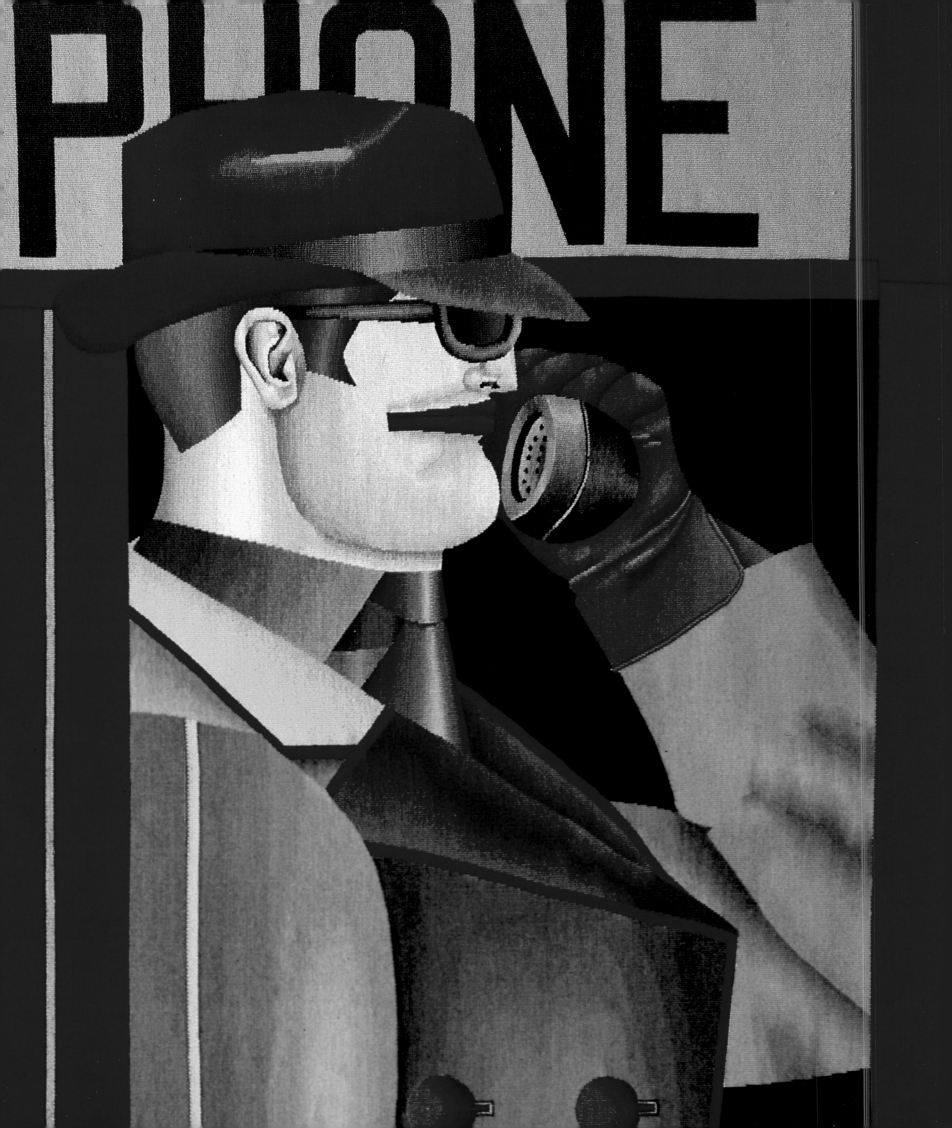

We have been showing the tapestries . . . and have had price resistance on a sustained basis. . . . Everyone loves the work, but they reject the prices.

—Grace Hokin[1]

[The collector] provides the market and launches national and international trends. Without amateurs [art-lovers], art cannot exist.

—Jacques Fadat[2]

. . . the price at which a work is sold is greatly influenced by its nature, by the identification and identity of its author, by its format and period, and by its degree of rarity and state of conservation.

—Judith Benhamou-Huet[3]

Architects have commissioned paintings, sculpture, fountains; but it has been only in the recent past that they have commissioned tapestry, and have placed them throughout their buildings. It is only recently that banks, offices, homes and contemporary museums have been tapestried.

—Gloria F. Ross[4]

Although Gloria's work started as a hobby—making a few *objets* for herself— she was soon making art for sale. Her hooked and woven pieces were shown in successful commercial establishments and were valued as artistic commodities. Tapestry making became a business, not just an aesthetic calling.

Unlike some French colleagues in the early twentieth century, Gloria never owned or worked for a gallery. Instead, she engaged a series of independent urban American galleries. Some she approached; others sought her out. In a few cases a gallery already represented painters and sculptors who worked with her; other relationships grew out of new gallery connections. A few galleries specialized in tapestry, but Gloria was interested in art galleries with broader scope. Her emphasis was always on elevating the textile arts, giving them the same level of exposure received by mainstream painting and sculpture.

This chapter addresses the marketing, selling, exhibiting, reviewing, collecting, and financing of GFR Tapestries & Carpets. Because these activities took place continuously throughout Gloria's career, the stories move, as in previous chapters, from the 1960s to the 1990s within each topic. The events and issues described here document the slow but growing recognition of tapestry as a legitimate art medium, largely spurred on by Gloria's professional activities and those of her closest colleagues.

Marketing Tapestries

Gloria participated actively in selling her tapestries and lost no opportunity to educate dealers, prospective collectors, and the general public about the medium. This was important because, as she once opined in a letter to Archie Brennan, "Most New York galleries are so dreadfully unimaginative in terms of tapestries and really don't know quality when they see it."[5] She often contributed to gallery press releases and edited catalogue copy. She courted news writers, provided tours during gallery shows, spoke at professional conferences, and lectured to civic and cultural groups. Not only did she eagerly meet with architects to discuss tapestry commissions, but she was equally eager to meet with building superintendents to discuss installations. She kept annotated price lists for many tapestry concerns. Watching vigilantly for critical responses to textile art, she also kept extensive cross-referenced clipping files.

With the advice of experienced colleagues such as Richard H. Solomon at Pace Editions, she linked her work to other key art events. Her projects with Stuart Davis, Romare Bearden, and Lucas Samaras were all coordinated with major retrospectives of their paintings and other work. She recognized and seized opportunities, as one 1991 note poignantly suggests, "Perhaps you know that Motherwell died this last week, which of course was Page 1 news in the *New York Times*. Although he has not been well and this was no surprise, he was my friend and a former member of our family, it has brought sadness. In relation to our work, these happenings bring added incentive to do some advertising of our tapestries."[6]

Realizing that tapestry was especially marketable as mural art, she believed that major architects and corporate commissioners would find it compelling.[7] Early in her career, in a quick note championing her cause to Max Bill, the Swiss architect and visionary designer, she wrote, "I do believe that contemporary tap[estry], particularly within the framework of modern arch[itecture], affords a beauty, warmth and grandeur sometimes not offered by another medium."[8] The prominent firms of Walter Gropius,

Detail, Richard Lindner, "after *Telephone*," 1974, woven by Atelier Raymond Picaud. (See plate 39.)

Skidmore, Owings & Merrill (SOM), Kallmann McKinnell & Wood (KMW), and C. F. Murphy Associates all purchased her work for clients.

She connected tapestry and architecture in both historic and contemporary contexts. Her lecture notes record, "After a 19th century decline in tapestry production, there was a 20th century revival. . . . Contemporary architecture, with its marble, glass and metal certainly presented fertile field for the aesthetic warmth of tapestry. . . . The revival as we see it today reflects the classical period of tapestry which began in the Middle Ages when Medieval architecture certainly offered it the opportunity to serve as truly monumental, elegant decoration."[9]

Occasionally, family members collaborated on marketing. Gloria and her son Clifford often discussed potential collaborations, both artistic and entrepreneurial. Notes from 1975 suggest considerable thought about a project codenamed "MOMMY," in which they mused, "Why not take the best paintings from the best museum and make the best tapestries?" They discussed a large selection of MoMA paintings that could be translated into tapestry in a precedent-setting "museum-artist collaboration." In many respects, presaging the museum craze for licensing collections for reproduction but ignoring the labor-intensive processes that had already engaged Gloria, they listed dozens of well-known European and American modernists whose works might be translated. Despite the filial brainstorming, Gloria pursued three further decades of close work with painters, weavers, and galleries, without formal museum collaboration.

On another tack, Gloria's older sister, the writer Marjorie Iseman, sent a magazine clipping to her, using a pet name, "Googs: About crafts. Interesting piece and relevant to you, I thought. Also thought you might file it away for the bits of it useful in our next PR effort. Love, Marj."[10] What that next effort was is not identified in the archives.

Selling Tapestries

Gloria initially intended to sell her own tapestries. In their earliest correspondence, Olivier Pinton wrote, "I do understand your wish of being your own agent for America. I do hope you can do all these jobs which usually are under the responsibility of several people, if you really think you can assume the responsibilities of contacting the artists, choosing the designs, supervising the weaving AND organizing exhibitions and watching over timing and payments." Gloria responded, "You are right in that acting as agent et al would be too much for me to do (I think I was unaware of all this entailed). I must think it through a bit further now that I have [your] letter."[11] From then on, she relied on professional galleries to sell her work.

Richard Feigen Gallery

The first gallery to represent GFR Tapestries was owned by Richard Feigen, a dynamo in the art world. The Yale-trained Feigen launched his Chicago gallery in 1957. Quickly gaining prominence in collecting circles, Richard L. Feigen & Company, later Richard Feigen Gallery, specialized in modernist masters—"expressionism, surrealism, and the twentieth century."[12] Feigen began showing Gloria's work in 1967.

Despite the gallery's reputation, notices in the news media lacked sophistication. Writers misunderstood the process and found Gloria's role confusing—some didn't even mention her. Often critics wrangled with the decorative aspect of tapestry at the expense of the medium's expressive nature. The *Chicago Tribune* story on the 1967 opening began with a question: "Did you know that tapestry people, like lithographers, speak of 'editions'? Neither did we. The sumptuous examples of the designer's and weaver's art on exhibit in Feigen's, 226 E. Ontario St., have no more than four duplicates in the world."[13]

A reviewer in the *Chicago Sun-Times* barely got his facts straight but made some interesting comparisons: "Tapestry has a different disciplinary effect [from printmaking], by virtue of its materials and methods, and because the weaver is not usually the designer. . . . The discipline of hooked wool brings unity to their [Noland, Frankenthaler, and Goodnough] designs and what is lost in spontaneity is more than made up by repose."[14] The *Arts Magazine* couldn't get Gloria's name right, headlining their story "*GLORIA ROTH*."[15]

Another Chicago writer noted the diverse and decorative nature of the show: "The translation of paintings into textiles—into tapestries, rugs, banners and the like—has been a popular international practice in recent decades. Not only has this century delighted in the juggling and hybridization of materials and techniques; it also has invented the ideal formal common denominator to assist in and encourage this process—abstract form. . . .

"Painting thus turns into tapestry in a group show at the Richard Feigen Gallery, 226 E. Ontario. . . . it is elegant, rich, blandishing, and undemanding, rather like the air of a collection of *haut décor*, which in a certain sense it is. . . .

"That handsomeness . . . [of] the items at Feigen, is both their strength and their weakness. They are comely things, now strikingly bright, now nicely subtle, always constructed flawlessly. One reflects, however, almost in spite of himself, that they would look well in an interior, and this reaction again suggests that decoration has counted for more than expressiveness."[16]

After inclusion in several Chicago shows, Gloria's work came home to New York, where Feigen had established the first art gallery in Lower Manhattan's SoHo district (the gallery

operated at 141 Greene Street just south of Houston Street from 1965 to 1973). After putting wall hangings into several group shows, the gallery held the first exhibition devoted exclusively to Gloria's work in May 1969. The show, called simply Gloria F. Ross Tapestries, included hooked rugs designed by eight artists (Feeley, Frankenthaler, Goodnough, Motherwell, Noland, Ross, Smith, and Youngerman). This was well timed to coincide with Robert Motherwell's one-man show at the Marlborough-Gerson Gallery on 57th Street. Michael Findlay, then Feigen's director of exhibitions and subsequently director of impressionist paintings at Christie's, became Gloria's lifelong friend and colleague.

Feigen showed more GFR Tapestries in his new Upper East Side gallery in early 1971. The works were displayed in Feigen's stellar Wiener Werkstätte building at 27 East 79th Street, designed by Austrian architect Hans Hollein. Gloria F. Ross Tapestries in Woven and Hooked Rug Techniques featured eleven artists, adding Gottlieb, Louis, and Poons to the previous mix. With major connections in the corporate collecting worlds, Feigen sold three wall hangings to the International Bank for Reconstruction and Development; two to Skidmore, Owings & Merrill for the Quaker Oats headquarters; one each to the New York Port Authority and the John Hancock Building in Chicago; and other works to other major corporations. Feigen also placed work in significant private collections.

Gloria learned much about the gallery business from Feigen, whom she considered a friend and mentor in those early years. In turn, apparently prompted by Gloria's work, Feigen studied the tapestry world and contemplated going around Gloria. Archie Brennan wrote to Gloria about this incident. "Something surprising to us. A few days after you left Edinburgh in November, we had a letter from the Feigen Gallery, asking us to weave some tapestries for them. They then wrote again, asking for editions of 10!! which I flatly refused. I am being very careful, but it may be, at our discretion, that we weave some works for them— not by any artist you work with, of course, and on our terms. I thought in fairness I would let you know of this possibility. It will not, however, be allowed to delay any production of work for you, and we still confidently aim for March/April for the next two (Youngerman, Frankenthaler)."

Later, Brennan added, "Our Feigen story accumulates many letters and calls but no commitment as yet by us." After which Gloria noted to herself in a typically sketchy but pithy form, "Don't want to compete w/ F— anyone else —His choice—If for him, cancel Gott.[lieb]—will have others Fall show." In the end, nothing appears to have developed from these inquiries.[17] In late 1971, Gloria announced

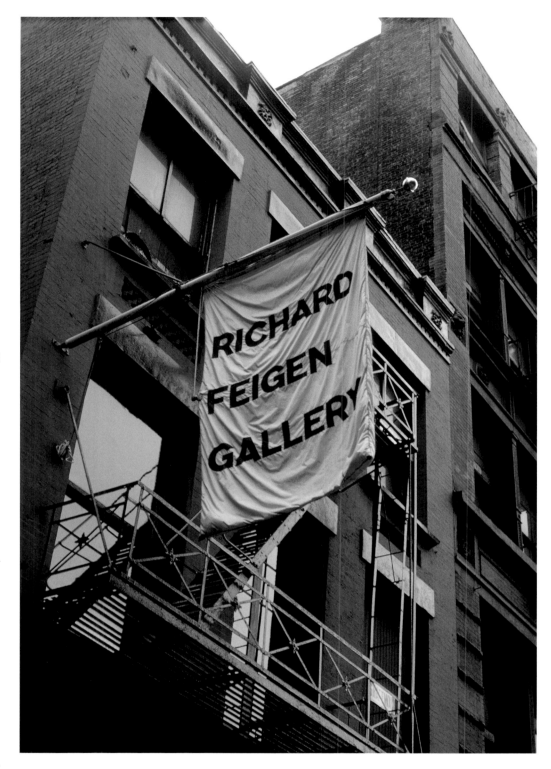

to Brennan that she was no longer with Feigen Gallery.[18]

Two years after Gloria left the gallery, she and Richard Feigen embarked on a large commission from Westinghouse Broadcasting Company of Philadelphia—two large, hooked hangings designed by Frankenthaler and Motherwell. The commissions themselves went smoothly, but a months-long dispute between Gloria and Feigen arose concerning the manner and cost of installation, further degrading their relationship.

Pace Editions, New York

In 1972, Gloria signed a contract with Richard H. Solomon, president of Pace Editions, Inc.[19] This

Gallery banner, New York, 1969. Photo by Clifford Ross.

agreement established Pace as the exclusive worldwide sales agent for all artist tapestries manufactured under her supervision for a period of two years. Solomon clearly grasped what this éditeur was about: "Gloria is a missionary of tapestries. She has so much commitment and enthusiasm. For the artist, it's flattering to be part of a medium with such a history."[20]

Pace Editions showed fine art prints by several GFR artists, including Frankenthaler and Motherwell, but in 1972 no other Pace artists were already working with Gloria. Over time, however, the gallery served as intermediary, and Gloria collaborated with several of its artists, notably Jean Dubuffet, Louise Nevelson, Lucas Samaras, and Ernest Trova.

The first solo show for GFR Tapestries & Carpets at Pace was held in fall 1972. Gloria reported at length to Archie Brennan. "The show included all the tapestries from Dovecot. Youngerman's show of his recent work i.e. shaped canvases, opened yesterday too at Pace Gallery on the third floor. The tapestries are shown at Pace Editions Inc. on the second floor and it all made for a beautiful presentation. The galleries are in an office building with an inner staircase joining these two floors. They are rather stark, simple, typical of the work of I. M. Pei, the architect who designed them. Some of the last editions of my earlier tufted hangings are at the gallery along with 3 Olivier Pinton made. They are well-done, very typical of P. F. [Pinton Frères] for the designs are straightforward, flat pieces."

The 1972 show was apparently well attended. The curator of contemporary art at the Metropolitan Museum of Art left some brief and somewhat hedged thoughts, handwritten on Pace stationery: "Gloria, I like the Gottlieb (though not the lighting)— with Motherwell and Goodnough it seems to me the most successful. I can suggest no changes—Congratulations. [s] Henry G[eldzahler].[21] Françoise Gilot—Picasso's former mistress, who was by then married to Jonas Salk—left an elegant calling card and personal note.[22]

An article by arts critic Rita Reif, however, was relegated by the New York Times to the "family food fashions furnishings" section. She wrote two pages about the show, beginning with some jaunty name dropping. "What do Garry Moore, the television personality; Robert S. McNamara, president of the World Bank; Dr. Jerome B. Wiesner, president of the Massachusetts Institute of Technology, and the David, Winthrop and Nelson Rockefellers have in common?

"Tapestries, that's what. They each own one or more of the proliferating number of what are, for the most part, woven paintings by famous artists. And, as of this week, they and thousands of other people who have been buying tapestries over the last decade have an even larger selection of works from which to choose.

". . . Pace Editions, Inc., in its first venture into tapestries, has mounted stunning hooked and flat weavings by Louise Nevelson, Ernest Trova and Adolph Gottlieb, to mention three

Pace at 32 East 57th Street, Manhattan, 1974

of the 15 artists represented in the collection of 25 examples executed under the supervision of Gloria F. Ross."

Reif goes on to describe just two works—the Nevelson and the Trova. Her discussion, unusual for an arts review of that time, addresses prices and pricing, describing tapestry as "big business in the art world," and noting that the hooked works were available "from $1,000 to $4,500 (prices are lower than the woven works which are from $2,800 to $12,500)."[23]

Another writer returned to the theme of decorative art. "Made at the celebrated Aubusson tapestry works in France or in Scotland, the tapestries prove that public decorative art need not be second rate. The color, workmanship and craft are simply breathtaking. It's interesting that most of the art people see is not in museums but in banks, offices and lobbies. If the architects, decorators, real estate developers, etc. could develop a taste for high art instead of its poor imitations, how much the visual environment could be upgraded immediately. Lobby art no longer has to be synonymous with lousy art."[24]

From 1972 into the 1990s, Pace Editions was the major East Coast representative of GFR Tapestries & Carpets, with solo exhibitions in 1973, 1975, and 1978. Dick Solomon became both agent and mentor, advising on all aspects of the business. The gallery inventory averaged twenty pieces on consignment and maintained an up-to-date sales list of over thirty works.

While critical acclaim did not arrive, handwritten fan mail from the public did: "Dear Mrs. Ross, I want to tell you how much pleasure I derived from viewing your current exhibit. It seems such a short time ago that I went over to the Pan Am to see the first examples of your art and then down town to Feigen's. Now this prodigious display! There was so much excitement in it for me. I shall not easily forget the spattered white paint of Gottlieb's 'Black Disc.' It is the consummate artistry; the Trova 'Falling Man' & the Nevelson are also stunning adaptations. I would not have believed it possible to so capture the essence of a painter and transform it so beautifully to your medium. Certainly this successful productivity must give you great fulfillment. If my applause is somewhat unrestrained, believe me, it is only a small measure of my reaction. I cannot remember when, last, I was so thrilled and delighted. Very best regards, I hope everything in your life goes in the same tenor as your work."

In 1975, after several years of successful projects, including the translation of Jean Dubuffet's Hourloupe into tapestry and pile carpets, Solomon reported that he was concerned "that Pace is getting awfully small return on these sales which means we will have to adjust the prices based on replacement costs." Gloria and Pace nevertheless

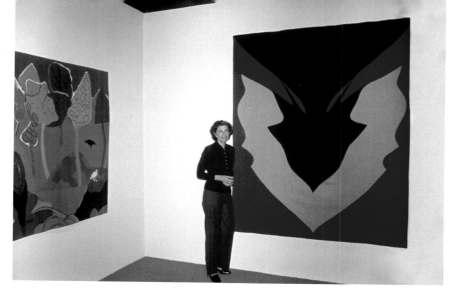

Gloria at Pace Editions, New York, 1975

continued to work together. From time to time the gallery shared and even provided full expenses for making certain tapestries.

Like Feigen, Pace pursued corporate homes for GFR Tapestries. Seven works went into IBM's growing corporate collection. Three were bought for the offices of The Limited stores. Others were sold to Prudential Insurance and nearly a dozen major financial institutions around the country. Although the buyers were sometimes illustrious, Dick Solomon wrote to Gloria in 1974, "I'm glad neither of us is depending on this performance [the sale of five major tapestries] for our food and shelter." In 1976 the gallery wrote to the General Services Administration Fine Arts Program and the National Endowment for the Arts, offering tapestries for the new Health, Education and Welfare building in Washington DC, but this project did not materialize.

After many years, tapestry promotion at Pace slackened. In 1980, the gallery initiated a revised and reduced contract, which allowed Gloria greater leeway to show at other galleries. In turn, in 1987, Gloria suggested to Archie Brennan that his independent work, in addition to their jointly produced works, might be shown at Pace Editions. She then had second thoughts and wrote, "Pace seems to be focusing more on prints . . . as opposed to tapestry. They have never handled tapestries other than those designed by artists."

In 1992 the gallery registrar wrote to Gloria, "Unfortunately, we have come to a crisis in warehouse. We are running out of storage space. As a result we are returning work that we have retained here on consignment," enclosing a list of twelve tapestries to transfer. Although the gallery no longer maintained her inventory, Gloria stayed in touch with Arne Glimcher and Dick Solomon throughout the rest of her life. She valued "the sound advice of my friend RHS," and always considered both men her trusted mentors.

Other Galleries and Brokers
Gloria was acquainted with most of the major New York galleries of the time, and

she frequented Christie's, Sotheby's, and other sales venues. Although she delighted in surrounding herself with fine art, her own purchases were made primarily during travels in Europe and at relatively small and lesser-known shops. André Emmerich had represented Helen Frankenthaler beginning in 1959; Gloria considered him a good friend, consulting with him on occasion for advice and appraisals. She worked closely with him and his esteemed mid-Manhattan gallery on each of her Hans Hofmann tapestries and carpets.

In 1967 the fine arts department of Ruder Finn, a well-known public relations firm, organized the exhibition Art for the Office in a downtown gallery in the imposing Pan Am (now MetLife) building on Park Avenue. Several hooked wall hangings took their place in the appropriately modern surroundings. Gloria was proud of the connection between this show and its location in the international-style skyscraper designed by Emery Roth & Sons with the assistance of Walter Gropius and Pietro Belluschi. Her Ruder Finn colleague Caroline Lerner Goldsmith reported that the gallery near Grand Central Station received between one and three thousand visitors each week, "and that doesn't count passersby who look in from the lobby." In an article titled, "Work Can Be Fun . . . With Art Around," the *New York World Journal Tribune* continued the theme of tapestries as décor.

"'Art for the Office,' an exhibition designed to demonstrate decorating possibilities in the business world, will open tomorrow at the American Greetings Gallery . . .

"The exhibition will present a group of rugs designed by painters, graphics, contemporary furniture and accessories, and glass display pedestals which can be used for sculpture or to show a company's products.

"The exhibition is especially designed to brighten offices in windowless buildings. It is aimed not only at businessmen, but at their wives and secretaries as well."[25]

Kauffman Fine Arts, Houston, 1977

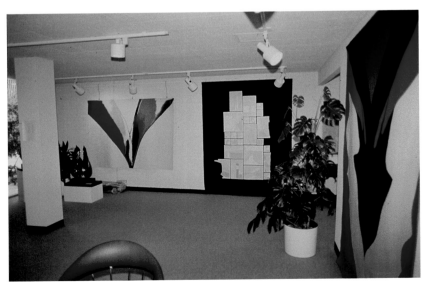

With one or two exceptions, Gloria elected not to work with the few American galleries that specialized in tapestries. Lee Naiman and Elaine Weiss, principals at Tapestry Associates on Central Park West in Manhattan, exchanged price lists and slides with her during the early 1970s. Apparently, they brokered several major tapestries, including Frankenthaler's "after *Blue Yellow Screen*," which was sold to the J. C. Penney corporate collection via Ruder Finn (plate 20).

The Jane Kahan Gallery was established in Manhattan in 1973, around the time Gloria moved from Feigen to Pace. Kahan focused on Aubusson tapestries and prints, sculpture, and ceramics by European masters such as Picasso, Chagall, Léger, Miró, and Calder. Although Gloria knew Jane Kahan (beyond tapestry interests, they were both Mount Holyoke alumnae), they never worked together closely. The gallery has become internationally known as an important source for twentieth-century tapestries. Today GFR Tapestries occasionally appear in Kahan's inventory of modern woven works.

Gloria dealt with a few other American art dealers on an ad hoc basis. In 1980 Hokin Gallery inquired about handling the tapestries in Palm Beach and Chicago. Making a number of significant private and corporate sales, Gloria worked with Grace and Eddie Hokin sporadically for about eight years. Three tapestries were also sent to the Phyllis Krause Gallery in Pontiac, Michigan, for a 1985 exhibition.[26]

For a short but intense time, Gloria worked closely with the preeminent Salander-O'Reilly Galleries, who represented the Stuart Davis estate for Earl Davis, the artist's son and executor. This partnership cosponsored the three Stuart Davis tapestries that were displayed in November 1991 at New York's Town Hall in conjunction with the Davis Centennial Retrospective at the Metropolitan Museum of Art.

When opportunities arose, GFR Tapestries were occasionally brokered by other galleries, including ACA Galleries on 57th Street, which held a memorial exhibition for Bearden in 1989. With Acquavella Galleries on East 79th Street, Gloria switched roles in 1992, brokering a major 1941 tapestry designed by Raoul Dufy and woven in France, which Acquavella sold to a Japanese museum.

Asian connections continued as Gloria worked with somewhat mysterious Gallery Urban, with showrooms in Paris, New York, Tokyo and Nagoya. Between 1985 and 1990, Gallery Urban (pronounced Ur-BAN) bought eight GFR Tapestries designed by Kenneth Noland and executed by Native American weavers, apparently for a single Japanese client. Gloria and François Pinton also made plans with Joumana Rizk, a Gallery Urban representative, for twenty-four master tapestries designed by Calder and Miró to go to Japan.

The gallery raised Gloria's hopes for further work. She wrote to François Pinton in 1991, "Urban New York is about to open a Calder exhibition of tapestry, gouaches and mobiles; and Urban Paris will soon open a Noland show of tapestry (my Navajo weavings), paintings, etc." She also expected a Stuart Davis show to materialize. Unfortunately, Gallery Urban declared bankruptcy and closed in March 1991.

The Southwest Boom

With Gloria's focus on tapestries woven by Navajo and Hopi weavers during the 1980s came opportunities to work with galleries that represented arts of the American Southwest. On a trip to Santa Fe in 1980, she met the imperious Elaine Horwitch, who had expressed interest in a French-woven tapestry designed by Paul Jenkins. In those days, the Elaine Horwitch Gallery established the cutting edge in southwestern art. Although her gallery never actually showed GFR Tapestries, Elaine gave Gloria tantalizing glimpses into the Santa Fe art world's inside track. Other friendships formed, and Gloria's regular Santa Fe visits became a significant part of her life.

Gallery 10, with locations in Arizona, New York, and New Mexico, hosted three exhibitions of GFR Tapestries in a decade's span. Established in the mid-1970s in Scottsdale, the gallery featured high-quality American Indian art and fine craft—elegantly displayed paintings, pottery, jewelry, and sculpture. A Chicago native, owner Lee Cohen was a steel industry executive before moving to the Southwest. Together with his wife Adele and their son Phil, Cohen developed the gallery's reputation as "one of the most important centers in the country for collector-quality fine art by Native Americans."[27] They showed the leading native artists of the time and launched many careers by forging connections to top-flight collectors. In addition to his American Indian focus, Lee Cohen served on the board of Taliesin West, and his gallery represented Frank Lloyd Wright's decorative arts and furniture. He and Adele had a longstanding association with the Art Institute of Chicago and other mainstream arts organizations. These interests led to their recognition of GFR Tapestries and the corresponding artists.

The first show, Kenneth Noland and the Navajo Weavers: The Ross Tapestries, was held in the downtown Scottsdale gallery, March 8–20, 1984. The invitation explained: "The internationally known minimalist painter KENNETH NOLAND integrates his creativity with the sensibilities of the Navajo weaving traditions. Works exhibited are textiles designed by Noland and woven by Navajo weavers in collaboration with Gloria F. Ross Tapestries."

Six tapestries—*Painted Desert," "Rainbow's Blanket," "Nizhoni Peak," "Twilight," "Games,"* and *"Morning Star"*—were exhibited. Noland

was expected to attend but did not, as he was preparing for a painting exhibition in Paris. Gloria lectured in the gallery on March 10. The local newspaper announced, "Exhibition Makes New York–Navajo Fine Art Connection," with six columns of description and three photos in the Entertainment section, but no context or critical commentary.[28]

A second show with eighteen Native/Noland tapestries was hung at Gallery 10's Manhattan showroom at 29 East 73rd Street from November 1985 to January 1986. This venue, initially held in partnership with the venerable ACA Gallery, brought American Indian art to the Upper East Side. The advertisement in the *New York Times* featuring the title as "KENNETH NOLAND and the American Indian Weavers: Gloria F. Ross Tapestries," with a bold chevron tapestry for illustration, signaled what and who was deemed important as a marketing tool. The accompanying announcement further emphasized: "An exciting new series of Gloria F. Ross Tapestries designed by internationally known minimalist painter Kenneth Noland and woven by Southwestern Native American weavers. This show represents a magnificent interaction between Anglo and Indian vision. The ideas of Noland, a crisp and abstract image maker, are complemented by outstanding Native American weavers who embody his designs in a distinctively American statement."

One gallery representative was unabashedly starstruck: "The artists were such celebrities. I was just so impressed by Gloria Ross and her work with these famous people."[29] During the show, Gloria lectured to the Mount Holyoke Club of New York. The American Museum of Natural History hosted a lecture titled "Navajo Weaving and Abstract Expressionism: Kenneth Noland and the Gloria F. Ross Tapestries."[30] Much to Gloria's disappointment, this New York show received no significant notice in the press.

The final Gallery 10 show, Gloria F. Ross Tapestries by Famous Painters, was held in Scottsdale in March 1994. This expanded showing featured four Native/Noland tapestries (*"Line of Spirit," "Ute Point," "Time's Arrow,"* and one untitled work) along with twenty-eight GFR Tapestries designed by other American artists and European weavers.

Although GFR Tapestries were never featured at the New Mexico venue of Gallery 10, the Rutgers Barclay Gallery offered Gloria a prime-time slot in August and September 1989, to coincide with Santa Fe's popular Indian Market. The gallery generally featured impressionist, modern, and contemporary master paintings, drawings, and sculpture. For the occasion, Rutgers Barclay, former director of Portraits, Inc., in Manhattan and Gloria's personal friend, requested both the European- and Native American–woven tapestries. The

show, titled Tapestries by Gloria Ross and
Avery, Bearden, Frankenthaler, Held, Hofmann,
Jenkins, Motherwell, Noland, featured twenty
GFR Tapestries, including ten of the Native/
Noland series. A local radio station took notice:
"Gloria Ross is a bridge . . . an artistic mediator
who creates an extraordinary union between
contemporary artists such as Kenneth Noland,
Helen Frankenthaler, Roy Lichtenstein and fine
Navajo weavers such as Mary Lee Begay and
Sadie Curtis. Opening tomorrow at Rutgers
Barclay Gallery are the fruits of the collabora-
tion of painters, weavers and the genius of
Gloria Ross."

For the vernissage (she delighted in using
the French word for *opening*), Gloria lectured
on "Tapestries—New Focus for Art Collectors"
at the Santa Fe Public Library.

Ever enterprising, Gloria occasionally
brokered fine Navajo rugs apart from her
GFR Tapestries and, in the process, enjoyed
expanding her Santa Fe network. Eager for
another trip west, she wrote to me of her
1982 plans, "I have been in touch with Steve
[Getzwiller, an Arizona dealer] because he is
looking for two weavings for me which I have
been asked to find for a corporate space in
Boston, where I need a small Burnt Water
for the floor of one of the executive offices,
and a Crystal or Wide Ruins for a wall. . . .
[Santa Fe dealer] Mary Kahlenberg visited
me earlier in the summer, and as a result of
that visit, she may help me fill some walls in
this very same space." Kauffman Galleries
in Houston hosted a 1982 show of fourteen
Navajo weavings that Gloria assembled.

European Outlets

GFR Tapestries & Carpets were never rep-
resented on a regular basis by commercial
galleries in Europe. Gloria and Parisian dealer
Alain Inard (a former nightclub owner from
Toulouse) discussed a fall 1978 gallery show.
The French gallery was willing to include
the Scottish Dovecot-woven tapestries
only "if the majority of the work were Made
In Aubusson," as Gloria noted to Dick Solo-
mon. A balance was not found and the deal
not made.

In the late 1980s, François Pinton opened
le Centre Internationale d'Architecture Tissée
(Galerie Pinton) on fashionable Rue Saint
Germaine in Paris. A fall 1990 exhibition, Les
Tapisseries Américaines, featured eight GFR
Tapestries. It is unclear whether anything sold
as a result of this effort; certainly few if any
buyers of Gloria's work were European.

Crane Gallery in London provided a brief
venue for Twentieth Century Tapestry, an exhi-
bition circulated by Pinton Frères that included
two GFR Tapestries; Motherwell's "after *In
Brown and White*" was properly labeled, but
the Marca-Relli "after *Multiple Image*" was
not identified as a GFR Tapestry.[31]

In addition to weaving many GFR Tapestries,
François Pinton and Gloria developed a variety
of complex financial and marketing plans con-
cerning other tapestries. These included co-
producing works by American and French
artists, collaborating on their sales, and broker-
ing non-GFR Tapestries in the United States.
Always such undertakings required much
back-and-forth wrangling.

Pinton arranged for a December 1989 sale
of tapestries by the venerable auction house
of Drouot Montaigne in the Theatre Champs
Elysées. None other than Denise Majorel wrote
the catalogue introduction. Among the sixty
Pinton-woven pieces for sale were three tap-
estries edited by Gloria, with imagery by Moth-
erwell, Marca-Relli, and Youngerman. Gloria
questioned the wisdom of the sale: "About
auctioning these works, we agreed that they
will not be auctioned in the U.S. where they
never do well at this kind of sale. As for auc-
tioning them in France, don't you think it is far
preferable to sell them from your gallery? I am
hesitant about an auction of this work at this
time. Give me your thoughts."

François replied, "I have, with your agree-
ment, included your three tapestries along
[with] other major works, . . . I am absolutely
convinced of the necessity of these prestigious
sales, which put tapestry at the level of the
most important expression. If I am proved
right, the prices at auction should be notably
increased since the last sale."[32]

Competing or Common Interests?

Gloria protected her business interests against
all comers—her own artists, weavers, and
dealers, as well as outsiders. As she became
established, news of work conducted, or even
attempted or considered, behind her back
traveled quickly. Artist Gene Davis wrote her
in 1972, "You might be interested to know that
last week [less than a month after signing a
contract with Gloria] I received a phone call
from a man in N.J. who said he represents the
Aubusson Tapestry Co. (?) He asked if I would

like to do a commission for them. I told him that I was already doing one for you. He said we could do another one. However, since I signed that exclusive contract of yours, I guess that rules such a project out. I just thought I would mention it."

To the weaving workshops, Gloria wrote repeatedly through the years with entreaties such as, "Olivier, will you confirm that you are not and will not weave tapestries for anyone else from works of 'my artists?'"[33] She implored individual weavers to protect her interests: "[The artist] may be interested in having other images translated into tapestry about which I expect he will contact me. If he should contact you directly, kindly confirm to me, that you will notify him that all such work is to continue being done as a collaboration with me. . . ."[34]

Most of her contracts with artists included a standard clause: "For one year from the date of this letter, you will not permit any of your work to be reproduced on rugs, tapestries, banners or other like fabrics, unless you and I so mutually agree." Many contracts, however, were hand-amended, e.g., "an exception is a tapestry in progress by Modern Masters." In fact, Avery, Bearden, Goodnough, Gottlieb, Hofmann, Lindner, Marca-Relli, Motherwell, Noland, Stella, Trova, and Youngerman all worked with that enterprise as well as with Gloria.

Indeed, Modern Master Tapestries, Inc., located first on East 92nd Street and later near Pace Editions on 57th Street, was likely GFR Tapestries' biggest competitor. Established in the early 1960s, it paralleled Gloria's own professional start. The ambitious company represented the Charles E. Slatkin Collection of Contemporary Tapestries and Sculptures, featuring wall hangings and carpets in hooked, handwoven, tufted, and other techniques, designed by over fifty modern artists.

Modern Masters gallery director Bill Weber played on a theme important to Gloria: "Quite simply, nothing fills a wall like a tapestry." One ad quoted AIA architect Robert Felson, saying "Tapestries . . . I find they provide a design solution for nearly any kind of architectural problem." He continued, "With their remarkably rich colors, warmth and texture, tapestries become a wonderful focal point in the over-all design scheme. In fact, they add to the quality of my work. As for client approval, it is easily obtained before installation—not after, as in the case of murals and paintings. And comparatively, the cost of a tapestry is extremely reasonable." Gloria filed price lists for 1970 and 1974 and kept *Contemporary French Tapestries* and *American Tapestries*, the catalogues for two Modern Masters exhibitions that toured across the United States during the 1960s.[35] Despite the common goals, she pronounced this gallery "too commercial" for her taste.[36]

In the early seventies, Joel and Dorothee Lewis of Art Vivant, Inc., in New Rochelle, set themselves up as "exclusive agents, manufacture de tapisseries d'aubusson—pinton . . . specializing in art from abroad." Gloria wrote to the Pinton workshop about them.

"Olivier, another artist with whom I am working (and whose designs you are actually making into tapestry now) has told me that Art Vivant is trying to work with them also. I think that this situation creates all sorts of problems, particularly in light of the proposed project you and I will undertake together. Can you somehow request Art Vivant to clear calls with me—or with you. There are so many artists with whom I have not worked [and presumably with whom others could work]. Or perhaps we can resolve it another way. What do you think?"[37]

The workshop director replied, "You know that Mr. Lewis is my exclusive agent as far as my tapestries *in stock* are concerned. So I am not to lend to anyone but him, any tapestry which I am the publisher of. He wanted to edit by himself a certain number of American artists, and asked for designs from a certain number of your friends, without my knowledge. He should have stopped now; he is about to come to France, as he does every year. We shall talk it over, and I shall write to you about it. A pity I was not aware of it before you [visited last month]!"

"To avoid complications, Olivier," Gloria wrote back, "I would expect that if I bring an artist to you, that you not do another tapestry with that artist without my permission. Perhaps Mr. Lewis and I might even consult with each other directly before approaching an artist for work with you." Despite her initial optimism, Gloria later complained, "They showed no interest in working with us. They regard themselves only as direct competitors, and based on the relationship they have brought about, it would be impossible to work with them." Several months later, Gloria wrote a note to herself: "Art V OUT − G work direct Pace in East only."

One short-lived enterprise with which Gloria coexisted peacefully was founded by a friend of hers. British pop artist Gerald Laing (b. 1936) showed sculpture and paintings at Feigen in New York from 1964 to 1970, at which point he escaped from the glamour and fast pace of New York by moving to the Scottish Highlands, buying the ruined Kinkell Castle, and restoring it. In addition to his own painting, from 1970 to 1974 he operated Brose Patrick (Scotland) Ltd., a tapestry workshop, following the model of the not-too-distant Dovecot Studios. The workshop's young team (five local teenagers, four boys and a girl) skillfully produced a number of tapestries designed by Laing and other artists. Then, at the suggestion of London dealer Thomas Gibson, they embarked on the challenging project of working from drawings by Henry Moore. Significantly, these tapestries were, as

Laing observed, "what made the survival of my workshop possible. Moore's final selling prices could easily absorb the cost of manufacture."[38] Gloria softened to this competing enterprise, perhaps because of the stellar quality of the internationally renowned tapestries, maybe because of her inclusion in the famed weekend parties held at Kinkell Castle, or perhaps it was Laing's endearing personal purpose for initiating the workshop in the first place: "This was not because I had any particular passion for the medium . . . [Tapestries] satisfied three crucial criteria – 1. They used a local material (wool) 2. They required no fuel or machinery 3. Their production is labour intensive. These were the qualities required for an activity which would provide intelligent work in an area of chronic underemployment and the project was opposite in character to the oil industry."[39]

Exhibiting beyond Art Galleries

Although Gloria and her galleries took great pains to inform visitors about the nature of tapestry and to provide auxiliary information, museums and other nonprofit venues place more emphasis on educational approaches and attract broader audiences than commercial enterprises. Major expositions tend to remain in the public mind longer and to produce long-lasting public records. Museum exhibitions and juried art fairs also represent refined processes of selection and interpretation. Over the years, Gloria sought such opportunities, and her work benefitted from the exposure.

GFR Tapestries & Carpets had their public debut in a New York group exhibition. "I guess I owe it all to an exhibition at the Museum of Modern Art in 1965 in which I was the only representative of the U.S.A." The invitational show, Tapestries and Rugs by Contemporary Painters and Sculptors, was organized by MoMA's International Council and included Gloria's hooked wall hangings designed by Robert Motherwell and Helen Frankenthaler.

The International Tapestry Biennial (Biennale Internationale de la Tapisserie) in Lausanne, Switzerland, represented one of the most desirable venues for textile artists from 1962 until 1995. The juried show has been called "legendary," "transformative," and a "key fiber art event" for its role in "a dramatic move away from traditional, smooth-surfaced, rectangular tapestries." The inclusion of tapestry-woven works by Magdalena Abakanowicz—"powerful, rough-textured, curved forms related to the human body"—and other signal figures in the fiber art world "elevated fiber art to a new level of importance."[40]

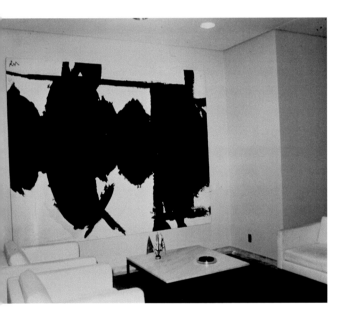

The Port Authority of New York and New Jersey offices, World Trade Center, New York

Gerald Laing unloading his first batch of wool, Kinkell Castle, 1970

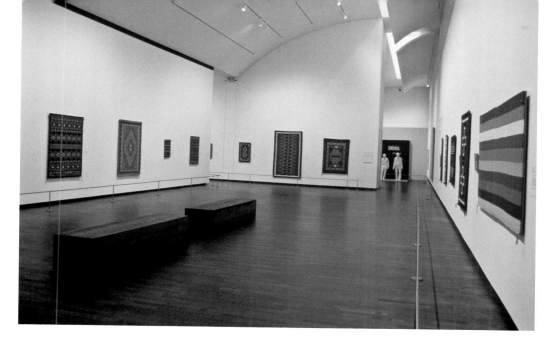

Joslyn Art Museum, Omaha, Nebraska, 1994

Ringling Museum of Art, Sarasota, Florida, 1978

Gloria and Robert Motherwell submitted an *"Elegy No. 116"* tapestry for the Sixth International Tapestry Biennial in 1971 (plate 44). Woven at the Dovecot with wool and linen in a heavily textured weave, this elegant piece was nevertheless rejected by the jurors. Two other Dovecot tapestries, designed respectively by Archie Brennan and Maureen Hodge, were not accepted either. An Eduardo Paolozzi tapestry woven at the Dovecot three years earlier, however, was exhibited. Despite this slight, Gloria traveled to view the show. Archie quipped afterward, "I wonder if you found more patisserie than tapisserie at the Biennale in Lausanne. I thought it 99.9% boring, & spent only 20 minutes there."[41]

A pair of GFR Tapestries designed by Richard Anuszkiewicz and woven at Pinton was selected for the Eighth International Tapestry Biennial in Lausanne and Lisbon (plates 1–2). These pieces, ironically, were perfect examples of classical French tapestry weaving with ultra-smooth texture. Gloria placed a full-page ad in the exhibition catalogue, with her picture, a list of the artists with whom she worked, and reference to Pace Editions/Gallery.

A year later, Fiona Mathison of the Dovecot queried Gloria about again submitting to the Biennial: "While discussing the Nevelson Uniques, may we enquire about the possibility of Louise Nevelson entering one of these into the tapestry Biennale at Lausanne or it being submitted by yourself or the Dovecot, with her permission. I feel that they constitute a very successful series and an exciting development in the translation of an artist's work into tapestry, as such, and would very much like to see one of them represented in Switzerland."[42] Despite their suitability for the Biennial, with their mix of fibers in textured and layered weaves, these Nevelsons were never entered.

The Mount Holyoke Art Museum organized an exhibition with nineteen GFR Tapestries in 1979—the largest body of her work displayed

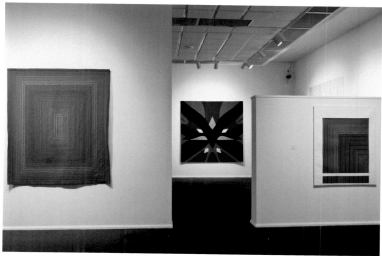

in one place, before or since.[43] Gloria was a proud graduate of the college and had served on its art museum board since 1975.

After the show closed, Gloria received a note from a Massachusetts businessman, who wrote, "I must tell you how enthusiastically your tapestries were received. It was indeed a real pleasure to see them, especially the Bearden tapestry. When I visited the museum I was with three other businessmen and they were highly elated by those tapestries. I selected the Bearden for myself and I wanted it for my home and when I called you it was a serious matter, but after examining my financial situation I find that it's very difficult at this time for me to come up with that dollar figure, so please accept my apology for letting my emotions override my balance sheet. In the future I will contact you and maybe we can make some sort of arrangements. Bearden just happens to be a personal friend of mine and at the present time I am collecting his art work."[44]

Mounted jointly by the Edinburgh International Festival and the Scottish Arts Council, the exhibition Master Weavers—Tapestries from the Dovecot Studios 1912–1980 included nine GFR Tapestries.[45] One of the workshop organizers wrote to Gloria in anticipation, "The

exhibition looms large on our horizon, we are all very excited at the prospect of being able to gather together in one place tapestries we have woven designed by famous names such as Nevelson."[46]

In 1980 and 1981, the exhibition traveled to four regional art centers.[47] Much to Gloria's concern, neither she nor her tapestry involvements were mentioned in the press release or invitations. Nevertheless, one reviewer, raising important questions, brought her name and role into focus: "'Master Weavers' at the Royal Scottish Academy reveals in fascinating manner the extraordinary change in emphasis between the tradition-bound 'gobelins' which were the product of the Morris revival . . . and recent tapestries in which a creative balance has been struck between the disciplines proper to the technique and the demands of artists as diverse as Stanley Spencer and Eduardo Paolozzi, Adolph Gottlieb of the brooding discs and David Hockney or Scotland's own Elizabeth Blackadder. . . . Herein lie the tensions of an interpretive technique and the value of an exhibition such as this. Does the complex structure of a collage by Paolozzi gain or lose stature when interpreted in tapestry? Can the dynamic implosions of colour experienced by Gottlieb survive translation into the exactitudes of warp and weft? These tapestries from the Dovecot provide a number of valid answers. . . . The vibrant icons which the Dovecot weavers have created for the Gloria F. Ross limited editions from Robert Motherwell's starkly grand, black on white *Elegy to the Spanish Republic No. 116*, from a dancing scatter of abstract elements by Robert Goodnough, the glowing 'oomph' of a

giganticised zooming *Blackout* by Jack Yougerman [*sic*] or the subtle mottling of the stacked architecture of Louise Nevelson's *Sky Cathedral* are masterly and enduring examples of the liberated art of the weaver."[48]

Five years later, the Edinburgh College of Art organized an exhibition, Edinburgh–Dublin 1884–1984, during the Edinburgh Festival of August 1985. Gloria and her son Clifford loaned three tapestries ("*Blackout*," "after *Black Disc on Tan*" and "*Elegy*") for this exposition, but the show seems to have made little impact. In 1986 the Edinburgh Tapestry Company planned a brochure in which they hoped to publish photographs of select GFR Tapestries in collectors' American homes or businesses. In a move to protect collectors' identities, Gloria declined this request, and, in fact, when the company attempted to publish archival photos of GFR Tapestries woven at Dovecot, she brought in her attorneys to settle the case.

Working with Native American weavers opened new worlds to Gloria. At the suggestion of Sheila Hicks, in 1984 Gloria wrote and sent slides to Dr. William Sturtevant, then director of North American Anthropology at the Smithsonian National Museum of Natural History.[49] After describing her work with Navajo weavers and Kenneth Noland, Gloria received a phone call from Sturtevant, suggesting that the Renwick Gallery, the crafts and design division of the National Museum of American Art, might be interested in an exhibition. It would be one decade before GFR Tapestries were shown at the Renwick.

The five-year traveling exhibition organized by the Denver Art Museum showcased two Native/Nolands, "*Reflection*" and "*Nááts'íílid*" (plates 73, 76), among thirty-six other Navajo-designed and -woven works that make up the Gloria F. Ross Collection of Contemporary Navajo Textiles (belonging to the museum's permanent collection; see Hedlund 1992). This 1992–97 exhibition, funded in part by the National Endowment for the Arts, toured to the Renwick Gallery, the Joslyn Art Museum in Omaha, the Heard Museum in Phoenix, and the National Museum of the American Indian in New York City.

From time to time, individual GFR Tapestries & Carpets have also appeared alongside other artworks in thematic exhibitions organized by the Metropolitan Museum of Art, Art Institute of Chicago, Museum of Fine Arts in Boston, Minneapolis Institute of Arts, Cleveland Museum of Art, Denver Art Museum, Princeton University Art Museum, Textile Museum in Washington DC, Birmingham Museum of Art in Alabama, and others. Listed in the Chronology, these reflect a broader recognition that certain GFR Tapestries & Carpets belong within the varied contexts of modern art, individual artists, world tapestry, and Native American cultural arts.

Ringling Museum of Art, Sarasota, Florida, 1978

Collecting Tapestries

GFR Tapestries & Carpets have been acquired by individuals, corporations, and museums. In addition to those bought from galleries, eleven unique works were commissioned directly for private or corporate collections. To our knowledge, interest has come strictly from American and Japanese collectors, with few if any commissions from Europe or elsewhere. Some tapestries eventually entered the secondary market through auction houses and dealers, making ownership more difficult to trace. On occasion, Gloria joined with galleries and artists to make museum donations. A few works became charitable gifts to museums from other private owners. Gloria was especially proud of her tapestry-woven Ark curtain installed at Temple Emanu-El in Manhattan through the generosity of one contributing family. A final bequest from Gloria herself distributed seven works remaining in her estate to public institutions, bringing the total of GFR Tapestries & Carpets in public collections to thirty-four in 2009.

Why were collectors attracted to GFR Tapestries? In all likelihood for a wide variety of personal, aesthetic, fiscal, and other reasons. Gloria almost never used the "good investment" argument for her tapestries, but as an advertisement from one gallery points out, "Tapestries offer the opportunity to own a large, authentic example of the absolute best work of an important artist for up to 1/100th of the cost of a painting."[50]

Public Collections

Museums with GFR Tapestries & Carpets in their permanent collections are focused primarily on the fine arts, in keeping with Gloria's original goals for elevating contemporary tapestry to mainstream status in the arts. All these farsighted institutions tend toward encyclopedic scope rather than narrowly focused or regional collections. The Metropolitan Museum of Art, Art Institute of Chicago, Museum of Fine Arts in Boston, Minneapolis Institute of Arts, and Cleveland Art Museum have specialized departments of textiles with curators who champion the textile arts. As well as having a strong textiles and costumes program, the Denver Art Museum was the first major art museum in the early twentieth century to develop a separate division for Native American art. With two GFR Carpets, the Racine Art Museum operates the Charles A. Wustum Museum, representing one of the finest contemporary craft collections in the nation. Several museums have acquired associated archival materials along with the tapestries, to interpret the works in as much depth as possible.

Four GFR Tapestries & Carpets reside in the Art Museum of Mount Holyoke College, Gloria's alma mater and site of the largest

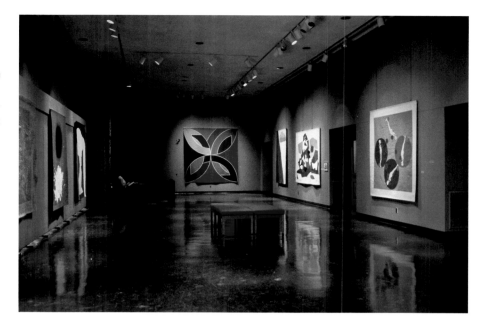

Mount Holyoke College Art Museum, South Hadley, Massachusetts, 1979

exhibition of her work. In addition to the Ark curtain designed by Mark Podwal, three other works are part of the Herbert and Eileen Bernard Museum of Judaica at Temple Emanu-El in Manhattan. Emphasizing the educational value of these complicated artworks as well as their associations with famous artists, other academic owners of Gloria's work include Bard College, Drake University, Pennsylvania State University, Tougaloo University, Neuberger Museum of the State University of New York, Vassar College Art Gallery, and York College of the City University of New York.

Corporate Collections

Of the 248 recorded GFR Tapestries & Carpets, at least 70 were purchased by major American businesses, especially during the 1970s and 1980s—boom years for corporate art collecting nationwide. Among those buyers were the corporate offices of household names like Avon, Clorox, and Liquid Paper; philanthropies; law firms and financial services firms; manufacturers and the building trades; and major retailers. Poignant stories are attached to two such corporate collectors.

Saul Wenegrat, the legendary head of corporate art collections at the Port Authority of New York and New Jersey, purchased Goodnough's "Red/Blue Abstraction" (1/5) and Motherwell's "after *Elegy to the Spanish Republic No. 116*" (1/5) from Feigen Gallery in 1971 (plates 28, 44). Ten years later, he acquired Bearden's "*Recollection Pond*" (3/7), and two Noland/Navajo tapestries, "*Nizhoni*

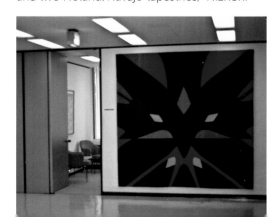

IBM corporate headquarters, Armonk, New York, 1975

315

Edith Green–Wendell Wyatt Federal
Building, Portland, Oregon, 1976

Nabisco Brands Gallery, East Hanover,
New Jersey, 1978

including works from corporate and private collections that were installed in various office spaces in the Twin Towers. . . . Also among the missing are large-scale commissions for public areas of the World Trade Center, valued at more than $10 million."[51] The GFR Tapestries were in company with Joan Miró's enormous 1974 tapestry, another huge loss.[52]

The corporate giant IBM established a major art collection beginning in 1937. Between 1974 and 1976, ten GFR Tapestries & Carpets were acquired through Pace Editions for this venerable collection. The tapestries were photographed in IBM's state-of-the-art administrative offices furnished by leading modernist designers. In 1995, however, in step with Reader's Digest, CBS, and Time Warner, IBM sold much of its collection through Sotheby's. The 160 artworks, which included the GFR Tapestries, realized more than $31 million. Those works are now disbursed to other corporate and private collections.

Financial Matters

The economics of art—production costs, artists' fees, retail and wholesale prices, gallery expenses, and various other financial arrangements—are a sticky subject, difficult to document and discuss. Because many non-fiscal values—aesthetic, historic, symbolic, spiritual, mystical, and other intangibles—are placed on art, discussing finances may appear out of place in certain circles. And yet everyone wants to know "What's it worth?" and "How much did they get for it?"

Record Keeping

A careful businesswoman, Gloria maintained meticulous private records about her tapestries, from conception to final sales and resales. Not only were all receipts and invoices annotated and filed, but detailed summary sheets documented the costs of weaving, shipping, photography, and other expenses for each tapestry within every edition. She calculated each tapestry's cost and retail price per square foot. Sales prices and the portions disbursed to artists, weavers, galleries, and other parties were recorded. Actual sales records and receipts were filed separately and no longer survive.

Production Costs

The initial cost of producing a tapestry or hooked rug depended on the studio and weavers that were selected, the fineness of the fabric, complexity of design, any special materials to be used, and the overall size. Larger-scale pieces, of course, warranted a premium. "Weaving a tapestry, even in the same stitch [number]," one workshop director explained, "may cost very different prices according to the intricacy of the tapestry, the number of colors . . . etc."[53] Each workshop

Peak" and "Twilight" (plates 5, 61, 62). The latter two were displayed in the lobby of the World Trade Center when, on February 26, 1993, a bomb was detonated by Middle Eastern terrorists below the WTC's North Tower. One tapestry was smoke-damaged; the other escaped harm. Conservator Maureen Eidelheit and her team at St. John the Divine conservation labs in Manhattan returned the injured tapestry to health.

At its height, the Port Authority's collection held more than 1,200 artworks, but in 1997, following a national trend among corporate collections, many works were sold at Sotheby's. The Motherwell "after *Elegy No. 116*" sold for $4,250, considerably more than the published estimate of $1,000–$1,500. The other tapestries avoided the auction block, only to be destroyed completely in the terrorist devastations of September 11, 2001. As *Art in America* reported, "at least $100-million worth of art was destroyed in the catastrophe,

operated under distinct circumstances and calculated its labor, materials, and overhead expenses in different ways. For comparisons, Gloria reduced production costs to the overall price per square foot, with appropriate adjustments for quality and related factors.

Total production costs, as Gloria calculated them, reflected the artist's design payment (whether received in kind or in cash; see below), usually prorated across the first four tapestries of an edition. She also routinely incorporated shipping, applicable customs charges, and professional photography. Her own travel and related business expenses were never integrated into these records, which were shared with cost-sharing galleries, as we shall see.

Paying the Workshops and Weavers

For the hooked works, Gloria paid by the square foot for patterns that were hand marked onto canvas, into which the yarns were applied. Gloria ordered her own yarns directly from Paternayan in New Jersey, and supplied them to Anna di Giovanni, who did the hooking, also by the square foot.

The organized workshops in both France and Scotland established cost scales that took into account many factors beyond simple square footage. On their first project, Olivier Pinton wrote to Gloria: "I shall confirm the exact weaving price when sending the samples. . . . But I want to make sure I do not overcharge, by weaving samples. This price takes into account the difficulty of weaving much more than the number of warps, number of colors, etc., which are not so determinant. I understand it does not simplify your own calculation; it is a matter of habits for evaluation much more than an arithmetic system."[54]

At the Dovecot, Brennan patiently explained the workshop's pricing as Gloria expressed surprise at rising costs in 1977. "I cannot reduce the figure for #5 maquette," he wrote. "I don't intend to explain in full detail the background to our costing, but would make the following points." He enumerated, "1) In the manner that we work, the cost per estimated number of man-days is *not* high, by any comparative standards. If the workshop is to continue, these must be the current rates.

"2) I am familiar with costs in various European workshops.

"3) Comparing the sq. foot costs of any 2 tapestries is not the way to arrive at a price estimate. I wish it was so easy.

"4) All costs I have given to date . . . hold only for work completed at 1 April 77. All our work will then be re-costed, and regularly assessed."[55]

Regardless of the financial system in place, Gloria would often remind a workshop of the value of her business and her expectations for financial favors. She wrote Pinton, for example, "we mentioned the possibility of my receiving a discount because of the large number of tapestries I am ordering . . . I know that this is commonly done in such cases, so will you let me know what arrangement you wish to make on this."[56]

There is something of a Peer Gynt quality to her reasoning.[57] "I work with many of the leading artists here (now with some abroad)," she wrote, "and the tapestries are sold through one of New York's finest galleries. Therefore, I not only look for the quality of a Picaud tapestry, but since I now hope to work with you on a relatively large scale, I hope that you will quote the lowest cost estimates possible, without compromising quality. Most of the tapestries will be woven in editions of 7–8, although I will order generally one at a time."[58]

Pricing the Tapestries

Retail prices for tapestries have rarely, if ever, approached those of original paintings and sculptures. Gloria worked closely with each gallery to determine appropriate pricing. Early on, one gallery director advised her that the overhead cost for tapestry sales was expensive and that retail prices should equal at least three times the total production costs. Whether she kept to this or not, she kept close track of all expenses for each tapestry and set retail prices only after conferring with her galleries and, sometimes, with the artists. Workshops and weavers were generally not involved in final pricing or sales.

Establishing the retail price for a tapestry involved many factors beyond basic production costs. The latter provided a baseline but did not fully reflect "the intrinsic value of the work by highly skilled master craftspeople."[59] In particular, gallery prices took into account "the artist's status in his field and the price of his paintings and collages."[60] In setting tapestry prices, the value of the original artwork or model sometimes helped. Gloria asked one artist, "Please let me know the selling price of the collage," which, she explained, "with the tapestry's actual cost, affects the selling price of the tapestry."[61]

According to the available records, during the 1970s and 1980s actual sales prices for GFR Tapestries & Carpets varied widely over time and depending upon circumstances. The hooked wall hangings ranged from $750 to $3,500, with an average of $1,663 and median price of $1,200. For handwoven tapestries, prices ranged from about $1,500 to $50,000, averaging $12,000, with a median of approximately $10,000.[62] Special individual commissions ranged from $25,000 to the low six figures.

For tapestries woven as multiples—similar to limited edition prints and bronze castings—when earlier pieces sold, the prices generally

Detail, Jack Youngerman, *"Rumi's Dance,"* 1976, hooked by the Ruggery. (See plate 95.)

increased within each edition. Not only did the artwork become rarer and therefore more valuable, but quite naturally the production costs for hooked rugs and handwoven tapestries increased over the years. Gloria collected price lists from other contemporary tapestry brokers and made constant evaluations, often recalculating a tapestry's cost by the square foot for comparison with previous sales. For the secondary market, auction catalogues show an initial rise and subsequent drop in the values of GFR Tapestries through the decades from the 1980s into the early twenty-first century. Perhaps this falloff in value reflects, in part, a decline in Gloria's own marketing efforts toward the end of her life and the cessation of such efforts after her death.

Compensating the Artists

Each contract between Gloria and an artist specified the way payment was to occur. Early on, especially with the hooked editions, artists received a flat percentage (usually 20–25 percent) of the sales price. Later, with the more costly handwoven work, her standard contract stated that the artist would receive a tapestry denoted as the artist's proof (AP or *Edition Artiste*, "E/A," in French; usually numbered 0/7). She typically explained to potential designers, as she did to Max Bill in 1971, "I have varying financial arrangements with artists, depending upon whether you prefer to have an edition (they are made in editions of 5) or a percentage of their sale price." To another prospect, Henry Moore, she wrote in 1972, "The artists receive as compensation either an edition of the tapestry or a percentage of the sale price of each tapestry as it is sold. Most have selected the former." In fact, the most established artists generally accepted the tapestry; other artists usually requested more direct forms of payment. In a few cases, artists asked Gloria to sell the artist's proof and provide all or a portion of the price to the artist.

If an artist chose to receive a tapestry, it was usual to wait until one or two were sold, to build up revenues and cover the costs of further production. Most contracts stipulated that the artist would receive edition 0/7 after the sale of one or two tapestries in the series. Many are hand-annotated with, "if possible before then."

In contrast to Gloria's standard arrangements, one European system was to use a tapestry's actual production costs to calculate an artist's fee. Archie Brennan may have introduced Gloria to such "continental royalty fees." After a discussion with him, her 1977 notes about two artists (neither of whom she worked with) record tersely: "Lurçat 120% weaving costs. Hockney 100%." Gloria used a variation on this practice in several instances: one artist received 20 percent of the production costs (not sales price) for the first four and 10 percent

for the subsequent three in the edition of seven. Another received 25 percent of production costs on the first four, and also acquired the right to buy four of the eight woven tapestries at a price equal to cost plus shipping and customs clearance, and maintained the right to sell these independently.

On several occasions, Gloria and either the artist or their representing gallery, or both, entered into full financial partnerships. In these cases each party shared in the production costs, became part owner of the tapestry, and received a respective portion of the proceeds.

Robert Motherwell represented another special case, inasmuch as Gloria and he had worked together since her beginnings, he was her brother-in-law and friend, and he was characteristically blunt in all negotiations. He expressed growing concerns about collaborating with anyone: "I no longer sign a contract with anybody about any art thing, especially one drawn by a lawyer. If you want to send me an informal note just saying what you would like to agree with me, if I find it okay, I will initial it. But to be brusk [sic], which has nothing to do with you, but being swomped [sic] with projects and the correspondence related, what I basically feel is that I hear a lot about you and your weaving problems, but I never see a tapestry of mine that I really like, [n]or for several years have I received one nor do I ever see any money. And all this in relation to translation of my work that I am not sure that I approve of anyhow.

". . . I got involved with you when you yourself wanted to make a tapestry from an Elegy with your own hands and as I then thought for your own house, and naturally my sentimental commission was quite different than if you had approached me as an entrepreneur and tending to start a business in selling translations of my works.

"But if it is indeed a business as it seems to be, then I have a suspicion that I would never take which appears to be a seventh of the proceeds from any deal. I generally take from 67 to 75% of the total proceeds, or if manufacturing costs are involved, 50% of the selling price.

"Please understand that I am not trying to 'sell' you anything. But the truth is that the market for any individual artist is relatively limited, and therefore it is foolish for him to put himself in competition with himself—in this case in regard to huge works, when he gains nothing but a souvenir from it.

"For the rest, I have to have my gall bladder out at the beginning of October, which is a bit tricky with my irregular heartbeat and meanwhile live on tea and toast and boiled chicken and skim milk. So at the moment I am in a kind of limbo."

Gloria responded with a sympathetic get-well note and summary: "I am sorry to learn

of your gall bladder problems and can fully appreciate what a trying time this is

"I feel I should review the history of the hangings that we have made together. With your kind permission many years ago I did make an *Elegy* with my 'own hands,' expressly for my home. This hanging made in a hooked-rug technique will never be sold. The next tapestry, also in a hooked-rug technique, was made in an edition to be sold, which you knew at the time of our agreement. You signed the labels and received edition #0, and Marlborough Gallery received edition #00. Next, you received a fee for the Westinghouse commission. We last agreed to the weaving of an *Elegy* to be made in an edition of five, which again you knew was to be sold. You were to receive #0 as your royalty. Unbeknownst to me this #0 was woven in a manner different from the ones you had seen and I have assured you that a new one has been ordered, which should meet with your satisfaction. You must know how very sorry I am that this happened for it takes such a long time to replace it, but *this* is on order. This 'souvenir' as you call it, is worth some $10,000 today and is growing in value constantly, because it is a Motherwell image and because it is made by an outstanding atelier with very limited production.

"Bob, except for the very first work, done as a hobby and quite experimental, I have always approached you 'as an entrepreneur.' I discussed each project with you openly and honestly, and obviously I would not ask you to sign labels for a multiple edition for my own home. Because of my trust in you and in deference to your wish, I have never insisted on a written letter or contract. I trust this clarified all matters and that your reply will erase the unhappiness I have felt since I received you[r] last letter. As always I send good wishes."

Motherwell replied: "I am sorry about writing you bruskly [*sic*] before. Not only was I feeling rotten, but someone else had just shown me rotten trial proofs of 'elegies' in lithography, and I realized that, from my standpoint, I made a terrible error in ever allowing that image to be reproduced."[63] Fortunately, he was referring to a print and not a tapestry.

Working with the Galleries

Gloria negotiated agreements with both Feigen and Pace Editions galleries that took into account the considerable cost of making tapestries. Their most common approach was to take the actual sales price, minus total production costs (weaving, shipping, customs, photography, and artists' fees), and divide the remainder equally between Gloria and the gallery. This split after costs represented a relatively generous gallery/artist relationship, as most artists must bear their own material and labor expenses. Occasionally, the percentages varied according to the roles played by each party. Gloria worked with other galleries primarily on a postproduction basis, and so the business agreements reflected standard consignment procedures.

A Fragile Enterprise

As early as 1969, Archie Brennan dourly noted, "Today, economics make a rarity of the traditional conception of woven tapestry, with its fine detail and large scale."[64] Tapestry is indeed a costly and labor-intensive endeavor, involving many players and roles. The worlds of marketing and promoting, collecting and exhibiting are integral to the many-faceted enterprise of tapestry making. The sales of GFR Tapestries & Carpets owed their success to Gloria Ross's indomitable marketing and to extremely important support from Richard Feigen, Arnold Glimcher, Richard Solomon, and Lee Cohen, and their prominent galleries. Without these experts' understanding, flexibility, and worldly experience, GFR Tapestries & Carpets could not have survived as it did for more than thirty years.

Gloria Ross understood that to preserve this relatively fragile and labor-intensive art form and to move it toward the future, aesthetic values must translate into financial considerations and vice versa. Many years after she left Pace Editions, Dick Solomon summarized, "Gloria Ross had the courage of her convictions. She was creative and energetic and was determined to combine her love and appreciation for the craft and creativity of skilled artisans with her appreciation for the art of her generation. It was her persistence and confidence that persuaded some of the most important artists of her time to prepare maquettes for her with the faith that she would deliver sensational tapestries, which she did. It was the quality of these tapestries and the artists with whom she had collaborated and her persuasiveness, that resulted in our having a very productive relationship with her."[65]

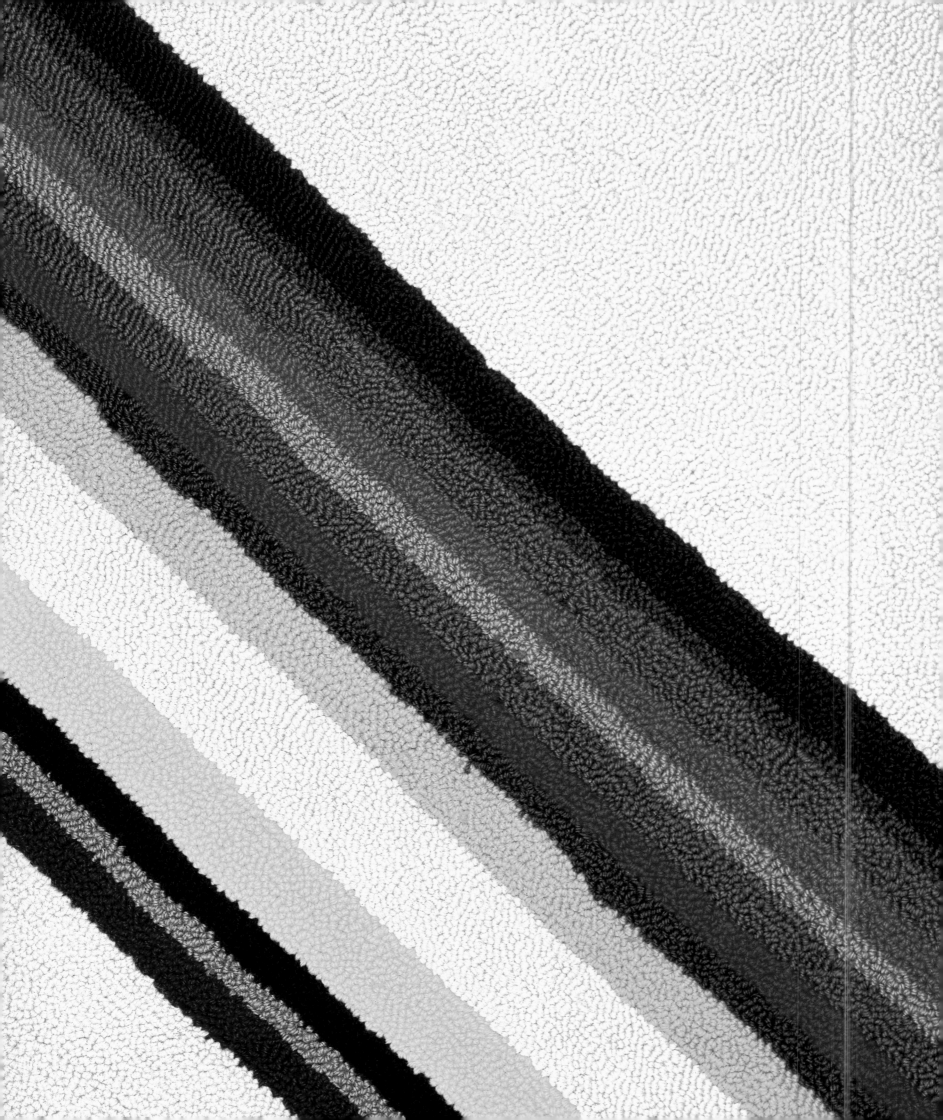

La Tombée du Métier

Tapestry has a long long life and it takes on new forms of beauty as it ages. . . . I look ahead to increased interest in this monumental art form.

—Gloria F. Ross[1]

I have been fortunate in knowing many of the artists well and to know their work intimately. I have also known the craftspeople well and have learned their techniques and how to apply them.

—Gloria F. Ross[2]

In the French tapestry tradition, when a work is finished and cut off the loom, the event is called *la tombée du métier*—literally the "fall" of the loom, completion of the project.

In bringing together the original work of mid-twentieth-century artists and the creative efforts of inventive craftspeople, Gloria Ross explored new directions, combined different media, and crossed boundaries before these practices were common. She established a visual language for contemporary tapestry in America as she negotiated with artists, weavers, galleries, collectors, and museums in the United States and abroad. She began working in the 1960s and 1970s, when artistic collaboration was ascendant, and she brought together ad hoc teams of people to combine their talents on singular artworks and notable series.

Like many passionate undertakings, her work held contradictions and challenges. She maintained that her projects were distinct in the history of American art, and yet she worked with established studios that produced tapestries for generations through open collaboration between traditional artisans and contemporary artists. In essence, her work represents a modern American extension of traditional European weaving systems, which in turn reflect long and fascinating histories.

Throughout her career, Gloria attempted to remain true to her original, albeit contradictory, goals—to follow the artists' aesthetic intent and yet create unique objects in a vital tactile medium. As *éditeur,* she tapped into the artists' views by getting to know them personally, conducting interviews and studio visits, studying museums, galleries, and books, and living directly with some of the artwork. One museum director applauded her approach: "It is the hallmark of Ross's work that her tapestries re[-]create the image and essence of the artist's statement. Her translation is not a literal one, but rather the broader interpretation which in the end allows for the truest adherence to the artist's intent. As Ross explained, she does not let her own personality intrude on her translations, but aims only to heighten the special character of the artist's original work."[3] Gloria wrote to a prospective artist, "I collaborate with the artist in all ways, trying to project your artistry into this medium. Too, I am greatly concerned with the materials used, the dyeing, the craftsmanship, etc. I not only enjoy working this way, but have thus far been satisfied that my tapestries reflect the high quality of the many disciplines involved."[4]

She took pride in creating unique works, but many tapestries were planned as multiple editions as in printmaking, sculpture casting, and the European weaving traditions. Had she been working with contemporary European artists and galleries, she would have belonged to an elite group of specialized twentieth-century European tapestry producers, including Marie Cuttoli, Pierre Baudouin, and Yvette Cauquil-Prince.

In their time, GFR Tapestries & Carpets celebrated abstract expressionism and the current styles of color field, op, and pop art. "A Gottlieb must look like a Gottlieb," she would say, "A Nevelson must have the heart and soul of a Nevelson." It could be argued that the GFR Tapestries & Carpets even broadened the exposure of the famous artists who painted, collaged, and sculpted models for the woven and hooked works. "For the artist, it's flattering to be part of a medium with such a history," Dick Solomon has commented. "Also, when artists make a painting, they select a certain scale appropriate for them to handle. That scale isn't necessarily the only way the image could be done, and I think artists are often intrigued by the translation

Detail, Morris Louis, "after *Equator*," 1970, hooked by Anna di Giovanni. (See plate 40.)

process when their work becomes a mural, major sculpture, or a tapestry."[5]

Tapestry at its best is not a reproduction of another artwork—it is an original handcrafted object. An insistence on the primacy of this work in fiber, regardless of the models used, allied Gloria's work with the specific Scottish, French, and American weavers and other artisans whom she selected.

As previous chapters illustrate, relationships between éditeur, designers, weavers, and galleries grew complicated as each exerted influence on the imagery, process, materials, and final woven product. Gloria represented a common denominator, orchestrating each project. Her relationship with every partner was unique and constantly renegotiated. What emerged from such creative connections was a diverse assemblage of modern tapestries, differing significantly from one another in pedigree and character. Each time one was cut from the loom, la tombée du métier represented the beginning of yet another story.

Spool rack with many-colored yarns, 1972. Photo courtesy of Dovecot Studios.

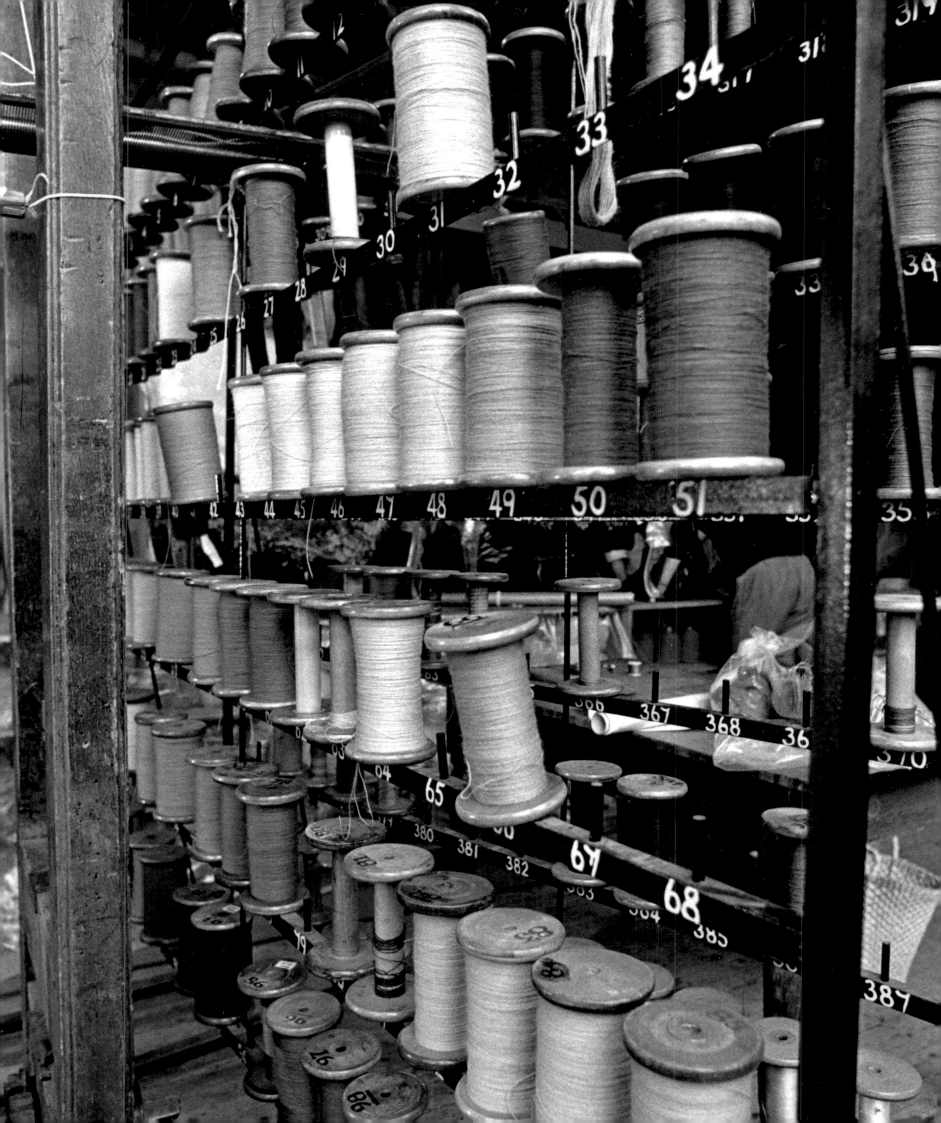

1923
Born September 5 in New York City to Alfred Frankenthaler (1881–1940), New York Supreme Court Justice, and Martha Lowenstein Frankenthaler (1895–1954); their second child, following Marjorie, born on July 23, 1922. Living at 1192 Park Avenue.

1928
Sister Helen Frankenthaler is born on December 12.

Attends Dalton and Horace Mann schools. Gloria's sisters attend Dalton, Brearley, and Horace Mann schools.

1939
Graduates from Horace Mann School, New York. Living at 791 Park Avenue.

1940
Father Alfred Frankenthaler dies, January. Martha moves to 1016 Park Avenue.

1940–43
Attends and graduates with a major in economics and sociology, Mount Holyoke College, South Hadley, MA, December 1943.

1946
Marries Arthur Ross (1910–2007), New York.

1946
Son Alfred F. Ross is born, December. Living at 324 E. 41st Street.

1948
Daughter Beverly Ross is born, November. Living at 935 Park Avenue.

1951
Attends Helen Frankenthaler's first solo exhibition, Tibor de Nagy Gallery, New York, November.

1952
Son Clifford A. Ross is born, December.

1954
Mother Martha Lowenstein Frankenthaler dies, April.

Makes first needlepoint work from design by sister Helen Frankenthaler.

1955–70
Serves as trustee, Child Development Center, Inc., New York.

1958
Sister Helen Frankenthaler marries Robert Motherwell. Living at 888 Park Avenue.

1960
Helen Frankenthaler names a series of works on paper the Gloria series.

1963
Executes first hooked "rug," after a painting by Helen Frankenthaler (plate 17).

1964
Executes second hooked wall hanging, after a painting by Robert Motherwell (plate 42).

1965
Group exhibition, Tapestries and Rugs by Contemporary Painters and Sculptors, International Council, Museum of Modern Art, New York.

1966
Establishes the Gloria F. Ross Studio, New York.

Group exhibition, Third National Exhibition of the Embroiderer's Guild, New York.

1967
Group exhibition, Art for the Office, American Greetings Gallery, Pan Am Building, New York.

Group exhibition, Feigen Gallery, Chicago.

Elected Chair, Management Committee, Child Development Center, Inc., New York (1967–70).

1968
First solo exhibition, Feigen Gallery, Chicago.

Group exhibition, Wool Works, World Gallery, J. Walter Thompson Co., New York.

1969
Solo exhibition, Feigen Gallery, SoHo, New York.

Diagnosed with uterine cancer, treated with surgery.

Feigen Gallery, New York, 1969

1970
Group exhibition, Feigen Gallery, SoHo, New York.

Gloria F. and Arthur Ross divorce.

Visits the Dovecot Studios in Scotland for first time, July.

Views Fifth International Tapestry Biennial, in Lausanne, Switzerland.

Closes Gloria F. Ross Studio; contracts all work to other artisans.

1971
Group exhibition, Kolner Kunstmarkt, Germany.

Makes first working trip to Aubusson and Felletin, France; visits Picaud and Pinton workshops during summer.

Submission rejected from Sixth International Tapestry Biennial; visits Sixth International Tapestry Biennial, Lausanne, Switzerland.

Travels on business to France and Scotland.

Helen Frankenthaler and Robert Motherwell are divorced, July.

Final solo exhibition with Feigen Gallery, New York.

1972

Moves to 630 Park Avenue.

Solo exhibition, Pyramid Gallery, Washington DC.

Group exhibition, Fiber Structures, Denver Art Museum.

1973

Proposes tapestries by Anuszkiewicz and Lindner as first GFR Tapestries, Atelier Raymond Picaud, Aubusson, May.

First solo exhibition, Pace Editions, Inc., New York.

Lecture, "How Contemporary Paintings Are Translated into Tapestry," Art Section, Scarsdale Woman's Club, September.

Exhibits GFR Carpet in Robert Motherwell: Recent Work, The Art Museum, Princeton University.

1974

Makes multiple trips to France, June/July, September/November, and December.

Takes first trip to Spain.

1975

Marries Dr. John J. Bookman (1911–1988) on April 4; moves to his home at 21 E. 87th Street, New York.

Solo exhibition, Pace Editions, Inc., New York.

Group exhibition, 14 × 10, World Gallery of J. Walter Thompson (Ruder Finn), New York.

Elected to Mount Holyoke College Art Museum advisory board, South Hadley.

Travels to Europe, September/October—visits Alice Lund Textilier in Sweden.

Archie Brennan visits NYC, October, following several months in Australia.

1976

Travels to France and Great Britain, September.

Group exhibition, Beyond the Artist's Hand, California State University, Long Beach.

Exhibits tapestry in Milton Avery and the Landscape, the William Benton Museum of Art, University of Connecticut, Storrs, CT.

1977

Archie Brennan visits NYC, May; meets with Ross, Glimcher, Nevelson, Motherwell; views Miró tapestry at the World Trade Center.

Travels to Scotland and France.

Group exhibition, Eighth International Tapestry Biennial, Lausanne, Switzerland.

Group exhibition, Eighth International Tapestry Biennial, Gulbenkian Foundation, Lisbon.

Solo exhibition, The New Gallery, Cleveland.

Solo exhibition, Kauffman Fine Art, Houston.

Group exhibition, Tapestries and Banners, Jacksonville Art Museum, Jacksonville.

Brennan working in Papua New Guinea, August–December.

1978

Solo exhibition, Gloria F. Ross: Contemporary Tapestries, Ringling Museum of Art, Sarasota.

Solo exhibition, Pace Editions, Inc., New York.

Exhibition, Louise Nevelson: Tapestries, Pace Gallery, New York, September–October.

Archie Brennan leaves Dovecot Studios, April.

First correspondence with a prospective Navajo weaver, October.

Kauffman Fine Arts, Houston, 1977

Ringling Museum, Sarasota, 1978

1979

First travels to seek weavers in the Navajo Nation, followed by annual visits.

Plans trip to China.

Solo exhibition, Gloria F. Ross Tapestries, Mount Holyoke College Art Museum, South Hadley. Lecture, April.

Group exhibition, Thomas Segal Gallery, Boston.

Group exhibition, Art from Corporate Collections, Union Carbide Corporation Gallery, New York. Benefit for the Inner-City Scholarship Fund.

GFR Tapestry in The Art of Louise Nevelson, Farnsworth Art Museum, Rockland, Maine.

1980

Exhibition, Dovecot Tapestry: Work of the Edinburgh Tapestry Company, 1912–1980, and catalogue, *Master Weavers: Tapestry from the Dovecot Studios, 1912–1980,* Edinburgh International Festival, Royal Scottish Academy, Scotland, August–September.

Group exhibition, Foire Internationale d'Art Contemporain '80, Grand Palais, Paris.

1981

Solo exhibition, Gloria F. Ross Tapestries, Limited Editions and Unique Commissions in the Aubusson and Gobelin Techniques, Carol Hooberman Gallery, Birmingham, Michigan, January–February.

Visits Navajo Nation, April.

Visits Vesti Corporation, Boston.

Begins work with Hokin Gallery, Chicago, June.

Kenneth Noland and wife Peggy Schiffer visit Navajo Nation and environs.

Visits Santa Fe with daughter Beverly and travels to Window Rock, Chinle, Gallup, and environs.

1982

Visits Southwest and Houston, May; attends Shared Horizons conference, Santa Fe.

Travels to Paris and Spain—visits Josep Royo in Tarragona and Galeria Maeght in Barcelona.

Travels to Houston, Durango, Santa Fe, and Ganado.

GFR Tapestry in Louise Nevelson: Wood Sculptures, Collages, Prints and Multiples, Tapestries, Fay Gold Gallery, Atlanta, October/November.

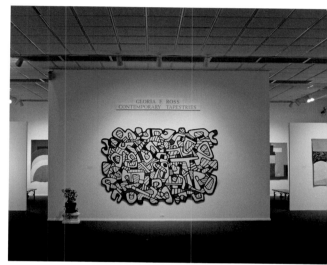

1983

Curates exhibition, Navajo Weaving: The State of the Art (with textiles from Hubbell Trading Post and Steve Getzwiller), [Larry and Marjorie] Kauffman Galleries, Houston, January/February.

Travels to Colorado (Denver and Yellow Jacket) and the Southwest, June/July.

Symposium panel participant, "The Textile Arts in America: Origins & Directions," Fashion Institute of Technology, New York, organized by Charles Talley, November.

Travels to France, December.

1984

Solo exhibition, Gallery 10, Scottsdale, March.

Solo exhibition, Gallery 10, New York, November.

1985

Travels to Egypt, tours Wissa Wassef School, and to France, January.

Invited speaker, "The Roles of Patrons in the Development of Navajo Weaving," Recursos Seminar, Santa Fe, May.

Travels to Santa Fe and Navajo Nation, July.

Group exhibition, Edinburgh–Dublin 1884–1984, Edinburgh International Festival.

Group exhibition, 50 Years of Contemporary Tapestry from Aubusson, Montreux, Switzerland.

Exhibits three tapestries, Phyllis Krause Gallery, Pontiac, Michigan.

Solo exhibition, Gallery 10, New York, November.

1986

Elected to the Mount Holyoke College Board of Trustees (to 1991), South Hadley; serves on Building & Grounds Committee.

Attends symposium, European Tapestries, Renaissance and Later, Metropolitan Museum of Art, New York, April.

Group exhibition, Tapestry: Contemporary Imagery/ Ancient Tradition, curated by Valerie Clausen, Cheney Cowles Museum, Eastern Washington State University (including Frankenthaler's "after *This Day*" woven at the Kennedy/Kunstadt workshop, New York).

Lecture, Shared Horizons seminar, Santa Fe, May.

Travels to London, Paris and Aubusson, September.

1987

Tapestry exhibited and published in *Well Shall They Be Made: Navajo Textiles . . . Selections from the Denver Art Museum,* Birmingham Museum of Art, Birmingham, Alabama, October/December; Palm Beach, January/February.

Travels to Southwest, May.

Travels to Dominican Republic with niece Ellen Iseman, December.

1988

Husband John J. Bookman dies, March 27, 1988.

Slide presentation, International Tapestry Conference, Melbourne, Australia; visits Canberra, Cairns, Honolulu, May/June.

Travels to Paris and Aubusson, summer.

Travels to Santa Fe and Navajo Nation, August.

Travels to Paris and Aubusson, November.

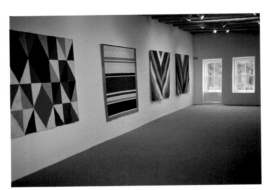

Rutgers Barclay Gallery, Santa Fe, 1989

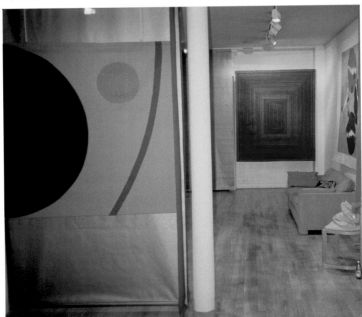

Atelier Pinton, Paris, 1990

1989

Travels to Denver Art Museum, February.

Participates in symposium and publication, *American Tapestry Weaving since the 1930s and Its European Roots,* organized by Courtney Shaw, University of Maryland, March 31–April 1.

Solo exhibition, Master Tapestries/Gloria F. Ross, Rutgers Barclay Gallery, Santa Fe, August–September.

Slide presentation/lecture, "Tapestries—New Focus for Art Collectors," Santa Fe Public Library, August.

Travels to Paris and Aubusson, October.

1990

Travels to Felletin, Aix-en-Provence, Riviera, February.

Travels to Navajo Nation and Santa Fe, August.

François Pinton and Jacques Bourdeix visit New York.

Establishes GFR Award for Excellence in Navajo Weaving, Southwest Association for Indian Affairs, Santa Fe.

Solo exhibition, Les Tapisseries Américaines, Centre International de l'Architecture Tissée (Atelier Pinton), Paris, October–December.

Lecture, "Tapestries," Luncheon Lecture Series: Women in the Arts Part III, The Brooklyn Museum.

Travels to Russia with Mount Holyoke group.

Visits the Textile Museum, Washington DC, November.

1991

Lecture, "Tapestry Today," the Yale Club of New York, January.

François Pinton visits NYC; GFR and François Pinton visit Earl Davis, major architects et al., June.

Robert Motherwell dies, October.

Travels to Brazil, visits landscape architect/artist Roberto Burle Marx.

Meets with François Pinton in London, September.

1992

Elected to Textile Museum Board of Trustees, Washington DC (two three-year terms); serves on Contemporary Textile Exhibition Committee, chaired by Jack Lenor Larsen.

Lecture, "Collecting Goals," at symposium, Presenting Navajo Weaving at the Denver Art Museum: Multiple Roles, Motives, & Goals, cosponsored by the Denver Art Museum and University of Denver, September.

Exhibition, Contemporary Navajo Weaving: The Gloria F. Ross Collection, Denver Art Museum, October–January.

Lecture, at symposium, Textiles East and West: Women's Art, Women's Perspectives, cosponsored by the Asia Society and ArtTable, Inc., New York, December.

1993

Exhibition, Tapestries after Stuart Davis by Gloria F. Ross, Salander-O'Reilly Galleries, New York, April–May.

Exhibition, Contemporary Navajo Weaving: The Gloria F. Ross Collection of the Denver Art Museum, Renwick Gallery, National Museum of American Art, Washington DC.

GFR Tapestries damaged in World Trade Center bombing.

Heard Museum, Phoenix, 1994

1994

Exhibition, Contemporary Navajo Weaving: The Gloria F. Ross Collection of the Denver Art Museum. Heard Museum, Phoenix, February–April. Renwick Gallery, National Museum of American Art, Smithsonian Institution, Washington DC, June–August. Joslyn Museum, Omaha, November 1994–January 1995.

Lecture, "Contemporary Collecting" at Navajo Weaving since the Sixties symposium, cosponsored by Recursos, the Heard Museum, and Arizona State University, Phoenix, March.

1995

Diagnosed with lung cancer, begins chemotherapy at Mount Sinai Hospital, June.

1996

Completes Temple Emanu-El Ark curtain project, October.

1997

Founds the Gloria F. Ross Center for Tapestry Studies and hosts first annual meeting of the board of trustees, November.

Establishes Mount Holyoke College scholarship for students from Brearley, Stuyvesant, and/or Hunter College high schools, New York.

Exhibition, Contemporary Navajo Weaving: The Gloria F. Ross Collection of the Denver Art Museum, National Museum of the American Indian, George Gustav Heye Center, Customs House, New York.

1998

First Annual GFR Lecture, by Archie Brennan, Yale Club, New York, April.

Nominated for an honorary degree at Mount Holyoke College.

Dies at Mount Sinai Hospital, New York, June 21.

Gloria and Michael Monroe, museum curator-in-charge, with a pictorial rug by Navajo weaver Ason Yellowhair, Renwick Gallery, National Museum of American Art, Smithsonian Institution, Washington DC, 1994

Naming conventions for tapestries: Titles of tapestries and carpets appear within quotation marks. Titles of tapestries and carpets made from original designs (maquettes) and titles of works in other media are italicized. Titles of tapestries and carpets made from another artwork are designated as "after *Original Title*."

Key to Checklist Entries

Plate number
Artist
"Tapestry title"
Series, dates (time span indicates multiples within edition)
Maquette/Made after *Title*, date, medium, size. Owner of
 artwork; copyright holder. *If illustrated:* Photographer of
 artwork, unless by Gloria F. Ross
Studio. Artisans
Technique, structure; warp and weft materials
Length × width in inches (sizes may vary for tapestries of an
 edition)
Edition details
 Edition no. Owner of tapestry
Copyright holder. Photographer of tapestry unless by Gloria F.
 Ross

1
Richard Anuszkiewicz
"Purplish-Cool Rectangle"
A Gloria F. Ross Tapestry, 1973–79
Maquette, 1973, acrylic on canvas, 49 × 36 in. GFR Papers;
 © Richard Anuszkiewicz/Licensed by VAGA, New York.
 Photo by Jannelle Weakly, ASM
Pinton S.A., Felletin, France. Olivier Pinton, workshop director;
 staff weavers
Aubusson low-warp loom, tapestry weave; wool weft on
 cotton warp
82 × 70 in.
7 plus 1 artist's proof authorized/5 made
 0/7 Teleflex Incorporated (formerly Arrow International),
 Reading, Pennsylvania
 1/7, 3/7, 4/7 Private collections
 2/7 IBM corporate art collection, Armonk, New York
 (sold 1995)
© Estate of Gloria F. Ross. Photo by Al Mozell

2
Richard Anuszkiewicz
"Purplish-Warm Rectangle"
A Gloria F. Ross Tapestry, 1973–79
Maquette, 1973, acrylic on canvas, 49 × 36 in. GFR Papers;
 © Richard Anuszkiewicz/Licensed by VAGA, New York.
 Photo by Jannelle Weakly, ASM
Pinton S.A., Felletin, France. Olivier Pinton, workshop director;
 staff weavers
Aubusson low-warp loom, tapestry weave; wool weft on
 cotton warp
82 × 70 in.
7 plus 1 artist's proof authorized/5 made
 0/7 Teleflex Incorporated (formerly Arrow International),
 Reading, Pennsylvania
 1/7, 3/7, 4/7 Private collections
 2/7 IBM corporate art collection, Armonk, New York
 (sold 1995)
© Estate of Gloria F. Ross. Photo by Al Mozell

3
Milton Avery
"after Dunes & Sea II"
A Gloria F. Ross Tapestry, 1973–89
Made after *Dunes and Sea II*, 1960, oil on canvas, 52 × 72 in.
 Ex-collection Sally Avery; © Milton Avery Trust/Artists Rights
 Society (ARS), New York
Pinton S.A., Felletin, France. Olivier and François Pinton,
 workshop directors; staff weavers
Aubusson low-warp loom, tapestry weave; wool weft on
 cotton warp
63 × 86 in.
7 plus 1 artist's proof authorized/5 made
 0/7 The Limited Stores, Columbus, Ohio
 1/7 Bard College, Annandale-on-Hudson, New York,
 gift of Eric Goldman
 2/7, 4/7 Private collections
 3/7 Herbert and Eileen Bernard Museum of Judaica,
 Congregation Emanu-El, New York
© Milton Avery Trust/Artists Rights Society (ARS), New York.
 Photo by Eric Pollitzer

4
Milton Avery
"after Excursion on the Thames"
A Gloria F. Ross Tapestry, 1992
Made after *Excursion on the Thames*, 1953, oil on canvas,
 40 × 50.4 in. Ex-collection Sally Avery; © Milton Avery
 Trust/Artists Rights Society (ARS), New York. Photo by
 Malcolm Varon
Pinton S.A., Felletin, France. François Pinton, workshop
 director; staff weavers
Aubusson low-warp loom, tapestry weave; wool and metallic
 wefts on cotton warp
69 × 87 in.
6 plus 1 artist's proof authorized/1 made
 1/6 Horace Mann School, Riverdale, New York
© Milton Avery Trust/Artists Rights Society (ARS), New York.
 Photo by Malcolm Varon, courtesy of Horace Mann School

5
Romare Bearden
"Recollection Pond"
A Gloria F. Ross Tapestry, 1974–90
Maquette, 1974, watercolor, ink, and pencil on paper, 18 ×
 23.5 in. The Metropolitan Museum of Art, gift of Gloria F.
 Ross; © Romare Bearden Foundation/Licensed by VAGA,
 New York
Pinton S.A., Felletin, France. Olivier and François Pinton,
 workshop directors; staff weavers
Aubusson low-warp loom, tapestry weave; wool weft on
 cotton warp
61.25 × 79.25 in.
7 plus 1 artist's proof authorized/8 made
 0/7, 1/7, 5/7, 6/7 Private collections
 2/7 Mount Holyoke College Art Museum, South Hadley,
 Massachusetts, 1983.9, gift of Gloria F. Ross
 3/7 Port Authority of New York and New Jersey (destroyed
 9/11/2001)
 4/7 York College, City University of New York
 7/7 The Metropolitan Museum of Art, 1996.551.1, gift of
 Gloria F. Ross
© Romare Bearden Foundation/Licensed by VAGA, New York.
 Photo by Al Mozell

6
Romare Bearden
"Mille Fleurs"
A Gloria F. Ross Tapestry, 1976–90
Maquette, 1976, watercolor on paper, 16 × 18 in. © Romare
 Bearden Foundation/Licensed by VAGA, New York
Pinton S.A., Felletin, France. Olivier and François Pinton,
 workshop directors; staff weavers
Aubusson low-warp loom, tapestry weave; wool weft on
 cotton warp
53 × 58 in. (0/7, 1/7, 2/7), 60 × 67 in. (3/7)
7 plus 1 artist's proof authorized/4 made
 0/7, 1/7, 2/7, 3/7 Private collections
© Estate of Gloria F. Ross. Photo by Al Mozell

7
Gene Davis
"after Lincoln Center"
A Gloria F. Ross Tapestry, 1972
Made after *Lincoln Center*, 1971, acrylic on canvas
Pinton S.A., Felletin, France. Olivier Pinton, workshop director;
 staff weavers
Aubusson low-warp loom, tapestry weave; wool weft on
 cotton warp
72 × 40 in.
7 plus 1 artist's proof authorized/1 made
 1/7 IBM corporate art collection, Armonk, New York
 (sold 1995)
© Estate of Gloria F. Ross

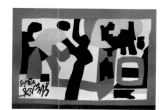

8
Stuart Davis
"after Punch-Card Flutter No. 3"
A Gloria F. Ross Tapestry, 1989
Made after *Punch-Card Flutter No. 3*, 1963, oil on canvas,
 24 × 33 in. © Estate of Stuart Davis/Licensed by VAGA,
 New York
Pinton S.A., Felletin, France. François Pinton, workshop
 director; staff weavers
Aubusson low-warp loom, tapestry weave; wool weft on
 cotton warp
192 × 270 in.
Unique 1/1 Rudin Management Co., 345 Park Avenue,
 New York
© Estate of Stuart Davis/Licensed by VAGA, New York.
 Photo by Malcolm Varon, courtesy of John Gilbert,
 Rudin Management Co.

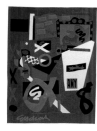

9
Stuart Davis
"after Semé"
A Gloria F. Ross Tapestry, 1991
Made after *Semé*, 1953, oil on canvas, 52 × 40 in. The
 Metropolitan Museum of Art, George A. Hearn Fund, 1953,
 53.90; © Estate of Stuart Davis/Licensed by VAGA, New York
Pinton S.A., Felletin, France. François Pinton, workshop
 director; staff weavers
Aubusson low-warp loom, tapestry weave; wool weft on
 cotton warp
88 × 68 in.
3 plus 2 artist's proofs authorized/1 made
 1/3 Earl Davis
© Estate of Stuart Davis/Licensed by VAGA, New York

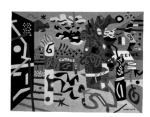

10
Stuart Davis
"after Report from Rockport"
A Gloria F. Ross Tapestry, 1991
Made after *Report from Rockport*, 1940, oil on canvas,
 24 × 30 in. The Metropolitan Museum of Art, bequest of
 Edith Abrahamson Lowenthal, 1991, 1992.24.1; © Estate
 of Stuart Davis/Licensed by VAGA, New York
Pinton S.A., Felletin, France. François Pinton, workshop
 director; staff weavers
Aubusson low-warp loom, tapestry weave; wool weft on
 cotton warp
72 × 90 in.
3 plus 2 artist's proofs authorized/1 made
 1/3 Earl Davis
© Estate of Stuart Davis/Licensed by VAGA, New York

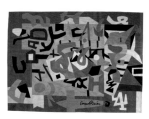

11
Stuart Davis
"after Pad No. 4"
A Gloria F. Ross Tapestry, 1991
Made after *Pad No. 4*, 1947, oil on canvas, 14 × 18 in. Brooklyn
 Museum, bequest of Edith and Milton Lowenthal, 1992.11.5;
 © Estate of Stuart Davis/Licensed by VAGA, New York
Pinton S.A., Felletin, France. François Pinton, workshop
 director; staff weavers
Aubusson low-warp loom, tapestry weave; wool weft on
 cotton warp
70 × 90 in.
3 plus 2 artist's proofs authorized/1 made
 1/3 Earl Davis
© Estate of Stuart Davis/Licensed by VAGA, New York

12
Jean Dubuffet
"Tapis nº 1"
A Gloria F. Ross Carpet, 1973
Maquette, 1972, vinyl on paper, 26 × 41 in. Fondation Dubuffet,
 Paris; © 2010 Artists Rights Society (ARS), New York/ADAGP,
 Paris
Edward Fields, Inc., New York
Commercial pile carpet, wool
61 × 93.5 in.
Prototype 1/1 Private collection, France
© 2010 Artists Rights Society (ARS), New York/ADAGP, Paris.
 Photo courtesy of Fondation Dubuffet, Paris

13
Jean Dubuffet
"Tapis nº 2"
A Gloria F. Ross Carpet, 1976–77
Maquette, 1972, acrylic and vinyl on paper (assemblage),
 54.5 × 82.5 in. Fondation Dubuffet, Paris; © 2010 Artists
 Rights Society (ARS), New York/ADAGP, Paris
Edward Fields, Inc., New York
Commercial pile carpet, wool
84 × 127 in.
3 plus 1 artist's proof authorized/3 made
 1/3, 3/3 Private collections
 2/3 IBM corporate art collection, Armonk, New York
 (sold 1995)
© 2010 Artists Rights Society (ARS), New York/ADAGP, Paris.
 Photo courtesy of Fondation Dubuffet.

14
Jean Dubuffet
"Untitled (with Personnage)"
A Gloria F. Ross Tapestry, 1974
Made after:
a. *Ji la Plombe (Personnage)*, 1971, acrylic on klégécell,
 74 × 38 in. Private collection, USA; © 2010 Artists Rights
 Society (ARS), New York/ADAGP, Paris
b. *Les Péréquations*, 1971, acrylic on klégécell, 115 × 160 in.
 Walker Art Center, Minneapolis, gift of T. B. Walker
 Foundation; © 2010 Artists Rights Society (ARS), New York/
 ADAGP, Paris
Dovecot Studios, Edinburgh Tapestry Co., Scotland. Archie
 Brennan, director of weaving; Douglas Grierson, Fred Mann,
 and apprentice Gordon Brennan
Gobelins high-warp loom, tapestry weave; (0/1) wool on
 cotton warp, (00/1) linen and wool on cotton warp
a. 44 × 21 in., b. 72 × 122 in.
Two prototypes; production of an edition was not approved
 by Jean Dubuffet.
 0/1 Minneapolis Institute of Arts (a only), 2003.160, gift
 of the estate of Gloria F. Ross
 00/1 Fondation Dubuffet (a, b)
© 2010 Artists Rights Society (ARS), New York/ADAGP, Paris.
 Photo of *Personnage* (a) courtesy of Minneapolis Institute
 of Arts

15
Paul Feeley
"after Untitled (Yellow, Red)"
A Gloria F. Ross Carpet, 1970
Made after *Untitled (Yellow, Red)*, 1962, oil and enamel
 on canvas, 47 × 59 in. Private collection; © Estate of
 Paul T. Feeley
Gloria F. Ross workshop, New York
Hooked (tufted) on canvas, sheared; Paternayan wool yarn
 on commercial cotton cloth
48 × 60 in.
5 plus 1 artist's proof authorized/3 made
 0/5 Paul T. Feeley Foundation
 1/5 Private collection
 2/5 Cooper & Lybrand
© Estate of Gloria F. Ross. Photo by Eric Pollitzer

16
Paul Feeley
"after Lacona"
A Gloria F. Ross Carpet, 1969
Made after *Lacona*, 1962, oil and enamel on canvas, 60 × 48 in.
 Private collection; © Estate of Paul T. Feeley
Gloria F. Ross workshop, New York
Hooked (hand-tufted); Paternayan wool yarn on commercial
 cotton cloth
60 × 48 in.
5 plus 1 artist's proof authorized/4 made
 0/5 Paul T. Feeley Foundation
 1/5, 2/5 Private collections
 3/5 Ex-collection Gene Baro
© Estate of Gloria F. Ross. Photo by Eric Pollitzer

17
Helen Frankenthaler
"after The Cape"
A Gloria F. Ross Carpet, 1963
Made after *The Cape*, 1962, oil on canvas, 53 × 69.75 in. Clifford
 Ross collection; © 2010 Helen Frankenthaler/Artists Rights
 Society (ARS), New York
Gloria F. Ross workshop, New York
Hooked (hand-tufted); Paternayan wool yarn on commercial
 cotton cloth
54 × 72 in.
Unique 1/1 Collection of the artist
© 2010 Helen Frankenthaler/Artists Rights Society (ARS),
 New York/Estate of Gloria F. Ross. Photo courtesy of
 Helen Frankenthaler

18 (not illustrated as a plate)
Helen Frankenthaler
"after Buddha's Court"
A Gloria F. Ross Carpet, 1966
Made after *Buddha's Court*, 1964, acrylic on canvas, 98 × 94 in.
 © 2010 Helen Frankenthaler/Artists Rights Society (ARS),
 New York
Gloria F. Ross workshop, New York
Hooked (tufted) on canvas, sheared; Paternayan wool yarn
 on commercial cotton cloth
72 × 72 in.
Unique 1/1 Ex-collection Harold Rosenberg
© 2010 Helen Frankenthaler/Artists Rights Society (ARS),
 New York/Estate of Gloria F. Ross

19
Helen Frankenthaler
"after Point Lookout"
A Gloria F. Ross Carpet, 1966
Made after *Point Lookout*, 1966, acrylic on canvas, 69 × 28 in.
 © 2010 Helen Frankenthaler/Artists Rights Society (ARS),
 New York
Gloria F. Ross workshop, New York
Hooked (tufted) on canvas, sheared; Paternayan wool yarn
 on commercial cotton cloth
72 × 30 in.
5 plus 1 artist's proof authorized/5 made
 1/5 Private collection
 2/5 Quaker Oats Building/SOM, Chicago
 3/5 City Financial Services of Canada, Ltd
 4/5 Mount Holyoke College Art Museum, South Hadley,
 Massachusetts, 1986.10.2, gift of the Storm King Center
 5/5 Wells Rich Greene, New York
© 2010 Helen Frankenthaler/Artists Rights Society (ARS),
 New York/Estate of Gloria F. Ross. Photo by Laura Weston,
 courtesy of Mount Holyoke College Art Museum

20
Helen Frankenthaler
"after Blue Yellow Screen"
A Gloria F. Ross Carpet, 1966
Made after *Blue Yellow Screen*, 1966, acrylic on canvas,
 29 × 66 in. Private collection; © 2010 Helen Frankenthaler/
 Artists Rights Society (ARS), New York
Gloria F. Ross workshop, New York (1/5, 2/5, 3/5). Hound
 Dog Hookers, Blackey, Kentucky (4/5, 5/5)
Hooked (hand-tufted); Paternayan wool yarn on commercial
 cotton cloth
66 × 30 in.
5 plus 1 artist's proof authorized/5 made
 1/5 International Bank for Reconstruction & Development
 2/5, 3/5, 4/5, 5/5 Private collections
© 2010 Helen Frankenthaler/Artists Rights Society (ARS),
 New York/Estate of Gloria F. Ross. Photo by Eric Pollitzer

21
Helen Frankenthaler
"after 1969 Provincetown Study"
A Gloria F. Ross Tapestry, 1970–90
Made after *1969 Provincetown Study*, 1969, acrylic on canvas,
 17 × 11 in. © 2010 Helen Frankenthaler/Artists Rights Society
 (ARS), New York
Dovecot Studios, Edinburgh Tapestry Co., Scotland (1/5–4/5);
 Archie Brennan, director of weaving; Fred Mann, Harry
 Wright, Douglas Grierson, and Maureen Hodge. Editions
 MH, Tapisseries d'Aubusson, Aubusson, France (5/5);
 Micheline Henry, Patrice Sully-Matégot
Gobelins high-warp loom, tapestry weave; wool weft on
 cotton warp
102 × 68 in. (1/5, 2/5), 90 × 57 in. (3/5), 103 × 77 in. (4/5),
 75 × 50 in. (5/5)
5 plus 2 artist's proofs authorized/6 made
 00/5, 1/5, 2/5, 3/5, 5/5 Private collections
 4/5 Destroyed
© 2010 Helen Frankenthaler/Artists Rights Society (ARS),
 New York/Estate of Gloria F. Ross. Photo by Eric Pollitzer

22
Helen Frankenthaler
"Untitled (R. M. Halperin commission)"
A Gloria F. Ross Carpet, 1969
Maquette, *Untitled*, 1969. Private collection; © 2010 Helen
 Frankenthaler/Artists Rights Society (ARS), New York
Gloria F. Ross workshop, New York
Hooked (hand-tufted); Paternayan wool yarn on commercial
 cotton cloth
48 × 120 in.
Unique 1/1 Private collection
© 2010 Helen Frankenthaler/Artists Rights Society (ARS),
 New York/Estate of Gloria F. Ross. Photo courtesy of
 R. M. Halperin

23
Helen Frankenthaler
"Untitled (Westinghouse Broadcasting Company commission)"
A Gloria F. Ross Carpet, 1971
Maquette, *Untitled*, 1971, acrylic and oil pastel (?) on canvas,
 10.25 × 8 in. GFR Papers; © 2010 Helen Frankenthaler/
 Artists Rights Society (ARS), New York/Estate of Gloria F.
 Ross. Photo by Jannelle Weakly, ASM
Anna di Giovanni, with the Ruggery, Glen Cove, Long Island
Hooked (hand-tufted); Paternayan wool yarn on commercial
 cotton cloth
132 × 96 in.
Unique 1/1 Philadelphia Convention Center, Reading Termi-
 nal, Redevelopment Authority of the City of Philadelphia
© 2010 Helen Frankenthaler/Artists Rights Society (ARS),
 New York/Estate of Gloria F. Ross. Photo by Kubernick

24
Helen Frankenthaler
"Untitled (Winters Bank Tower commission)"
A Gloria F. Ross Tapestry, 1972
Maquette, *Untitled,* 1971, acrylic and marking pen on canvas,
8.75 × 25.5 in. GFR Papers; © 2010 Helen Frankenthaler/
Artists Rights Society (ARS), New York/Estate of Gloria F.
Ross. Photo by Jannelle Weakly, ASM
Pinton S.A., Felletin, France. Olivier Pinton, workshop director;
staff weavers
Aubusson low-warp loom, tapestry weave; wool weft on
cotton warp
108 × 303 in.
Unique 1/1 CB Richard Ellis Asset Services, The Kettering
Tower, Dayton, Ohio
© 2010 Helen Frankenthaler/Artists Rights Society (ARS),
New York/Estate of Gloria F. Ross. Photo by Jack Holtel,
Photographik

25
Helen Frankenthaler
"Untitled (Fourth National Bank and Trust commission)"
A Gloria F. Ross Tapestry, 1975
Maquette, *Untitled,* 1973, acrylic on canvas, 9.25 × 42.5 in.
Collection of the artist; © 2010 Helen Frankenthaler/Artists
Rights Society (ARS), New York
Pinton S.A., Felletin, France. Olivier Pinton, workshop director;
staff weavers
Aubusson low-warp loom, tapestry weave; wool weft on
cotton warp
114 × 510 in.
Unique 1/1 Bank of America Art Program
© 2010 Helen Frankenthaler/Artists Rights Society (ARS),
New York/Estate of Gloria F. Ross. Photo by Kirk Eck,
Wichita Art Museum, Wichita, Kansas

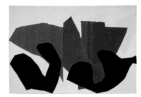

27
Robert Goodnough
"Abstraction with Black Forms"
A Gloria F. Ross Tapestry, 1967–1969
Maquette, 1967, cut-paper collage, 7 × 10.5 in. GFR Papers;
© Estate of Gloria F. Ross. Photo by Jannelle Weakly, ASM
Gloria F. Ross workshop, New York
Hooked (hand-tufted); Paternayan wool yarn on commercial
cotton cloth
60 × 84 in.
5 plus 1 artist's proof authorized/5 made
1/5 Quaker Oats Building/SOM, Chicago
2/5 Mount Holyoke College Art Museum, South Hadley,
Massachusetts, 1986.10.1, gift of the Storm King
Art Center
3/5 Thrall Car Manufacturing, Chicago
4/5 International Bank for Reconstruction & Development
5/5 Private collection
© Estate of Gloria F. Ross. Photo by Eric Pollitzer

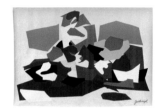

28
Robert Goodnough
"Red/Blue Abstraction"
A Gloria F. Ross Tapestry, 1971–75
Maquette, 1969, cut-paper collage, 8.25 × 11 in. GFR Papers;
© Estate of Gloria F. Ross. Photo by Jannelle Weakly, ASM
Dovecot Studios, Edinburgh Tapestry Co., Scotland. Archie
Brennan, director of weaving; Fred Mann, Harry Wright,
Douglas Grierson, and Maureen Hodge
Gobelins high-warp loom, tapestry weave; wool weft on
cotton warp
77 × 103 in.
5 plus 1 artist's proof authorized/6 made
0/5 Museum of Fine Arts, Boston, 2009.4394, gift of
Susan and Larry Marx
1/5 Port Authority of New York and New Jersey, Kennedy
International Airport
2/5 Palmer Museum of Art of The Pennsylvania State
University
3/5 Ernst & Ernst, New York
4/5 Liquid Paper Company, Oak Brook, Illinois
5/5 IBM corporate art collection, Armonk, New York
(sold 1995)
© Estate of Gloria F. Ross. Photo courtesy of Palmer Museum
of Art of The Pennsylvania State University

29
Robert Goodnough
"Tapestry III"
A Gloria F. Ross Tapestry, 1976–90
Maquette, 1976, cut-paper collage, 11 × 15 in. © Estate of
Gloria F. Ross
Pinton S.A., Felletin, France. Olivier and François Pinton,
workshop directors; staff weavers
Aubusson low-warp loom, tapestry weave; wool weft on
cotton warp
44 × 58 in. (1/7), 52 × 68 in. (2/7)
7 plus 1 artist's proof authorized/2 made
1/7, 2/7 Private collections
© Estate of Gloria F. Ross

30
Adolph Gottlieb
"after Black Signs"
A Gloria F. Ross Carpet, 1970–71
Made after *Black Signs,* 1967, serigraph on paper, 18 × 24 in.
GFR Papers; © Adolph and Esther Gottlieb Foundation/
Licensed by VAGA, New York. Photo by Jannelle Weakly,
ASM
Anna di Giovanni, with the Ruggery, Glen Cove, Long Island
Hooked (hand-tufted); Paternayan wool yarn on commercial
cotton cloth
54 × 72 in.
5 plus 1 artist's proof authorized/6 made
0/5, 1/5, 2/5, 3/5 Private collections
4/5 Newman Stores
5/5 Tougaloo College, Jackson, Mississippi
© Adolph and Esther Gottlieb Foundation/Licensed by VAGA,
New York. Photo by Eric Pollitzer

31
Adolph Gottlieb
"after Black Disc on Tan"
A Gloria F. Ross Tapestry, 1972–76
Made after *Black Disc on Tan,* 1970, oil on paper, 24 × 19 in.;
© Adolph and Esther Gottlieb Foundation/Licensed by
VAGA, New York.
Dovecot Studios, Edinburgh Tapestry Co., Scotland. Archie
Brennan, director of weaving; Fred Mann, Harry Wright,
and Douglas Grierson
Gobelins high-warp loom, tapestry weave; wool and linen
weft on cotton warp
84 × 66 in.
5 plus 2 artist's proofs authorized/7 made
0/5 Adolph and Esther Gottlieb Foundation
00/5 IBM corporate art collection, Armonk, New York
(sold 1995)
1/5 Private collection
2/5 First National Bank of Tampa
3/5 City National Bank, Los Angeles
4/5 The Limited Stores, Columbus, Ohio
5/5 Clifford Ross
© Adolph and Esther Gottlieb Foundation/Licensed by VAGA,
New York. Photo by Al Mozell

26
Helen Frankenthaler
"after This Day"
A Gloria F. Ross Tapestry, 1982
Made after *This Day,* 1980, acrylic on canvas, 50 × 73 in. Private
collection; © 2010 Helen Frankenthaler/Artists Rights
Society (ARS), New York
Kunstadt-Kennedy Workshop. Janet L. Kennedy
Multi-harness floor loom, tapestry and float weaves (hand-
picked overshot Hernmarck technique); wool, linen, cotton,
and rayon wefts on orange linen warp
58 × 81 in.
Unique 1/1 Peter and Aileen Godsick
© 2010 Helen Frankenthaler/Artists Rights Society (ARS),
New York/Estate of Gloria F. Ross. Photo by C. G.

32
Al Held
"after Cultural Showcase"
A Gloria F. Ross Tapestry, 1974
Made after *Cultural Showcase,* 1967, serigraph, 46 × 30 in.
Atelier Raymond Picaud, Aubusson, France
Aubusson low-warp loom, tapestry weave; wool weft on
cotton warp
80.5 × 52.5 in.
7 plus 1 artist's proof authorized/1 made
1/7 Private collection
© Estate of Gloria F. Ross. Photo by Al Mozell

33
Hans Hofmann
"after To Miz—Pax Vobiscum"
A Gloria F. Ross Tapestry, 1976–86
Made after *To Miz—Pax Vobiscum*, 1964, oil on canvas,
 77.4 × 83.6 in. Modern Art Museum of Fort Worth, museum
 purchase, 1987; © 2010 Estate of Hans Hofmann/Artists
 Rights Society (ARS), New York
Pinton S.A., Felletin, France. Olivier Pinton, workshop director;
 staff weavers
Aubusson low-warp loom, tapestry weave; wool weft on
 cotton warp
72 × 76 in.
7 plus 1 artist's proof authorized/5 made
 0/7, 2/7, 3/7 Private collections
 1/7 The Limited Stores, Columbus, Ohio
 4/7 Neuberger Museum of Art, Purchase, New York,
 gift of Gloria F. Ross
© Estate of Gloria F. Ross. Photo courtesy of Pinton S.A.

34
Hans Hofmann
"after Blue Loup"
A Gloria F. Ross Carpet, 1981–86
Made after *Blue Loup*, 1956, oil on cardboard, 48 × 30.75 in.
 Ex-collection André Emmerich; © 2010 Estate of Hans
 Hofmann/Artists Rights Society (ARS), New York
Edward Fields, Inc., New York
Commercial pile carpet, wool
48 × 90 in. (prototype), 61 × 132 in. (edition)
100 authorized/prototype plus 5 made?
 1/100 Private collection
 Prototype Edward Fields, Inc.
© 2010 Estate of Hans Hofmann/Artists Rights Society (ARS),
 New York. Photo courtesy of Edward Fields, Inc.

35
Hans Hofmann
"after Purple Loup"
A Gloria F. Ross Carpet, 1981–87
Made after *Purple Loup*, 1956, oil on cardboard, 48 × 30.75 in.
 Ex-collection André Emmerich; © 2010 Estate of
 Hans Hofmann/Artists Rights Society (ARS), New York
Edward Fields, Inc., New York
Commercial pile carpet, wool
48 × 90 in. (prototype), 61 × 132 in. (edition)
100 authorized/prototype plus 5 made?
 1/100, 2/100, 3/100 Private collections
 4/100 Wichita Art Museum, 2007.2.1, bequest of Elton
 Greenberg
 5/100 Goulston & Storrs, Boston
© 2010 Estate of Hans Hofmann/Artists Rights Society (ARS),
 New York. Photo courtesy of Edward Fields, Inc.

36
Paul Jenkins
"after Phenomena Peal of Bells Cross"
A Gloria F. Ross Tapestry, 1973–79
Made after *Phenomena Peal of Bells Cross*, 1972, watercolor on
 paper, 22 × 30 in. Minneapolis Institute of Arts, 99.99.4, gift
 of the estate of Gloria F. Ross; © Paul Jenkins/Licensed by
 ADAGP
Boccia collection, Turkey (1/7, 2/7). Pinton S.A., Felletin, France.
 Olivier Pinton, workshop director; staff weavers (00/7, 3/7,
 4/7, 5/7)
Aubusson low-warp loom, tapestry weave; wool weft on
 cotton warp
57 × 82 in.
7 plus 2 artist's proofs authorized/8 made
 00/7 Minneapolis Institute of Arts, 99.99.3, gift of the estate
 of Gloria F. Ross
 1/7, 6/7, 7/7 Private collections
 2/7 First National Citibank, Los Angeles
 3/7 Republic Bank, Houston
 4/7 First National Bank of Greater Miami
 5/7 Rosenman, Colin, Freund, Lewis & Cohen, New York
© Estate of Gloria F. Ross. Photo by Al Mozell

37
Paul Jenkins
"after Phenomena Mandala Spectrum Turn"
A Gloria F. Ross Tapestry, 1978–81
Made after *Phenomena Mandala Spectrum Turn*, 1971,
 watercolor on paper, 30 × 22 in. © Paul Jenkins/Licensed
 by ADAGP
Editions MH, Tapisseries d'Aubusson, Aubusson, France.
 Micheline Henry, Patrice Sully-Matégot
Aubusson low-warp loom, tapestry weave; wool weft on
 cotton warp
60 × 74 in., 77 × 56 in.
6 plus 1–2 artist's proofs authorized/3 made
 0/6 Collection of the artist
 1/6 Private collection
 2/6 Herbert and Eileen Bernard Museum of Judaica,
 Congregation Emanu-El, New York
© Estate of Gloria F. Ross. Photo by Al Mozell

38
Alexander Liberman
"after #41"
A Gloria F. Ross Tapestry, 1975
Made after *#41*, 1963, acrylic on canvas, 30 × 30 in.
The Ruggery, Glen Cove, Long Island. George Wells and staff
Hooked (hand-tufted); Paternayan wool yarn on commercial
 cotton cloth
63 × 63 in.
7 plus 1–2 artist's proofs authorized/1 made
 1/7 Private collection
© Estate of Gloria F. Ross. Photo by Al Mozell

39
Richard Lindner
"after Telephone"
A Gloria F. Ross Tapestry, 1974
Made after *Telephone*, 1966, oil on canvas, 70 × 60 in.
 Private collection, Hamburg, Germany; © 2010 Artists
 Rights Society (ARS), New York/ADAGP, Paris
Atelier Raymond Picaud, Aubusson, France
Aubusson low-warp loom, tapestry weave; wool weft on
 cotton warp
84 × 72 in.
Unique 1/1 Private collection
© 2010 Artists Rights Society (ARS), New York/ADAGP, Paris.
 Photo by Al Mozell

40
Morris Louis
"after Equator"
A Gloria F. Ross Carpet, 1970
Made after *Equator*, 1962, acrylic resin (Magna) on canvas,
 63 × 63 in. Private collection, Washington DC
Anna di Giovanni, with the Ruggery, Glen Cove, Long Island
Hooked (hand-tufted); Paternayan wool yarn on commercial
 cotton cloth
63 × 63 in.
5 plus 1 artist's proof authorized/4 made
 0/5, 1/5, 2/5 Private collections
 3/5 American Cancer Society, Atlanta
© Estate of Gloria F. Ross. Photo by Eric Pollitzer

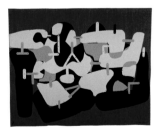

41
Conrad Marca-Relli
"after Multiple Image"
A Gloria F. Ross Tapestry, 1975–90
Made after *Multiple Image*, 1969, collage, 57 × 69.5 in.
Pinton S.A., Felletin, France. Olivier and François Pinton,
 workshop directors; staff weavers
Aubusson low-warp loom, tapestry weave; wool weft on
 cotton warp
71 × 86 in.
7 plus 2 artist's proofs authorized/3 made
 00/7 Minneapolis Institute of Arts, 99.99.2, gift of
 the estate of Gloria F. Ross
 1/7, 2/7 Private collections
© Estate of Gloria F. Ross. Photo courtesy of Minneapolis
 Institute of Arts

42
Robert Motherwell
"after Elegy to the Spanish Republic No. 78"
A Gloria F. Ross Carpet, 1963
Made after *Elegy to the Spanish Republic No. 78*, 1962, oil and acrylic on canvas, 71 × 132.25 in. Yale University Art Gallery, 1962.62, gift of the artist; © Dedalus Foundation/Licensed by VAGA, New York. Photo courtesy of Yale University Art Gallery
Gloria F. Ross workshop, New York
Hooked (hand-tufted), sheared; Paternayan wool yarn on commercial cotton cloth
71 × 132 in.
Unique 1/1 Mount Holyoke College Art Museum, South Hadley, Massachusetts, 1978.6, gift of Marjorie F. Iseman
© Dedalus Foundation/Licensed by VAGA, New York. Photo by Laura Weston, courtesy of Mount Holyoke College Art Museum

43
Robert Motherwell
"Homage to Rafael Alberti—Blue"
A Gloria F. Ross Carpet, 1970–71
Made after *A la pintura: Blue 1-3*, 1972, aquatint, lift-ground etching and aquatint, and letterpress on paper, 25.5 × 38 in. limited edition illustrated book by Universal Limited Art Editions; © Dedalus Foundation/Licensed by VAGA, New York. Photo courtesy of Dedalus Foundation
Anna di Giovanni, with the Ruggery, Glen Cove, Long Island
Hooked (hand-tufted), sheared; Paternayan wool yarn on commercial cotton cloth
108 × 66 in.
5 plus 1 artist's proof authorized/6 made
 0/5 Private collection
 1/5 The Frances Lehman Loeb Art Center, Vassar College, Poughkeepsie, New York, anonymous gift, 1981.19
 2/5 The Clorox Company, Oakland
 3/5 Louisiana Arts & Science Center, Baton Rouge, gift of Clifford Ross
 4/5 Chow's Restaurant, Beverly Hills
 5/5 International Art Foundation, Meriden, Connecticut
© Dedalus Foundation, Inc./Licensed by VAGA, New York. Photo by Eric Pollitzer

44
Robert Motherwell
"after Elegy to the Spanish Republic No. 116"
A Gloria F. Ross Tapestry, 1970–76
Made after *Elegy to the Spanish Republic No. 116*, circa 1969, acrylic on canvas board, 7 × 9 in. Clifford Ross collection; © Dedalus Foundation/Licensed by VAGA, New York
Dovecot Studios, Edinburgh Tapestry Co., Scotland. Archie Brennan, director of weaving; Fred Mann, Harry Wright, Douglas Grierson, Maureen Hodge, and Fiona Mathison
Gobelins high-warp loom, tapestry weave with knotting and wrapping; wool and linen weft on cotton warp
84 × 108 in.
5 plus 2 artist's proofs authorized/7 made
 0/5, 00/5, 3/5 Private collections
 1/5 Port Authority of New York and New Jersey (sold 1997)
 2/5 River Tower Association, New York
 4/5 Clifford Ross
 5/5 IBM corporate art collection, Armonk, New York (sold 1995)
© Dedalus Foundation/Licensed by VAGA, New York. Photo by Eric Pollitzer

45
Robert Motherwell
"Untitled (Westinghouse Broadcasting Company commission)"
A Gloria F. Ross Carpet, 1972
Maquette, *Untitled*, 1972, acrylic on canvas, 22 × 11.5 in. Private collection; © Dedalus Foundation/Licensed by VAGA, New York. Photo courtesy of Dedalus Foundation
Anna di Giovanni, with the Ruggery, Glen Cove, Long Island
Hooked (hand-tufted); Paternayan wool yarn on commercial cotton cloth
108 × 72 in.
Unique 1/1 Philadelphia Convention Center, Reading Terminal, Redevelopment Authority of the City of Philadelphia
© Dedalus Foundation/Licensed by VAGA, New York. Photo by Kubernick

46
Robert Motherwell
"after In Brown and White"
A Gloria F. Ross Tapestry, 1974–89
Made after *In Brown and White*, 1960, collage, 90 × 58 in. Ellen M. Iseman collection; © Dedalus Foundation/Licensed by VAGA, New York. Photo by Malcolm Varon
Pinton S.A., Felletin, France. Olivier and François Pinton, workshop directors; staff weavers
Aubusson low-warp loom, tapestry weave; wool weft on cotton warp
85 × 57 in.
7 plus 1 artist's proof authorized/4 made
 0/7 Dedalus Foundation, Inc. (plate 46c)
 1/7 The Limited Stores (plate 46a)
 2/7, 3/7 Private collections (plate 46b)
 3/7 Private collection (similar to plate 46c)
© Dedalus Foundation/Licensed by VAGA, New York. Photograph of 0/7 (plate 46c), courtesy of Dedalus Foundation

47
Louise Nevelson
"Sky Cathedral I"
A Gloria F. Ross Tapestry, 1972
Maquette (also for 48), 1972, lead intaglio reliefs bonded to paper, 29 × 23.5 in. GFR Papers; © 2010 Estate of Louise Nevelson/Artists Rights Society (ARS). Photo by Jannelle Weakly, ASM
Dovecot Studios, Edinburgh Tapestry Co., Scotland. Archie Brennan, director of weaving; Douglas Grierson and Fiona Mathison
Gobelins high-warp loom, tapestry weave; wool, linen, and metallic/synthetic wefts on cotton warp
84 × 68 in., 88 × 70 in.
5 plus 1 artist's proof authorized/1 made
 1/5 Collection not located
© Estate of Gloria F. Ross

48
Louise Nevelson
"Sky Cathedral II"
A Gloria F. Ross Tapestry, 1974–77
Maquette (also for 47), 1972, lead intaglio reliefs bonded to paper, 29 × 23.5 in. GFR Papers; © 2010 Estate of Louise Nevelson/Artists Rights Society (ARS), New York. Photo by Jannelle Weakly, ASM
Dovecot Studios, Edinburgh Tapestry Co., Scotland. Archie Brennan, director of weaving; Neil McDonald, Jean Taylor, Fiona Mathison, and apprentice Gordon Brennan
Gobelins high-warp loom, tapestry and float weaves; wool and other natural fiber wefts on cotton warp
88 × 70 in.
5 plus 2 artist's proofs authorized/7 made
 0/5, 1/5, 4/5 Private collections
 00/5 Clifford Ross
 2/5 Union Federal Savings & Loan, Kewanee, Illinois
 3/5 Port Authority of New York and New Jersey
 5/5 Teleflex Incorporated (formerly Arrow International), Reading, Pennsylvania
© 2010 Estate of Louise Nevelson/Artists Rights Society (ARS), New York. Photo by Peter Ferling, courtesy of Teleflex Incorporated

49
Louise Nevelson
"Night Mountain"
A Gloria F. Ross Tapestry, 1977
Maquette, 1976, mixed-media collage, 11 × 8.5 in. Collection not located; © 2010 Estate of Louise Nevelson/Artists Rights Society (ARS), New York
Dovecot Studios, Edinburgh Tapestry Co., Scotland. Archie Brennan, director of weaving; Fiona Mathison, Jean Taylor, and staff
Gobelins high-warp loom, tapestry and float weaves; wool and other natural fiber wefts on cotton warp
80 × 49 in.
Unique 1/1 Private collection
© 2010 Estate of Louise Nevelson/Artists Rights Society (ARS), New York. Photo by Hans Namuth in the GFR Papers, © 2010 Hans Namuth Estate

50
Louise Nevelson
"Dusk in the Desert"
A Gloria F. Ross Tapestry, 1977
Maquette, 1976, mixed-media collage, approx. 13 × 11 in. Collection not located; © 2010 Estate of Louise Nevelson/Artists Rights Society (ARS), New York
Dovecot Studios, Edinburgh Tapestry Co., Scotland. Archie Brennan, director of weaving; Fiona Mathison, Jean Taylor, and staff
Gobelins high-warp loom, tapestry and float weaves; wool and other natural fiber wefts on cotton warp
84 × 58 in.
Unique 1/1 Wells Fargo Bank, San Francisco
© 2010 Estate of Louise Nevelson/Artists Rights Society (ARS), New York

51
Louise Nevelson
"Desert"
A Gloria F. Ross Tapestry, 1978
Maquette, 1976, mixed-media collage, 12.5 × 6.75 in. Collection not located; © 2010 Estate of Louise Nevelson/Artists Rights Society (ARS), New York
Dovecot Studios, Edinburgh Tapestry Co., Scotland. Archie Brennan, director of weaving; Fiona Mathison, Jean Taylor, and staff
Gobelins high-warp loom, tapestry and float weaves; wool and other natural fiber wefts on cotton warp
96 × 51 in.
Unique 1/1 Museum of Fine Arts, Boston, 1998.245, gift of Gloria F. Ross
© 2010 Estate of Louise Nevelson/Artists Rights Society (ARS), New York

52
Louise Nevelson
"Mirror Desert"
A Gloria F. Ross Tapestry, 1978
Maquette, 1976, mixed-media collage, 8.5 × 6 in. Collection not located; © 2010 Estate of Louise Nevelson/Artists Rights Society (ARS), New York
Dovecot Studios, Edinburgh Tapestry Co., Scotland. Fiona Mathison, director of weaving; Harry Wright, Jean Taylor, Gordon Brennan, and Dot Callendar
Gobelins high-warp loom, tapestry and float weaves; wool, other natural fibers, and metallic wefts on cotton warp
82 × 60 in.
Unique 1/1 Private collection
© 2010 Estate of Louise Nevelson/Artists Rights Society (ARS), New York

53
Louise Nevelson
"Reflection"
A Gloria F. Ross Tapestry, 1978
Maquette, 1976, mixed-media collage, 11.5 × 11 in. Collection not located; © 2010 Estate of Louise Nevelson/Artists Rights Society (ARS), New York
Dovecot Studios, Edinburgh Tapestry Co., Scotland. Fiona Mathison, director of weaving; Fiona Mathison, Jean Taylor, and staff
Gobelins high-warp loom, tapestry and float weaves; wool and other natural fiber wefts on cotton warp
72 × 71 in.
Unique 1/1 Private collection
© 2010 Estate of Louise Nevelson/Artists Rights Society (ARS), New York

54
Louise Nevelson
"Landscape (within Landscape)"
A Gloria F. Ross Tapestry, 1979
Maquette, 1976, mixed-media collage, 11.5 × 8.5 in. Collection not located; © 2010 Estate of Louise Nevelson/Artists Rights Society (ARS), New York
Dovecot Studios, Edinburgh Tapestry Co., Scotland. Fiona Mathison, director of weaving; Jean Taylor and staff
Gobelins high-warp loom, tapestry and float weaves; wool and other natural fiber wefts on cotton warp
82.5 × 63 in.
Unique 1/1 Private collection
© 2010 Estate of Louise Nevelson/Artists Rights Society (ARS), New York. Photo by Eric Pollitzer

55
Louise Nevelson
"The Late, Late Moon"
A Gloria F. Ross Tapestry, 1980
Maquette, 1976, mixed-media collage, 19 × 20 in. Collection not located; © 2010 Estate of Louise Nevelson/Artists Rights Society (ARS), New York
Dovecot Studios, Edinburgh Tapestry Co., Scotland. Fiona Mathison, director of weaving; Jean Taylor and staff
Gobelins high-warp loom, tapestry and float weaves; wool and other natural fiber wefts on cotton warp
69 × 73 in.
Unique 1/1 Private collection
© 2010 Estate of Louise Nevelson/Artists Rights Society (ARS), New York. Photo by Eric Pollitzer

56
Kenneth Noland
"after Bell"
A Gloria F. Ross Carpet, 1966
Made after *Bell*, 1959, acrylic on canvas, 96 × 96 in.
 © Estate of Kenneth Noland/Licensed by VAGA, New York
Gloria F. Ross workshop, New York
Hooked (hand-tufted); Paternayan wool yarn on commercial cotton cloth
96 × 96 in.
5 plus 1 artist's proof authorized/6 made
 0/5 Collection of the artist
 1/5, 3/5, 4/5, 5/5 Private collections
 2/5 Linwood State Bank, Kansas City, Missouri
© Kenneth Noland/Licensed by VAGA, New York. Photo by Eric Pollitzer

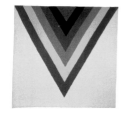

57
Kenneth Noland
"after Every Third"
A Gloria F. Ross Tapestry, 1970
Made after *Every Third*, 1964, acrylic on canvas, 72 × 72 in.
 © Estate of Kenneth Noland/Licensed by VAGA, New York
Anna di Giovanni, with the Ruggery, Glen Cove, Long Island
Hooked (hand-tufted); Paternayan wool yarn on commercial cotton cloth
72 × 72 in.
5 plus 1 artist's proof authorized/6 made
 0/5 Collection of the artist
 1/5, 4/5 Private collections
 2/5 Security Pacific National Bank, Los Angeles
 3/5 Bank of America Art Program
 5/5 Fisher Brothers Manufacturing Co., Detroit
© Estate of Kenneth Noland/Licensed by VAGA, New York. Photo by Eric Pollitzer

58
Kenneth Noland
"after Seventh Night"
A Gloria F. Ross Tapestry, 1972
Made after *Seventh Night*, 1972, acrylic on canvas, 91.4 × 33 in.
 © Estate of Kenneth Noland/Licensed by VAGA, New York
Dovecot Studios, Edinburgh Tapestry Co., Scotland. Archie Brennan, director of weaving; Archie Brennan and Harry Wright
Gobelins high-warp loom, tapestry weave; wool weft on cotton warp
91 × 33 in.
5 plus 1 artist's proof authorized/1 made
 1/5 Lost in transit (1982)
© Estate of Kenneth Noland/Licensed by VAGA, New York

59
Kenneth Noland
"Painted Desert"
A Gloria F. Ross Tapestry, 1979
Maquette (PC-110), 1979, handmade paper, 18 × 23 in.
 © Estate of Kenneth Noland/Licensed by VAGA, New York
Martha Terry, Wide Ruins, Arizona, Navajo Nation
Southwest vertical loom, tapestry weave; vegetal-dyed handspun wool weft on wool warp
54 × 67 in.
Unique 1/1 Private collection, Japan
© Estate of Kenneth Noland/Licensed by VAGA, New York. Photo by Eric Pollitzer

60
Kenneth Noland
"Rainbow's Blanket"
A Gloria F. Ross Tapestry, 1980
Made after *Silent Adios I*, 1979, acrylic on canvas, 18 × 24 in.
 © Estate of Kenneth Noland/Licensed by VAGA, New York
Mary Lee Begay, Ganado Mesa, Arizona, Navajo Nation
Southwest vertical loom, tapestry weave; pre-carded handspun
 wool weft on wool warp
58 × 78 in.
Unique 1/1 Private collection
© Estate of Kenneth Noland/Licensed by VAGA, New York.
 Photo by Eric Pollitzer

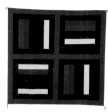

63
Kenneth Noland
"Morning Star"
A Gloria F. Ross Tapestry, 1982
Maquette *R*, 1981, gouache, ink, and pencil on graph paper,
 4.75 × 4.75 in. GFR Papers; © Estate of Kenneth Noland/
 Licensed by VAGA, New York
Mary Lee Begay, Ganado Mesa, Arizona, Navajo Nation
Southwest vertical loom, tapestry weave; pre-carded handspun
 wool weft on wool warp
66 × 66 in.
Unique 1/1 Collection of the artist
© Estate of Kenneth Noland/Licensed by VAGA, New York

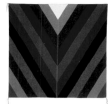

66
Kenneth Noland
"Mood Indigo I"
A Gloria F. Ross Tapestry, 1985
Maquette (1b), 1984, gouache on graph paper, 4 × 4 in.
 GFR Papers; © Estate of Kenneth Noland/Licensed by
 VAGA, New York
Mary Lee Begay, Ganado Mesa, Arizona, Navajo Nation
Southwest vertical loom, tapestry weave; Brown Sheep Co.
 wool weft on wool warp
64 × 65 in.
Unique 1/1 Private collection, Japan
© Estate of Kenneth Noland/Licensed by VAGA, New York.
 Photo by David Heald

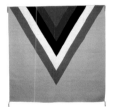

61
Kenneth Noland
"Nizhoni Peak"
A Gloria F. Ross Tapestry, 1980
Maquette *K*, 1980, acrylic on paper, approx. 18 × 18 in.
 Collection of the artist; © Estate of Kenneth Noland/
 Licensed by VAGA, New York
Mary Lee Begay, Ganado Mesa, Arizona, Navajo Nation
Southwest vertical loom, tapestry weave; natural and
 synthetic-dyed wool weft on wool warp
70 × 70 in.
Unique 1/1 Private collection
© Estate of Kenneth Noland/Licensed by VAGA, New York.
 Photo by Eric Pollitzer

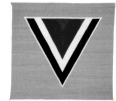

64
Kenneth Noland
"Shooting Star"
A Gloria F. Ross Tapestry, 1983
Maquette *B* (PT-83-01), 1983, acrylic on paper, 14.3 × 15.5 in.
 © Estate of Kenneth Noland/Licensed by VAGA, New York
Mary Lee Begay, Ganado Mesa, Arizona, Navajo Nation
Southwest vertical loom, tapestry weave; Brown Sheep Co.
 wool weft on wool warp
67 × 69 in.
Unique 1/1 Private collection
© Estate of Kenneth Noland/Licensed by VAGA, New York

67
Kenneth Noland
"Mood Indigo II"
A Gloria F. Ross Tapestry, 1985
Maquette (1a), 1984, gouache on graph paper, 4 × 4 in.
 GFR Papers; © Estate of Kenneth Noland/Licensed by
 VAGA, New York
Mary Lee Begay, Ganado Mesa, Arizona, Navajo Nation
Southwest vertical loom, tapestry weave; Brown Sheep Co.
 wool weft on wool warp
64 × 65 in.
Unique 1/1 Private collection, Japan
© Estate of Kenneth Noland/Licensed by VAGA, New York.
 Photo by David Heald

62
Kenneth Noland
"Twilight"
A Gloria F. Ross Tapestry, 1980
Maquette *N*, 1980, acrylic on paper, approx. 15 × 15 in.
 Collection of the artist; © Estate of Kenneth Noland/
 Licensed by VAGA, New York
Mary Lee Begay, Ganado Mesa, Arizona, Navajo Nation
Southwest vertical loom, tapestry weave; pre-carded handspun
 wool weft on wool warp
71 × 71 in.
Unique 1/1 Port Authority of New York and New Jersey
© Estate of Kenneth Noland/Licensed by VAGA, New York.
 Photo by Eric Pollitzer

65
Kenneth Noland
"Hawkeye"
A Gloria F. Ross Tapestry, 1984
Maquette *V*, 1983, acrylic on paper, 14.25 × 15.5 in. GFR Papers;
 © Estate of Kenneth Noland/Licensed by VAGA, New York;
 Jannelle Weakly, ASM
Mary Lee Begay, Ganado Mesa, Arizona, Navajo Nation
Southwest vertical loom, tapestry weave; Brown Sheep Co.
 wool weft on wool warp
66 × 66 in.
Unique 1/1 Private collection
© Estate of Kenneth Noland/Licensed by VAGA, New York.
 Photo by C. G.

68
Kenneth Noland
"Valley"
A Gloria F. Ross Tapestry, 1986
Maquette (85-21), 1985, gouache on paper, 8 × 8 in.
 GFR Papers; © Estate of Kenneth Noland/Licensed by
 VAGA, New York
Mary Lee Begay, Ganado Mesa, Arizona, Navajo Nation
Southwest vertical loom, tapestry weave; Brown Sheep Co.
 wool weft on wool warp
60 × 60 in.
Unique 1/1 Wheelwright Museum of the American Indian,
 Santa Fe, New Mexico, gift of Susan Brown McGreevy
© Estate of Kenneth Noland/Licensed by VAGA, New York.
 Photo by David Heald

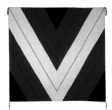

69
Kenneth Noland
"Untitled"
A Gloria F. Ross Tapestry, 1991
Maquette (85-23), 1985, gouache on paper, 8 × 8 in.
 Collection of the artist; © Estate of Kenneth Noland/
 Licensed by VAGA, New York
Mary Lee Begay, Ganado Mesa, Arizona, Navajo Nation
Southwest vertical loom, tapestry weave; Brown Sheep Co.
 wool weft on wool warp
64 × 64 in.
Unique 1/1 Joslyn Art Museum, Omaha, Nebraska
© Estate of Kenneth Noland/Licensed by VAGA, New York

72
Kenneth Noland
"Time's Arrow"
A Gloria F. Ross Tapestry, 1991
Maquette (90-31), 1990, ink, gouache, and pencil on paper,
 11.5 × 11 in. GFR Papers; © Estate of Kenneth Noland/
 Licensed by VAGA, New York; Jannelle Weakly, ASM
Rose Owens, Cross Canyon, Arizona, Navajo Nation
Southwest vertical loom, tapestry weave; Brown Sheep Co.
 wool weft on wool warp
43 in. diam.
Unique 1/1 The Textile Museum, Washington DC, 1998.2.2, gift
 of Gloria F. Ross
© Estate of Kenneth Noland/Licensed by VAGA, New York.
 Photo by David Heald

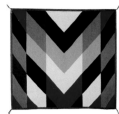

75
Kenneth Noland
"Line of Spirit"
A Gloria F. Ross Tapestry, 1993
Maquette (85-25), 1985, gouache and pencil on paper, 8 × 8 in.
 © Estate of Kenneth Noland/Licensed by VAGA, New York
Sadie Curtis, Kinlichee, Arizona, Navajo Nation
Southwest vertical loom, tapestry weave; Brown Sheep Co.
 wool weft on wool warp
61.9 × 59.75 in.
Unique 1/1 The Art Institute of Chicago, 1995.156, gift of
 Mr. and Mrs. Clyde E. Shorey, Jr.
© Estate of Kenneth Noland/Licensed by VAGA, New York.
 Photo © The Art Institute of Chicago

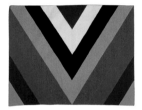

70
Kenneth Noland
"Arizona Sky"
A Gloria F. Ross Tapestry, 1996
Maquette (84-30), 1984, gouache and pencil on cardstock,
 4 × 5 in. Collection of the artist; © Estate of Kenneth
 Noland/Licensed by VAGA, New York
Mary Lee Begay, Ganado Mesa, Arizona, Navajo Nation
Southwest vertical loom, tapestry weave; Wilde and Wooly
 brand wool weft on wool warp
48 × 60 in.
Unique 1/1 The Textile Museum, Washington DC, 1998.2.3, gift
 of Gloria F. Ross
© Estate of Kenneth Noland/Licensed by VAGA, New York

73
Kenneth Noland
"Reflection"
A Gloria F. Ross Tapestry, 1983
Maquette I, 1983, ink and gouache on graph paper, 8.5 × 11 in.
 Denver Art Museum, 1992.291, gift of Kenneth Noland;
 © Estate of Kenneth Noland/Licensed by VAGA, New York.
 Photo courtesy of Denver Art Museum
Sadie Curtis, Kinlichee, Arizona, Navajo Nation
Southwest vertical loom, tapestry weave; pre-carded handspun
 wool weft on wool warp
50 × 60 in.
Unique 1/1 Denver Art Museum, 1990.164, Native Arts
 acquisition funds
© Estate of Kenneth Noland/Licensed by VAGA, New York.
 Photo courtesy of Denver Art Museum

76
Kenneth Noland
"Nááts'íílid (Rainbow)"
A Gloria F. Ross Tapestry, 1990
Maquette (90-32), 1990, ink on paper, 3 × 5 in. Denver Art
 Museum, 1992.292, gift of Kenneth Noland; © Estate of
 Kenneth Noland/Licensed by VAGA, New York. Photo
 courtesy of Denver Art Museum
Irene Clark, Crystal, New Mexico, Navajo Nation
Southwest vertical loom, tapestry weave; vegetal and synthetic
 dyed handspun wool weft on mohair warp
49 × 99 in.
Unique 1/1 Denver Art Museum, 1992.133, gift of Gloria F. Ross
 and Kenneth Noland
© Estate of Kenneth Noland/Licensed by VAGA, New York.
 Photo courtesy of Denver Art Museum

71
Kenneth Noland
"Games"
A Gloria F. Ross Tapestry, 1982
Maquette F, 1981, gouache and ink on graph paper, 3 in. diam.
 © Estate of Kenneth Noland/Licensed by VAGA, New York
Rose Owens, Cross Canyon, Arizona, Navajo Nation
Southwest vertical loom, tapestry weave; pre-carded handspun
 wool weft on wool warp
43 in. diam.
Unique 1/1 Private collection
© Estate of Kenneth Noland/Licensed by VAGA, New York

74
Kenneth Noland
"Four Corners"
A Gloria F. Ross Tapestry, 1985
Maquette (85-24), 1985, ink and watercolor on paper, 8 × 8 in.
 Collection of the artist; © Estate of Kenneth Noland/
 Licensed by VAGA, New York
Sadie Curtis, Kinlichee, Arizona, Navajo Nation
Southwest vertical loom, tapestry weave; Brown Sheep Co.
 wool weft on wool warp
59 × 59 in.
Unique 1/1 Private collection, Japan
© Estate of Kenneth Noland/Licensed by VAGA, New York.
 Photo by David Heald

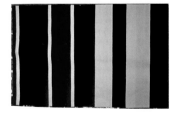

77 (not illustrated as a plate)
Kenneth Noland
"Ute Lake"
A Gloria F. Ross Tapestry, 1984
Maquette O, 1983, acrylic on canvas, 8 × 11.75 in. © Estate of
 Kenneth Noland/Licensed by VAGA, New York
Ramona Sakiestewa Studio, Santa Fe, New Mexico. Ramona
 Sakiestewa, Candace Chipman, and Rebecca Bluestone
Multi-harness floor loom, tapestry weave; Harrisville wool weft
 on wool warp
46 × 70 in.
Unique 1/1 Private collection
© Estate of Kenneth Noland/Licensed by VAGA, New York

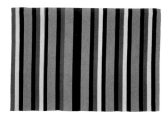

78
Kenneth Noland
"Ute Canyon"
A Gloria F. Ross Tapestry, 1985
Maquette *J*, 1983, acrylic on canvas, 3.25 × 4.5 in. © Estate of
 Kenneth Noland/Licensed by VAGA, New York
Ramona Sakiestewa Studio, Santa Fe, New Mexico. Ramona
 Sakiestewa, Candace Chipman, and Rebecca Bluestone
Multi-harness floor loom, tapestry weave; wool weft on
 wool warp
50 × 71 in.
Unique 1/1 Private collection, Japan
© Estate of Kenneth Noland/Licensed by VAGA, New York.
 Photo by David Heald

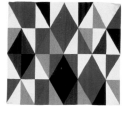

81
Kenneth Noland
"Dazzler"
A Gloria F. Ross Tapestry, 1985
Maquette *C2*, 1984, colored pencil on graph paper, 6.5 ×
 7.25 in. GFR Papers; © Estate of Kenneth Noland/Licensed
 by VAGA, New York
Ramona Sakiestewa Studio, Santa Fe, New Mexico. Ramona
 Sakiestewa, Candace Chipman, and Rebecca Bluestone
Multi-harness floor loom, tapestry weave; Brown Sheep Co.
 wool weft on wool warp
65 × 70 in.
Unique 1/1 Private collection, Japan
© Estate of Kenneth Noland/Licensed by VAGA, New York.
 Photo by David Heald

84
Larry Poons
"after Julie"
A Gloria F. Ross Carpet, 1970
Made after *Julie*, 1963, acrylic and fabric dye on brown linen
 canvas, 80 × 90 in. © Larry Poons/Licensed by VAGA,
 New York
Anna di Giovanni, with the Ruggery, Glen Cove, Long Island
Hooked (hand-tufted); Paternayan wool yarn on commercial
 cotton cloth
80 × 90 in.
5 plus 1 artist's proof authorized/4 made
 0/5 International Art Foundation
 1/5 Racine Art Museum, gift of Gloria F. Ross
 2/5, 3/5 Private collections
© Estate of Gloria F. Ross. Photo by Eric Pollitzer

79
Kenneth Noland
"Twin Springs Canyon"
A Gloria F. Ross Tapestry, 1985
Maquette *T*, 1984, colored pencil and ink on paper, 7.25 ×
 7.5 in. Collection of the artist; © Estate of Kenneth Noland/
 Licensed by VAGA, New York
Ramona Sakiestewa Studio, Santa Fe, New Mexico. Ramona
 Sakiestewa, Candace Chipman, and Rebecca Bluestone
Multi-harness floor loom, tapestry weave; Churro wool weft
 on wool warp
69 × 71 in.
Unique 1/1 Private collection, Japan
© Estate of Kenneth Noland/Licensed by VAGA, New York.
 Photo by David Heald

82
Kenneth Noland
"Ute Point"
A Gloria F. Ross Tapestry, 1991
Maquette *E (80-28)*, 1980, acrylic on paper, 12.25 × 11.25 in.
 © Estate of Kenneth Noland/Licensed by VAGA, New York
Ramona Sakiestewa Studio, Santa Fe, New Mexico. Ramona
 Sakiestewa, Candace Chipman, and Rebecca Bluestone
Multi-harness floor loom, tapestry weave; Swedish wool weft
 on wool warp
74 × 66 in.
Unique 1/1 Minneapolis Institute of Arts, 99.99.1, gift of the
 estate of Gloria F. Ross
© Estate of Kenneth Noland/Licensed by VAGA, New York.
 Photo by David Heald

85
Clifford Ross
"after Big John's Special"
A Gloria F. Ross Tapestry, 1978
Made after *Big John's Special*, 1977, acrylic on canvas,
 93.5 × 86 in. Corcoran Gallery of Art, Washington DC,
 1980.59, gift of Gloria Bookman; © Clifford Ross
Mollie Fletcher
Multi-harness floor loom, tapestry and float weaves (hand-
 picked overshot, Hernmarck technique); wool, linen,
 rayon, and cotton
78 × 72 in.
Unique 1/1 Bank of Tokyo-Mitsubishi Trust Co., New York
© Clifford Ross/Estate of Gloria F. Ross. Photo by R. E. M.

80
Kenneth Noland
"Jeddito"
A Gloria F. Ross Tapestry, 1985
Maquette *P*, 1985, ink on cardstock, 7.5 × 4.5 in. © Estate of
 Kenneth Noland/Licensed by VAGA, New York
Ramona Sakiestewa Studio, Santa Fe, New Mexico. Ramona
 Sakiestewa, Candace Chipman, and Rebecca Bluestone
Multi-harness floor loom, tapestry weave; wool weft on wool
 warp
45 × 75 in.
Unique 1/1 Private collection, Japan
© Estate of Kenneth Noland/Licensed by VAGA, New York.
 Photo by David Heald

83
Mark Podwal
"Ark Curtain (Temple Emanu-El commission)"
A Gloria F. Ross Tapestry, 1996
Maquette, 1995, hand-drawn on computer, 24.5 × 13.8 in.
 GFR Papers and collection of the artist; © Mark Podwal
Pinton S.A., Felletin, France. François Pinton, workshop
 director; staff weavers
Aubusson low-warp loom, tapestry weave; wool weft on
 cotton warp
98 × 65.5 in.
Unique 1/1 Congregation Emanu-El, New York
© Mark Podwal. Photo by Malcolm Varon, courtesy of Herbert
 and Eileen Bernard Museum of Judaica, Congregation
 Emanu-El, New York

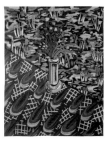

86
Lucas Samaras
"after Flowers 2"
A Gloria F. Ross Tapestry, 1975
Made after *Flowers 2*, 1974, pastel on black paper, 13 × 10 in.
 © Lucas Samaras
Pinton S.A., Felletin, France. Olivier Pinton, workshop director;
 staff weavers
Aubusson low-warp loom, tapestry weave; wool weft on
 cotton warp
84 × 64 in.
Planned as a series of 8 images/1 made
 1/1 Prudential Insurance Co., Jacksonville, Florida
© Lucas Samaras. Photo courtesy of Pace Editions

87 (maquette shown here; not illustrated as a plate)
Richard Smith
"after *Cold Corner*"
A Gloria F. Ross Carpet, 1966
Made after *Cold Corner*, 1965, pastel on paper glued to
shaped form, 12 × 12 × 3.75 in., in Plexiglas Kulicke frame.
GFR Papers; photo by Jannelle Weakly, ASM
Gloria F. Ross workshop, New York
Hooked (hand-tufted), sheared; Paternayan wool yarn on
commercial cotton cloth
60 × 60 in.
Unique 1/1 Collection not located
© Estate of Gloria F. Ross

90
Ernest Trova
"*Falling Man/Canto T*"
A Gloria F. Ross Tapestry, 1972–81
Maquette, 1972, mixed media, 14 × 14 in.
Pinton S.A., Felletin, France. Olivier Pinton, workshop director;
staff weavers
Aubusson low-warp loom, tapestry weave; wool weft on
cotton warp
83 × 83, 85 × 85, 84 × 83 in.
7 plus 1 artist's proof authorized/7 made
 0/7 Collection of the artist
 1/7, 5/7, 6/7 Private collection
 2/7 Cleveland Museum of Art
 3/7 IBM corporate art collection, Armonk, New York
 (sold 1995)
 4/7 Washington University, St. Louis
© 1972 The Trova Studios, LLC. Photo by Al Mozell

88
Richard Smith
"after *Patty, Maxine and Laverne*"
A Gloria F. Ross Carpet, 1967
Made after *Patty, Maxine and Laverne*, 1967, medium,
60 × 60 in.
Gloria F. Ross workshop, New York
Hooked (hand-tufted); Paternayan wool yarn on commercial
cotton cloth
72 × 72 in.
5 plus 1 artist's proof authorized/3 made
 1/5 Private collection
 2/5 Arthur Anderson LLP, Chicago
 3/5 Racine Museum of Art, gift of Gloria F. Ross
© Estate of Gloria F. Ross. Photo by Eric Pollitzer

91
Jack Youngerman
"*September White II*"
A Gloria F. Ross Carpet, 1968
Maquette, 1967, gouache on paper, 21.5 × 15 in. GFR Papers;
© Jack Youngerman/Licensed by VAGA, New York. Photo
by Jannelle Weakly, ASM
Anna di Giovanni, with the Ruggery, Glen Cove, Long Island
Hooked (hand-tufted); Paternayan wool yarn on commercial
cotton cloth
84 × 60 in.
5 plus 1 artist's proof authorized/6 made
 0/5 Collection of the artist
 1/5 International Bank for Reconstruction & Development
 2/5 Quaker Oats Building/SOM, Chicago
 3/5 John Hancock Building/SOM, Chicago
 4/5 U.S. Steel, Pittsburgh
 5/5 Wolf Associates
© Jack Youngerman/Licensed by VAGA, New York

89
Frank Stella
"after *Flin Flon XIII*"
A Gloria F. Ross Tapestry, 1972–74
Made after *Flin Flon XIII*, 1970, acrylic and fluorescent paint on
canvas, 108 × 108 in. Kreeger Museum, Washington DC;
© 2010 Frank Stella/Artists Rights Society
Pinton S.A., Felletin, France. Olivier Pinton, workshop director;
staff weavers
Aubusson low-warp loom, tapestry weave; wool weft on
cotton warp
106 × 106 in.
7 plus 1 artist's proof authorized/4 made
 1/7, 2/7, 3/7 Private collections
 4/7 Clifford Ross
© 2010 Frank Stella/Artists Rights Society (ARS), New York

92 (not illustrated as a plate)
Jack Youngerman
"*Untitled (John Hancock Building/SOM commission)*"
A Gloria F. Ross Carpet, 1969
Maquette, 1969, acrylic on paperboard, 19 × 48 in. © Jack
Youngerman/Licensed by VAGA, New York
Anna di Giovanni, with the Ruggery, Glen Cove, Long Island
Hooked (hand-tufted); Paternayan wool yarn on commercial
cotton cloth
102 × 264 in.
Unique 1/1 John Hancock Building/SOM, Chicago
© Jack Youngerman/Licensed by VAGA, New York.

93

Jack Youngerman

"Blackout"

A Gloria F. Ross Tapestry, 1972–77

Made after *Tapestry Study: Blackout*, 1970, cut paper, 8 × 8 in. GFR Papers; © Jack Youngerman/Licensed by VAGA, New York. Photo by Jannelle Weakly, ASM

Dovecot Studios, Edinburgh Tapestry Co., Scotland (all but 2/5). Archie Brennan, director of weaving; Fred Mann, Harry Wright, Douglas Grierson, Maureen Hodge, and Fiona Mathison

Tapeçarias de Portalegre, Portugal (2/5). Guy Fino, director of weaving, and staff weavers

Gobelins high-warp loom, tapestry weave; wool weft on cotton warp

96 × 96 in.

5 plus 2 artist's proofs authorized/3 made

 0/5 Collection of the artist

 00/5 Clifford Ross

 1/5 Private collection

 2/5 Avon Products, New York

 3/5 City National Bank, Los Angeles

 4/5 IBM corporate art collection, Armonk, New York (sold 1995)

 5/5 Drake University, Des Moines, Iowa

© Jack Youngerman/Licensed by VAGA, New York. Photo by Eric Pollitzer

95

Jack Youngerman

"Rumi's Dance"

A Gloria F. Ross Carpet, 1976, commissioned by the Art in Architecture Program, U.S. General Services Administration

Maquette, 1975, acrylic on canvas, 14 × 14 in. © Jack Youngerman/Licensed by VAGA, New York

The Ruggery, Glen Cove, Long Island. George Wells and staff

Hooked (hand-tufted); Paternayan wool yarn on commercial cotton cloth

168 × 168 in.

Unique 1/1 Edith Green–Wendell Wyatt Federal Building/SOM, Portland, Oregon

© Jack Youngerman/Licensed by VAGA, New York. Photo by Carol M. Highsmith, courtesy of U.S. General Services Administration

94

Jack Youngerman

"Enter Magenta II"

A Gloria F. Ross Tapestry, 1975–76

Maquette, 1974, cut paper, 25 × 20 in. GFR Papers; © Jack Youngerman/Licensed by VAGA, New York. Photo by Jannelle Weakly, ASM

Pinton S.A., Felletin, France. Olivier Pinton, workshop director; staff weavers

Aubusson low-warp loom, tapestry weave; wool weft on cotton warp

90 × 72 in.

7 plus 1 artist's proof authorized/3 made

 0/5 Collection of the artist

 1/7, 2/7 Private collections

 3/7 Herbert and Eileen Bernard Museum of Judaica, Congregation Emanu-El, New York

© Jack Youngerman/Licensed by VAGA, New York. Photo by S. S.

96

Jack Youngerman

"Maritimus"

A Gloria F. Ross Carpet, 1989

Maquette, 1987, acrylic on paper

Edward Fields, Inc.

Commercial pile carpet, wool, with relief shearing

63 × 84 in.

20 authorized/1 made

 1/20 Collection of the artist

© Jack Youngerman/Licensed by VAGA, New York. Photo by Kubernick

Glossary

Words in *italics* are French or of French origin. Words in CAPITALS are also defined in this Glossary. For more about tapestry terms, structures, tools and techniques, see Emery (1966), Beutlich (1967), Pianzola and Coffinet (1971), Galice (1990), Russell (1990), and Harvey (1991).

Artist's proof. In printmaking, the first official imprint from a press for an artist's review. In twentieth-century tapestry making, one or two artist's proofs were made as payment to the artist/designer and ÉDITEUR. Ideally, these were made first but sometimes produced out of sequence, that is, later than pieces in the numbered EDITION. Identical in appearance and construction to the numbered works in an edition, artist's proofs are enumerated 0/x for the first proof, 00/x, if made, for the second, with x being the total number in the edition without counting artist's proofs.

Atelier. A workshop or studio.

Aubusson. A town in France famous for its tapestries woven on the LOW-WARP LOOM; a style of weaving using such looms. The neighboring town of Felletin is also well known for the same kind of weaving. Traditional weavers generally work facing the reverse side of the fabric and use multicolored strands of WEFT yarn to create Aubusson tapestries, flat-weave carpets, and furnishings.

Aubusson-style loom. See LOW-WARP LOOM.

Bobbin. A slender spool on which the WEFT yarns are wound; used to insert the weft between the WARP yarns. Some weavers use a pointed bobbin to position and pack the weft into place; when blunt bobbins are employed, a fork, beater, COMB or *GRATTOIR* may also beat the wefts into place.

Bolduc. A label identifying a tapestry's designer and maker(s), title, edition number, and date, usually sewn to the reverse side of a tapestry.

Carpet. A TEXTILE used as a floor covering or less commonly as a wall hanging; made in a wide variety of techniques and materials; often synonymous with the term "rug."

Carton. A tapestry CARTOON.

Cartonnier. Maker of tapestry CARTOONS.

Cartoon. A full-scale or small-scale drawing, sketch, or photograph from which a tapestry is woven, usually made from an original MAQUETTE, the colored model for a tapestry. If full scale, this may be placed under the warps (low-warp) or behind them (high-warp). Cartoons take many forms. The classic AUBUSSON variety is a full-scale image, showing a mirror image of the design in black-and-white, with numbered codes for the colors; others may be smaller and sketchier or depicted in full color.

Chaîne. WARP.

Chapelet de couleurs. Literally, a rosary of color; in weaving, a series of dyed yarn samples, coded according to colors chosen for a prospective TAPESTRY and corresponding to numbers on its CARTOON; usually small skeins of yarn are tied or looped together and form a record for weaving future versions of a tapestry EDITION.

Comb. A toothed hand tool used to pack the WEFT yarns between the WARP yarns. Native American weavers use the pointed handle of their wooden comb to position the weft and the toothed end to beat the wefts into place.

Dovetailed join. Method of changing colors in a tapestry without creating a SLIT, in which adjacent color areas are connected by the WEFT yarns passing around a common WARP and returning in the reverse direction; often produces a slightly more jagged line of demarcation than the INTERLOCKED version.

Échantillon. A sample, usually of dyed yarns for a prospective TAPESTRY.

Éditeur. Producer of EDITIONS; the person who orchestrates production of a TAPESTRY or a limited EDITION of tapestries.

Edition. A series of tapestries woven in the same design from a single CARTOON. Limited editions have a fixed number of works produced with the understanding that no further works will be made. In AUBUSSON workshops, the usual approved number is seven with one or two additional ARTIST'S PROOFS; in the Dovecot workshop, the standard is five plus one or two artist's proofs.

Essai. A woven TRIAL or proof for a prospective TAPESTRY.

Float weave. A simple over-under interlacing in which WARP or WEFT yarns may extend over two or more yarns in the opposite set; used to create patterns and/or texture in a fabric.

Gobelins. A workshop in France famous for its tapestries woven on the HIGH-WARP LOOM; a style of weaving using such looms. (Spelled without a final *s*, Gobelin is the surname of a family of French dyers dating back to the mid-fifteenth century.) In France, a colored CARTOON in mirror image to the final design is placed behind the WARP yarns and the pattern is transferred onto the warps; the cartoon is then removed and placed nearby as a reference; a mirror behind the warps allows the weavers to view the finished side of the fabric as they weave facing the reverse side. At the Dovecot workshop in Scotland, Gobelins looms are used, but weavers face the proper side of the fabric and dispense with the mirror.

Gobelins-style loom. See HIGH-WARP LOOM.

Grattoir. A toothed comb of wood or metal, used to pack the WEFT yarns into place between the WARP yarns.

Hachures. In TAPESTRY weaving, a system of stylized shading in which two or more contrasting colors of WEFT yarn form graduated stripes or lozenges that interfinger to suggest depth or texture in the imagery.

High-warp loom. Mechanical weaving device with WARPS oriented in a vertical position (at right angles to the floor), operated with hand-controlled string heddles (leashes); also called *haute lisse* and arras. Used in the GOBELINS and Dovecot workshops. The SOUTHWEST VERTICAL LOOM is also upright and lacks foot treadles but has a different operating system.

Hooked-rug technique. A method in which PILE is added to an existing fabric by hooking yarns or fabric strips through a fabric backing in loops, sometimes called TUFTING.

Interlocked join. A method of changing colors in a TAPESTRY without making slits, in which adjacent color areas are connected by WEFTS passing around each other and returning in the direction they came; the line of demarcation appears somewhat smoother than in the DOVETAILED version.

Lissier (also *licier*). Weaver.

Loom. Any device on which WARP yarns are fixed in place so that WEFT yarns can be interlaced to form a cloth. Looms range from the simplest of frames to complex computerized mechanisms.

Low-warp loom. A mechanical weaving device with WARPS oriented in a horizontal position (parallel to the floor), operated with foot treadles that control a series of harnesses with heddles. Used in AUBUSSON and nearby villages; many variants exist worldwide.

Maquette. Model; an original painting, collage, drawing, print, or other artwork used as the model from which an intermediary CARTOON is made and a TAPESTRY produced; may result in a uniquely woven artwork or a limited EDITION. The maquette may be a preexisting artwork or made expressly as a tapestry design. In sculpture, a maquette is the model from which a single work or multiple edition may be cast.

Maître-lissier. Master weaver.

Métier. A weaving loom; a career; a profession, sometimes with connotations of a good match between person and job, as in *un bon métier*.

Mille Fleurs. Literally, a thousand flowers; tapestries with a floral ground, produced in Europe in the fifteenth and sixteenth centuries.

Oeuvre. Work of art, body of work.

Plain weave. A woven structure in which WEFT yarns interlace in regular fashion over and under a set of WARP yarns. The resulting cloth may be warp-faced, weft-faced, or balanced.

Peintre-cartonnier. Painter-cartoonmaker, in France, usually a classically trained fine artist.

Peintre-lissier. Painter-weaver.

Pile carpet. Floor covering made with PILE WEAVE in any of a number of handmade or commercial techniques.

Pile weave. A woven structure in which supplemental warp or weft loops, or tufts, project above the plane of the fabric.

Rayures. Banded design elements; stripes; streaks.

Slit tapestry. A method of changing colors in a tapestry, in which two adjacent color areas have no connecting WEFTS and form a vertical slit; slits may remain open or be sewn together. Contrast with the DOVETAILED and INTERLOCKED versions. Found in many fabrics worldwide, including European tapestries in which the slits are sewn closed after the cloth's removal from the loom and kelim carpets in which short slits are left open.

Southwest vertical loom. Upright weaving device with WARPS oriented in a vertical position (at right angles to the ground or floor), operated with hand-controlled shed sticks and string heddles. By using a continuous uncut warp, the weaver produces a fabric with four complete selvages. Used by Pueblo and Navajo Indian weavers of the American Southwest and other handweavers who have adopted the tool.

Soumak. A woven structure in which WEFT yarns pass over two and under one WARP yarn; a wrapping technique that creates a slightly raised line or textured surface.

Tapestry. A textile handwoven with TAPESTRY WEAVE, or one of its variants; also used generically by novices for any decorative TEXTILE used as a wall hanging.

Tapestry weave. A WEFT-faced plain weave with discontinuous WEFT patterning, or any of a number of variants of this textile structure.

Tapis. CARPET, usually constructed in PILE WEAVE or with TUFTING.

Tapisserie. TAPESTRY.

Textile. In the strictest sense, a fabric woven with interlaced WARP and WEFT yarns. More generally, the term often refers to any woven, looped, linked, knotted, felted, or otherwise constructed fabric made of fibrous materials that are flexible in nature.

(La) tombée du métier. Literally, the fall of the LOOM; the removal of new work from a loom by cutting the WARP yarns, sometimes accompanied by a celebratory "cutting off" party.

Trial. A woven sample, used to plan a larger TAPESTRY.

Trompe l'oeil. Literally, "fool the eye"; an artwork that provides the illusion of a three-dimensional subject.

Tufted/tufting. A textile structure in which supplemental strands of yarn or bunches of fiber are inserted into a backing fabric; yarns may be continuous, looped, and subsequently cut, or may be cut in short strands before insertion.

Vernissage. The inauguration or opening of a museum exhibition or gallery show, usually accompanied by a celebration.

Warp. In weaving, the tensioned yarns that are strung between the warp beams on a LOOM to form the foundation into which WEFT yarns are woven over-and-under to construct a cloth. In TAPESTRY WEAVE, which is usually weft-faced, the weft (pattern) yarns usually cover the hidden warp (foundation) yarns.

Weft. In weaving, the yarns that interlace over-and-under the WARP (foundation) yarns. In TAPESTRY WEAVE, the weft yarns form the visible pattern on the face of the fabric.

For abbreviations and an explanation of the GFR Papers' numerical codes and organization of these primary sources, see page 352.

Preface (pp. viii–ix)

1. ALH field notes, 7/6/1979, p. 18.

2. Hedlund (2005).

3. Kuh (2006:86).

1. Introduction (pp. 3–5)

1. Ross (1983).

2. Throughout this book, I refer to Gloria F. Ross by her first name. She was born Gloria Frankenthaler and took the name Gloria F. Ross when she first married. After a divorce in 1970, she kept her first husband's surname as her professional name. In notes and other informal records, she referred to herself as "GFR" or just "G." The body of work that she orchestrated is known as the Gloria F. Ross Tapestries & Carpets, or the GFR Tapestries. During her second marriage, Gloria became known socially as Mrs. John J. Bookman and Gloria Bookman. For other individuals in this book, following the first mention of their full name, I generally refer to them by last name only.

3. The focus here is on weaving collaborations, but the rise of individual weaver-artists, who independently design and produce their own tapestries with or without studio assistance, is another important twentieth-century movement (Phillips 1994:148; Shaw 1989:9–13).

4. One of the most common imitations of tapestry weave occurs in fabrics woven on the mechanized Jacquard loom (an elaborate contraption that was the precursor to modern-day computers), but the pattern wefts pass across the entire width of the fabric and are not discontinuous as in "true" tapestry. The technique is used to replicate historic designs for commercial upholstery fabric and wall hangings and has recently entered the creative tool kit of inquisitive modern artists.

5. The development of European tapestry is well documented and illustrated by Adelson (1994), Bennett (1992), Campbell (2002, 2007), Cavallo (1967, 1993, 1998), and Standen (1987), among others. For a popularized worldwide summary, see Stack (1988).

6. For further descriptions of the Scottish, French, and Australian workshops, see chapters 4, 5, and 6. A special issue of *FiberArts* (1983) describes some organized tapestry studios at the time, including the American workshops, which are further profiled in Shaw (1989), Lurie and Larochette (2008), and New Jersey State Museum (1985). Ramses Wissa Wassef Art Centre (2006) recounts its remarkable history.

7. Constantine and Larsen (1973).

8. René [d'Harnoncourt] to HF and RM, 7/28/1965.

9. Ross (1988).

10. GFR to François Pinton, 9/26/1990, 204-013.

11. Harris (1979:3).

12. Métier is variably defined in *Dictionnaire Larousse* (1955:160) as "trade, profession, craft; loom (*à tisser*); handicraft (*manuel*)"—all would seem appropriate in this case.

13. Ross (1990).

2. A New York Life (pp. 9–23)

1. The perspectives expressed here come from the vantage point of the author's friendship with Gloria Ross during the latter part of her life, from 1979 to 1998, and from archival research conducted since her death. Unless otherwise noted, all directly quoted statements by Gloria Ross in this chapter are from tape-recorded interviews with the author on 10/22/1995 and 2/19/1996 and in 1979–98 correspondence between GFR and ALH, in the files of the author.

2. Many particulars of the Frankenthalers' and Rosses' lives were drawn from articles and announcements in the *New York Times*, 1900–1958.

3. Farther west on Cedar Street, in Greenwich Village, was the original location of the Cedar Bar. Later, the Cedar Bar, no longer on Cedar Street, was where Helen Frankenthaler and a circle of rising artists and musicians (Robert Goodnight, Grace Hartigan, Joan Mitchell, Larry Rivers, and John Cage among them) hung out and held "heated conversations about art" (Cross in Guggenheim 1998:11).

4. I. Maurice Wormser, letter to the editor, *New York Times,* 10/5/1926.

5. *New York Times,* 6/16/1922.

6. Box holders were listed annually in the *New York Times*. Alternating weeks was a common opera house custom, and Mondays were "the smart night for opera-going . . . for the simple reason that Mrs. Astor and [Ward] McAllister had chosen Monday as their night to go" (Birmingham 1967:359). The Frankenthalers' box is also significant because just five years earlier "no Jew could be a Metropolitan Opera box holder." In 1917, financier and Jewish philanthropist Otto Kahn was finally offered a box in the Diamond Horseshoe, as recognition of the several million dollars he had contributed to the opera (Birmingham 1967:360–63).

7. *New York Times,* 4/4/1922.

8. *New York Times,* 1/8/1940. The entire account is instructive: "The law at the time was inadequate; its constructions, as far as the rights of guaranteed mortgage-certificate holders were concerned, non-existent; and the machinery for rehabilitation inadequate and inefficient and open to political corruption. It was Justice Frankenthaler's task, with the aid from the State Department of Insurance and other agencies, to fashion rules and construct procedures to recover for investors values threatened with destruction by wholesale bankruptcy. . . .

"This plan for reorganizing guaranteed mortgage certificate properties, in which he developed a special type of trusteeship out of a situation of unique complexity and peculiar difficulty, won the admiration not only of attorneys and their clients benefited by what they frequently describe as 'almost miraculous improvement in the income and condition of the security behind defaulted issues' but also of his colleagues. . . .

"Besides initiating what came to be known over the country as the Frankenthaler plan for recognition, he paid close attention to the details of administering the properties under control of the court, and his decisions on the apportionment of income and the allocation of assets saved investors millions of dollars and paved the way for the construction of a body of law safeguarding modern real estate investment. . . ."

9. Rebecca Straus, New York, NY, personal communication, 6/21/2007.

10. In 1932, when her term expired, she was replaced by no less than William Randolph Hearst, Jr.

11. Congregation Emanu-El of the City of New York, "Temple Emanu-El," http://www.emanuelnyc.org.

12. Ibid.

13. Iseman (1974).

14. In a later interview, Gloria also noted, "My mother was a professional woman, but did not paint professionally." She may have been referring to her mother's earlier secretarial work, but the reference is not clear.

15. Gloria maintained a special fondness for the Horace Mann School throughout her life. Founded in 1887 as an experimental and developmental unit of Teachers College at Columbia University, the school was named for the nineteenth-century Massachusetts legislator and former president of Antioch College, known as the "Father of American Education" for his liberal championing of public schools open to all. Horace Mann School was initially co-educational. The all-girls division formed sometime around 1912, merged with the Lincoln School in 1940, and closed its doors in 1946. In 1975, the school, no longer located in Morningside Heights, again became co-educational.

16. Rebecca Straus, New York, NY, personal communication, 6/21/2007.

17. Ibid.

18. *New York Times,* 1/10/1940.

19. *New York Times,* 2/6/1940.

20. *New York Times,* 12/28/1941.

21. Frankenthaler quoted in Guggenheim (1998:27).

22. *New York Times,* 1/21/1946.

23. Founded in 1946 and sponsored jointly by the Jewish Board of Guardians and the New York Section of the National Council of Jewish Women, the Center was a specialized clinic for the study and treatment of children suffering from behavioral disorders and an advanced training program for psychiatrists and other specialists focused on preschool children.

24. File 174, GFR Papers.

25. To publicize this committee's efforts, the *New York Times* pictured Gloria seated between two other volunteers: Mrs. R. Thornton Wilson, Jr., who was married to a descendant of John Jacob Astor, and Mrs. Nancy Olsen Lerner, actress and wife of lyricist Allan Jay Lerner—at the Carlyle with cups of tea delicately positioned in front of them. Also serving on this committee was Gloria's good friend Ruth Lowe Bookman (*New York Times,* 10/17/1958).

26. *New York Times,* 4/7/1958.

27. GFR to Archie Brennan, 1/5/1976, 193-151.

28. George Wells to GFR, undated, 210-002.

29. GFR to Robert Motherwell, 7/16/1974, 057-042.

30. In fact, Helen had even had tapestries made before Gloria began her work. In 1956, she designed a set of Ark curtains for a signal modernist building—the Temple of Aaron in Saint Paul, Minnesota—designed by architect Percival Goodman. An article and notes about this project are included in file 171, GFR Papers (Greenberg 1994; Rose 1972:261).

31. See Goossen (1969) and Rose (1972).

32. GFR to Archie Brennan, 3/31/1975, 193-108.

33. GFR to Archie Brennan, May 1987, 191-022/023.

34. GFR to ALH, 11/29/1987, in the files of the author.

35. GFR to Archie Brennan, 10/14/1987, 191-018.

36. GFR to Archie Brennan, 11/21/1987, 191-016.

37. GFR to François Pinton, 4/24/1988, 12-139.

38. GFR to Archie Brennan, 10/19/1988, 191-014.

39. Gloria's initial travels abroad may have been inspired by her younger sister's extensive global explorations. Helen Frankenthaler made her first trip to Europe for two months during 1948, visiting London, Amsterdam, Brussels, Geneva, and Paris, and a pattern of nearly annual European trips followed.

After her 1958 marriage to Motherwell, visits and extended stays in Europe became part of her life (Guggenheim 1998:85–93).

40. GFR to Sheila Hicks, 10/16/1979, 195-001.

41. GFR to Olivier Pinton, 4/23/1972, 202-045.

42. Gloria's southwestern interests may also have been obliquely linked to her sister's. Helen Frankenthaler visited the Southwest for the first time in March 1976, while lecturing at the Phoenix Art Museum; she returned in 1977 (Carmean 1989:98). In 1986 Frankenthaler began conducting master classes at the Santa Fe Institute of Fine Arts, where she has returned periodically. About this time, Gloria began planning her solo exhibition at Rutgers Barclay Gallery in Santa Fe for 1989. However, the two sisters only occasionally met in the Southwest.

43. Founding trustees of the GFR Foundation included Simon H. Rifkind (1901–1995), a family friend best known as the attorney of Jacqueline Kennedy Onassis; attorney Jack O'Neil, also a partner at the powerful firm of Paul, Weiss, Rifkind, Wharton & Garrison; and her son, the artist Clifford Ross.

44. Her close friend Caroline Goldsmith, senior vice president for Arts & Communications Counselors in New York, was executive director at the time. Other members included many of Gloria's friends who were prominent in the arts, museum, and media worlds of New York.

45. Hedlund (1992).

46. GFR to Koch, 2/27/1985, copy in the files of the author.

47. *New York Times,* 6/24/1998.

48. Some plans, however, were never put into action: "I have had my first talk with Liz Kennan about long-term plans for establishing a craft center at Mount Holyoke, of course with a focus on textile exhibition and studio activities. She is very, very enthused about the whole idea, as no other liberal arts colleges (certainly in our area) offer such a program. MHC, like most other colleges, offers fine arts courses and exhibitions, and the collections to date have focused on the fine arts. . . . It would have to be approved by the board of trustees; and that knowing some of their attitudes that it would provoke some lengthy talks. At any rate, she is hopeful and confident that the proposal will be accepted" (GFR to ALH, 5/9/1986, in the files of the author).

49. McCracken (1998).

50. Jack Lenor Larsen to Edwin Zimmerman, 11/16/1992, 176-029.

51. I am grateful to Dr. Ann Bookman for pointing out the significance of *tzedakah* in Gloria's life. Judaism considers charity to be an act of justice more than an act of good faith. According to the tradition, people in need have a right to food, clothing, and shelter and this must be honored by others more fortunate. Giving *tzedakah* is thus not voluntary. One of the more meritorious forms of giving is that in which the donor's identity goes unrecognized.

52. Eulogy by Ann Lane Hedlund, June 23, 1998, Temple Emanu-El, New York, in the files of the author. In the context of explaining aspects of conceptual art collaborations in the late 1960s and '70s, Green has noted that "'Work' was the operative word, . . . for [the artists] Burn and Ramsden would not quite designate their works as 'art,' preferring instead an intermediate imaginative zone of reflexive critique connoted by 'work'" (Green 2001:46). Possibly Gloria's use of the word for the woven creations she orchestrates takes on some of this self-consciousness even as it was used with pride.

53. GFR notes, 9/11/1992, 167-003.

54. GFR notes, 10/1992, 167-002.

55. Christie's twentieth-century art auction catalogue, 11/20/1998, p. 56, lots 755–758, New York, NY. Many of the artworks mentioned here were sold by Gloria's estate at this and other sales on 1/19/1998, 1/21/1999, 2/3/1999, and 5/5/1999.

56. Programs ranged widely: from tapestry's origins in the Middle East; ancient Coptic tapestries in Egypt; the development of Native American weaving in the Southwest; European medieval and renaissance tapestry history; the marketing of European tapestries in the nineteenth century; and contemporary art tapestries by individual weavers from around the globe.

57. The GFR Center does not collect textiles. In addition to her substantial gift of thirty-eight textiles plus research and exhibition funding to the Denver Art Museum (see Hedlund 1992), Gloria and her estate donated the remaining GFR Tapestries & Carpets to the Metropolitan Museum of Art, Museum of Fine Arts in Boston, Cleveland Museum of Art, Minneapolis Institute of Arts, Neuberger Museum of Art at SUNY–Purchase, Racine Art Museum, the Textile Museum in Washington DC, Mount Holyoke College Art Museum, Herbert & Eileen Bernard Museum of Judaica at Temple Emanu-El, and Horace Mann School.

58. Grace Glueck, "Gloria F. Ross, 74, Tapestry Designer." *New York Times,* 6/23/1998.

59. Eulogy, Hedlund, 1998.

3. Hooked Wall Hangings, Pile Carpets (pp. 25–35)

1. GFR interview with the author, 10/22/1995, transcription in the files of the author.

2. GFR notes.

3. Richard Feigen Gallery press release, 4/9/1969, 139-009.

4. The term *tapestry* is used here because that is what Gloria called her needlework even though it was not handwoven in a tapestry weave. As discussed later in this chapter, these hooked works should technically be called carpets, rugs for the wall, or wall hangings, rather than tapestries.

5. Ross (1989).

6. Cuyler (1974:89). These rugs were made by Leslie Stillman, Gertrude Palmer, Margery Humphrey, and Elodie Osborn, none of whom worked with Gloria F. Ross.

7. The artists included Helen Frankenthaler (1963–71), Robert Motherwell (1963–71), Kenneth Noland (1966–70), Richard Smith (1966–67), Robert Goodnough (1967–69), Jack Youngerman (1968–76), Paul Feeley (1969–70), Larry Poons (1970), Morris Louis (1970), and Adolph Gottlieb (1970–71).

8. Cuyler (1974:24).

9. Faraday (1929:293).

10. Weeks and Treganowan (1969:176).

11. Emery (1966:174, original emphasis).

12. Ibid., 245.

13. Ibid., 173.

14. Ibid., 148.

15. The two previous citations are from *American Heritage Dictionary of the English Language,* fourth edition, 2000, online.

16. Often used in needlepoint, embroidery, antique rug repair, and knitting, these exceptionally strong and lustrous three-ply worsted tapestry yarns were developed by Harry and Karnick Paternayan, rug

restorers who immigrated to America from Turkey in 1916.

17. Cuyler (1974:5).

18. Cuyler (1974:46). Gloria's original tool, which the Geo. Wells Ruggery and many other professionals also used, was a "Deluxe Rug Needle Set," supplied with interchangeable No. 2 and No. 0 needles, made by Columbia-Minerva Corporation, famous for their wool yarns. A "Craftsman Punch Needle" is now made and marketed by the Ruggery (www.theruggery.com).

19. See Cuyler (1974:4-5).

20. Quotations are from GFR notes in file 101.

21. GFR quoted in Pyne (1984).

22. Ross (1977).

23. Invoice 7/2/1970, 38-3. This Anna di Giovanni is not to be confused with another Anna di Giovanni of New York who was born in Castel di Ieri, Abruzzo, Italy, in 1904; came to America in 1922 with her husband, Rocco, a steel worker, coal miner, and cobbler; worked as a seamstress in a Coney Island shirt factory; raised six children and lived most of her life in Brooklyn; and died on Staten Island in 2001 (Thomas DeAngelo, personal communication, 4/20/2006).

24. GFR notes, 4/16/1969, 116-006.

25. Invoice, 9/11/1969, 116-003.

26. The same in appearance and construction as the numbered pieces, the artist's proofs received numbers 0/5 and 00/5. GFR note, 055-005.

27. GFR note, 094-002.

28. GFR to George Wells, c. July 1970, 051-025.

29. Anna di Giovanni to GFR, 9/30/1971, 126-061. However, George Wells shipped the finished "rugs" to Richard Feigen Gallery in April 1972. Perhaps the project was too large for Anna and Wells did the hooking, or perhaps Anna was working for Wells at the time.

30. Pat Kle, "The Ruggery: A Feast for the Eyes and Feet." *Oyster Bay–Glen Cove Guardian,* January 1977, "Scene" section, p. 3.

31. Clipping, 132-024.

32. Grace Madley "He's Dye-ing to Hook Rugs." *Daily News,* 5/8/1983, p. MB9.

33. The Ruggery, http://www.theruggery.com, Glen Cove, NY.

34. GFR to George Wells, 038-002.

35. George Wells to GFR, 117-007, 117-005, and 117-039.

36. Information relating to this commission is located in files 124 and 132.

37. Dianne Dromley to GFR, 6/23/1986, 132-005.

38. GFR to ALH, 9/9/1986, in the files of the author.

39. Seaboard Outdoor Advertising Co. to GFR, 7/17/1986.

40. George Wells to GFR, undated, 210-003.

41. GFR notes, file 210.

42. Statements by the Hound Dog Hookers' descendents are recorded in email correspondence with ALH, 2007–08, in the files of the author.

43. Gloria and Schoenfeld may have worked together briefly. During Gloria's first Feigen Gallery show, the latter wrote, "Dear Gloria: I am sure you are getting many letters just as this one. I saw your show and liked it immensely. It was a tremendous pleasure to see all these various 'hooked rugs' in such elegant surroundings. I love the way in which the rugs were clipped. Perfection everywhere. Best to you, Laura.

P.S. I have been sending all my former and present students to see the exhibit." (Laura Schoenfeld to GFR, 5/7/1969, 139-015).

44. V'Soske, Inc., http://www.vsoske.com, New York.

45. The workshop was operated by Ronald K. (Romne) Mosseller. Mosseller originally contacted Gloria in June 1986 after learning about her projects from artist Preston McAdoo who ran a hooked rug business in North Bennington, VT, and had a New York shop for years.

46. Receipt, 10/27/1969, 034-001.

47. These included all editions of Frankenthaler's "after *Blue Yellow Screen*" and "after *Point Lookout*" in 1966, Goodnough's "*Abstraction with Black Forms*" in 1969, and Noland's "after *Every Third*" in 1970.

48. GFR to Barbara Dixon, *Architectural Digest*, 11/6/1980, 042-054.

49. In 2005, Edward Fields, Inc., with seven showrooms in New York, Chicago, Dallas, Dania (FL), Houston, Los Angeles and San Francisco, was purchased by Tai Ping Carpets Americas of Hong Kong.

50. Rostov to China National Native Produce & Animal By-Products Import & Export Co. (China National Native Produce), Beijing, People's Republic of China, 2/26/1979, 118-18. This reference and all other notes and correspondence that provide the following information about the Chinese project are found in file 118.

51. GFR to Dorothy Berenson Blau, director, Hokin Gallery, Bay Harbor Islands, FL, 4/27/1982, 163-027.

52. In 1980 the work was shown briefly in Manhattan at the Washburn Gallery on 57th Street and in the carpet department at Bloomingdales. At Youngerman's suggestion, Gloria and Rostov considered also showing the piece through Modern Masters, Inc., also in the 57th Street art district, but this never happened.

53. While in Melbourne, Australia, in 1988 Gloria met Mu Guang, the artist manager of the Beijing Artistic Tapestry Center, part of China International Trust & Investment Corporation. They shared information but no plans were made (196-027 to 196-029).

54. Weeks and Treganowan (1969:176).

55. GFR to Frank Stella, 8/7/1971, 112-047.

4. Archie Brennan and the Dovecot Studios (pp. 39–57)

1. Ross (1988).

2. Brennan (1980:35).

3. Hodge (1980:41).

4. Soroka (1983:59).

5. Grierson, email to ALH, 2/25/2010.

6. Hodge (1980:43).

7. Marcia Morse, "Weaver reveals the vitality of an ancient art: Maui artist links tradition and modernity." *Honolulu Star-Bulletin & Advertiser*, 5/24/1987.

8. Barnes (1980:43).

9. Morse (1987).

10. Unless otherwise noted, citations in this chapter drawn from Gloria's notes and from correspondence between Gloria, Archie Brennan and other employees at Dovecot Studios are in the GFR Papers, files 177 and 191–193.

11. McCullough (1980).

12. Brennan (1998; emphasis added).

13. Walker (2007:200).

14. Brennan (2003).

15. Brennan (1998).

16. Morse (1987).

17. Brennan (2003).

18. Brennan (2003).

19. Soroka (1983:59).

20. Grierson, email to ALH, 2/25/2010.

21. Brennan, email to ALH, 10/26/2005.

22. In fact, at one time this led Gloria to declare, "from here on I shall request a 'series' from each artist so that each tapestry can be unique," but this didn't actually happen (GFR to Archie Brennan, 1/30/1974, 015-024).

23. Barnes (1980:39).

24. Hodge (1980:41).

25. Barnes (1980:40).

26. Hodge (1980:43).

27. Clausen (1986:[29]).

28. These included editions of Motherwell's "after *Elegy to the Spanish Republic #116*" (1970), Frankenthaler's "after *1969 Provincetown Study*" (1970); Goodnough's "*Red/Blue Abstraction*" (1971), Youngerman's "*Blackout*" (1972), Nevelson's "*Sky Cathedral*" (1972), Gottlieb's "after *Black Disc on Tan*" (1972), Dubuffet's "*Personnage*" (1974), Nevelson's "*Sky Cathedral II*" (1974), and seven other unique Nevelsons (1977–1980).

29. Scottish Arts Council (1980:90; emphasis in original).

30. Curiously, there are no conclusive records that this final tapestry in the Motherwell edition was actually executed.

31. The fourth piece (4/5) woven at the Dovecot in 1977 met with considerable controversy because of contentious finances. Douglas Grierson has recalled, "The tapestry was eventually burned on the orders of G. F. R. in the Dovecot back garden with both sets of legal representatives looking on at what was an act of artistic vandalism." Grierson to ALH, 2/25/2010.

32. Brennan (1998).

33. Brennan, email to ALH, 10/26/2005.

34. Brennan (1998).

35. Ross (1988).

36. Soroka (1983).

37. Draft letter from Joanne Soroka to Charles Talley, *Craft International*, 2/18/1983, 192-041.

38. Talley (1983).

39. Gloria intended the 00 versions of each edition as a personal collection for herself.

40. In rapid succession, the tapestries included number 3/5 completed in September 1976, 4/5 in December 1976, and 0/5 and 5/5 in February 1977.

41. Brennan (2003). Cf. New Jersey Center for Visual Arts (2003).

5. The Workshops of Aubusson and Felletin (pp. 61–79)

1. Ross (1977). In this lecture, Gloria acknowledged, "Archie . . . introduced me to weaving in Aubusson in France. Certain tapestry is best woven there."

2. GFR notes, c. 8/1971, 202-028.

3. Lesné (2005:40).

4. Fontes (2006) and Fadat (1992) provide excellent background for the discussion of twentieth-century French tapestry history that follows.

5. Fadat (1992:11).

6. Fontes has documented as least twenty-five artists who executed fifty-four tapestry CAF cartoons,

which were woven by Pinton between 1940 and 1945 (2006:94).

7. This and the following paragraphs about Cuttoli are drawn from the excellent work of Virginia Gardner Troy (2006a). The two following citations are taken from p. 241 of this article.

8. Jean Manuel de Noronha, 2009, "Who Produced Robert Indiana's First Love Rug? Charles E Slatkin, Marie Cuttoli or John Gilbert?" http://thecarpetindex.blogspot.com/2009/07/who-nproduced-robert-indianas-first.html.

9. Troy (2006a:243). Fontes (2006:61) also emphasizes the extent to which the Pinton workshop was involved.

10. GFR to Duncan MacGuigan, Acquavella Galleries, 12/29/1992, 018-043.

11. Ross (1991).

12. Troy (2006a:241). The following information about Lurçat has been drawn from Fadat (1992), Kahan (2008), Guinot (2003), Galerie Denise René (1974), and Musée departemental de la tapisserie (1992a, 1992b).

13. Moulin in Galerie Denise René (1974, not paginated).

14. Sources for these monikers are Fontes (2006:132), Majorel (1991:10), Tourlière (1991:11), Majorel (1991:10), and Lagrange (1991:13).

15. Mathias (1991:15), translated from French by Hedlund.

16. All citations in this paragraph are from Guinot (2003:48), translated from French by Hedlund.

17. Majorel (1991:10), Tourlière (1991:12).

18. Information about Majorel is available in Lévêque (1968) and Contamin (1990, 1998), and in her own works (Majorel 1972, 1991). See also Stoodley (2009).

19. Galerie Denise René (1974).

20. Kahan (2008:19–29) has documented the professional life and work of Cauquil-Prince.

21. James Auer, "Chagall Artistry to Be Unveiled." *Milwaukee Journal Sentinel*, 4/29/1973, pp. 129–42.

22. Correspondence between Gloria and Cauquil-Prince and Gloria's notes about working with the French artiste-cartonnier appear in files 129 and 173 of the GFR Papers.

23. The unpublished work of tapestry scholar Nathalie Fontes (1997, 1998, 2006) provides a wealth of information about the Pinton empire, past and present.

24. Fontes (2006:141).

25. Guinot (2003:50).

26. Lesné (2005:42).

27. Citations from correspondence between Gloria and Olivier and Francois Pinton, and her notes about working with Manufacture Pinton appear in files 12, 29, 47, 113, 168, 169, 200, 202, 203, 204, 205, and 206 of the GFR Papers.

28. Gloria frequently termed those with whom she worked "my artists." She always placed the words within quotation marks, however, as if to mock herself or to indicate the irony of her "possessing" the artists.

29. I am grateful to Olivier and Marie Pinton for these reminiscences shared during a visit at their home at Sèvres, outside Versailles, in 2005.

30. Apparently François took over while his brother Olivier was on vacation. After this "coup," the brothers rarely interacted and François remained director until 2003.

31. In contrast to her relationship with Olivier, however, Gloria never visited François at home nor met his wife. She did know their son Lucas as a very young man who occasionally came into the workshop.

32. These were Avery's "after *Dunes and Sea*," Bearden's "*Recollection Pond*" and "*Mille Fleurs*," Frankenthaler's "after *1969 Provincetown Study*," Goodnough's "*Tapestry III*," Marca-Relli's "after *Multiple Image*," and Motherwell's "after *In Brown and White*."

33. Citations from correspondence between Gloria and Raymond Picaud, and her notes about working with Picaud appear in files 32, 197, and 198 of the GFR Papers.

34. Guinot (2003:47).

35. Guinot (1996:77, translated from French by Hedlund.

36. Guinot (2003:51).

37. Literally, "the fall of the loom," but colloquially meaning the removal of a new work from the loom—a common cause for celebration. Ironically given the scheduling nightmares, *tomber bien* also carries the connotation of "to come at the right time" or "to happen opportunely."

38. The artist's name was, however, misspelled as "Linder," which unfortunately has been repeated in subsequent publications (Guinot 2003:77).

39. These statements and those following came from email correspondence from Micheline Henry to ALH, 5/22/2008. Henry's original French messages were translated by Hedlund.

40. Citations from correspondence between Gloria and Micheline Henry, and Gloria's notes about working with Henry appear in files 27, 190, and 194 of the GFR Papers.

41. GFR postcard to ALH, 3/25/1987, in the files of the author.

42. Congregation Emanu-El (1996).

43. Citations from Gloria's notes about the Congregation Emanu-El commission and her correspondence with others involved in this project appear in files 171 and 205 of the GFR Papers.

44. Bertrand, Joubert, and Lefbure (1995). An earlier American exception for the Pinton workshop was Hilaire Hiler, an American-born artist and jazz musician (1898–1966) who lived in Paris during the 1920s and early 1930s and designed for Pinton an amusing series depicting stylized American Indians in war dress (Fontes 1998:III).

45. Association du développement du pays d'Aubusson (1983:78–80).

46. This and the following statements derive from email from Micheline Henry to Hedlund, 5/22/2008, translated from the French by Hedlund.

47. Lucas Pinton, Felletin, personal communication, October 2005.

6. Other Explorations (pp. 81–89)

1. GFR to Sue Walker, 3/20/1988, 165-33.

2. Helena Hernmarck, personal communication, 6/11/2005.

3. This and the following citations are from Fino (2002).

4. Ribeiro (2002).

5. GFR to Archie Brennan, 1/3/1970, 193-012.

6. All subsequent versions of "*Blackout*" were made at the Dovecot Studios. The Scottish pieces were labeled 1/5, 3/5, 4/5, and 5/5. The Portuguese one was apparently renumbered 2/5 and sold by Pace Editions to Avon Products, Inc., for the staff cafeteria in New York.

7. The Manufactura has continued into the twenty-first century under the directorship of Guy Fino's daughter, Vera Sá de Costa, a dye specialist with a PhD in chemical engineering from MIT. A series of tapestries that Guy Fino initiated with British artist Tom Phillips, who had worked also with the Dovecot Studios, was celebrated in Portugal in 2002–3. Artists from as far away as Australia had other successful tapestries woven in Portugal (Walker 2007:13–14).

8. Correspondence between Gloria and Archie Brennan appears in file 193, GFR Papers.

9. Letters and notes to and from Mexico, 1972–73, are located in file 196. The workshops included Antonio Delgadillo D., Saul Borisov, Centro de Diseño, San Jorge, and Tejidos y Tapices in Mexico City, and Artes Populares de Tequis and Casas Coloniales of San Miguel de Allende, Artesanías Antonio Mata of Guadalajara, Tapetes y Alfombras de Lujo of Cichoncuac, and Telares Uruapán of Michoacán.

10. The Belgian correspondence is located in file 196. The workshops included Becker, Gaspard de Wit and Braquenie, all in Mechelen, and Atelier Chaudoir in Brussels.

11. GFR Papers, 196-013 to 196-026.

12. Simon and Faxon (2010); Stritzler-Levine (2006).

13. GFR to Hicks, 10/16/1979, 195-001; Hicks to GFR, 2/25/1980, 195-016.

14. An active fiber artist and teacher, Fletcher is an adjunct faculty member at the College for Creative Studies in Detroit. At Hernmarck's invitation, she participated as an "innovative emerging artist" in Generations/Transformations: American Fiber Art, a 2003 collaborative exhibition organized by the American Textile History Museum in Lowell, Massachusetts.

15. Correspondence between Gloria and Mollie Fletcher are located in file 103, GFR Papers.

16. Boman and Malarcher (1999).

17. Correspondence and information regarding this project were obtained from file 197 in the GFR Papers, and a June 2008 interview with Carole Kunstadt. Later, Kennedy moved her portion of the operation as Kennedy Tapestries to Long Island City. Sometime between 1984 and 1988, Kennedy Tapestries moved to Newburg Street in San Francisco. Janet L. Kennedy died in California in the 1990s.

18. After the partnership dissolved in 1982, Kunstadt continued to pursue an art career, working with collages, drawings, and other works on paper. More recently she has begun working in fiber again, with a focus on the expressive textures of stitching and papermaking.

19. GFR to Tamara B. Thomas, President, Fine Arts Services, Inc., of LA and NYC, 10/20/1982, 007-046.

20. All correspondence and notes related to the Vesti projects are located in file 173, GFR Papers. "The Vesti Entities" were described in a brochure, circa 1980: "*Wayne Andersen Associates* is the art consultant to several of the largest corporations in the United States, including Bechtel Corporation, American Telephone and Telegraph Company, IBM Corporation, and the Federal Reserve Bank. *Vesti Corporation, Fine Art Management*, is both the curatorial and support body of Wayne Andersen Associates and a complete art management organization serving private collections. Vesti Corporation offers acquisition and marketing counsel, curatorial and technical services, expertise, appraisals, and (through its agents) art law, tax and insurance counsel. *Vesti Corporation, Middle East Division* is under contract for extensive art programs in Saudi Arabia, including the Royal Reception Pavilion at Jeddah, the King

Abdul Aziz International Airport, the new Riyadh International Airport, and new mosques at Jeddah and Riyadh and a new town. *Vesti Corporation International* is a unit investment offshore subsidiary, managed by Vesti Corporation. *Vesti Trust* is a domestic unit investment trust managed by Vesti Corporation. *Saturday Gallery*, managed by Vesti Corporation, is the only aspect of the Vesti Entities which resembles an art gallery. . . . Except for the Saturday Gallery, Vesti operates by appointment only, and all works of art are reserved for private clients."

21. Undated postcard, with Miró tapestry on reverse, 030-026.

22. Walker (2007).

23. Correspondence between Sue Walker and GFR and Gloria's notes relating to the VTW work are located in file 165, GFR Papers.

7. The Native/Noland Tapestries (pp. 93–117)

1. Ross (1986).

2. Ross (1986).

3. Ross quoted in Sikes (1985:[1]).

4. Ross (1986). Unless otherwise noted, information for this chapter was drawn from correspondence between GFR and ALH, 1979–98, in the files of the author, and from file 163, GFR Papers. In this chapter, photos are by the author unless otherwise noted.

5. Cf. Moffett (1977:38).

6. Noland in Wilkin (1990:8).

7. Moffett (1977:56).

8. Moffett (1977:46).

9. Moffett (1977:15, 17, 47).

10. In October 1978, Gloria first corresponded with Shawna Lee Robbins, a Navajo woman living in Washington DC. Robbins's brother lived in Window Rock, the Navajo Nation's capitol, and their mother, Bertha Robbins, was a weaver in Cameron, Arizona. Gloria inquired about possibilities of collaborating with Mrs. Robbins, but no agreement was made.

11. In contrast to these initial entries, surprisingly few notes about Gloria and her project appear in my field journals, as I was concentrating on museum work and dissertation field research at the time (cf. Hedlund 1983). I recall pondering the value of her project, realizing that Navajo weavers had successfully responded to outside requests for over a century while keeping their identity clear, and thinking that they should have a chance to say yes or no directly to Gloria (and to her money), without me as gatekeeper. When Gloria called me in Gallup, New Mexico, on August 5, I agreed to meet with her. Subsequently, on our numerous southwestern trips together, I introduced her to many weavers, traders, and dealers, but then stayed relatively clear of her negotiations with them. My account of how I decided to work with Gloria and what I explained to her of Navajo circumstances is published elsewhere (Hedlund 1992:9–11). Gloria was also very respectful of my relationships with the weavers and didn't want to intervene in my scholarly research.

12. Hedlund (1992:10).

13. At Third Mesa, my husband and I introduced Gloria to the famed Hopi jeweler and family friend Charles Loloma. We continued to Boulder, Colorado, where she met archaeologist Joe Ben Wheat, my mentor since college days. They began a long friendship that prompted her to support his award-winning book, *Blanket Weaving in the Southwest* (Wheat 2003).

14. Ross (1986).

15. I am grateful to America West Airlines (now U.S. Airways) for providing plane tickets for this entire group and to the NMAI staff and many individual donors for hosting them in New York City.

16. Contemporary Navajo weaving practices and perspectives described here are documented in Hedlund (1983, 1992, 1994, 2004a, 2009).

17. Pyne (1984).

18. Duke University (1983), Noland quotation originally from Moffett (1977:39).

19. Higdon in Duke University (1983).

20. Cf. Fanelli (2005:58–59).

21. Correspondence and notes for Martha Terry's work appear in files 98, 100 and 211, GFR Papers.

22. Grace Henderson Nez was the first Navajo weaver to receive a National Heritage Fellowship Award from the National Endowment for the Arts, which honored her in Washington DC, at the age of 92 in 2005. She passed away in 2006.

23. Correspondence and notes relating to Mary Lee Begay's work are drawn from files 64–67, 71, 73, 79, 77, 82, 83, 86, and 96, GFR Papers.

24. It is not clear what Gloria was referring to here; it was not something I counseled her about in this manner. She was likely thinking about the Navajo cultural avoidance of enclosing oneself and one's designs in a solid surrounding border—concentric circles as in some well-known Noland target paintings would have this effect.

25. Correspondence between Gloria and Kenneth Noland and her notes regarding their projects are located in files 69–70, 97, and 211, GFR Papers. Additional notes about these projects appear in files 42, 77, 90, 95, and 163.

26. However, given that all this wool was scoured, carded, and dyed as roving, it is likely that the colors were actually mill-produced with some amount of dye (cf. Hedlund 2003:47–49).

27. Robert Vogele, Chicago, IL, personal communication, 6/27/2007. In the 1960s, Robert Vogele founded the RVI Corporation, which helped to establish Chicago as a major center of corporate design. Active in the Folk Art Society and head of VSA Partners, Inc., Vogele had the training and "eye" to spot a work inspired by Kenneth Noland.

28. Wilkin (1990:19, cf. pp. 13–18).

29. Correspondence and notes relating to work with Rose Owens are located in files 69, 84, and 211, GFR Papers.

30. Agee (1993:18, fig. 3); cf. "Untitled" from 1947 in Moffett (1977: fig. 12) and Waldman (1977:10).

31. Many Navajo artists express strong preference for quadrilateral symmetry over other visual systems.

32. Correspondence and notes relating to work with Sadie Curtis are drawn from files 74, 85, 89, and 98, GFR Papers.

33. M. S. Mason, "Navajo Weavings Unravel Distinction between Fine Art and Craft." *Rocky Mountain News* 7/12/1992, pp. 134, 136.

34. This design closely resembles Ramona Sakiestewa's later "*Jeddito*," woven from Noland's maquette "P."

35. Correspondence and notes relating to work with Irene Clark are drawn from files 80 and 211, GFR Papers. Clark's son Ferlin earned his MBA at Harvard and was appointed president of Diné College in Tsaile, Arizona, in 2003.

36. See Hedlund (1992:40–41).

37. Sharyn Udall, "Introduction—Ramona Sakiestewa," http://www.ramonasakiestewa.com.

38. Molly Mahaffe left the studio in 1985. Candace Chipman has continued a very productive relationship with the studio for over two decades. Rebecca Bluestone started in 1989 and worked off and on at the studio until 1996. Since working for Sakiestewa, her career has grown to include many independent commissions, exhibitions, and articles based on her contemporary handwoven tapestries (cf. Fauntleroy 2003).

39. Correspondence and notes relating to work with Ramona Sakiestewa are drawn from files 72, 75–77, 81, and 90, GFR Papers.

40. Churro sheep are a particular breed of long-legged animals with smooth shiny wool, first brought to North America in 1598 by the Spaniards. In 1980 Gloria began contributing to McNeal's dynamic project, dedicated to reviving the historic breed and providing fibers with improved color and texture to weavers.

41. Sakiestewa (2001).

42. These two insect dyes were used in nineteenth-century European fabrics that were exported to the United States, unraveled by weavers, and rewoven into Native American blankets—the origins of the famous *bayeta* in classic Navajo blankets (cf. Wheat 2003).

43. This rather patronizing perspective rarely appears in the GFR Papers, but does suggest that certain cultural gaps, especially regarding timing and deadlines, persisted. Gloria tried to grasp and appreciate Navajo women's challenges in maintaining their many roles in a changing world while complying with her requests and scheduling, but sometimes the English/Navajo language barrier and other communication obstacles (lack of phones and faxes, for example) got in the way. And sometimes cultural and regional distinctions got the better of everyone.

44. Many Navajo weavers like Sarah Natani are skilled at selecting yarns of appropriate weight for specific projects, but some weavers and collectors still attach a stigma to using commercial yarns in contrast to home-grown and hand-processed fibers.

45. Cf. Hedlund (1992:86–87; 2004a:94, pl. 70).

46. Correspondence between Gloria and Stella from 1990 is drawn from file 112, GFR Papers. Personal communication, Paula Pelosi, assistant to Frank Stella, 2/18/2010.

47. Ross (1983).

48. Baer (1987), Rodee (1981:65–66, pls. 11, 12).

49. Sakiestewa (2001).

50. Noland quoted in Sikes (1985:[4]).

51. Pyne (1984:97-16).

8. The Gloria F. Ross Tapestries & Carpets (pp. 121–299)

1. Clausen (1986).

2. Richard Solomon quoted in *Museum Views* (1992).

3. Art historian Virginia Troy reported the same sense for Marie Cutolli's early twentieth-century work: ". . . the Cuttoli tapestries that were designed with tapestry in mind, and that incorporate bold, unmodulated form and decorative borders, such as those by Le Corbusier, Matisse, and Léger, appear more successful today, and were in fact transformative to the artists then" (Troy 2006a:242).

4. Gloria wrote, "I know that your work would translate most successfully into tapestry." Bill replied, "in fact i feel that my work is not well suitable to be done in tapestry. i dislike the floating surface of all tapestries i saw, and even those of albers and noland

and so forth, are certainly not as well as the paintings." (GFR Papers, file 53).

5. A note from Owen R. Lee in March 1972 acknowledged Gloria's request, "Mr. Johns has asked that I write to you and express his regrets that he will not be interested in having his work translated into tapestry."

6. François Pinton told Gloria that La Fondation Le Corbusier, representing the famed architect's estate, did not approve of tapestries that would differ from the scale of the artist's original works. Nevertheless, the architect had worked for years with Marie Cuttoli and, as one scholar notes, he "came to view textiles as occupying a middle ground between standardized object and work art by functioning as large-scale murals in a non-painterly, textured, moveable, and utilitarian medium, thereby expanding the artistic potential of the original conception. Indeed he later referred to his woven tapestries as 'nomadic murals,' perfectly suited to modern life because one could roll them under one's arm and move them whenever necessary" (Troy 2006a:242).

7. In June 1980, Gloria approached Lichtenstein about creating a series of "Indian theme" maquettes to be woven by Navajo weavers. The artist sent several photographs of his "Indian" paintings. A series of Lichtenstein tapestries were made by Modern Masters in New York. At least one of these, *Amerind Landscape,* toured with a later exhibition of his work, "American Indian Encounters," organized by the Montclair Art Museum in New Jersey.

8. Unless otherwise noted, citations in this section are drawn from Gloria's notes and her correspondence with Georgia O'Keeffe, which are in the GFR Papers, file 102. O'Keeffe's statements are reprinted with permission; © 2010 Georgia O'Keeffe Museum/ Artists Rights Society (ARS), New York.

9. Unless otherwise noted, citations in this section are drawn from Gloria's notes and her correspondence with Henry Moore and Archie Brennan in the GFR Papers, files 54 and 193. See chapter 9 for description of Moore's work with Gerald Laing at Kinkell Caste. Shortly after Gerald Laing's workshop closed in 1974, the West Dean Studio in Chichester, England, took up the translation of Moore drawings into tapestry with considerable publicity. The twenty-three tapestries that resulted are well documented in Garrould et al. (1999).

10. Anuszkiewicz quoted in MoMA (1963).

11. Sources for Anuszkiewicz include ACA Galleries (1991); David Findlay Jr. Fine Art (2005); Mattison (2007).

12. Grad (1981).

13. Greenberg (1958:199–200).

14. Kuh (2006:157).

15. Studio Museum in Harlem (1991).

16. Wall (1975:6–7).

17. Robert Hughes, "Seeing Life in Jazz Tempo." *Time,* 1/20/1992, pp. 60–61.

18. Kuh (2006:111).

19. Urdang (1976:1).

20. Salander-O'Reilly brochure, 011-202.

21. Presumably to forestall comments or complaints, a memo about the new lobby installation explained to the building's tenants, "Davis's signature appears in the lower left—upside down—an inversion that calls attention to the calligraphic quality of the letters as a purely compositional device, but also to the prevalence of signage in the visual experience of modern life" (circa 1989, 012-033).

22. Sims (1991:312).

23. Ibid., 105.

24. Ashton (1983:6–12).

25. Dubuffet, 1972, quoted in Guggenheim (1973:36).

26. General sources for Dubuffet in English include Freidman (1973a), Donald Morris Gallery (1983), and Schjeldahl (1980). For a review of Coucou Bazar, see John Canaday's article, "Both Sides of the Watershed." *New York Times,* 5/6/1973, p. D-23.

27. Canaday (1973).

28. I am grateful to Sophie Webel, director of the Fondation Dubuffet, for information on Dubuffet's works and other records in the foundation's collection. The flexible painted pieces were likely destroyed (Loreau fasc. XXV, no. 159, p. 140; Loreau fasc. XXV, no. 161, p. 141). The original maquettes remain in the collections of the Fondation Dubuffet in France (Loreau fasc. XXV, no. 158, p. 140; Loreau fasc. XXV, no. 160, p. 141).

29. Loreau fasc. XXVIII, no. 24, p. 33. Sophie Webel, Fondation Dubuffet, personal communication, 6/14/2007.

30. Fondation Dubuffet fasc. XXXI, no. 7, p. 83. The first (1/3) was described as "One shaped small scale Dubuffet rug in Savon quality, 10.6 × 7.0" on 6/29/1976 (Invoice 016-02).

31. Loreau fasc. XXV, no. 162, p. 142.

32. *Les Péréquations* (background): Loreau fasc. XXVII, no. 29, p. 34; *Ji la Plombe* (figure): Loreau fasc. XXVII, no. 22, p. 31.

33. The original Practicable background painting in acrylic is owned by the Walker Art Center in Minneapolis and the first handwoven *Personnage* figure is in the collections of the Minneapolis Institute of Arts. Thus, by coincidence two components of the original Dubuffet plan, one painted and one woven, are neighbors.

34. In 1975 a pair of embroideries were made by Mrs. Andrée de Vilmorin after two Dubuffet drawings, *Poisson* and *Paysage,* given to her by Dubuffet.

35. The sole example of this tapestry, 165 × 127 cm (Fondation Dubuffet fasc. XXXI, no. 10, p. 88), remains in the archives of the Fondation Dubuffet.

36. Fondation Dubuffet (1979–91), Loreau (1964–79).

37. Goossen (1970:2).

38. Paul Feeley, "Bennington Art Policy," http://paulfeeley.com.

39. In a curious twist of fate, Helen Feeley later married George Wheelwright, whose aunt was Mary Cabot Wheelwright of Boston, founder of the Santa Fe museum with which Gloria became involved during her work in the American Southwest. The two women exchanged warm correspondence through ensuing years, a pattern that Gloria developed also with other artists' family members.

40. In 1960 Helen Frankenthaler named one suite of her paintings the Gloria series, encompassing at least five works on paper, composed of boldly drawn isolated splatter shapes (Wilkin 1984:66, 120, pl. 23, fig. 16). Although scholars and the artist herself caution that her painting titles "are sometimes helpful in identifying a general theme and sometimes not" (Carmean 1989:7), the possible reference to her sister remains tantalizing. The "Gloria" paintings appear even more unusual as Frankenthaler has generally avoided creating work in a series or formal sequence (Rose 1972:96). In addition, just a year earlier, Frankenthaler painted *Mother Goose Melody,* in which "three central figural shapes might refer to Frankenthaler and her two sisters" (Rose 1972:22). Still, the reference to the sisters is inconclusive. Frankenthaler has commented that as she worked through the formal aspects of the painting, "I thought of 'three sister-shapes.' But they could just as well have been four green octagonals that day" (Carmean 1989:26).

41. Pope in Wilkin (1984:6); Baro (1975:104); Daniels in Goldman (2002:vii).

42. Rose (1972:105).

43. Wilkin (1984:69).

44. Goldman (2002:2).

45. Rose (1972:53–54); cf. Wilkin (1984:90).

46. Frankenthaler in Carmean (1989:7).

47. Rose (1972:261).

48. 1977.48.44; exhibited in The Flexible Medium: Art Fabric from the Museum Collection, 1984–85, Washington DC.

49. Harry Seidler and Associates, "Hong Kong Central," http://www.seidler.net.au/projects/020.html; see also http://www.berggruen.com/ which says that the tapestry was "designed and executed by the artist after a painting maquette."

50. Frankenthaler quoted in Carmean (1989:8).

51. Carmean (1989:34); Rose (1972: plate 106).

52. For *Buddha's Court,* see Rose (1972: plate 34); Carmean (1989:40, plate 14).

53. Carmean (1989:46).

54. Scottish Arts Council (1980:94).

55. See "The Human Edge" (1967) in Carmean (1989:48); Rose (1972:100).

56. Carmean (1989:60).

57. This followed after Gloria first approached the Atelier Raymond Picaud to weave the tapestry and the work was inexplicably delayed.

58. Charles F. Moran, 1976, "Frankenthaler Original Tapestry Hands at Fourth." *Etc. Monthly/And So Fourth Newsletter* 6(2):1, 3.

59. Wilkin (1984:98).

60. Christie's twentieth-century art auction catalogue, 2/23/1999, p. 33, lot 73. Other gifts from Frankenthaler might well have become tapestries, but apparently were not: see a small oil on canvas board, inscribed "Frankenthaler April 78 for dear, dear Gloria love Helen 9 Aug '78" (Christie's 2/3/1999, p. 29, lot 223), and "Celebration Bouquet," a 1962 acrylic on canvas (Christie's 2/23/1999, p. 32, lot 70).

61. Gedeon (1999:3).

62. Goodnough quoted in Shippee Gallery (1987).

63. Scottish Arts Council (1980:92).

64. Nancy Litwin, Gottlieb Foundation, emails to ALH, 10/8/2007, 7/8/2009.

65. GFR quoted in Sikes (1985[3]).

66. I am grateful to Nancy Litwin, art collection manager at the Gottlieb Foundation, for information on the painting (6730), prints (6779P), drawing (6615) and tapestries (6885 and 7280) in the foundation's collection.

67. McCullough (1980).

68. Scottish Arts Council (1980:102).

69. McCullough (1980).

70. Tucker (1974).

71. Rose (2001:7).

72. Sandler (1980).

73. Ibid.

74. Kuh (2006:255).

75. These were *South Wind* (60 × 48 inches) and *Leise Zieht Durch Mein Gemueht Liebliches Gelaute* (74 × 48 inches).

76. Louis A. Zona, "Biography—Paul Jenkins," http://www.pauljenkins.net/bio/bio.html.

77. Ameringer Howard Gallery (2001).

78. "Hirschhorn bot [sic] red one so G can't use."

79. GFR to Liberman, 047-008.

80. Unfortunately, the painting was damaged on its voyage but was restored by a Manhattan paintings conservator (cf. Watherston 1971).

81. Ashton (1977).

82. Elderfield (1986:80).

83. Ibid., 81.

84. Although she acquired permission from Louis's estate, Gloria did not actually need it, as New York copyright laws stipulated that an artwork's purchaser prior to 1966 automatically acquired reproduction rights; after 1966, the law assured that artists retained those rights unless expressly granted to another in writing.

85. Guggenheim (1998:89).

86. Varian (1980).

87. Arnason (1982:17).

88. Motherwell quoted in Carmean (1980:77). Unless otherwise noted, citations in this section are from Gloria's notes and her correspondence with Robert Motherwell, files 55–58 and 126, GFR Papers. Motherwell's correspondence is used with permission; © Dedalus Foundation.

89. Motherwell quoted in Ashton (1982:10).

90. Hilton Kramer, "The Folklore of Modern Painting," New York Times, 1/1973.

91. Ashton (1982:10).

92. Motherwell quoted in Miller (1959:56).

93. GFR notes, 6/19/75, 057-055. I am very grateful to Katy Rogers, project manager for the Catalogue Raisonné of Paintings and Collages by Robert Motherwell at the Dedalus Foundation, for her generous assistance and advice.

94. Motherwell (1979, not paginated), ellipse in original.

95. These included Cabaret I, Burnt Sienna, Blue and Green, and Beige Figuration, none of which are Gloria F. Ross Tapestries. For more about Modern Masters, see chapter 9.

96. Katy Rogers, Dedalus Foundation, email to ALH, 11/28/2007.

97. On an early photograph of the 1962 painting Elegy No. 78, Gloria wrote "Original—later RM whitened background" (58-1). Apparently, by the time she hooked her version, the artist had modified the painting's ultimate appearance.

98. Scottish Arts Council (1980:90).

99. Nevelson quoted in Freidman (1973b:7).

100. Nevelson quoted in Gordon (1967:12).

101. "Louise Berliawsky Nevelson," Wikipedia, http://en.wikipedia.org/wiki/Louise_Berliawsky_Nevelson.

102. Pace Gallery press release, 8/12/1978, 059-020.

103. Cf. Nevelson (1976). I am grateful to Susanna Cuyler for this observation in October 2007.

104. Kramer quoted in John Russell's obituary, "Louise Nevelson, Artist Renowned for Wall Sculptures, Is Dead at 88." New York Times, 4/18/1988.

105. Rita Reif, "Putting Down the Brush and Painting on a Loom." New York Times, 9/29/1972.

106. Brennan (1998).

107. Scottish Arts Council (1980:126).

108. This tapestry was previously published under the name "Reflections" (Scottish Arts Council 1980:126).

109. This tapestry also acquired an alternate name, "Landscape upon Landscape" (Scottish Arts Council 1980:126).

110. Moffett (1977:56).

111. Agee (1993:42).

112. Wilkin (1990:7).

113. Moffett (1977:17).

114. Moffett (1977:38).

115. Moffett (1977:47); Agee (1993).

116. Noland quoted in Marzio (2004:vi).

117. Agee (1993:26, 41).

118. Greene (2004:5, citing Painters Painting, a film directed by Emile de Antonio).

119. Cf. Moffett (1977: pl. 118, Shield, 1962); Wilkin (1990:17, Magic Box, 1959).

120. Moffett (1977:58).

121. Moffett (1977:73).

122. Wilkin (1990:15).

123. Moffett (1977:73).

124. Mark Podwal, "Author Spotlight," Random House, Inc., http://www.randomhouse.com.

125. Congregation of Emanu-El (1996).

126. Congregation Emanu-El of the City of New York, "Temple Emanu-El," http://www.emanuelnyc.org.

127. Podwal, ibid.

128. Jane Harris, Arts Magazine 38 [January 1964], p. 31.

129. Sidney Tillim, Arts Magazine 39 [January 1965], p. 22.

130. This and following statements by Poons are taken from an oral history interview with Larry Poons by Dorothy Seckler, 3/18/1965, Archives of American Art, Smithsonian Institution, Washington DC.

131. Connie Rogers, "Clifford Ross." Arts Magazine, [January 1979], p. 25.

132. Hilton Kramer, "The Daring Theatricality of Lucas Samaras." New York Times, 2/26/1978.

133. Grace Glueck, "To Samaras, the Medium Is Multiplicity." New York Times, 11/24/1975.

134. Ibid.

135. Translated to English by Hedlund; OP to GFR, 3/18/1975, 202-141. Original text: "Plutôt que de réaliser un échantillon qui ne saurait être éloquent, j'ai décidé de faire tisser la tapisseries a mes risques et périls. Vous recevrez donc sous deux mois environ, cette tapisserie réalisée intégralement. Vous serez évidemment libre de la refuser si elle ne convenait pas. Il m'a paru plus facile finalement de réaliser l'intégralité plutôt qu'un fragment qui ne saurait être clair."

136. Richard Kimmelman "Another Look at Richard Smith, 30 Years Later," New York Times, 6/5/1992, p. C-22.

137. Robert Ayers, "'Abstraction is what I like . . .' Robert Ayers in conversation with Frank Stella," http://www.askyfilledwithshootingstars.com.

138. Ross (1983).

139. Bruce Weber "Ernest Trova, 'Falling Man' Artist, Is Dead at 82." New York Times, 3/13/2009. Grace Glueck "Art: Ernest Trova, His Fanciful Side." New York Times, 4/4/1980.

140. Around this time, Gloria was also asking Archie Brennan about metallic threads for a prospective Nevelson tapestry.

141. A sample of the actual metal-like yarn was subjected to Fourier Transform Infrared Spectroscopy (FTIR), a non-destructive analytical technique, and it proved to be a Mylar-based substrate with a coating of aluminum (Nancy Odegaard, Arizona State Museum, personal communication, 5/9/2006).

142. Rita Reif, "Putting Down the Brush and Painting on a Loom." New York Times, 9/29/1972.

143. Jack Youngerman, personal communication, 3/2/2010.

144. Scottish Arts Council (1980:98).

145. Jack Youngerman, 1982, exhibition brochure. Transworld Art, Alex Rosenberg Gallery, New York.

9. The Business of Tapestry (pp. 303–319)

1. Grace Hokin to GFR, 11/20/1980, 163-059.

2. Fadat (1992:79).

3. Benhamou-Huet (2008:25).

4. Ross (1990).

5. GFR to Brennan, 10/19/1988, 191-014.

6. GFR to FP, 7/24/1991, 011-108.

7. This was apparent to other experts as far away as Australia. As Sue Walker, founding director of the Victorian Tapestry Workshop, has written, ". . . a tapestry could answer the architectural need for a work of art of monumental scale presenting a continuous surface across the wall. Practical advantages included the fact that tapestries are easily transported, rolled and stored, enabling the work to be installed after construction was finished and also taken down from time to time if required. Conservation requirements of the 200-year life of the building would also be easier to meet with a tapestry than, for example, a panel painting. Finally it was pointed out that tapestry is a valuable form of acoustic control and would offer a useful level of sound absorbency when crowds congregated at important public functions in the Hall" (Walker 2007:177). Furthermore, the workshop gained much from this exposure: "Architects were the main source of much of the VTW's early work. Coming with well-articulated briefs and clear expectations, they created business and gave the Workshop commercial credibility while providing serious public art opportunities for artists. Early work with architects gave us valuable project management experience which prepared us for the monumental projects that lay ahead" (Walker 2007:77).

8. GFR to Max Bill, 5/24/1971, 053-010.

9. Ross (1991).

10. Marjorie Iseman to GFR, 8/4/1980, 164-011.

11. OP to GFR, 6/6/1972, 202-56. GFR to OP, 6/20/1972, 202-058.

12. Feigen (2000:36).

13. Edward Barry, "Art Happenings," Chicago Tribune, 4/9/1967.

14. Harold Haydon, "Discipline Draws Best from Artist," Chicago Sun-Times, 3/26/1967, section 4.

15. Arts Magazine, April 1969, p. 66.

16. Franz Schulze, "The Triumph of Décor," 137-047, published in an unidentified Chicago newspaper.

17. A year later, Brennan noted, "Incidentally, I have just declined a work by De K— for the F— Gallery, for the same reasons!" Apparently "the same reasons" referred not to any gallery intrigue, but to Brennan's judgment that this particular artist's work could not be appropriately interpreted in tapestry (see discussion about Henry Moore in chapter 8).

18. The Brennan/GFR correspondence in 1971 and 1972 is located in files 191 and 193, GFR Papers.

19. Founded in 1968 and focused on graphic arts, Pace Editions is now known as Pace Prints. Although never commercially involved with the separately incorporated Pace Gallery, Gloria sometimes consulted with its director, her friend Arnold Glimcher. Pace Gallery later became PaceWildenstein, a powerful amalgam of two venerable galleries.

20. Richard Solomon quoted in "Art in Wool: Navajo Weavings to Be Shown at Denver Art Museum." *Museum Views,* March 1992, pp. 1–2.

21. Henry Geldzahler to GFR, 164-017.

22. This note and all subsequently cited correspondence and articles relating to galleries are located in files 127, 128, 137, 163, and 164, GFR Papers.

23. Rita Reif "Putting Down the Brush and Painting on a Loom." *New York Times,* 9/29/1972.

24. Clipping, unidentified author or source, 164-028.

25. *New York World Journal Tribune,* 3/14/1967.

26. Krause was mother of foreign correspondent Chuck Krause, head of the Latin American Bureau for the *MacNeil/Lehrer NewsHour.* Alfred Ross and Krause had been classmates at Penn, and Gloria doted on such connections.

27. Correspondence and printed materials relating to Gallery 10 are located in files 97, 162, 195, GFR Papers.

28. Pyne (1984).

29. Alice Kaufman, Larkspur, CA, personal communication, 7/8/2009.

30. Hedlund (1985).

31. Crane Gallery (1990).

32. Correspondence from file 204, GFR Papers, translated from French by Hedlund.

33. GFR to OP, 5/28/1972, 202-091.

34. GFR to Micheline Henry, 6/11/1981.

35. Despite their titles, the catalogues and exhibitions included works in a variety of rug techniques, not solely handwoven tapestry (cf. Charles E. Slatkin Galleries 1965, 1968).

36. File 163, GFR Papers.

37. Correspondence between GFR and Olivier Pinton and notes regarding this issue, 1972–74, are located in file 202, GFR Papers.

38. Gerald Laing, email to ALH, 8/21/2009.

39. Gerald Ogilvie-Laing, 2008, "My Tapestry Company: Brose Patrick (Scotland) Ltd 1970–1974," manuscript in the files of the author.

40. Lauria et al. (2005:96–97).

41. Brennan to GFR, 9/2/1971, 193-028.

42. Mathison to GFR, 6/27/1978, 192-086.

43. Mount Holyoke College Art Museum (1979).

44. Robert M. Hughes to GFR, 4/16/1979, 143-043.

45. These included Goodnough's *"Red & Blue Abstraction"* (02/5), Nevelson's *"Sky Cathedral II"* (00/5), *"Mirror Desert"* (1/1) and *"The Late, Late Moon"* (1/1), Frankenthaler's "after *1969 Provincetown Study"* (3/5), Youngerman's *"Blackout"* (00/5), Motherwell's "after *Elegy to the Spanish Republic #116"* (4/5), and Gottlieb's "after *Black and Tan Disc"* (5/5). For the show, Gloria also loaned an original three-dimensional tapestry, *"Steak & Sausage"* (1/1), by Archie Brennan. Originally, the exhibition committee hoped also to include the untitled Dubuffet, but this was not available. Cf. Scottish Arts Council (1980).

46. Robertson to GFR, 2/21/1980, 192-098.

47. Venues included Mostyn Art Gallery, Llandudno (North Wales); Ferns Art Gallery, Hull; City Art Gallery, Stoke-on-Trent; Fitzwilliam Museum, Cambridge.

48. McCullough (1980).

49. GFR letter to William Sturtevant, 2/1984, 097-027.

50. Jane Kahan Gallery (2008:4–5).

51. David Ebony, 2002, "World Trade Center art works destroyed." *Art in America* 90(1):27.

52. Donna Urschel, "Lives and Treasures Taken: 9/11 Attacks Destroy Cultural and Historical Artifacts." *Library of Congress Information Bulletin,* November 2002, 61(11). Saul S Wenegrat, "Public Art at the World Trade Center." Paper presented at "September 11th: Art Loss, Damage, and Repercussions." Reprinted in *Proceedings of an IFAR Symposium,* February 28, 2002. International Foundation for Art Research, New York, NY.

53. OP to GFR, 8/3/1972, 202-062.

54. OP to GFR, 10/13/1971, 290-086.

55. AB to GFR, 2/4/1977, 193-185.

56. GFR to RP, 5/9/1973, 198-018.

57. As the story orchestrated by Edvard Grieg goes, in the Hall of the Mountain King, captive Peer Gynt pretended to be royalty with great wealth and power, in an attempt to convince his captors to let him go. His plan backfired when they thought they held a valuable hostage. He then had to reverse his story and prove that he was indeed nothing but a common person.

58. GFR to RP, 8/8/1973, 198-010.

59. Jane Kahan Gallery (2008:36).

60. GFR to FP, 6/13/1989, 204-108.

61. GFR to Marca-Relli, 3/18/1974, 052-017.

62. Judging from available figures, the rough average and median price for Navajo-woven work was $13,600; Dovecot weavings averaged approximately $10,685, with a median of $9,225; and Aubusson tapestries averaged about $9,889, with a median of $8,500.

63. The preceding correspondence between Robert Motherwell and Gloria in 1974 is located in file 57, GFR Papers. Motherwell's correspondence is used with permission; © Dedalus Foundation.

64. Archie Brennan, ca. 1969, copy in the author's files.

65. Richard Solomon, email to ALH, 12/16/2009.

10. La Tombée du Métier (pp. 321–322)

1. Ross (1983).

2. Ibid.

3. Harris (1979:3).

4. Letter from GFR to Max Bill, 5/10/1971, 053-009.

5. Richard Solomon quoted in "Art in Wool: Navajo Weavings to Be Shown at Denver Art Museum," *Museum Views,* March 1992, pp. 1–2.

References

Abbreviations

AB	Archie Brennan
ADAGP	Société des Auteurs dans les Arts Graphiques et Plastiques
ALH	Ann Lane Hedlund
ARS	Artists Rights Society, New York
ASM	Arizona State Museum, Tucson
CAF	Compagnie des Arts Français, Paris
CDC	Child Development Center, New York
DAM	Denver Art Museum, Denver, Colorado
ENAD	École Nationale des Arts Décoratifs d'Aubusson
FP	François Pinton
HDH	Hound Dog Hookers, Blackey, Kentucky
HF	Helen Frankenthaler
GFR	Gloria F. Ross
GFR Center	Gloria F. Ross Center for Tapestry Studies, Inc., Tucson, AZ (1998–2010)
GFR Papers	Gloria F. Ross Papers, Estate of Gloria F. Ross, bequeathed to the Archives of American Art, Smithsonian Institution, Washington DC; on loan to the GFR Center (1998–2011).
GFR Tapestry Program	Gloria F. Ross Tapestry Program & Fund, Arizona State Museum, University of Arizona, Tucson (2009–present)
GFR Tapestries	The Gloria F. Ross Tapestries & Carpets
MHC	Mount Holyoke College
MoMA	Museum of Modern Art, New York
NMAI	National Museum of the American Indian
OP	Olivier Pinton
RM	Robert Motherwell
SOM	Skidmore, Owings & Merrill, architectural firm
VAGA	Visual Artists and Galleries Association, New York
VTW	Victorian Tapestry Workshop, Melbourne, Australia

Primary Sources

Gloria F. Ross Papers (GFR Papers), Estate of Gloria F. Ross, bequeathed to the Archives of American Art, Smithsonian Institution, Washington DC; on loan to the Gloria F. Ross Center for Tapestry Studies, 1998–2011. Files are organized by artists' names, weaving workshops, galleries, exhibitions, and other relevant categories. Specific citations from this source are given in the form of xxx-xxx-xxx, referring to file number-document number-page number in the scanned versions of the files.

Interviews with Gloria F. Ross by the author, 10/22/1995, 2/19/1996, New York; tapes, transcriptions and notes in the files of the author.

Correspondence between Gloria F. Ross and Ann Lane Hedlund, 1979–98, in the files of the author.

Public Lectures

Brennan, Archie

1998 "The Work o' the Weaver: Fifty Years in Tapestry." The First Annual Gloria F. Ross Lecture, March 10. Yale Club, New York.

2003 "Art and Magnificence . . . but . . : Reflections on the 2002 Exhibition of Renaissance Tapestries at the Metropolitan Museum of Art in New York." The Fifth Annual Gloria F. Ross Lecture, March 21. Looking at Tapestries: Views by Weavers and Scholars, a conference co-organized by the American Tapestry Alliance and the Gloria F. Ross Center for Tapestry Studies, Hyatt Regency Hotel, Chicago.

Hedlund, Ann Lane

1985 "Navajo Weaving and Abstract Expressionism: Kenneth Noland and the Gloria F. Ross Tapestries." December 11. Linder Theater, American Museum of Natural History, New York.

Ross, Gloria F.

1973 "How Contemporary Paintings Are Translated into Tapestry." September 18. Scarsdale Woman's Club, New York.

1977 Lecture. Presented at John and Mabel Ringling Museum of Art, Sarasota.

1979 Lecture. April 8. Mount Holyoke College Art Museum, South Hadley.

1982 "Inside Today's Art World." October 4. New School for Social Research, New York.

1983 Panel discussion. The Textile Arts in America: Origins and Directions, a symposium organized by Charles Talley, November 12. Fashion Institute of Technology, New York.

1984 Lecture. March. Gallery 10, Scottsdale.

1986 "Tapestries—New Focus for Art Collectors." Harvard Business School Club of Greater New York, May 5. Harvard Hall, New York.

1988 "Gloria Ross." Slide presentation, May 21. International Tapestry Symposium, Melbourne.

1989 "Collaborating with Artists and Weavers." International Tapestry Symposium, April. University of Maryland, College Park.

1990 "Tapestries." Woman in the Arts Part III, Luncheon Lecture Series, November 8. The Brooklyn Museum, Brooklyn.

1991 Lecture. January 27. Yale Club, New York.

Sakiestewa, Ramona

2001 "Tapestry & Beyond: Exploring the 'Slender Margins Between Real & Unreal.'" The Third Annual Gloria F. Ross Lecture, May 10. McGraw-Hill Auditorium, New York.

Publications

ACA Galleries

1991 *Richard Anuszkiewicz, Constructions and Paintings: 1986–1991*. Introduction by Martin H. Bush. April 25–May 18. ACA Galleries, New York.

Adelson, Candace J.

1994 *European Tapestry in the Minneapolis Institute of Arts*. Minneapolis Institute of Arts, distributed by Harry N. Abrams, New York.

Agee, William C., with Alison de Lima Greene

1993 *Kenneth Noland: The Circle Paintings, 1956–1963*. Museum of Fine Arts, Houston.

Ameringer Howard Gallery

2001 *Alexander Liberman: Maquettes for Monuments.* June 14–August 10. Ameringer Howard Gallery, New York.

Arnason, H. H., editor

1982 *Robert Motherwell,* 2nd ed. Harry N. Abrams, New York.

Arnason, H. H.

1982 "Robert Motherwell: The Work," in Arnason (1982:17–99).

Ashton, Dore

1977 *Richard Lindner.* March 3–19. Harold Reed Gallery, New York.

1982 "Introduction—Robert Motherwell: The Painter and His Poets," in Arnason (1982:8–14).

1983 "Jean Dubuffet: The Culture of Anti-Culture," in *Jean Dubuffet: Two Decades: 1943–1962.* November 1–December 31. Pp. 6–12. Donald Morris Gallery, Birmingham.

Association du développement du pays d'Aubusson

1983 *Tapisserie d'Aubusson.* Montibus, Saint-Léonard-de-Noblat.

Baer, Elizabeth

1987 "Research for a Catalog of the Navajo Textiles of Hubbell Trading Post. National Endowment for the Humanities," grant no. GM-22317-84. Final report in the files of the author.

Barnes, Harry

1980 "Dovecot Tapestries." *Scottish Review* 19:39–45.

Baro, Gene

1975 *34th Biennial of Contemporary American Painting.* February 22–April 6. Corcoran Gallery of Art, Washington DC.

Benhamou-Huet, Judith

2008 *The Worth of Art (2).* Assouline, New York.

Bennett, Anna Gray

1992 *Five Centuries of Tapestry from the Fine Arts Museums of San Francisco.* The Fine Arts Museums of San Francisco.

Bertrand, Pierre-François, Fabienne Joubert, and Amaury Lefbure

1995 *Histoire de la tapisserie en Europe du Moyen Age à nos jours.* Flammarion, Paris.

Beutlich, Tadek

1967 *The Technique of Woven Tapestry.* Watson-Guptill, New York.

Birmingham, Stephen

1967 *"Our Crowd": The Great Jewish Families of New York.* Dell, New York.

Boman, Monica, and Patricia Malarcher

1999 *Helena Hernmarck, Tapestry Artist.* Translated by Robert Dunlap. University of Washington Press, Seattle.

Brennan, Archie (see previous section for lectures)

1980 "Transposition of a Painting into Tapestry," in Scottish Arts Council (1980:33–36).

Campbell, Thomas P., editor

2002 *Tapestry in the Renaissance: Art and Magnificence.* The Metropolitan Museum of Art, New York, and Yale University Press, New Haven and London.

2007 *Tapestry in the Baroque: Threads of Splendor.* The Metropolitan Museum of Art, New York, and Yale University Press, New Haven and London.

Carmean, E. A., Jr.

1980 "A Journal of Collaboration Presented by E. A. Carmean, Jr.," in *Robert Motherwell: Reconciliation Elegy.* Editions d'Art Albert Skira, Geneva, and Rizzoli International, New York.

1989 *Helen Frankenthaler: A Paintings Retrospective.* Harry N. Abrams, New York.

Cavallo, Adolfo Salvatore

1967 *Tapestries of Europe and Colonial Peru in the Museum of Fine Arts, Boston.* 2 vols. Museum of Fine Arts, Boston.

1993 *Medieval Tapestries in The Metropolitan Museum of Art.* The Metropolitan Museum of Art, New York.

1998 *The Unicorn Tapestries at The Metropolitan Museum of Art.* The Metropolitan Museum of Art, New York.

Charles E. Slatkin Galleries

1965 *Contemporary French Tapestries.* September 20–October 20. Introduction by Mildred Constantine; with a note on tapestries and rug hangings by Albert Chatelet. Charles E. Slatkin, Inc., New York.

1968 *American Tapestries.* Introduction by Mildred Constantine; critical notes by Irma B. Jaffe. Charles E. Slatkin, Inc., New York.

Clausen, Valerie, guest curator

1986 *Tapestry: Contemporary Imagery/Ancient Tradition, United States, Canada, United Kingdom.* Cheney Cowles Memorial Museum, Eastern Washington State University, Spokane.

Congregation Emanu-El

1996 "Dedication of Ark Curtain and Torah Mantles," commemorative brochure. Congregation Emanu-El of the City of New York, October 5. The Sanctuary, Fifth Avenue and 65th Street, New York.

Constantine, Mildred, and Jack Lenor Larsen

1973 *Beyond Craft: The Art Fabric.* Van Nostrand Reinhold, New York.

Contamin, Odile

1990 *La Galerie La Demeure, 40 ans de tapisserie contemporaine,* Mémoire de DEA, Université de Toulouse Le Mirail, Toulouse.

1998 *La tapisserie contemporaine en France dans les années soixante,* Thèse de Doctorat, Université de Toulouse Le Mirail, Toulouse.

Crane Gallery

1990 *Twentieth Century Tapestry.* March 1–April 16. Introduction by Mildred Constantine (reprinted from Charles E. Slatkin Galleries, 1965). Crane Gallery, London.

Cuyler, Susanna

1974 *The High-Pile Rug Book.* Harper & Row, New York.

David Findlay Jr. Fine Art

2005 *Richard Anuszkiewicz: A Survey.* January 8–27. David Findlay Jr. Fine Art, New York.

Donald Morris Gallery

1983 *Jean Dubuffet: Two Decades: 1943–1962.* November 1–December 31. Donald Morris Gallery, Birmingham.

Duke University Museum of Art

1983 *Kenneth Noland: Recent Paperworks.* March 4–April 15. Duke University Institute of the Arts Catalogue Series No. 1, with essay by Elizabeth Higdon. Duke University, Durham.

Elderfield, John

1986 *Morris Louis.* October 6, 1986–January 4, 1987. Museum of Modern Art, New York.

1989 *Frankenthaler.* Harry N. Abrams, New York.

1997 *Helen Frankenthaler.* Harry N. Abrams, New York.

Emery, Irene

1966 *The Primary Structures of Fabrics.* The Textile Museum, Washington DC.

Fadat, Jacques

1992 *La tapisserie d'Aubusson.* Gehan, Parthenay.

Fanelli, Franco

2005 *Kenneth Noland.* Silvana, Milan.

Faraday, Cornelia Bateman

1929 *European and American Carpets and Rugs.* The Dean-Hicks Company, Decorative Arts Press, Grand Rapids.

Fauntleroy, Gussie

2003 "Rebecca Bluestone's Visual Language." *Shuttle, Spindle & Dyepot* 34(4): 33–36.

Feigen, Richard L.

2000 *Tales from the Art Crypt: The Painters, the Museums, the Curators, the Collectors, the Auctions, the Art.* Knopf, New York.

FiberArts

1983 Special Issue: Tapestry. *FiberArts* 10(3).

Fino, Guy

2002 "The Fascination of Wool." Essay for Woven Music, an exhibition of works by Tom Phillips and Portalegre Tapestries, December 2002–February 2003. Galeria Tapeçarias de Portalegre, Lisbon.

Fondation Dubuffet

1979–91 *Catalogue des travaux de Jean Dubuffet, Fascicles XXIX–XXXVIII.* Éditions de Minuit, Weber, and Fondation Dubuffet, Paris.

Fondation Maeght

1985 *Jean Dubuffet, rétrospective, peintures, sculptures, dessins.* Fondation Maeght, Saint-Paul.

Fontes, Nathalie

1997 *Le mobilier en tapisserie moderne d'Aubusson entre 1900 et 1940.* 2 vols. Master's thesis, Art History, Université de Toulouse Le Mirail, Toulouse.

1998 *La tapisserie moderne à la manufacture Pinton entre 1900 et 1945.* 2 vols. Mémoire de DEA, Art History, Université de Toulouse Le Mirail, Toulouse.

2006 *La manufacture Pinton et l'art du vingtième siècle. Le désir d'innover dans la tradition.* Thèse de Doctorat, Université de Toulouse Le Mirail, Toulouse.

Friedl, Helmut, and Tina Dickey, editors

1998 *Hans Hofmann.* Hudson Hills Press, New York.

Freidman, Martin

1973a *Jean Dubuffet: Monuments, Simulacres, Praticables.* February 4–March. Walker Art Center, Minneapolis.

1973b *Nevelson: Wood Sculptures.* E. P. Dutton, New York.

Galerie Denise René

1974 *Tapisseries d'Aubusson.* Introduction by Raoul-Jean Moulin, Galerie Denise René, Paris, New York, and Dusseldorf.

Galerie La Demeure

1972 *Des peintres, un lissier, une oeuvre concertée.* February 1–20. La Demeure, Paris.

Galice, Roland

1990 *La technique de A à X de la Tapisserie de haute et basse lice et du tapis de Savonnerie.* Chromographie, Paris.

Garrould, Ann, Valerie Power, and Henry Moore

1999 *Henry Moore Tapestries.* Lund Humphries, Surrey.

Gedeon, Lucinda H.

1999 "Foreword," in *Goodnough: Paintings and Sculpture.* May 2–August 29. Neuberger Museum of Art, State University of New York, Purchase.

Goldman, Judith

2002 *Frankenthaler: The Woodcuts.* Naples Museum of Art and George Brazilier, New York.

Goossen, E. C.

1969 *Helen Frankenthaler.* Frederick A. Praeger for Whitney Museum of American Art and International Council, Museum of Modern Art, New York.

1970 *Paul Feeley: A Selection from the Late 1950s Paintings.* March 10–28. Betty Parsons Gallery, New York.

Gordon, John

1967 *Louise Nevelson.* Frederick A. Praeger for Whitney Museum of American Art, New York.

Grad, Bonnie Lee

1981 "Introduction," in *Milton Avery.* Strathcona, Royal Oak.

Green, Charles

2001 *The Third Hand: Collaboration in Art from Conceptualism to Postmodernism.* University of Minnesota Press, Minneapolis.

Greenberg, Clement

1958 *Art and Culture: Critical Essays.* Beacon Press, Boston.

Greenberg, Evelyn L.

1994 "The Tabernacle in the Wilderness: The Mishkin Theme in Percival Goodman's Modern American Synagogues." *The Journal of Jewish Art* 19/20:45–53.

Greene, Alison de Lima

2004 "Kenneth Noland: The Nature of Color," in *Kenneth Noland: The Nature of Color,* pp. 2–17. Museum of Fine Arts, Houston.

Guggenheim Museum

1998 *After Mountains and Sea: Frankenthaler 1956–1959.* January 15–May 3. Guggenheim Museum, New York.

1973 *Jean Dubuffet: A Retrospective.* The Solomon R. Guggenheim Foundation, New York.

Guinot, Robert

1980 *Aubusson: son histoire, ses rues, sa tapisserie.* Éditions Imprimerie d'Aubusson.

1996 *La tapisserie d'Aubusson et de Felletin: une passionnante épopée.* Librairie des Trois Épis, Brive.

2003 *La tapisserie et les tapis d'Aubusson.* Éditions Allan Sutton, Saint-Cyr-sur-Loire.

Harris, Jean C.

1979 "Introduction," in Mount Holyoke College Art Museum (1979:3).

Harvey, Nancy

1991 *Tapestry Weaving: A Comprehensive Study Guide.* Interweave Press, Loveland, CO.

Hedlund, Ann Lane (see previous section for lectures)

1983 *Contemporary Navajo Weaving: An Ethnography of a Native Craft.* Unpublished dissertation. Department of Anthropology, University of Colorado, Boulder.

1992 *Reflections of the Weaver's World: The Gloria F. Ross Collection of Contemporary Navajo Weaving.* Denver Art Museum, distributed by University of Washington Press, Seattle.

1994 *Contemporary Navajo Weaving: Thoughts that Count.* Special issue of *Plateau* 65(1). Museum of Northern Arizona, Flagstaff.

2003 "Commercial Materials in Modern Navajo Rugs." *American Indian Art* 28(3):44–55.

2004a *Navajo Weaving in the Late Twentieth Century: Kin, Community, and Collectors.* University of Arizona Press, Tucson.

2004b "Tapestry Translations in the Twentieth Century: The Entwined Roles of Artists, Weavers, and *Éditeurs.*" Paper presented at the 9th Biennial Symposium, Textile Society of America, October 8. Oakland.

2005 "Documenting a 20th Century Tapestry Project: The Gloria F. Ross Archives and Ethnographic Inquiry." Paper presented at the 50th Anniversary Conference of Centre International d'Études des Textiles Anciens (CIETA), September 27. Lyon.

2009 "Hot Trends in Southwestern Weaving," in *Sculpture Objects & Functional Art,* pp. 36–41. The Art Fair, Chicago.

Hodge, Maureen

1980 "A History of the Dovecot Studios," in *Scottish Arts Council* (1980:39–43).

Iseman, Marjorie F.

1974 "My Father and Mrs. Roosevelt's Dogs." *American Heritage* 25(5):48–51.

Jane Kahan Gallery

2008 *Fine Art Tapestries in the 20th Century.* Jane Kahan Gallery, New York.

Kuh, Katharine

2006 *My Love Affair with Modern Art: Behind the Scenes with a Legendary Curator,* edited and completed by Avis Berman. Arcade, New York.

Lagrange, Jacques

1991 "Les couleurs d'un amis," in Musée départemental de la tapisserie (1991b:13).

Lauria, Jo, Suzanne Baizerman, and Toni Greenbaum

2005 *California Design: The Legacy of West Coast Craft and Style.* Chronicle Books, San Francisco.

Lévêque, Jean-Jacques

1968 "La Galerie La Demeure." *Extrait de Cimaise: art et architecture actuels* 15:88–89.

Lesné, Sabine

2005 "Ateliers Pinton: Le fil du temps." *Ateliers d'Art* 58:24–27. English translation on pp. 40–42.

Loreau, Max, compiler

1964–79 *Catalogue des travaux de Jean Dubuffet, Fascicles I–XXVIII.* Jean Jacques Pauvert, Paris.

Lurie, Yael, and Jean Pierre Larochette

2008 *Water Song Tapestries: Notes on Designing, Weaving and Collaborative Work.* Genesis Press, Berkeley, and El Tuito, Jalisco.

Majorel, Denise

1972 "Introduction," in Galerie La Demeure (1972).

1991 "A propos de Pierre Baudouin," in Musée départemental de la tapisserie (1991b:10–11).

Marzio, Peter C.

2004 "Foreword," in *Kenneth Noland: The Nature of Color.* Museum of Fine Arts, Houston.

Mathias, Martine

1991 "Pierre Baudouin, ou la tapisserie absolue," in Musée départemental de la tapisserie (1991b:15–17).

Mattison, Robert S.

2007 *After Image: Op Art of the 1960s.* March 8–April 28. Jacobson Howard Gallery, New York.

McCabe, Cynthia Jaffee, editor

1984 *Artistic Collaboration in the Twentieth Century.* Smithsonian Institution Press, Washington DC.

McCracken, Ursula

1998 "Gloria F. Ross 1923–1998." *The Textile Museum Bulletin,* Fall issue, p. 13.

McCullough, Felix

1980 "Edinburgh Festival." *Arts Review,* August 29.

McEvilley, Thomas

1992 *Art and Otherness.* Documentext/McPherson, Kingston.

Miller, Dorothy C., curator

1959 *The New American Painting as Shown in Eight European Countries, 1958–1959.* Museum of Modern Art, New York; distributed by Doubleday, Garden City.

Moffett, Kenworth

1977 *Kenneth Noland.* Harry N. Abrams, New York.

MoMA (Museum of Modern Art)

1963 *Americans 1963.* Museum of Modern Art, New York.

Motherwell, Robert

1979 *Robert Motherwell: Prints 1977–1979.* May 12–June 9. Foreword and footnotes by the artist. Brooke Alexander [Gallery], New York.

Mount Holyoke College Art Museum

1979 *Gloria F. Ross Tapestries.* March 29–April 27. Introduction by Jean C. Harris. Mount Holyoke College Art Museum, South Hadley.

Musée départemental de la tapisserie, Centre Culturel et Artistique Jean-Lurçat

1991a *Le XXe siècle au tapis: aspects du tapis en France de l'art nouveau à l'art contemporain.* Musée départemental de la tapisserie, Aubusson.

1991b *Pierre Baudouin: Tapisseries de Peintres.* Musée départemental de la tapisserie, Aubusson.

1992a *Jean Lurçat et la renaissance de la tapisserie a Aubusson.* Proceedings of the 1992 colloquium. Musée départemental de la tapisserie, Aubusson.

1992b *Jean Lurçat: le combat et al victoir.* Aubusson 92 Centenaire. Musée départemental de la tapisserie, Aubusson.

Nevelson, Louise

1976 *Dawns and Dusks: Taped Conversations with Diana McKown.* Charles Scribner's Sons, New York.

New Jersey Center for Visual Arts

2003 *Contemporary Tapestry: Archie Brennan, Susan Martin Maffei.* New Jersey Center for Visual Arts, Summit.

New Jersey State Museum

1985 *From American Looms: Scheuer Tapestry Studio.* March 9–April 28. New Jersey State Museum, Trenton.

Phillips, Barty

1994 *Tapestry.* Phaidon, London.

Pianzola, Maurice, and Julien Coffinet

1971 *Tapestry.* Van Nostrand Reinhold, New York.

Prival, Marc

1982 "Memoire de la tapisserie: De la tradition à la rénovation," in *Une ville dans son pays: Aubusson, hier at aujourdhui, approche ethnologique,* edited by Maurice Robert, pp. 187–95. Societé d'ethnographie du Limousin et de la Marche, Limoges.

Pyne, Lynn

1984 "Exhibition Makes New York–Navajo Fine Art Connection." *The Phoenix Gazette,* March 7, 1984, Section F, p. 1.

Ramses Wissa Wassef Art Centre

2006 *Egyptian Landscapes: 50 Years of Tapestry Weaving at Ramses Wissa Wassef Art Centre.* Ramses Wissa Wassef Art Centre, Cairo.

Ribeiro, José Sommer

2002 "Postscript," from an essay for Woven Music, an exhibition of works by Tom Phillips and Portalegre Tapestries, December 2002–February 2003. Galeria Tapeçarias de Portalegre, Lisbon.

Rodee, Marian E.

1981 *Old Navajo Rugs: Their Development from 1900 to 1940.* University of New Mexico Press, Albuquerque.

Rogers, Connie

1979 "Clifford Ross." *Arts Magazine,* January, p. 25.

Rose, Barbara

1972 *Frankenthaler.* Harry N. Abrams, New York.

2001 "The Construction, Deconstruction, and Reconstruction of Abstraction," in *Al Held: Large-scale Watercolor Paintings.* Pillsbury Peters Fine Art, May 18–July 7, Dallas, and Gerald Peters Gallery, October 12–November 10, Santa Fe.

Rosenberg, Harold

1969 *Artworks & Packages.* University of Chicago Press, Chicago.

Russell, Carol K.

1990 *The Tapestry Handbook.* Lark, Asheville.

Sandler, Irving

1980 *Al Held, 1959–1961.* April. Robert Miller Gallery, New York.

Schjeldahl, Peter

1980 "Dubuffet, 1980," in *Jean Dubuffet: Recent Paintings.* October 31–November 29. Pace Gallery, New York.

Scottish Arts Council

1980 *Master Weavers: Tapestry from the Dovecot Studios, 1912–1980.* Canongate Books, Edinburgh.

Shaw, Courtney Ann, guest curator

1989 *American Tapestry Weaving since the 1930s and Its European Roots.* March 27–April 26. The Art Gallery, University of Maryland, College Park.

Shippee Gallery

1987 *Robert Goodnough: Cubism in Transition.* December 3–January 9, 1988. Shippee Gallery, New York.

Sikes, Gini

1985 "By Design." *Metropolis* 4(8):39–41, 46.

Simon, Joan, and Susan Faxon

2010 *Unbiased Weaves: Sheila Hicks, Fifty Years.* Yale University Press, New Haven and London, with Addison Gallery of American Art, Andover.

Sims, Lowery Stokes

1991 *Stuart Davis: American Painter.* The Metropolitan Museum of Art, New York, distributed by Harry N. Abrams.

Soroka, Joanne

1983 "The Edinburgh Tapestry Company: A Thriving Anachronism in Scotland." *FiberArts* 10(3):59.

Stack, Lotus

1988 *The Essential Thread: Tapestry on Wall and Body.* Minneapolis Institute of Arts, Minneapolis.

Standen, Edith Appleton

1987 *Renaissance to Modern Tapestries in The Metropolitan Museum of Art.* The Metropolitan Museum of Art, New York.

Stoodley, Sheila Gibson

2009 "Dream Weavers: Picasso, Calder, Chagall and Other Modern Artists Breathed New Life into the Medieval Craft of Tapestry." *Arts & Antiques* 32(8):72–81.

Stritzler-Levine, Nina, editor

2006 *Sheila Hicks: Weaving as Metaphor.* Yale University Press, New Haven and London,

for the Bard Graduate Center for Studies in the Decorative Arts, Design and Culture, New York.

Studio Museum in Harlem, The

1991 *Memory and Metaphor: The Art of Romare Bearden, 1940–1987.* April 14–August 11. The Studio Museum in Harlem, New York.

Talley, Charles

1983 "The Navajo Tapestry: A Medium of Exchange." *Craft International* 2(4):16–20.

Tourlière, Michel

1991 "Pierre Baudouin: Le 'maître-d'oeuvre,'" in *Musée départemental de la tapisserie* (1991b: 11–12).

Troy, Virginia Gardner

2006a "Marie Cutolli: Patron of Modern Textiles," in *Textile Narratives + Conversations, Proceedings of the 10th Biennial Symposium,* pp. 237–44. Textile Society of America, Toronto.

2006b *The Modernist Textile: Europe and America, 1890–1940.* Lund Humphries, Aldershot.

Tucker, Marcia

1974 *Al Held.* October 11–December 1. Whitney Museum of American Art, New York.

Urdang, Beth

1976 *Stuart Davis: Murals, an Exhibition of Related Studies, 1932–1957.* January 27–February 14. Zabriskie Gallery, New York.

Varian, Elayne H.

1980 "Preface," in *Marca-Relli.* November 6, 1979–January 1, 1980. John and Mabel Ringling Museum of Art, Sarasota.

Waldman, Diane

1977 *Kenneth Noland: A Retrospective.* Solomon R. Guggenheim Museum and Harry N. Abrams, New York.

1986 *Jack Youngerman.* Solomon R. Guggenheim Museum, New York.

Walker, Sue

2007 *Artists' Tapestries from Australia, 1976–2005.* Beagle Press, Roseville, New South Wales.

Wall, Donald, editor

1975 *Gene Davis.* Introduction by D. Wall. Praeger Publishers, New York.

Watherston, Margaret

1971 "The Cleaning of Colorfield Paintings." Paper presented at the meeting of the International Institute for Conservation of Historic and Artistic Works (American Group), Oberlin, June. Reprinted in *The Great Decade of American Abstraction.* Museum of Fine Arts, Houston, 1974.

Weeks, Jeanne G., and Donald Treganowan

1969 *Rugs and Carpets of Europe and the Western World.* Weathervane Books, New York.

Wheat, Joe Ben

2003 *Blanket Weaving in the Southwest,* edited by Ann Lane Hedlund. University of Arizona Press, Tucson.

Wilkin, Karen

1984 *Frankenthaler: Works on Paper, 1949–1984.* George Braziller, New York.

1990 *Kenneth Noland.* Rizzoli, New York.

Note: Numbers in italics following page sequences indicate illustration page numbers.